FLORENTINE PAINTING
AND ITS SOCIAL BACKGROUND

FREDERICK ANTAL

FLORENTINE PAINTING
AND ITS SOCIAL BACKGROUND

THE BOURGEOIS REPUBLIC
BEFORE COSIMO DE' MEDICI'S ADVENT TO POWER:
XIV AND EARLY XV CENTURIES

ICON EDITIONS

HARPER & ROW, PUBLISHERS

New York, Evanston, San Francisco, London

This work was originally published in 1948 by Routledge & Kegan Paul Ltd.

FLORENTINE PAINTING AND ITS SOCIAL BACKGROUND. All rights reserved. Printed in the United States of America. No part of this book may be used or reproduced in any manner whatsoever without written permission except in the case of brief quotations embodied in critical articles and reviews: For information address Harper & Row, Publishers, Inc., 10 East 53rd Street, New York, N.Y. 10022. Published simultaneously in Canada by Fitzhenry & Whiteside Limited, Toronto.

FIRST ICON EDITION

ISBN: 0-06-430067-6

75 76 10 9 8 7 6 5 4 3 2 1

CONTENTS

PREFACE p. xxiii

INTRODUCTION p. 1

I. THE FOUNDATIONS. FOURTEENTH AND EARLY FIFTEENTH CENTURIES

1. ECONOMIC, SOCIAL AND POLITICAL HISTORY p. 11

2. ECONOMIC, SOCIAL AND POLITICAL IDEAS p. 38

v

CONTENTS

CONTENTS

CONTENTS

CONTENTS

CONTENTS

CONTENTS

LIST OF ILLUSTRATIONS

LIST OF ILLUSTRATIONS

LIST OF ILLUSTRATIONS

LIST OF ILLUSTRATIONS

LIST OF ILLUSTRATIONS

LIST OF ILLUSTRATIONS

LIST OF ILLUSTRATIONS

LIST OF ILLUSTRATIONS

LIST OF ILLUSTRATIONS

LIST OF ILLUSTRATIONS

PREFACE

THIS book was written between 1932 and 1938. Exterior circumstances, among them the war, have held up its publication until 1947, so that I have had to fulfil, literally if involuntarily, Horace's postulate of *nonumque prematur in annum.* Since, however, this is not poetry, I have at least tried, as far as prevailing conditions allowed, to keep up to date references in the book to scientific literature appearing in the interval. More pleasant than looking back upon this enforced delay is to recall the varied help I have experienced in producing the book. I feel most sincere gratitude to the Society for the Protection of Science and Learning, which enabled me to work on it during a particularly difficult period. Prof. F. Saxl, Director of the Warburg Institute, has given very efficacious support in many ways to the book. I owe much to Mr. Herbert Read for his sympathetic understanding in matters relating to the publication. Conversations with colleagues, in particular Dr. H. D. Gronau, Prof. R. Offner of New York University, Mr. J. Pope-Hennessy, Mr. P. Pouncey and Dr. E. Wind have helped to clarify various points. Dr. Gronau and Prof. Offner, in addition to Prof. O. Siren of the Stockholm Museum, were also kind enough to put photographs at my disposal. I am greatly obliged to Sir Robert Witt for the liberal use of his Art Reference Library. I wish to offer warm thanks both individually and collectively to the numerous public galleries and owners of private collections by whose courtesy I have been able to reproduce pictures belonging to them. I am most indebted to Prof. E. Weekley and to the following friends and colleagues who have endeavoured to assist me over difficulties of wording, since English is not my mother tongue: Messrs. A. Blunt, J. Byam Shaw, G. Clutton, P. Floud, Dr. F. D. Klingender, Messrs. C. Mitchell, D. Streatfield and A. West. I should not like to finish this preface without a deeply felt tribute to my wife for her encouragement, endurance and criticism.

<div align="right">FREDERICK ANTAL.</div>

London, 1947.

INTRODUCTION

IN the great central hall of the National Gallery in London, two paintings of the Madonna and Child hang *en pendant*: one by Masaccio (Pl. 102), the other by Gentile da Fabriano (Pl. 103)*. Both pictures were painted in Florence, and their dates, 1426 and 1425, differ only by a single year. And yet there is a vast difference between the two pictures.

Masaccio's picture is matter-of-fact, sober and clear-cut. The sacred personages have a marked earthly flavour. Mary is depicted as an unpretentious woman, who appears somewhat weary. The child, shown quite naked, asserts his divine character even less, and looks more like an infant Hercules than an infant Jesus. His hands are not engaged in a ritual gesture; he is sucking his thumb like any human baby. This matter-of-fact conception is in harmony with the matter-of-fact treatment of the figures and their placing in space. The structure of the figures is clear, and so are their poses. Mary's simple dress and draped mantle plainly show the formation of her body. The nudity of the infant Jesus serves the same purpose; the artist obviously attached the greatest importance to this problem of the human body. The frugal use of colour (blue mantle, rose-red tunic, grey stone throne) and the meticulously calculated fall of light are also intended to stress the modelling. Space and the arrangement of figures and objects in it are treated as rationally as the figures themselves. Mary's throne recedes into the background with a foreshortening of almost text-book precision; in the foreground, depth is achieved by steps leading up to the throne. The throne is planted solidly in the centre of the picture-space with two angels placed in front of it and two others behind it, again stressing depth. All the figures in the picture are grouped in natural balance, giving a clear, simple composition of horizontals, verticals and calm diagonals.

Gentile's picture has none of this clarity and objectivity, none of Masaccio's austerity. His Mary's bearing and pose are those of a lovely and gracious queen, enthroned in a pomp-loving Court of Heaven. Her mantle, open in front, reveals richly ornamented robes. Compared with Masaccio's figures, her body has little plasticity. She is seated in hieratic frontal pose, without the fore-shortening that makes clear the volume of her body in Masaccio's picture. Gentile does not build up his figure robustly from within, but defines it by means of rhythmic, undulating outlines. The hands have no firm grip; they are daintily bent, with the fingers elegantly spread. The drapery too serves a different purpose from that of Masaccio. It is used not to emphasise the modelling of the

*They were so hung at the time of writing this book, before the Second World War.

I

body, but to create a delicate fluctuating rhythm of lines around it. Nor does it fall in natural folds in accordance with the laws of gravity; it is arranged in graceful, ornamental festoons. Gentile's infant Jesus is the child of a very wealthy house; he is dressed in a gold-embroidered garment, and wrapped in a dark golden shawl, so that no part of his body is left uncovered. Courtly pomp is as much a characteristic of the subject-matter of this picture as two-dimensional flatness is of its form. The hangings and cushions of the throne are of a costly material very similar to that of Mary's robes, thus strengthening the effect of a two-dimensional intertwining of fabrics and figures. The great expanse of backcloth with its pattern of large golden flowers further stresses the ornate, depthless, prevalently decorative character of the whole picture, as do the elongated angels who form Mary's court and who hardly seem to have standing room, arranged as they are one above the other. The impression given by the whole picture is that of a surface covered with rich materials into which figures are introduced in a rhythmic pattern.

How could two such widely differing pictures have been painted in the same town and at the same time? What answer would art history give to this question?

Art history, as hitherto understood, primarily concerned itself with a formal analysis of Masaccio's severe composition or a description of Gentile's swinging linear rhythm. It would seek to explain the difference between these two pictures by saying that each belongs to a different stylistic trend, one to what it calls the "classic" or "renaissance" style and the other to the "late-Gothic".* Each style has its own specific development, and art history is the history of these styles.

But can styles be explained merely by putting labels on them and describing their characteristics? In other words, is the co-existence of various styles in the same period explained by merely stating the fact that they do co-exist?

Here and there attempts to account for this co-existence of styles have been made. One answer sometimes given to the question is that the artists concerned, although they painted at the same time, belonged to different generations. The style of the younger artist is then generally described as "progressive" and that of his elder contemporary as retrogressive, reactionary, or the like. Thus, in this case, the younger Masaccio's style would be called progressive and the older Gentile's retrogressive. But what if the artists are not only contemporaries but

* Some time ago, in two essays ("Studien zur Gotik im Quattrocento", *Jahrb. der Preuss. Kunstslg.*, XLVI, 1925; "Gedanken zur Entwicklung der Trecento- und Quattrocento-Malerei in Siena und Florenz", *Jahrb. für Kunstwiss.*, II, 1924–25) I made the attempt to distinguish between these two main trends. By extending the use of Wölfflin's cinquecento terminology, I applied the term "classic" to the similar quattrocento style as well. To-day, I should regard it as more appropriate to call both styles—that of Masaccio as well as that of Raphael—"classicist" (see. p. 305, footnote); though, in point of fact, I am not so much concerned with stylistic nomenclature as with the roots and origins of the different styles themselves.

2

coevals as well? I have selected these two pictures because their identity of subject, date and present location makes them specially suitable for such a comparison. But what if we substitute for Gentile his much younger imitator, Antonio Pisano, also a painter famed throughout Italy? Or, if we wish to keep to Florence, what if we compare Masaccio's work with the contemporary style of such outstanding artists as Fra Angelico or Paolo Uccello? In either case, we find stylistic discrepancies substantially as great as in our previous comparison.

By what standards does art history, basing itself solely on stylistic criteria, classify certain artists as progressive, others as retrogressive? In general, it is the older style which is classed as retrogressive, while the more recent style is described as progressive. But are things really quite so simple? Riegl and Dvořák, the two great art historians of the Viennese school, have shown that increasing naturalism is not necessarily the hall-mark of a more recent style, but that, on the contrary, chronological development often runs in the opposite direction. The trend in Florentine painting after Masaccio is a case in point. No painter of the second half of the fifteenth century really carried on the Masaccio tradition; all the painting of this period can be classed, more or less, as "late-Gothic". Does this mean that we must regard such very great artists as Botticelli or Filippino as retrogressive? Can we describe as retrogressive the art of long periods or entire centuries?

Another explanation which should be mentioned here is that of "influence": variations of style, and hence the co-existence of different styles, are often ascribed to different influences. In our case, the style of Masaccio would perhaps be described as "specifically Florentine" with a possible mention of Giotto's influence, while in the case of Gentile, who was not a native of Florence, there might be detailed reference to North Italian, French, Umbrian, Sienese influences. But how do such influences arise? Why have some quite definite influences affected certain styles but not others? These confusingly numerous and frequent influences require explanation as urgently as the styles themselves. For influences can take effect only if the ground is prepared for them and the need for them felt. Influences do not explain essentials; they are merely concomitant factors. In assuming the operation of influences, then, we find ourselves no nearer an explanation.

The history of styles, preoccupied as it has been mainly with the formal elements of art, thus fails to give a satisfactory answer to our question. Its terms of reference permit only of judgments based on personal taste, hardly of really valid historical explanations. Nor is further progress possible so long as we consider the problem of style from a purely formal point of view—as in the main art history still does—and so long as we continue to study the development of styles in a sort of vacuum, unconnected with other aspects of historical development. We must therefore go beyond the history of styles and look deeper for our answer. In the analysis of the pictures by Masaccio and Gentile, I have

referred to their thematic elements; indeed, I deliberately began the analysis with them. After Riegl and Dvořák, after the research work done at the Warburg Institute and by numerous American, British and Russian art historians in the last two decades, it appears permissible to assume that the subject-matter of a work of art is of no less importance than its formal elements. Considering each style as a specific combination of the elements of subject and form, the thematic elements offer an immediate transition to the general outlook on life, the philosophy, from which the pictures in question derive. Works of art considered thus are no longer isolated; we have penetrated beyond the formal and are touching upon something deeper, upon the conception of life. The formal elements, for their part, are on final analysis also dependent on the philosophies of the day; but the relationship is less direct and can be clearly discerned only after the primary connection is understood. For the theme, the subject-matter of a picture, shows more clearly than anything else how completely the picture as a whole is but part of the outlook, the ideas, of the public, expressed through the medium of the artist.

But the public is by no means unanimous in its outlook on life, and this divergence of outlook among its various sections explains the coexistence of different styles in the same period. Such divergence is, in its turn, due to the fact that what we call the public is not a homogeneous body, but is split up into various often antagonistic groupings. Since the public is merely another word for society in its capacity as recipient of art, what is required next is to examine the structure of society and the relationship between its various sections. To this end, we must ascertain the economic and social causes which have produced these divisions. This should be our first concern, for here alone have we solid ground under our feet.* To sum up: we can understand the origins and nature of co-existent styles only if we study the various sections of society, reconstruct their philosophies and thence penetrate to their art.

This is what has been attempted in the present book, which deals with the history of Florentine painting during the period in which the middle class was, for the most part, the dominant section of society. During the last years of the thirteenth century, the extremely prosperous Florentine middle class had gained a final victory over the aristocracy and given the city a constitution; in 1434, Cosimo de' Medici put an end to the regime of several warring bourgeois factions and made himself, in fact if not in name, ruler of the city, which was now rapidly declining in prosperity. The painting of the intervening period, i.e.

* As Dvořák has pointed out, economic facts throw light upon the whole development of art, even if only indirectly. In speaking of the art of the van Eycks, he remarked that art history had so far offered no explanation of its sudden emergence; the sources of the new bourgeois culture, of which this art was a product, were not known, since the growing importance of Flanders "is mentioned only in books of economic history which no one ever reads". As matters stand to-day, greater knowledge and understanding of the origins of the Renaissance are often to be found in general handbooks of economic history than in works on art history.

4

the fourteenth century and the first third of the fifteenth, the period which opens with Giotto and closes with Masaccio, is the subject of this book.

It takes for its starting-point certain facts, now firmly established, concerning the economic, social and political conditions in the Florence of the period. In the early twentieth century, new research uncovered hitherto unknown materials relating to Florentine economic and social history and revealing such dynamic factors in them as dispel for ever the conception of Florence as a community living in conditions of carefree prosperity, general harmony and timeless beauty. This new knowledge has so far hardly penetrated beyond the water-tight compartments of certain specialised branches of learning. I have here attempted to make use of this knowledge in the service of art history. It has enabled us to ascertain the specific characteristics of each section of society and to distinguish between them.* It has become possible to proceed with the attempt to reconstruct the outlook on life of these various sections, or at any rate so much of it as is required to deduce the nature of their art. I have endeavoured to discover what people belonging to different spheres of society thought and felt about the things that mattered most to them, again drawing upon the results obtained in other branches of historical science. The habits of thinking and the mutual relationships of the various social strata are probably nowhere so clearly revealed as in their economic, social and political ideas. Apart from these ideas, to which I have paid special attention, an important component—unquestionably the essential component in the outlook of our period considered from the point of view of art—is religious sentiment; scarcely any practical activity or trend of thought was dissociated from it.† I have had, therefore, to determine the attitude to religion prevailing in the various social groups and in successive generations. In my opinion, philosophy and literature, to which alone art history usually has recourse in explaining the art of a period, are much less important in this respect than religious sentiment, and should be regarded rather in the light of interesting parallel phenomena. Achievements of science, on the other hand, have occasionally furnished a vital impulse for certain stylistic trends.

The preliminary chapters dealing with the social conditions and the various ideologies offer nothing new to specialists in the fields with which they are concerned, but the art historian and the general reader may possibly find there some facts hitherto unknown to them, though much that will be familiar has had to be included as well. My object has been to cause the discussion of the

* The description of the latter half of the fourteenth century had to be comparatively full, since the relative strength of the various social forces was continually changing, in contrast to the greater stability at the beginning of the century for which a broad treatment was sufficient.

† Since religious feeling played so prominent a part in forming the general outlook, I have found it expedient to sketch its history over a period considerably antecedent to that of the art discussed; for acquaintance with the evolution of religious sentiment from the start of the early middle-class period is essential to an understanding of subsequent developments. The same applies to my account of economic and social history.

art of the period to arise naturally out of the previous social chapters, and to bring to light—by implication, if not always by direct reference—many important pre-requisites and analogies. Some of the facts relating to ideological developments and economic, social and political conditions may at first sight appear not germane to a history of art, even so unorthodox a one as this. Though no direct conclusions may be drawn from some of these facts, I would not willingly omit them.* For it is precisely such details which often throw the brightest light on the tangled web of facts and ideas before us; and which more than anything else enable us to form a realistic, unromantic picture of the people of the "Renaissance", to understand their outlook better and hence to appreciate their art the more fully.

When we have gained an understanding of the several viewpoints we shall be able, in the chapters on art, to associate each style with the conception of life corresponding to it. For, as already explained, the content of works of art provides a direct transition from conception of life to art. Hence this had to be considered first. Only then could the actual historical development of painting, the grouping together of styles and the analysis of individual works of art, be discussed. The arrangement of the material differs to some extent in the two parts of the book concerned with art history. In the first part, dealing with the fourteenth century, I have intentionally adopted a somewhat cumbrous procedure, advancing slowly, step by step; this method involves certain repetitions, but these are in my opinion unavoidable. I begin by discussing the subject-matter of the pictures in considerable detail; such discussion is necessitated by the tendency in the past to neglect the part played in art by subject-matter; for the same reason, much space is also devoted to the problem of content in the subsequent section on stylistic development. Religious and secular subjects have been dealt with separately, and among the former, narrative and purely ritual themes (Christ, Mary and the saints) have been kept apart from such as are symbolical and allegorical; this distinction has also been maintained in the presentation of stylistic development.† Having demonstrated the method in slow motion, so to speak, while dealing with the fourteenth century, and having listed the various subjects in detail, I have been able to proceed much more rapidly when discussing the early fifteenth-century paintings. In this section, I have begun almost at once with the stylistic development, merely maintaining the distinction between religious and secular themes.

Since the art of the period under discussion expresses mainly the outlook of the patrons of art, it is this that has been emphasised throughout rather than

* For brevity's sake, in the historical section, I have omitted many interesting details and facts which might have served to enlighten the theme or even to modify certain aspects of it. Further simplification would have meant falsifying the facts.

† I have not, however, applied this distinction very rigidly in a few cases where, without it, a more comprehensive view of a particular artist could be gained.

the views of the artists, who were generally much inferior to their patrons in the social scale. I have accordingly tried to trace particulars of individual commissions, since these were often as characteristic of those who gave them as of the artists who had to carry them out.* Naturally, the specific economic and social position of the artists has also been discussed, since it had a profound influence on the conditions in which works of art were produced. Closely connected with the artists' social position are the views on art held in their day, for these in their turn, like all ideologies, have their repercussions in practical life.

Once the various sections of the general public have been recognised, their way of thinking and their spiritual needs understood,† and due consideration given to the content of the pictures, it is soon apparent that stylistic divergences between various works of art are due not only to individual differences between the various artists but also to the fact that these works were intended for different sections of the public‡ or satisfied different artistic needs. I have endeavoured to do justice to the artists as personalities, but have deliberately refrained from pursuing the interpretation of individual artists or works of art to the extent hitherto customary in art history. The creative quality in the artist's personality, the uniqueness of the work of art, have naturally not been disregarded, but they have been set within the framework of historical evolution and have thus lost that all-importance and over-emphasis accorded them by an "art for art's sake" art history.§

My intention had been to limit myself to the history of painting alone. But it is hardly possible to separate the three arts rigidly; moreover, the method of this book has tended to throw a certain amount of new light upon sculpture and architecture as well.

It has not been my purpose to produce new art-historical material, or, for that matter, to discuss every well-known Florentine painting; what I have set out to do is to give an interpretation, on a new and firm basis, of material

* Although the majority of artists were of humble birth, their work often expressed the outlook of the more elevated classes by whom they were employed. When, therefore, I use such terms as "upper-middle-class" artist, I mean one who expressed the outlook of that class.

† In dealing with art before the nineteenth century, art history has paid scant attention to the question whether a given artistic trend was understood by the public as a whole or only by certain sections of it, and if so, by which.

‡ When comparing the styles appertaining to the different social sections and characterising various artistic intentions, the subjective conception of "quality" is no less misleading than a naturalistic yardstick would be. Expressions such as "stiff", "lifeless", etc., cannot, however, be avoided at present in describing the art of the relatively lower sections of society; but they are used here solely to make understanding easier. Difference of quality can be a subject of argument only when the artistic intentions are identical.

§ I have devoted more space to the explanation of complicated styles, as that of the democratic latter half of the fourteenth century, than to clear styles which can be easily understood even if the latter were connected with more prominent artistic personalities.

already more or less familiar. But the standpoint of this book has necessarily involved a consideration of works of art to which little attention has hitherto been paid.* Many questions of attribution and chronology, particularly in the fourteenth century, still await solution,† and classification according to the various stylistic groups and artists' workshops is as yet by no means complete.‡ I have been further hampered by the relatively little progress so far made in iconographical research,§ owing to the generally formalistic attitude until recently adopted by art history. Even less study has as yet been given to the very important question of patronage.** All these circumstances account for a number of uncertainties, even in matters relating to art history proper, which may have crept into this book. And I have not been concerned with art history alone. It is scarcely possible for the non-specialist, when exploring such enormous and varied spheres, to avoid mistakes, since even specialists in the field frequently differ in their opinions, and later books continually contradict earlier ones.†† Serious literature on the history of religious sentiment, or on that of political ideas in everyday life, is still in its infancy; although the groundwork has been laid, there are still innumerable gaps, even in the literature of social history, and at times guesswork or deduction has to take the place of fact. Above all, co-operation between the various branches of historical science is still in a rudimentary stage: the number of books on the psychology of the different social classes, particularly those which take the historical development genuinely into

* It would have been of assistance had more illuminations been published, especially more popular pen drawings. Art-historical research has been confined almost entirely to pictures, and to pictures of a certain standard of "quality"—others have remained practically unknown and unmentioned.

† I have had no intention of offering a dogmatic answer to the many much disputed questions of attribution and chronology (as, for example, the vexed question of the authorship of the St. Francis frescoes in Assisi); I have been concerned only with preserving the general line of development.

‡ Unfortunately only a part of Dr. Offner's great basic work on Florentine Painting of the Fourteenth Century has yet appeared.

§ Whatever has been achieved is due in great part to the initiative of the Warburg Institute.

** In cases where I have been unable to indicate the giver of the commission, I have tried at least to name the church or monastery for which the work of art was made. Even this may throw some light upon the purpose behind the commission, and in any case knowledge of this offers a basis for future research on the subject.

†† Moreover, I have frequently been obliged to take important ideas and facts from the original sources or from highly specialised material, and to present them anew in abbreviated and simplified form to suit the special purpose of this book.

A complete list of the works consulted would have been much too long, owing to the great variety of subjects treated. Hence I have mentioned only those books and essays to which I am indebted for fundamental ideas and facts, or which offer the best informative literature on the particular subject; I have also indicated a few relatively recent or lesser-known works if they contained material which has not yet become a part of general scientific consciousness. As a rule, handbooks of a general character have been omitted. I have quoted less literature in the art-history section, where I have pursued a line of my own, than in the other sections, where I have had to depend far more upon outside help.

INTRODUCTION

account, is very small. This being so, the risk of an occasional misinterpretation cannot be completely eliminated.

I can only hope that any such as yet inevitable errors will not serve as arguments against the method itself, or even against the main outlines and conclusions of this book. The time will undoubtedly come when the purely factual basis, no less than the method of sociological interpretation, will be much more solidly established than it is to-day, and when each detail will take its proper place and be correctly interpreted. Nevertheless, even at this primitive stage of research, some of the conclusions of this volume may be found enlightening. At any rate, I hope that a satisfactory answer has been given to the question asked at the beginning of this introduction: How can styles so different as those of the pictures by Masaccio and Gentile, which served us for a starting-point, exist side by side?

THE FOUNDATIONS. FOURTEENTH AND EARLY FIFTEENTH CENTURIES

1. ECONOMIC, SOCIAL AND POLITICAL HISTORY

IT is the purpose of this chapter to outline the causes of the outstanding economic importance of Florence, the development of its social structure, and the main events in its political history as seen against the economic and social background.[1]

The great economic power of Florence did not manifest itself at a specially early date; it grew up chiefly in the twelfth century, and expanded during the thirteenth and fourteenth centuries to dimensions unparalleled elsewhere in Italy or indeed in Europe. Its foundations were threefold; the textile industry, the trade in textiles and other products, and banking. This highly developed Florentine economic organisation was a primary factor in originating and furthering the penetration of a definitely monetary economy and of early forms of capitalism throughout Europe.

Of the two branches of the textile industry on which the growth and economic power of Florence depended, the Calimala, occupied with the finishing (dressing and dyeing) of cloths imported from France and Flanders, prospered only during the twelfth and thirteenth centuries, until it was ousted by the competition and hostile commercial policy of France. The second, the Lana, was engaged in weaving cloth imported from England, and to a lesser extent from France and Flanders; the *complete* process of manufacture thus took place in Florence. Wool was the most important item in the clothing of the medieval burgher, and the wealth of the towns in general was therefore founded upon it.[2] In no other town, however, did the cloth-weaving industry expand so fast or so far as in Florence. It reached its height in the period from about the mid-thirteenth to the mid-fifteenth centuries, and in the course of the fourteenth almost completely displaced the finishing industry. The Seta or silk industry assumed significance only in the fourteenth century, but played a much greater role in the fifteenth.

In all these industries it was no longer the master-craftsman, but the capitalist *entrepreneur*, who disposed of the wares to the customer. This change, which took place first in the towns of Italy and particularly in Florence, had a tremendous

effect all over Europe. The new *entrepreneur* merely directed the process of production and marketed the finished product; he had no concern with the actual manufacture. But all decisions were made by him, no one else retaining even a measure of independence. This supervision throughout the *whole* process of production, from the purchase of the raw material onwards, distinguished the Florentine woollen and silk industries from the older finishing industry.

In 1300 there were 300 firms engaged in the Florentine cloth industry; many smaller businesses were later amalgamated owing to the large amount of capital which the high cost of raw material called for, and by 1338 the number of firms had decreased to about 200. By this date these firms sold annually some 70–80,000 pieces of cloth at a price of about 1,200,000 florins,[3] and employed 30,000 persons out of Florence's total population of 90,000—one of the largest in Europe.[4]

The process of production was, however, quite irrationally decentralised. No coherent plan underlay the manner in which the work of production was divided; it was simply the chance outcome of historical conditions. The material had to pass twenty times from one place of work to another, and this naturally involved much loss of time and energy. Only a third of the workers were actually employed in the *entrepreneur's* workshop, and they carried out only the preparatory processes of cleaning and carding the wool. The other stages in production were either performed by home-workers (spinning and weaving), or in separate workshops (dyeing). The technique of Florentine wool-weaving was purely handicraft, but it was handicraft at a very high level of development, with a division and specialisation of labour and a refinement of method unknown elsewhere at the time. This refinement in the methods of production, particularly in its early stages, was partly due to the Humiliate monks, a branch of the Benedictines, who had established themselves in Florence about the middle of the thirteenth century and who actually employed wage labourers in their monasteries.

The industrialists of Florence also kept a monopoly of trade in their products, besides handling various other imported articles; for production for export was the most important aspect of Florentine industry, and the Florentine export trade in textiles conquered the world. Trade, unlike production, was organised on large-scale lines, with vast schemes of buying and selling abroad and a wide network of contacts, embracing most of the Christian and parts of the Islamic worlds; in all important foreign towns, particularly in England, France and Flanders, the merchants of Florence had their agencies and branches. From the East they imported, for re-export, spices and drugs, indispensable to Europe, and such luxury articles as pearls, precious stones, furs, etc.[5] Furthermore, as regards Italy itself, the trade of Rome, and even more that of Naples (export of grain), was almost completely in Florentine hands.[6] Experts in finance as well as in commerce, they changed over to a gold currency. Thanks to its

constant gold content, the Florentine florin[7]—introduced in 1252 by the upper middle class in celebration of their victory over the Ghibelline nobility in the previous year and of their first democratic constitution—displaced the fluctuating silver coinages as the international currency of the world market.

The industry of Florence, particularly the cloth industry and the international trade connected with it, was undoubtedly the most important enterprise of an early capitalist character in the whole of the later Middle Ages.[8] A greater power of calculation and rational foresight, and a more intimate knowledge of business conditions, were displayed in Florence than anywhere else in the entire Christian world.[9]

This judgment, however, needs modification in the light of other facts. It must be remembered that the basis of this system of production was not in every respect rationally organised. Moreover, the Florentine textile industry tended to become a luxury one. This was to be expected in the Calimala, the branch of industry which finished imported cloths, but it also holds good in great measure in regard to the genuine cloth-weaving industry. Even though good cloth for ordinary use formed a large part of the fourteenth-century production, preference was given to the finest woollen cloths, dyed with the best dyes, and later to the finest silk stuffs. It is significant that although the concentration of workshops in Florence during the first four decades of the fourteenth century resulted in a reduction of output from 100,000 pieces of cloth at the beginning of the century to 70–80,000, yet its value more than doubled owing to the use of the best imported English wool[10] instead of principally Spanish and North African, as hitherto. The value of a piece of cloth at the middle of the century was about sixteen florins, as compared with about six florins at the beginning. Apart from business dealings with the East, with foreign courts and the European nobility, the market was confined everywhere to the wealthiest sections of the middle classes, who alone could afford these luxury products; the fine cloth produced by the Calimala actually cost thirty florins a piece.[11] Large profits were often realised on these luxury articles, but these were only made possible, as we shall see later, by keeping the wages of the workers extremely low. This was imperative, if the articles were to be sold at a price which would cover the heavy risk, make a big profit, and yet be able to compete in the world market. For the expensive raw material had to be brought from a great distance and transport costs were high.[12] Further, the risks involved in doing business with feudal customers were always very great. In many cases, also, a percentage of the profits was earmarked for religious purposes in order to atone for the inevitable infringement of the canonical prohibition of interest. All these factors to some extent impeded rational and consistent industrial and commercial development.

The same Florentine citizens who were the world's greatest industrialists and merchants were also its chief bankers.[13] The trading offices of the Florentine

firms throughout the world were at the same time banks of exchange. Production, trade, and money-lending were all in the same hands. The unparalleled world-embracing power of the Florentine upper middle class was based on this combination. As a result of it the working capital of the big firms could be augmented and risks rationally distributed. The firms further increased their wealth by large acquisitions of landed property from the feudal nobility,[14] thus heightening their prestige and their capacity to obtain credit and at the same time investing their capital in the only safe way.

The bankers of Florence managed the monetary affairs of the greatest foreign courts and provided them with the ready cash they needed so badly. Much more important, from the middle of the thirteenth century, displacing the Sienese, they acquired an increasing and in the end almost exclusive control of the banking business of the Papal court, retaining their monopoly until the end of the fifteenth century, though it was somewhat relaxed during the Avignon "captivity". The Popes had more confidence in the Florentine bankers than in those of Siena, since the former, being at the same time industrialists and merchants, were in control of every aspect of Florentine life, including its politics.[15] At the end of the thirteenth century the most important of these banking houses, working with the Curia, were the Scali, the Mozzi, the Spini, and the Cerchi; in the first half of the fourteenth century the Bardi and the Peruzzi; in the second half, when the influence of the Florentine bankers at the Curia was less, the Alberti. Through its multitude of new and varied enterprises the Papacy indirectly created modern European banking; the collection of the Papal taxes, that is, the tenth of their income which the clergy all over Europe had to pay annually to the Pope, was the real source of the wealth of the great Florentine banking houses.[16] In addition, the Florentine bankers through their agents exchanged into coin of a single denomination the taxes paid to the Curia in the various currencies of the different countries, facilitated the transport of money by means of bills of exchange, which were now coming into use, and made advances against the church tax.[17] These various transactions all called for considerable capital and extensive connections. The Curia, for its part, contributed a great deal towards the extension of a monetary economy, for through its taxation it seized a large part of the European ground-rent and injected this money into the rising capitalism of Italy. The Papacy needed large financial resources to carry on world power politics on a grandiose scale, to strengthen its influence with the European princes, and, above all, to fortify its position in Italy itself: during the thirteenth century in particular, the Papacy extended its political power, restoring the Papal State, and emerging victorious from its struggle with the Emperor.[18] In pursuance of this worldly policy, which had reached a kind of climax under Boniface VIII and continued, in some degree, also under the Avignon Popes, the Papacy required additional supplies for the maintenance of its huge army of officials, the most up-to-date

and centralised administrative body of the time. By then its financial system was rationally organised on thoroughly capitalist lines.[19] The transactions of the Florentine bankers with the Papacy, their advances, credits, and loans, were entirely free from risk, since the ecclesiastical levies provided permanent security. Nor did the Church observe in practice its own theoretical prohibition of interest; it had been paying interest in disguised form at least since the thirteenth century. The monetary transactions of the Florentine bankers, the new banking business and the new economic system itself were, of course, all based on the taking of interest. Though it was still forbidden in theory, the bankers and merchants found countless means of evading the prohibition in fact, with the Church's connivance, both in their transactions with her and with others.[20] The average annual rate of interest charged in Florence was 15 to 25 per cent.; 30 to 60 per cent. was not uncommon; in a number of cases the rate exceeded 100 and even 200 per cent.[21]

The business dealings of the Florentine bankers with the Curia and even with the countless ecclesiastical dignitaries abroad[22] were attended with far less risk than those with foreign secular rulers, such as the kings of Naples, France and England. The great Florentine banking houses (in the late thirteenth century, the Guidi in France, the Frescobaldi and Pulci in England; in the first half of the fourteenth century, the Bardi and Peruzzi with still greater influence in both these countries, the Acciaiuoli, most prominent in Naples) had to trust entirely to the good faith of the respective sovereigns, and were therefore at the mercy of every crisis in a State administration which was in many ways still feudal. For the medieval princes had no such regular sources of income as had the Pope.[23] Their chief means of financing their frequent wars, their largest item of expenditure,[24] were extraordinary war levies, debasement of the currency, sale of offices and alienation of crown lands.[25] The bankers, therefore, endeavoured to cover themselves in every way possible, exploiting the element of risk by using it to acquire as many monopolies as possible from the princes. Moreover, the risk of dealing with princes was all the greater since bankruptcy on the part of the debtors was always possible. The princes had no hesitation in doing what the Church, significantly enough, never did: they went bankrupt, and justified their action by the canonical prohibition of interest.[26] Naturally, therefore, they were charged a much higher rate of interest than the Church. In 1339, Edward III's campaign against France was financed by the two largest Florentine banking houses, the Bardi and the Peruzzi, who early in the century had controlled between them the whole financial administration of England and had large investments in that country.[27] The failure of the campaign, the impoverishment of the country, the king's inability to settle his debts (1,365,000 florins) brought about the bankruptcy of the London branches of the two firms, and this, in its turn, led in 1343–46 to the failure of the parent houses themselves.[28] Since large sections of the middle classes had interest-

bearing deposits with the Bardi and the Peruzzi, and the banks' liabilities thus greatly exceeded their assets, Florence became involved in an economic catastrophe, from which it took a considerable time to recover. The almost complete bankruptcy of a whole city resulted from the crisis in the feudal or semi-feudal States and from the consequent failure of a prince to repay his debts. These causes, however, produced this result only because the wealth of Florence was largely based on the trading and banking activities of a few houses. It is precisely in this that we find one of the main features of Florentine capitalism.

The organisation of merchants and bankers in guilds, which was effected in all large European towns, came about in Florence at a very early date. As elsewhere, these collective groupings on a professional basis made up a kind of state within the State, transitional between the feudal State based on "orders" and the capitalist civic State. They aimed at protecting the economic interests of the professions they represented, and at the same time sought to acquire political emancipation and political power for their own bourgeois strata. In their early revolutionary phase in the thirteenth century, they were pitted against the established landed feudal nobility, the enemies of capitalist expansion, with the ultimate object of replacing them in their control of the State by the new, bourgeois, capitalist class.

In this struggle the great Florentine merchants and bankers, the Guelph party, opposed to the Ghibelline feudal lords loyal to the Emperor, were naturally bound to the Pope by economic interests. This attachment was responsible in part for their close economic and political connections with his more or less constant allies—the kings of France, and the house of Anjou, ruling in Naples[29] and Southern France, and related to the French royal family. It was a principle of the Florentine bourgeoisie, particularly its upper stratum, to keep up this political and economic friendship with their most important customers. The revolutionary contact of the bourgeoisie with the nobility reached its decisive stage in the second half of the thirteenth century. By then the guilds had become fighting organisations in the fullest sense of the word, being, from 1251 onwards, military as well as professional institutions. Moreover, in the thirteenth century the mentality of the upper middle class was sincerely republican and bourgeois, genuinely opposed to a nobility which clung tenaciously to the land from which it lived. Thanks to their economic power, the upper middle class, supported in the struggle by the middle and lower strata of the bourgeoisie and led by the Calimala, the wealthiest and most important guild of the time, succeeded step by step against the violent resistance of the nobility.[30] In 1266 the seven so-called greater guilds, representing the rich bourgeoisie and composed of merchants and bankers who had organised themselves earlier than the artisans,[31] won equality of rights with the nobles. By the constitution of 1282, only nobles who belonged to one of the guilds could enjoy political rights. By the decisive constitution of 1293, known as the *Ordinamenti di Giustizia*, a final and uncondi-

tional victory was won by the upper middle class, organised in their guilds, and to some extent by their allies, the middle strata; the guilds took over political power.

Henceforth, the guilds not only organised the economic and social forces, but functioned also as part of the communal administration with a very large measure of autonomy (separate jurisdiction, disciplinary powers, independent financial administration, the right to extend their constitution, supervision of the great civic buildings), and above all now became the guarantors of the political constitution. The *Ordinamenti di Giustizia* contained severe provisions directed against the nobility. For instance, only those actively engaged in the profession of their guild could now enjoy political rights, and even then several high offices were generally barred to them, while the harshest penalties (death or confiscation of property) were decreed against such Ghibelline nobles as did not come over unreservedly to the side of the bourgeoisie, or attempted resistance or used violence against citizens.[32] The execution of these emergency measures was entrusted to special authorities, particularly the Guelph party,[33] which had been organised as early as 1267 by the Pope and Charles of Anjou, brother of the king of France and himself king of Naples, whom the Pope had appointed Vicar of Tuscany. Full rights of Florentine citizenship were restricted by the constitution to active members, with full privileges, of one of the twenty-one guilds. This provision, as we shall see later, was directed against the lower classes who were not full members of the guilds, that is, the numerous small masters and all subordinates. In fact, even as early as 1295 and still more in the course of the fourteenth century, after the nobility had become relatively innocuous, decrees against them were marked by a certain leniency; the upper bourgeoisie were moderating their views very quickly, for the real danger now came from the lower classes and the workers.

The essential feature of the development may be summarised by saying that whereas the history of the thirteenth century was, in the main, that of the contest between the upper middle class with its lower-class allies on the one hand and the feudal nobility on the other, that of the fourteenth century, when the town was economically far more advanced, was the struggle of the upper middle class against the workers, with the nobility, no longer economically significant, tilting the balance.

The guilds in which the bourgeoisie were organised were very far from having equality of rights among themselves. The seven greater guilds, representing the wealth of the city, comprised, in addition to the four already mentioned—the cloth finishers[34] (Calimala), cloth manufacturers (Lana), silk manufacturers (Seta), and bankers (Cambio)—the furriers' guild, the guild of doctors and apothecaries, partly an intellectual and partly a traditional organisation, and lastly, the guild of judges and notaries, a purely intellectual body. These last, as the interpreters of the law, played an outstanding part in the

property relations of the wealthy. The judges were drawn from the patrician families of the city; the notaries, though not of such high social standing, were nevertheless very closely connected with the upper middle class. Their importance is shown by the fact that the vice-consul of the other greater guilds was always a notary. The first-mentioned four of the greater guilds were the most powerful; for, in spite of the economic decline of the Calimala at the beginning of the fourteenth century, the patrician families of the guild retained their social rank and something of their political influence. In law, and still more in fact, the greater guilds were far more influential in the administration of the city than the lesser. After the first two years of democracy which followed the *Ordinamenti* of 1293, the government of the city was exclusively in their hands till 1343. The highest officers of the city, the Gonfalionere and the six (later eight) Priors, who together formed the Signoria, were all chosen from among the members of the greater guilds, who generally also wielded decisive power in the various councils. And with the open and unscrupulous use of political power, possession of office was everything. But in actual practice, the real power was not in the hands of the Calimala, the Lana, the Cambio, etc., as such; it resided in a few cliques of very wealthy families within these greater guilds.[35] The policy of these families who ruled the town aimed, in short, at expansion in order to win new markets, at the protection of the most important means of communication and, of course, at the elimination of foreign competition. We shall speak later of the financial and social home policy which sustained these objectives.

The wealthy bourgeoisie, organised in the greater guilds, fought the aristocracy of birth in the economic and political fields[36] as long as there was need, that is, above all, in the thirteenth century; but they acknowledged the superior social standing of their adversaries. In fact, their attack was directed only against certain sections of that class. From the very beginning, certain members of the nobility had belonged to the Guelph party,[37] which was never mobilised against the nobility as such, but only against those nobles who would not side with the upper bourgeoisie. In the course of the fourteenth century the wealthy town patricians willingly conceded a share of political influence to this class— now economically harmless—on account of its social prestige. For example, when the two new councils of the *Consiglio del Popolo* (presided over by the *Capitano del Popolo*) and the *Consiglio del Comune* (presided over by the *Podestà*) were set up in 1327, half the members of the latter were of aristocratic origin. Intermarriage and the fusion of property interests between the two groups became customary. As most noblemen moved into town and entered commerce, forming a highly respected element of the upper middle class itself—only a few great families maintained their social and political independence—so the great bourgeoisie, in their turn, became landed proprietors. They acquired country seats, at which they spent four months of the year, and endeavoured to imitate

the habits and adopt the comforts of life of the aristocracy. With a sense of security[38] and a certain lack of ideological independence, they even kept up the ranks and titles of feudal times;[39] though knighthood was now conferred by the Commune, the citizen becoming a knight of the people (*Cavaliere del Popolo*).[40] Tournaments were held on these occasions, and from the beginning of the fourteenth century, whenever opportunity offered, on many others, in the Piazza di S. Croce, in which members of the middle class eagerly participated. They endeavoured to construct genealogical trees for themselves, and to acquire, on any suitable pretext, coats-of-arms.[41] This mania for imitating feudal habits steadily grew throughout the fourteenth century. It marked a great change from the "heroic" age of the bourgeoisie in the thirteenth century or even in the first decades of the fourteenth, when the rich burgher's private life had been puritanical in its simplicity.[42] Numerous edicts, it is true, were issued by the town—originally aimed against the aristocracy and their imitators—with a view to restricting luxury; but the wealthy could evade them more easily than could those of humbler station, and in practice their chief effect was to prevent any democratic equality in the matter of luxury and display.[43]

In the fourteen lesser guilds were organised the various independent craftsmen and small shopkeepers, such as butchers, shoemakers, tanners, masons, oil-dealers, linen-drapers, locksmiths, armourers, leather-workers, carpenters, innkeepers, blacksmiths, wine-merchants and bakers. Their members worked only for local demand. Economically, they were perpetually struggling for existence and could procure the necessary capital only with extreme difficulty and by paying high usury. At the beginning of the fourteenth century they had no say in political life, since their aid against the nobility was no longer required, and during its early decades they were kept down as much as possible by the upper bourgeoisie, which then wielded absolute authority. Nevertheless, from the forties onwards, various factors contributed to the steady increase of the power of these guilds, at any rate in politics. In the latter half of the century, Florence was no longer—as it had been in the first half—at the height of its economic power, and the greater guilds, owing to their many reverses of fortune, were generally speaking on the defensive. The Bardi, Peruzzi and Acciaiuoli— all the "old" financiers, that is—were bankrupt; trade and banking with France was stagnant; there had been a disastrous war for the possession of Lucca; costs of production were temporarily sent up by the high wages consequent upon the fall in population after the plague of 1348.[44]

In the conflict between the upper and the petty bourgeoisie which lasted from the forties to the nineties, the attitude of the middle stratum, changing with the circumstances, was often decisive. For the interests of certain sections of the upper middle class were by no means so sharply opposed to the petty bourgeoisie as to the oligarchy of the old families. These sections comprised those professions within the greater guilds which employed little labour, besides

intellectuals and members of the five so-called middle guilds, which ranked at first with the greater, later with the lesser guilds. As the lines of cleavage in these transitional strata were not rigid, the main social groups also could align themselves in various combinations.[45] The usual arrangement was an alliance of the upper bourgeoisie with the nobility against the lower middle class. But sometimes the upper bourgeoisie made use of the petty bourgeoisie against the nobility if the latter showed any sign of again becoming dangerous; on other occasions, the lower middle class joined with the nobility in a common anti-capitalist front against the upper middle class.[46] The conflict of social and political interests within the bourgeoisie, that is, the friction between the middle and petty bourgeoisie on the one hand and the oligarchy above on the other, was further intensified by speculation in State loans (*Monti*), now a usual practice.[47] These loans served the purpose of economic expansion and were increasingly used as the means of financing wars. The interest on these bonds was raised by indirect taxation which fell most heavily on the lower classes; direct taxation was considered detrimental to the accumulation of capital. The bonds themselves were too risky an investment for the wide sections of the middle class, but were a great attraction to the speculating capitalist of the great guilds who had influence on the conduct of State affairs and could raise the rate of interest on the loans.

The complexity of the social struggles at this period, the second half of the fourteenth century, is not explained by merely distinguishing the greater from the lesser guilds, that is, the upper middle class from the petty bourgeoisie. We must also consider the contrast between the employers and their subordinates (*sottoposti*), looking for a moment at the economic and social structure within the greater guilds themselves,* more particularly the three textile guilds (Calimala, Lana, Seta)[48] in which this contrast was sharpest.

In the woollen industry at that time, the most important and most highly capitalised in Florence,[49] only the *entrepreneurs* (industrialists, traders) were active members of the guilds and enjoyed the rights of membership; their numerous underlings were entirely or almost without rights.[50] Though they constituted by far the greater part of the population, they were debarred from all active participation in the affairs of their guild, and were thus automatically excluded from any political rights under the constitution.[51] This fact should be borne constantly in mind when judging Florentine "democracy". This situation, in so intense a form, was without parallel in Europe. Nowhere else was the capitalist upper middle class so highly developed and so powerful;

* This question is dealt with more fully than the plan of this book might seem to warrant. But the organisation of the greater guilds and their method of government throw much light on the mentality of the upper middle class, and the relevant facts are by no means well known. The material which is now being made available, especially by the researches of Doren, is very extensive and complex; general characteristics only can be indicated here, illustrated by a few typical examples.

nowhere else, consequently, had the great merchants and industrialists of the woollen industry attained such economic and political supremacy. In Flanders and France, in Germany and England, the cloth-workers had preserved many more of their rights.

The Florentine wool guild was not a real unity, save for its organised upper stratum. The owners of the two or three hundred undertakings, and in practice only the wealthiest of these,[52] ruled oligarchically over the organisation of the guild with an absolute authority corresponding to their unrestricted power in the process of production. Between employers and subordinate workers there was an impassable gulf at every point. Among the latter—the *sottoposti dell'arte di lana*, as they were called—the division of production into a number of different processes created a large number of specialised crafts; but these, broadly speaking, may be divided into two sections. There was an economically and socially superior group, consisting in particular of the dyers, who owned their own tools and dyeing plant, and had previously been small independent masters, employing several apprentices with whom they now worked as craftsmen for the *entrepreneur*.[53] As there was a very powerful movement in the Lana to reduce independent artisans to economic subjection to the mercantile element, the struggle for existence was made as difficult as possible for them as for all small businesses. Nevertheless, the dyers managed to keep some restricted rights in the guild and in political life.[54] The second and much larger section was made up of the lower grades of craftsmen, the true wool-workers, of whom the majority were wool-carders employed in workshops (known as *ciompi*) and spinners and weavers engaged in domestic industry. None of them owned their own tools; their part in the productive process and their standard of life made them a proletarian stratum of the population. Completely without rights, oppressed both economically and politically, they were not even permitted to associate.[55] A system carefully elaborated in every detail made it impossible for the worker to struggle for higher wages, yet enabled the employer to keep wages low and his wares cheap.[56] Wages, hours, conditions and methods of work were decided by the employer in an arbitary and one-sided manner.[57] The worker alone, not the employer, was pledged not to break his contract. He was entirely at the mercy of the officers of the guild, who were appointed by the employers,[58] and of its courts, against which there was no appeal, and whose members—the consuls of the guild—were drawn exclusively from the employing class. The judges were the very persons against whom the workmen brought their complaints.

Thus the guild, in its origin a professional organisation, was used to divide the population of the city into the two great classes of those with rights of active citizenship and those without, and to keep the latter in permanent subjection. The restraints placed upon the workers and the economic policy dictated by the upper middle class could be effectively carried out only because guild and

State represented a single authority. On the one hand, the guilds served the purpose of automatically depriving the worker of his rights as a citizen; on the other, every economic advance of the wage-earners at the expense of their employers was considered an encroachment on the State and its laws. The decrees of the wool guild—we shall return to this point later—were also carried out with the additional support of the Church.

Against this background of economic and social conflict, let us now glance at the main events in the history of Florence from the forties of the fourteenth century.

In 1342 Gualtieri of Brienne, Duke of Athens, scion of a French feudal family, a *condottiere* and adventurer, was summoned to Florence, partly at the instance of the great families of the Bardi, Peruzzi and Acciaiuoli, and installed as ruler. The object of this step was to make use of the duke's friendship with the king of Naples to restore good relations with Florence's Neapolitan creditors, who had recalled their deposits and were thus on the point of finally ruining the great Florentine banking houses, already thoroughly shaken by the English financial catastrophe. These hopes, however, were disappointed, and in attempting to maintain his position, the duke manoeuvred for the support not only of the aristocrats but also of the lower sections, even the *sottoposti*, appointing priors from members of the lesser guilds, granting the dyers the right to form a guild, and even according a banner to the *ciompi*.[59] These concessions encouraged the workers to demand higher wages. Finally the upper middle class and the still insufficiently placated aristocracy—the Bardi, who formally belonged to the latter, forming the link between them—brought about the duke's fall in 1343. The severity of the *Ordinamenti di Giustizia* was now mitigated somewhat in favour of the nobility, a number of them being permitted to hold office. This was intended as a prelude to dictatorial rule by the big banking houses—the only way, as it seemed to them, of avoiding bankruptcy. Their position, however, was so weakened that they could not resist a popular rising, in which the palaces of the Bardi were burned down, and consequently bankruptcy could be put off no longer. All this strengthened the political influence of the lesser guilds, and after 1343 they formed a very strong minority, holding more than a third of the priorships and other important State posts. During the following decades, they were supported not only by the dyers—who in 1343 had lost the right to form their own guild and were now struggling for higher wages—but also by all the *sottoposti* of the greater guilds, the lower-grade workers of the woollen trade even beginning to fight for the right of association.

In contrast to the rule of the upper-middle-class oligarchy, both before and after it, this relatively democratic period between the forties and the nineties of the fourteenth century may be regarded as one in which the rulers were the middle sections of the bourgeoisie, influenced by the upper or by the petty bourgeoisie according to the circumstances of the moment.

During these years the powerful Parte Guelfa, the organisation of the highest bourgeois families, which had always sabotaged the democratic provisions of the *Ordinamenti di Giustizia*, not only did everything in its power to restrict the lesser guilds' share in State offices,[60] but also proceeded against members of the upper middle class who had incurred its displeasure.[61] Yet even the Parte could not deprive the lesser guilds of all influence. This influence, however, like that of the middle sections of the bourgeoisie, became effective only through alliance with, and even under the direct guidance of, several upper-middle-class families; the Alberti principally, the Ricci, associated with them financially, and the Medici, the first and last named together with the Strozzi being at that time the most important banking and commercial houses in Florence. These families were actuated not by any particular love of democracy, but by the conflict of their interests with those of the great families of the Parte Guelfa, particularly the Albizzi. Concrete evidence of the political strength of the middle and lower sections of the bourgeoisie is to be found, however, in the war of 1374–78 waged by Florence against the Pope, then governing Italy through unruly French legates. The conflict, which centred around the question of grain, so indispensable to Florence,[62], was naturally opposed by the Parte Guelfa, that is, by the oligarchic upper section of the bourgeoisie, as it was greatly to their economic disadvantage. In fact, the marked economic difficulties of the upper middle class in this period appear very clearly in the output of cloth: in 1373 the yearly figure had dropped to 30,000 pieces; in 1378, after the war against the Pope and the *ciompi* revolt, to less than 24,000.

This revolt, made possible in part by the great business losses and the weakening of the position of the upper middle class which resulted from the war, was one of the greatest and most profound revolutions Italy experienced during the age of the city-republics. A workers' revolt, it was the climax of the petty-bourgeois and democratic left movement in Florence, whose steady growth since the forties had been stimulated by the provocations of the Parte Guelfa. In the course of a few months, in the summer of 1378, the pendulum swung, at least so far as the outward conditions of power were concerned, from the extreme right (with the Parte Guelfa supreme) almost to the extreme left. In the reawakened spirit of the *Ordinamenti* of 1293 all sections united against the oligarchy of the Parte Guelfa. Then, its aims achieved, the lower section of the upper middle class backed out. Very soon the lesser guilds, having secured a greater share in the government, also withdrew from the struggle. Their example was shortly followed by the 4,000 dyers and shirt-makers—small masters and highly skilled workmen in the textile industries—who had gained the right to form their own guilds. They were now both entitled, as organised negotiating parties, freely to conclude wage agreements, which meant that wage rates could no longer be fixed without their consent. Their further aim was mainly to obtain a share in the offices, for example, the nominations of some priors from

among their own ranks. Without much economic experience, lacking political independence and with a tendency in social life to imitate the upper classes (rich clothing, knighthoods),[63] these sections too allowed themselves to be led on every essential issue by a number of patricians, such as Salvestro de' Medici and Benedetto degli Alberti. But now, in 1378 ,the *ciompi*, the lowest group, consisting of some 9,000 wool workers, also won the right to form their own guild. The three new guilds obtained a third of the municipal offices, the other two-thirds being allocated equally between the lesser and the greater guilds. This represented a great advance on the left movement of 1343; for now not only the lesser guilds, but also the newly formed guilds of small masters, skilled and unskilled workers, were able to hold office. The *ciompi* even pressed through a number of radical measures, but in practice these were generally sabotaged by the other parties. The oligarchy of the Lana effectively used the threat of starvation by factory lock-outs to crush the revolt, and when the *ciompi* endeavoured to secure the resumption of work by force[64] all the other sections of the population formed a common front against them.[65] The great economic differentiations between the artisans, the workmen and the various intermediate groups engendered these conflicts among them and made possible the defeat of the *ciompi*.

So, after the push to the left had lasted only a few months, it was quickly followed by a violent swing of the pendulum ultimately reaching the extreme right, where it was to remain. The *ciompi* were deprived of the right to their own guild less than a month after they had won it, and the strata above them were also forced to surrender their power by rapidly succeeding stages.

The four years from 1378 to 1382, during which the lesser guilds and the two new lowest guilds held some preponderance of power over the greater guilds, formed a kind of democratic interval. The lesser guilds continued to be led by individual members of the upper middle class (Medici, Alberti); some important economic measures, first sketches of which had already been put forward in the *ciompi* period, were introduced in practice or agreed upon in theory under the pressure of the new guilds. The new workers' guilds demanded increases in wages, a fixed minimum wage instead of a fixed maximum as hitherto, and better working conditions. Their general economic measures aimed at the introduction of direct taxation,[66] and at checking the system of State loans and the indirect taxation connected with it.[67] Though, from the point of view of the new ruling sections, the demands were democratic, many of them were dictated at the same time by the conservatism natural to the petty bourgeoisie with the ultimate intention of keeping in check the development of capitalist industry; in practice, they were opposed to economic expansion—the guiding principle of the greater guilds—to military commitments and to the mercenary armies they made necessary. In foreign policy, the petty bourgeoisie was actuated by a genuine desire for peace.

In 1382 the upper stratum of the Lana, aided by the mercenary forces of the English *condottiere*, Sir John Hawkwood (known as "Acuto"),[68] succeeded in dissolving the two lowest guilds;[69] for this relatively small and isolated group of skilled workers was unable in the long run to resist the great and long-established power of capital.[70] Advantage was taken of this to reduce the lesser guilds to a minority in the allocation of offices in favour of the greater; their influence was rapidly waning, even if their power was still greater than before 1378; some of those whose prosperity was bound up with that of the greater guilds completely lost their former fighting spirit.[71] In 1387 the proportion of offices held by the lesser guilds fell from one-third to one-quarter. The dyers and other wool workers tried at first to ally themselves with the nobility, a step characteristic of their lack of independence, and only later turned to the lesser guilds. In 1383 the *ciompi* made a last desperate effort to regain their rights.[72] In 1393 the upper middle class and in 1396 their right oligarchic wing definitely secured the upper hand once more. Thus the undisputed rule of this class, in which the first breach had been made in 1343, was completely restored.

Before considering the new position, we must briefly describe the situation of the peasantry of the country round Florence, of which the bourgeoisie made use to weaken the landed feudal nobility. As every citizen could now acquire land, and Florentine capitalists had been gradually buying up the greater part of the countryside as a safe investment, the legal relations between owner and peasant had necessarily to be altered from their previous feudal form. The first "liberation" took place in 1289, the year of the bourgeois constitution, the second in 1415, when the bourgeoisie were at the height of their power; the change to the system of tenancy under contract was on the whole one in kind rather than in degree of bondage.[73] The whole system of agriculture and the more intensive tilling of the soil was now carried on in the interests of industry and trade; food prices were fixed by the bourgeoisie of the city;[74] the property-less country population was completely dependent on the town.[75] By "liberating" the peasantry from feudal dues, the urban middle class released a new supply of labour for industry. And not only was the country population without political rights, but all the small towns which had been subjected to Florence as well.

When the *ciompi* revolt had been suppressed, and particularly after 1393, a reaction of the upper middle class set in. But this class had already been weakened by the general economic situation. At first sight, however, the position in the first decades of the fifteenth century seemed a favourable one. Florence had now secured an outlet to the sea, which greatly stimulated trade with the East; the Florentine bourgeoisie were enjoying another brief spell of prosperity, and also felt themselves supreme in political life. But this well-being was only apparent. On closer examination, unmistakable signs of decay are revealed in the structure of Florentine capitalism. The woollen industry, the very life-blood of Florence,

was seriously threatened. The export trade to the rest of Europe was suffering greatly from Flemish competition; there was also a certain danger from the rising national industries and commerce of France, Germany and England, not to mention Italy itself, particularly Northern Italy. In some countries, and even in other parts of Italy, the importation of Florentine cloth was prohibited, so that the market for Florentine industries was continuously narrowing. After 1420 especially, the cloth manufacture steadily declined; the average yearly production sank to 20,000 pieces, and the number of workshops fell from 279 in 1380 to only 180 in 1427. Protective tariffs were introduced (1393, 1426) in order to retain at least the home market. The flight of many workers to other Italian towns after the *ciompi* revolt also had a detrimental effect on Florentine production. A further disaster for the woollen industry was the new fashion in high society for silk and brocade instead of wool, though the silk industry benefited. The manufacture of gold and silver brocades, in which important technical innovations were now being made,[76] brought this industry into the leading position in Florence. It is important to note that the gradual predominance of the manufacture of silk fabrics made Florentine textile production more definitely a luxury industry.

In the same way, since the middle of the fourteenth century, the banking business also had been on the decline. The biggest clients—the rulers of France, England and Naples, at times even the Pope—were aided by competing firms to free themselves from their dependence on the Florentine bankers. Moreover, owing to resistance from the most powerful countries outside Italy and the Papal schism connected with it, even the finances of the Curia no longer embraced the whole European economy as they had done in the first three-quarters of the fourteenth century.[77] The extensive purchases of land by the urban capitalists must also be regarded as a flight of capital from business.[78] The Florentine was now beginning to prefer the life of a *rentier*, deriving his income from landed property or State loans. Florentine capitalism was becoming stagnant, all the more since it was dependent on a few families, the heads of the big businesses; a numerous middle class could not come into being, for the oppressed artisans, with their low standard of life, had no possibility of advance. The working class was brought into definite subjection by the patrician upper middle class. The organisation of the silk guild now followed the same capitalist evolution as that of the woollen guild in the fourteenth century,[79] ending likewise with the complete subjection of the *sottoposti*. Nor had the absolute authority of the employing class ever been asserted so definitely as in the statutes of the Lana of 1415 or 1428.[80] From this point of view, the upper middle class were justified in considering themselves as now at the height of their power. And indeed, certain aspects of the silk industry, the export trade, and even banking[81] still gave grounds for satisfaction, though in general, particularly after 1420, economic decline and uncertainty in most fields became continuously more evident.

ECONOMIC, SOCIAL, POLITICAL HISTORY

The inequality in the division of wealth—always a feature of medieval town life—grew more blatant in Florence, since capital was increasingly concentrated in the hands of a few families. Hence the circles which held political power necessarily became more exclusive; in 1393 the middle sections and in 1396 the moderate wing of the upper section were reduced to political impotence. Political power was thus confined to the supreme oligarchy centred round the Albizzi as a nucleus.[82] In the first decades of the fifteenth century, the Albizzi, members of the Lana and big landowners, together with the great merchant and banking family of the Uzzano and the wealthiest bankers of Florence,[83] the Strozzi, held the chief political power in their hands or exercised it through their creatures. They endeavoured to prevent at all costs the rise of strong capitalist forces outside their own narrow circle, and to forestall the growth of any rival political influence. These few families from the richest guilds in fact dominated the domestic and foreign policy of the town, with even more exclusiveness than in the first period of their predominance, in the early fourteenth century, before the Duke of Athens' time, when a relatively much larger section shared in the government. Even the institution of the Parte Guelfa, re-established in 1393, was much weakened, while the leading merchant families kept a firmer grip than ever on the guilds.[84] Since the fourteenth century, the guilds had no longer possessed their own military forces; after the *ciompi* revolt, the ruling stratum employed armies of mercenaries led by *condottieri*, and their size was increased not only for war purposes, but also to keep the lower classes in subjection. In peace time (particularly after 1393) the lesser guilds were controlled by the simple process of enrolling in them the sons of rich merchants, who then took over their leadership.[85] The greater guilds might retain nothing but the show of power, but this was impressive enough. For, on a superficial view, Florence was now politically stronger than ever, and was playing a leading part in the whole Italian system and in the efforts to end the schism in the Church[86]—all of which reflected renown upon the greater guilds, particularly the Lana.

As regards military ventures during these years, prestige now played a very significant part (as, for instance, in the war against Lucca, 1429–33),[87] even if economic motives were still paramount. Florence's territory grew wider than ever. Arezzo was acquired in 1384,[88] Pisa in 1406, Cortona in 1410, and the port of Leghorn in 1421, the most important aim of the upper middle class, the opening of new trade routes, being thus achieved. The conquest of Pisa—a move ineffectively opposed by the petty bourgeoisie,[89] who feared a rise in taxes and were more concerned with internal trade than with the opening of sea routes—ended the struggle which for two centuries the Florentine upper middle class had been carrying on with their rival; for Pisa commands the mouth of the Arno, and was the natural outlet for Florentine trade. The possession of Leghorn made possible the creation of a mercantile fleet; Florentine products, woollen and silk cloth, could be more easily exported, and, still more important, the

raw material for the silk industry could be procured from the East. Trade connections with the Levant (Egypt) therefore now became very close, and special officials, the so-called sea-consuls, were appointed to supervise them. Since Florence as a naval power had a great deal of leeway to make up, there were numerous merely temporary successes. But these only intensified a gradual transformation which was taking place as a result of the decline of the solid woollen industry in favour of the luxury trades. A more restless, unbalanced spirit was tending to replace the former stability and sobriety, a condition of which pride was the outward manifestation. The notion prevailed that even the sea had been conquered. The upper middle class, victorious at home and abroad, demonstrated their pride in every way, investing all decrees of State with their sense of triumph.

After the definite elimination of the workers and the petty bourgeoisie, this heyday of the republic witnessed the narrowing down of political power to a conflict between the optimates, the few aristocratic-bourgeois families who were the actual rulers, and the popolani, representing the remainder of the wealthy bourgeoisie in the greater guilds; the declining lesser guilds naturally supported the popolani as far as they could. After 1393, and particularly in the later Albizzi period from the 1420s onwards, the ruling clique was able to do what it pleased, despite the resistance of some of the councils. To narrow the basis of government, the oligarchic reaction made more intensive use than formerly of the method of "asking" the people through the Signoria. The bell of the Palazzo della Signoria would summon the people to the great square, which would be surrounded by soldiers; this "parliament" would then be "asked" whether it was willing to empower a certain number of citizens, known as the *Balia*, to make changes in the laws. The intimidated assembly, of course, always assented to everything. The commission then appointed a select committee, known as the *accoppiatori*; their powers often remained valid for years, during which time the legislative councils were suspended. In order to assure their continuity of government, the voting bags, which should have contained the names of all those eligible for election by lot to the Signoria and other offices, contained only the names of those belonging to their own faction. The most varied measures were introduced to abolish the previous short tenure of office, which had been intended to secure better control of the administration; and freedom of election to the magistracies was also done away with. For the great majority of those legally entitled to exercise it, the right to hold office became far more illusory than before. The rights of citizenship were increasingly curtailed in favour of the possessing class; after 1421, for instance, no one could hold office who had not paid taxes regularly for thirty years. The restrictions on tenure of office by the nobility remained on the statute books, but in 1393 legal right to office was conferred on many noble families, and in general the obstacles in the way of an aristocrat's advance to office could be circumvented

much more easily than those in the path of the poorer classes. Moreover, these restrictions were now used much more than formerly as a mere cover for measures against political adversaries and those who were economically weaker. The growing sympathy of the ruling class with the aristocracy is clearly visible.

Political and economic measures go naturally hand in hand. The taxes fell as lightly as possible upon the rich, as heavily as possible upon the masses. Taxes on articles of consumption which hit the working population were very high. Although in 1427, as a result of the military defeat by Milan, a law was at last passed introducing the direct property tax, the so-called *catasto*[90], which the lower classes had long demanded and which they hoped would bring about a more equal incidence of taxation, yet in practice it also became a weapon against those who did not belong to the ruling circle. It was part of the same general policy that the small communes were bled for the benefit of Florence.

The manner of life and social intercourse of both the optimates and the popolani had by this time lost much of the bourgeois simplicity of the fourteenth century. The families which were raised to political pre-eminence with the reaction following the *ciompi* revolt were no longer such pure bourgeois as those in power during the first half of the fourteenth century. For many of the new-comers were noble in origin, although they had taken up commerce and settled permanently in town; having previously been connected with the nobility, many of these upper-middle-class families now all the more easily and rapidly became aristocratised. The fundamental reason for this strong aristocratising tendency was the growing instability of the economic position of the upper middle class and consequently a certain decadence, lack of solidity, and contempt for the earlier bourgeois simplicity. A predilection for country life, for acquiring landed property, for hunting and tournaments, was growing; in short, an almost parvenu-like imitation of feudal conduct of life and customs—with increased luxury and less of its attendant dangers. Even an event of such great economic importance to the upper middle class as the conquest of the harbour town of Pisa was celebrated by the Parte Guelfa with a knightly entertainment, a tournament on the Piazza di S. Croce.[91] Knighthoods were now bestowed more sparingly than in the fourteenth century; the ruling oligarchic clique wished to keep up the prestige of this distinction, and therefore reserved it for members of the wealthiest section of the upper middle class.[92]

To return now to the history of Florence. The exclusive stratum of the optimates could not maintain itself permanently by the political and economic measures we have described; its whole position was undermined, and it soon paid for its triumphs over the popolani, the petty bourgeoisie and the workers with its own decline and the loss of its political power. The struggle between two equally weakened adversaries necessarily ended with the victory of a third force stronger than either, namely the Medici, one of the greatest merchant families in Florence and soon to become the greatest banking family of Italy.

The Medici, like the other great families, combined every kind of profitable business—banking, trade and production (woollen and silk cloths). One particular aspect of their activities predominated in each of their branches. Their Florentine house was engaged chiefly in banking operations (the real rise of the Medici resulted from the financial association of Cosimo's father, Giovanni, with the Curia) and in trade; in Bruges, they were principally importers of spices; in England, exporters of wool and cloth, and so on. And they also bought up land on a large scale.[93] The Medici were not originally among the select families of the Lana who had been in political control of the city since the oligarchic reaction, but they manoeuvred cleverly among the factions without compromising themselves, making themselves popular among the lower classes at the same time by granting credits.[94] They allied themselves with the popolani and also with the lesser guilds—openly during the fourteenth century, more secretly after the reaction of 1393. They associated themselves openly with the democratic opposition only when it was in the ascendant—thus Salvestro de' Medici was one of those who profited from the rising of the *ciompi*. They always managed, however, to turn a deaf ear when the opposition was in difficulties, as the lesser guilds discovered when they appealed to Vieri de' Medici to lead them at the time of the oligarchic reaction in 1393. Thanks to their cautious policy, the Medici avoided the fate of the Alberti, who came out too openly on the side of the lesser guilds and in consequence were all banished. Giovanni de' Medici, after Palla Strozzi the richest man in Florence, did excellent business as the banker of that particularly worldly-minded Pope John XXIII, and at the Council of Constance (1414-18); after John's deposition, he became court banker to his successor, Martin V. His connections with the less wealthy classes made him leader of the peace party in Florence. Although Giovanni's action on the introduction of the direct property-tax in 1427 was very ambiguous,[95] he was given the credit for this measure, and the popularity of the Medici among the lower classes very greatly increased. On his death (1429), his son Cosimo carried on his father's business and policy; he remained banker to the Pope and made great profits at the Council of Basle (1431).

The real greatness of the Medici only now became apparent, as the other families declined (the Strozzi excepted, they were the only big banking house that escaped bankruptcy); for, as we have seen, the power of capital in Florence tended to concentrate in a few great houses strong enough to withstand the crises and at the same time to use them to eliminate competition. The optimates, the merchant oligarchs of the Lana, led by Rinaldo degli Albizzi, at first succeeded in banishing Cosimo de' Medici (1433).[96] But Cosimo's departure and the removal of his banking business to Venice plunged Florence into economic depression. He was recalled in triumph in 1434, gained a victory, with the Pope's help, over the optimates of the Albizzi clique, and ruled the city with his close business friends, the new optimates. How, by his domestic policy, parti-

cularly by his system of taxes, he then ruined the competitors who refused to come to terms with him, how he contributed to hasten the inevitable decline of the Florentine woollen industry and hence of the Florentine bourgeoisie, cannot here be told.[97] The great period of the Florentine bourgeoisie was now ended.

NOTES

[1] This account of the economic and social history of Florence is based chiefly, both for its facts and conclusions, on the researches of R. Davidsohn and A. Doren. See Davidsohn, *Geschichte von Florenz* (Berlin, 1896–1927); Doren, *Entwicklung und Organisation der Florentiner Zünfte im 13. und 14. Jahrhundert* (Leipzig, 1897); *Die Florentiner Wollentuch-Industrie vom 14. bis zum 16. Jahrhundert* (Stuttgart, 1901); *Das Florentiner Zunftwesen vom 14. bis zum 16 Jahrhundert* (Stuttgart, 1908); *Italienische Wirtschaftsgeschichte* (Jena, 1934). As I have made constant use of these books, I have not always given particular references. I have also consulted many specialist works, the most important of which are quoted in the footnotes.

[2] As the military preoccupations of the townsfolk lessened, the demand for linen decreased in favour of wool. See M. Weber, *General Economic History* (Eng. trans., London, 1931).

[3] To this sum must be added the high figures for the cloths imported by the Calimala industry. It is quite impossible to calculate even approximately the value of the florin in present-day terms; only a comparison of prices prevailing then and now could throw light on the matter. At the beginning of the fourteenth century in England, the florin was officially estimated as worth three shillings.

[4] These are the figures given by the great merchant and chronicler of the time, Giovanni Villani. They are accepted by R. Davidsohn (*op. cit.*; "Blüte und Niedergang der florentiner Tuch-Industrie," *Zeitschr. für die ges. Staats-Wissenschaften*, 1928) and by A. Doren (*Florentiner Wollentuch-Industrie*). G. Hermes ("Der Kapitalismus in der Florentiner Wollen-Industrie", *Zeitschr. für die ges. Staats-Wissenschaften*, 1916) thinks them exaggerated. But the result of the controversy between Hermes on the one side and Doren and Davidsohn on the other only confirms the reliability of Villani's figures, even though they may be rounded off on the high side. Cologne, the largest town of Germany, produced only 12,000 pieces of cloth in 1372. In the very important town of Strasbourg the production was about 1,800–2,000 pieces.

[5] The Crusades brought the Italian merchants into immediate commercial relations with the East. Until that time, the Byzantines had been the sole intermediaries. See for a more detailed account: L. Brentano, *Die Anfänge des modernen Kapitalismus* (Munich, 1916), and J. Strieder, *Studien zur Geschichte kapitalistischer Organisationsformen* (Munich, 1925).

[6] The hinterland of Florence did not produce enough grain to feed the city. This is one reason why the export of grain from Naples and the maintenance of good relations with its Angevin rulers were of such importance to her.

[7] See note 3 above.

[8] "Capitalist organisation reached its highest development during the whole of the Middle Ages in the Florentine cloth industry" (Doren, *Florentiner Wollentuch-Industrie*).

[9] The rationalisation of business in Florence was aided by the early introduction of single-entry book-keeping.

[10] For example, in 1315 Florentine agents bought up the wool of 200 English monasteries for years ahead.

[11] These unusually high prices were probably the reason why the Calimala was nearly supplanted by the Lana.

[12] A. Sapori, *Una Compagnia di Calimala ai primi del Trecento* (Florence, 1932) puts both transport costs and profits somewhat lower.

[13] "Tuscans" was the general name for dealers in exchange in the thirteenth and fourteenth centuries. In 1338 there were about eighty *bureaux de change* on the Mercato Nuovo. The Peruzzi alone had sixteen branches from London to Cyprus in the early part of the fourteenth century.

[14] At first the merchants assisted the feudal lords, still living on a barter basis, with loans to meet their continual need of money; later, they accepted their estates as security, and finally appropriated them altogether.

[15] The Florentine bankers were thus able to offer better security for the loyalty of Florence than the Sienese bankers—of whom there were only a few families—could offer for the more petty-bourgeois and Ghibelline Siena. The Sienese, still the chief bankers of the Curia in the first half of the thirteenth century, were thus in its second half ousted more and more by the Florentines. See G. Schneider, *Die finanziellen Beziehungen der Florentiner Bankiers zur Kirche* 1285–1304 (Leipzig, 1899).

[16] The Florentine bankers, in the numerous countries into which they had first penetrated as collectors of Papal taxes, were also able to establish the necessary business connections with the secular powers in need of money, above all with the princes.

[17] M. Meltzing, *Das Bankhaus der Medici und seine Vorläufer* (Jena, 1906).

[18] The ecclesiastical levies used entirely for the political aims of the Papacy, particularly in its struggle against the Emperor, developed, as customary law, out of the earlier Crusade taxes of the Curia, so that the fiction that the money was used for the Crusades was kept up right to the end of the thirteenth century. See C. Bauer, "Die Epochen der Papstfinanz" (*Hist. Zeitschr.* 128, 1928).

[19] Through the move to Avignon, and the opposition of the greater European States to the previous method of ecclesiastical levies, it collapsed, but the taxation of benefices at each change of incumbency—particularly from the time of John XXII—provided a substitute. This new method of taxation, however, was less lucrative and regular than its predecessor.

[20] But interest of about 15 per cent. was allowed legally, with the Church's approval. See A. Sapori, "L'interesse del danaro a Firenze nel Trecento" (*Archivio Storico italiano*, Ser. VII. Vol. X, 1928).

[21] A Florentine proverb of the period ran "Venticinque per cento è niente, cinquanta per cento passa tempo, cento per cento è buon guadagno".

[22] In case of necessity, the Curia compelled them to pay their debts.

[23] For instance, in the last quarter of the thirteenth century the total sum of the Papal tenth was more than three times as much as the income of the King of France.

[24] Sometimes, however, they needed money for the subjugation of the feudal powers and for the organisation of a bureaucratic civil service.

[25] R. Ehrenberg, *Capital and Finance in the Age of the Renaissance* (Eng. trans., London, 1928).

[26] Moreover, Florentine merchants abroad were constantly exposed to the danger of expulsion or imprisonment.

[27] The average yearly profits of the Bardi were about 20 per cent. (over 25 per cent. in the years 1310–20), and of the Peruzzi about 16 per cent. The banking houses also made a profit out of the princes by supplying their courts with pearls and precious stones. The splendour of the English court, for instance, was made possible only by the Florentine money-lenders.

[28] For the additional reasons see : A. Sapori, *La Crisi delle compagnie mercantili dei Bardi e dei Peruzzi* (Florence, 1926). See also p. 22 above.

[29] See also 31, note 6.

[30] For a detailed account of this struggle see G. Salvemini, *Magnati e Popolani* (Florence, 1899).

[31] The Calimala, to which originally all the great merchants of Florence belonged, was organised as early as the beginning of the twelfth century. Most of the other greater guilds were formed in the first half of the thirteenth century. The five middle guilds were organised in 1282, the nine lesser guilds in 1287.

[32] Fathers and sons, and even the most distant relatives, were held responsible for each other's actions.

[33] The power of the Parte Guelfa was largely based on the fact that one-third of the confiscated Ghibelline property belonged to it.

[34] It is significant that originally, in the twelfth century, these were called simply *Mercatanti*; they were in fact *the* merchants.

[35] They were known simply as *le famiglie*.

[36] So late as 1317 the statute of the Lana forbade its members to act as security for nobles.

[37] In 1355 the Parte Guelfa declared in its statutes: "The glory of a town is in the number of its knights, and when they diminish its honour is lessened."

[38] In the *Ordinamenti di Giustizia* the revolutionary bourgeoisie had still proudly called themselves "plebeians".

[39] For example, foreigners summoned to Florence to fill the highest offices of *Podestà* and *Capitano del Popolo* had to possess the title of knight. But they also had to be Guelphs.

[40] It was also a favourite custom to receive knighthood from a foreign prince or even from a Tuscan feudal lord. This was quite permissible, provided one belonged to the Parte Guelfa, for although this had originally been constituted against the Ghibelline aristocracy, it was later only nominally opposed to them. The Florentine merchants also acquired other titles besides that of knight at foreign courts, such as councillor, or merchant to the king; they also obtained fiefs and feudal estates, especially in the kingdom of Naples. Cf. the ironical remarks of Boccaccio (*Corbaccio*) and Sacchetti about merchants and bourgeois intellectuals who sought to become knights and to take part in tournaments.

[41] Sacchetti notes sarcastically that a burgher who has spent a few months or weeks as castellan in some country castle will have a coat-of-arms painted for himself.

[42] For example, until 1330, though not after that year, the Priors during their tenure of office had to live a completely isolated and Spartan life, sleeping on straw, and so on.

[43] See the relevant facts in Davidsohn, *op. cit.* For example, a decree was passed in 1338 that no nurse or maid-servant might wear a dress which reached the ground. As purveyors to the home market, the petty bourgeoisie were also economically interested in the repeal of the luxury laws.

[44] N. Rodolico, *Il Popolo minuto* (Bologna, 1899).

[45] G. Scamarella, *Firenze allo scoppio del Tumulto dei Ciompi* (Pisa, 1914).

[46] This alliance of petty bourgeoisie and nobility was especially common in Siena.

[47] The system of public debt was highly developed in Florence. In contrast to the non-interest-bearing compulsory loans of the princes, Florence had introduced interest-bearing compulsory and voluntary loans at a rather early date. Of special importance for the financial administration of the town was the institution of the Monte Comune into which all State loans were finally consolidated in 1343. See B. Barbadoro, *Le finanze della repubblica fiorentina* (Florence, 1929).

[48] This applies also to the guild of the linen-drapers, one of the lesser guilds in which the workers were not so numerous as in the great textile guilds.

[49] In addition to Doren, see also G. Bonolis, "Sull' Industria della Lana in Firenze" (*Archivio Storico italiano*, XXXII, 1903).

[50] In the lesser guilds, on the other hand, the members who enjoyed full rights outnumbered those who did not.

[51] Of the 90,000 inhabitants probably scarcely more than 4,000 had political rights. Of the 14,000 persons whom Davidsohn estimates to have been employed in the wool industry in 1378 (there was a very sharp drop in the population after the plague), 13,000 were without such rights.

[52] Only those who produced 100 pieces of cloth a year were eligible for the consulate (Statute of the wool guild of 1338).

[53] No one who himself worked at the loom was regarded as a real master in the Lana.

[54] This relatively prosperous section, in which the dyers of the Calimala and the Seta should be included, was the only one in Florence with any possibility of economic and social advance.

[55] The State itself (*Statuto del Podestà* of 1322–25), as well as the statute of the wool guild (1317, 1338, 1355), prohibited *sottoposti* from assembling even for religious reasons or at funerals. Any gathering of more than ten workers was illegal. An offender against this statute was expelled from the guild and could obtain no employment. Nevertheless, at the time of the democratic movement about the middle of the century some religious and social organisations of the wool workers came into being; they were, however, very strictly supervised. See N. Rodolico, "The Struggle for the Right of Association in Fourteenth-century Florence" (*History*, 1922).

[56] "The economic supremacy of the town, based upon industry, was only achieved through the exploitation of cheap proletarian labour" (Doren, *Florentiner Wollentuch-Industrie*).

[57] The workers' wages were paid exclusively in silver currency, whose value was continually sinking owing to bad minting. Besides receiving low wages, workers were often unemployed for a great part of the year. The enormous number of poor people is shown by the fact that in 1330, according to Davidsohn's estimate, 17,000 out of a population of 90,000 lived by begging, apart from those who were ashamed to beg or the needy in the hospitals.

[58] For instance, the wool guild maintained a notary appointed from outside Florence, as special bailiff (*Uffiziale forestiere*) whose duty it was to execute all sentences passed on any home-workers; he had to see that any worker suspected of disloyalty was imprisoned in the special jail of the guild, and he also had the right of torture. The Calimala, Seta, Cambio and Linaioli (linen drapers) had similar officials. Workers who were still bound to their employers were brought back to their workshops by force. See R. Pöhlmann, *Wirtschaftspolitik der Florentiner Renaissance* (Leipzig, 1878).

[59] The duke also repealed the sumptuary laws, a policy always popular among the less wealthy sections against whom they were principally directed. As a result, these sections also began to dress in the French fashion, which the gentry had adopted after the duke, who came from France, began to rule. The duke also held tournaments to increase his popularity.

[60] When in 1346 a large number of craftsmen immigrated into Florence, naturally enrolling themselves in the lesser guilds, the Parte Guelfa managed to pass a measure that none of those who had not been born in Florence or of a Florentine father should be allowed to hold office, because they could not prove that they were Guelphs (the immediate pretext was Henry VII's march on Italy). The lower sections were now called

Ghibellines in order to exclude them from power. Nothing could exhibit better the transformation in the upper middle class than this complete reversal in the use of names which had originated from a revolutionary mentality.

[61] Ironical as it may sound, coming from an organisation so friendly to the nobility, citizens who were disliked by the ruling clique were simply declared by an *ammonizione* (warning) of the Parte Guelfa to be Ghibellines or *grandi* (magnates), which barred them from all public office. This was particularly common after 1357, when the coming of the Emperor Charles IV to Italy provided the excuse.

[62] It is significant that just at this time the Florentine bankers did not possess an exclusive influence on the Papal finances, but were obliged to share it with others. The Pope laid an interdict on the town and ordered Florentine merchants to be banished from all European countries. The Parte Guelfa then made St. Catherine of Siena, who naturally supported the Pope's authority, not only preach against the war, but also support in her sermons the *ammonizioni* by which the Parte was able continually to weaken the middle and petty bourgeoisie. The Alberti, who were concerned in the Papal finances, finally succeeded in bringing the war to an end by a compromise. See also pp. 85-87.

[63] It is characteristic of the lack of independence in the attitude of the petty bourgeoisie and also of the workers that they clung to the traditions of chivalry; in celebration of their victory, sixty-four citizens, mostly rich, but some from the petty bourgeoisie, were knighted at the wish of the lesser guilds (included among them were the very Medici and Alberti whom we have mentioned). After the workers' revolt was ended, thirty-one of these "knights of the *ciompi*", as they were mockingly called, were again dubbed *Cavalieri del Popolo* by the synod of the knights in the presence of the Signoria in order to legalise their status.

[64] Rodolico, *La Democrazia fiorentina nel suo tramonto* (Bologna, 1905).

[65] Many of the *ciompi* fled to Siena, where the petty bourgeoisie ruled.

[66] This was also to include personal estate.

[67] With this object in view, it was intended to lower the rate of interest on State loans and even to repay capital to the subscribers.

[68] J. Temple-Loader and G. Marcotti, *Sir John Hawkwood* (London, 1899).

[69] The *condottieri* were always on the side of the nobility, from personal sympathy, or of the upper middle class, from which they could expect to receive good pay.

[70] As a consequence of the immigration of large numbers of weavers from Flanders and Germany at the end of the fourteenth century, especially in the eighties after the failure of risings in Flanders, Holland and on the lower Rhine, wages were depressed still further in Florence following the crushing of the *ciompi* revolt, and Florentine women were completely excluded from the labour market. These foreign workers could be deprived of the right of association and exploited more easily than the Florentine workers. See A. Doren, *Deutsche Handwerker und Handwerkerbruderschaften im mittelalterlichen Italien* (Berlin, 1903).

[71] How distinct the lesser guilds felt themselves from the workers, especially the unskilled workers, is shown by a motion brought forward in 1379 by the innkeepers, one of the lesser guilds, proposing that the day on which the revolt of the *ciompi* was crushed should be observed as a religious and national holiday. See Rodolico, *op. cit.*

[72] In 1385, with the help of the Florentine Government, the rule of the petty bourgeoisie was also overthrown in Siena. The Florentine workers had not only found refuge here, but had also made the city a base for their attempts to recover power in Florence.

[73] Moreover, the burgher was under no obligation to protect the peasant. For details of the changed situation, see Brentano, *op. cit.*, and Pöhlmann, *op. cit.*

[74] As we have seen, the Florentine countryside did not produce enough grain to feed the town.

[75] As attempts were also made by the peasantry to organise and carry out strikes, certain concessions were made to them at the time of the *ciompi* revolt, lest they should ally themselves with the town workers (see Rodolico, *op. cit.*).

[76] Improved methods in silk manufacture were introduced in particular by the Guelph masters who, having been driven from their native town of Lucca, came to Florence in 1314 and gave a great impetus to the whole Florentine silk industry.

[77] After the Council of Constance, the Pope was obliged to depend, in financial matters, mainly on the Papal State.

[78] For example, in 1427 the Strozzi, the richest family in Florence, had 53,000 florins invested in land and 45,000 florins in State loans, but their trading capital amounted to only 15,000 florins.

[79] P. Pieri, *Intorno alla Storia dell' Arte della Seta a Firenze* (Bologna, 1927).

[80] For instance, the statue of 1428 laid it down that the worker must give four months' notice to terminate his contract, while the employer was under no such obligation.

[81] In 1422 there were seventy-two *bureaux de change* on the Mercato Nuovo at Florence, and the amount of money in circulation was about 2 million florins daily.

[82] For a detailed account, see A. Rado, *Maso degli Albizzi* (Florence, 1926).

[83] Of the 620,000 florins which, according to the declarations of the *catasto* tax of 1427, made up the total income of the Florentine population, Palla Strozzi owned 101,400.

[84] The Mercanzia, the supreme commercial court, composed exclusively of members of the five great merchant guilds, now became more and more an organ of the State power against the individual guilds and especially a kind of High Court against the lesser guilds.

[85] The attempt was now made to reduce the number of the lesser guilds and thus to destroy the last remains of their influence. The attempt failed owing to the resistance of Giovanni de' Medici.

[86] See p. 87.

[87] The war against Lucca, however, must also be regarded in part as a fight for grain.

[88] Arezzo was important for Florentine trade, as the control of the town ensured free transit.

[89] Ph. Monnier, *Le Quattrocento* (Paris, 1901).

[90] Real and personal estate were both liable to taxation, but living expenses were exempted. See H. Sieveking, "Die kapitalistische Entwicklung in den italienischen Städten des Mittelalters" (*Vierteljahrschr. für Sozial- und Wirtschaftsgesch.*, VII, 1909).

[91] The tournament was subsequently held every year on the day of the conquest of Pisa, the feast of St. Dionysius.

[92] G. Salvemini, *La Dignità cavalleresca* (Florence, 1896).

[93] Cosimo de' Medici and his brother Lorenzo inherited from Giovanni real estate to the value of 39,000 florins, and investments in loans and trading capital to the value of 140,000 florins.

[94] For example, they turned to their own advantage the law passed under the influence of the Albizzi faction to exclude those in arrears with their taxes from holding office by paying out of their own pockets the taxes due from those whose support they expected or desired.

[95] B. Dami; *Giovanni Bicci dei Medici* (Florence, 1899).

[96] One point made by the prosecution was that fifty-five years previously the Medici family had been associated with the *ciompi* revolt. It is worth mention that Rinaldo degli

Albizzi, the leader of the ruling clique, had proposed an open alliance with the nobility in order to maintain himself in power—typical of the upper-bourgeois penchant for the aristocracy at this period—just as previously Cosimo himself had hoped to secure their support.

[97] The decline of capitalism throughout Italy, and of the formal democracy associated with it, became much more apparent in the second half of the fifteenth century: the rule of "tyrants" only became general at this period, when Florence also submitted to it. We cannot deal with this development here. This form of government varied very greatly in different parts of Italy, showing numerous gradations between an enlightened absolutism and mere *condottieri* rule; there were diversified combinations of a more or less capitalist structure with, frequently, very feudal methods by which the ruler maintained himself in power. The Medici rule in Florence, which began with Cosimo, also exhibited an ever-changing mixture of these various elements.

2. ECONOMIC, SOCIAL AND POLITICAL IDEAS

THE complex economic, social and political conditions of our period can be understood fully only if they are considered in the light of the ideas corresponding to them. Moreover, in no other field can we see so clearly the nature of the relations between the various factors which made up society—Church, nobility, upper middle class, intellectuals and lower middle class; it is these ideas in particular which bring the general outlook of these groups to life.[1] By considering how each class thought of society and economic life—the light in which they saw and valued the composition of the social system, economic activity, trade, usury and so on; and how they conceived of the State and of politics, we shall be able to form an idea both of current theories and of general everyday opinion.

An essential characteristic of economic, social and political ideas during this period was their intimate association, in many instances, with religion. This was naturally most pronounced in the ecclesiastical world, where religious conceptions determined the character and direction of all other lines of thought. In the upper-middle-class world, which was now achieving some degree of ideological independence from the Church, the relationship was not so close. As the Curia and the wealthy urban bourgeoisie were economically and in various other respects completely interdependent, the history of their economic, social and political ideas is essentially the history of the compromises arrived at in their common interest. Each side endeavoured to retain as much of its own ideological position as possible, but refrained in its own interest from asking the impossible of its ally. The very important scientific and literary activity of the cultured higher clergy bridged the gap between the two interests. In principle these clerical writers still adhered to the scholastic, monumental system of St. Thomas. Since his ideas exercised so persistent an influence, a brief summary of them must be given before we consider how the system was later modified by both the Church and the middle class.

St. Thomas Aquinas (1225–74), the great theologian of the Dominican Order and teacher at the University of Paris, embraced in a single grand system the whole ideological world of the Church of the "high" Middle Ages, including her views on economics, sociology and politics (*Summa contra Gentiles*, *c.* 1260–64; *Summa Theologica*, *c.* 1269–72; *De Regimine Principum*, *c.* 1265). That such a systematisation should have been thought necessary at all is, from a rationalist standpoint, very important. Moreover, Aquinas took over new and unknown ideas from Aristotle and incorporated them into an imposing structure, based

on compromises with the actual conditions. The Aristotelian conception of the State as an organisation aiming at the actualisation of virtue became embodied in and subordinated to the religious and ecclesiastical system: the doctrine of the sinful origin of the State had already been abandoned, but it was now conceived as an instrument of the execution of the divine world plan, that is, of preparation for the Kingdom of God. The orders of society, and their various kinds of work, are ordained by God; each order has its special *raison d'être*, each individual must remain in the station to which it has pleased God to call him—he must stay in his own order and at his own work. This applies to both rich and poor. The distinction of rich and poor is a necessary one, for the ideal of a universal abandonment of private property is unrealisable on account of the corruption of human nature. The poor, however, have a right to charity, especially alms. Each order has its own appropriate standard of life. This somewhat elastic principle of Aquinas was hardly affected by the assertion that economic work was not an end in itself, but should serve only to maintain life; for the kind of life to be maintained was always that which befitted one's station. Although his teachings assumed the existence of an urban population, Aquinas, following Aristotle, was somewhat cool towards traders: they are needed only in small numbers to ensure a moderate degree of intercourse between different towns. Within a single town there is no justification for trade, producer and consumer being in direct touch with one another. The doctrine of the unfruitfulness of money—that money has no productive power and cannot multiply itself—is also taken over from Aristotle,[2] and provides the basis for the prohibition of interest and usury. Every commodity has its own objective, just price (a conception likewise due to Aristotle),[3] to be determined by the authority appointed by God. As to the form of the State, Aquinas considered monarchy the best. His ideal "good ruler" must be just and observe the laws,[4] or he becomes a tyrant. To the Pope belongs supreme power, both spiritual and temporal, though he holds the latter indirectly rather than directly.

Aquinas, though he came of a feudal, south Italian family, was mainly active outside the socially and economically progressive Italy of his day. Although his ideas represent an enormous advance on those of his clerical predecessors, since he allows for the existence of a secular State and of a middle class, they still on the whole reflect a time when most secular States were weak and somewhat chaotic feudal principalities; when the middle class of the still largely self-sufficient agrarian and artisan towns was only in its beginnings, with the hierarchic ecclesiastical theocracy concentrated in the Pope as the only true sovereign organisation, and the only culture the culture of the Church.

The actual economic, social and political situation after Aquinas—at the end of the thirteenth century and still more in the fourteenth and fifteenth—was very different. The big business men and bankers were ruling in the towns, and the Pope was now allied with them, particularly with those of Florence,

since they were indispensable to the economic existence, the monetary affairs and the economic and political power of the Curia. As we have seen, the Curia could maintain itself as a great financial power only with the help of the interest-bearing transactions of the Florentine bankers. It therefore had every reason to be more than lenient towards bankers and merchants, and thus towards the taking of interest also. We have already mentioned how in Florence the canonical prohibition of interest was circumvented with the Church's consent, even though the guild statutes still upheld the prohibition in principle.[5] The word "interest", for instance, was avoided and replaced by others more harmless; in dealings with the Curia advantage could also be taken of the rates of exchange of foreign currencies in their country of origin and so on.[6] Moreover, the sin of usury could be expiated by penance and the danger of damnation avoided by good works and gifts for ecclesiastical and charitable purposes; we shall refer later in greater detail to this significant compromise.[7] In practice, a "just price"—though accepted in principle in the Florentine constitutional law of 1293—was usually fixed by the State authorities only when those who would bear the brunt of it belonged to a powerless social stratum. Food prices, for instance, were controlled to the detriment of the rural population; but when it was a question of goods produced by a powerful section—cloth, for example—the price was left, with few exceptions, to the individual employer, or to the most influential employers organised in the guild. The Curia, the institution most advanced in respect of economic activity and bureaucratic development, the most rational organisation of the Middle Ages until the rise of the city-States, understood quite well, as we have seen, from its own economic needs the carefully calculating mentality of the merchant, and itself reckoned just as accurately as the Florentine bankers and merchants.[8] In fact, this business mentality was so well developed among the clergy that many of them, particularly in Florence, took usury themselves. Such was the position in practice.

But a body such as the Church, burdened with a weighty tradition, needed a long time to revise its theories. So far as the Italian upper middle class was concerned, indeed, there was no particular need for it to hurry. The Italian bourgeoisie, particularly in Florence, was in close economic alliance with the Church, and was scarcely at all restrained by official ecclesiastical theory, which with the Curia's own help could be evaded without difficulty in practice. So in Italy the development of economic ideas on the part of the clergy proceeded *within* the Thomist system. Naturally, the Church was more ready to revise her official views in matters of detail than on questions of principle; the prohibition of usury was upheld in principle for the sake of its effect on the great masses of the less wealthy, and in order to maintain the Church's own ideal. For it was in the light of ideals alone that the Church looked upon her doctrines and principles; in Catholic business ethics, it is the toleration rather than the laudability of particular practices that really counts. Adaptation to the new

economic forces always took the form of compromises, of saving clauses, revealed by a slight shifting of accent.[9] So, even if in principle the fundamental Thomist doctrine was maintained, it was only those economic teachings which St. Thomas had treated as exceptions to his rules which the casuists developed in their "commentaries" and adapted to contemporary conditions.

Particular attention, therefore, was paid to the theory that the taking of interest is permissible in view of the risk attaching to a particular enterprise.[10] Similarly, a breach was made in the doctrine of the just price; Aquinas himself had distinguished between this and the market value. The Church admitted more and more provisos, until finally the merchants and bankers were covered in their economic activity, in their whole conduct of life and their penetration of the barriers hitherto existing between the social orders. Aquinas had already admitted in principle that a man might attempt to rise out of his order, but his endeavour must be judged in accordance with *magnanimitas*, with virtue. The merchant's profession, about which the Church had so hotly disputed, gradually came to take its place in the general system, as may be seen even from the various *Summae*—manuals which did not represent any particularly progressive thought, but were written for the guidance of the clergy and reflected average theological opinion. The most important reservation made by the ecclesiastical writers was not a concrete but a merely subjective one, namely, that the merchant ought not to be actuated in his economic activity by evil intention, particularly by avarice. Aquinas' injunction that work is to be looked upon as necessary, and not simply as a punishment for the Fall, was now more generally emphasised, and the earning of money for the support of life as the aim of such work came more and more into the foreground. At the same time, significantly enough, the theory that the standard of life to be maintained varied widely from one order to another was rigorously upheld. Aquinas' writings also provided a basis for the imposition of taxes and the issue of loans.[11]

Though the compromise between the Church and a developed upper middle class, that is to say, the Church's official view of the merchant, his business activity and his employment of usury, was systematised only in the time of Cosimo de' Medici by St. Antonino, then archbishop of Florence, such ideas were already in the air in the fourteenth century, still more in the early fifteenth; they were even actually formulated. Giovanni Dominici (1356–1419), teacher of St. Antonino and like him a Dominican, and later a cardinal, who was on terms of close intimacy with the wealthiest of the Florentine merchants, and whose writings, particularly the *De Regola Governi*, represented their religious and moral views, achieved a very complete fusion of conservative religious thought with practical common-sense. He preached the strict Thomist doctrine that Providence allots to each man his vocation.[12] One such vocation is to be rich; a man may be called to acquire wealth.[13] At the same time, he was fanatical in his insistence on the necessity of work. St. Bernardino of Siena (1380–1444),

a Franciscan and friend of St. Antonino, who by his sermons all over Italy, including Florence, endeavoured to hold the masses to the Church, made intense efforts to unite the interests of merchants and Church. The general tendency of his sermons, like those of the other wandering preachers of the Franciscan order, would appear to have been against usury. Their details, however, show them in a different light. This friar, who came from the Albizzeschi, one of the leading families of Siena, displayed greater knowledge of the details of economic life and a better understanding of the essential character of early capitalism than any Churchman in Italy before him. He it was, probably, who first examined the nature of capital in its various forms; and he justified it in the name of the Church. He explicitly recognised that it was creative. He explained, with numerous examples, when profit was allowable without its becoming interest —namely, when it represented a return on capital. On the delicate question of the just price he attempted a compromise between freedom and compulsion. He went far beyond Aquinas in extolling the principle of private property. Thanks are due to God's help for wealth gained in a righteous way. On the whole, in the sermons of St. Bernardino, the merchant's profession had already become respectable and his economic activity was regarded as capable of bringing advantage to the whole community.[14] Nevertheless, it was not till a relatively late date that theology accorded this theoretical justification to the merchant's profession in Italy.

In the more backward northern countries, in England, France and Germany, a different situation prevailed. There the bourgeoisie developed slowly, and instead of being economically allied with the Curia, they desired to free themselves from its economic pressure. In these countries the interests of the Pope and the middle class were opposed. So the paradoxical situation necessarily arose that the disintegration and indeed the abandonment of Aquinas' economic doctrines (Duns Scotus, Nominalists) in the interests of the expansion of the middle class (for instance, freedom of contract instead of the just price) chiefly came about, and that at a very early date, in countries where the bourgeoisie were less advanced than in Italy.[15]

As the individual States became more powerful, centralised and national, the Curia had to compromise in the field of political theory also. Aquinas' admission into his system of Aristotle's conception of the State was already one such compromise. But the truly modern political systems, like the economic, arose later and, for the most part, not in Italy at all, but in the new national States of the north, where middle classes and Churches were struggling for national independence and princes for centralisation. In these countries there was a strong tendency to put forward the principle of the sovereignty of the people, free from the influence of the Church (Marsilius of Padua, active outside Italy and supporting the Emperor; his *Defensor Pacis*, c. 1326),[16] and later among ecclesiastical writers, to uphold the rights of the democratic Councils

against the absolute predominance of the Pope. In Italy, on the other hand, the ecclesiastical writers of course remained, as regards politics as well, on the Pope's side, although they make some necessary concessions to the Guelph bourgeoisie, engaged in its struggle with the nobility and the Emperor.[17] The close alliance between Florence and the Curia is seen in the writings on political theory of two priors of the Dominican house of S. Maria Novella. These two men held the highest intellectual position in the Church in Florence, and, what is equally important, were both immediate pupils of St. Thomas Aquinas. One of them, Fra Remigio de' Girolami (1235–1319), who came of a Florentine patrician family, and occasionally acted as ambassador of the Republic, adhered, as was natural, to the Thomist thesis of the theoretical supremacy of the Church over the State.[18] The other, Ptolemy of Lucca (his real name was Fra Bartolommeo Fiadoni, 1236–1326), went beyond Aquinas in recognising even the temporal supremacy of the Pope over the State (this before Boniface VIII). The conception of the good ruler, though a precise one, necessarily remained vague in practice, and could be used by the Church to proclaim the right of resistance against a "tyrant"—that is, a powerful princely enemy (appeal to Old Testament precedents and even to those taken from ancient history was now more frequent); this very tendency to condemn the "tyrant", to a certain extent as already seen from the bourgeois standpoint, was significantly illustrated by Ptolemy of Lucca in his continuation (c. 1275) of Aquinas' treatise *De Regimine Principum*.[19]

Despite its respect for the Church as an authoritative institution and its own favourable situation in practice, the upper middle class of Florence could not be permanently satisfied with the compromising and somewhat condescending support given to it by the Church in the field of political and economic theory, or accept these ecclesiastical doctrines as exclusively binding. The great merchants, who were creating a new class with the help of their acquired wealth, required, for the consolidation of their position, spokesmen of their own to formulate their views, which, if not opposed to the tradition of the Church, would at least be supplementary to it.

Before discussing the systems of thought of the more important writers who represented the upper bourgeoisie, we will attempt to outline the general mental attitude, the average commonplace views of this section of society—to be found especially in contemporary documents of the town and the guilds*—with regard to economic, social and political questions, as they reflected the material conditions of everyday life.

In Florence, as elsewhere, behind the whole bourgeois order stood constantly the basic idea of God's Will: the Commune, the bourgeois authority

* In dealing with these everyday formulations, it is difficult to distinguish carefully between more or less explicit statements and the general outlook which is revealed in various small details.

and the economic organisation in its existing form were willed by God; the order as a whole, economic, social and political, was therefore set upon an unshakeable basis. This justified the conviction, evident in all guild statutes, especially those of the Lana, that capital must have absolute authority over labour, that all strikes or demands for increased wages must be punished as not only attacks on the peace and security of society but offences against the divine laws. In official documents, the workers were not reckoned as belonging to the people (*popolo*), whether the *popolo grasso* (the greater guilds) or the *popolo minuto* (the lesser guilds); they were not citizens, but simply *sottoposti*, and, as chronicles and tales further confirm, were not regarded as beings with human needs but as the "poor", "miserable creatures" who should be grateful for being allowed to work at all;[20] the *ciompi* especially were considered as the lowest of mankind. Many State decrees and guild statues, particularly from the time of the absolute rule of the upper middle class at the beginning of the fourteenth century and again at the beginning of the fifteenth, give abundant evidence of the pride felt in the city's power and renown, its wealth and liberty—the wealth as embodied in the woollen and later in the silk industry;[21] but by industry was meant the industrialists. This firm belief of the well-to-do bourgeoisie in their own unique righteousness, in the necessity of preserving their self-created social order, extended, of course, to politics. One statute, for instance, laid it down that every candidate for the *Consiglio del Comune* must be "a lover of a quiet and peaceful state in Florence". It is no wonder, therefore, that the revolt of the *ciompi*, that "sudden" appearance on the scene of the hitherto ignored mass of the workers, was regarded by all middle-class chroniclers as usurpation and robbery.[22]

As we have seen, only a wealthy minority had real political rights; and actually such institutions as the *Balìa*, the *accioppiatori*, the *ammonizioni* restricted power to a small clique even within this minority.[23] Yet the Florentine upper middle class naturally never officially admitted that the government was in the hands of a few families of the Lana, and was therefore an oligarchy. In Florence, the actual conditions would scarcely be so clearly and explicitly formulated as they were by the famous jurist Bartolus of Sassoferrato: he defined—and praised—the form of government in Florence as being like that of Venice, a government of *pauci divites*, that is of a few wealthy and good citizens (*Tractatus de regimine civitatis*, c. 1355–57).[24] Formally, the Florentine constitution was democratic; by the letter of the constitution, all those who possessed political rights were absolutely equal.* According to the political catchwords of the Florentine upper middle class, by which they justified their acts and decrees, "liberty" and "justice" held sway in this democratic republic ("liberty" was the

* We are therefore obliged to use the same word "democratic" here both of the theoretical disposition of the upper middle class just characterised, and of the practical endeavours of the lower middle class.

slogan used by all factions, particularly the patricians, in the Roman Republic;[25] "justice" was a fundamental conception of Aristotle and Aquinas). Used in Florence first in a revolutionary sense—the guild Priors were Priors of liberty, the constitution by which the bourgeoisie avenged themselves of the former wrongs inflicted by the nobility was the *Ordinamenti di Giustizia*, the officer who symbolised their victory over the nobility was called *Gonfalionere della Giustizia*—these slogans later acquired a different interpretation. "Justice" after the final victory of the upper middle class came to stand for the new social equilibrium in which inequalities between the various social groups were "impartially" lessened and security guaranteed for all.[26] After the upper middle class had come to power, "liberty" meant the merely theoretical political right of the individual which we have mentioned above—to participate in the constitution, to take part in the elections, above all, to hold office. For a city-State with its clearly defined territory, developed economically for profit's sake, with a central government capable of protecting and furthering trade, political independence was much more important than for a feudal, loosely-knit State;[27] "liberty", therefore, was also the catchword of the new bourgeois patriotism and nationalism.[28] In their fight for practical democracy and for economic and political rights, the oppressed petty bourgeoisie now endeavoured to use the same political slogans against the upper bourgeoisie as the latter had used against the nobility. When the dyers, for example, won the right to form a guild, their coat-of-arms included an arm holding a sword on which was inscribed "Giustizia". At the time of the oligarchic reaction at the beginning of the fifteenth century, the same catchwords, especially "liberty", served the small ruling clique of the upper middle class (primarily) and the Medici, who based themselves on the support of the rest of the population. In the same Albizzi period, when the exterior power and, as its ideological corollary, the inner moral strength of the republic was constantly played up, a great place was assigned to the speeches—whose general features were laid down in advance, as is made clear in the town statutes of 1408 and 1415—of the municipal officials on the occasion of their investiture and that of the ambassadors; never before were diplomatic and political commonplaces so carefully worked out on the basis of given themes: long dissertations of a quite general character dealt with the integrity of officials, good and bad government, and, above all, "justice" and "liberty".[29]

Finally, a very important feature of Florentine everyday life must be mentioned, namely, the law and its practical application. A new commercial customary law, a vital necessity for the new middle class, came into being, and was codified in the guild and town statutes. Germanic law, introduced by the emperors and based on conditions which were essentially those of a barter economy, could not permanently satisfy the bourgeoisie. Hence first the Lombard and later the Tuscan towns took over Roman law, which was typically bourgeois

in its protection of private property and could do justice to complicated business matters; more accurately, Roman law was adapted with the help of the outstanding civil jurists to the commercial customary law of the period. In 1346, a decree of the city ordered the use of Roman law in the Florentine tribunals. So the new economic order received legal forms adequate to it. Here, in this legal development, we can clearly see the material and ideological reasons for the "revival of antiquity", of which we shall speak in greater detail later. This "revival" could take place most easily in Italy, because so much classical knowledge had there survived, particularly a clear memory of Roman law. This knowledge was not, it is true, even in our period, a very deep one. The jurists, conservative as they were, did not go back to the original sources, but, in a somewhat scholastic spirit, were concerned only with details and contented themselves with glosses. The main task of the famous jurists was a practical one: to deliver legal opinions (*consigli*) to the various communes or to other corporations of the upper bourgeoisie whose interests they served through their authority.[30] If we descend further to everyday jurisdiction in Florence, we find statutes and judges imbued with the spirit of the ruling factions, with great arbitrary power in the hands of the magistrates and a great deal of corruption—circumstances which were likewise advantageous to the wealthy alone.[31]

It was only at the beginning of the fifteenth century that the character of Roman law was slightly changed in Florence, when the Tuscan jurists—not of course the more medievally-minded Bolognese—more familiar with classical culture, turned to the study of the antique sources themselves.[32] The Florentine notaries, closer to the humanists than to the judges and more versatile, contributed, in their sphere—particularly in the Chancellery—far more towards the "revival of antiquity". The notion of the city's fame also makes use of antique ideas; it proclaims the pride of the Florentines—the pride of the new bourgeois patriotism—in their town's foundation by the Romans; the notaries did much to disseminate this idea, already found under the bourgeois rule, and later coming more to the front. For instance, a letter from the city of Florence to Rome in 1396 ran: "We, who pride ourselves on having once been Romans, as our historians report, and remembering our ancient mother. . . ." This letter was composed by one of the most important spokesmen of the Florentine bourgeoisie, the notary and chancellor Salutati, himself a great humanist, and it is even more in the theoretical works of the humanists, the spokesmen of the middle class, that this classicising world of thought was further elaborated in detail.

The spokesmen of the upper middle class were at first, naturally enough, the great merchants and the business men themselves, but later, to an increasing extent, the professional intellectuals of this class, the humanists dependent on them.[33] In the merchants of the upper middle class, the economic and political interests of their stratum were very clearly expressed, even if they were often hidden behind the catchwords already mentioned. The economic theories of

ecclesiastical writers in Italy might lag behind those of northern countries, but in Florence the merchants themselves created a body of *lay* literature on practical business questions and of historical writing illustrated by economic facts, which was at that time unique in the Christian world. They were not, however, free from the traditional conceptions of the Church, but rather were peculiarly susceptible to them—a blending of ideas characteristic of the members of the upper middle class.

Giovanni Villani (b. before 1276, d. 1348) was a typical representative of the ideas of this class during the period of its absolute power in Florence previous to the rule of the Duke of Athens. A great wool merchant, and a partner in several large banking houses, including the Peruzzi, he was one of the most prosperous citizens of the town; he also took an active part in the government, being several times Prior and also Consul of the Calimala, and wrote a history of the city. In theory, his chronicle still expressed the scholastic conception of the general historical process, which explained everything by God's justice and regarded every misfortune as a punishment for wrongdoing.[34] But though its general framework was in harmony with the Church's official theory, it showed a very sturdy bourgeois will-power and self-assurance, besides a very keen interest in the economic and financial details of the historical events described. In contrast to the naïve narratives of the northern chroniclers, Villani desired accuracy; he loved figures. The first writer to be interested in statistics, he made investigations into the population of Florence, its production of commodities, the circulation of money, etc. This was an astonishing achievement, and even to-day his figures can be accepted as on the whole accurate.[35] He set out briefly theories on money, trade and credit. While professing the official ecclesiastical outlook, he was wholly a man of his class in his way of considering and judging individual historic facts; he stood by and expressed his real economic and political interests, even though he generally added religious and moral reservations and justifications. But on one side of his activity he was silent; the strength of the traditional view and the canonical prohibition of usury made him consider himself, as a money-lender, the social inferior of the merchant.

Villani was a Florentine patriot, proud of the fame of his city, its freedom and its wealth. But by wealth he always implied that of the merchants. He made a vague general demand that all should share in the government, thus preserving the appearance of democracy, but every particular, concrete statement was to the effect that the decisive political influence must lie with the rich citizens of the greater guilds (*maggiori e più possenti popolani grassi*), whom he distinguished from the nobility on the one side and the middle section of the bourgeoisie (*mezzani*) and small men (*popolo minuto*) on the other. By "liberty" and "justice" Villani understood the middle-class order ordained by God, which ought not to be disturbed.[36] He was averse to all violent change, since, as he said, he himself could only lose by it. Hence at the end of his life his view

47

of the future was very gloomy; the bankruptcies, the rule of the Duke of Athens, and especially the advance of the lesser guilds were threatening the absolute rule of his class. At first Villani was opposed to the nobility; though he gave the whole credit for their defeat to the upper middle class, completely ignoring the co-operation of the petty bourgeoisie. Later, during and after the reign of the Duke of Athens, he regarded the lesser guilds as the growing danger. The ideological justification which appealed to Aristotle and to the Bible (Solomon) was most characteristic of the ruling class: the *popolo minuto* thought only of their own advantage, and were therefore not fit to rule the State. He called the artisans idiots who had come into the town from the country or even from foreign parts. How greatly Villani preferred the now politically innocuous nobility to the *popolo minuto* is shown, for instance, by his lament over the battle of Courtrai: "Here chivalry was humbled by the meanest people of the world, by weavers, cloth-fullers, and by other mean guilds and craftsmen." Villani was against a monarchy for Florence, because, said he, monarchs ruled arbitrarily and would not respect the laws. Behind this concern for republican democracy lay the same fear as in his dislike of the petty bourgeoisie, lest the interests of the upper middle class should no longer be protected by the rule of the merchants themselves. Though Villani was no friend to "tyrants", many passages in his book show that he had a great respect for princes, provided they were well off; he had nothing but contempt for disorderly feudal administration and the continual money troubles of the German emperors. As a Florentine Guelph, he naturally considered the Emperor as subject to the Pope. The Guelphs were, in his eyes, "those who love the Church and the Pope"; nevertheless, the details of his book once more make it clear that Florence derived great economic advantages from her alliance with the Holy See.[37] Villani, of course, also favoured the House of Anjou and France, and regarded the French king as the first and most powerful ruler in Christendom. Further, it is worth noting, as this early appearance of the "revival of antiquity" ideology is remarkable, that Villani spoke with admiration of ancient Rome, the former mistress of the world, tracing to the Romans the foundation of Florence.[38]

Other merchants living in this time of the economic expansion of the upper middle class wrote on questions of practical economics.[39] Francesco Pegolotti, for example, a partner and agent of the Bardi, wrote a treatise for the instruction of his countrymen entitled *Practica della mercatura* (1339),[40] in which he not only described his commercial travels in Europe and Asia and showed an extraordinary grasp of business conditions in the various countries, but also discussed questions of insurance, transport, and so on. The corn merchant Domenico Lenzi in his *Diario* (1320–35) gave a detailed description of the movements of the Florentine corn trade, and noted prices; like Villani, he declared himself in favour of uncontrolled food prices for the merchants, and of complete freedom of private economic initiative.

ECONOMIC, SOCIAL, POLITICAL IDEAS

The great merchant Giovanni Morelli (1371–1441), whose life falls partly within the Albizzi period, wrote a chronicle covering the years from 1393 to 1421, which dealt at length with family matters and was intended for his son's reading. Although he had himself held various municipal offices, he recommended his son not to take part in public life, so that he might be able to give himself up wholly to business and money-making; only in case of absolute necessity was he to support the stronger side, namely the Guelphs, for Morelli too could imagine nothing more disastrous for the State and himself than the rule of the petty bourgeoisie.[41] So at this new yet unstable apogee of the upper middle class, there appeared, in contrast to the earlier, politically active Villani type, the ideology of the other "private", relatively non-political type.[42] Morelli, in consequence of this more private attitude, gave his son detailed, calculated, sober and exact advice on how to run his business, with particular attention to methods of taking advantage of the State on every possible occasion.[43] Morelli consistently gave expression to the economic ideology of the possessing class of his time; like Villani before him, though more consistently, he expressed a synthesis, important for the future, between religious and worldly thought, characteristic of early capitalism. Morelli based himself on Dominici, drawing further conclusions from his doctrine that money-making was a profession according with the will of God. It was God's will that a man should look after himself; the proportions in which God distributed worldly goods depended on men's merits. So wealth and business success signified God's reward for piety. In Morelli we hear less about the sinfulness of making profit from business, but he has all the more to say about making business safe. It shows the calculating and anxious mentality of a part of the upper middle class in the Albizzi period that Morelli wished to avoid great business risks; he was afraid of the ever-increasing hazards, since times were now becoming undeniably less secure, and, belonging as he did to a solid, old-established family, he disapproved of the chance speculations of the new-comers. He preferred a lower rate of profit, provided it was safe: he advocated moderation, and wanted to feel sure of his ground. His love of "moderation" is also seen in his acceptance of the Romans as ancestors and as patterns of virtue, but only so far as they did not interfere with money-making: in practical, everyday affairs, he proposed as the best model a contemporary living the same kind of life.

While dealing with this heyday of the upper middle class, reference may also be made to the treatise *De Usuris* (1403) of Lorenzo Ridolfi, a member of the eminent family of that name, himself a jurist, and therefore, like the great merchants, in close touch with actual economic conditions and with a thorough understanding of them. In his treatise he endeavoured by skilful argument to protect the economic activity of the upper middle class in many cases from the consequences of the effete doctrine of usury. He was impelled to write, he said, because of his anxiety for the salvation of his fellow-citizens, whom he saw

49

engaged in a number of dangerous pursuits. On the other hand, it is characteristic of the lack of sentimentality and of the sobriety which governed even the theory of this period that Ridolfi quite openly refused to admit love of one's neighbour as an argument against taking interest. Belonging to the Albizzi clique and occasionally acting as ambassador of the Republic, Ridolfi also justified in theory the compulsory State loans with the help of which the ruling oligarchy maintained itself in power. [44]

Just as formerly the clergy had acted as intellectuals to the nobility, so the bourgeoisie now had need of their own secular professional intellectuals, the humanists, drawn from their own ranks, generally from the middle sections, to expound their relatively rational economy and outlook. The culture they had acquired and their scientific work provided them with a livelihood; a bond of interest knit them to the merchants—the one body representing learning, the other wealth, and both in their own way having broken through established social barriers. [45] The Florentine humanists were also frequently employed by the Republic, even as chancellors of Florence (Salutati, Bruni, Poggio); they were often the chroniclers of the city as well, and naturally were closely associated with the interests of the rulers. The humanists were now theorists in the full sense of the term, and had evolved coherent systems of moral philosophy in contrast to the business men, whose writings dealt mostly with particular practical questions. It is clear, however, from these systems themselves, that even if the humanists were in close economic dependence on the ruling stratum —partially, indeed, because of this dependence—there were inevitably certain points of opposition between them, living as they did in their own artificial world of culture, and the upper middle class of the fourteenth and fifteenth century. In the work of the humanists, at any rate in their theoretical writings, we find a certain note of passivity, of *bel esprit* and esoteric culture, a "superior" ignoring of economic matters, a contempt for money-making. It is noteworthy that the unfavourable judgment passed on merchants both by the humanists and the Church was strongly influenced by antique thought, appeal being made especially to the authority of Aristotle, who took up a similar position, [46] and of Cicero, who, however, had confined his censure to the lesser merchants. For the humanists borrowed their political and social ideas chiefly from the different trends of the political and social literature of the middle classes of antiquity. As with the doctrines of the Church, certain reservations were made when once the ideal—more extreme and intolerant even than the Church's—had been proclaimed by which the merchant was "suffered" to pursue his calling. The humanists found a justification for wealth and for those who acquired it in Roman Stoicism (as well as in Cicero), the philosophy of the upper middle class and intellectuals in Rome's peak period; what counted with the humanists (not unlike the Church) was the intention and the inner effect. They thus represented, within the general outlook of the upper middle class, an aspect

which appeared only towards the end of the Albizzi period, but became completely topical at the time of the Medici when, with the decline of the rational-bourgeois development, a pleasure- and luxury-loving aristocratic mentality got the upper hand. Nevertheless, it seems desirable to give a general description of the ideas of the humanists here, since they anticipate the line of later development and had a considerable influence even at this stage in strengthening this tendency of the middle class.

Petrarch (1304–1374), with whose theoretical writings and epistles rather than his poetry we are here mainly concerned, forms a chapter in himself among the humanists. He was not one of those who lived in Florence or the Florentine territories; nor was he employed by any other city-State. Choosing, as a "free" intellectual, to "flee the world" and to live mostly away from towns, in the country, he nevertheless kept in close touch with the great ones of the earth—the Pope, the Emperor, and the princes—and he loved a courtly atmosphere. In a wider sense, however, he must be dealt with as a representative of Florentine thought, for not only was he born at Arezzo of a Florentine family of notaries, exiled at the same time as Dante, but the Florentines counted him as one of themselves and his writings were particularly influential in Florence. From the point of view of contemporary Florence, if from no other, Petrarch is the typical émigré. Though his whole outlook is, of course, early bourgeois, and is inconceivable without the existence of an advanced urban bourgeoisie such as that of Florence in particular, it is nevertheless also a reaction against such a class—a reaction which has its origin in the past, and yet, with its elements of a decadent bourgeois mentality, points towards the future. Particularly in his partial dependence on aristocrats and courts, Petrarch is a forerunner of the neo-aristocratic mentality of the Medici period.[47] From the complexity of his historical position the complexity of his views on those questions that here concern us follows.

Petrarch was one of the first to find arguments, above all in the rich sources of antiquity, for Italian nationalism[48] and for many middle-class principles in general. He regarded Roman history as that of the national past. As an Italian, not a Florentine, patriot, he was inspired by the idea of the new Rome continuing the sovereignty and world-empire of the old. This historical and political standpoint explains his hatred for the immediately preceding period of the Middle Ages, with its "Gothic" and "German" feudal lords, which was for him the time of national decline and the rule of the "barbarians". It also explains his dislike for the Roman feudal lords of his own day and his enthusiasm for the bourgeois revolutionary, the tribune of the people, Cola di Rienzo, who attempted a revolt against the feudal lords of Rome,[49] and, again recalling ancient Rome, proclaimed the ideal of a nationally united, independent and free Italy.[50] In his enthusiasm for the republican Rome of ancient times, Petrarch wished to see the nobility excluded from office, after the contemporary

Florentine pattern. But his democratic views ultimately applied only to Rome,[51] and never to Florence. What chiefly attracted Petrarch even to Rienzo was the glamorous and tyrannical strain in him. For at the bottom of his heart— another of his self-contradictions—the Florentine émigré despised the bourgeoisie and the bourgeois city-States. He was not concerned about the participation of the citizens in public life; he is too far from reality to have a continuing political interest, and he even reproaches his literary model, Cicero, for having mixed in politics and held office. As with many later humanists, consciousness of his own spiritual singularity made him prefer the aristocratic and the courtly, and in politics, the prince, the man of action on a grand scale, the tyrant. So Petrarch's sympathy with Rienzo was necessarily very short-lived; like most intellectuals, he attached himself politically to those whom he thought most likely to help him in gaining a livelihood. He therefore entertained relations (before Rienzo's rise to power it is true), with Rienzo's open enemies, the Colonna, the leaders of the Roman aristocrats, and also with the Curia at Avignon, and in later life still more exclusively with the courts of the princes. It was at this time that the north Italian communes were going down and were being transmuted into Signorie, and in fact Petrarch, as orator and politician, was in the service of the most notorious tyrants of northern Italy, the Visconti of Milan and the Carrara of Padua. In his late work, dedicated to his patron Francesco da Carrara (*De Republica optime administranda*, about 1373), he depicted these princes as true Romans with all the appropriate ancient virtues; in reality, he connived at all their cruelties.[52] Thus the ideology of antiquity, here associated with Italian nationalism, was already given, by its first and most important representative, the most varying political interpretations according to the actual political forces of the moment.

Though Petrarch's views as to the best form of the State differed at different periods, under cover of them all he was advancing his demand for the security of the few important intellectuals and for the possibility of their uninterrupted inner development.[53] To him, as an exceptional personality, the life or death of the common people was a matter of indifference (*Invectiva in Medicum*).[54] Petrarch favoured a return to static economic and social conditions, as in Aquinas' system—a return equivalent, so he considered, to the blessed simplicity of an earlier age, to the agricultural life of the old Roman peasantry (dependence upon Virgil[55] and Seneca) so that the elect few might have peace for contemplation. He despised every form of economic activity which aimed at making money; money was intended to meet the needs of the moment, and ought to be spent. Nevertheless, he approved of wealth as the necessary condition of a certain standard of life, more particularly of the wealth of a landed *rentier* (also praised by Cicero and Seneca), whose circumstances were best suited to that remoteness from the world which he desired for himself. On the other hand, though he was one of the first admirers of country life and of nature since anti-

quity, he considered the peasantry as the meanest of beings (*De Remediis utriusque fortunae*). Many of his views on economic and social matters are conflicting, self-contradictory[56] and, like his whole conduct of life, full of compromises. In many of his theories he drew upon the past, not only upon Thomism but even more upon the Church's pre-Thomist views; he imbibed much feudal-aristocratic sentiment; he was especially indebted to Roman Stoicism, particularly in its late Senecan form, which had likewise been intended only for an élite.[57]

Giovanni Boccaccio (1313–75) too was a humanist in science and philosophy, and a pupil of Petrarch; but he was also a member of the Florentine upper middle class, taking an active part in the political life of his city, and with him begins the line of "resident" Florentine humanists who necessarily had more bourgeois views than Petrarch; though, like Petrarch, he had the usual theoretical aversion to wealth. His political views resembled Villani's rather than Petrarch's. A republican and hater of tyrants (Duke of Athens), he attacked Petrarch for earning his livelihood at the tyrant court of the Visconti. On the other hand, he despised the existing government of Florence, which was then more under the influence of the lesser guilds than in Villani's day, and in which sat people from the small villages of the countryside, from "the mason's trowel and the plough" (*Epistola consolatoria a Messer Piero de' Rossi, c.* 1363).[58]

Another follower of Petrarch was the notary and chancellor of Florence, Coluccio Salutati (1331–1406, chancellor from 1375). A shrewd diplomat and a realist in politics, he yet at the same time, in his treatises and his letters (written for publication), appeared as the first true lay theorist of the Florentine upper middle class.[59] Out of the systems already formulated, by the Church, by Petrarch and by the bourgeois scholars (Marsilius of Padua, Bartolus of Sassoferrato), he constructed an eclectic system which should satisfy him both as a religious Florentine citizen and as a humanist. Since the Church's system was the most complete and elaborate, Salutati necessarily linked up his ideas most directly with this, and had to define his position with particular reference to it. The secular bourgeois and the ecclesiastic were carefully balanced in his work, but this high official of the city shows deep regard for the interests of the bourgeoisie; from Petrarch he took only so much as was necessary to keep the way open for practical bourgeois reality.[60]

Salutati held to the view that Providence is active in history. He also held in general to the ideal of the Church: to the medieval conception of a beneficent State based on morality and religion, whose mission it was to promote the good. He drew no important conclusions, however, from these traditional ideas. In Salutati arose a new, more secular and natural view of politics. He made use of history to try to awaken a national consciousness and to draw practical lessons. The new conception of the secular-national State was already developed in his writings in the form the Florentine middle-class republic required, and the previous theoretical dependence of the State on the Church was repudiated.[61]

He took his start from the individual modern State, while the feeling of patriot-ism, the Florentine national consciousness, formed his leading conception. The duty of service to the State and fatherland is in his writings second only to the service of God.[62] As regards the form of the State Salutati, like nearly all theorists of the time (not those of the Church alone) followed tradition in favour-ing monarchy. But in all his writings which deal concretely with Florence, and not only in the official letters of the chancellery, he supported the republic. In every State, the humanists placed themselves at the service of the form of government which existed at the time. Salutati naturally described Florence as the seat of liberty—an upper-middle-class notion which we have already met.[63] The Florentine conception of the State was particularly supported in Salutati's work by the "antique" theory, of which there were hints in Villani and a more definite idea in Boccaccio: the Florentines were the successors of the Romans, the "free" people chosen by God for the empire of the world. In fact, there was now a growing tendency to support political theory by arguments drawn from ancient history, besides those from the Old Testament. Salutati, like Petrarch before him, drew parallels, but even closer ones, with republican Rome, with the virtues of the patriots of the early republic and, again like Petrarch, appealed to Cicero in support of patriotism.

Salutati's conception of the various social classes within the State displays the same static conservatism as Aquinas and Petrarch, but this time with regard to the fatherland. Outward conditions of life are not important; each must serve his country, as Christ did, in the station in which God has placed him. Thus religious and ecclesiastical ideas once again receive a national and patriotic significance. The underlying tendency of course remains equally conservative: the bourgeois order must be maintained,[64] while the appearance of democracy is preserved. Salutati was therefore anxious to justify and encourage the parti-cipation of the middle class in public life. Though in principle he agreed with Petrarch and with the Church that the contemplative life was the higher, in particular cases (including his own) he often set a higher value on the full active life of the citizen in the service of his country.[65] This solution, favourable to the bourgeoisie (or rather to the small ruling clique of the upper middle class whose interests this system of ideas reflects), was just as important as Salutati's mental reservation with regard to money-making—which in theory he despised[66]— that wealth was to be used only for the satisfaction of praiseworthy desires; and he acknowledged that, in practice, it brought salvation to many. At a time when politically the nobility was completely innocuous, the chancellor of the bour-geois commune naturally commended them—provided they were cultured. On the other hand, he expressed boundless contempt for the masses, as in fact did all the intellectual representatives of the upper middle class, whether humanists or great merchants. Salutati, who was chancellor at the time of the *ciompi* revolt, showed himself, during the democratic period, extremely lenient towards

the victors, praising them as "mild and excellent men", and was well treated by them in return; but when the revolt had been crushed he spoke of the *ciompi* as "ignorant" and "innovating" artisans, horrible monsters who were a danger to the glorious republic of Florence.[67]

Leonardo Bruni (1369–1444) and Poggio Bracciolini (1380–1459) lived at a time when Florentine democracy was formally at its height; moreover, Bruni stayed for many years in the Curia, that modern, bureaucratic institution with a relatively democratic organisation, and Poggio even spent most of his life there. Bruni was chancellor of Florence from 1427 till 1444; Poggio returned to Florence for good only in 1453 as an old man, when he also became chancellor.

Bruni, most of whose writings fall within the period we are considering, was much more secular-minded than Salutati. He made no open attack on the Church; he simply ignored her importance and her activity. For him (*Historiarum Florentinarum Libri II*), history was no longer the manifestation of divine providence, as Villani and, in theory, even Salutati had considered it.[68] Critical and well-balanced historical thought showed itself in this work of Bruni far more forcibly than in any previous writer.[69] Even ancient Rome, which Petrarch had blindly adored, was now given its historical place, and instead of a vague enthusiasm for Italy, still connected with the old world-imperialism, Bruni definitely instituted a concrete and active Florentine patriotism. He felt an affinity between the Greek city-State and the Florentine.[70] He was more emphatic than Salutati in upholding the republic and democracy,[71] in advocating an active life and the participation of the individual in public affairs. No one approved so enthusiastically as he of "liberty", the political slogan of the ruling oligarchy with its appearance of democracy. In Bruni, the liberty of the citizens is closely connected with the theory that all are equal before the law and have a right to hold office (*Oratio in funere Johannis Strozzae*, 1426)[72] but, as usual, he is obviously thinking here only of that small minority which really possessed political rights. With the Florentine upper middle class at the zenith of their power, Bruni not only wrote an elaborate history of the city[73] but also sang the praises of Florence in his intentionally over-confident *Laudatio Urbis Florentiae* (1405). Everything in this State is good.[74] Florence is the heir of Rome and of Roman liberty, all the more since she was founded by the Romans in the time of the Republic. The institutions of Florence are in such perfect "musical" harmony with one another as to be aesthetically pleasing; in this he imitates a phrase of Aristotle. The Parte Guelfa corresponds to the censors of ancient Rome. Justice and right rule: the republic protects the weak against the strong. It must, however, be observed that according to Bruni the majority were always the better citizens. Starting from such assumptions, he was naturally able to draw up a very optimistic summary of the general state of Florence, being concerned, as he says, less with fidelity to fact than with effectiveness of

rhetorical manner (imitation of the speeches of Aelius Aristides on Athens and Rome, delivered during the enlightened monarchy of Antoninus Pius; in the speech on Rome, the rule of the "best" men who had Roman civic rights and as such were called to rule over the masses was welcomed as an accomplished fact).[75] Indeed, his rhetorical phraseology, adapted from the antique, is a very significant expression of the whole sham democracy and purely formal republicanism of the Florentine upper middle class. Now that the republic was in fact drawing to its end and power was actually concentrated in the hands of a few families, all the louder, the more rhetorical and clearly formulated did republican ideology become. This high-flown antique-imitating ideology deliberately rejected the detailed realism of a Villani.[76] "Noble" motives alone were operative in Bruni's Florentine history; the economic and financial motives so numerous in such earlier chroniclers as Villani or Marchionne Coppo di Stefano were suppressed. The haphazard events of the chronicles were also eliminated, and Bruni, on his rhetorical and at the same time scientific plane, emphasised what seemed to him important, and tried to uncover historical relations. The principle of grouping together and of typifying prevailed; historical personalities, in imitation of Livy, made fictitious patriotic speeches to motivate their actions. Bruni's historical and political thought, adapted to the ideological needs of the upper middle class of the Albizzi period, was both secular and patriotic, coherent and calculating.

Bruni's manner of thought manifested itself also in the written instructions which during the Albizzi period he gave, as chancellor, to the Florentine ambassadors for their speeches. Since Florence's foreign policy was a very active one at this time, and more ambassadorial missions were undertaken than ever before, this new type of speech, its main features precisely laid down in advance, played a notable part in political life.[77] The analogy imposes itself between the importance of political speeches in Florence at this period and in Rome during the late Republic, and under the enlightened absolutism of the Emperors of the first two centuries A.D., when the speeches were already intended to be taken rather "theoretically". In these speeches of prominent Florentine statesmen and in Bruni's writings, a similar classicising phraseology, the same rhetorical panegyrics of Florence and Florentine liberty, a similar calculated construction prevailed. These Ciceronian speeches differ entirely from the more casual efforts of the fourteenth century, and it is no accident that Rinaldo degli Albizzi, the head of the oligarchic clique which ruled Florence, is the most important representative of this patriotic and antiquity-imitating eloquence.[78]

Poggio's writings, impregnated like those of Bruni with a democratic and rationalist mentality, were mostly composed in his later years, after Cosimo de' Medici's seizure of power. For this reason, we do not here deal with them in detail, but give only a very general characterisation. In an early work (*De Avaritia*, 1428) Poggio, like the Church, pronounced himself against avarice,

though, once more like the Church, he left himself a way out for the wealthy middle class; they had only to make a morally right use of their wealth.[79] Broadly speaking, Poggio is perhaps even more sober-minded, more sceptical and more sincerely democratic than Bruni. A realist in his view of politics and history, he discarded Salutati's traditional moral phrases. He considered general social relations in a surprisingly dispassionate way, often anticipating Machiavelli. He was so clear-headed a rationalist that, like Villani before him, he condemned the wars of prestige waged by the patricians on account of their high cost. He was also extremely bitter in his attacks on the idle and ignorant aristocracy of birth, and substantiated his charges much more concretely than was usual with the humanists.

The intellectual world of Poggio and Bruni—and the somewhat later one of Alberti, whose writings fall outside our period—were the clearest ideological expressions of the potentialities of bourgeois "democracy" in Florence. The general political and social ideas of Bruni and Poggio are strongly influenced by Roman Stoicism. This is no wonder, since this philosophy, with its ideals of humanity, of men's theoretical equality and of what this implied in politics, is the fruit of the heyday of the Roman upper middle class,[80] that is of the time of the late Roman republic and of the enlightened absolutism of the early Emperors. In the Bruni-Poggio period it was the early rationalistic trend of Roman Stoicism as handed down by Cicero which was influential, with its praise for Rome's republican constitution, its emphasis on the duties of the citizen, its advocacy of his active participation in political life,[81] its opportunist valuation of exterior advantages, particularly wealth.[82]

While the upper middle class were thus formulating their economic, social and political ideas through their intellectuals and their own members, there could naturally be no question of the economically and culturally retarded lower middle class developing such complex conceptions; at most, they could put forward only individual, concrete demands in the economic and political fields. The petty bourgeoisie, with their artisan mentality, were certainly filled with a general fear of capital, which seemed to them uncanny and overpowering; they were as much impressed by money as by nobility. We have seen that when the lower middle class gained any real influence, their economic conceptions tended of necessity to hold back the development of capitalism. We have also seen that the petty bourgeoisie and the workers, particularly at the time of the revolt of the *ciompi*, were without any independent or consistent political programme. The workers were probably even more incapable than the petty bourgeoisie of expressing their thoughts save in the sphere of religion. We shall therefore become acquainted with the world of ideas of these strata only when we come to deal in the next section with religious sentiment. The "intellectuals" of the poorer and impoverished classes either came from the upper classes or else were individual mendicant friars—sometimes Dominicans, sometimes

Franciscans; in the latter case, generally expelled members of the order.[83] They gave expression, even if in a modest degree, to some of the momentary economic needs of the lower strata, or uttered vague and confused general demands. It was apparently not until 1347 that individual workers themselves began to realise that their most essential need was freedom of association; it is true that these ideas became general later on before the *ciompi* revolt, but only then. Of all the numerous chronicles of the period only one was written by an adherent of the *ciompi* and from their standpoint. This, an anonymous work, was known as the *Cronaca dello Squittinatore*; in daily entries over the years 1378–1387 it describes with sad resignation in a simple, wooden style the ill-success of the workers, without making any general reflections on the events it sets forth. After the revolt of the *ciompi*, the workers were not only deprived of all political rights but had no voice of any kind.

NOTES

[1] Some books of importance for the subject of this section may be mentioned here once for all. I have mostly made use of F. Engel-Janosi, *Soziale Probleme der Renaissance* (*Beihefte zur Vierteljahrsschr. für Sozial- und Wirtschaftsgesch.* Stuttgart, 1924). This work not only describes the economic and social thought of the period, but also discusses to some extent their connection with actual conditions. With regard to political thought, this connection is the subject of some remarks in F. Ercole, *Da Bartolo all'Althusio; Saggi sulla Storia del pensiero pubblicistico del Rinascimento* (Florence, 1932). For the social doctrines of the Church, and especially of Thomism, the most useful book has been E. Troeltsch, *The Social Teaching of the Christian Churches* (Eng. trans., New York, 1931). There are many just remarks of a general nature in A. v. Martin, *Sociology of the Renaissance* (Eng. trans., London, 1944). Most of the political and many of the economic and social views of our period derive from the literature of classical antiquity. But to indicate actual sources in all these cases would have unduly lengthened the notes, and I have done so only where a reference to origins seemed of special interest.

[2] According to Aristotle, the citizens should live not on trade and financial transactions but on ground rent, on the resources of the land. Aristotle, who lived as a foreigner in Athens under the protection of the Macedonian, aristocratic-feudal governor Antipater, was ill-disposed towards the well-to-do business middle class which ruled the city, and in general towards its increasing commercialisation. In spite of this, he was the first to give a systematic analysis of economic problems, particularly money and trade.

[3] R. Kaulla, *Theory of the Just Price* (Eng. trans., London, 1940).

[4] According to R. B. and A. J. Carlyle (*A History of Medieval Political Theory in the West*, Edinburgh, 1928) this means the dependence of the princes on feudal law.

[5] The statutes of the Calimala guild of 1301, on the other hand, also stated quite openly how the prohibition of interest could be circumvented. The consuls of the Calimala made arrangements in advance with the friars who carried out the duties of inspection to secure that offending members of the guild should be acquitted.

[6] Sometimes interest was covered by a nominal increase in the sum-total of money lent; or goods were lent instead of money and their value reckoned at more than their price. The account-books of the Peruzzi, for example (published by A. Sapori, Milan, 1934) contained a great variety of such substitutive terminology.

[7] The novelist, Sacchetti, jokingly tells the story of a preacher who, to increase his small congregation, announced at the end of his sermon that next time he preached he would demonstrate that it was permissible to take interest. This promptly drew a large crowd.

[8] The Church had long been acquainted with the intellectual outlook which methodically rationalised life. (Cf. St. Benedict's *Rule* for monastic life.) From the point of view of the history of philosophy, this was an inheritance from classical, middle-class Stoicism.

[9] Therefore, while the doctrine is fundamentally similar in all ecclesiastical writers, every new word, every subtle nuance, but above all the different arguments they put forward, have their importance. Even in canon law the definitions are framed so carefully as to leave open many possibilities of usury. See G. Salvioli, "La dottrina dell' usura secondo i canonisti e i civilisti italiani dei secoli XIII e XIV" (*Studi giuridici in onore di C. Fadda*, Naples, 1906).

[10] Florence's eastern trade, which formed a large proportion of the total, met with no difficulties whatever from the Church, which regarded any degree of profit as allowable when dealing with infidels.

[11] G. Ricca-Salerno, *Storia delle Dottrine finanziarie in Italia* (Palermo, 1896).

[12] Dominici also favours the maintenance of the differences of the various stations in matters of dress; that of the lower orders must not be too luxurious.

[13] "If God says to thee, Be rich, or Keep thy riches, then keep them; if He says to thee, Flee from them, then become poor; and if again He says to thee, Seek once more thy riches, then obey" (*De Regola Governi*).

[14] This point is fully discussed in E. Schreiber, *Die volkswirtschaftlichen Anschauungen der Scholastik seit Thomas v. Aquin* (Jena, 1913), and E. Salin, "Kapitalbegriff und Kapitallehre von der Antike zu den Physiokraten" (*Vierteljahrsschr. für Sozial- und Wirtschaftsgesch.*, XXIII, 1930).

[15] Hence we find St. Bernardino of Siena invoking the authority of Duns Scotus, who lived a century and a half before him.

[16] The thesis of Marsilius that the hierarchy of the Church was a man-made institution was declared heretical by the Curia.

[17] Aegidius Romanus, general of the Augustinian Friars and political jurist of Boniface VIII, was no longer in favour, as Aquinas in a sense still was, of the feudal State based on free service; he preferred the civic State based on Roman law. See A. Dempf, *Sacrum Imperium* (Munich, 1929). The canon law, codified in the twelfth and thirteenth centuries, and the literature based on it, interacted in the closest way with Roman law. It would lead us too far to show in detail to what an extent the Church, to ensure her own supremacy, accepted the principle of the sovereignty of the people (taken over from antiquity) long before it had been advanced by Marsilius. It may be mentioned that the Curia was perhaps the only institution of the time in which offices were filled in a relatively democratic way on the basis of talent.

[18] See for a detailed account M. Grabmann, "Studien über den Einfluss der aristotelischen Philosophien auf die mittelalterlichen Theorien über das Verhältnis von Kirche und Staat" (*Sitzungberichte der Bayer. Akad. der Wiss. Phil.-Hist. Abt.*, 1934). Remigio was also Dante's teacher at the priory school of S. Maria Novella. See G. Salvadori, *Sulla Vita giovanile di Dante* (Rome, 1906). But the political views of the Florentine *émigré*, Dante, as expressed in his *De Monarchia*, which was directed against Boniface VIII and condemned by the Curia, did not serve the interests of any particular party. They were a complex blend of elements from extreme Thomism, from the Spirituals and from Ghibelline theory—a mixture, from an Italian point of view, partially out of date.

[19] M. de Wulf, *Philosophy and Civilisation in the Middle Ages* (Princeton, 1922).

[20] Doren, *Florentiner Wollentuch-Industrie.*

[21] State decrees of the beginning of the fifteenth century represented the development of the woollen and silk industries as of the nature of a national task. See Pöhlmann, *op. cit.* At the same time the wool guild itself proclaimed in its statute (1428) with equal pride that the chief strength of the city lay in the woollen industry.

[22] Doren, *op. cit.*

[23] F. Ercole, *Dal Comune al Principato* (Florence, 1928).

[24] Bartolus considered this "aristocratic" form of government the most suitable for States of a moderate size, such as Florence and Venice. For smaller States (such as Perugia, where the middle class had more of the character of a petty bourgeoisie) he advocated democracy. There were, however, very many reservations in Bartolus' conception of a democratic form of State: the *vilissimi*, the lowest sections, were excluded from it. Even for Marsilius of Padua democracy did not mean a numerical majority, but only the *major et sanior pars*—that is, the wealthy. See C. N. S. Woolf, *Bartolus of Sassoferrato* (Cambridge, 1913), and H. S. Laski, "Political Theory in the Late Middle Ages" (*Cambridge Medieval History*, VIII, 1936).

[25] For a detailed account see R. Syme, *The Roman Revolution* (Oxford 1939).

[26] To take a practical example, nowhere was justice so exalted as in the statute of the Lana of 1428, the very statute in which the policy of pure force towards subordinates was put forward most openly.

[27] The statutes repeatedly mention that Florence had trade and industry to thank not only for the wealth of her citizens but also for the maintenance of the liberty of the State and for the expansion of its power. See Pöhlmann, *op. cit.*

[28] J. Luchaire, *Les Démocraties italiennes* (Paris, 1920).

[29] E. Santini, *Firenze e i suoi "Oratori" nel Quattrocento* (Milan, 1922). See also p. 56 above.

[30] The most famous jurist of his time, Francesco Accursio, who taught at Bologna and made a compilation of the glosses of his predecessors, was born in Florence, and occupied the position of judge there in 1263. Baldo, who with Bartolo was the most important lawyer and commentator of Roman law of the fourteenth century, taught in Florence from 1358 to 1365 and was given the freedom of the city. In 1385, after the return of the upper middle class to power, he was again called to Florence. The civil even more than the canon lawyers, while upholding the condemnation of usury as a principle, in fact condemned only excessive rates of interest, such as 100 per cent. See Salvioli, *op. cit.*

[31] L. Chiappelli, "L'amministrazione della Giustizia in Firenze" (*Archivio storico italiano*, Ser. IV, Vol. XV, 1885).

[32] L. Chiappelli, "Firenze e la Scienza del Diritto nel periodo del Rinascimento" (*Archivio giuridico*, XXVIII, 1882).

[33] It is difficult, however, to draw a clear line, even so early as the fourteenth century, between the patrician merchants and the humanists. As they became more cultured, merchants like Giovanni Villani claimed for themselves the title of humanist, whereas in their early revolutionary phase the merchants still often spoke of themselves with pride as "illetterati".

[34] E. Mehl, *Die Weltanschauung des Giovanni Villani* (Leipzig, 1927).

[35] A. Sapori, "L'attendibilità di alcune testimonianze cronistiche dell' economia medievale" (*Archivio Storico italiano*, ser. VII, vol. XII, 1929).

[36] A. v. Martin, "Zur kultursoziologischen Problematik der Geistesgeschichte" (*Hist. Zeitschr.* 142, 1930).

[37] It is significant that Villani, with his great respect for the wealth of Pope John

XXII, over-estimated it. He put it at 25 million florins; in reality, it amounted only to one million.

[38] Villani greatly extended this idea of the Roman origin of Florence and other patriotic theories which had already appeared in the *Chronica de origine civitatis*; this was the earliest history of Florence to have been written, and probably dates from the early thirteenth century. See N. Rubinstein, "The Beginning of Political Thought in Florence" (*Journal of the Warburg and Courtauld Institutes*, V. 1942).

[39] For this literature, see G. Toniolo, *Scolastica ed Umanesimo nelle Dottrine economiche al tempo del Rinascimento in Toscana* (Pisa, 1886).

[40] The book actually remained in use for more than a century

[41] Morelli looked on the peasants as knaves and thieves.

[42] A similar type of great merchant, uninterested in politics and concerned only with profit-making, was Francesco Datini (1355–1410) who actually succeeded in living untroubled at Avignon during the war between Florence and the Pope. Afterwards he lived at Prato, but had his main place of business in Florence. All his accounts and correspondence have been preserved. See E. Bensa, *Francesco di Marco da Prato* (Milan, 1928).

[43] For example, Morelli advised his son to invest his property in such a manner that no one could take it away from him, either placing it in wedding dowries or transferring it to reliable persons. If he possessed any cash, he must see that no one knew of it. He should either let it lie fallow, or use it in foreign trade, or bring it concealed to Genoa or Venice, where he could exchange it for bills, etc.

[44] Schreiber, *op. cit.*

[45] For a detailed account, see Martin, *op. cit.*

[46] See page 58, note 2.

[47] A comparison with Dante is suggested here. Whereas Dante, the former *émigré*, the *laudator temporis acti*, felt a conservative aristocrat's hatred for the merchant bourgeoisie of Florence, Petrarch, who was a commoner, had to a certain extent, though only to a certain extent, already passed beyond the bourgeois phase and again showed a trend towards the aristocratic.

[48] Petrarch's Italian nationalism was directed chiefly against the "barbaric", "backward" French, those "runaway slaves of Rome"; he had no cause, like the Florentine upper middle class, to be afraid of upsetting commercial relations with France. The deeper reason of his hate lay in France's possession of the Popes, about which he was far more openly bitter than Villani dared to be; for Petrarch, Avignon was the whore of Babylon (we shall return to the significance of the terminology of the Apocalypse). Thus cultural, antique and religious ideas all serve the same political purpose.

[49] He had the support of the bourgeoisie, the lower nobility, and the lower clergy.

[50] For Rienzo's political ideas, see the full account in K. Burdach, *Rienzo und die geistige Wandlung seiner Zeit* (Berlin, 1913), and P. Piur, *Cola di Rienzo* (Vienna, 1923).

[51] Cf. H. Eppelsheimer, *Petrarca* (Bonn, 1926), and U. Chiurlo, "Le idee politiche di Dante Alighieri e di Francesco Petrarca" (*Giornale Dantesco*, 1908); see also N. Zingarelli, "Le idee politiche del Petrarca" (*Nuova Antologia*, 1928).

[52] Eppelsheimer, *op. cit.*

[53] During the Rienzo period, however, when he was relatively in closest contact with the world, Petrarch considered a republic to be the form of government where all professions would come into their own—where, therefore, not only would the scholar have his leisure, but the merchant his security.

[54] F. Bezold, "Republik und Monarchie in der italienischen Literatur des 15. Jahrhunderts", in the volume *Mittelalter und Renaissance* (Munich, 1918).

[55] Praise of agriculture, the idea of a return to the virtuousness and simplicity of the old Roman peasantry, as expressed in Virgil's *Bucolics* and still more in the *Georgics*, were a part of Augustus' policy, aiming at the revival of the old Roman customs, the creation of settlements for penurious peasants, and raising the grain production of Italy; at the same time, these notions also served as a sentimental, idyllic ideology for the rational-scientific management of the big country estates, which was also taking place under Augustus. See O. Neurath, "Zur Anschauung der Antike über Handel, Gewerbe und Landwirtschaft" (*Jahrbücher für Nationalökonomie*, XXXII-XXXIV, 1906-7); W. E. Heitland, *Agricola* (Cambridge, 1921) and M. Rostovtzeff, *Social and Economic History of the Roman Empire* (Oxford, 1926).

[56] For instance, he gave advice on rational State administration in *De Republica optime administranda*.

[57] Seneca, in despotic times, also retired into himself, likewise without giving up contact with the court. Although Petrarch reproached Seneca with inconsistency, he was attracted by the latter's inner discord, which he felt to be congenial.

[58] For a full account see F. Macri-Leone, "La Politica di Giovanni Boccaccio" (*Giornale Storico della Letteratura italiana*, XV, 1890).

[59] Most of the opinions here referred to are to be found in his treatise *De Tyranno* (1400) and in his letters. For the former, see the introductions to the editions by A. v. Martin (Berlin, 1914) and F. Ercole (Berlin, 1914).

[60] The transitional character of Salutati's views on every subject is brought out by A. v. Martin, *Mittelalterliche Welt- und Lebensanschauung im Spiegel der Schriften Salutatis* (Munich, 1913), and *Coluccio Salutati und das humanistische Lebensideal* (Leipzig, 1916), by the same author.

[61] The old opposition of Pope and Emperor fundamentally no longer interested him.

[62] Salutati conceived love of one's country as a form of love of one's neighbour; so in this transitional period, this new idea could still be linked up with religion.

[63] In a polemic against the humanist Antonio Loschi, who wrote for the Visconti, he had to defend Florence against the accusation of tyrannical government, to which he replied by bringing the same charge against the Visconti. The theory of the tyrant—which is found in all writers, the only difference being in the arguments employed—is used by the Church, even by the "tyrants" themselves, and by the bourgeois commune as a weapon of realist policy against their enemies. Moreover, Salutati's views on tyranny changed with the political conditions in Florence. At the time of the war between Florence and the Curia, when Salutati held the most democratic opinions, he said that every government which was not a republic was a tyranny. In the *De Tyranno*, written a quarter of a century later, when reaction was already in power in Florence, he was infinitely more conservative.

[64] Salutati appealed, as Petrarch had done before him, to the statement attributed to Augustus that only a supporter of the existing form of State could be considered a patriot.

[65] Salutati had actually planned a polemic against Petrarch with the significant title *De Vita associabili et operativa*. He also approves—in contrast to Petrarch—of Cicero's taking part in political life.

[66] He ranked agricultural work above the merchant's profession, as does all the literature of classical antiquity.

[67] E. Walser, "Coluccio Salutati" in the volume *Gesammelte Studien zur Geistesgeschichte der Renaissance* (Basel, 1932).

[68] E. Füter, *Geschichte der neueren Historiographie* (Munich, 1911).

[69] H. Baron, "Das Erwachen des historischen Denkens im Humanismus des Quattrocento" (*Hist. Zeitschr.* 147, 1933).

ECONOMIC, SOCIAL, POLITICAL IDEAS

⁷⁰ It may be noted in this context that Bruni did not accept the abolition of private property for the ruling class, demanded in Plato's *Republic*, any more than did Aristotle, whom Bruni had translated.

⁷¹ For example, Bruni was against the "tyrant" Cæsar and on the side of Brutus, his tyrant's murderer. This one characteristic example from Roman history well shows how political valuations, even within the classicising range of ideas, changed according to the political position and intentions of the writer passing judgment. Dante, the Ghibelline, banished Brutus into the lowest Hell; Petrarch, with his emotional Roman republicanism, praised him. The conservative Salutati, who was most concerned for the maintenance of the existing order, was, especially in his late period, again on Cæsar's side.

⁷² Cicero shows a similar trend of ideas. See A. J. Carlyle, *op. cit.* and *Political Liberty* (Oxford, 1941).

⁷³ Florence is no longer treated as a mere part of the entire Christian world, as in Villani (whose chronicle is fundamentally still a world chronicle), but is brought into prominence even more than in Salutati as its acknowledged centre.

⁷⁴ To what an extent, in Bruni's political theory, everything that concerned Florence must be good, is illustrated in this treatise, written a year before the conquest of Pisa, where (probably using Plato's idea about the ideal situation of a town) he proved that the position of Florence, without a harbour but near the sea, was ideal, and much more favourable than if she had had a harbour.

⁷⁵ As to the actual composition, made up of rich and cultured people, of the Roman Senate, which had no political influence, see M. Rostovtzeff, *op. cit.*

⁷⁶ But the contemporary Florentine chronicle (dealing with the years 1406–38), written in Italian by Bartolommeo del Corazza, a wine-merchant—that is, one who came from an inferior and uncultured section of the middle class—described the ecclesiastical and secular festivities, above all the tournaments.

⁷⁷ This new conception of the general importance of ambassadors' speeches, of their inner logic and compact construction, is related to the rationalist mentality of the upper middle class now once more in power; this is shown in actual practice by the fact that systematic ambassadorial reports date only from 1394, and only after 1409 were detailed instructions given to ambassadors. See Santini, *op. cit.*

⁷⁸ In the political poetry also, written or backed by Rinaldo degli Albizzi and aimed at the Medici, there was continual reference to Tuscan and ancient Roman liberty.

⁷⁹ But in one of the *facetiae* (collections of anecdotes from the Curia) in which Poggio indulged, he spoke quite openly of the two millstones which were more precious than jewels because they brought in every year twenty times their original cost.

⁸⁰ Greek Stoicism, originating in the time of the new Hellenistic kingdoms with their fusion of Greeks and barbarians, was of a general human, and at first rather "unpolitical" character; its adjustment to the ideological needs of the Roman ruling class in the political and social spheres was accomplished by Panaetius (second century B.C.). His teachings were taken over and publicised by Cicero. See for a detailed account E. V. Arnold, *Roman Stoicism* (Cambridge, 1911).

⁸¹ It was in the same frame of mind that Bruni translated Plutarch's *Lives* of famous men, especially those of Romans of the Republic. He also wrote an introduction to a collection of Demosthenes' speeches, dedicated to Nicola di Vieri de' Medici (after 1421).

⁸² See also pp. 102–3. It is historically instructive to note at what precise period of antiquity a particular philosophical trend emerged, which was later to influence a corresponding Florentine one; for it will usually be found that the tendency arose under comparable social and political conditions in both cases. If we go forward a few decades from the Albizzi period to the time of the absolutist rule of Cosimo and Lorenzo de'

63

Medici, when the Florentine middle class were economically ruined and politically powerless, we find, as the fashionable philosophy of the upper stratum and sponsored by the Medici, Marsiglio Ficino's Neoplatonism, mystical and irrational in character, inclining away from reality, disinterested, on the whole, in the political activity of the citizen. This Florentine philosophical current is mainly determined by the Neoplatonism of Plotinus, who taught the withdrawal of the individual into himself, emphasised the importance of contemplation, and discouraged political activity. Plotinus lived in the third century A.D., at the time of the decline of the Roman middle class and the arbitrary rule of the soldier-emperors; his activity was chiefly carried on at the court of Gallienus, the most cultured of these emperors, who protected and encouraged him.

[83] The radical Franciscans who sometimes were not only opposed to the possession of property by their Order, but also put forward general social and political demands within the framework of religion, will be dealt with in the next section.

3. HISTORY OF RELIGIOUS SENTIMENT

WE have seen that even in the ideas which bore most closely on practical life there were many compromises with religious sentiment. The thoughts and emotions of all sections of medieval society, even to a large extent the early bourgeoisie, revolved around the religion which played so great a part in their everyday life. The thread of the sacraments bound together the believer's whole course from birth to death, and the administration of these divine means of salvation was in the hands of the Church. Over a long period, her doctrines alone offered men's minds real stability. What the Church did and taught, what attitude she adopted towards the various social strata, what she permitted or forbade—all this deeply influenced every sphere of human action and thought. Many of the facts and ideas in the economic, social and political fields to which we have already referred stand out more sharply when seen from the religious standpoint. Religion, whether as the framework for other ideas or as a determining factor in their development, decisively affected men's whole outlook on life.

In his early struggle for economic and political power the rising burgher not only frequently fought under a religious banner and justified his actions by religious arguments, but he also particularly wished to have some share in religion itself. Neither the secular clergy nor the monasteries satisfied his spiritual and religious needs. The monasteries generally lay outside the towns; their inmates were concerned above all else with the salvation of their own souls, and moreover were often aristocrats; the Benedictine monasteries were the most typical in this early period. More was now required of religion than didactic theology; it had to be an emotional experience, one that could be shared. Again, the rising bourgeoisie resented the Church's rigid separation between priesthood and laity, whereby the latter were excluded from all participation in active worship. The layfolk now expressed a desire for a share in religious activity; the bourgeois wanted to enter into a direct personal relationship with God.

The struggle of the middle class with the Church for an active part in religion and worship varied in intensity in the different social groups and at different periods. The efforts of the wealthy burghers to realise their wishes took the form of direct opposition to the Church only so long as she retained a feudal character and employed her secular power against the bourgeoisie. When later the Church allied herself economically and politically with the upper middle class—that is, from the thirteenth century onwards—their relation to each other underwent a change in the religious sphere also. Both now had an interest

in finding a compromise. As we shall see later, the Church made the necessary concessions with the founding in the thirteenth century of the mendicant Orders, devoted principally to preaching and to the care of souls in the towns. With these gains the upper middle class were satisfied.

The attitude of the poorer sections of the urban population was different. It was the small artisans, particularly the wool workers,[1] who felt most deeply the need of salvation, for their social and political hopes could find expression only when transformed by religion, and could be ultimately realised only in union with God.[2] The social unrest of the period, due to the sudden appearance of tremendous inequalities between rich and poor, resulting from the rise of a money economy, found expression in sectarian movements. The poorer strata insisted that the Church, at any rate, should not possess wealth. They intensely desired to take an active part in worship, and evinced a strong dislike of the wealthy Church that stood at the centre of the money economy and of the clergy who had become very worldly-minded. The Church's ensuing re-action was so violent that these sections cut themselves off from her completely. This was the basis of the sectarian movements, made up of enthusiastic bodies of laymen and appealing to the authority of the primitive Church, such as the Waldenses, Cathari, Albigenses, which sprang up in the eleventh and twelfth centuries and the first half of the thirteenth,[3] in the rising towns of Italy and southern France. Within these sects, the laity were allowed to share in the administration of the means of grace and to preach without hindrance; the efficacy of the sacraments depended upon the pure, ascetic and usually penurious lives of their own priests; the Bible could be studied freely and in independence of authority.

But in this early combative period of development in the towns, the sects did not derive their membership exclusively from the poorer classes. When the Church was still in her feudal phase, the wealthy bourgeoisie sympathised with these movements and took part in them. Later, however, they inclined to a position of neutrality, and finally, when they had themselves come to power and entered into a definite alliance with the Church, they violently attacked the sects. Such transitional phases are characteristic of the constant ferment in the early capitalist towns before the definite seizure of power by the upper middle class.[4] Thus in Florence for a fairly long period—until the middle of the thirteenth century—many merchants belonged to the sects,[5] though not the wealthiest of them, whose economic interests were bound up with the Curia: for the doctrines of some of these bodies, such as the Cathari and the Patarini, closely linked with them and particularly strong in Florence, could quite well be made to accord with capitalist and commercial ideas.[6] Thus even among the prosperous classes, subjective religious needs were so great that a tendency towards separation from the official Church long persisted. The main strength of the sects, however, naturally continued to be drawn from the poor. The

Church's reaction against them, especially after she felt her position secure with the support of the upper bourgeoisie, took the form of ruthless persecution and of intensified counter-measures. By these means, any form of independent lay Christianity, any active participation of the layfolk in worship, was prevented; laity and priesthood were strictly separated. In Florence in particular, the Church suppressed the Patarini in the middle of the thirteenth century with the support of the mendicant Orders and the upper middle class, the Dominican St. Peter Martyr being the chief agent in this. To gain a proper understanding of this new situation, we must consider the part played in it by the two great mendicant Orders, the Franciscans and the Dominicans, and how they developed.

Arising in Umbria, a district already strongly permeated by earlier sects, the movement founded by St. Francis of Assisi (1182–1226) was originally a religion of the laity, like that of the other sects, and was at first essentially heretical. St. Francis preached as a simple layman, without spiritual preparation or guidance, without even—at first—any permission from the Pope.[7] He traversed the whole of Italy (1209 is the date of his first visit to Florence), preaching to the laity in their mother tongue and gaining an immediate hearing. His sermons revealed a religious feeling more intense than his hearers had ever found in the priests; he called to prayer and repentance, appealing not to the reason, but to the heart. He made the Gospel live in the ears of his listeners, and brought God, Christ and Mary down to them, almost humanising them. When he told the story of Christ's Passion, he spoke of him as "the poor Christ" and made his hearers share His sufferings. Under the influence, probably, of Peter Waldo, leader of the "Poor Men of Lyons", St. Francis asserted men's equality before God; he brought the poor into a specially personal relationship with Christ, proclaiming the possession of riches a hindrance to that relationship. Yet, at the same time, he adjured the poor to look upon the rich as their brothers and to endure their poverty patiently and cheerfully. His leading themes were poverty (*paupertas*) and humility (*humilitas*). To love God, to follow in the path of poverty and suffering which Christ and the Apostles trod, was all that mattered. Like the sectarians, St. Francis went back to primitive Christianity, and himself lived before the eyes of all men the poor and humble life of the Gospels.

As we can see even from this short summary, the whole Franciscan movement, with its intellectual and emotional content,[8] was only possible, and could only be successful during this early combative period of the middle class, before their separation from the masses below them was as complete as it later became.[9] The Franciscan movement possessed the courage and impetus natural to a religious movement of the laity. It was therefore of very great significance for all sections of society, none of whom had hitherto received sufficient spiritual care or had had the opportunity of hearing proper sermons; the line of demarcation between people and priesthood became less distinct. The movement was

directed chiefly to the illiterate, who at this period included many of the bourgeoisie. But it was the poor above all others whom St. Francis helped, even if only in religious matters,[10] so that their economic misery and their deprivation of political rights found a certain compensation and consolation. The Curia, occupied at the time with the ruthless suppression of the Albigenses, displayed more diplomacy and astuteness towards the new movement, by giving it a new direction; the disciples and preachers, living an apostolic life of poverty in a community grouped loosely round St. Francis, were slowly incorporated, as the years passed, into a closed Order within the Church. In following this policy, the Curia was actuated by the realisation that this newly-founded religious Order could be of the greatest service in maintaining that constant contact with the new urban bourgeoisie, both rich and poor, which it now recognised to be necessary, and in winning back those sections of the townsfolk whom it was in danger of losing. The Church needed an Order whose preaching would help to crush those "real" heretics and sectarians who were bent on applying the principle of poverty consistently to the whole Church, who demanded that the Church should be without possessions, should concern herself only with religious matters, and that the Pope should have no temporal power. The Curia was also well aware that the primitive Christian ideal of poverty and an ascetic life could, when controlled and guided by the Church, assist her general aims.

The old conception of the Christian community as an organism, made up of various groups whose functions complemented each other, could easily be applied to contemporary conditions under a social system based on "orders", and made it possible to incorporate the friars on a large scale. Within this organism, the task of the friars was to do vicarious penance for all the other members by their asceticism and by representing the ideal of Christian perfection. In this way the Church retained her supremacy, for in the last resort, of course, the Church and the sacraments, not monasticism or asceticism,[11] were the means to salvation. The wealthy bourgeoisie, however, could secure for themselves a share in the efficacy of the friars' achievements by endowments to their communities. Thus the Church and the middle class were in the end the gainers: the original revolutionary urge in the Franciscan ideals of equality and poverty was sterilised and made harmless. So with the oral approval of the first Franciscan Rule about 1209[12] and particularly after the confirmation of the new Rule by the Pope in 1223, the mendicant Order of the Franciscans was firmly and officially established. But at bottom it now no longer represented the conception of its founder, to whom the whole idea of monasticism was originally alien,[13] and who later left the central management of the Order to others so that he himself might work up and down the country in immediate touch with the masses. An equally stable organisation of the movement amongst women was achieved with the establishment of the Poor Clares, the so-called

Second Order of St. Francis; their first convent was founded in Florence at Monticelli, on the outskirts of the town, as early as 1219. On the other hand, the foundation of the Tertiaries—the Third Order of St. Francis—represented a concession on the part of the Curia, for here the distinction between laymen and friars was somewhat weakened: laymen performed fervent religious exercises together, under the supervision of a Franciscan friar, thus forming a semi-monastic body, a kind of supplement to the Franciscan order. It was in Florence itself and at the wish of the Florentines that St. Francis drew up the first Rule for the Tertiaries.

After St. Francis' death, the Order rapidly and wholly changed its character. Originally, by the testament of its founder, neither the friars nor the Order might possess property; it was this absence of property which gave this Order of wandering preachers its peculiar character. St. Francis had also laid great stress upon the importance of the friars doing real manual work—an idea taken over from the sects.[14] But an Order which really owns no property, and friars who have no personal possessions, who openly declare that they are imitating the life of Christ and the Apostles, who live from day to day by the labour of their hands, and only in case of necessity by begging, are acting socially and ideologically as a subversive force and therefore do not perform the function required by the Church and the wealthy middle class. It was desirable, indeed, to create and maintain a generally visible ideal of humility and penance, but not an ideal so radical as to revolutionise the masses, who always regarded the *poor* friars as their especial champions. An Order inspired with so radical a spirit might really make common cause with the lower classes. Above all, such an Order would of necessity extend the ideal of complete poverty to the whole Church; and this the Church, inextricably involved as it was in a monetary economy, could not possibly contemplate for a moment. In fighting against St. Francis' ideals, therefore, the Church was fighting for her very existence. In 1230 Gregory IX, in his Bull *Quo elongato*, declared the saint's testament invalid; in it St. Francis had charged the members of his Order, which he expressly characterised as a lay order, to remain true to the ideals of poverty, humility and manual labour, and had forbidden them to make changes in the Rule or to endeavour to win further privileges from the Pope. But henceforth the lay brothers were steadily pushed into the background and excluded from office. By the same Bull, and by another of 1245, the poverty of the Order was in practice brought to an end; the fiction of poverty alone was maintained by the Church becoming, in theory, the owner of the Order's property, the Order itself enjoying "merely" its usufruct.[15] Collections were now openly made in money instead of in kind. While St. Francis permitted only very simple chapels and the humblest of housing for the friars (he even prohibited fixed places of residence), the Church, and the upper middle class, needed an Order with imposing churches and monasteries in the town from which it could exercise

through preaching an immediate influence on the masses. The wealthy bourgeoisie provided the money for these buildings, or caused it to be provided, thus performing works beneficial for the salvation of their own souls.

The whole thirteenth century was taken up with the struggles between the official Church and those friars—known as the Spirituals—who still believed in St. Francis' ideals of an evangelical life and wished to return to the earlier strictness of their Rule. The Spirituals wanted to see the whole priesthood leading lives of poverty and humility after the example of Christ and the Apostles; they regarded the acquisition of property for its own sake as the great evil of the Church, and were opposed to their Order becoming more ecclesiastical in character and to the hierarchy in general. The Spirituals soon combined the ideas of St. Francis, who had felt himself to be the forerunner of a not distant Kingdom of Heaven, with the earlier prophecies of the Calabrian abbot of the Cistercian Order,[16] Joachim of Fiore (d. 1202). Joachim believed that the history of humanity was to close somewhere about 1260[17] with the establishment of an earthly Church or kingdom of the Holy Spirit (*Ecclesia Spiritualis*); the coming of this kingdom, in which perfect peace would reign, had been promised in the Apocalypse, and it was to be set up by monks who led lives of perfection and poverty.[18] The Spirituals referred this last prophecy to the Franciscan Order, which they regarded as the Church of the Holy Spirit of the final period. They considered the mission of St. Francis and his Order as of such decisive importance for the immediate future that they drew a parallel between him and Christ, and regarded the coming of the Messianic or Third Kingdom as imminent. The adherents of the Spirituals were chiefly the lower sections of the population, who in this period of the rise and victory of the upper bourgeoisie looked to the future for the realisation of their hopes, or at least felt that the champions of a propertyless Church were in some way akin to themselves. To these sections, a poor friar was "pious" as a matter of course. In the turbulent thirteenth century, however, before the final victory of the upper bourgeoisie, many members even of the wealthy middle class—some of them Tertiaries—were also more or less loosely linked with the Spirituals. In the late thirteenth and early fourteenth centuries a large number of Spirituals still adhered to the Franciscan Order. In S. Croce, the great Franciscan monastery at Florence, were living at the same time the two most important writers among the Spirituals of that period: Pietro Olivi (*c.* 1248–1298) and Ubertino da Casale (1259-*c.* 1338). From 1287 till 1289 the former actually gave lectures at S. Croce, which also served as the university of the Franciscan Order.[19]

After the final consolidation of the upper middle class however, the ruling opinion among the Franciscans also favoured the Order's possession of property. This tendency, which was in harmony with the whole economic and ideological development, could not be arrested. The wealth of the Order was continually increasing, not only on account of the numerous bequests made to it, but also

because the novices—among whom were members of wealthy and highly respected Florentine families—bestowed on it their property and particularly their land. From these various sources of income the friars now lived, and no longer from begging, though this continued to be very fruitfully practised; least of all did they draw their livelihood from manual labour. The wealth of the monasteries in its turn became an additional inducement to entering the Order. The inmates of the convent of the Poor Clares at Monticelli came chiefly from the highest Florentine families. Among the Tertiaries the change of attitude was even more noticeable than in the First Order. Differences of origin and wealth acquired very obvious importance; from about 1298 one group of women Tertiaries from patrician families kept themselves apart from all those of more lowly origin and were generally known as *le baronesse*.

Under these circumstances it was only natural that, in the course of the thirteenth and early fourteenth centuries, more or less radical groups of Spirituals were continually breaking away from the Franciscan Order, some of them even drawing the general political consequences of their opposition to the Order's possession of property.[20] Naturally these secessions produced no effect on the situation as a whole. Every battle in this dispute over the the doctrine of poverty ended in a victory for the official Church, and after every such success the ruling ideas in the Church moved one step nearer to the side of property.[21] The persecuted Spirituals appealed in vain to the Pope for the right to independence. So as to escape persecution and to be able to live in isolated monasteries under their own Rule, the Spirituals of Florence (S. Croce) and Siena endeavoured in 1312–13 to occupy the monasteries where they were in a majority—at Carmignano near Florence, Arezzo, and Asciano near Siena; they were however expelled, imprisoned and excommunicated. Finally, Pope John XXII, the most capitalistically-minded of all the Popes of that period, would no longer tolerate even the fiction that the Order possessed no property rights or that the Church should continue to do the Order the favour of acting as owner; the Order was now obliged to manage its property itself (1322).[22] At the same time in 1323 he used his authority to wrest from the Spirituals their chief weapon by deciding in his Bull *Cum inter nonnullos* that to maintain that Christ and the Apostles possessed no property was heresy.[23]

As distinguished from the Spirituals, who in the thirteenth century and the beginning of the fourteenth endeavoured to organise opposition within the Franciscan Order, the name of *Fraticelli* was given to those who, during the remainder of the fourteenth century and in the fifteenth, accepted the consequences of the position created by the papal bull and continued their agitation outside the Order, thus becoming open heretics.[24] The Fraticelli, these last representatives of the tendencies embodied in the sects, and the Spirituals, whose following was now drawn exclusively from the poorer classes, were regarded by the upper middle class and the Church as most dangerous enemies. With the help of the

Inquisition they were exterminated by fire and sword, the Franciscans making themselves particularly prominent in the combat in order to silence any suspicion which might rest upon them by reason of their own democratic and revolutionary past.

After the exclusion of the Spirituals, even though the official Order occasionally acknowledged the principle of poverty, in practice it was no longer binding upon either the monasteries or the individual brethren.[25] The point had actually been reached where the so-called "strict" Observants, who in opposition to the lax Observants, the so-called Conventuals, maintained that individual friars should not own property even if the Order did, had become the radicals and looked upon themselves as strict followers of the Rule in the spirit of St. Francis. The whole question of property, however, now ceased to have much significance within the Order, even among the strict Observants—a sign of the new period, which was now definitely upper middle class in spirit. What the Observants now principally stressed was the discipline of the Order. In significant contrast to the earlier movements, they did not emphasise imitation of Christ's life of poverty so much as the necessity of a life of strict asceticism and contemplation, a complete withdrawal from the world. Characteristic of the new times is the attitude of Blessed Giovanni delle Celle (1310–96), Vallombrosan abbot of S. Trinità, who sympathised with the Franciscan Observants.[26] He attacked the extremist position of the Fraticelli with regard to poverty, stigmatizing it as pride and contrasting it with the *umiltà* of St. Francis. The movement of the strict Observance, which developed during and particularly towards the end of the fourteenth century, was in its commencement a movement of lay brothers, whereas the majority of the Provincial and General Chapters followed the laxer tendency.[27] At the time of the Schism the Popes sided with the Conventuals because they were in the majority. Later in the fifteenth century, however, the Papacy found the strict Observants useful in mitigating the evil effects of the Schism—moral, ascetic preachers being always popular with the masses, and particularly suitable for such a purpose. The upper bourgeoisie were even more decided in their support of the Observants, seeing in their ascetic programme an excellent means of preventing a revival of the old dispute about poverty which was liable to cause social disturbance. The Observants thus attained great importance. Their chief representative at the beginning of the fifteenth century was St. Bernardino of Siena, who in his youth, in 1417, was guardian of the recently founded Observant monastery of S. Francesco at Fiesole. They received privileges from the Curia, possessed a large number of monasteries and were allowed to have their own vicar for Italy (a position held for a time by St. Bernardino). Yet it was precisely the Franciscan Observants, relatively the left wing of the Order, who now, regarding themselves as official exponents of the Church's policy, made themselves most conspicuous in exterminating the Fraticelli.

The second great mendicant Order, that of the Dominicans, founded in 1215 by St. Dominic (*c.* 1170–1221),[28] went through the same inevitable development as the Franciscans, from complete poverty to superfluity and wealth.[29] The various reforms of the Dominican Observants, who appeared in the fourteenth century and in the fifteenth enjoyed, like the Franciscan Observants, the favour of the Popes and the upper middle class, were unable and, in the last resort, did not really wish to arrest this change. Even more than the Franciscans, the Dominicans side-tracked the question of poverty in favour of that of moral strictness. In practice it was always merely a question of founding some houses, with the material help of members of the upper bourgeoisie, which would exhibit a relatively rigorous standard of religious life. The most important of these attempts at reform was that of a Florentine, Giovanni Dominici, at various times Vicar General of the Dominican Observants in Italy, an office newly created by the Curia. The model houses which he proposed to found were chiefly intended, like those of the Franciscans, to counteract the harmful effects of the Schism upon the Church; these objectives carried on the purist Dominican ideals which, originating in Siena with St. Catherine, spread to Florence through Pisa, where Dominici had resided as a young man (Raymund of Capua, confessor and biographer of Catherine of Siena, was active here; Caterina Gambacorti established at Pisa the first priory of the Dominican Observants, S. Domenico). Dominici founded the priory of S. Domenico near Fiesole with gifts from wealthy Florentine merchants.[30] His most important pupil, St. Antonino, son of a Florentine notary of good family and later a friend of Cosimo de' Medici, was at first prior of the Dominican house of Fiesole (1421); later (1437) he too became Vicar General of the Dominican Observants of Italy.

The spiritual attitude of the Dominicans was based from the first on those objectives to which that of the Franciscans had later to be diverted: the defence of the official Church and her doctrines, and the fight against heretics. Usually, therefore, the Dominicans provided the Inquisitors against the heretics, though in Tuscany—after Umbria the territory in greatest danger—the office was filled after 1254 by Franciscans, who, in consequence, incurred unpopularity, particularly among the lower classes.[31] But in Florence also, by virtue of their general supervisory mission in the service of the Church's teaching, the Dominicans secured spiritual power in their own hands. They cultivated learning, personified, as we shall see in detail, the intellect of the Church, and held a much more dominating position in the spiritual life of the city than the more ignorant Franciscans. For the latter were placed at an intellectual disadvantage by the outlook of their founder, who had called himself an *idiota* and deliberately placed a higher value on simple piety than on learning; the brethren who were relatively true to his ideals regarded study as a betrayal of the spirit of the Order. Compared with the Dominicans, who were a clerical Order from the beginning, the Franciscans, with their original equality between clerical and

lay brothers,[32] seemed a degree more "democratic". But this was true rather in tradition than in fact. Actually the Franciscans were somewhat embarrassed by their democratic past, and were continually afraid of being compromised as Fraticelli. The Dominicans, on the other hand, whose past had not prejudiced them in the eyes of any particular section of society, could pursue a more skilful and elastic policy. Ultimately, of course, both Orders, as instruments of the Curia, were also, though in varying degree, instruments of the upper middle class in alliance with it. As was equally natural, that Order was most important and useful in the eyes of the upper bourgeoisie which entertained close relations not only with them but also with the petty bourgeoisie, could hold them spiritually in a solid grip and could exercise the greater influence on them. In thirteenth-century Florence this position was undoubtedly held by the Franciscans, but in the course of the fourteenth century the Dominicans became their bitter rivals for it. The Dominicans, mentally more alert, now came into more intimate and personal relationship with the upper bourgeoisie;[33] members of good families now entered the Dominican Order more often than the Franciscan. At the same time, the Dominicans were supple enough to be able to adopt a democratic attitude in times when the rule of the upper bourgeoisie was in decline and the petty bourgeoisie, as in and after the middle of the fourteenth century, were acquiring political significance. They ostentatiously endeavoured to speak to the small men in their own language, and to win over these sections, in any case closely dependent on them, by making an approach to them in every sphere in which they were interested. They took from the Franciscans their old popular weapons, and thereby gradually pushed them into a false position. In the democratic period before the revolt of the *ciompi*, for example, the Dominicans, unlike the Franciscans, supported the petty-bourgeois demands for a reduction of the rate of interest on the *Monti* and agitated for the prohibition of speculation in these State loans (1353). No wonder that, in the course of the fourteenth century, their many-sided policy enabled the Dominicans to get the upper hand and to drive the Franciscans from the strong position they still held at the beginning of the century. And although the Observance movement, which at the beginning of the fifteenth century swept all Italy, was generally dominated by the Franciscans, who wandered, preaching, over the whole country, particularly the petty bourgeois and peasant districts, yet in Florence it was the Dominicans, with their connections with the upper bourgeoisie, who reaped the benefit. Though St. Bernardino of Siena won great acclaim when he preached for a time in Florence (1424, 1425), the enduring success was won by the Dominican Dominici and his Observant priories, founded with the money of the upper middle class. His foundation of S. Domenico at Fiesole was the favourite of the upper bourgeoisie; later enlarged into the house of S. Marco with money given by Cosimo de' Medici, it became the symbol of the alliance between the ruling Medici and the Dominican Observants.

Before examining the influence of these two mendicant Orders on the religious and social life of Florence in greater detail, we must briefly consider their systems of theology in their relation to one another;[34] we shall then be better able to appreciate their attitude to the various social strata, particularly to the upper bourgeoisie. The various scholastic systems, as is well known, were built up of numerous elements: Aristotle, Stoicism, and Neo-Platonic mysticism all had their share, for all had been translated into Christian terms by the Fathers of the Church, especialiy by Augustine. As the structure of society changed, and intellectual and religious needs changed with it, different elements in this vast body of religious thought were given greater prominence in the various systems according to the special tradition of each Order.

The official theology of the Franciscans crystallised soon after the death of their founder. Faith was conceived, on Augustinian and Platonic lines, as the subjective, immediate experience of God, as a matter of the emotions. This personal and psychological conception still expressed the early, ardent period of the Franciscan movement, while somewhat abruptly separated from it, Franciscan theology insisted most emphatically on belief in the authority of the Church[35]—an attitude necessary, of course, in order to make clear the contrast between the Franciscan Order and the Spirituals. By very reason of its revolutionary origin, this older Franciscan theology could not possibly provide the basis for developing, on the lines required, the social ideas so important for the growing bourgeoisie. Alexander of Hales, the chief representative of this theology (d. 1245, teacher at the Sorbonne), was bitterly opposed to private property, and wished to impose the strictest limitations on it. He maintained that rich men who did not give away all their surplus in alms to the poor were thieves.

Shortly afterwards, the Dominican Order formulated its official theology in the work of St. Thomas Aquinas. It was more unified, more sober, and more opportunist than the Franciscan, and adapted itself far more to the actual conditions, to the spiritual needs of the "enlightened" bourgeoisie, who were now consolidating their position. As with the Franciscan theology, its foundations were Augustinian, but important intellectualist elements taken from Aristotle were added. With the help of these Aquinas created a theology which so far as possible was rational; faith and reason, revelation and natural knowledge were made complementary to each other. Even the power to believe was a gift of God to the intellect. The rationalism of this doctrine was, of course, a pious and moderate one, but it was consistently carried out to form a completely unified system. Aquinas' social ideas, with which we are already acquainted, fitted smoothly into this system. By conceiving the Christian community as an organism, with its different groups and orders[36] complementing each other and all having Salvation as their final aim, the impression of a harmonious whole was produced. Within this whole all injustices spoiling the harmony, that is to say, offending against the law of God, could be removed. Aquinas idealised and

eternalised the actual conditions, and identified them with the true ideal demanded by reason and revelation.[37] Here, then, was to be found that sobriety and safety and that compromise between the Church and the world which the religious sentiment of the upper bourgeoisie so much required; at the same time, the expectations of the other social classes were, in theory, not disappointed.

So far as its fundamentally anti-intellectualist and voluntarist position permitted, the official Franciscan theology now endeavoured to draw closer in principle to the Thomist system and thus, in practice, to the upper middle class. St. Bonaventura (c. 1221/22–74), General of the Order, to whom fell the task of putting an end to the Spiritual movement and bringing about a compromise between the moderate and the radical elements in the Order, created a theology which represented a similar compromise—between Aristotelianism and Augustinian-Platonic mysticism. But even Bonaventura stressed the latter element too strongly, leaving a contradiction between faith as inner experience and the equally emphasised belief in the authority of the Church. Thus the Franciscans could not in reality offer the upper bourgeoisie the same clarity and consistency as did Thomism. This is true also in the field of social ideas, for St. Bonaventura's few scattered remarks on the subject of economic activity, even if they did not perhaps display quite the previous degree of hostility towards merchants, yet could not be summarised into a system.[38] And the theology of Duns Scotus (1266–1308), the Franciscan teacher at Paris, which in the fourteenth century became more or less the general doctrine of the Franciscan Order,[39] with its growing antagonism between dogma and knowledge, was still less suitable for the upper bourgeoisie, who did not want a religion which faced them with problems.

The Dominicans were fully aware of the advantages of their system—Thomism was declared the official doctrine of the Order as early as 1286[40]—and they continued to hold resolutely to it. They were thus obliged to become increasingly conservative. They could not allow any visible breaches to be made in their doctrine, or the entire Thomist system, whose strength rested in its—at least, apparent—unity, would fall to pieces. As we saw in the previous chapter, the necessary emergence of new ideological requirements among the upper bourgeoisie, which Aquinas had not sufficiently recognised, could be met by slight variations of emphasis in his teachings, which actually covered considerable concessions in the field of practical life. Through their intensive theologico-scientific yet orthodox activity and propaganda, the Dominicans succeeded in keeping Thomism alive as a form of religious expression, in which all sections of society could find some kind of an answer to their needs; the famous Dominican school of S. Maria Novella was the teaching centre of this system.[41] The Franciscans, on the other hand, as a consequence of their basic attitude, less occupied with intellectual pursuits, necessarily found themselves left behind.[42] Such was the theological situation in fourteenth-century Florence,

as distinct from Europe as a whole,[43] and such more or less the practical situation of the two Orders towards each other and towards the upper middle class.

These two mendicant Orders, the Franciscans and the Dominicans, were by far the most important, both in Florence and throughout Italy: their magnificent churches and the monasteries connected with them, the Franciscan S. Croce and the Dominican S. Maria Novella, dominating their respective districts, and much larger than those of any other Order, give—with the Duomo rising between them—its character to the city of Florence. There were two other mendicant Orders: the Carmelites, whose church and monastery was S. Maria del Carmine, and the Augustinian Hermits or Friars, with their church and monastery of S. Spirito.[44] More aristocratic than the mendicant Orders, and more reserved, were the older Orders, especially the Benedictines and their various branches: the Camaldolensians (S. Maria degli Angeli), Vallombrosans (Badia and S. Trinità), and Olivetans (S. Miniato). The Benedictines had been the representatives of ecclesiastical culture until the rise of the mendicant Orders, and even thereafter did not lose all their importance.[45] At the beginning of the fifteenth century they also took part in the Observance movement, particularly the Camaldolensians under their General, Ambrogio Traversari. A very peculiar offshoot of the Benedictines was the Humiliati,[46] already referred to; they occupied themselves with the manufacture of woollen cloth, and regarded work as a religious duty; their church and monastery was that of Ognissanti. The Servites ("Servants of Mary"), originally drawn exclusively from good middle-class families, followed the Rule of St. Augustine and devoted themselves to an intense cult of the Virgin Mary, and possessed the church and convent of SS. Annunziata. The close attention paid by the Church to the function of each social class in her organisation of the Orders may be seen from the fact that there were even spiritual Orders of knighthood for the nobility—for example, the *Fratres Militiae Beatae Mariae* founded in the thirteenth century, and on account of their gay and not particularly pious life popularly known as *Cavalieri gaudenti* or *Frati gaudenti*; they could live like knights, without having to fear the democratic laws of the bourgeoisie, and at the same time were half regarded as clergy, though not obliged to observe celibacy; they lived on lines most congenial to them—combining a courtly mariolatry with campaigns of wild violence against the heretics.[47]

By means of the mendicant Orders—new, or at any rate transformed in a conservative spirit—the Church exercised a decisive influence on the city's religious and intellectual life. The Church favoured the Mendicants as against the secular clergy, and facilitated their influence over the laity in every way, for it was through this influence that she had been able in the thirteenth century to win back the faithful, and assure her subsequent sovereignty. The influence she wielded through the mendicant Orders was felt at every important moment by

the townsmen, whose whole way of life and death was steeped in religious sentiment.[48]

This influence was exerted chiefly through sermons, especially sermons in the vernacular. Formerly only the bishops preached, but now the Mendicants were accorded the papal privilege of preaching in all places without obtaining the bishops' permission. With the rise of these Orders sermons became far more frequent—indeed, it was only then that the sermon became a regular part of the religious service. The sermons were intended for the people—in this lay their great importance—and were the means by which the Church came into closest contact with them. They covered the whole field of dogma and morals. A passage was quoted from the Bible, explained, allegorised at great length, and finally its moral consequences were drawn.[49] By the insertion of a great number of anecdotes and instances (esempi) this framework could be made to include any subject whatever; it was these esempi, taken from legend or from daily life and vividly related, which were most appreciated by the people, to whom, indeed, they were particularly intended to appeal. The same means were also employed to impart knowledge, drawn, of course, from the ecclesiastical encyclopaedias and to a certain extent, even in the early fourteenth century, knowledge about antiquity. For the sermons were not only important in forming religious sentiment and dealing with religious-social questions; they were of decisive and educational significance for the majority of the laity, particularly its lower sections. As compared with the liveliness of the thirteenth-century sermons, a certain stiffness made itself felt in the fourteenth century, during the dominance of the upper bourgeoisie. The sermons became more superficial and mechanical; the earlier type of appeal to the emotions grew less common. In describing Christ's Passion no longer did the same intensity obtain as in the time of St. Francis; but much was said of the Day of Judgment, and the pains of Hell were set forth in great detail to render the idea of punishment as vivid as possible. Heaven and Hell, vices and virtues, the indispensability of the sacraments, the exploits and miracles of the saints of the various Orders—such were the favourite subjects for sermons. The Dominicans popularised Thomism, and often preached theological ideas very similar to those found in the *Divina Commedia*.[50] This popularisation of Thomist theology by means of sermons was all the easier because the Thomist doctrine of universals, according to which general conceptions have a real existence, found an echo in the symbolic thinking of the conservative masses, according to which the symbol of an object is its substance.[51] In general, the preachers purposely refrained from treating concrete political questions of topical interest in order to have a free hand in any direction (this applied to Florence till the time of Savonarola, but there were exceptions); abuses in public life, however, were taken up. From the beginning of the fifteenth century, particularly as a result of the activity of the wandering preachers of the Franciscan Observance, the sermons increased in number, quality, and

above all, in intensity, throughout the whole of Italy. But these Franciscan sermons were now less occupied with spreading theological or scholastic knowledge than with treating moral questions of public life in a more spontaneous and at the same time more popular way.[52]

In addition to their sermons, the mendicant friars exercised great influence by their spiritual care of their flocks—they could, for instance, hear confession and give absolution without the bishop's permission, in cases which were otherwise reserved to bishops—and by their penetration into private and public life. The innumerable lay fraternities (*Confraternità* or *Compagnie*) organised in fairly close accordance with the social strata, were a specially important means of spreading the Church's influence; they gave the whole public religious life of the city its particular character. Not only the upper bourgeoisie (the most respected families of the city, for instance, were united in the *Compagnia della Madonna d'Orsanmichele*), but even more the petty bourgeoisie were organised in these fraternities. Shopkeepers and artisans could here indulge in a substitute for politics which flattered their self-importance and brought them certain distinctions. Each of these fraternities had a cleric—generally a friar—as its moral supervisor, with a strong hold over the members, and through him the influence of the Church reached all sections of the population.[53] When these fraternities were originally founded about the middle of the thirteenth century, opposition to heresy was one of the main considerations; a leading part in this was naturally played by the Dominicans, especially St. Peter Martyr, who from his headquarters at St. Maria Novella brought into existence the *Compagnia Maggiore della Vergine*, which was composed of citizens of good family.[54] In the fourteenth century, particularly after the plague of 1348, these fraternities, especially those in which the humbler classes were organised, provided a harmless outlet, under ecclesiastical control, not only for the strong religious emotions excited by the catastrophe but also for some of the democratic inclinations of the time. The Third Order, which St. Francis had founded with the intention of making the distinction between friars and laity less rigid, now also acquired a different character: it became a means whereby the Church could spread its influence among the poor, and at the same time often a respectable and comfortable source of edification for the well-to-do, to whom it also brought considerable material advantages (for example, exemption from municipal taxes).[55] For the Church was now unwilling to tolerate any real trespassing by the laity on its own preserves.

For this reason official theology was also opposed to any popular religious literature, save that of a purely ecclesiastical character, for the lower classes; for such a literature, in concerning itself with religious, would also touch on the social problems of these sections.[56] Thus for instance, the Dominican Fra Giordano da Rivalto (beginning of the fourteenth century) declared in a sermon that for cobblers, furriers, and even women, to endeavour to interpret Holy

Scripture was nothing less than desecration. The Church did not readily countenance any excessive interest on the laity's part in the Bible. The Dominican prior of S. Maria Novella, Jacopo Passavanti (about the middle of the fourteenth century) required that Italian translations of the Bible should be read only with great caution.[57] The ruling upper middle class was, of course, in perfect agreement with this policy towards the religious needs of the lower classes; for it was in its interest that the religious sentiment of these sections should be completely passive, untroubled by problems, opposed to any dynamic mysticism, and yet very intense.

Turning now to discuss the religious feeling of the upper bourgeoisie themselves, it is necessary to distinguish between their various upper and lower levels. We must also distinguish between those periods when the higher section, whose sober-mindedness would also be reflected in religious matters, held undisputed power, and those when (either on account of an increase in the political influence of the petty bourgeoisie or some other cause of instability within the upper bourgeoisie itself) their lower strata gained greater influence in religious as in other spheres, and religious sentiment tended to become more excited and emotional. With every slight alteration in the social structure or in the time-factor, religious feeling presents a very different complexion.

We will first consider that higher section of the upper bourgeoisie whose characteristic mentality was of necessity confined exclusively to that class. The religious sentiment of this topmost section, after the upper middle class had come to power, especially when they alone were ruling, as at the beginning of the fourteenth and of the fifteenth centuries, was rather detached, averse to any exaggerated mysticism,[58] and showing little trace of inner religious conflict.[59] Their religious rationalism, which reached its climax during the periods referred to, is illustrated by a remark of Villani that piety should not lead man to commit any follies,[60] or by the opinion of Morelli, already quoted, that the reward of piety is business success. The upper middle class did not want to have complicated religious problems; they accepted—though with no touch of fanaticism —the authority of dogma. But this belief was not a simple, primitive return to the dogmatic piety of the early Middle Ages, to the stage of development before the rise of an individual, emotional relationship to God. The rationalist, Thomist religious sentiment of the upper bourgeoisie, with its more self-assured, more calculating relationship to God, naturally still retained many elements from this stage, which had been a necessary preliminary. Their religious attitude, with its newly-acquired more private character, contained both elements. At the beginning of the fifteenth century, the sober rationalism of this class, especially of their leading intellectuals with their growing scientific knowledge, strengthened from antique sources, was able to carry the secularisation of religion much further than in the fourteenth century. In Salutati, the blending of religious sentiment with secular and national thought went so far that he even

found in the latter a place for Christ himself; just as Jesus remained true to the country and the people where God had placed him at birth, said Salutati, so it was likewise the duty of "every good citizen" to do the same. The controversy between Salutati and Poggio shows how great was the difference of outlook in these two successive generations of upper-bourgeois intellectuals; for Salutati, Christian doctrine and truth were still absolutely identical; Poggio was more sceptical and showed a greater reserve. But even he never turned against religion; nor, with all his indifference to religious feeling, did the detached Bruni.[61] A tolerant rationalism was also favoured at the beginning of the fifteenth century by the closer relations of the upper middle class with the non-Christian world of Islam necessitated at that time by intensive commercial intercourse.

The members of the upper bourgeoisie, like all men in the Middle Ages, were, of course, dominated by a deep consciousness of sin and by fear of God's judgment. This fear was one of the sources of the cultus of the saints, whose good works, it was believed, enabled them to intercede with God on man's behalf.[62] The upper middle class, or at any rate their conservative majority, did not feel, particularly in the fourteenth century, that there was any contradiction between their own rationalism and that propensity to symbolical interpretations so rife in official Church thought and in the general medieval outlook —a symbolism according to which the explanation of every phenomenon was to be found solely in its relation to the doctrines of salvation and their embodiment in the Church. For an attitude of "worldly-indifferent" rationalism was adopted only by the cultured élite of the upper middle class, and even their rationalism, it must be emphasised, generally remained religious in character. The more we approach the lower levels of the upper bourgeoisie, the clearer it becomes that the majority retained an intense religious feeling, which at the beginning of the fifteenth century actually grew stronger owing to the sense of economic insecurity, which was already widespread just at this time of apparent stability.

We have already spoken of the theoretical belief in an ideal of life, which the laity—and not the upper bourgeoisie alone—found so necessary amidst universal and personal sinfulness, and which they saw embodied in the friars. Nevertheless, the upper middle class—Villani is a classic example—made a very clear distinction between the Spirituals' ideal of poverty, which they hated because they suspected its practical dangers, and the ascetic ideal of monasticism, which they admired and by their large gifts helped to make materially possible. Hence their preference, as we have seen, for the Observance movement. For the same reason, however, they distrusted on principle visions and religious ecstasy,[63] because they feared the dangerous revolutionary potentialities of mysticism.[64] It is significant that the companies of the Disciplinati, whose tendency was towards a more ecstatic religion than that of the ordinary lay

companies, and whose penitential practices included flagellation, arose not at times when the upper middle class was supreme,[65] but in democratic periods, particularly in the seventies of the fourteenth century. It was certainly a source of satisfaction to the upper bourgeoisie when prominent ecclesiastics like Jacopo Passavanti, or the Blessed Giovanni delle Celle, or Giovanni Dominici uttered warnings against attaching too great significance to visions and dreams, and in particular gave instructions how to distinguish between them, for not all of them came from Heaven. But visions and a "healthy" mysticism were acceptable enough to the rationalistic upper middle class (and of course to the clergy), if they answered their own religious needs, and encouraged the growth of a docile Observance movement. We may cite the visions of St. Bridget (1303-1373), to which Papal recognition gave that stamp of authenticity so important in the eyes of the upper bourgeoisie, and which—what is equally significant—occurred just when a stormy period was brewing: for the Curia, it was the eve of the return to Italy, the period preceding the Schism; for Florence, a democratic period and one of frequent crises. St. Bridget was related to the Swedish royal family, and after 1346 lived in Italy, where she moved in the highest circles (Curia, cardinals, Neapolitan court). Her visions were looked upon as having been dictated by Christ himself. They gave authoritative answers not only to numerous questions of theology,[66] but also on matters of ecclesiastical policy, and she expressed strong approval of various Papal measures. John XXII's bull against the Spirituals was justified, she asserted, for the coat woven for Christ by Mary, for which the soldiers cast lots, was possessed by Him as property. It is easy to understand, therefore, that both the Curia and the upper middle class favoured St. Bridget's call to repentance and the Order which she founded, based on a strict, monastic life.

Good works held a high place in the religious sentiment of the upper bourgeoisie. The conception and performance of good works were an essential link between their interests on the one hand, and those of the Church and the mendicant Orders on the other. The bourgeoisie in the period of early capitalism saw in good works the plain solution of all the moral conflicts which might and for them necessarily did arise between the outer world and the religious, canonical commandments. Alms atone for sins; good works can propitiate God and ensure the salvation of the soul.[67] These good works generally took the form of gifts to monasteries, whose inmates by the perfection of their lives had acquired an excess of merit, the benefit of which was then passed to the laity. What made the wealthy most fearful for their souls was their continual transgression of the prohibition of interest, on which indeed their whole life was built. But, as we saw in the previous section, they found no great difficulty in coming to terms with the clergy. In practice, good works were one of those measures by which the upper middle class made it possible for themselves to take interest and at the same time make good their offence against the canon law. Always desirous

of atoning for their sins, the merchants and bankers naturally felt this need most keenly at the end of their lives, when their usurious activity had definitely ceased. The wealthy bourgeoisie, therefore, performed works pleasing to God, that is, they bequeathed, generally only on their death-bed and then "in repentance", more or less considerable legacies—usually a relatively small proportion of the fortune they had amassed by usury[68]—to the Orders, to their churches and monasteries, to the confraternities,[69] to the poor. The gifts were made in consultation with the Church, with the priest concerned, who then granted the dying usurer absolution.[70] The Church also saw to it that these legacies should not damage the dying man's business firm, the whole merchant company—individual cases being decided according to the principle of Aquinas, that generosity must be limited by respect for commercial obligations and further must not imperil the economic existence of the family, so that its members can no longer live according to their station.[71] But what were the social results of their bequests, who benefited by them, whether the poor benefited at all—to these questions the donors were indifferent.[72] Villani or Salutati are good instances of this attitude.

In any case, the two great mendicant Orders of the Dominicans and the Franciscans, and their churches and monasteries, profited greatly from this desire of the wealthy middle class to save their souls. We are thus brought back again to our starting-point: the acquisition of wealth by the mendicant Orders, which was a dominant problem in the religious life of the upper bourgeoisie. But the question of monastic discipline, by using which the upper middle class were able to shelve the problem of poverty, was necessarily closely connected with the material position of the friars and the way they fitted into the capitalist economy of the upper bourgeoisie. In general, the friars were regarded—and, often no doubt rightly—as calculating and businesslike, corrupt and pleasure-loving.[73] Nor were the upper middle class exceptional in holding this view. But their "disappointment" with the friars must not be exaggerated.[74] The upper bourgeoisie by no means felt the situation to be a vicious circle, for they could distinguish quite well between the office and the holder of the office. Precisely because they were opposed to the poverty of the Order, they had every interest in maintaining in principle the ideal of monastic asceticism and an intense belief in it,[75] though lack of asceticism among the friars was common in actual practice.

We have seen that the upper middle class and the Church, which protected the worldly interests of her ally, were extremely skilful in making compromises with one another in economic and political thought, and still more so in practice. We may now proceed to estimate the extent of the ramifications of religious "influence" as wielded by the Church and by that class. How far, that is, did the Church on the one hand, by the exercise of her spiritual authority, further the interests of the upper middle class in the economic field? How far, on the other hand, did the upper middle class support the Curia in the political field?

That the clergy served as a means of very real economic pressure on the poor in the interests of the upper middle class is shown by a sermon delivered in 1304 by a famous Dominican preacher, Fra Giordano da Rivalto (*c.* 1260–1311).[76] He was appalled that merchants of the wool guild should cause wretchedly paid women weavers to be excommunicated because the spun yarn did not come up to the merchants' requirements, and that the clergy in their sermons should threaten workers with the same penalty.[77] Official confirmation of this is to be found in the statutes of the wool guild of 1317, which were approved by the commune and subsequently re-enacted yearly; they ordered that the consuls of the Guild should approach the bishops of Florence and Fiesole annually for this purpose. These bishops actually issued instructions in this sense to the clergy of their dioceses (1333, 1428): on great feast-days they were to instruct their parishioners that they should proceed in an orderly manner when winding the spun yarn and that they should not misappropriate the raw wool which was given them to spin; severe ecclesiastical penalties were imposed for any breach of these regulations, and anyone who offended a fourth time was to be excommunicated and only absolved after a period of severe probation and payment of a considerable sum to the priest.[78] The Church thus compelled the observance of industrial regulations, and became interested in doing so because she benefited from the fines. We give this example because it throws light on the whole situation. Nothing could show more clearly than this long-established practice how the interests of Church and industry became interconnected and how the clergy were drawn into industrial affairs. Such action on the part of the Church was possible because she recognised the poor merely as objects of Christian charity, alms and good works, not as workers, with a right to better pay and greater freedom of movement.[79]

What then was the attitude of the rationalistically pious upper middle class and their enlightened intellectuals to the worldly power-politics pursued by the Curia?*

Even if the upper bourgeoisie did not believe in the infallibility of the Pope, they did believe that the Church, as an institution, was unimpeachable. In general, the alliance between the Curia and the upper middle class worked very satisfactorily in the interest of both, though the continually changing circumstances naturally caused friction from time to time. The norm for the policy of the upper bourgeoisie in their general dealings with the Curia was, in the typically Guelphian words used by their spokesman, the judge Oddone Altoviti, in 1285: "Comune Florentie oportet obedire Ecclesie Romane." The Curia, for its part, was very outspoken in its support of the wealthiest section of the

* An examination of particular historical situations in which this relationship assumed very varying forms gives us a good insight into the mentality of the various sections of the Florentine bourgeoisie, in their attitude towards religion, the Church and the Pope. So we must needs deal with some of these situations in a detailed way.

upper middle class, as against influences from below, but at the same time was desirous of including the nobility in the régime of the upper bourgeoisie. This is most clearly revealed by the policy of Boniface VIII. He considered the democratic *Ordinamenti di Giustizia* of 1293 too indulgent towards the lower middle class; he approved of the modifications introduced in 1295 in the interest of the middle class and the nobility.[80] The upper bourgeoisie could, however, offer serious opposition to the worldly power of the Curia if it was used against their interests. Yet they did so rarely, and only if obliged; when it was necessary, they also found justification for their opposition, as cases from Villani's Chronicle show. Originating among the lower sections of the population in Florence, a general critical mood towards the worldly power and policy of the Curia prevailed—it might be described as an ever-present repetition of the attitude of the "moderate" Spirituals—but on the whole the upper middle class resisted it successfully. Such was the situation when the upper bourgeoisie held unquestioned power, and it is this attitude alone that was genuinely characteristic of this stratum.

The behaviour of the ruling sections towards the Curia underwent modification when the upper middle class had to share power with the petty bourgeoisie, a situation which obtained on and off in Florence from the forties till the eighties of the fourteenth century. As the petty bourgeoisie had no foreign economic interests, they were not afraid to take measures detrimental to the worldly or economic interests of the clergy or the Curia, regardless whether or not the latter resorted to far-reaching reprisals.[81] In democratic periods, therefore, it sometimes happened that a considerable part of the upper bourgeoisie and more particularly the middle sections of the bourgeoisie were carried away by the general mood of criticism of the Curia in worldly and economic matters, and agreed to measures which were hostile to it. Only the Parte Guelfa, representing the upper middle class *par excellence*, or more accurately their upper oligarchic layer, always sided with the Curia. The Curia, however, treated all sections, including the upper bourgeoisie when at any time they turned against the Pope, as heretics, should they infringe its economic or political power. This occurred during the war against the Pope from 1374 to 1378, which broke out in consequence of the aggressive policy of the Curia and its French legates, whereby a powerful Papal State, hostile to Florence, was set up in Italy. The upper middle class were divided according to their interests: some of them joined with the middle and petty bourgeoisie in supporting the war; in fact, enthusiasm for the "national" war was so general that the Parte Guelfa could make no stand against it. The displeasure felt for the "Frenchified", "mercenary", "avaricious", papacy at Avignon, which prudence had hitherto kept in check, now burst out with such vehemence that the commune of Florence had no scruples in stirring up the population of the Papal State and organising, under the watchword of "liberty", a league of republican towns throughout

Italy. Salutati, who as chancellor of Florence was the official spokesman of the city, was for a time excommunicated by the Pope, together with other leading magistrates. But whereas in Villani's time excommunication, whether just or unjust, was something to be dreaded, secular and national thought had now progressed so far that these political excommunications were not taken too seriously either by the laity[82] or the great majority of the Florentine clergy. The Blessed Giovanni delle Celle wrote to the wealthy merchant Guido Neri, who held office during this war but was doubtful whether it was right for him to remain at his post, that "il buon stato della città" must be defended; excommunication was not valid in the sight of God, unless it was for mortal sin. Giovanni's friend, the famous theologian Luigi Marsigli (1330–1394), Provincial of the Pisan province of the Augustinian Hermits, a cultured and liberal friar, wrote to Neri in even sharper terms; he shared all Petrarch's hatred for the French and the Avignonese clergy and, in German fashion, proclaimed himself an adherent of the national Church.[83] The commune also found courage to tax the clergy and Church property in order to meet the costs of the war. Presently an interdict was laid on the town. But the magistrates of Florence responsible for the conduct of the war, the so-called *Otto Santi*, ordered the churches to be broken open and services held. St. Catherine, who in collaboration with the Parte Guelfa and the Dominicans of S. Maria Novella (the leading figures among whom were from such prominent Florentine families as the Adimari and the Strozzi) was striving to negotiate a peace between the Pope and Florence, was terrified by the taxation of the clergy and accused the Franciscans of supporting the commune in holding religious services.[84] As politically she was wholly on the side of the Parte Guelfa and therefore against all other sections of the population, a crowd demonstrating against the Parte Guelfa— on the eve of the *ciompi* revolt—threatened her with death.[85] As the social conflicts grew more acute and fear arose that the lower sections might really gain the upper hand, an increasing number of the upper middle class and the clergy became inclined for peace. This was finally negotiated by that section of the upper bourgeoisie which, though hostile to the Parte Guelfa, had an interest in the Papal finances and in any case suffered economically through the interdict.

A brief word must be said about the religious attitude of the upper middle class intellectuals during this period. As a result of the political situation, Salutati's secular and national ideas might come into momentary conflict with the Curia, but never with religion as such. The piety of the circle round Salutati and Marsigli is above all suspicion. Marsigli was head of the academy at the monastery of S. Spirito, which had a reputation for enlightenment, and where the most important Florentine intellectuals, including Salutati, discussed philosophical questions. Marsigli was not only held to be the most learned man in Florence, but was also an important theologian[86] and an effective popular

preacher. Salutati is also a good example of the extent to which during the whole fourteenth century all secular ideas including the extraordinarily increased knowledge of classical antiquity were finally subordinated to religion; this is true also of Petrarch, who furnished the intellectual foundation of the S. Spirito circle. When Salutati was carrying on a polemic against the enemy of humanism, the Dominican Dominici, at the beginning of his pamphlet he withdrew in advance—and this was no recantation, but a genuine statement of faith—anything in his arguments that might be in opposition to the Christian faith.

We turn next to the attitude of the Florentine upper middle class to the secular policy of the Curia at the beginning of the fifteenth century, when they enjoyed absolute power. With the help of their intellectuals (Bruni), they did everything possible to end the Schism, for a divided Church, with divided authority, damaged their commercial interests.[87] For though the return of the Popes to Italy and their removal from the French sphere of influence was economically advantageous to Florence, yet the whole benefit was nullified by the existence of two opposing popes. On the strength of the expert opinion of the clergy and university of the city, the upper middle class succeeded in having a Council summoned, in 1408, which met in Pisa, territory recently conquered by Florence.[88] This Council, held under Florentine auspices, was regarded by the Florentine upper bourgeoisie as a kind of reparation for the war they had waged against the Pope thirty years earlier.[89] The Council of Pisa endeavoured to end the Schism by deposing the two rival Popes as heretics, and electing a single new pope. Both Alexander V, the Pope elected at this Council, and his violent successor John XXIII,[90] were close allies of the Florentine upper middle class. When the latter Pope also failed to put a definite end to the Schism, the Florentines, in their anxiety for a unified Papacy, supported the plan of a fresh Council, which was held at Constance (1414–18). At this Council the Florentine upper bourgeoisie, through their clergy and intellectuals (Bruni and Poggio were secretaries to the Pope), first supported John XXIII as long as his chances were at all bright, but after his deposition transferred their support to the new pontiff, Martin V.[91] This Pope, too, who made the see of Florence into an archbishopric (1420), formed an alliance between Florence and the Curia which was to continue so long as members of the Florentine upper middle class, namely, the Medici, were the papal bankers. Florence was now a kind of second Papal city, a strong citadel to which the Popes fled for lengthy periods when danger threatened in Rome. It is significant that they then took up their quarters at S. Maria Novella, the Dominicans providing, as always, an important link between the Curia and the town. Florence offered hospitality to Martin V while unrest continued in Rome (Bruni provided the link at that time between the Pope and Florence), and the same is true of his successor Eugenius IV, who fled to Florence in 1437. In 1434 the latter had been largely instrumental in the recall of his banker, Cosimo de' Medici. Very characteristic was the attitude

of the Florentine upper bourgeoisie to the new Council of Basle (1431–44). Previously, when the Councils were used to restore the unity of the Church, Florence, to whom this unity was useful, had been in favour of strengthening their power, and therefore supported the conciliar theory also. But once unity had been restored to the Church and the Northern States translated the conciliar theory into practice by actually employing their power against the Pope and attempting to democratise the Church, the Florentine upper middle class turned violently against the Councils and the "foreign" conciliar theory, confirming the Pope in his resistance to them. The Council of Basle, which, in contrast to those of Pisa and Constance was genuinely democratic, simple doctors having the right to take part, wished to abolish the yearly ecclesiastical tribute to the Pope. That the Florentine upper bourgeoisie, the Popes' bankers, were indignant at this proposal, is natural. Equally indignant, in spite of his usual scepticism and superiority, was Poggio, an official of the Curia; for very real economic interests were at stake here. The Florentine, Ambrogio Traversari, General of the Camaldolensian Order and papal ambassador at the Council, in a letter to the Emperor indicated the true opinion of the Florentine upper middle class of this period with regard to democracy in practice by saying openly that he disapproved of the Council because it was composed of the lower clergy and not of bishops;[92] he called it a "band of mad criminals".

All these details go to show how the different forms of religious sentiment in the various sections, their attitude to the Curia, ecclesiastical problems, economic and political interests were closely interwoven with one another, and can only be understood in terms of this connection, and within the framework of the given historical situation. As we have seen, at the beginning of the fifteenth century, at the very time when their religious indifference was most pronounced, the oligarchic upper middle class and their most progressive intellectuals did everything possible, from well-understood motives of self-interest, to strengthen the secular power of the Curia; their relations could not have been closer. But in a time like the seventies of the fourteenth century, when the weakened upper middle class were drawing nearer to the democratic lower middle class, and inclined to a more intense religious sentiment, when their leading intellectuals were also very far from indifference in religious matters, then they made war on the Pope. These two diametrically opposed situations characterise the religious attitude and the ecclesiastical policy of the upper bourgeoisie.

Very different in type from the upper middle class, which was more or less continually in power, was the religious feeling of the petty bourgeoisie, the artisans and workers. More ignorant, less cultured, less calculating, more passive, they could only give expression to their needs and wishes through religious forms. They showed a much more pronounced interest than the upper bourgeoisie in religious problems, with at the same time the crudest belief in miracles.

As we have seen, the adherents of the sects, later and to an increasing extent of the Spirituals, finally and exclusively of the Fraticelli, were drawn from the lower sections. Nevertheless, after about the middle of the thirteenth century, open hostility to the Church in these strata grew continually less. In general, especially during periods of calm, they accepted without question everything which the Church and the mendicant friars instructed them to believe, even though earnest seekers after God were disappointed by the extent of corruption and by the business acumen of the clergy, particularly the Mendicants. There was therefore always a spirit of criticism among the lower sections against the Church's economic activity and the temporal privileges of the clergy. At times of distress, famine, or plague, and especially of social conflict, the intense religious feeling of these strata, particularly of the poorest, could rise to an excited pitch. Religious ecstasy, economic and political demands were blended. The purely religious equality of the primitive Gospel, the Messianic prophecies so common since Joachim of Fiore, were sometimes translated into terms of democracy and politics. These democratic ideas and prophecies, however, appealed not only to the authority of the Gospels, but also—and particularly when force was mentioned—to the Old Testament and the Apocalypse.[93] The very obscurity, the difficult symbolism of these prophecies—the Apocalypse, since it lent itself to widely differing interpretations, being, of course, a favourite source—made them acceptable to these excitable, uncritical strata, who were thinking in terms of symbolism, in exterior analogy.

Like all the oppressed in Europe, engaged in a struggle for better standards of life, the lower sections, especially the *ciompi*, naturally called themselves "God's people". In 1378 the three new guilds of the *ciompi*, the dyers, and the shirt-makers were called, even in official documents, by the collective name of "*Popolo di Dio*", as a third factor against the greater and lesser guilds. The poor thus placed themselves under God's special protection; they wanted a God who would care for *them*.[94] Although there were certainly a number of Fraticelli among the *ciompi*, the great majority of them—that is to say, the very poorest of the Florentine population—were not really hostile to the official Church, even during the revolutionary situation of 1378. It is significant that shortly before their revolt, they took up their residence at the Dominican monastery of S. Maria Novella, where they elected their own priors, whom they called *Otto di S. Maria Novella*. Still more significantly they asked the prior of that house for pious friars to give them wise counsel—that is, correct political advice—in their difficult situation.[95]

Only the intellectually alert among the poor supported the radical friars who had broken away from the official Franciscans, the Fraticelli, known also as the *Fraticelli della Povertà*. After Pope John XXII's dictum denying the poverty of Christ, the Fraticelli regarded all Popes and even all priests consecrated by them as heretics. They were opposed to the Church's absolutism;

they considered that, like the primitive Church, she should own no property. They awaited the coming of a Pope who would hold no temporal rule, and regarded their own sect as the only true Church, their priests as alone authentic. They were strongest in the Marches and in Umbria, whence their wandering preachers went out on missionary journeys through the country, holding secret services in suitable houses of their adherents. One of their centres was, of course, Florence, where the lower middle class were sinking into poverty and the workers had no rights.[96] The revolt of the *ciompi* had even been foretold—though with a favourable issue—ten years before its outbreak, apparently by one of the Fraticelli; indeed, such prophecies made by the Fraticelli shortly beforehand contributed not a little to the insurrection.[97] In the democratic period preceding it, the Fraticelli suffered little persecution, but in 1382, immediately after the final political elimination of the petty bourgeoisie, when the upper middle class reaction set in, a municipal statute imposed the death penalty on all who spread the ideas of the Fraticelli, and an energetic persecution of heretics began. Under this statute, one of the most popular wandering preachers of the Fraticelli, Fra Michele da Calci, was burnt by the inquisitors as an obstinate heretic, having been enticed to Florence by certain women Tertiaries at the instigation of the Franciscans, on the pretext that they wished him to hear their confessions. One of the Fraticelli wrote a *Storia di Fra Michele Minorita*, which describes his death in the simple, direct, popular style of the Gospel story of the Passion and of the early Christian martyrologies. In 1400, Fraticelli were still being burnt in Florence. A statute of the city of 1415 spoke of the Fraticelli "who are led by the Devil into the orthodox town of Florence".

But open heresy, adherence to the heretic Fraticelli, remained always only a latent possibility, a last resort, as it were, of the lower middle class of this period. In this section of society, there generally lived on the ideal of a hermit-like, purely religious life of solitude, away from towns, without property, as free as possible from the compulsion of authority. The hermit, a common figure especially in the twelfth and thirteenth centuries, led his saintly life before the eyes of all, and was therefore a much more popular figure than the monk, who lived in seclusion in his monastery.[98] But this institution of hermits living independent lives, not bound by the definite rules of any Order, subject only to the discipline of their own priest, was increasingly restricted by the Church;[99] the number of the so-called orthodox Fraticelli, recognised by the Church, was exceedingly small in the fourteenth century. It was no wonder that the Observance movement became so popular among the petty bourgeoisie, for it did realise to a certain extent, even though within a strictly ecclesiastical framework, the ideal of the *vita contemplativa*.

The general spiritual state of the petty bourgeoisie was marked by passiveness with sudden outbursts of religious ecstasy, especially in times of misery or on the occasion of particularly stirring penitential sermons.[100] For this stratum

had a constant even if somewhat concealed leaning towards mysticism. With its uncritical, non-pragmatic conservative mentality, it also had a natural bent towards the age-old symbolical and allegorical way of thinking impressed on it by the liturgy of the Church and the language of the Bible, whether the immediate influence came from the Spirituals or from the official Church. As the Church could not entirely stamp out this mysticism without doing herself the gravest injury, she directed it into the symbolical and allegorical, the formalistic and architectonic line of official, conservative religious thought. In contrast to the passionate, fermenting, obscure symbolism in the Biblical interpretations of the Spirituals, the symbolism of the Church, however far-fetched, created an impression of greater clarity, and was certainly more systematic, more unified, more elaborated in its details. It dominated the official sermons, particularly those of the Dominicans, with their scholastic classifications and distinctions, and their arguments based on numerical symmetry.[101] By this allegorical interpretation of the Bible, the lower strata were imbued with strict ecclesiastical theology. By this means their mysticism was robbed of its dangerous potentialities and was given a passive, rigid and politically harmless character.

NOTES

[1] And also the needy peasants, who were influenced by revolutionary tendencies from the town.

[2] See G. Volpe (*Movimenti Religiosi e Sette ereticali nella Società medievale italiana*, Florence, 1922) and E. Troeltsch (*Social Teaching of the Christian Churches*). Troeltsch proves that a continual shift of emphasis on to different elements of the New Testament made democratic-individualist and socialist-communist ideas possible within the framework of Christian doctrine.

[3] At their height, during the three generations before the middle of the thirteenth century, the membership of the sects in Europe attained the huge figure of about $3\frac{1}{2}$ million, more than half of these being found in North and Central Italy.

[4] For a detailed study of these transitional phases, see Volpe, *op. cit.*

[5] The nobility, in process of disintegration, were at that time, for economic and political reasons, ill-disposed to the Church, and consequently some of them took the side of the heretics—in Florence generally speaking until about the middle of the thirteenth century. A more cultured section of the Ghibelline nobility, following Frederick II, was also often heretical, or, in this early period, supported the heretics, because they had little faith, unlike the poorer classes, who had too much.

[6] While the sects in general turned away from all worldly concerns, and some, particularly the Waldenses and those allied to them, regarded trade as sinful, the Cathari, who included merchants among their number, gave a different turn to the idea of fleeing from the world: as the earth was a creation of the Devil, what happened on earth was a matter of indifference, and not only trade but also usury were permissible. In this manner religious arguments were used to get the better of the Church in the economic field as well. The merchants who belonged to the Cathari spread their beliefs when on their business journeys. In Florence during the twelfth century and the first half of the thir-

teenth the middle class were, in general, opposed to any persecution of the heretics, because they were industrious and of strict and sober life. See Volpe and Engel-Janosi, *op. cit.*; also the latter's "Die soziale Haltung der italienischen Heretiker" (*Vierteljahrschr. für Sozial- und Wirtschaftsgesch.* XXV 1931)

[7] W. Goetz, "Franz von Assisi und die Entwicklung der mittelalterlichen Religiosität" (*Archiv. für Kulturgesch.* XIII, 1927).

[8] See the full discussion in H. Thode, *Franz von Assisi und die Anfänge der Renaissance in Italien* (Berlin, 1904).

[9] It is characteristic of this transitional period, with its sudden contrasts of poor and rich, that in some cases individual members of the wealthy bourgeoisie chose personal poverty as an atonement for the sin of wealth. St. Francis himself was the son of a prosperous clothier in Assisi; St. Clare, who under his influence founded the female Order of Poor Clares, came of an aristocratic family in the same town; Peter Waldo of Lyons was originally a rich merchant.

[10] His followers were called "Poverelli of St. Francis", just as the earlier sects in various countries and districts were called "Poor Men of Lyons", "Poor Men of Lombardy", etc. In the official name of "Fratres Minores", soon given to the Franciscan Order, there is a reminiscence of these earlier designations, a reference to their life of poverty and humility.

[11] Troeltsch, *op. cit.*

[12] Innocent III, who gave the approval, came from the wealthy and noble family of the Conti. When in 1204 the Florentines had aroused his anger and wished to placate him, they chose the banker Lamberti as their most suitable ambassador.

[13] There is much dispute in the literature on the subject, and it is doubtful whether it will ever be settled finally in all details. A view differing somewhat from that here put forward will be found, e.g. in W. Goetz, "Die ursprünglichen Ideale des hl. Franz von Assisi" (*Hist. Vierteljahrsschr.* VI).

[14] In the earlier aristocratic Orders, particularly the Benedictines, there were, in addition to the monks, lay-brothers of lower status whose duty it was to perform the heavy manual labour. In the Vallombrosan Order, a branch of the Benedictines, the monks were explicitly forbidden to do manual work, in order that they might lead a life of pure contemplation.

[15] We cannot here consider in detail the very complicated and continually changing methods by which the Order's possession of property was denied in principle and at the same time maintained in fact. See K. Balthasar, *Geschichte des Armutsstreites beim Franziskanerorden* (Münster, 1911).

[16] Later abbot of a reformed Benedictine Order.

[17] The date is variously interpreted.

[18] For full details see E. Benz, *Ecclesia Spiritualis* (Stuttgart, 1934) and A. Dempf, *Sacrum Imperium* (Munich, 1929).

[19] It is possible that Dante attended his lectures at this time. It was under the guidance of Ubertino that the Florentine Tertiaries experienced Christ's Passion with such intense physical sympathy that they thought they were drinking the blood from his wounds. Blessed Humiliana (1219–46), a member of one of the wealthiest banking families of Florence, the Cerchi, was also a Tertiary. While her family conducted their usury and banking operations on the ground floor, the Saint was tormenting herself to death by exaggerated asceticism in a room above; they allowed her no money, so that she should not be able to give it to the poor. Among Humiliana's miracles was the liberation of Guelphs, supporters of the Church, from persecution by the Ghibellines. See Davidsohn, *op. cit.*

[20] Some groups of Spirituals sided with the Emperor in order to break the worldly power of the Pope. Generally speaking, the Spirituals were treated by the Church and the upper bourgeoisie as Ghibellines and heretics. Sometimes also *déclassé* members of the upper middle class gave a Ghibelline interpretation to Joachim's prophecies. Dante is an instance (for the similarity of his views to those of the moderate Spirituals see F. Tocco, *Quel che non c'è nella Divina Commedia*, Bologna, 1899). For a time Rienzo was also influenced by the Joachimite Spirituals. When, in contrast to the early groups of Spirituals (with whom the social question existed only as a background), a programme of social reform played a larger and more active part, as in the revolt of the poor in northern Italy led by Fra Dolcino (*c.* 1305–7), the whole sect was rooted out with fire and sword in a crusade proclaimed by the Pope; in Florence also the adherents of this sect were burnt.

[21] The famous poet and Spiritual, Jacopone da Todi (1230–1306), who composed a poem on Christ's love for poverty, was imprisoned by Pope Boniface VIII. It was the same Pope who finally suppressed the Spirituals after his predecessor, Celestine V, a former hermit, had been compelled to retire (1294) on account of his "ignorance of the ways of the world", one manifestation of which was his friendly attitude towards the Spirituals; he had allowed them to follow the original Rule of St. Francis in some of their oratories.

[22] It is significant that the same Pope placed the papal finances on a new and secure footing by his great tax reforms (see p. 32, note 19) and with the assistance of Florentine bankers. He had a Papal gold florin minted on the model of the Florentine gold coin. He himself came of a wealthy bourgeois family from Cahors, one of the chief seats of French banking.

[23] The way had already been prepared for this view by Aquinas.

[24] It is impossible to draw a definite line between the Spirituals and the Fraticelli, as the latter were in fact the continuation of the former. See F. Ehrle, "Die Spiritualen, ihr Verhältnis zum Franziskanerorden und zu den Fraticellen" (*Archiv für Literatur- und Kirchengesch. des Mittelalters*, III–IV, 1887–88).

[25] Ehrle, *op. cit.*

[26] He actually resigned from his position as abbot of S. Trinità in order to lead a life of contemplation in the monastery of Vallombrosa.

[27] O. Hüttebräuker, *Der Minoritenorden zur Zeit des grossen Schismas* (Berlin, 1893).

[28] St. Dominic was in Florence in 1219.

[29] There was a Spiritual movement among the Dominicans also at the end of the thirteenth and beginning of the fourteenth centuries.

[30] See p. 336.

[31] In 1292 the inquisitors obtained the right to invest their third of the confiscated property of heretics in landed property on behalf of the Franciscan Order. The greed of the Inquisition is illustrated by the fact that the inquisitors sold licenses to carry arms to all those who liked to show off with their weapons, on the pretext that such persons needed breastplate and sword to defend the true faith. See Davidsohn, *op. cit.*

[32] The Dominicans also had their Tertiaries, in imitation of the Franciscans.

[33] This is clear from Villani's Chronicle.

[34] After the coming into being of the mendicant Orders they were responsible for most of the progress made in theological thought, though less so in Italy than in the northern countries, and particularly at the University of Paris. In a few instances only— though those were very important (Aquinas, Bonaventura)—were these theologians Italians. Italy, being already to a certain extent bourgeois, was not particularly interested in the specific development of Church teaching; for the Italian bourgeoisie, linked as

they were with the Curia, loyal acceptance of the Church's doctrine was a matter of course.

[35] The more the Spirituals became the intellectual representatives of the poor and of the uncultured petty bourgeoisie, the more opposed were they to every form of theological knowledge and to the pride of intellect in general, citing St. Francis in their support (Jacopone da Todi, Ubertino da Casale). In any case, they were against a too "rationalist" Aristotelian theology. The extreme Spirituals definitely proclaimed themselves in favour of ignorance (see also p. 113, note 6).

[36] Troeltsch (*op. cit.*) rightly observed that the social system of orders and scholastic thought, with its external architectonic unity, mutually condition one another.

[37] Troeltsch, *op. cit.*

[38] Opinions are divided with regard to the interpretation of these passages in Bonaventura. See F. Glaser, "Die franziskanische Bewegung" (*Münchener volkswirtschaftl. Studien*, 1903), and Schreiber, *op. cit.*

[39] Later, for instance, St. Bernardino of Siena was a Scotist, but, significantly enough, he had little to say on theological questions.

[40] It was no mere accident that after the very varying early judgments passed upon his doctrine by the Church, Aquinas was canonised (in 1323) by John XXII, the most rationalist of the Popes of that period and the most friendly to the upper bourgeoisie.

[41] Fra Remigio de' Girolami, lecturer in theology, enlarged this school of the Order and made it more accessible. In this way, Dante became a pupil of Remigio and studied Thomist philosophy under him.

[42] The University of S. Croce, which suffered under the dispute with the Spirituals, was much less important than that of S. Maria Novella.

[43] In the controversy over the Immaculate Conception, the Dominicans were in the course of time (fourteenth-fifteenth century) defeated by the Franciscans. The Franciscans, defending the doctrine, represented the popular mystical standpoint; the Dominicans, on the other hand, took up a rationalist position.

[44] The official theology of the learned Augustinian friars, known as the Aegidian doctrine (after the General of the Order, Aegidius Romanus, 1247–1316), was related to the Thomism of the Dominicans; it was in fact, a kind of eclectic Thomism, with elements from the older Franciscan school.

[45] Petrarch, whose individualism included feudal-aristocratic as well as bourgeois elements, inclined towards the old, socially superior contemplative Orders, rather than the mendicants. He preferred solitariness in an individualistic-humanistic sense to a hermit's life in the desert, which he found insufficiently intellectual and too democratic (*De Vita solitaria*).

[46] The Humiliati movement was probably heretical in its origins.

[47] The creation of such spiritual Orders of knighthood was only one of the ways by which the Church endeavoured to christianise chivalry and to spiritualise the courtly life, while leaving untouched the feudal-military code of honour.

[48] A great part of life was passed in church. Weddings in Florence were generally postponed until the end of June, so as to coincide with the feast of St. John the Baptist. On Saturday in Holy Week 5,500–6,000 children were baptised (figures from the end of the fourteenth century). All letters, including business memoranda, were full of religious formulas. For example, the business books of the Peruzzi all opened in the name of Christ, Mary and all the saints, with a prayer that the Peruzzi might be granted grace to do nothing which would not redound to the divine honour and glory. Again, the silk merchant and chronicler Goro Dati (1362–1435) wrote in his *Ricordi* of his five children who all died in childbirth "God's will be done".

[49] L. Marenco, *L'Oratoria sacra italiana nel Medioevo* (Savona, 1900) and A. Galletti, *L'Eloquenza* (Milan, 1904–09).

[50] Galletti, "Fra Giordano da Pisa" (*Giornale Storico della Letteratura italiana*, XXXI, 1898).

[51] On this very important relationship between philosophical Realism and symbolic thinking see J. Huizinga, *The Waning of the Middle Ages* (Eng. trans. London, 1929).

[52] These Observant sermons were directed chiefly against the superficiality of religious life, demanded the reform of the Church and of monastic life (in a sense favourable to the Curia), attacked heretics, and at the same time—apparently, at least—usury (see pp. 14–42.) See H. Hefele, *Der Hl. Bernhardin von Siena und die Franziskanische Wanderpredigt in Italien während des 15. Jahrhunderts* (Freiburg, 1912). The sermons of St. Bernardino of Siena with their apocalyptic, almost Joachimist tone were not—in spite of their severe ecclesiastical spirit and decidedly affirmative attitude to life—quite of the type usual in Florence. The real field of activity of these Franciscan Observants was the petty-bourgeois Siena and Umbria rather than Florence. How easily sermons of this kind could take on a political aspect was seen later in Florence in the case of Savonarola.

[53] Volpe, *op. cit.*

[54] A special kind of Compagnia, the *Laudesi*, formed for the purpose of singing evening lauds to the Virgin Mary in the churches, also owed its origin in Florence to the initiative of St. Peter Martyr, and it also was connected with S. Maria Novella.

[55] Davidsohn, *op. cit.*

[56] It is significant that the poet Francesco Sacchetti wrote his *Sposizioni di Vangeli*—an important example of religious laic mentality struggling with itself—shortly after the revolt of the *ciompi*, when the influence of the lower middle class still persisted. Taking passages in the Gospels as his starting point, Sacchetti with deep religious faith endeavoured to solve doubtful cases of conscience from everyday life; as might be expected, symbolism was here mingled with a sense of practical realities. See B. Croce, "Il Boccaccio e Sacchetti" (*Critica*, XXXI 1931).

[57] About the middle of the thirteenth century numerous Italian translations of the Bible were made; they were mostly read in Tuscany, and they were certainly connected with heretical and early mendicant movements. Many manuscripts of the Bible were the work not of professional writers but of members of the middle class. The laity generally were not acquainted with the whole Bible in Italian, but only with parts. Villani's Chronicle makes clear that apart from the Gospels even he probably knew only certain parts of the Old Testament (the first four books of the Pentateuch, Kings, Maccabees, the Psalms, Proverbs).

[58] But not to astrology, which was a mixture of religion and science, representing a kind of secularisation and scientific transformation of religion, with the help of classical and Arabic learning. In the period under review, astrology was compatible with practically every kind of religious sentiment. In all sections and all professions, everyone believed in signs and omens, everyone was superstitious. The clergy often practised witchcraft and fortune-telling as a secondary profession. (In spite of its notoriety, the burning of the astrologist Cecco d'Ascoli in 1317 was an isolated event, not characteristic of Florence, and probably the result of personal motives. See L. Thorndike, *A History of Magic and Experimental Science*, New York, 1929).

[59] For the easy-going way in which Niccolo Acciaiuoli (founder of the Certosa in Florence, a monastery with the most severe rules of conduct) regarded his own doubts as to the immortality of the soul, see p. 132, note 23.

[60] In 1340 the Florentine upper middle class were so alarmed by famine and epidemics

that, to win God's favour, they recalled banished members of the nobility and restored their confiscated property. Villani called this an act of political stupidity, and said that they should have placated God by some other means.

[61] Bruni, in contrast to Villani and even Salutati, did not believe in miracles. Poggio was himself religious, and went to church daily. He was prone to alternate periods of scepticism and of religious sentiment, as is evident from his letters. Neither Poggio nor Bruni were particularly friendly to the Observants, whom they considered too demonstrably given over to piety.

[62] As regards the canonisation of their own members, the two mendicant Orders were favourably placed, because they had most influence at the Curia, and afterwards could carry on intense propaganda to ensure that their saints were actually venerated. The wealthy bourgeoisie took no part in the cult of Barduccio (d. 1331), a layman of humble origin regarded as a saint by the people (see Davidsohn, op. cit.). Closely connected with the cultus of saints was that of relics, greatly stimulated by the sermons of the wandering friars.

[63] With what ease and light-heartedness the members of the Florentine upper middle class made their pilgrimages is well illustrated by the journey to Arezzo (1399) of Francesco Datini, a merchant of whom we have already heard. He travelled there with his family, friends and neighbours, horses and mules loaded with excellent provisions, which were continually supplemented en route.

[64] For example, in 1310 and again in 1399, the Signoria discouraged the Flagellants who wished to march into Florence. On the former occasion, Villani, significantly enough, called the Flagellants "Molta gente minuta".

[65] When in 1419, at the time the upper middle class had unlimited power, action was taken against numerous suspected companies, and particularly energetically against these Disciplinati. See G. M. Monti, Le confraternità medievali dell' Alta e Media Italia (Venice, 1926).

[66] The bishop of Florence told the notary Ser Lapo Mazzei, who passed on the statement in a letter to the merchant Datini, that these visions had settled all doubtful points in the Holy Scriptures.

[67] In medieval theology the early Christian conception of a radical ethic of love was of necessity considerably weakened (see Troeltsch, op. cit.). It would take us too far afield to consider here the theoretical foundation of the doctrines of grace and the sacraments, combining elements from Augustine and Aquinas; nor can we deal with the manner in which theology in the thirteenth century came to mechanise the sacraments and give them character, how grace came to be confined to the sacraments and the priests who administered them, how good works and absolution began to figure more prominently in the process of acquiring grace than the moral rebirth of the individual. For a full discussion of these questions see R. Seeberg, Die Dogmengeschichte des Mittelalters (Leipzig, 1913).

[68] Sometimes the dying man also bequeathed a very modest part of his property as "repayment" of his gains to those whom he had injured by his usury; it is uncertain, however, whether his heirs ever actually carried out this provision.

[69] One of the greatest attractions of the confraternities was that the salvation of all their members was vicariously furthered by the good works of each individual.

[70] While they were still within the Franciscan Order, the Spirituals reproached the Conventuals with giving absolution for money. Sacchetti relates that Bishop Antonio degli Orsi—the same bishop who issued a ban on the practice of usury by the clergy in 1310—did indeed prohibit the ecclesiastical burial of usurers, but only until the compensation he required had been paid.

[71] Troeltsch, *op. cit.* and O. Schilling, *Die Staats- und Soziallehre des hl. Thomas von Aquin* (Munich, 1930).

[72] Indeed, the grants made to the enormous number of poor in Florence either in the form of private charity or by the various corporations were hopelessly inadequate. This remains true even when we count the sums, in themselves not inconsiderable, distributed in relief particularly by the *Compagnia dell' Orsanmichele*, which was mainly concerned with this question. The gifts of the wealthy Parte Guelfa were so small as to be merely nominal. See Davidsohn, *op. cit.*

[73] The injunctions of Bishop Francesco Silvestri (1327) give an alarming picture of the immorality of the Florentine clergy. All the story writers also pour scorn upon the greed and immorality of the clergy.

[74] Huizinga (*op. cit.*) rightly emphasises that the abuse of the clergy was only the reverse side of a deep general attachment to them.

[75] Whenever a striking preacher appeared, the members of the upper middle class (and many others) were full of praise for him and his holiness of life.

[76] This Pisan friar, who was regarded by the people as a saint, still had something of the mentality of the thirteenth century; somewhat later, a lecturer in theology at the *Studio* of S. Maria Novella—the position which Fra Giordano da Rivalto held during his stay at Florence—would hardly have spoken in such a strain. But even this preacher identified himself so completely with the Church, that he did not dare to accuse the bishops and clergy, but attacked only "the dirty practices of the merchants". In another sermon he said that it was necessary for the majority to be poor in order that the rich might merit Heaven by aiding them.

[77] At Pisa this was already a usual practice in the thirteenth century.

[78] Yet these domestic spinners were especially exposed to the temptation of embezzlement: as they lived in the country, their wages were extremely low.

[79] Doren, *Florentiner Wollentuch-Industrie*. It was also quite usual for the upper bourgeoisie to invoke religious arguments to support their interests in dealings with the workers. For instance, the statutes of the Lana of 1335 argue that associations of the workers are breaches of St. Paul's precepts concerning brotherly love and Christian charity.

[80] T. I. R. Boase, *Boniface VIII* (London, 1933).

[81] In 1346, for instance, after the great bankruptcies, the following situation developed, revealing very clearly the attitude of the various strata; the commune, which was partly under the control of the lower middle class, was not concerned about the financial losses suffered by the higher clergy through these bankruptcies; the inquisitor, supported by the Parte Guelfa, therefore treated the town as heretical and laid an interdict on it; the Florentine bishop Agnolo Acciaiuoli, who wished to protect the interests of the Acciaiuoli house, which had also collapsed, disregarded the interdict and supported the commune, even consenting in the family interests to the restriction of his personal power by the town and to the abolition of the immunity of the clergy and their privileged courts. In 1355, when the liquidation of the firms had been settled, the bishop again took the side of the Curia on the question of ecclesiastical jurisdiction. Cf. A. Panella, "Politica ecclesiastica del comune Fiorentino dopo la cacciata del Duca d'Atene" (*Archivio storico italiano*, LXXI, 1913).

[82] For example, in Sacchetti (*Sposizione di Vangeli*). A saying passed current that the Florentines could not live without excommunication.

[83] F. Selmi, "Documenti cavati dai Trecentisti circa al Potere temporale della Chiesa" (*Rivista Contemporanea*, XXX, 1862).

[84] E. v. Seckendorff, *Die kirchenpolitische Tätigkeit der hl. Katharina von Siena und der Papst Gregor XI* (Berlin, 1917).

[85] See p. 35, note 62. Catherine was still in Florence at the time of the revolt of the *ciompi*; but she was already living in concealment, probably hidden by Giovanni delle Celle, who, then, like most of the clergy, went over to her side.

[86] Marsigli, who came of a distinguished family, was twice proposed by the Signoria as bishop of Florence, but the Curia opposed the choice on account of his political views sketched above. Marsigli was the theological expert of the commune (where the upper middle class was again in power) at the time of the Schism, when it was a matter of dispute which Pope's ambassadors should be received, or which Pope's excommunication feared.

[87] E. I. Nitts, *The Days of the Councils* (London, 1908).

[88] The members of the higher clergy who assisted Florence in holding the Council were promoted to the cardinalate. Francesco Zabarella, who taught canon law at the university of Florence and had published writings in support of the power of the Councils, was made bishop of Florence and cardinal. Alaman Adimari, till then bishop of Florence, was made archbishop of Pisa and cardinal. For the fate of Cardinal Dominici, who supported the Antipope Gregory XII, opposed the Council and the Florentines' efforts for unity, and with whom the Florentine upper middle class (Bruni) therefore broke, see p. 351, note 82.

[89] Indeed as soon as the upper bourgeoisie regained power, steps were taken to punish the surviving members of the magistracy who had carried on the war.

[90] H. Blumenthal, "Johann XXIII, seine Wahl und seine Persönlichkeit" (*Zeitschr. für Kirchengesch.*, XXI, 1901).

[91] The Medici, the former bankers of John XXIII, ransomed the latter from imprisonment, and in the interests of ecclesiastical unity the Florentine upper middle class brought about a reconciliation between the new Pope and his predecessor (1419). John XXIII died later in the house of the Medici.

[92] M. Creighton, *History of the Papacy from the Great Schism to the Sack of Rome* (London, 1897).

[93] Troeltsch, *op. cit.*

[94] Rodolico, *op. cit.*

[95] The extent to which the workers were misled by the Dominicans of S. Maria Novella becomes clear when we realise that these latter were actually the allies of their fellow-Dominican St. Catherine of Siena and the Parte Guelfa in the fight against the lower sections.

[96] During the war against the Pope in the years 1375–78 the activity of the Inquisition had ceased and the people in their joy had destroyed its prison.

[97] See Rodolico, *op. cit.*, where a large number of prophecies from Fraticelli circles about this period are collected, foretelling revolutions in Florence and elsewhere.

[98] This popularity of the hermits also comes out in the *Chansons de Geste* and novels of adventure of the twelfth and thirteenth centuries, where the hermit generally gives his hospitality to those who have lost their way and shows them the right road. See L. Gougaud, *Ermites et Reclus* (St. Martin de Liguge, 1928).

[99] Dominici warned against the hermit-life as leading to arrogance and "dangerous" speculations.

[100] Their success, however, was in almost every case only momentary.

[101] For a full discussion see Marenco, *op. cit.*

4. PHILOSOPHY, LEARNING, AND LITERATURE

BEFORE beginning our analysis of the visual arts, a few remarks on the philosophy, learning, science, and literature of the period may be made, in view of their parallel interest.

It is only as a part of the general theological or scientific culture of the time that philosophy concerns us. There is no need to deal in detail with the rise, maturity and later forms of scholasticism. One of its highest achievements—the Thomist system of the thirteenth century, the philosophy preferred by the Curia and the Florentine middle class alike—we have already discussed. It is interesting to note that the sceptical and rationalist evolution in theology—the evolution of philosophy within a theological framework—took place not in Florence, the most progressive city of Europe, nor for that matter in Italy at all, but in the more backward northern countries. In these national States, now gradually taking shape, the practical and ideological interests of the bourgeoisie and the princes found expression not only in new economic and political theories, but also in a new philosophy. This new current emphasised the importance of individual phenomena in contrast to generalities; still the creation of clerics, particularly Franciscans, who in these countries were able to preserve some elements of their original relatively democratic and progressive tendencies, it gave rise in the second half of the thirteenth century to the philosophy of Duns Scotus, and linked up with it, in the first half of the following century, the much more radical Nominalism of Occam.[1] The middle class in these regions were still too weak to produce a new secular philosophy of their own; their philosophy could be formulated only within theology, within the general culture of the Church, even though their ultimate aim, here as elsewhere, in union with political thought of similar tendency, was to relegate the over-powerful, centralised Papacy to the background.[2]

The situation in Italy, especially at Florence, was completely different. There, in view of the dependence on each other of the Pope and the most advanced section of the middle class, the latter accepted the Church's preferred philosophy, Thomism—that originally progressive but now conservative rationalism, which was upheld by her most faithful watchdogs, the Dominicans. The upper bourgeoisie accepted this philosophy openly throughout the fourteenth century and more or less tacitly even at the beginning of the fifteenth, at the time of their greatest power.[3] In Florence, where the Church and the mendicant Orders worked in complete harmony, the Franciscans would always take good

99

care not to display progressive tendencies against the will of the Curia; at most, they adhered to the moderate doctrines of Duns Scotus. Nominalism, imported from abroad, had not the significance of a progressive system of thought in bitter opposition to the Realism of Aquinas; it was taken up only later, as a scholastic fashion, and by then it already passed for conservative.[4] Nor were there in Florence many adherents of Averroism as a systematic doctrine. This system, somewhat akin to Nominalism, but more modern, officially condemned by the Church, and particularly attacked by Aquinas, was nevertheless adopted even by layfolk in certain parts of Italy, especially in Padua, in the fourteenth and fifteenth centuries. An interpretation of Aristotle along the lines of the Arabian philosopher Averroes (twelfth century), it appealed only to a small élite of left intellectuals, particularly physicians and natural scientists. They claimed to be pure rationalists and empiricists,[5] and formed a kind of secret society from which the over-intellectual character of its doctrines excluded the masses; some of its adherents may actually have gone to the length of free thought. The shades of opinion to be found amongst them were so varied that individuals here and there in the ranks of the sober-minded, indifferent Florentine upper middle class may very well have been vaguely called Averroists or Epicureans, as happened, for instance, to Pope Boniface VIII, the ally of this class. But things never went further than that. In the eyes of the Florentine upper middle class neither radical Nominalism nor radical Averroism was worth a quarrel with the Church.[6]

The unique intellectual movement among the Florentine bourgeoisie germinated only after a long period of preparation, in the second half of the fourteenth century, and came to full fruition at the beginning of the fifteenth, when Nominalism was already past its zenith in the northern countries. But though it started late, its range went far beyond Nominalism. In spite of their professed or indifferent acceptance of Thomism, the Florentine middle class, that is the layfolk, the actual citizens themselves, were able to acquire an independent knowledge of the secular philosophy of antiquity, and thus to create a philosophy, increasingly freed from theology, which became steadily more rationalist and gradually took on something of the nature of a secular science; against this no theological system of the time, however advanced, could match itself. If Thomism was not openly attacked in Florence, as it was elsewhere by Nominalism—for this would have been contrary to the interests of the Florentine upper bourgeoisie—it was undermined, in the long run, all the more effectively from within. Its essential classical element was eliminated by transforming it in a perfectly new, more secular and scientific direction, which became ever more incompatible with Thomism. Hence, from the point of view of the future, something much more important for middle-class culture had been created here than in the north. The high esteem in which classical secular philosophy was held in Florence and the new scientific knowledge connected with it, stemming from

an urban lay culture at that time unique, can only be fully appreciated if we go further afield; we must glance for a moment at the significant role of ancient culture, not only in its bearing on philosophy, but also on the whole scientific culture of the Florentine middle class—we have already seen its imprint in several ideological fields—as it was a source of knowledge which deeply affected the visual arts as well.

The new cultured élite of the middle class, especially of their upper stratum, drew support from classical knowledge for their increasingly secular cultural interests and science. It was therefore no longer a question, as in the early Middle Ages, of inserting and using fragments of antique learning within a purely ecclesiastical system of thought; for even in its early days, the bourgeois world-view naturally called for more, relatively purer and more congenial elements from antiquity than did an ecclesiastical or feudal one; for in that important period there already existed a developed middle class and a comparatively secular middle-class culture. This dissimilarity in the degree of their indebtedness to the antique makes all the difference between the "Renaissance" of the fourteenth and fifteenth centuries and earlier "Renaissance" periods. For no other middle class could antiquity offer a source of knowledge so significant or so topical as for the Italian, not only because of the far greater maturity of their development, but also because of the patriotic motivation implied. Obviously, it was of great moment to the rising patriotic Italian bourgeoisie, that Italy displayed many more relics of classical knowledge, of the knowledge of the "ancestors", in every field of thought, than did any other country; the "old" knowledge of antiquity could be adduced as an authority when attempts were made to justify the new bourgeois knowledge.

But even now there could very seldom be any really genuine historical understanding of antiquity, since they usually referred to antiquity only as it affected themselves. Classical culture was an ally of very great importance, but each generation and social section transmuted it into something different. From the complex and often contradictory ideas of the ancient world, each selected what was most congenial to it, and inserted it into its own intellectual world. Fantastic and inorganic as it may seem to us to-day, it was precisely this transformation and combination of different elements which lent its own peculiar stamp to each new classical revival and even to antique-imitating fashions. All this applies not only to the idea of antiquity as exploited politically, in the interest of the new middle-class spirit of nationalism, but also to the use of the scientific (philosophy, history, natural science), literary and artistic values of the ancient world. Above all, during the early bourgeois period, particularly in the fourteenth and to a lesser degree in the early fifteenth centuries, antique or antique-imitating ideas were usually in the last resort subordinated to religion —though at times, perhaps only rather hypothetically. Classical poetry in particular owed its preservation during a long period to this subordination to

religion; where it departed from the word of God, it was interpreted allegorically. Nevertheless, these religious and other transpositions of classical culture do not lessen its extraordinary importance in Italy, as compared with other parts of Europe, during this period. Thus particularly during the fourteenth century, when the ecclesiastical world-view was still authoritative even in intellectual circles, we often find elements from antiquity peculiarly and arbitrarily combined in such a manner as to strengthen both the national feeling of the bourgeoisie and also religious sentiment; Dante, Rienzo and Petrarch are, each in his own way, characteristic examples.[7]

In the philosophical field, this process of transformation and combination was applied to every antique school. The desire for concordance, fundamentally still scholastic, required that classical philosophy should be brought into agreement with Christian religious feeling (Salutati); this applies to the treatment not of Aristotle alone, but also to the Stoic philosophy of the patrician-bourgeois and intellectual upper stratum of ancient Rome, so popular in the progressive circles of the Florentine middle class, and, of course, of the Christian-classical eclecticism of Boethius.[8] Characteristic of this new secular lay philosophy in its early phase is Salutati's endeavour to incorporate this latter trend into, or at least reconcile it with, the Thomist system; both he and Petrarch find a close relation between the late-Stoic contempt of the world and Christian asceticism.[9] Petrarch, however, had already rejected scholasticism as a whole, putting ancient philosophy, which he found perfectly compatible with religious sentiment in its place; an admirer of Augustine, he tended rather towards Plato,[10] who in his eyes was less compromised by scholasticism than Aristotle (in any case probably too analytical for him) and more spiritual.[11] Petrarch also owed much to the late phase of Stoicism (Seneca), from the time of the absolutist emperors, which had a religious, passive, near-Platonic colouring. There was, however, nothing spiritual or mystical about the philosophy of Bruni, that representative of a sober Roman *gravitas*, though in his youth he had been influenced by Plato. Attracted by the lucidity and systematisation of Aristotle, he merged his ideas far less than Aquinas had done with foreign Christian-religious thought, and interpreted them in a considerably more secular and rationalist manner— characteristic of that period, the early fifteenth century, when the Florentine upper middle class held supreme power.[12] So, having "restored" the classical Aristotle, Bruni attempted to bring him into agreement with the other philosophical schools of antiquity: with Stoicism and Epicureanism[13] (*Isagicon moralis disciplinae*, 1421–24). This was no forced attempt to bring about agreement in the service of scholasticism, but rather an eclectic harmonisation of ancient philosophy. In particular, Bruni set forth a more or less Stoic philosophy of life. This ever firmer attachment to Roman Stoicism now, however, in a more secular and unemotional form (that it had assumed in its early phase at the time of the Roman republic and the political implications of which, pertinent

to the Florentine upper bourgeoisie, we have already seen) is revealing; for this philosophy not only afforded calmness and security against suffering, based upon man's own inner strength, but by emphasising the will encouraged him to push ahead in the world, to live a life useful to his fellow-creatures.[14] Though Bruni did not actually develop any independent or closely woven method of thought, nevertheless he freed it from the authority of the Church with the help of ancient philosophy and introduced new forms of thought from antiquity; the scholastic logic already attacked by Petrarch was now replaced by rhetoric.[15]

The changed attitude, or rather the greater consistency displayed by bourgeois intellectuals in approaching their own and the classical philosophy, is characteristic of their whole attitude to their own and to classical culture at the beginning of the fifteenth century. It is therefore worth while to note a few fundamental facts concerning the conquest of classical culture from the thirteenth century onwards, for the whole manner and process of it throw a very clear light on the general cultural attitude of the Florentine middle class.

As early as the second half of the thirteenth century, but still more in the first half of the fourteenth, numerous translations were made from ancient authors, particularly by clerics (Fra Guido da Pisa, Bartolommeo da S. Concordio) with a religious and moral intention. Most of the ancient authors chosen were regarded as being particularly close in spirit to Christianity—Cicero, Virgil, Seneca, Boethius; but Livy and Sallust were translated also. Through these translations into the Italian "vulgar" tongue, portions of classical knowledge (philosophy, history, literature) were made accessible to the general public, even though transposed into a very scholastic form. The most important of these translations the *Ammaestramenti degli Antichi*, a collection of maxims from classical philosophers[16] by the Dominican Bartolommeo da S. Concordio (1262-1347) was undertaken, significantly enough, at the instigation of members of the Florentine upper middle class.

These translations, however, are still essentially ecclesiastical literature, in which the antique is one interest alone. Very different are Petrarch's fervent yet systematic and scientific labours devoted to antiquity, which mark a phase of the greatest moment in this development. Petrarch saw antiquity as a whole and quite consciously linked up with classical culture as such; it was from this decisively new standpoint that he aimed at collecting and spreading classical knowledge. His passionate propagation of antiquity and his enthusiastic return to the political, philosophical and literary values of the ancients represent an attempt to associate the Italy of his day with its national past, an attempt, of course, which was of very lively and immediate interest to the intellectual world of the bourgeoisie.[17] This reconstruction of classical culture, particularly of Rome and of its great figures, naturally stimulated scientific study and research. In this field, too, Petrarch was the first to occupy himself zealously with collecting Latin manuscripts, particularly Cicero, and correcting them philologically. But

in their activity in the service of antiquity neither Petrarch nor his ardent follower Boccaccio had any contact, for the time being, with wider circles. All the important writings of these humanists were in the language of Roman antiquity itself, in Latin, which in the fourteenth century was understood by only a relatively small intellectual circle, for example, Petrarch's *Epistles*, his *De Viris illustribus* (biographies of famous Romans), and his *De Rebus memorandis* (a collection of the sayings of famous men, chiefly of antiquity). In his use of Latin, Petrarch's practical aim was, of course, to revive the Roman spirit, but at the same time it also implies a conscious limitation to upper-bourgeois cultured circles and to the clergy. He tried to write a more lucid, more euphonious Latin than the scholastics; Petrarch, Boccaccio up to a point, and later numerous exclusive humanist circles, regarded it as vulgar to write in Italian.

Boccaccio's classical pursuits were not so profound as those of Petrarch; he occupied himself rather in collecting a great number of details and notes. Towards the end of his life, when he no longer devoted himself to literature, he made erudite compilations such as that of the classical myths, the *De Genealogiis deorum gentilium*, on which he worked during his last twenty-five years. This book, which was by far the most ambitious enterprise of its kind so far undertaken, and whose importance for many generations to come can scarcely be exaggerated, contains carefully worked-out genealogical trees of all the gods of mythology; at the same time Boccaccio, following medieval and late classical tradition, gives allegorical explanations of the myths. While he made some use of Homer, his work is mainly based on Roman (particularly late-Roman) authors and medieval writers who summarised these stories.[18] Two other similar compilations from classical literature are his *De Claris mulieribus* and *De Casibus virorum illustrium*; the theme here, as often in Petrarch also, is the mutability of happiness. These writings of Boccaccio provided not only basic material for scholars and poets, but also an inexhaustible supply of subjects for the fifteenth-century artists; like the works of Petrarch already mentioned, they became disseminated in wider circles of the middle class only by translations into Italian, which were soon made necessary by the increasing interest in ancient history. Made shortly after the publication of the Latin originals, these translations of Petrarch and Boccaccio, together with those of numerous classical authors,[19] were often undertaken not by purely professional humanists, but by writers who carried on other professions (notaries, for instance) and were not so strictly esoteric in their attitude. After a comparatively short time, Petrarch's writings on the classics lived on only in these Italian translations, as the originals soon became too old-fashioned, too medievally moralising for the intellectual circles who read Latin and who now turned instead to more modern works. For though antiquity penetrated into all social sections, it did so everywhere in a different way, under a different form.

To acquire a more perfect picture of antiquity, the humanists, the intel-

lectuals, continued during the second half of the fourteenth century their search for Latin manuscripts, and somewhat later for Greek ones also[20]—a search carried on most intensively at the beginning of the fifteenth century by Poggio.[21] That knowledge of Greek now became current among the humanists and that they gained an acquaintance with Greek philosophy and poetry in the original was of great consequence. Manuel Chrysoloras, the first Byzantine with any real philosophical culture to settle in Italy, acted as a potent intermediary and drew all Italian intellectuals to the university of Florence, where he taught from 1397 to 1401.[22] And Florence now became a centre for translating. When Bruni rendered Aristotle (*Ethics, Politics*) into Latin, the translation was clearer and more precise, more elegant and eloquent too, than the versions of Aquinas' day. His translations of Aristotle (and Plato)[23] enjoyed great success among the cultured public, and enabled them to free themselves at least in part from the ecclesiastical-scholastic versions of the Greek philosophers; the upper middle class were supplied with an efficacious ideology. So in the progressive circles of this class, the contact with classical philosophy and classical culture in general became continually closer, more rationalist, more affirmative towards life, more secular.

In this respect, a big step separates Salutati's generation at the end of the fourteenth century from the more radical generation of Bruni and Poggio at the beginning of the fifteenth.[24] Among the intellectuals, a much sharper spiritual distinction now appears. In the time of Salutati, who regarded secular, including classical, knowledge as a preparation for theology, it was still possible for a cleric, Luigi Marsigli (who was, it is true, on the side of the commune rather than of the Church and was particularly well versed in classical philosophy) to belong to the most progressive and rationalist circle in Florence. But towards the end of Salutati's life, as a consequence of the secularisation of the humanist movement, the Church, particularly the mendicant Orders, was already in some degree hostile to classical knowledge and to humanism.[25] In general, however, the humanists, like the upper middle class, were, as we have already seen, on the best of terms with the Church.[26] In his attitude to antiquity, Salutati occupied approximately a middle position between the Dominican Dominici on the right, who considered that classical influence on education was a danger to youth (*Lucula Noctis*, 1405), and Bruni, Niccoli and Poggio on the left, who concerned themselves much more intensively with ancient culture than Salutati, and adopted a much more positive attitude towards it, though they were certainly not irreligious.[27] Niccolo Niccoli (1364-1437), the son of a prosperous merchant and scientific adviser to Cosimo de' Medici, was the most accurate connoisseur of classical texts, besides having a good knowledge of ecclesiastical literature, and possessed the largest library of classical manuscripts in Florence—or, for that matter, in the learned world at that time.[28]

In the circle of Bruni and Niccoli, Petrarch's classicising world of ideas

reached its highest manifestation so far; in this circle, the idea was even beginning to take form that a new scientific systematisation with its own standards and order was required.[29] The value attached to knowledge of antiquity (in Bruni's case, particularly of philosophy and Roman history) and to its expression in a good Latin style, contempt for the vulgar tongue as a vehicle for philosophy or any serious studies, was here most pronounced; opposition to scholasticism, previously voiced by Petrarch, was now expressed openly in Florence. Popular, written in Italian, old-fashioned, scholastic—all these terms held the same meaning for this circle. The radical and secular spirit of this new generation of humanists is most clearly revealed in Bruni's *Dialogi ad Petrum Paulum Histrum* (1401) in which, as was the case in actual fact, Salutati is the spokesman for the conservative and Niccoli for the modern outlook. Niccoli here declares openly that with the help of the increasing, though for the time being still imperfect, knowledge of antiquity the whole structure of learning must be built anew. In any case, scholasticism, with its casuistical method of treating each case in isolation, is considered by Niccoli a hopeless chaos. We also find in him, as in Petrarch, the same contempt for Dante on account of his scholasticism and "lack of learning"—that is, in the eyes of the moderns, lack of classical learning.[30] The same reproach, together with an attack on their Latin style, now considered insufficiently lucid and Ciceronian, is directed even against the early humanists of the fourteenth century, that is, against Petrarch and Boccaccio themselves.

But the quest for classical knowledge was not confined to the narrow highly-cultured circle round Bruni and Niccoli, nor to the university where precisely in those years the greatest Italian humanists vied with each other in teaching Greek and Latin literature. The Bruni-Niccoli circle formed merely the rationalist and intellectual summit, the most radically secular and most classically cultured section of the upper middle class. Compared with the sporadic meetings of men devoted to learning at the end of the fourteenth century (the only important circle then was that of Marsigli and Salutati, which met in the monastery of the Augustinian Hermits of S. Spirito, and which Niccoli had also attended) very many groups now sprang up among the upper bourgeoisie in which classical authors were seriously discussed and translated.[31] The famous humanist, Francesco Filelfo, probably the best connoisseur of both Greek and Latin of his day, taught not only at the university, but also to a circle of distinguished private pupils; the Bruni-Niccoli circle, which really formed a compact group only at the very beginning of the fifteenth century, produced numerous offshoots. For instance, at times when the Pope was in Florence, the Curial circle (Bruni, Poggio) discussed ancient philosophy. The rather more clerical group of the Camaldolensian abbot, Ambrosio Traversari, met at the monastery of S. Maria degli Angeli (1430; Niccoli belonged to this) and occupied itself chiefly in translating Greek ecclesiastical writers. In spite of slight variations between them, these humanist circles were more or less linked with one another;

Bruni and Niccoli, or more religiously-minded humanists like Manetti (another group met at his house), pure scientists like the mathematician Toscanelli, or members of the wealthy middle class like Cosimo de' Medici, all belonged to several groups at the same time. Roberto de' Rossi, who came of wealthy stock and was a pupil of Chrysoloras, held a kind of free university for Florentine youths of good birth in his house; Cosimo de' Medici, together with an Albizzi, studied here in his youth. In this circle, Greek and Latin and their literatures were taught, and also Aristotelian philosophy; the cult of the *tre corone fiorentine* (Dante, Petrarch and Boccaccio) was still kept alive, and the somewhat conservative tradition of Salutati and Marsigli carried on. We find cases of merchants, intensely industrious in their profession, who had, at the same time, acquired some classical knowledge and took part in literary activity. For instance, the merchant Cristoforo de' Buondelmenti, who for business reasons lived in Crete and the Greek archipelago from 1414 to 1422, wrote books in Latin about these classical lands, using his knowledge of ancient authors. He dedicated one of these works to Niccoli in order to emphasise his connection with the humanists. Surely in no other country did so relatively large a section of the upper bourgeoisie display so great an interest in antique learning and science.[32]

But the more we move within the upper middle class from the humanists to the conservative mass, the more scholastic in character does the interest in, and teaching of, classical culture become. Thus, for example, in the monastery of S. Spirito (1421–30) learned Augustinian Hermits gave instructions in theology and the Fathers of the Church, held discussions according to the rules of scholastic dialectics, and at the same time read Aristotle. At the university, too, where Dominici, for instance, discoursed upon Biblical interpretation, much Aristotelian scholasticism was taught.[33] Giovanni Morelli's family chronicle is characteristic of the average upper-bourgeois mentality which only accepted classical ideas with reservations. Although Morelli himself possessed little humanist culture, he advised his son to spend an hour every day reading Aristotle, Virgil, Seneca and Boethius (the ancient authors most compatible with the Christian religion and also read in the Latin schools) and, in addition, Dante and the Bible.[34] Once again we see that the cult of ancient philosophy and learning, even at its height, varied in character according to the particular section of society concerned.

The learned radical intellectuals drew scorn upon themselves from the conservative intellectuals, whose standpoint was popular and scholastic. The poet Cino Rinuccini (after 1350–1407, merchant and member of the Lana) for example, ridiculed their imitation of the classics, frowned upon their "lack of religion", protested against their elevation of Plato above Aristotle (a tendency noticeable in Petrarch and in the young Bruni) and defended the old scholastic *Trivium* and *Quadrivium*. In the opinion of the conservative Rinuccini, the

cleavage between the two humanist generations of Salutati and Bruni is clearly discernible; he objected only to Bruni and Niccoli, not to Salutati and Marsigli. A whole circle of conservative intellectuals, like the great mass of the bourgeoisie, still lived in the world of Dante and of scholasticism;[35] included among them were many other writers of the Rinuccini stamp, besides, for instance, friends of the deeply religious Sacchetti.

Right on during the fourteenth century, the average member of the upper middle class, like Villani, still understood by learning universal scholastic erudition. For the instruction of the laity interested in learning, nothing was available except encyclopaedias, summaries of knowledge in the ecclesiastical spirit, mere compilations (largely from the Bible, Aristotle, the Fathers of the Church, Ptolemy, Pliny, etc.)—unified explanations of the universe, with the help of allegorical concepts and external analogies, mixtures of fact and legend. The great scholastic, official ecclesiastical encyclopaedias, as is well known, were written in the thirteenth century in Latin, mostly in France, and chiefly by Dominicans—they signified a striving towards "rationalist" unification and systematisation of the learning of the Church in this century. In Italy, particularly in Florence, they were popularised in Italian, generally by lay writers, in a more or less expanded form. The first of these works was the *Libri del Tesoro*, written in French by the Florentine notary and town chancellor Brunetto Latini and soon translated into Italian, and the *Tesoretto*, written in rhymed Italian by the same author (in the sixties of the thirteenth century); then followed Dante's *Convivio* (between 1293–1308), and the numerous books of rhymed lore in the fourteenth century. Even Dante's strictly Thomist *Divina Commedia* held the same significance for the fourteenth century, being one of the encyclopaedic didactic poems so typical of Florence; in the eyes of the Florentine citizen, even of only average culture, it was a comprehensible summarising of learning on an ecclesiastical basis. At first, it is true, the Church was somewhat opposed to these vulgarisations of knowledge, particularly in the case of the *Commedia*; she disapproved of the popularisation of divine truth in Italian, for it seemed to her to smack of the secular and to be, in any case, an encroachment upon her own monopoly of knowledge.[36] But she became increasingly aware that, in this age of radical secularisation which nothing could arrest, current scientific tendencies represented her greater enemy, and in the struggle against them she needed the assistance of the great conservative masses. As sources of instruction for the general run of the people, for the more backward section of the upper bourgeoisie and specially for the middle and petty bourgeoisie, these Italian popularisations of medieval learning and particularly the *Divina Commedia* could be a useful conservative force.[37] It is worth remarking in this context that, resulting from a petition of a number of citizens that the *non grammatici* might also receive instruction about Dante, the Signoria in 1373 appointed Boccaccio as first public interpreter of him in the vernacular; passed at a time when the petty

bourgeoisie exercised some influence, this measure may probably be regarded as to some degree democratic and popular. These public interpretations of the *Divina Commedia*—held in a church—served to bring home to the masses the details of ecclesiastical symbolism and allegory in the poem (their processes of thought being *ab ovo* of the same symbolic character). In these lectures the various meanings of a single passage of the poem would be explained just as in sermons the allegorical meaning of passages in the Bible was expounded (or for that matter as Boccaccio himself did with ancient mythology): in this, his latest phase, as Dante commentator, Boccaccio, in striking contrast to Petrarch, inclined towards contemporary theology, towards scholasticism. It is significant that these Dante interpretations, which were based intellectually on Salutati— regarded even before his death as no longer up to date—showed a general tendency to become steadily more conservative[38] (e.g. Giovanni da Prato, 1417).

At the beginning of the fifteenth century, when upper-middle-class ideology was at its ripest, aided not only by antiquity, but also by Arab learning and contemporary research, natural science and the associated disciplines began to emerge from the ecclesiastical-encyclopaedic framework.[39] Moreover, they were acquiring added importance and respect by reason of their increasing value to the bourgeoisie in mastering the external world. The difference between Salutati's old and Poggio's new point of view in this respect is illustrative: Salutati still considered research in natural science a hopeless waste of energy, and the study of jurisprudence, deriving directly from God, as more important than that of medicine (1399, *De Nobilitate legum et medicinae*).[40] Poggio the empiricist reversed this judgment.

In these important decades at the beginning of the fifteenth century under the stimulus of practical technical needs, mathematics, optics and mechanics began to achieve independence. Mathematics in particular was studied in Florence with great keenness; in fact, it flourished at those very times when the power of the upper bourgeoisie was at its greatest: at the beginning of the fourteenth and fifteenth centuries. The teaching of mathematics in the Florentine school was most advanced.[41] From the experiments of technicians and of progressive artists with technical interests (the close connection between the two is very noteworthy), systematic science arose.[42] An architect, such as Brunelleschi, was as much "artist" as technician. He had to solve important technical problems, not only in building the dome of the cathedral, but also, for instance, in regulating the Arno or in constructing the fortifications which the new technical methods of warfare made necessary. By applying mathematical principles, Brunelleschi arrived at the laws of perspective in painting: he was the first to construct pictures around a vanishing point, according to the laws of central perspective. Brunelleschi was assisted in his arithmetical and geometrical work by the most important theoretical mathematician in Florence at the time, Pozzo Toscanelli. Thus the technicians and the artists

were the first to unite theory with practice, to draw immediate practical consequences from the emancipated natural sciences. Brunelleschi was not the only artist to be interested in mathematics; the most progressive painters and sculptors followed him in applying and divulging the laws of perspective. We shall see later what revolutionary consequences this new method of constructing pictures involved for painting, and also for reliefs. Here it is enough to observe that the workshops of the most important and progressive artists in these decades played a decisive part in the rise of a science based on empirical methods and pronouncedly bourgeois in its general outlook.

Frequent reference to Dante, Petrarch and Boccaccio brings us from science to literature. It is not our task here to analyse the literary style of their works according to the same method which we shall endeavour to apply to works of visual art—by showing their emergence from a particular view of the world.[43] If we mention a few isolated examples of literary works, it is chiefly because most of them served as direct sources for the visual arts.

The *Laude*, for instance, the spiritual popular poetry of the Franciscans and the *Compagnie* associated with them, which arose in the thirteenth century, particularly in Umbria, and dealt with the Passion of Christ, sprang from the democratic-mystical views of the middle class at their most revolutionary period. The lyrical love poetry of the urban knights and of the upper bourgeoisie at the end of the thirteenth century, the *dolce stil nuovo*, also contained much Franciscan mysticism, but in a more refined and courtly form, while at the same time it represented a bourgeois transformation of the earlier troubadour poetry. Religious symbolism is sublimated in the secular poetry into courtly, and later increasingly mythological, allegory,[44] the religious basis being for a long time preserved. This religious character is particularly strongly marked in the allegorical didactic poems, even in the "rationalist" ones which were written round about 1300 when the Florentine upper middle class were at the height of their power. We may mention, for example, the *Documenti d'Amore* of the notary Francesco da Barberino (1264–1348) or the poem attributed to the chronicler and silk merchant Dino Compagni (d. 1324), with its characteristic title *Intelligenza*, an exaltation of the human understanding—that is to say, of the scholastic conception of the human intellect emanating from God. The general viewpoint underlying the Florentine stories written in the second half of the fourteenth century may be briefly indicated. Boccaccio's *Decameron* (1348–53) still reflects the outlook of the mundane, slightly aristocratising upper bourgeoisie susceptible to novelty, and extols in a remarkable manner human intelligence and its successes;[45] the simple, harmless tales written by Sacchetti (between 1388 and 1395) after the revolt of the *ciompi* already show a democratic middle-class attitude, with a petty bourgeois trend, and are the product of a conservative culture;[46] finally, the *Paradiso degli Alberti* (1389) of Giovanni da Prato (b. *c.* 1367, d. between 1442 and 1446) also reveals a conservative mentality, but with

once again a suggestion of aristocratic courtly tendencies. The poetry of chivalry, imported from France and translated in Florence, was in great favour about this time, and particularly round 1400, not only with the nobility and the sections of the bourgeoisie which imitated them, but also with the petty bourgeoisie who could not read (minstrels).[47] It was the task of minstrels and town criers employed by the State to influence the lower classes in a manner favourable to the Signoria and, for instance, to cry up its wars; thus Antonio Pucci (1310–88) with the object of awakening the Florentines' national pride, described their past campaigns[48] and put Villani's chronicle into rhymed verse (*Centiloquio*): in general, he spread the philistine views of the conservative bourgeoisie in popular form.

More important perhaps than these casual examples—from the point of view of its parallelism in art—is the fact that towards the close of the period under review a definite change in the judgment of poetry had taken place in the progressive intellectual circles of the upper middle class. This change was the expression of a more secular outlook and was of fundamental significance for the future attitude to literature, and also to art. It may be said to have begun as early as Petrarch and to have acquired a much more radical character in the circle of Bruni and Niccoli.[49] A poem was now no longer judged exclusively by its content—that is, from the standpoint of theology and morality, since "content" up till then always meant religious content; but as the content became more worldly, so the poem came to be measured by aesthetic, or more accurately rhetorical, standards.[50] Rhetoric was regarded as the indispensable and fitting medium for eulogising ancient heroes. Bruni considered the classical origin of the art of poetry in itself sufficient reason for defending it, and he maintained with Horace's *Ars Poetica* that it affords not only instruction but also pleasure (*De Studiis et Litteris, c.* 1405). The radical humanists now laid the greatest stress on form and style, on simplicity and clarity of language, though chiefly in regard to Latin. Poetry with a theological content had necessarily made use of allegory in order to express its abstract truths in poetic form, and it was this hidden theological meaning of the allegory which had been hitherto the justification of poetry, particularly of classical poetry;[51] the humanists of the early quattrocento on the contrary no longer looked upon allegory as an obligatory artistic device, as Petrarch and Boccaccio had still done, but only—and this followed from the new themes and the new understanding of them—as a serviceable method of interpretation.[52] The theological and allegorical *Divina Commedia* became the touchstone in the dispute between moderns and conservatives, and the controversy grew increasingly acute. Petrarch's aversion to the *Commedia* written in Italian was very strong. "The rude applause of dyers, innkeepers, and their like cannot move me", he wrote in this connection to Boccaccio. At the end of the fourteenth century, Matteo Ronto, an Olivetan monk, put the *Commedia* into hexameters in order to give it more dignity. This low estimate

of Dante was most outspoken in the circle of Bruni and Niccoli, where there was no longer the slightest understanding of the theological depths of his poem.[53] Diametrically opposed to this circle—leaving aside the numerous transitional attitudes—were the opinions held by such conservative-religious poets and writers as Cino Rinuccini, Giovanni da Prato and his brother Domenico, Antonio Pucci, the musician Landini, and others. They still maintained that poetry must be religious and allegorical. Many of the poems by members of this circle were written in the form of allegorical visions, in imitation of the *Commedia* (for example, Giovanni da Prato, *Trattato d'una angelica cosa* and *Philomena*; Francesco Landini's poem in defence of Occam's logic). It is the contrast between the most progressive section of the upper middle class and the average mentality of the bourgeoisie as a whole which expresses itself in this characteristic controversy, which concerned not only literature, but in the last resort the whole general outlook. A clear appreciation of this fundamental contrast will help us to comprehend the artistic situation of the period.

NOTES

[1] The Franciscan Nominalists did not base themselves on Aquinas, for the Aristotelian spirit in theology had by now become an obstacle to rationalist progress; instead, they linked up with the old Franciscan school before his time. For in this school reason was not so indissolubly linked to revelation as in Thomism; the doctrines of the Church, rational or not, were to be accepted unconditionally. Precisely because, for the Nominalists, theological tenets needed no rational proof, since behind them was the authority of the Bible (which was now stressed more frequently than that of the Church) they could establish practical individual truths which went far beyond Thomism. Thus originated a new and more modern compromise than that of the Thomists between theology and a gradually strengthening rationalism. Faith was thus preserved, but the unity of the system, the concord of philosophy and dogma, was given up, and thought became independent. This development opened up possibilities for both mysticism and scepticism.

[2] Occam, who, like Marsilius of Padua, was in the service of the Emperor Louis the Bavarian, shows most clearly the connection between Nominalist philosophy and the democratic ideas of the northern countries. Like Marsilius, he supported the Spirituals' theory of poverty, as applied to the Curia, and also the Conciliar theory as against the exclusive rulership of the Pope. Thus all these "left" ideological tendencies were apt to converge. See P. Honigheim, "Die soziologische Bedeutung der nominalistischen Philosophie" (*Erinnerungsgabe für M. Weber*, Munich, 1923).

[3] It is no mere coincidence that, in the general European revival of Thomism from the second half of the fifteenth century, so important a part was played by Florence in the person of St. Antonino (this was the period of Cosimo de' Medici).

[4] For Petrarch, and still more for the radical humanists at the beginning of the fifteenth century such as Bruni, Occam's philosophy was as barbarously scholastic as Aquinas' Aristotelian interpretation of theology. Hence we often find the same conservatives defending both Occam and Dante. Thus, e.g. the musician and conservative philosophical writer, Francesco Landini (1325–97), composed a poem in defence of Occam's Logic and at the same time of scholasticism in general.

PHILOSOPHY, LEARNING, LITERATURE

[5] In their doctrine, perception was twofold, truth was twofold: there was the natural and more obvious truth of philosophy, with which alone they were concerned; and the ecclesiastical truth of theology, with which they were not concerned, but which must be accepted, for not to do so would be too risky. They did not believe in the immortality of the soul. There were also numerous clerics, not consistently Thomist, who attempted a compromise between theology and Averroism. See E. Renan, *Averroës et l'Averroisme* (Paris, 1866), and K. Werner, *Der Endausgang der mittelalterlichen Scholastik* (Vienna, 1887).

[6] It is significant that adherents of Averroism were to be found in Florence, if at all, only among the Ghibellines, the nobility of the early bourgeois period. The poet Guido Cavalcanti, who despised the *popolo minuto* and was banished even before Dante on account of his Ghibelline sympathies, was an Averroist; Dante was probably also under Averroist influence in his early period (he placed in Paradise the most important Averroist theologian of the thirteenth century, Siger of Brabant, who had been cited before the Inquisition). A line also leads from Averroism to Marsilius of Padua. Petrarch denounced the Averroists as heretics; their attitude was too scientific and materialist for him. Franciscan Spirituals, on the other hand, were not only opposed to theological learning (see p. 94, note 35), but even more to science, which they regarded as corrupted by Arabian influence. At an earlier period, however, when the Spirituals were still supported by a section of the middle class, they included a more progressive and scientifically rationalist type, of which a physician (Arnaldus of Villanova, 1248–1314) was the chief representative. There were also numerous physicians among the Patarini of Florence. But in the fourteenth century, when the prosperous bourgeoisie had gone over completely to the other camp, this type had ceased to exist.

[7] K. Burdach, *Reformation, Renaissance, Humanismus* (Berlin, 1918). Here, however, too exclusive emphasis is laid on the religious-mystical factor in the new national movement and the revival of the antique.

[8] In Boethius (early sixth century), Aristotelianism and Platonism—those antique trends which afterwards influenced medieval theology in its essentials—are reconciled with each other and with Christianity.

[9] Salutati still applied to the classics the method of allegorical interpretation practised in the Middle Ages. In a polemic with the Camaldolensian Giovanni da S. Miniato, who regarded antique studies as valueless, he maintained (1406) that the hidden sense of the pagan poets was in agreement with the theological truth of the Bible.

[10] In evolving his inner life, so very absorbing to himself, and analysing his moods, Petrarch associated himself with, and gave a new sense to, an old ecclesiastical ideal which the Fathers of the Church had taken over from Neo-Platonism—the ideal of the *vita contemplativa*.

[11] It is typical of Petrarch that he supported his preference for Plato over Aristotle by the argument that the former was praised by famous men (Cicero, Seneca, Augustine), the latter by the multitude.

[12] H. Baron, *Leonardo Bruni Aretino* (Leipzig, 1928).

[13] These were the three philosophical systems which exercised the greatest influence in the time of the Roman Republic, and particularly on Cicero, who, although strongly impressed by Stoicism, was yet on the whole more inclined towards Aristotelianism.

[14] As to the contrast between this very alert antique and Florentine philosophy and the passive and religious Neo-platonism, also deriving from antiquity but from a different period, and popular among the Florentine intellectuals of the absolutist Medici period, see p. 63, note 82.

[15] C. Prantl, *Geschichte der Logik im Abendlande* (Leipzig, 1855–70).

FLORENTINE PAINTING AND ITS SOCIAL BACKGROUND

[16] It was translated from Latin into Italian at the suggestion of Geri degli Spini; Bartolommeo's translation of Sallust was inspired by Nero Cambi.

[17] Although—so far as he himself was concerned—the study of antiquity also presented him with a kind of escape into the past and gave him a sense of his own singularity.

[18] A. Hortis, *Studii sulle Opere latine del Boccaccio* (Trieste, 1879) and C. Coulter, *The Genealogy of the Gods* (Vassar Medieval Studies, 1923).

[19] For example, Arrigo Simintendi, a notary of Prato, translated Ovid's *Metamorphoses* into Italian prose as early as the beginning of the fourteenth century. The Florentine notary Alberto delle Piagentine rendered Boethius *De Consolatione philosophiae* in 1332. At the end of the century the Florentine merchant Niccolo Sassetti translated Boccaccio's *De claris mulieribus*.

[20] The constant allusions in Roman literature, above all in Cicero, to the importance of the Greek philosophers and poets as models for the Romans themselves, was brought to the notice of the Florentines.

[21] The ecclesiastical literature was also sought for, but this was a secondary interest.

[22] Chrysoloras was invited to Florence by members of the wealthy upper bourgeoisie to teach at the university; Bruni and Marsuppini were among his pupils. Another of his pupils, the famous pedagogue Guarino of Verona, who translated Plutarch, taught Greek here from 1410 to 1414. Francesco Filelfo, the translator of Aristotle's *Rhetoric*, who was called to Florence by the Albizzi clique, taught at the university from 1429 to 1434. A few exceptions apart, such as Niccolo da Uzzano and Palla Strozzi, the upper middle class were not inclined to give money for the university (founded as early as 1321, reorganised in 1413). However, among the curators, a continual struggle went on between the Medici and the partisans of the Albizzi.

[23] Translations, however, were never made direct from the Greek into the vernacular; the humanists who knew Greek, especially Bruni, would have considered this beneath their dignity.

[24] E. Walser, *Poggius Florentinus* (Leipzig, 1914).

[25] Even Marsigli was attacked by the other friars of S. Spirito, who considered that the holding of philosophical meetings in the monastery displayed too secular a spirit and a lack of asceticism. See p. 115, note 36.

[26] It is, however, going too far when G. Toffanin (*Che cosa fu l'Umanesimo*, Florence, 1929) regards the humanists as in every respect the allies of the Church and attaches decisive importance to the common aversion of the Church and the humanists to the popularisation of learning in the Italian language.

[27] Symptomatic of the new attitude is the letter of Poggio—at that time an official of the Curia—in which he writes to Bruni from the Council of Constance, bestowing the halo of a Roman Stoic upon Jerome of Prague, whose alleged heresy he viewed most sceptically and of whose calm demeanour during his trial and burning at the stake he was a witness.

[28] Closely associated with Niccoli was Carlo Marsuppini, whose knowledge of Greek and Latin literature was very nearly as wide. He was the teacher of Lorenzo de' Medici, brother of Cosimo. After 1431, he taught at the university of Florence and later became city chancellor.

[29] P. Joachimsen, *Aus der Entwicklung des italienischen Humanismus* (*Hist. Zeitschr.* 121, 1920).

[30] See pp. 111–12 and p. 116. note 53.

[31] For a full description, see G. Voigt, *Die Wiederbelebung des classischen Altertums* (Berlin, 1880), and A. della Torre, *Storia dell' Accademia Platonica di Firenze* (Florence, 1902).

PHILOSOPHY, LEARNING, LITERATURE

[32] But the difference between the culture of the new generation and that appertaining more to the fourteenth century is very great. The inventory of the Medici house made in 1418 shows that while Cosimo possessed sixty-three books, mainly of antique and some Italian authors (history, mythology, poetry), the "library" of his father Giovanni contained only three books: the Gospels, a life of St. Margaret (patroness of pregnant women), and a sermon of Dominici.

[33] Another sphere in which the fusion of antique and religious thought is very apparent is that of the speeches by Florentine ambassadors of the Albizzi period already referred to. Though classical thoughts certainly predominate, Biblical phrases are nevertheless frequent. What compromises the classicising Chancellery was capable of making for opportunist reasons is shown by the fact that in 1425 it gave instructions to the Florentine ambassador sent to Pope Martin V to leave out all antique phraseology, as the Pope had no humanistic interests.

[34] This corresponds to a standpoint such as that of Dominici, who also did not exclude classical literature from the education of the young, but reserved it for a time when religious education had already been given.

[35] For a full account of this circle see Wesselofsky, *op. cit.*

[36] Marsigli was bitterly reproached by the Benedictines, for instance by the Blessed Giovanni delle Celle, on account of the philosophical discussions he held which were carried on in Italian and attended chiefly by laymen; the charge was that learning should not be popularised. See p. 114, note 25.

[37] Round about 1400, the Church herself was already using Italian in her own spiritual defence (e.g., Dominici).

[38] Wesselofsky, *op. cit.* In spite of the generally conservative character of the Dante commentaries, the great humanist, Filelfo, gave some of them in the Cathedral in order to gain a wider popularity with the bulk of the population at a time when he was trying to acquire Florentine civic rights. The manner in which the *Divina Commedia* was used for conservative purposes by the Church is illustrated by the fact that St. Bernardino of Siena often quoted Dante in his sermons and recommended the study of his poem from the pulpit. (See K. Hefele, *Der hl. Bernhardin von Siena und die franziskanische Wanderpredigt in Italien während des 15. Jahrhunderts*, Freiburg, 1912).

[39] The intensive study of natural science within the Franciscan Order was carried on chiefly in the northern countries, where it represented one aspect of the relatively progressive attitude already described. Such an important figure in the world of natural science as Bacon, who was active in England in the middle and second half of the thirteenth century, could hardly be imagined among the Florentine Franciscans.

[40] Salutati considered even music more important than medicine because it was one of the seven liberal arts of the scholastic system of education. Petrarch too placed medicine below rhetoric.

[41] G. Uzielli, *La Vita e i Tempi di Paolo del Pozzo Toscanelli* (Rome, 1894).

[42] L. Olschky, *Die Literatur der Technik und der angewandten Wissenschaften vom Mittelalter bis zur Renaissance* (Heidelberg, 1918).

[43] E. Auerbach (*Dante als Dichter der irdischen Welt*, Berlin, 1929) finds in the Thomist system an unequivocal explanation not only of the contents and teachings of the *Commedia*, with its striving for order and universal harmony, but also of its whole psychology. K. Vossler (*Die philosophischen Grundlagen zum süssen neuen Stil*, Heidelberg, 1904) brings evidence to show that in twelfth-century France each social section had its own type of poetry. In thirteenth-century Italy, according to the same author, these strict divisions began to be blurred as a result of a general democratisation and the spread of education; and the differences in literary taste now began to correspond not simply to differences in

social status, but to the degree of education, which coincided only in part with the former.

⁴⁴ Huizinga, *op. cit.*

⁴⁵ In Boccaccio's *novelle*, in accordance with the general view of the middle class, the workers are a dirty, disreputable crew, and their representatives are only good to serve as foils for the remarks of a wit.

⁴⁶ Some of the social and political views which Sacchetti expressed in his literary works may be mentioned here. He was a member of the upper bourgeoisie, a banker but on a small scale; and he frequently held public office. Even he says openly that the Florentine courts were prejudiced in favour of the rich. In the war of the *Otto Santi* he was against the Pope. Before the Revolt of the *ciompi* he welcomed the advance of the middle class under the leadership of Salvestro de' Medici; shortly afterwards he rejoiced at the defeat of the revolt and at the return of power to the *mezzane genti*. In his stories there is a contempt for the workers rather similar to that in Boccaccio.

⁴⁷ The cycles of sagas in which there was a love motive (Arthur, Tristan, Lancelot) appealed more to the first section, the pure stories of adventure (the Carolingian sagas) more to the second. Even St. Francis often alluded to the ideals of chivalry, and when speaking of his disciples, compared them with the Knights of the Round Table and the paladins of Charlemagne.

⁴⁸ In 1424, Antonio di Meglio (1382–1448) called on the Florentines in verse (referring to the tyranny of the Duke of Milan), after their defeat by Milan to provide money for the continuation of the war. The barber and popular poet, Burchiello (1404–49) was paid by the Albizzi to write sonnets against the Medici. Niccolo da Uzzano wrote poems requesting the members of the ruling oligarchy to moderate their politics, in contrast to the extreme tendencies of Rinaldo degli Albizzi.

⁴⁹ K. Vossler, *Poetische Theorien in der italienischen Frührenaissance* (Berlin, 1900).

⁵⁰ As to Poggio's new views, determined by an aesthetic, not a moral point of view, see C. S. Gutkind, "Poggii Bracciolinis geistige Entwicklung" (*Deutsche Vierteljahrsschr., für Literaturwiss.* X, 1932).

⁵¹ For example, the great importance of Virgil, both in the *Divina Commedia* and previously, is due to the fact that on account of his fourth *Eclogue*, he was regarded as a prophet of Christ's coming. For full discussion, see D. Comparetti, *Virgil in the Middle Ages* (Eng. trans., London, 1895). Even Petrarch's veneration for Virgil was to a great extent based on this Christian-allegorical interpretation of the Latin poet.

⁵² J. Spingarn, *A History of Literary Criticism in the Renaissance* (New York, 1925).

⁵³ Niccoli said in Bruni's *Dialogi ad Petrum Paulum Histrum* that Dante was a poet for cobblers; his name should be deleted from the lists of the learned and cultured and he should be left to weavers, bakers and such people. Such remarks are, however, extreme even in the circle of Bruni and Niccoli. Bruni himself seems to have shared these views only partially, or perhaps his attitude became less extreme in later years. In 1436 he wrote an Italian biography of Dante, which was consciously a so-called "light" work, not intended for the cultured. See E. Santini, "La Produzione volgare di Leonardo Bruni Aretino" (*Giornale Storico della Letteratura italiana*, LX, 1912). Bruni portrayed Dante less as a poet than as a man of action who had taken a very prominent part in the political life of Florence. With regard to the *Divina Commedia*, he considered that Dante would have done better to write it in Latin, but did not possess sufficient knowledge of the language. Brunelleschi endeavoured to work out mathematically the exact position of the different regions in the poem; this was characteristic of the attitude in progressive circles, where the generally popular *Commedia* was not completely rejected, but was subjected to an attempt at rationalisation.

II

THE ART OF THE FOURTEENTH CENTURY

1. THE OUTLOOK ON WHICH IT IS BASED

THE ideas in the various fields so far discussed combine to make up the general outlook of each separate class. We must now see how these attitudes to life bore on the approach of the various strata to the visual arts.

A decisive new factor in the fourteenth century which affected these arts, as it did all other forms of culture, both in Italy and elsewhere, was the increasing independence of outlook of whole classes of the laity, in particular of the ruling upper middle class. The works of visual art were now no longer, as in the early Middle Ages, of an esoteric, monastic nature, unintelligible to the majority of the layfolk and created with little desire to appeal to them. These works were now produced not only *for* the laity as well, but more and more exclusively— in the fourteenth century almost entirely—*by* them, and they increasingly reflected their point of view. This new outlook, and the new art that followed from it, necessarily appeared in its most vigorous form in Italy, the country of the new middle class *par excellence*. Central Italy, with its highly advanced Tuscan city republics was, in this respect, of paramount importance for all future development,[1] the smaller city republics, such as those of Umbria, playing in the earlier phases a minor role. Outstanding among these Tuscan towns were Florence and Siena, each having its special outlook in accordance with its social structure and reflecting this strongly in its art. Florence had a uniquely powerful oligarchic upper bourgeoisie, whereas Siena was more of a petty-bourgeois democracy; nowhere, therefore, was an art to be found so pronouncedly upper-middle-class as that of Florence.

In Florence ruled the export merchants and the financiers, a self-satisfied bourgeoisie capable of unlimited expansion who had overcome the nobility with the aid of their financial resources, and had also won a position of economic and political supremacy over the petty bourgeoisie and the workers unique in the Europe of the time. They were prepared to exercise this power to the utmost in whatever way seemed material to their interests, and without sentiment; in this their alliance with the Church and their close and purposeful relations with the great mendicant Orders assisted them. In the outlook of the fourteenth-

century Florentine upper bourgeoisie, whose commerce embraced the whole world and whose calculations were far-reaching, there necessarily ruled a kind of rationalism, a desire and a capacity for giving full weight to material relations. This factor was more pronounced than it could be in any other part of the Christian world at that time.[2] It implied a manner of thinking which—to put it briefly—followed naturally from the essence of capitalism, of monetary economy, a manner of thinking by which the world could be expressed in figures and controlled by intelligence.[3] But as we have seen, there were many factors tending to obstruct the free economic development of the Florentine upper bourgeoisie,[4] and these also must be taken into account, for they show themselves in the mentality of this *early* capitalist class as a tendency towards pure speculation and irrationalism. The early capitalist *entrepreneur* possessed a very definite make-up; side by side with his faith in God went a firm belief that the world could be controlled by rational thought, and a serene confidence in his own power to multiply capital; he also exhibited much irrationality, many almost feudal-aristocratic elements, such as a love of adventure, and even courtly traits, for he still felt himself to be and in some respects actually was related to the nobility.*
This "irrational" factor is highly complex. It was very evident in the early revolutionary period of the upper middle class of Florence during the thirteenth

* To call the sum of these qualities "individualism" does not get us much further. It is necessary, in each case, to define the particular kind of "individualism", for as a mere general concept the word is valueless. J. Burckhardt (*The Civilisation of the Renaissance in Italy*, Eng. trans., London, 1929) saw in "individualism", in the development of the personality, the foundation of Renaissance culture. In his view, the political conditions at the time of the Renaissance —the rise of the tyrants and *condottieri*—were favourable to individualism, and this development of one's own personality made it possible to recognise what was individual in others. But in my opinion the unrestricted individualism of the types just mentioned is rather a continuing form of feudal individualism, deriving from the social system of orders and characteristic of the knighthood of the Middle Ages, which recognised no restrictions except those imposed on it by its order. In the *condottiere* there is also something of the early capitalist *entrepreneur* and of the adventurer-type. It is the revolutionary merchant, breaking through social barriers with the help of his wealth and creating a new and recognised class, or being accepted into an old one, who paves the way for a bourgeois individualism. It is this economic calculation with which he must operate (even though in this early period it is rarely found in its pure form) which may be considered as the strongest contrast to the uncontrolled aristocratic individualism. Refutations of Burckhardt's theory of the heroic individualism of the Renaissance are to be found, though developed exclusively from the standpoint of the history of ideas, in Troeltsch (*Renaissance und Reformation*) and Burdach (*op. cit.*). For the relation between the individualism of the Renaissance in Burckhardt's sense and that of the feudal knights of the Middle Ages, cf. Huizinga, *op. cit.*

The question whether the Renaissance "as a whole" is to be regarded as belonging to the late Middle Ages or to the beginning of modern times is as pointless, owing to its lack of precision, as the discussion on Renaissance individualism. As Troeltsch rightly says, we can maintain either view, according to which factor we emphasise. J. Neumann and Huizinga, with the medieval theory, and Thode, with the modern, are all in their way correct. But we are not concerned with general classifications; our problem is rather to bring out the specific, definite features of each period, each decade even. The chief weakness of Burckhardt's whole Renaissance thesis is precisely that it neglects too much the course of historical development.

century, and although its intensity diminished in some directions during the fourteenth, it is felt all the more clearly in others, even if continually fused with the rational factor. It shows itself in various ways; sometimes in a reckless adventurousness, sometimes in an emphasis on sentiment, sometimes in a hankering after the seigneurial manner of life; according to the different spheres in which it appeared, diverse names can be given to it. Its variations are many, and it can only be brought, by a rough generalisation, under some sort of common denominator. During the period we are considering these two components of the attitude to life, the rational and the irrational, are in a continuous state of conflict and adjustment; no strict line of demarcation can be drawn between them, for they blend with one another to form the most varied compromises; some touch of adventurousness, for instance, is indispensable to even the most calculating of great merchants. Among the upper bourgeoisie, the rational factor ultimately proved the stronger;[5] in its own way it absorbed the irrational, whose elements were nevertheless continuously existent and clearly recognisable even if they tended to vary in intensity.

In the field of religious sentiment, it goes without saying that even this powerful class sought to feel themselves close to God. But they now drew much exterior support from the Curia, effectively grasped the practical use of the mendicant Orders, and of good works, and no longer retained a belief emotional enough to require, in their relationship to the Almighty, the element of personal ecstasy. A composed, self-confident aloofness sufficed, while at the same time the cult of the saints as mediators was fully allowed for. This sobriety, this religious detachment, as it were, was supported by the Church with her emphasis on dogmatic faith and aided by the diversion of the mendicant Orders into paths useful both to the Church and the upper bourgeoisie.

We have already considered the numerous compromises the Church made with the upper middle class in economic, social and political matters; we have seen that at the same time she upheld in principle her own ideals, generally in the form of reservations. For, given the close relations between these two parties, the maintenance of ecclesiastical-religious ideals in a pure form was of the greatest importance, as they had to hold sway, even if only ideologically, over the practical difficulties relentlessly presented by everyday life. The upper middle class believed on the one hand in practical everyday life, in which they ruthlessly exacted their claims, and on the other in the religious ideal—yet each on a different plane of thought.[6] Though the upper bourgeoisie were perfectly realistic in their recognition of the definite advantages which accrued from their alliance with the Curia and from the activity of the mendicant Orders, their own religious ideals, that is, those of the Church, were nevertheless an ever-present factor. The alliance with the Curia naturally prompted an emphasis upon the ideal of the immunity of the Church as an institution. Furthermore, the privileged position accorded to the mendicant Orders by the middle

class sprang from the firm belief that in this sinful world their pious ascetic life was essential for the salvation of the laity; the upper middle class strove, in making this ideal of life possible by their large bequests to monasteries, to save their own souls, and no acts of impiety or lack of asceticism on the part of the friars could have made them waver in their belief. Similarly, behind the practical collaboration of the Church and the upper middle class in good works lay the desire of this prosperous social section to obtain salvation—in other words, the ideal of charity. But, in accordance with their general views and interests, even these religious ideals of the upper bourgeoisie were free from any trace of exaggerated emotionalism; they were sober and moderate. They approved the ideal of an ascetic, but not of a truly propertyless, monasticism. Only if the mendicant Orders accepted this monastic ideal were the upper bourgeoisie ready to support them; for only then would they be supporting themselves.

The Church and the mendicant Orders used to the full their close relationship with the upper middle class (and indeed with the middle class as a whole) to exercise a cardinal influence on their private lives, on their manner of thought, and to a great extent on their culture. In the fourteenth century this was in its essentials an ecclesiastical culture. Everything in the last resort was subordinated to religion, even though in a temperate and rational manner. It is characteristic of the complex mentality, embracing different levels of thought, among the members of this section that they felt no consciousness of any opposition between the Church's interpretation of the world, the interrelation of all phenomena in terms symbolic of the coming Kingdom of God, and their own ways of thought, which recognised the causal relationship of individual events. It is merely a question of a shift of stress; of whether we emphasise the fact that the Church became, to a high degree, secular and adapted herself to the bourgeois-capitalist mode of thought, or that the new bourgeois laity became ecclesiastical by taking up ecclesiastical culture and winning a share in it themselves. Either statement would be equally true.

How did this general outlook of the Florentine upper middle class affect their art? As their thought centred round religion, their art was, perforce, above all religious. But it is natural that this religious art, all over Europe, and especially in Italy, should no longer have the mere symbolic, dogmatic and didactic character it had assumed when produced in isolated monasteries before town life had really begun to flourish; as the urban bourgeoisie became pre-eminent, the purpose of art tended to gravitate towards a humanisation of the Divine. The Florentine upper middle class of the fourteenth century, however, now firmly seated in the saddle and more or less rationalist in outlook, had already passed beyond the early revolutionary phase of middle-class art, which aimed chiefly at bringing God emotionally close to man. It was natural that this class should still need a devout art, but—and it is this that is essentially new—a tranquil art, not so devout as to be too emotionally disturbing. In such a manner did they

wish to have their objects of worship and veneration represented. Similarly, they liked to have their own religious ideals portrayed—for example, the pious friar (usually in the guise of a friar saint), charity (often in the form of good works)—by which the justification of their own everyday life was elevated into the stable, religious sphere. Such representations helped to make these ideals convincing and binding for the other social classes as well. Obviously, a class which, despite all its religious sentiment, was so sober-minded and so close to reality as was this could find satisfaction only in a religious art which already showed a considerable degree of fidelity to nature. So much only need be said here of the formal side of their artistic requirements.

As the Church's fundamental views roughly coincided with these, it was not difficult for her to adapt herself to these artistic demands, just as she did in numerous other fields. It is true of Europe generally that with the rise of the urban middle class an increasingly worldly Church took earthly life far more into account, and correspondingly changed her attitude to art. So did the Church come to participate in the formation of an art that humanised God and brought him nearer, even though she still preferred, as the conservative partner, symbol and allegory. Here again, however, the Church and the upper bourgeoisie compromised by adapting symbolical art to the latter's practical needs. The Church now generally laid increasing emphasis on this world as the scene of meritorious acts, as an effective preparation for the world beyond. She was therefore increasingly ready to permit art to incorporate earthly objects as God's creations,[7] and even moderated her proscription of the portrayal of the human body.[8] These various concessions were nowhere taken up and exploited so vigorously as in the art of the Florentine upper middle class, the most progressive in Europe and the most closely allied to the Pope.

Very different from the relationship between the upper middle class and the Church, which grew out of mutual dependence and expressed itself in the field of art in mutual voluntary concessions, was that between the same class and the lower bourgeoisie. From the upper bourgeoisie, keeping themselves in power by the crudest means, artistic concessions to the lower classes—concessions to their religious sentiment at once emotional and symbolically restricted, and to their cultural deficiency—could be expected only for very cogent reasons. Sometimes they were compelled to make them simply on account of the conservatism and lack of culture of certain of their own strata. This occurred rather on the part of their collective associations, such as guilds or fraternities, than with individuals. For—since general ideological changes are necessarily slow— the culturally conservative elements were, as a rule, in the majority. The upper bourgeoisie also inclined to accommodate themselves artistically at times when the political balance was tilted in favour of the petty bourgeoisie. For at such times their own lower levels, culturally closer to the lower middle class, usually made their influence felt. In these situations, therefore, their own insecurity

induced, or forced, the upper bourgeoisie to give way—for example, in the period between the collapse of the big banks and the revolt of the *ciompi*, and again immediately after that revolt. On the other hand, they were wont to give artistic expression to their increasing social and ideological sympathy with the now harmless nobility; but since the nobility at this period were culturally rather backward, the effects of such an approximation were not always to be distinguished from those of the approach towards the lower middle class.

If this is true of religious, it is even more so of secular art, now slowly emerging to an independent life. For the full share which the bourgeoisie took in ecclesiastical culture in no way precluded, during the fourteenth century, the growing secularisation of the cultural needs of their higher strata. So long as was possible, this secularisation took place within the old ecclesiastical and religious boundaries; and indeed, long after secular culture had achieved a certain independence, no marked contrast is to be discerned between it and religious culture. Here again it is a question of accent—of whether we emphasise the degree of secularisation or the degree of subordination to religion. The concrete desires and interests of the upper middle class in purely mundane spheres (economics, politics) can be linked up with the religious sphere through a "secular" art: they can be represented as equally desired by Heaven and so, as ideals, enjoying Heaven's sanction. Anything resembling a really widespread secular art could spring up only in a city as large and as economically advanced as Florence, with her highly developed upper bourgeoisie; it was less possible in Siena, still less in, for example, Perugia. Yet just at the very time when the worldly-cultural and hence the artistic needs of the upper bourgeoisie became particularly pronounced, at the end of the fourteenth century, both the speed of their development and the possibility of their consistently following their own bourgeois way were to a certain extent hindered, as we have seen, by a marked propensity for the old feudal ideals of chivalry. The predilection for classical culture, on the other hand, which helped to sustain the self-confidence and national feeling of the new bourgeoisie was confined in the fourteenth century to an upper-bourgeois intellectual élite, and even then had not penetrated their consciousness sufficiently to receive distinct expression in the visual arts.

We have seen that in the matter of political power, in the formation of guilds and the right of association, the social strata beneath the upper middle class were oppressed as nowhere else in Europe. It is therefore no wonder that we find so little evidence of their feelings and thoughts. Even the highest section amongst them in the social scale, the petty bourgeoisie, though concerned in principle to improve their position, were conservative, lacking in independence, reactionary rather than revolutionary. To the petty bourgeois, his small shop was his world, his commercial activity was strictly defined by the statutes of his guild, he had no possibility of making large profits.[9] His orientation was above all religious. The social and political aspirations of all the lower sections

were closely linked up with their longing for God. We have seen often enough how the upper bourgeoisie made concessions to their political demands and, with the Church, to their emotionally religious sentiment, when such concessions could not be avoided. The lower social sections could scarcely conceive their mental needs or their art except within a religious framework. Their highly emotional religious feeling, and at the same time their greater lack of culture and their ignorance, were, of course, incompatible with a rationalist and logical art. The Church and the mendicant Orders saw to it that their mystical yearning for God was given a rigid character by strict adherence to dogma, or even fused with it; so the religious art corresponding to these strata, in spite of their inclination to emotionalism, displayed to a high degree a didactic, rigidly hieratic character. These conservative, uncultured sections were much more prone than the upper bourgeoisie to be governed, both in their daily life and in their religious ideas, by the old, symbolic, ungenetic process of thought which identified the externals of things with their reality, and on the basis of these outward marks discovered relations and created identities between the symbol and what it symbolised.[10] Thus the symbolic and didactic art of the past, in which the figures were represented not in their own right but as symbols of something else, could still persist, to a certain extent, among these sections at a time when this no longer suited the most progressive and rationalist part of the upper middle class.[11] Whilst formerly the lower classes had probably been content with a vague general understanding of the images, without grasping their every detail, the Church now made symbolical and allegorical art in every respect much more comprehensible to the masses, bringing it nearer to them in all its details.

Yet none of the lower sections in Florence, not even the petty bourgeoisie, ever attained sufficient economic or political power to place, independently, large artistic commissions. Lacking means, they scarcely counted as customers for works of art. Their artistic requirements generally became manifest only in the form of concessions made to them by others in their own commissions for works of art.* These were often the reflex of deeper concessions in the religious sphere. Sometimes, as we have seen, they were necessitated by a sense of insecurity on the part of the upper middle class. Sometimes they were indulgences or precautionary measures rather than concessions on the part of the Church, particularly of the mendicant Orders. These latter feared the critical attitude of the lower sections towards the Curia, and therefore caused a strictly ecclesiastical note to be introduced whenever they could directly or indirectly influence the commissions. At the same time, account was often taken of the greater primitiveness and lack of naturalism in the artistic language of these people. In short, the motives for these various artistic adjustments and indulgences on the

* Since the part played by the petty bourgeoisie in art was chiefly passive, I generally apply the terms "petty bourgeois" and "popular" to art in a wide sense—not only to denote that of the petty bourgeoisie proper, but also the general line of taste of the more conservative section of the upper and of the whole of the middle bourgeoisie.

part of the upper middle class and the Church were, in most cases, interwoven with and had their origin in the ideological complexity of Florentine society. When, for instance, the upper bourgeoisie made adaptations to suit the proneness of these strata for symbolic art, they are also to be understood in part as adaptations to the Church's outlook, and in part as emanations of their own cultural conservatism.

<div align="center">NOTES</div>

[1] North Italy, that is to say Venice, Milan and Genoa with their less developed industry, which we do not discuss here, have not quite the same significance.

[2] That is why Florentine financiers and manufacturers were called in all over the world as experts, and often decided the entire financial policy of other countries.

[3] For a full discussion, see W. Sombart, *The Quintessence of Capitalism* (Eng. trans., 1915) and Martin, *Sociology of the Renaissance*.

[4] Such as the extremely complicated process of production in the woollen industry, the dependence of financial transactions on the feudal and semi-feudal courts, the irrationally huge risks and almost irrationally huge profits, and the limits set by the Church to their economic activity.

[5] The position was quite different in the northern countries, particularly France and Germany, where the middle class had not reached nearly the same degree of economic and ideological development as in Florence. The bourgeoisie in these countries were, therefore, less consistently rationalist in their outlook and the irrational element played a more important part in their art.

[6] The absence of conflict between these two planes—business acumen, even trickery, on the one hand and emphasis on religious and moral ideals on the other—is well illustrated by the *Book of Good Examples and Good Manners*, written by Paolo di Ser Pace, a Florentine merchant, about the middle of the fourteenth century. See G. Biagi, "The Mind and Manners of a Florentine Merchant of the Fourteenth Century", in the volume *Men and Manners of Old Florence*, Eng. trans., London, 1909.) I do not suggest that the Florentine merchant did not sometimes feel religious scruples contrary to his everyday activities (e.g., the "restoration" of usurious profits on his death-bed). But these scruples were relegated as far as possible to the periphery of his mind. They were only to disappear in the outlook of the English-Scotch puritan merchant of the sixteenth and seventeenth centuries, to whom the close association between business success and the claim to salvation afforded a sense of inward security. See M. Weber, *The Protestant Ethic and the Spirit of Capitalism* (Eng. trans., London, 1930), and R. H. Tawney, *Religion and the Rise of Capitalism* (London, 1926).

[7] M. Dvořák, "Idealismus und Naturalismus in der gotischen Skulptur und Malerei" in the volume *Kunstgeschichte als Geistesgeschichte* (Munich, 1927).

[8] For a fuller treatment of the aesthetic ideas of the Church, see the chapter on Contemporary Views on Art.

[9] G. Luzzatti, "Piccoli e grandi mercanti nelle città italiane del Rinascimento" (*Volume commemorativo in onore di Giuseppe Prato*, Turin, 1930).

[10] For a full treatment of the symbolic thinking of this period, see Huizinga, *op. cit.*

[11] The predilection for religious symbolism among the lower sections is shown, e.g. in the coats-of-arms designed in 1378 for the newly-created guilds of small masters and workers. Whereas the lesser guilds already in existence generally displayed in their coats-of-arms an instrument of their calling, the tailors now chose the arm of the Lord reaching down from heaven with an olive branch, and the *ciompi* an angel with sword and cross.

2. ARCHITECTURE

AS a prelude to the history of painting, we will rapidly survey the most important undertakings of Florentine architecture in the thirteenth and fourteenth centuries, and the social positions of its patrons; for these buildings enshrine some of the principal Florentine frescoes and altarpieces of the fourteenth and fifteenth centuries.

The finest productions of Florentine fourteenth-century architecture were public buildings, religious and secular. Their erection helped to express the power of the commune, and at the same time to maintain an appearance of democracy throughout all sections of the city. The commissions themselves were generally placed either by the city itself or by one of the two great mendicant Orders. In practice, the former was identical with the greater guilds, whether the nominal administration of the undertaking rested with the city or, as happened far more frequently, one of the greater guilds was entrusted with its control.

The Palazzo del Podestà (the palace of the chief magistrate, the Bargello, begun 1255, completed 1346) and the Palazzo della Signoria (later known as the Palazzo Vecchio, and built between 1299 and 1314 to the plans of Arnolfo di Cambio, d. 1302), which contained the offices of the Priors and other municipal officials,[1] are examples of the former category. These were the buildings erected when the middle class were still revolutionary, or shortly after they had finally taken over power. The Bargello symbolises the victory of the bourgeoisie over the nobles in 1250;[2] the building of the Palazzo della Signoria was the result of their final assumption of power in 1293.[3] Nevertheless it is a sign of the slow development of middle-class taste that these buildings were still constructed after the manner of the fortified castles of the feudal nobility; though the simple requirements of defence and security were partly responsible for this. Thus the Palazzo della Signoria, with its towers and battlements, is an imitation of the castle of the Count of Poppi, one of the most famous feudal lords of Tuscany.[4] The later Loggia dei Lanzi (1376-92) was built when the lesser guilds had influence in city affairs. It is an open Gothic hall, perhaps the earliest public hall of its type, and is designed for the democratic purpose of enabling the Signoria to address the people assembled in front of it; it also served for public ceremonies such as the reception of distinguished visitors, or the investment of prominent citizens with the honour of knighthood. Its essential novelty lies in its openness, enabling the populace outside to witness the ceremonial actions of the Republic staged within its walls.[5]

FLORENTINE PAINTING AND ITS SOCIAL BACKGROUND

All the three great churches of Florence—the Cathedral, S. Croce, and S. Maria Novella—were begun around the middle or end of the thirteenth century by the middle class which had just achieved power. The commencement of S. Maria del Fiore (begun by Arnolfo, 1294), the Cathedral of Florence, and the city's largest enterprise, and that of S. Croce and of the Palazzo della Signoria, were all an immediate expression of the new civic pride of the middle class, following on the issue of the *Ordinamenti di Giustizia*.[6] The construction of the Cathedral was supervised at first, in Arnolfo's lifetime, by the city itself, for a time from 1303 to 1331 (when building activity was stagnant) by the silk guild, and continuously from 1331 onwards by the most important and wealthy of the guilds, the Lana. The decoration of the Baptistry, particularly its marble facing, which dates partly from this period, was by the middle of the twelfth century already under the supervision of the Calimala.[7] In order to finance the construction of the Cathedral the city imposed for two years a poll-tax and death duty.[8] The different sums, municipal contributions as well as voluntary gifts, were all disposed of by the Lana (which identified itself with the city) as it thought fit; for in all cases the guild, or rather its relatively few fully privileged members, administered and controlled the undertaking in question through a commission specially elected for this purpose, but did not itself finance the building apart from small contributions. During just those years when the lower middle class were making their influence felt, and the power of the Lana was declining, that is, from about 1368 to 1382, the building operations on the Duomo made little progress.[9] But after the Albizzi party had once more gained control in 1382, the construction went forward with tremendous energy, the Duomo being to the upper middle class the symbol of their power over the city. From every point of view, the two great churches of the mendicant Orders, the Dominican S. Maria Novella (begun 1246) built before the Cathedral,[10] and the Franciscan S. Croce (begun 1294), contemporary with the Cathedral, and like it, planned by Arnolfo, were, after the Duomo, the most important in Florence. The erection of these buildings was, of course, made financially possible only by gifts from the laity, the mendicant friars collecting money from the entire population, and the city also contributing to the cost.[11] As we have seen, the richest citizens, who had gained their wealth by usury, gave specially large endowments to the churches of the mendicant Orders; that is to say, it was the importance attached to good works, as contributing to the spiritual salvation of the bourgeoisie, which alone made the construction of these monumental buildings possible. S. Croce was particularly favoured by the rich banking families—the Bardi, Peruzzi, Alberti, and Baroncelli.[12] On the other hand, in 1310, Ubertino da Casale, describing the excessive luxury of the building as the mark of Antichrist, gave eloquent expression to the prevailing bitterness felt by the Franciscan Spirituals at the magnificence of the new S. Croce and the huge sums of money raised for it.[13]

FOURTEENTH-CENTURY: ARCHITECTURE

As to the style of these churches—we need think here solely of the features common to all three—it is only with reservations that they can be called Gothic, even late-Gothic. In any case, owing to the emphasis on space, the tendency towards the horizontal, the unbroken expanses of wall, this Gothic style is more rational, clearer, and more lucid in design than that of France and Germany. In Florence it lacks, to a great extent, that dynamic spirituality, that verticalism seeking a link with Heaven, so typical of those equally middle-class but less advanced and less upper-bourgeois countries.[14] The style of Gothic architecture derived from France was transmuted in character in Florence, showing a more rationalist, progressive tendency; the ground plan can always be taken in at a glance. This is true even of the earliest Florentine Gothic church, S. Maria Novella,[15] and still more so of the later ones, the Duomo and S. Croce, both built by Arnolfo, as we have seen, after the middle class's definite assumption of power. Here the Gothic elements were pushed much further into the background, and in their place classicising elements from the previous Romanesque architecture of Italy, and even real antique elements, were adduced to serve their own monumental disposition of space and the harmony sought for.[16] Despite the undeniable presence of Gothic elements, the style of these two latter churches might perhaps more fitly be called "classic"; it is conceived in a more upper-bourgeois, rational sense as compared with Gothic, and is indeed somewhat outside, or better beyond, Gothic.[17]

In these typical town churches preaching to the people was all-important; each member of the congregation had to be able to see and hear the preacher in the pulpit and the celebrant at the altar. So through the spaciousness and hall-like character of these monumental Florentine churches, a "democratic" general view of the whole congregation was afforded. S. Croce, in particular, closely resembles a single hall in appearance, so wide are the apertures of the arcades. In the Cathedral, a great step forward was taken towards the unification of the interior space when Francesco Talenti increased the distance between the single pillars (1357). A certain deliberate, though of course merely relative, simplicity and bareness also determines the effect of these interiors. This simplicity does not retain much of the original "Franciscan plainness", but rather fits in with the quiet, calculated statics of the new "classic" style.[18] The manner in which the choir was treated in the churches of the mendicant Orders, the extremely long east wall being broken up by a large number of single chapels, is typical; this implies no conflict with the "democratic" character of the general arrangement, but is in fact closely linked to it, and is especially illustrative of the period of early capitalism, democratic and oligarchic at once. This disposition of the choir-chapels enabled two important objectives to be attained. In the first place the high altar, formerly isolated from the laity, was now "democratised", for it was supplemented by many subsidiary altars so that the number of masses was greatly increased, and every friar could say mass daily. Secondly,

a collection of individual chapels, endowed and owned by wealthy families, were now erected; the best possible example of this arrangement is to be found in the Franciscan church of S. Croce—built at the time when this Order and the upper middle class were in closest alliance[19]—with its row of family chapels, five on each side; their painted decoration was of capital import for the whole development of Florentine art.

It is not our task here to describe the stylistic development of Florentine architecture in the fourteenth century. We will only mention that Arnolfo's "classic" style, springing from an upper-bourgeois mentality, was not developed at a later period when a certain lower-middle-class influence made itself felt, on the lines originally intended, yet as a general artistic heritage the style persisted. Only one artist can be said to have really followed Arnolfo's style: Giotto, with his project of the Campanile (1334). His career as Arnolfo's successor in charge of the building of the Cathedral coincided even more exactly than that of his predecessors with the period of uncontested upper middle-class supremacy; and he it is whom we shall later recognise as the chief representative of upper-bourgeois art in painting

In 1336 the silk guild was entrusted by the Signoria with the task of rebuilding Orsanmichele, the old Corn Hall[20] (where the corn market was held) which stood on the site of the old church of S. Michele in Orto; this building contained a popular and greatly revered image of the Madonna, and had a kind of semi-ecclesiastical character. Its arrangement is very characteristic of early middle-class mentality, religious and rationalist at once: underneath, was an Oratory (an open loggia with the image of the Madonna); above, the city granary and the offices of the fraternity, the Compagnia dei Laudesi di San Michele, whose task it was to serve the holy image. This building very soon became a symbol of the power of the Florentine guilds, for in 1339 the external pillars were given over to the twelve superior guilds and the Parte Guelfa, so that they could display on them the statues of their respective patron saints. During the democratic period, 1366–80, after the above-named Compagnia had (in 1352) already gained control of the building and a magnificent new tabernacle to the Madonna had been set up, the Oratory was transformed into a double-naved "hall-church", a church whose nave and aisles were of the same height. So this "popular" type of construction—very common in the more petty-bourgeois Umbria and still more so in Germany—in which the democratic levelling of the entire congregation is carried through even more consistently than in the large church buildings, is to be found only as an exception in upper-middle-class Florence, that is in this little guild-church, where it is only technically conditioned by the presence of a floor above.[21] Apart from Orsanmichele, S. Remigio, also built in the democratic period about the middle of the century, approaches nearest to a hall-church.

All the guilds built their own guild-halls.[22] The fraternities also put up

buildings—though chapels, not churches; thus, for example, the Compagnia di S. Maria della Misericordia, which undertook charitable works and cared especially for foundling children, erected in 1352-58 an Oratory, known later as the Bigallo. Very wealthy individual citizens at times erected monasteries; the Florentine banker and statesman Niccolo Acciaiuoli, for instance, who not only had amassed great wealth in Naples but had even reached a dominant position there and been elevated by the King to the rank of High Steward, built the Certosa (the Carthusian Monastery) in 1341.[23] More frequently these opulent burghers would build hospitals—a sign of the increasing culture of the middle classes in a rather more secular direction; Folco Portinari (the father of Dante's Beatrice, a partner in the banking firm of Cerchi, who practised usury on a considerable scale)[24] erected the Ospedale of S. Maria Nuova (1287), and the banker Lemmo Balducci the Ospedale S. Matteo (1356), though the city often contributed towards the cost of foundations of this kind.

The private houses of the wealthy, even in the fourteenth century, still resembled fortresses, and continued somewhat uninviting, though they gradually became less so than in the previous century.[25] This was to some extent still a manifestation of conservative and feudal taste, but also expressed middle-class puritanism and severity, shown equally by the way in which the upper middle class transformed the old aristocratic palaces into commercial houses.[26] The average middle-class house generally had the same simple scheme, being planned as part of a row and able to house as many people as possible in a small space; its façade was broken only by the simple line of round-arched windows and a round-arched portal. There were usually more than two floors, and several rooms on the ground floor opened on to the street for trading purposes. It is worth noting that nowhere in Europe outside Florence, not even in any other Tuscan town, was this "large town" house scheme, probably deriving from the cities of Roman antiquity, to be found.[27] Again, this most pronouncedly middle-class city of Europe was the first to have paved streets, at least at the most important points.[28] The wealthy middle class, especially it would seem from the 1330s onwards, also built a large number of villas in the environs of Florence,[29] a consequence of their new mode of life on buying up the estates of the nobility.

NOTES

[1] Certain special ceremonial meetings of the city authorities—at their assumption of office, for example—often took place in the churches, a token of the close link between the municipality and the Church.

[2] As early as 1255 the new middle-class government placed inscriptions on the palace, indicating its political ideology, which imitated that of ancient Rome: Florence, after the model of Rome, would unite the whole world under its just rule.

[3] As a counterpart to the erection of these buildings, a number of defensive measures affecting architecture were taken against the resident feudal aristocracy: thus, the palaces

of the Ghibellines were demolished, and limits were set (1250) to the height of the towers of the nobles' palaces. After the final victory of the middle class, a new city wall was begun in 1285, and was extended far beyond the inner city, containing the palaces of the aristocracy, to include the new middle-class districts also. See C. Frey, *Die Loggia dei Lanzi* (Berlin, 1885).

[4] The Italian Gothic castles and palaces of the nobility, however, were not used so exclusively for military purposes as were those of the North; they were also more regular and symmetrical in design. Arnolfo was disappointed that he could not build the Palazzo della Signoria as symmetrically as its model. (Apparently a vow prevented him from building on the site previously occupied by the palace of the Ghibelline Ubertini family, which had been demolished by the middle class in 1248.) The Duke of Athens later instructed the municipal architect, Andrea Pisano, to fortify the Palazzo della Signoria for his protection. This was probably why Andrea lost his official appointment after the Duke's fall in 1343.

[5] The extent to which political ideas influenced the city's building activities is shown by the debate which took place in 1356 over the first draft plan for the Loggia. Some thought it too imposing, and considered that a large public hall was more suitable for a tyrant than for a free city. The question therefore arose whether this distinctly modern building was more closely linked with a monarchical or with a republican ideology; and ultimately, therefore, which of these two forms of State was the more modern.

In 1391, when the upper middle class and the Parte Guelfa were once more in control, a number of coats-of-arms were added to the loggia, which very clearly indicate the political orientation of the upper-bourgeois Commune: among others, those of the Church, of Charles and Robert of Anjou (the early Guelph Signori of Florence allied with the Papacy), of France and of the Parte Guelfa. Many Florentine buildings, private houses especially, were decorated with similar coats-of-arms, emphasising the political sympathies of the upper middle class with the Guelphs, the Papacy, the house of Anjou and the French; in this way one could show one's loyalty, above all, to the dreaded Parte Guelfa. By the statutes of the Painters' Guild, moreover, the designing or painting of the coats-of-arms or insignia of enemies of the Commune and the Parte Guelfa was expressly forbidden.

[6] In 1294 the city resolved that the old cathedral of S. Reparata should not be repaired, but replaced by a new one "in honour and praise of God and the Blessed Virgin Mary, and in honour of the commune and people of Florence and to beautify the city". These words were repeated in all later documents concerning grants of money to the cathedral. The document of 1332 sanctioning Giotto's plan for the Campanile is phrased with similar bourgeois self-confidence. It may be mentioned that the new name of the Duomo itself, S. Maria del Fiore, was purposely linked up with the city's name, Fiorenza. This connection of the Deity with the town, which recalls antiquity, was at that time unique.

[7] Similarly the interior decoration of the distinguished Benedictine church of S. Miniato, which, dating from the eleventh century, belonged first to the Black Benedictines and after 1373 to the Olivetans, was closely linked up with the old and respectable Calimala guild.

[8] In addition, after 1331—that is, after the Lana had taken over control—a levy of 5/6 per cent. on all official payments of the district treasuries was raised for the building of the Cathedral, as well as a further one of 2/3 per cent. on all farming of taxes and customs dues. In every workshop, and on every tradesman's stall, stood a box for the "Danaro di Dio" (Davidsohn, *op. cit.*).

[9] Just before this, in 1366, during a somewhat democratic period of Florentine

history, the guild asked the population of the city to choose by vote between two publicly exhibited models. Within two days 420 men had voted.

[10] It was probably owing to the great popularity of St. Peter Martyr that the new monumental church was required to replace the previous smaller one.

[11] Within three years, for instance, the city twice contributed 1,200 florins and a year later another 500 towards the cost of S. Maria Novella. Part of the fines imposed on heretics by the Franciscan Inquisition was also used towards the building expenses of these two churches.

[12] Nevertheless, respect was so far paid to democracy that the Quaratesi, who had contributed towards the building expenses, were refused permission to have their coat-of-arms on the façade of S. Croce.

[13] In particular he blamed Fra Illuminato Caponsacchi, who together with Fra Giovenale degli Agli, another guardian of the monastery of S. Croce—both, significantly, came from patrician Florentine families—was the initiator of the building. The fact that the most popular Florentine preacher of the time, the Augustinian Hermit Fra Simone Fidati, regarded the flooding of the Arno in 1333 as a punishment for the building of these over-luxurious churches, shows how widespread opposition to them was among the lower classes (Davidsohn, *op. cit.*).

[14] For the same reason, in the northern countries themselves, French Gothic lays more stress on the horizontal than does the Gothic of the more petty-bourgeois and thus more spiritually inclined German towns. Within France it is the Gothic of the south French towns, economically the most important, which exhibits most clearly the principle of horizontality and spaciousness and so comes nearest to the style of the Florentine churches.

[15] Following the example of S. Maria Novella, the numerous churches of the mendicant Orders which arose in the fifties and sixties of the thirteenth century—the great building activity of these years is connected with the victory of the middle class—were all kept in Gothic style. It is characteristic of the predilection for Gothic architecture of the religious Orders that only one building, and that not a monastic one (S. Bartolommeo dei Pittori) should have been built in the Romanesque style at this time.

[16] While the building authorities of S. Maria Novella were monastic in spirit and Gothic in taste, in those of the Duomo and S. Croce a layman, namely Arnolfo, exercised a determining influence. Arnolfo's monumental, non-Gothic, "classic" building of S. Croce, erected nearly forty years after S. Maria Novella, actually represents a late stage of Franciscan architecture. For it was the third Franciscan church on the same spot, each of the two former having in turn been pulled down. The building immediately preceding Arnolfo's was much simpler, and still closer to the early type of church peculiar to the mendicant Orders in Tuscany and Umbria. These latter churches united the Gothic architectural forms introduced by the Cistercians from France with their own plain ascetic tradition of a single-naved, unvaulted hall (the "barn church"). These early Franciscan churches (the luxurious building of S. Francesco at Assisi was an exception) were, in accordance with the building regulations of the General Chapter of Narbonne (1260), which still gave actual expression to the spirit of St. Francis, simple and averse to the arts. But this early type of Franciscan architecture was soon given up, and in the churches of the religious Orders, which were becoming consciously artistic, an evolution and transformation of French Gothic took place. See H. Schrade, "Franz von Assisi und Giotto" (*Archiv für Kulturgesch.*, XVII, 1927) and W. Paatz, *Werden und Wesen der Trecento-Architektur in Toskana* (Burg, 1937).

[17] For the combination of Gothic and antique elements, ever-present but always differently proportioned in the individual churches, see Paatz, *op. cit.* The most anti-

FLORENTINE PAINTING AND ITS SOCIAL BACKGROUND

Arnolfian and anti-"classic" style of Tuscan architecture was that of Giovanni Pisano, who generally worked in the more petty-bourgeois Siena and its territory (we refer especially to his early work, the choir of the Cathedral of Massa Maritima); in spite of the presence of antique elements, the Gothic elements here have a strong dynamic character.

[18] This is also the sense in which Arnolfo's beamed roof in S. Croce should be interpreted; moreover it was painted, and was therefore not so very severe and bare. Still more elegant was the somewhat earlier beamed roof of the "aristocratic" Benedictine church of the Badia, also built by Arnolfo (1284–1310). See Paatz, *op. cit.*

[19] Later, in 1361, the municipality recommended the Calimala to look after the building operations at the monastery of S. Croce.

[20] The market dues, along with other sources, were used to defray the cost of building. For further details see P. Franceschini, *L'Oratorio di San Michele in Orto in Firenze* (Florence, 1892).

[21] H. Bechtel, *Wirtschaftsstil des deutschen Spätmittelalters* (Munich, 1930).

[22] For example, in 1308 the Lana reconstructed for its own official purposes a house belonging to the Ghibelline family of Compiobbesi, which had been burnt down in 1284.

[23] Niccolo Acciaiuoli, in a letter to his brother (1356), gives the following information about the building of the Certosa: "Whatever else God has granted me will go to my descendants and I know not whom; this monastery and its decorations alone belong to me for all time to come, and will preserve my name in my country. And if the soul is immortal, as Monsignor the Chancellor says, then my soul, wherever it is ordered to go, will delight in this building." (G. Gaye, *Carteggio inedito d'Artisti dei secoli XIV, XV, XVI*, Florence, 1839.) This quotation is interesting not merely as showing how Acciaiuoli regarded this Carthusian monastery, devoted to the contemplative life, in which he himself intended to live and to be buried, as his own—a clear indication of how private a matter religion had become—but also (in spite of all its religious sentiment) for the slight scepticism, akin to Averroism, which it reveals regarding the immortality of the soul.

[24] Davidsohn, *op. cit.*

[25] The great families, a severely restricted number, were allowed to build loggias for their family reunions because the interiors of the houses themselves provided no suitable place.

[26] A. Schiaparelli, *La casa fiorentina* (Florence, 1908).

[27] W. Paatz, "Ein antikischer Stadthaus-Typus im mittelalterlichen Italien" (*Kunstgesch. Jahrb. der Bibliothek Hertziana*, III, 1939).

[28] During the fourteenth century the houses took on a more regular form, and the better streets had to be levelled and paved.

[29] Nevertheless in Villani's time these persons were still regarded as somewhat foolish and extravagant.

3. PAINTING (AND SCULPTURE)

A. GENERAL REVIEW

TURNING to the figurative arts—painting and, though only incidentally, sculpture—we will first consider in general terms what type of commissions were given to the artists, and by whom.

By European standards, the early flowering of painting in Italy, at first almost exclusively religious, was the result of the early development of the Italian town. It was in Italy that panel-painting first appeared on a large scale, just because Italy was the first country to develop a numerous middle class. During the fourteenth century the main Florentine paintings were still intended as a rule for the decoration of churches; but the old mosaic decoration[1] had given way to the relatively cheaper and more "intimate" frescoes, while as the century advanced, altarpieces forming the central decoration of individual chapels assumed increasing importance. These paintings were generally ordered by very wealthy citizens whose families claimed proprietary rights over these chapels; others were commissioned by the religious Orders to which the churches belonged. These would usually commission the painting for the high altar. Throughout Italy it was above all in the great mendicant churches, those typical sanctuaries of the urban middle class, that works of art were gradually accumulated. In Florence the Franciscan S. Croce (Pl. 8, 21a, 18, 19a, 20a, 22b, 23, 43, 48, 66, 124, 67) was a case in point, especially at the beginning of the fourteenth century, since it was the Franciscan Order which was most directly connected with the revolutionary rise of the middle class and the new bourgeois outlook. The Dominican church of S. Maria Novella (Pl. 25b, 34, 36, 37, 38, 40, 58, 60, 61a, 62, 63, 83, 86) began to have equal importance only as the century advanced, after the consolidated upper middle class had become more conservative in outlook. Frescoes and altarpieces were to be found in the urban palaces of this century no less than in the churches. The number of domestic altarpieces in private palaces, as well as of portable travelling altarpieces, rapidly increased after the first quarter and more still after mid-century.[2] The development of a more private and personal attitude to religion, already evidenced by the transition from the Romanesque churches of feudal society to the Gothic churches with their numerous family chapels owned by wealthy citizens, was taken a step further when special domestic altarpieces were introduced for religious observances in the home (Pl. 44b). But the quality of these

pictures was not always very high.[3] As a rule, the most outstanding of the works of art commissioned by the rich burghers were still exhibited to public view in the churches: the "democratic" concept was thus satisfied, and with it those of the family reputation and the credit of the family firm likewise found visible expression. The city, of course, also ordered frescoes for its public buildings, even including some of secular subjects (Pl. 92). These commissions, however, were rarely placed direct; as a rule, the organs of the town, the guilds, and mostly the greater ones, acted as its trustees and carried out these large schemes with public funds. In addition, the guilds, again in particular the greater guilds with their vast financial resources, ordered works of art on their own account, usually altarpieces for their assembly halls, chapels and oratories (Pl. 21b). The fraternities did the same (Pl. 45b, 88, 96), often commissioning painted banners (*gonfaloni*) as well.[4] Miniatures were painted mainly for the large liturgical books, especially the choir books of churches and monasteries, and to a lesser extent also for the manuscripts of the wealthy members of the middle class (Pl. 76b); these, however, would occasionally be simply inexpensive pen drawings. In some cases these miniatures, commissioned or purchased by individual laymen, dealt with secular themes (Pl. 93b, 94, 95, 98b); this was the case also with the frescoes which, towards the end of the century, decorated the rooms of the affluent burghers (Pl. 97). The use of sculpture, whether statues or reliefs, was almost confined to the adornment of public buildings or of tombs in family chapels in the churches.[5]

We shall discuss the style of all these works in detail later. But here, while dealing with the different types of commissions, we must point out an important feature which, though not invariable, was very frequent, and which will be confirmed in many specific instances. On the whole, the majority of the types of commission just referred to were determined by the taste and outlook of the upper middle class: whether it was a case of an individual order, an order placed by a greater guild acting on behalf of the city, by a greater guild on its own account, or by one of the fraternities. Yet this upper-bourgeois taste and outlook found varying expression in these commissions, according to which of these circumstances operated when the orders were given. The upper-middle-class outlook could be expressed in its purest form when the commission came from some individual patron who, from the point of view of his own stratum, was very progressively-minded. The same was true to some extent when commissions were transferred by the city to the guilds, that is to say, where a relatively small and select committee of a greater guild, often composed of its leading members, played the decisive role. The larger the committee, the greater the possibility that many more conservative-minded members would bring their influence to bear. The commissions corresponding least of all to the advanced taste of the upper bourgeoisie were those placed by the fraternities, even the wealthiest of them: in these purely charitable and religious organisations mem-

bers of conservative and backward taste were always in the majority. The poorer fraternities and the lesser guilds could of course order works only from insignificant, very artisan-like artists.

NOTES

[1] The last great mosaic produced in Florence—that of Christ between the Virgin Mary and St. Miniato in the choir of S. Miniato (1297)—was executed for a church belonging not to the mendicant Orders, but to the aristocratic Benedictines, situated outside the city walls, and under the patronage of the conservative Calimala.

[2] These domestic altarpieces had already appeared sporadically at the end of the previous century.

[3] The Dominican Giovanni Dominici wrote in a book of pedagogical rules (*Regola del Governo di Cura familiare*, 1400) intended for his penitent, the wife of the exiled Antonio degli Alberti, that a number of small altarpieces should be set up in the house for the children to look after and decorate every feast-day, exactly as was done in the churches. It seems probable therefore that at times less important votive pictures, rather than valuable paintings, were used for private services even in wealthy houses. Furthermore, Dominici held that children should not become accustomed in the churches to glittering pictures decorated with gold and precious stones, but to the old smoke-blackened ones. This view was general in conservative circles, where pictures of the latter kind were considered more devotional.

[4] The sermons of St. Peter Martyr seem to have given the original impulse for the erection of the numerous street tabernacles. They again became especially frequent as a consequence of the pestilence of 1348.

[5] The tombs of the nobility, like those of the rich burghers, were in general fairly simple in the fourteenth century. Only a few of the wealthiest citizens, who had paid very large sums towards the building of the churches concerned (as, for instance, the Bardi, Baroncelli and Acciaiuoli), and a few of the high church dignitaries, had tombs at all imposing. But even in these cases they were generally unpretentious, and not as yet really sumptuous. The prevailing spirit still tended to repudiate pomp and ostentation, the legacies themselves being regarded as the chief claim to fame. Towards the end of the century, the city as such contemplated the erection of some grand-scale tombs, but these plans were never carried through. Thus in 1394 the Signoria voted a splendid grave to the English *condottiere*, Sir John Hawkwood, then still living, who fought a number of successful campaigns for Florence, and whose intervention in 1382 had made the victory of the upper middle class over the lesser guilds possible. In 1396, again, a plan was prepared for setting up magnificent tombs in the cathedral in honour of the greatest Florentine writers, in particular Dante and Petrarch, and at the same time very significant of upper-bourgeois mentality—the great civilian, Accursio. Distinguished people could generally hand down their memory to posterity only in the form of life-size images, the so-called "Boti", votive offerings to the Virgin, copied in wax as faithfully as possible from nature, and displayed in the church of the Servite Order, SS. Annunziata (earlier in Orsanmichele). For the still existing connection between such works and the witchcraft of images and magic, see J. Schlosser, "Geschichte der Porträtbilderei in Wachs" (*Jahrb. der Kunsthist. Sammlng. in Wien*, XXIX, 1911).

B. RELIGIOUS PAINTING

a. Representations of Christ, the Virgin and the Saints

a. *GENERAL ASPECTS AND SUBJECT-MATTER*

THE new middle class of Italy, especially of Tuscany, was the most advanced in Europe, and the most certain of itself. It stands to reason that the art of previous centuries (or, for that matter, of contemporary but less bourgeois France) could not really satisfy its members, for it made little appeal to their spiritual interests and emotions, and its very content was intelligible to most laymen only in a general way and in its elementary ideas.[1] As a whole this art was symbolical, dogmatic and—at least in principle—didactic in character, though less so in Italy than elsewhere. Narrative motives, which might have lent themselves to a more personal appeal, had had to come into line with this general character. But the Italian middle class already expected of their art, as a main quality, that it should be capable of bringing God both intellectually and emotionally nearer to man. This implied a reversal in the relative importance of the two elements, the symbolic and the narrative. What had formerly been of chief moment was now relegated to the background. The general symbolical and dogmatic character was toned down, and the story-telling motives, which could be more directly humanised, were given far more prominence than the allegorical. The cult-images and religious narratives, consisting in the main of representations and stories of Christ, the Virgin Mary and the Saints, were separated from the framework of the old dogmatic and symbolical Cycles of Salvation; becoming independent, they lost that impersonal character which had formerly made them so remote from the average layman.

Naturally, this does not imply that all narrative representations lost every trace of symbolism. The dividing line between the religious narrative and symbolical art—even taking the latter in its narrowest sense—was a continually shifting one. In numerous works or in single details, an open or concealed symbolic significance remained, and there are cases—which will be discussed in a separate chapter—in which the symbolical and didactic elements were retained to a remarkable degree. Nevertheless, there can be no doubt that the general character of the new middle-class art was essentially determined by the ritual representations and narrative pictures we have mentioned.

The changes that occurred in the treatment of ritual representations and religious narratives during the thirteenth and fourteenth centuries can be grouped under three headings.[2]

FOURTEENTH CENTURY: CHRIST ETC. (SUBJECT-MATTER)

In the first place, the old cult-images were humanised. The gigantic representations of Christ and the Virgin Mary enthroned which from apse or dome had dominated the whole interior of the church, were now superseded. The ritual pictures with all their appearance of timelessness which had served purely for worship, such as those of the crucified Christ and the Virgin, were now rendered more personal, more life-like, and thus made accessible to personal devotion.

Secondly, the religious narratives now took on a new significance: they lost their dogmatic and purely ideal character within a solidly established, didactic theological programme, detached themselves in some degree from this context, and became real stories. A large number of such themes had already been in existence earlier, when the urban middle class was less developed, and the monasteries were still isolated from the people; yet even these older themes now received an entirely new interpretation. Quite apart, however, from this transformation of old subjects, the most striking feature of the new phase is an immense thematic enrichment. The new themes possessed a high degree of descriptive narrative interest and a spontaneity which brought them both emotionally and intellectually nearer to the spectator.[3] The middle class wished to come into contact with God directly, or at any rate through the mediation of the saints who now, as patrons, played a far more eminent role than before. The earthly lives of Christ, the Virgin and the Saints therefore were depicted, those scenes especially being selected which would arouse the greatest personal sympathy and make the strongest human appeal.[4] The themes newly invented or particularly emphasised from the thirteenth century onwards were taken from the life of Christ—scenes from his childhood and still more, a very important fact, from his Passion; from the life of the Virgin, deriving from stories of Christ's childhood, and finally from the legends of the saints.

To the humanisation of cult-images and the formation and transformation of religious narratives must be added, as a third feature, especially from the fourteenth century, the emergence of purely devotional images, which cannot always be included in the first category. Made up mostly of lyrical scenes associated with the Passion, and showing practically no action, these made an emotional relationship with the spectator possible to a degree hitherto unknown; for instance, the Man of Sorrows supported by Mary (Pl. 27a) and the figure of the solitary Christ bearing the Cross (Pl. 46).[5] But in point of fact, the real milieu for these purely devotional images was not so much Italy, certainly not upper-middle-class rationalist Florence, as the more lower-middle-class countries of the north.[6]

The two concepts of "increase of feeling" and "increase of intelligibility", which we are frequently using bear a significance differing with each successive phase of our period, and still more with each social class. The boundary between them is indefinite; they shade into each other, with most varied nuances,

according to the historical situation. Following the development of the upper bourgeoisie—with phases of advance no less than of decline, periods of unchallenged political supremacy when they could give expression to their own outlook in a pure form no less than periods when concessions to the petty bourgeoisie were necessary—in every phase, their art tended to gravitate either towards greater intelligibility, more conformable to their own preference, or towards placing greater stress on emotional elements, which appealed rather to the lower sections. Moreover, intelligibility meant one thing to the rationalist, matter-of-fact upper middle class and quite another to the irrationalist lower middle class, who sought an outlet in religious emotionalism. In the early Middle Ages, the ecclesiastical conception of the didactic, subordinate role of art and of its inability to fulfil its instructional functions unaided,[7] led to the combination of picture and inscription (*titulus*), with the emphasis on the latter; but by this time the more cultured circles could appreciate a picture which spoke for itself. Nevertheless, in those paintings especially in which the lower strata also were considered, or when a specific literary unit was to be created, inscriptions were even now frequently retained. Just as the conception of "intelligibility" varied, so also did the closely related one of "enlivenment"; here we are at once reminded, more insistently perhaps than in the case of the two other similar concepts, how impossible it is to draw a strong line of demarcation between the new shaping of the content and the forms, and even at this stage we cannot entirely exclude consideration of the formal elements.

From a formal standpoint, as a result of the new subject-matter the old formulas of composition—memory images, they might be called[8]—no longer played their former decisive part; for, as we have seen, new experiences had to be infused into the old schemes, and many additional compositions created.[9] The immense thematic enrichment, even if derived mainly from literary sources, brought in its train a new criterion for judging of truth to nature, and a new and independent way of looking at nature itself. Figures were now portrayed in quite a new manner, as the result of this independent and individual observation of nature, and the old traditional types of figure-presentation were more or less abandoned.[10] New figures were introduced into the stories to enliven them and increase their emotional appeal, figures were massed to form crowds, genre-elements were employed, landscape, now more accurately observed, played a big part. This all leads to far-reaching realism of detail. But even this realism of detail could be surpassed in the course of development. At a time when the rationalism of the upper middle class had attained a certain peak—we shall recognise Giotto as the most consistent example—the events from the life of Christ, the Virgin, and the Saints, as they had occurred among human beings, were clearly understood in their relationships and lucidly built up with regard to form as well. This naturalism, demanded by the Florentine upper bourgeoisie at the height of their development, was sober and concentrated, going beyond a mere realism of

detail. These few preliminary remarks will suffice for the present to indicate what will have to be elaborated later, namely that the new themes, demanding new formulations, gave rise to a number of new and different styles and combinations of styles corresponding to the different social classes and their successive generations.

The new naturalistic themes, as we have seen, mostly began to appear in the course of the thirteenth century, when the middle class were struggling for power and the Franciscan Order was in its heroic phase; but after the final victory of the upper bourgeoisie in the early fourteenth century, and after the mendicant Orders had become a definite stabilising factor, these themes were to some extent rationalised. Here we must confine ourselves to a very general characterisation of these new themes, and for the moment only glance at some of their later variations, which appeared in the democratic phase of the mid-fourteenth century, as well as during the period of reaction that marked its close. There is no inherent contradiction between the tendencies we have noted towards a more emotional and human art, and the fact that in the course of the social changes during the fourteenth century, certain themes became more hieratic and ecclesiastical in character; for naturally it was then no longer a hieraticisation in the extremely impersonal, rigid manner of the preceding age. Finally, together with the democratisation that took place in the mid-fourteenth century, the lives of Christ, the Virgin, and the Saints were sometimes also associated with contemporary life by the purely exterior device of presenting the scenes anachronistically, in the setting of the ordinary Italian middle-class family of the time. Close contact with the public, in this regard, once established, was never again to be lost; so towards the end of the century, with the growing reaction, the same scenes, particularly in the case of the larger commissions, were depicted more and more frequently in wealthy, distinguished, and especially increasingly aristocratic surroundings.

The Gospels alone were nothing like a rich enough source for all these new themes and their presentation, even for the lives of Christ and the Virgin. Therefore the apocryphal gospels with their more genre-like details were drawn upon more often than before, especially for scenes dealing with the life of Mary. Yet even these were by no means adequate. Contemporary ecclesiastical writers, usually mendicant friars, now became particularly helpful, as they brought certain scenes from the stories of Christ and the Virgin to the fore, spun them out with innumerable details, and added new emotional emphasis. The *Legenda Aurea* (1263–88) of the Dominican Jacobus de Voragine (1230–98) was an essential source for scenes from Mary's life. But the fullest enrichment of painting undoubtedly came from the *Meditationes Vitae Christi* (*c.* 1300) of Giovanni de Caulibus, known as the Pseudo-Bonaventura,[11] a Franciscan friar from San Gimignano, not far from Florence. A typical Franciscan mentality went to the making of this work, in which Christ's life, in particular his childhood and his

Passion, is elaborated in the greatest detail and described as if it were the story of some contemporary Italian citizen, or rather craftsman.[12] It is also characteristic that Mary, with her joys and sorrows, is brought very much to the fore in these narratives. To over-emphasise the significance of this work for the visual arts is impossible; it was very soon translated into Italian, and was in its turn just as much a sign of the new middle-class outlook as were the pictures themselves. For representations of the Nativity, the visions of St. Bridget (1303–73), who lived in Italy, were of cardinal importance. In addition, painting was inspired by the various types of religious drama and displays:[13] the liturgical dramas and the dramatised *Laude*, which were sung as part-songs (called *Devozioni*), in the performance of which the Fraternities took a large share, and the Church festivals and processions, in Florence especially that of St. John the Baptist. From these beginnings arose in the course of the fifteenth century, and probably even earlier, the *Rappresentazioni Sacre*, the most popular form of religious drama and that which was most frequently drawn upon for painting.[14] These plays soon came to include many scenes from the lives of Christ (again particularly from the Passion) and of the Virgin, many of them taken directly from the *Meditationes*, and elaborated in detail in their turn. The artists certainly obtained new motives and new situations from these plays.[15]

We will now enumerate some of the principal scenes from the lives of Christ and Mary, which will be met with again and again in later chapters,[16] and of which many received in Florence a form decisive for their whole future development.

In the scenes from the childhood of Christ and from the earlier life of the Virgin, it was possible to bring out the homely and tender aspects of middle-class family life with the affectionate attachment of its members to each other, and particularly to show the love of the Mother of God for her Child; while use was also sometimes made of the still earlier story of her parents, Joachim and Anna. The birth of Mary (Pl. 25a, 48) was an occasion for showing the chamber of a middle-class woman in child-bed with the customary nursing arrangements. Then follows her visit to the Temple (again providing much scope for genre-like elaboration) and her marriage with Joseph. The scene (Pl. 113a, 22a) in which the Angel announces to Mary that she is destined to give birth, through the Holy Spirit, to the Saviour of mankind, was one of the favourite and most frequently commissioned subjects on account of its deep significance; here could be illustrated Mary's pious resignation to God's will,[17] and in time her complete bourgeois domesticity also.

The story of Christ was linked with that of St. John the Baptist through the common Motherhood:[18] the two expectant mothers, the Virgin Mary and St. Elizabeth, meet (Visitation). The scene from Christ's childhood most frequently depicted was the Nativity (Pl. 20a, b, 55). This was rendered more touching and intimate by adding many realistic genre-details: Christ is brought into the

world in a simple stable; at the side of the recumbent mother are an ox and an ass; Joseph has fallen asleep on the floor, and angels surround the group; for the introduction of angels was now general in order to render the narrative more vivid and more intimate at the same time.[19] We shall find, however, that during the second half of the fourteenth century the Nativity was treated in a less realistic manner, more like a mystic vision, with Mary kneeling in adoration before the Child (Pl. 54). The divine message announcing the Saviour's birth to the shepherds as they watched their flocks provided an opportunity for showing peasant life (Pl. 19a)—though one not very often made use of in Florence. In the more frequently repeated companion-theme, on the other hand, in which the Magi, having likewise received the Angels' message, adore the Infant and offer their gifts (Pl. 107a),[20] the well-to-do could be painted in all their pomp and luxury.[21] Then follows the Presentation of Christ in the Temple. The flight of the Holy Family into Egypt to escape Herod's Massacre of the Innocents, gives rise to one of the favourite genre-scenes: the Virgin Mary, holding the Child in her arms, rides on an ass led by Joseph, while ministering angels accompany the group. At the same time the Massacre of the Innocents is depicted (Pl. 50, 51): Herod's mercenaries murder the new-born children, while their despairing mothers try to protect them. This gave an opportunity for representing a horrible massacre, a not uncommon occurrence in those days on the capture of a town. A further scene was that of the boy Christ disputing with the doctors in the temple.

Christ's public ministry provided far less scope for emotional treatment than his childhood and Passion, and was illustrated much more rarely and with less detail. As a rule only his Baptism in the river Jordan, with occasionally the Marriage at Cana, and the Resurrection of Lazarus, were shown.

The Last Supper (in which the motive of St. John resting his head on Christ's breast was treated with ever-increasing emotionalism; (Pl. 18, bottom) and Christ washing the disciples' feet, are preludes to the Passion. The Passion itself begins with the scene in which Christ prays in the garden of Gethsemane. Immediately afterwards comes his arrest by the soldiers, guided by Judas. He is then represented as bound and dragged before Pilate, and often before Caiaphas also. The story of the Passion was used to illustrate Christ's martyrdom in a deeply moving and exceedingly detailed manner, as that of one who suffered a terrible death for the salvation of all mankind, including the poor. This was the best opportunity for arousing sympathy, and for showing Christ as a suffering human being. No other subject, therefore, was so popular,[22] even though the sentient and realistic aspects of its representation varied with the different phases of our period. Here the more emotionally-inclined sections of the middle class as well as the poor, bowed down with the cares of life, were given, as beholders of these frescoes and altarpieces, a visual opportunity of feeling close to God, who himself had suffered. The same was the case with repre-

sentations of Christ bound to the column and scourged, or crowned with thorns and mocked by his tormentors (Pl. 28). One of the most momentous scenes was that which showed Christ, beaten and dragged along, himself bearing the cross on which he was to suffer death, while his weeping mother—a motive of striking innovation—follows the procession, which tended to include an ever-increasing number of figures (Pl. 35, 75b). Mary, sharing in the sufferings of the Passion, was by now—chiefly on the authority of Pseudo-Bonaventura[23]—not merely introduced into many of its scenes, but made to stand out as the chief of the mourning spectators, so that the events might appear more moving and human. The drama reached its climax with the Crucifixion itself, throughout the whole period one of the favourite and most frequently repeated themes, sometimes preceded by Christ's Devestment and the Nailing to the Cross. The dead Christ hangs on the cross between the two thieves; the fainting Virgin is supported by the women who accompany her, and by St. John the Evangelist, the beloved disciple; Mary Magdalene clings to the cross weeping, and the whole group is often surrounded by a large crowd of compassionate onlookers and heartless soldiers (Pl. 3a, b, 16a, b, 17a, 57, 58, 59). The introduction of Mary Magdalene into the story of the Passion in this intensely emotional fashion, a motive particularly popular with the Franciscans, should be noted.[24] The witnessing crowd was greatly enlarged, especially after the middle of the fourteenth century, when the democratic movement grew in intensity. The next scene, the Descent from the Cross, again offered great possibilities in its exhibition of the martyred body of Christ, and the sorrow of Mary (Pl. 22b). It was succeeded by the Mourning for Christ (Pietà, in the wider sense), the main theme of which is the Lamentation of Mary and of the Magdalene over the dead body (Pl. 6, 7, 17b, 29, 56b)—an intensification of the effusions of sorrow of all the earlier scenes. This is one of the most significant episodes of the whole Passion cycle; it is practically devoid of action, and, more than any other, affords the spectator the opportunity for sympathetic participation in the mourning. Though it contains more action, the Entombment is closely related to the last-mentioned scene in both theme and sentiment.

The actual story of the sufferings of Christ as man ends here, but many subsequent scenes of the Passion also provided ample opportunities for representing Christ, the Virgin, and the apostles, in a most evocative and human manner: Christ in Limbo (Pl. 60), the Women visiting the Tomb, the Resurrection, the *Noli me tangere* (Pl. 5a), the Ascension (Pl. 74), the Doubting Thomas, the Supper at Emmaus, and the Descent of the Holy Spirit. The story of the Virgin terminates with the scenes of her death, her Assumption, and her Coronation (Pl. 45a). Representations of the Assumption in fourteenth-century Florence are mostly conceived hieratically, Mary being always portrayed as the Queen of Heaven and as intercessor.[25] The Coronation of the Virgin, though the theme is in itself hieratic, was at times somewhat emotionalised, and became

very popular in Florentine painting from about the middle of the fourteenth century onwards.

Even the representation of the Last Judgment now lost its former purely dogmatic character. It no longer merely presented the dogmatic concept of the end of the world, but, combined with a detailed representation of Heaven (Pl. 36) and Hell (Pl. 4, 38, 39), became a kind of penitential sermon[26] in which the torments of Hell were especially emphasised, often by making use of Dante. The deliberate placing of certain classes or individuals among the blessed or the damned—likewise on the model of Dante—was a favourite means of artistic propaganda. The portrayal of the blessed and the damned provided scope for psychological penetration of the figures and dramatisation of the scenes (Pl. 37). Moreover, the representations of Hell afforded one of the rare opportunities for showing the nude figure in every conceivable pose, and also for depicting in accordance with popular imagination the grotesque forms of devils, who figured so prominently in religious drama.[27]

But the changes in this period were not confined to the bringing forward of these historical cycles of newly invented or reinterpreted scenes from the lives of the Virgin and of Christ;[28] the purely ritual representations of these sacred persons also underwent a profound transformation. They were humanised, brought into direct relation with the spectator, and treated as real devotional images. Here again the influence of Pseudo-Bonaventura's *Meditationes*, the Laude, and probably also of contemporary sermons, was very marked.

Christ on the Cross had formerly been depicted as a pure cult-image: standing alive and upright on the cross, he was sometimes even partially clothed, for in the Middle Ages nakedness was a sign of bondage and inferiority. But from the twelfth, and still more from the thirteenth century onwards—the revolutionary period of the middle class—the image of the crucified Christ took on a new significance, becoming more and more radically transformed in appearance. This change was associated with the rise of the democratic Franciscan movement, and stimulated by the fact that St. Francis had shown a special devotion to the suffering Christ and to the Crucifix. This new class in society— the middle class—not to mention the poor, could feel a direct attachment to a God who had suffered and died—who had died for *them*. Gigantic life-size crucifixes, and paintings even larger than life-size, became the favourite votive pictures of the Italian middle class; these paintings were given the shape of a cross, the mourning figures of St. John and the Virgin being often depicted on the horizontal arms, while the upright was widened to give space for small scenes from the Passion. These vast pictures, suspended from the chancel-arch or placed on the entrance-wall, dominated the whole interior of the church, in contrast to the former majestically aloof and enthroned Christ of the choir-apse mosaics. Not only was Christ now always represented naked, except for a loin-cloth, but especially after about the mid-thirteenth century, it seemed the

image of a real corpse that was suspended from the cross (Pl. 2a). The body is emaciated, often the feet are crossed and transfixed with a single nail, the ribs protrude visibly from the chest: Christ has suffered an agonising death, all the marks of his last struggle being plainly visible.[29] But during the early fourteenth century, when the upper middle class were no longer revolutionary-minded and the poor had far less political importance, the agony of Christ as shown in these Crucifixes commissioned by upper-middle-class patrons was greatly subdued in character as compared with the often ferocious renderings of the previous century. Giotto's representation (Pl. 2b) and the many Crucifixes derived from it, show an heroic, relatively idealised Christ. On the other hand, this greater calmness—already the specifically upper-middle-class conception—by no means implied a lessening but rather an intensification of interest in anatomical studies.

A change similar to that in the Crucifix took place in another originally hieratic type of picture (derived from Byzantine painting), the *Imago Pietatis*, the naked half-figure of Christ which, in fourteenth-century Italy, was transformed into the Man of Sorrows composition. The upright half-figure of the dead Christ in the sarcophagus is held by the Virgin and St. John, who mourn over it (Pl. 27a).[30] Thus in Florence, the Man of Sorrows theme was more or less combined with action akin to that of the Mourning, the boundary-line between the two remaining undefined. Yet to a certain extent the Man of Sorrows was a devotional image without action, intended for reverent contemplation, and to evoke an intimate union between the spectator and the Divine. Although the dead Christ shown in these pictures is not so piteously mournful as in the lower-middle-class north, yet the theme expressed, even in Florence, mainly a tendency of popular mysticism, and was particularly in demand following upon the intensive democratic efforts of the mid-fourteenth century.[31] With this democratic implication, it is *par excellence* the Italian counterpart of the single group of the Virgin holding her dead Son on her lap, the *Pietà* in the strict sense of the word: this motive (even if, possibly, of Tuscan origin)[32] was greatly favoured and really widespread only in the North. In this "northern" *Pietà*, in contrast to the type previously mentioned, the main accent is placed, not on Christ, but on Mary. This group of the Lamentation of Mary (Pl. 47), based on a passage in Pseudo-Bonaventura, and detached from the larger composition either of the Mourning or of the Deposition from the Cross, was far too lacking in action, too passively emotional and purely devotional to make much appeal, generally speaking, in the upper-bourgeois and rationalistic atmosphere of Florence. But it occasionally occurs in Siena, which occupied an intermediate position between Florence and the lower-middle-class North.

Under the influence of the new cult of the Virgin, which set in mainly during the thirteenth century, largely through the rise of the Franciscan movement (St. Bonaventura, Jacopone da Todi, Pseudo-Bonaventura), the image

of the Madonna also underwent a complete transmutation. Mary was no longer exclusively the purely formal Queen of Heaven—although this basic type still persisted and was even very much alive.[33] She now became to an ever-increasing extent the gentle, loving mother of God,[34] for it was precisely this intensely human conception which formed the basis for the rapturous homage now paid her.[35] The small and intimate painting of the Virgin and Child became the typical devotional image of the fourteenth-century middle-class home, and was the subject by far the most frequently depicted during the whole of our period. The relationship of Mother and Child came in time to be purely maternal and intimate.[36] The Infant lost all ceremonial distinction, and was rendered as a real child; he is nursed by his mother, caresses her, plays with her, takes flowers from her, or holds a bird in his hand (Pl. 24a, 68a, b).[37]

Sometimes, too, Mary sits no longer on a throne, but on a low cushion, or even on the ground (Pl. 44, a, b). This "democratic" motive of the Madonna of Humility (*Madonna dell' Umiltà*) appears at the beginning of the fourteenth century and it is certainly connected in its origin with the ideas of the Spirituals,[38] the virtue of humility exalted by St. Francis being transferred to the Madonna. But from its very first appearance this pictorial theme began to receive numerous theological and symbolical interpretations (the Heavenly Woman of the Apocalypse with sun, moon and stars, *Mater omnium*, *Regina coeli*, *Regina humilitatis*, etc.) at the hands of the Franciscans and still more of the Dominicans, who took it up with particular intensity. The original motive of poverty and humbleness was thus as far as possible weakened, and in some cases even transformed into its direct opposite.[39] But the intimacy and simplicity inherent in this motive could not, of course, be entirely theorised out of existence, and, during the fourteenth century at least, something of the original conception always remains. The motive, then, of the Madonna seated on the ground is but one example among many of a general tendency towards naturalness and at the same time sentiment in the religious representations of the late thirteenth and fourteenth centuries, which expresses itself by bringing sacred figures as close as possible to the ground, and depicting them by preference as kneeling, sitting or even lying. This change took place also in the representations of the Nativity: it becomes increasingly common for Mary to be portrayed kneeling or seated on the ground as she tends the Child (Pl. 20a, b). Finally this group, with its appeal to sentiment, is shown alone, extracted from the framework of the story, and thus we have the independent picture of the Madonna of Humility.[40]

Before these pictures of the Madonna and Child, the spectator often has the impression that he is looking at a typical middle-class or at least domestic family group,[41] all the more as new figures came to be added to accentuate this family note.[42] The same tendency towards family pictures appears in the emergence, towards the mid-fourteenth century, of the group of the Mother and Child with St. Anne, where the Virgin is seated in St. Anne's lap, herself holding

her Child in her own. To understand the further significance of this group, we must remember that St. Anne was intended to emphasise the Immaculate Conception, consummated in her, and that the popularity of this Saint with the wealthy Florentine middle class was largely due to the fact that it was on her feast-day that the Duke of Athens, who for a time had interrupted the continuity of upper-middle-class rule, had been expelled in 1343.

A particularly striking expression of the quest for a personal approach to the Divine is the image of the Madonna of Mercy (*Madonna della Misericordia*) which also became widespread from the thirteenth-fourteenth centuries onwards. Whole corporations, religious fraternities especially, had their group-portraits painted under the protective mantle of the Virgin, on frescoes, altarpieces (Pl. 65), miniatures and banners. The two great mendicant Orders, whose influence with the fraternities was decisive, contributed a good deal to the development of this motive.[43] Intimately related to the Madonna of Mercy theme was that of Mary as Mediator, protecting man against the plague, a motive which enjoyed a similar popularity, especially with the brotherhoods. The desire to seek the protection of the Mother of God, the citizen's personal relationship towards her, could have found no more striking or tangible embodiment than in these images.

Even the ritual picture *par excellence*, the altarpiece with Madonna and Saints, was increasingly transformed into a personal guardian image. During the fourteenth century, it is true, the arrangement still retained many hieratic and ceremonial elements; the gold background remained, and the Virgin was shown seated on a raised throne surrounded by standing or kneeling angels (Pl. 24a) and saints symmetrically grouped, the saints usually being still relegated to the wings. The saints, however, were now brought into closer and closer relation to the Virgin, not merely through the thematic treatment and its pervading sentiment, but sometimes also by the technical device of unifying the whole altarpiece by omitting side-wings (Pl. 81a). Moreover, personal contact with the placer of the commission was established not only by humanising the figure of the Virgin, but even more through the medium of the saints surrounding her. For these no longer interceded merely for sinful humanity in general, but for the donor of the picture in particular, and in some cases they would be his special patrons and name-saints. In this way a very special relationship between donor and picture was established, as well as between him and the Virgin herself, to whom he wishes to be recommended by his patrons.[44] Nor was this all, for from the beginning of the fourteenth century the donor himself appeared more and more frequently in the altar-panel he had presented—a further consequence of the more private attitude towards religion. At first he was intentionally portrayed as a disproportionately small figure (Pl. 68a), but often he grew larger, and with his patron saint was placed closer and closer to the Virgin. Frequently, moreover, his whole family was included (Pl. 24b, 68b). In some cases the

donors were also allowed to participate as spectators at a Passion scene, such as the Crucifixion (Pl. 16a, 18).[45]

Christ and the Virgin apart, the saints and their legends provided the richest subject-matter for religious painting for both frescoes and altarpieces, and one which was by now quite independent. For, from the religious point of view, history was regarded essentially as the story of salvation, and in particular as the history of the saints; secular history in comparison was scarcely considered. A large literature had come into being, written by clerics, in which the material of the Biblical books and the legends of the saints was arranged, and this was often also translated into the vernacular. Just as the Franciscan Giovanni da S. Gimignano (Pseudo-Bonaventura) was the main source for the pictured stories of Christ and the Virgin, so the Dominican Jacobus de Voragine, already mentioned, was drawn upon for the legends of the saints. His *Legenda Aurea* popularised the moral textbooks of the Middle Ages just as the *Meditationes* popularised the Gospels. The numerous thirteenth-century descriptions and interpretations of the life of St. Francis, the variations of which were due to different views as to his place in the history of salvation, do not at present concern us. The pictorial representations of the Saint were at first based on the *Tractatus de miraculis* by the Franciscan Tommaso da Celano written about 1250, in which popular miracles and healing play a major part. Later, especially during our period, the chief source was the official Life of St. Francis, the *Legenda Major* (1263), written by St. Bonaventura, General of the Franciscan Order; this account, as a compromise, still shows a certain Spiritual influence.[46] But danger from the Spirituals was considered so acute that, by resolution of the General Chapter of Paris, in 1266, all earlier Franciscan legends, including that of Celano, had to be destroyed. Representations of the hermit-saints were based on the popular vernacular *Vita dei Santi Padri*, by the Dominican friar Domenico Cavalca of Pisa (1270?–1342).

Typical of the middle class of the fourteenth century in their gradual social differentiation was the very great increase in the portrayal of saints and their legends. A far larger number and greater variety of patron saints now appeared; the patron of each guild, each fraternity, each wealthy citizen was given his own altarpiece. These altar panels, as a rule, contained a large-size figure of the saint, still somewhat ritual in character, even if individualised. To counterbalance this, a more intimate, emotional, and personal note was introduced by adding small compartments to the right and left and sometimes even on three sides of the central figure, showing scenes from his life and especially his martyrdom. This last was always very popular, since the sight of a saint undergoing suffering appealed also to the poor. These narrative scenes were vividly and circumstantially treated, with elaborate detail of accessories, architecture, and landscape. Such was the general practice during the thirteenth century (Pl. 10), and in the case of the more "popular" artists during the early

fourteenth century also. It was followed, for example, by the Master of St. Cecilia (Pl. 11), a younger contemporary of Giotto, though more popular in the sense that he did not work exclusively for the wealthiest sections of the middle class. But the arrangement described recurs throughout the fourteenth century (Pl. 30), during its more democratic phases, though the number of separate scenes tended to be reduced. This manner of disposition was fundamentally due to the desire of the less educated public to "read off" the events depicted.[47] The vivid description these scenes demanded necessarily implied an increasing amount of naturalistic observation of detail (Pl. 12a, b, 31). This narrative manner, so appropriate to the portrayal of interesting events in the stories of the saints, was carried over into the predellas, which about the beginning of the fourteenth century were coming to replace the earlier arrangement of compartments around the central figure and contained a smaller number of scenes, taking up much less room (Pl. 40, 41a, 49). In shape these panels were long and narrow, usually divided into three or five sections, either in a single piece or detached, and they were simply placed below the altarpiece, thus imparting greater unity and concentration to the ensemble, more in conformity with the artistic requirements of the upper middle class.[48] But even this greater unity was only relative. Since there was not much space on these narrow panels, a single predella often combined several scenes distinct in space and time; the events, that is, were presented in a continuous narrative. This method of representation was much more frequently employed in the predellas than, for example, in the frescoes. Such an interpretation of the stories of the saints, still largely medieval, popular, and not as yet consistently rationalist, again made possible closer contact with the illiterate and lower strata as beholders. Moreover, the figures in such narratives were as a rule anachronistically clothed in contemporary dress, a fact which greatly facilitated sympathetic contact with the spectator; this became more usual after the middle of the century, in particular in the democratic years after 1370.

The choice of the saints depicted, both in altarpieces and in frescoes, was naturally of great moment, for it was often determined not merely by the use of the donor's actual name-saint,[49] but also by the way in which a given saint's legend could be interpreted. Consequently there was a great variety in the types of artistic patrons, each favouring stories of different saints.

SS. Peter and Paul, the so-called Princes of the Apostles, were the official representatives *par excellence* of the Church, and as such were preferred by the Dominicans. This applied especially to St. Peter, head of the Church and its first Pope; the handing of the keys to Peter was regarded in official ecclesiastical literature, particularly by Dominican writers, as signifying the bestowal of spiritual and temporal power on the Church. In the commissions given by the Dominicans St. Thomas Aquinas, the supreme representative of conservative and strictly ecclesiastical learning, naturally played an outstanding part. He

was usually shown teaching, holding his chief work, the *Summa*, in his hand, and crushing the heretics, especially Averroes (Pl. 41b, 84, 85);[50] for in their sermons the Dominicans were continually warning laymen against and protecting them from the extreme rationalist views of the Averroists, which had been adopted by certain radical intellectuals and so vigorously combated by St. Thomas himself. The same ecclesiastical tendency was also expressed in the cult of the severely orthodox and anti-heretical St. Dominic (1170-1221), although he came off badly in representations, since on the one hand St. Thomas was an even greater authority on matters of dogma, while on the other the visions (Pl. 25b) and deeds of St. Dominic (who moreover was not an Italian by birth) could not hope to rival those of the much beloved St. Francis.[51] With St. Peter Martyr (1205-52), one of the most inveterate persecutors of heretics, especially in Florence, where he founded fraternities for the purpose (Pl. 45b, 61a, 62, 63), St. Thomas Aquinas and St. Dominic were the most representative figures in commissions given by Dominicans. While in the thirteenth century even St. Dominic himself had no role in Florentine art, in the fourteenth all three figures appear very frequently as a consequence of the growing influence of the Dominican Order.

The story of St. Sylvester and the Emperor Constantine, who was baptised by the Saint—an event which initiated, in the official conception, the thousand years' rule of the Church—naturally appealed to the upper middle class, while the Spirituals regarded it as the hated symbol of the official Church's secularisation, bureaucratisation, paganisation and decay. St. Catherine of Alexandria, who, legend says, disputed successfully with heathen scholars, was, like St. Thomas, though in a more popular sense, a representative of ecclesiastical learning (Pl. 26a, b, 69, 71, 76a). The life of St. Benedict, founder of the Benedictine Order, who had spent long periods in solitude as a hermit, was often illustrated in Benedictine churches (Pl. 72). At the end of the fourteenth century, under the influence of the Observance movement and its ideals, the representation of his life was also favoured by the upper middle class. Less official-ecclesiastical in character, generally speaking, and more popular in their appeal, were the stories of the holy hermits of the Egyptian desert (Pl. 32, 33); outstanding among these was St. Anthony the Abbot, who, moreover, had given his wealth to the poor (Pl. 75a) and had been tormented by devils (Pl. 67), but whose popularity was probably based to a great extent on the protection he gave from illness. The lives of these hermits fascinated the masses, who yearned after a similar existence of peaceful devotion undisturbed by the forces of temporal authority; the fraternity of dyers, for instance, had as their patron the hermit St. Onophrius. Especially popular—again in a less rigorously orthodox sense—was St. Margaret, whose dying request, according to the *Legenda Aurea*, was granted by God, that everybody, especially women in childbed, should meet with success if they prayed to her. A whole group of popular illuminated

manuscripts is composed entirely of the passion of this saint (Pl. 76b), a fact unique in Florence.[52] Of the actual artisan-saints, only a few were portrayed. For the lesser guilds with their occasional craftsmen-saints,[53] in contrast to the more petty-bourgeois north, played but a negligible role in Florentine art commissions, while on the other hand the greater guilds—again unlike their northern counterparts—did not include any artisan-saints among their patrons; thus the patron of the wool guild in Florence was not the craftsman Severus, but the deacon Stephen, proto-martyr and a figure of great ecclesiastical importance.

Whilst in thirteenth-century Florentine art the tales of St. Francis were drawn upon far more frequently than the legends of any other saint, and, as scenes which had to be created entirely from contemporary life, offered wide pictorial scope, after the early fourteenth century representations of his legend show a marked decrease. This reflects the lessening importance of the Franciscan Order and the ascendancy of the Dominicans already mentioned. Even so late as the early fourteenth century, the wealthy middle class were still using the representations of the Franciscan legend as an opportunity of demonstrating their respect for the popular idea of poverty, yet in a manner prudently non-committal, bereft of its thorns and, in point of fact, ultimately purely pictorial. The revolutionary view widely held during the thirteenth century, according to which St. Francis occupied a decisive, almost divine position in the plan of salvation,[54] had by now completely disappeared in official circles. This change was naturally reflected in the pictures illustrating his legend,[55] although even in the thirteenth century the most radical conceptions of him could not be portrayed. In the early pictures of St. Francis, most of which were still based on Tommaso da Celano's biography,[56] the greatest stress was laid on the Saint's well-known miracles and healings, and it is significant that the popular arrangement of the thirteenth-century altarpieces, in which small scenes surround the central figure, is most consistently applied precisely to these early paintings of St. Francis, and even appears to have emerged with that theme. In the fourteenth century, on the other hand, the scenes from the life of the Saint most frequently illustrated were those connected with the Pope, with monastic life, and with the life of the nobles or the wealthy citizens, while legends of mystical character or those of healings and "popular" miracles (Pl. 13), in which the lower sections had necessarily to appear, are far less frequent. The conception of the life of the Poverello now became eminently middle-class and restrained in character, especially in the frescoes painted by Giotto in S. Croce in the family chapel of the Bardi, the wealthiest bankers in Florence. Of the innumerable really popular legends of the Saint, of all those with an intense visionary element, or which lent themselves to the interpretation of his significance in the plan of salvation, that of the Stigmatisation was almost the only one to be retained (Pl. 18, left top corner). As the climax of the Saint's life and as the miracle in which the Franciscans took the greatest pride, it could not be omitted;[57] for the Stig-

matisation was the symbol of Francis' imitation of Christ, of his personal union with the Saviour. That is why he was so frequently depicted in paintings of the Crucifixion, as a witness of and sharer in Christ's passion; probably the first saint in such a position, he already appears in the monumental crucifixes of the thirteenth century, while later he is represented standing or kneeling at the foot of the cross in Crucifixion scenes (Pl. 16a, 18), especially in those commissioned by the Franciscans.[58] It was only in such forms as these that elements from the earlier period of popular mysticism still survived. In the fourteenth century, on the other hand, the theme of the Pope's confirmation of the Franciscan rule (Pl. 8), in other words, of the movement being drawn into official channels, was very much favoured. The same applied to a scene of comparatively minor importance, in which the Saint offered the ordeal of fire to the Sultan; this episode, first described by Bonaventura, provided an opportunity of depicting a monarch. The same tendency comes out as regards the Saint's physical appearance; represented in the thirteenth century in accordance with historical truth as puny and ugly, in the fourteenth century he stands forth idealised and imposing. Even where some trace of the Spirituals' mentality was necessarily allowed to remain, as in the huge monastic centre and popular atmosphere of Assisi, it was clothed in ecclesiastical forms, as in the Saint's betrothal to Poverty (Pl. 78) or in his apotheosis, where he appears seated on a throne, surrounded by a vast throng of attendant angels. It is also a sign of the changing times that in the fourteenth century, of all the great number of Franciscan saints, St. Louis of Toulouse (1274–97), a royal prince of France, enjoyed a most favoured place in the artistic commissions given by the Order itself (Pl. 18, left side) and by the Florentine upper middle class, allied to the House of Anjou. The Order required and appreciated the mark of decorum provided by having a prince among its members. This was of great practical use, and in fact St. Louis, an Angevin and therefore a Guelph also, immediately after his canonisation in 1317 was adopted as patron by the Parte Guelfa, the most proudly exclusive and oligarchical organisation of the Florentine upper middle class.[59]

While the presentation of tales of St. Francis and other saints of his order was steadily acquiring more distinguished features, at the same time—the mention of this is apposite in connection with the legend of St. Francis—the very poorest class, the beggars, came to be included in pictorial representations almost as a matter of course. They were given a place far more readily than were the average citizens or the artisans, for the presence of beggars in the pictures was intended to meet the charitable requirements of the rich, caused by their anxiety to save their souls. We have already seen that the beggar was the object of the wealthy burgher's good works, fulfilling an indispensable though passive role in the ecclesiastical programme of salvation. The well-to-do middle class very often chose scenes of almsgiving from the saints' legends (Pl. 56a), since in this way they represented their own ideal of *caritas*, and at

the same time let it be clearly seen by the lower social strata. The legend of St. Francis in particular, and also those of other mendicant saints, such as St. Anthony of Padua (1195–1231), or of certain non-Franciscan saints such as St. Anthony the Abbot (Pl. 75a), St. Stephen, St. Lawrence and St. Martin (Pl. 61b) provided many opportunities for depicting beggars. These motives necessarily contributed in their turn towards a further advance in artistic naturalism.

So far we have not mentioned the Apocalypse, a description of the world in its final phase on the eve of the Last Judgment. Since the faithful regarded history as above all the history of salvation, the most important stages of which were foretold in the Apocalypse, symbolical and allegorical interpretations of the latter were very general, as we have seen, during the troubled period of the thirteenth century. Many of the mystical interpretations of the Apocalypse advanced by the Franciscans, when still of democratic inclinations, and especially by their left wing under the influence of prophecies by Joachim of Fiore, were often directed against the Papacy and the official Church.[60] The natural place in which to deal with these symbolical expositions of the Apocalypse, which changed with every generation and differed as between the Spirituals and the supporters of the official Church, would be the chapter on symbolic art. But since the majority of them date from a period earlier than our subject, and their main influence was exercised in a literary and verbal form, it is impossible to do more than touch upon them.[61] It is perhaps worth recording, however, that it was precisely St. Francis, whose life was axiomatic in the history of Christian religious sentiment, who figured so frequently in the Apocalyptic account; and there the degree of radicalism in the manner of interpretation depended upon whether the Spirituals or the official current were followed. The opinion of St. Bonaventura, mystic and General of the Order, accepted by the Franciscans in 1266 as an official article of faith, that the angel seen by St. John at the opening of the sixth seal was St. Francis himself, still represented a certain compromise with the Spirituals. For according to them, this angel, marked with the seal of the living God, that is with the Stigmata, was identified with St. Francis, and was at the same time the initiator of the reign of peace on earth. This view was of topical import because the Spirituals identified their own time with that of the opening of the sixth seal and of the emptying of the vial of the sixth angel; because, in other words, they thought the time had come for the immediate establishment of the realm of the Spirit under the leadership of St. Francis, and in accordance with the original rules laid down by the Saint for his Order. (Official church circles of the fourteenth century on the contrary, in attempting to weaken St. Francis' important role, identified this same sixth angel of the Apocalypse with the Emperor Constantine, a most significant change, and one which expresses the sharp contrast between the two tendencies.)[62] St. Francis was also often compared with the Archangel Michael. Cimabue's cycle of frescoes of the Apocalypse in the Upper Church of Assisi, painted in the late

thirteenth century, was based on the official Franciscan compromise as put forward by St. Bonaventura. But for the upper middle class and for the Franciscans of the fourteenth century, even the more moderate views of the thirteenth century were no longer of current interest, and almost smacked of heresy; thus paintings of the Apocalypse were scarcely ever commissioned.[63]

We must finally mention the representations of the Old Testament, the function of which from the first was to serve as antetypes to the stories of the New, which in their turn fulfilled the predictions. The different events and figures of the Old Testament were interpreted symbolically, each book being brought into symbolical relationship with the other. The two cycles were either confronted in their entirety and compared in their general historical sequence—this was the manner adopted earlier—or an exact typological relationship (i.e., the prefiguration of the New Testament in the Old) was established for individual scenes; it was this latter method which prevailed during the "high" and late Middle Ages. In spite of their largely narrative content, I have discussed such parallel scenes from the two Testaments in the chapter on symbolic art, whenever this symbolical programme of unity was still as pronounced as in these typological cycles (Pl. 91a). The important phenomenon for art history, that with the increasing interest in more secular themes there could also arise an almost independent demand for Old Testament scenes and figures, did not, on the whole, make itself felt in Florence until the fourteenth century had ended.

NOTES

[1] That paramount problem of art, namely, how far it was intelligible to the general public, has been discussed but little—at any rate never treated with real precision, phase by phase and country by country. (Some suggestions regarding the difficulties of a general understanding of symbolical art in the Middle Ages are to be found in G. G. Coulton, *Art and the Reformation*, Oxford, 1928.) The general opinion here expressed refers to the great Cycles of Redemption embodied in the sculpture of the French thirteenth-century cathedrals, whose basic ideas were certainly understood, even if their complicated details were not.

[2] E. Panofsky, "Imago Pietatis" (*Festschrift für M.I. Friedländer*, Leipzig, 1927).

[3] The "democratic" tradition of this narrative religious art derived originally from the fourth-century monasteries of Syria. It was preserved in the monastic art of the whole East, especially of Byzantium, where it contrasted with official Byzantine art. This popular Byzantine monastic art began to exert a great influence, above all in Italy, as soon as the Western middle class was sufficiently developed, that is, in the thirteenth century. (See R. Byron and D. Talbot Rice, *The Birth of Western Painting*, London, 1930.) This influence was not confined to the narrative themes of Byzantine painting, especially the scenes of the Passion; the types of its cult-images, such as the maternal figure of Mary, also took on decisive significance for Italian thirteenth-century painting, as soon as the times were ripe. It is not, of course, possible here to discuss the archetypes of all these representations, many of them derived from Byzantine art; we must confine ourselves to statements of the changes which occurred within Italian, especially Florentine, painting.

⁴ There are important suggestions in Dominici's *Regola del Governo* on how these representations should be made to appeal more strongly to children, and which of them were suitable for an early age.

⁵ Panofsky, *op. cit.*

⁶ These divergences between the social structure of Italy and the northern countries also determined the manner in which new religious themes originating in Italy, the most progressive bourgeois country, were adopted elsewhere. Towards the end of the thirteenth century changes in subject-matter also begin to be noticeable in France, the country next to Italy in the strength of its middle-class structure. For example, within the great Cycles of Salvation of the French cathedrals, the Passion now took on an important role —especially a more human interpretation of the Crucifixion was introduced—the maternal aspect of the Virgin was given greater prominence, etc. But the full development of the new subject-matter did not occur in French painting until the fourteenth century. (M. Dvořák, "Die Illustratoren des Johannes von Neumarkt", *Jahrb. der kunsthist. Sammlng. in Wien*, XXII, 1901.) It is significant that in Italy itself, and especially in Florence, these new themes in general take on a far calmer character after about 1300, that is, under the rule of the upper middle class. In the much more petty-bourgeois northern countries, on the other hand, these themes—those of the Passion provide the most striking examples—attained during the fourteenth, and even more during the fifteenth century, a degree of intensity and excitement in the long run inconceivable in Italy, with its more permanently upper-middle-class structure.

⁷ See chapter on Contemporary Views on Art.

⁸ J. Schlosser, "Zur Kenntnis der künstlerischen Überlieferung des späten Mittelalters" (*Jahrb. der Kunsthist. Sammlng. in Wien*, XXIII).

⁹ Though often as analogies of earlier compositions.

¹⁰ M. Dvořák ("Idealismus und Naturalismus in der gotischen Skulptur und Malerei", in the volume *Kunstgeschichte als Geistesgeschichte*, Munich, 1928) shows how the new naturalism in the Gothic sculpture of the north first took the form of an emotional spiritual enlivenment of the figures.

¹¹ This identification is established in P. Livorio Oliger, "Le *Meditationes Vitae Christi* del Pseudo-Bonaventura" (*Studii Francescani*, Arezzo, 1922).

¹² But in spite of its popular simplicity and humanity, even this work (which was dedicated to a Poor Clare) had of course a didactic and moral purpose.

¹³ Although less so in Italy than in France. In the Carmine in Florence at the end of the fourteenth century—as Sacchetti tells us in one of his stories—the Ascension of Christ was produced annually as a play. Later, in S. Felice the Annunciation, and in S. Spirito the Descent of the Holy Spirit were so represented.

¹⁴ For further details see A. d'Ancona, *Origini del Teatro italiano* (Turin, 1891). He shows how the procession in honour of the festival of St. John the Baptist in Florence was arranged differently during periods of lower-middle-class influence from its presentation at other times.

¹⁵ Suggestions as to direct connections between various works of art and religious drama are made in V. Mariani, *Storia della Scenografia italiana* (Florence, 1930) and V. Galante-Garrone, *L'Apparato scenico del Drama sacro in Italia* (Turin, 1935).

¹⁶ It is not, of course, the object of the following passages to provide even a brief and casual summary of Italian iconography during our period. The best source for the subject-matter of Florentine thirteenth- and fourteenth-century painting is H. v. Gabelentz, *Die kirchliche Kunst im italienischen Mittelalter* (Strasbourg, 1907). A good deal can also be found in H. Thode, *Franz v. Assisi und die Anfänge der Kunst der Renaissance in Italien* (Berlin, 1904). For the Florentine crucifixes and passion scenes of the thirteenth and

fourteenth centuries, and also for the general development of Italian medieval icono-graphy, see E. Sandberg-Vavalà, *La Croce dipinta italiana* (Verona, 1928). On the icono-graphy of contemporary French art, which, however, has only a limited application to Italy, see E. Mâle, *L'Art réligieux du XIIIe siècle en France* (Paris, 1910) and *L'Art réligieux de la fin du Moyen-Age en France* (Paris, 1922); also L. Bréhier, *L'Art chrétien* (Paris, 1918).

[17] From the fourteenth century onwards the Holy Trinity was also usually shown in the upper part of the picture (God the Father and Christ, in one person, surrounded by Cherubim, and the Holy Ghost as a Dove descending towards the Virgin).

[18] It was particularly Pseudo-Bonaventura who linked up the story of the young John the Baptist with Christ's childhood. This link was particularly stressed in Florence, where the Baptist was specially honoured not only as the last forerunner of Christ and the herald of his coming, but also as the Patron Saint of the city. On his feast day the most important religious plays were performed, and the famous Pallio race run. His image was stamped on the Florentine florins.

[19] For a full exposition see H. Mendelsohn, *Die Engel in der Bildenden Kunst* (Berlin, 1907).

[20] A sumptuous procession of the three Magi was staged by the Dominicans in Milan in 1366.

[21] An important motive in the Adoration of the Magi is that of King Balthazar, bare-headed and kneeling, paying homage to the infant Christ like a vassal to his feudal lord; this probably appeared in the Kingdom of France (twelfth–thirteenth century) in connection with the mystery plays. (See H. Kehrer, *Die Heiligen drei Könige in Literatur u. Kunst*, Leipzig, 1908.) The episode, frequently found in Tuscany, of the same king kissing the Infant's foot, occurs in Pseudo-Bonaventura.

[22] This is confirmed by the dramatic literature of the early middle-class period. A Passion play was given in Padua as early as 1243.

[23] The universally known *Stabat Mater* of Jacopone da Todi was also important in this respect.

[24] We shall discuss later the introduction of St. Francis into the Crucifixion scene.

[25] In the northern countries, on the contrary, she is presented in a more emotional way as the mystic bride.

[26] Naturally the new interpretation of the Last Judgment, like that of all other religious themes, was "undogmatic" only as compared with the merely didactic art of the early Middle Ages; for the sober rationalism of the upper middle class in its turn implied—though in terms of the universal and now irresistible new emotionalism—an exterior emphasis on the dogmatic content in art. But the treatment of the Last Judgment as a medium of punishment did not in the least conflict with the interests and sentiments of this class.

[27] The popular Mystery plays exercised a paramount influence on the manner in which the Last Judgment and the devils connected with it were portrayed. Ever since the twelfth, and more especially in the thirteenth century, the figure of the Devil had been greatly affected by the classical type of satyr (horns, shaggy fur, tail and claws). From the early fourteenth century an even more grotesque type came in, having a scaly, wasp-like body and bat's wings, which was combined in Florentine art with the satyr type (Pl. 60, 67). See O. Erich, *Die Darstellung des Teufels in der christlichen Kunst* (Berlin, 1931).

[28] The frescoes—such as those in the family chapels of a church—usually illustrate the cycle of one of these main themes, while the chief panel of the chapel altar generally shows only a single scene, such as the Annunciation or the Crucifixion.

[29] The successive phases of this change are described in detail by Sandberg-Vavalà,

op. cit. The motive itself came to Florence from the popular Byzantine art of the late twelfth century, through the medium of Pisa (Giunta Pisano, second third of the thirteenth century), which had close trade connections with Byzantium. (See V. Lazareff, "New Light on the Problem of the Pisan School", *Burl. Mag.*, LXVIII, 1936.)

[30] Panofsky, *op. cit.*

[31] This applies more to painting than to sculpture, where this theme, the Man of Sorrows alone, was extremely common as an expression of grief for the dead on tombs.

[32] G. de Francovich, "L'Origine e la Diffusione del Crocifisso gotico doloroso" (*Kunstgesch. Jahrb. der Biblioteca Hertziana*, II, 1938).

[33] As already indicated, this applies also to certain narrative themes (the popularity, for example, of representations of the Coronation of the Virgin).

[34] A transitional stage to the all-important presentation of the Virgin as the humanised Mother of God is provided by the new but still symbolical role of the Virgin in the monumental Cycles of Salvation, with the Church as their central theme: for in the allegorical interpretation of the Song of Solomon, not only the Church, but also the Virgin, now identified with the Church, is regarded as the bride of Christ. In these cycles it is often difficult to decide in any particular case whether Mary is still represented as a symbolical figure, or already to a certain extent as an historical personage.

[35] In the universal European cult of Mary, the troubadour-like homage of the Knights to the Queen of Heaven also plays some part, though this motive had relatively little significance in the middle-class Florence of the fourteenth century, as compared with Siena. The following legend, told by Caesarius of Heisterbach and embodied in the *Legenda Aurea* of Jacobus de Voragine, is typical of the chivalrous aspect of the cult of the Virgin: a certain knight after attending Mass arrived late for a tournament in which he was to take part; the Virgin, in gratitude for his homage, took his place on the field and won the joust for him. This story was first illustrated in French fifteenth-century miniatures.

[36] As regards the premises of this development in the fourteenth century see C. Weigelt, "Über die 'mütterliche' Madonna in der italienischen Malerei des 13. Jahrhunderts" (*Art Studies*, vi, 1928); E. Sandberg-Vavalà, *L'Iconografia della Madonna col Bambino nelle Pitture italiane del Dugento* (Siena, 1934); R. Jaques, "Die Ikonographie der Madonna in trono in der Malerei des Dugento" (*Mitteilungen des kunsthist. Institutes in Florenz* V, 1937) and V. Lazareff, "Studies in the Iconography of the Virgin" (*Art Bull.*, XX, 1938).

[37] Many of these motives have not only a genre-like, but also a symbolical significance. The bird, for instance, is the symbol of the soul redeemed from evil, but there are several other symbolical interpretations of it as well. The lily is the symbol of Mary's virginal purity. The nursing of the Child implies at the same time that Mary is *Nutrix omnium, Mater omnium.*

[38] G. Goddard King ("The Virgin of Humility", *Art Bull.*, XVII, 1935) is of the opinion that the literary source of this motive is to be found in Syrian and Armenian gospels, which were known to the Spirituals.

[39] The Virgin Mary and the Virtue of Humility had already been symbolically interpreted in theological writings, and the literary interpretation now influenced the new pictorial motive. Even before the appearance of the Madonna of Humility, miniatures painted outside Italy show the Woman of the Apocalypse seated in a similar pose (she was sometimes identified with the Church, sometimes with Mary). For a full discussion, see Goddard King, *op. cit.*, and M. Meiss, "The Madonna of Humility" (*Art Bull.*, XVIII, 1936).

[40] Meiss, *op. cit.*

[41] It should be remembered that the protection of the Christian family was one of the main themes of the friars' sermons, and that the Holy Family was continually cited and described as the eternal example of this.

[42] The various relationships of the Holy Family are enumerated in detail not merely by Pseudo-Bonaventura, but also by Brunetto Latini in his *Tesoretto*.

[43] While originally all Christendom was regarded as under the protection of the Mother of Mercy, the Cistercian Order (Caesarius of Heisterbach) was the first to apply this motive to itself in particular: in a vision one of the monks saw all the members of his Order protected by the Virgin's mantle. The Dominicans, who had few miracles or legends of their own, adopted this vision towards the end of the thirteenth century; but in this case it was a Dominican, or even St. Dominic himself, who had the vision, which was now referred to his own Order. In the pictorial representations the motive is usually applied to one or other of the fraternities—more rarely to Christendom as a whole. See P. Perdrizet, *La Vierge de Miséricorde* (Paris, 1908) and V. Sussmann: "Maria mit dem Schutzmantel" (*Marburger Jahrb. für Kunstwiss.*, 1929).

[44] For an account of the manner in which, for instance, every saint and every scene in T. Gaddi's Berlin domestic altarpiece is related to the donor's family, to some event in that family, or to one or other of the children, see P. Schubring, "Ein Sieneser Totenbild" (*Festschr. zum 60. Geburtstag von Paul Clemens*, Düsseldorf, 1926).

[45] In the Lamentation attributed to Giottino (Uffizi) and probably dating from the 1360s, the two donors—a nun and a lady arrayed in rich apparel—are only slightly smaller than the biblical figures, and themselves actually take part in the Lamentation for Christ. Two other notable examples of pictures with particularly large-sized figures of donors, both dateable from perhaps a slightly earlier period than this painting, are: Andrea da Firenze's (H. Gronau's attribution) fresco with three saints, the donor being in front of St. Miniato (S. Miniato); close to Giovanni da Milano, Madonna with Saints, Jacopo Boverelli and his wife as donors (1360s, Carmine). But apart from the upper-bourgeois Giotto period (Pl. 1, 16a), the large donor figures are, in the fourteenth century, rather exceptional.

[46] In the second half of the fourteenth century, the period of lower-middle-class influence, there appeared in Tuscany, probably at Florence itself, an Italian translation by a Franciscan, the *Fioretti di San Francesco*, a work relating the deeds of St. Francis and his early companions and reflecting many ideas of the Spirituals. The original Latin text was based on verbal tradition and originated in the Marches during the second half of the thirteenth century (see B. Bughetti, "Alcune Idee fondamentali sui 'Fioretti di S. Francesco'", *Archivium Franciscanum Historicum*, XIX, 1926).

[47] Thus the same arrangement recurs in the popular woodcuts of the fifteenth century.

[48] Predellas were attached to all types of altarpieces, including those showing the Madonna with a number of saints. Here also the predella was used for the same purpose of vivid description, but in such cases each section of it was devoted to the life of only one of the saints.

[49] The following instance shows how important it was to the donor that his own particular name-saint should be represented. In 1365, Giovanni Ghiberti donated an altarpiece by a painter close to Nardo di Cione, for his chapel in S. Maria degli Angeli, showing the Trinity between SS. Romuald and John the Evangelist (now Florence, Academy). In 1372, when Andrea della Stufa acquired the same chapel, he left the altarpiece in position, but substituted a St. Andrew for the John the Evangelist, and even added an inscription honouring the new name-saint.

[50] The literary source of this representation was Guillaume de Tocco's Legend of St. Thomas Aquinas. See Renan, *op. cit.*

[51] Not even for the reliefs on the Saint's sarcophagus (Arca di S. Domenico, Bologna, S. Domenico, 1264–7) carried out by the Dominican Fra Guglielmo da Pisa, could enough interesting scenes be found from his own life, so that they had to be supplemented from those of his companions.

[52] Her legend was later also produced in the *Rappresentazioni Sacre*. The numerous Florentine pictures of the popular SS. Sebastian and Roch, protectors from the plague, are mostly of a later date (St. Roch died only in the fourteenth century).

[53] By no means all the lesser guilds had artisan-patrons. Thus the patron of the butchers was the apostle Peter, the most ecclesiastical of all the saints; that of the shoemakers was the apostle Philip (though in the North usually the shoemakers Crispin and Crispinian).

[54] One of the main themes of the Spirituals in the preceding era, though it was also widely adopted as a literary theme in later years, was therefore the consistent parallel between his life and that of Christ. The frescoes in the Lower Church of Assisi, attributed to the Umbrian Master of St. Francis (thirteenth century) also show a parallelism.

[55] In the picture of St. Francis with six scenes from his life painted in 1235 by Bonaventura Berlinghieri of Lucca (Pisa, S. Francesco), the Stigmatisation is still rendered in the manner customary in illustrating Christ in Gethsemane, in order to emphasise the parallel between their lives. This analogy in the composition very soon disappeared.

[56] B. Bughetti, "Vita e Miracoli di S. Francesco nelle Tavole istoriate dei Secoli XIII e XIV" (*Archivium Franciscanum Historicum*, XIX, 1926).

[57] Out of jealousy, the Dominicans tried to suppress this theme as far as possible. Later they attempted to rival it with the Stigmatisation of St. Catherine of Siena.

[58] Soon other Franciscan saints also appeared as witnesses of the Crucifixion, while in pictures commissioned by Dominicans their place was of course taken by St. Dominic and the members of his Order.

[59] E. Bertaux, *Études d'Histoire et d'Art: Les Saints Louis dans l'Art italien* (Paris, 1911).

[60] The extreme Spirituals for example identified the official Church with the Whore of Babylon.

[61] For full details see Benz, *op. cit.*

[62] Benz, *op. cit.*

[63] The vision of St. John the Evangelist on Patmos, however, was represented, but only as one scene among others from the Saint's story.

(b). STYLISTIC DEVELOPMENT

T HE lives of Christ, the Virgin and the Saints were the subject matter of most of the important paintings and sculptures commissioned in the four-teenth century. We will now discuss the history of the stylistic development of these themes, mentioning others only when that is necessary for complete under-standing. An enumeration of the most important commissions will throw much light not merely on the patrons and the artists engaged, but also on the choice of themes.

The artistic career of Giotto (b. 1266, d. 1337) is intimately connected with the Commune and its most representative citizens, and also with the Curia, the close associate of the Florentine upper middle class and with the King of Naples, the ally of both. In the chapel of the Palazzo del Podestà at Florence he (or to be more accurate, probably his workshop) painted a Paradise, a Hell, and scenes from the life of the Magdalen (completed in 1337, to-day only partially recognisable). He also decorated the family chapels of the wealthiest citizens of Florence and Padua. In the latter city he painted the lives of Christ and the Virgin in the private chapel of Enrico Scrovegni's palace, S. Maria Annunziata (generally known as the Cappella dell'Arena) some time between 1303 and 1306 (Pl. 1, 3b, 4, 5a, 6). Enrico Scrovegni was Padua's richest citizen; his father had been imprisoned for usury, being on that account placed by Dante among the damned, and the son no doubt had the chapel built and decorated as an atonement for the sins of usury committed by his father.[1] Giotto portrayed Enrico in the scene of the Last Judgment (Pl. 1), where his kneeling figure—almost as large as the angels themselves—is seen offering to three celestial figures the chapel he has endowed.[2] In S. Croce he painted the life of St. Francis in the Bardi chapel (Pl. 8)[3] and those of the two St. Johns in the Peruzzi chapel (Pl. 21a). The Bardi and Peruzzi were the two greatest banker families of Florence and court bankers of the kings of England and Naples, to the latter of whom Giotto was court painter (about 1328-32).[4] The Peruzzi Chapel shows a signal innovation: the ornamental frieze of the frescoes has ten medallions with portrait heads of what are most probably members of the Peruzzi family. Significantly, then, it was the wealthiest citizens of Florence who were the first to be represented, outside a fresco or religious painting, in almost wholly independent portraits, though still for the time being inside the same frame. Small portable domestic altarpieces for wealthy individual citizens were already produced in Giotto's workshop—a sign that religious sentiment in these circles was taking on a more private character, and also

that the objects of veneration were sometimes of a rather distinguished nature.

For Boniface VIII, who more than any other Pope embodied the world-wide political ambitions of the Papacy and who required that art should serve more than ever before as political propaganda for the Church, Giotto, according to tradition, painted in S. Giovanni in Laterano, at Rome, a fresco of the Pope himself giving the papal blessing from the loggia of that church on the occasion of the Jubilee of 1300 (a ruined fragment still exists). [5] The influential Cardinal Stefaneschi, offspring of a Roman patrician family and canon of St. Peter's, commissioned Giotto to execute for the porch of St. Peter's a mosaic of the Navicella, that is, St. Peter walking on the sea beside the ship which symbolises the Church Triumphant (preserved in a ruinous state; two original fragments are extant); Giotto was also commissioned by the same cardinal to paint the high-altarpiece of St. Peter's (now in the Sacristy) with the life and martyrdom of the Saint. All typical commissions for the Curia, these, demonstrating the Church's power and honouring her founder. Finally it should be added that Giotto's patrons also included the new very official-ecclesiastical Franciscans: he not only painted for the wealthiest Florentine families in the local Franciscan church, but also received important commissions for the headquarters of the Order, S. Francesco at Assisi, where the frescoes in the Lower Church include scenes from the life of Christ, of St. Francis, of the Franciscan virtues (Pl. 78), etc. Some of these commissions—which were executed by Giotto's workshop or by independent pupils—were placed by high ecclesiastical dignitaries: the frescoes in the Magdalen chapel with the story of Mary Magdalen, probably by Teobaldo Pontano, Bishop of Assisi, a Franciscan; those of the Nicholas chapel with the legend of St. Nicholas by the Cardinal Napoleone Orsini, in memory of his brother Giovanni, a Franciscan.

It is not enough, however, to note that the patrons of this bourgeois and official-ecclesiastical art of Giotto were the Curia, the Commune and the most wealthy of the upper middle class, [6] bound together by common interests and outlook on life—that is to say, the most modern factors in Italy. In analysing the work of an artist of unique importance in his century, his own social position and, with it, his personal world of ideas are also of interest. The social status of the Florentine artist in general will be discussed later, in a wider context, but a word must be said here about that of Giotto.

Thanks to his fame, his large workshop, his position as official architect to the city, and also to his business skill, for which we have the evidence not merely of anecdotes but also of legal documents, Giotto was perhaps the only Florentine artist of the fourteenth century who achieved real wealth. [7] He hired out looms to weavers who were too poor to procure these indispensable tools for them-selves [8]—a device commonly resorted to in Florence for making money without infringing the prohibition of usury—and made thereby a profit of 120 per cent.

per annum.[9] He stood guarantor for loans of moderate sums, and when the debtor was unable to repay them, had himself nominated receiver by the creditor so that he could dispose of the property given as security, which the courts had assigned to the creditor. In 1314 he was employing no less than six lawyers in actions against debtors who were either tardy or unable to pay, in order to obtain possession of their property; in other years he employed only two procurators for this purpose. He was thus continually occupied in the collection of debts and acted as a professional money-lender, an able business man, who increased by usury what he earned by his art.[10] It is most significant that he wrote a hymn to Poverty (it begins "Molti son quei che lodan povertade") which is a convinced and powerful poem *against* poverty. Its theme is that Poverty is the cause of all evil, for involuntary poverty leads to sin and voluntary to hypocrisy; Christ's own words are misconstrued if his praise of poverty is applied to the affairs of man. Viewed in the light of the poverty controversy of these years and of the victory of the official Church and upper middle class over the Spirituals, the poem leaves no room for doubt (if doubt there were) as to the side on which Giotto stood. St. Francis was hostile not only to wealth but to art also, for art was connected with wealth. Giotto, who with his assistants was commissioned to decorate large parts of the most revered of Franciscan churches, that of Assisi, built over the grave of the Saint himself, had in his outlook outgrown the original Franciscan movement as much as the upper middle class themselves, or their ally the Pope, who, at about the same time as this poem, had denied in a Bull the poverty of Christ and the apostles. It is no mere chance that Giotto's patrons, the cardinals Stefaneschi and Orsini, who made preparatory reports to the Pope on this matter, both declared themselves against the Spirituals.[11] Rarely is it possible to hear upper-middle-class thought expressed so nakedly as in this *Canzone* of Giotto's,[12] one phrase of which, "Extremes are rarely free from evil", might justly be regarded as the leading idea of his monumental yet anything but exuberant art. His sceptical remarks about the Immaculate Conception are likewise wholly in keeping with this sober rationalism.

There was a pronounced atmosphere of rationalism—probably the most pronounced in Italy—in the university town of Padua, where Giotto worked for several years. Here Averroism had spread first among the physicians, and later increasingly in the university itself.[13] In Giotto's time, the most famous representative of this materialistic trend was the learned Pietro d'Abano (1250–1316), professor at the university and physician to the richest citizens of the town.[14] There is, of course, no question of Giotto's having been "influenced" by Averroism as a definite philosophical current. But a somewhat sceptical, detached atmosphere undoubtedly pervaded the Paduan circles in which the artist moved, and it is unlikely that, possessed as he was of a distinctly secular mentality, it left him entirely untouched.[15]

FLORENTINE PAINTING AND ITS SOCIAL BACKGROUND

The roots of Giotto's style are mainly to be found in Rome, the city of the Curia, with its up-to-date, rational organisation. Just as the interests and outlook of the Curia and those of the Florentine upper middle class, now rising to power, were closely interlinked, so the corresponding art of Rome and of Florence in the late thirteenth century were inextricably bound up with one another. The mosaics and frescoes of the Roman artist Pietro Cavallini (active 1291–1321),[16] the frescoes of the so-called Isaac-Master working in Assisi, who was probably also a Roman,[17] the classicising sculptures of the Florentine Arnolfo di Cambio,[18] also working in Rome (d. 1302), decisively influenced Giotto's style in the direction of rationalism, of clear, compact composition.

We will start with the early Paduan frescoes (about 1303–6; Pl. 1, 3b, 4, 5a, 6). Although the Passion accounts for twelve scenes of the cycle, yet the fact that Christ's public ministry is also represented in six scenes indicates a rather more secular outlook on the artist's part. As might be expected, the more lyrical Passion scenes, especially those portraying Christ's spiritual struggles (scenes which for this reason were particularly popular in Siena) are omitted: e.g. the Agony in the Garden, the Temptation, the Journey to Emmaus. With all its deep emotion and dramatic tension—in particular the Passion scenes—and in spite of it, the whole cycle is pitched on a note of clarity and precision. This clarity and precision of conception has as its consequence a fresh formulation of the individual scenes of greatest importance for the future, a fresh formulation not, generally speaking, in the sense of introducing new characters, but rather of creating a spiritual and psychic contact between the various figures.[19] But Giotto's new conception, and in particular the severely economic style of composition accompanying it, did not come to full maturity at once. Not only the Last Judgment (Pl. 4), but some others of the frescoes whose theme does not present such an obstacle to compactness, still fall somewhat short of that degree of concentration, assured calm and severity which characterises the works after Padua.[20] The powerful and penetrating naturalistic ability of the later works is still, to some extent, missing; there are frequent signs of uncertainty, of a struggle for mastery of space. Nor has the grouping of the figures quite the sureness and freedom of the later period. Despite this, throughout the whole Arena cycle, starting with the scenes from Mary's life and passing through the stories of the public ministry of Christ to those of the Passion, an ever-increasing tendency appears to create organic structure, compositional clarity and compactness, and spatial unity.[21] Yet this decisive fact apart, there is, for instance in the Massacre of the Innocents and in the Lamentation (Pl. 6), an impetuosity of sentiment which later tends to diminish: compositions built up in diagonals, violently agitated figures, and gestures full of passionate expression. Works of this type still have kinship with, and form a sort of epilogue to, the earlier art of the upper bourgeoisie in their revolutionary, vehement period of rapid and triumphant rise. But the intense ferment of that early stage, when the mendicant

Orders, particularly the Franciscans, were still a very dynamic factor and which had found its expression, in the period immediately before Giotto, in the impetuous yet hieratic art of Cimabue (active 1272-1303) is now, on the whole, over. A juxtaposition of the Crucifixions of the two masters—Cimabue's fresco at Assisi (Pl. 3a) and Giotto's at Padua (Pl. 3b)—is enough to illustrate the softening that had taken place.[22] Yet Cimabue's art, as a stylistic comparison of the compositions immediately reveals, was the necessary preliminary step to Giotto's calm and concentrated idiom. Moreover, a link is clearly apparent between the early Giotto and another artist of the older generation whose style corresponds to a certain extent to that of Cimabue and who collaborated with Giotto in the decoration of the Arena chapel, namely Giovanni Pisano (c. 1245/8–after 1314). The Massacre of the Innocents, for instance, in many respects (convulsive movements, draperies pulled taut) still betrays the unmistakable influence of the most important figure work of the preceding heroic phase of the Tuscan middle classes, the pulpit reliefs by Giovanni Pisano in S. Andrea at Pistoia (1298-1301),[23] a work in which Giovanni's dramatic movement and inner animation reached their zenith.

The early frescoes in Padua may be regarded as a kind of transitional stage within Giotto's *œuvre*. After them, a calming down in every respect is noticeable. When compared with similar thematic works of the thirteenth century, or even with the very detailed fresco cycle of the legend of St. Francis in the Upper Church at Assisi, which probably dates from the last years of the thirteenth or the first decade of the fourteenth century and is often ascribed to the young Giotto,[24] the few scenes from the life of the saint in the Bardi chapel of S. Croce (some time about 1320) drawn from St. Bonaventura's official *Vita* of St. Francis[25] show how the legend has been rationalised, made bourgeois and official—ecclesiastical (emphasis on the representation of the Pope's Confirmation of the Rule of the Order; Pl. 8). The frankly popular miracles and healings are relegated to the background (the Casting-out of the Devils, for instance, or the Freeing of the Heretic which occur at Assisi could not well be imagined in the Bardi chapel). In the Bardi chapel the outlook on life of the now firmly entrenched upper middle class and of the Neo-Franciscanism allied to it finds clear and unmistakable expression. We have also mentioned the preference shown in these frescoes for exalted persons (e.g., the Ordeal by fire before the Sultan). It should be added that the scenes from the legend are linked together by the introduction of the single figures of four Franciscan saints, selected naturally by the Bardi. With the exception of St. Clare, only those saints were chosen who were members of princely houses, among them St. Louis of Toulouse, the new royal saint of whom the Franciscans were so proud, who in 1317[26] had only just been canonised and had, therefore, to be portrayed as speedily as possible; he was, moreover, a member of the Angevin House of Naples, whose bankers the Bardi were.[27] In comparison not only with the earlier repre-

sentations of the legend of St. Francis, but also with the Paduan frescoes, especially those of the Passion, the treatment of the content shows an extraordinary degree of tranquillisation: a deliberateness, a kind of lofty objectivity (naturally still far removed from lack of religious feeling) has replaced the vehement gestures and emotional expressions of the earlier works. This deliberateness is even more pronounced in the potentially animated scenes of St. John the Evangelist in the Peruzzi chapel, especially, for example, in the Vision on Patmos.[28]

In keeping with this manner of conception is the serenity of form in these frescoes. Here again there is a marked difference in degree between those in the Bardi chapel, and the somewhat later ones in the Peruzzi chapel (Pl. 21a).[29] In the latter, especially, that clear grouping of the figures, that compact and severe monumentality of style, which in Padua were only just emerging, attained complete maturity. In point of formal composition Giotto is now markedly in advance of Giovanni Pisano, who had in the meantime travelled along similar paths.[30] In the S. Croce frescoes it becomes particularly apparent how the task of depicting religious stories in a vivid and convincing manner demanded clarity of vision, close observation of nature and all the devices of a logical, nature-imitating naturalism. The upper-middle-class rationalism of the early fourteenth century expressed itself, then, in art, in the work of Giotto, by a convincing representation of space, in an attempt to discover the true structure of the human body—though so far only rarely of the nude—in a creation of severe drapery, falling in accordance with the gravity and the relative position of the body, and in a demand for a colouring true to nature—although in Giotto's work the colouring was still superimposed on the plastic form. With Giotto every part of the picture was of equal importance and was treated in the same naturalistic manner. He logically constructed a single spatial unity, and was one of the first artists clearly to dispose his figures in their correct spatial order. In his narrative paintings there is but little trace (and, what from the point of view of historical development is most important, that little becomes less) of the rhythmical, architectonic scheme of the Gothic style, of a naturalistic formal idiom in the sense of this style, the style of the relatively more backward North. For Giotto's naturalism is not confined solely to details, but completely transforms the whole composition of the sacred narratives. By means of an austere, compact composition the stories were given the greatest possible efficacy and credibility. Through sense-impression of the individual object, that is to say, by way of and beyond the new naturalism, Giotto had already arrived at a balanced figure-composition and a systematised monumentality of sense-impression. Thus Giotto's aim was not a descriptive realism of detail: only in the Gothic composition of the North with its originally strong religious-metaphysical basis was such a realism the sole form of naturalism possible. Giotto summarised and reduced the realism of detail, creating thereby a new, heroic, "classic" idealised style.[31] To organise sense-impressions into a monumental, artistic

pattern was thus the Florentine upper-middle-class way of transposing the basic-ally spiritual Gothic of the backward North. Therefore it must be understood in this sense that Giotto took over only "classic" elements of French high Gothic. In his efforts toward composition he naturally derived valuable aid from the formal tradition and formal wealth of antiquity—and this, to so great an extent, was possible only in Italy. However much Giotto's art may be considered a great personal achievement, it must never be forgotten that it was at the same time the artistic expression of the undisputed rule of the Florentine upper middle class at their ideological zenith. This new, very developed, and above all consistent and systematic upper-bourgeois naturalism[32] was of the greatest importance for the whole future, and created in Florence an artistic situation[33] quite different from that which existed at the same period in France or Germany, or even in the other relatively advanced cities of Italy.

This is confirmed by even a cursory comparison of Giotto with another artist, almost his contemporary in age, Duccio (1260?-1319; Pl. 9), the repre-sentative of that upper middle class of Siena which was still closely connected with the middle and petty bourgeoisie, and which, though in power, was much weaker than in Florence.[34] It is in the different social structure of Siena that the reason for the great variation in the artistic conceptions of the two artists is ultimately to be found. Duccio's position—to express it in a formula—is some-where between the tempestuous style of the rapidly advancing Florentine middle class of the late thirteenth century (Cimabue) and the clarity of Giotto, which is the expression of the outlook of the securely established Florentine upper middle class during the early fourteenth century.[35] Duccio is more lyrical, emotional and ecstatic than Giotto (on the predella panels of the high altar for Siena cathedral he illustrated no less than twenty scenes from the Passion). The different social milieu was clearly expressed also in differences of formal treat-ment. Giotto's conception and sense of space implied a systematic innovation as compared with the decorative two-dimensionality of the thirteenth century: he introduces real ground-planes, depth and perspective, and if his efforts are not always convincing, there is at any rate a uniform and consistent plan. This is exactly what is lacking in Duccio's work, which, on the other hand, shows sporadic, unsystematic and quite surprising observations of spatial detail not to be found in Giotto, a sense of landscape and a preference even for distant vistas. The same difference may be seen in their representation of the human figure. Giotto had a definite, though not anatomically sure, conception of the structure of the human body; he constructed consistently statuesque, solid figures in positions as convincing as he was able. His figures create real space around themselves and are firmly planted on the ground; their bodies can often be sensed through their drapery. In Duccio's figures there are frequently striking naturalistic details not to be found in Giotto, but again there is no clear, per-vading plan. Although Duccio's composition schemes are derived from Italo-

Byzantine art, the so-called *maniera bizantina*, they nevertheless reveal certain formal signs of the Gothic style, preparing the ground for the later development of Sienese painting after his death. In Giotto's frankly upper-middle-class art, on the other hand, Gothic figure relation and linear rhythm are deliberately almost ignored (his frescoes merely contain Gothic architecture); as already pointed out, he assimilated only the "classic" elements of the high Gothic. His method of composition implied to such a great extent a logical combination, based on principles, of bodies and objects organically constructed in space, that he no longer required the decoratively two-dimensional context of the Gothic style.

There is a certain similarity between a comparison of Giotto's art with that of a city less advanced economically, socially and ideologically, as was Siena, and with that of one of the more backward social sections in Florence itself. But, of course, the art of these sections—in spite of many similarities—cannot be simply identified with that of the Sienese upper middle class. It can only be understood in terms of its specific Florentine background, of which the unique, developed upper middle class is the most decisive feature.

Wholly different from Giotto is his most notable contemporary in Florentine painting, the Master of St. Cecilia, who was active about the nineties of the thirteenth and in the first two decades of the fourteenth century.[36] He was not, like Giotto, the painter of the wealthiest and most cultured members of the upper middle class who had "arrived", though he certainly painted for some sections of that class. His slightly more "popular" art still carries on the more emotional and agitated artistic tradition of the middle class of the thirteenth century. In his early period he worked for the Franciscans in the Upper Church at Assisi. From his hand come the first and the last three frescoes of the legend of St. Francis cycle, including such "popular" themes as that of the Woman of Beneventum who returned to life in response to St. Francis' prayers in order to confess sins she had not admitted before her death, and for whose soul angels and devils were fighting (Pl. 13), and especially the story, orthodox, though still relatively conciliatory to the Spirituals, of the heretic Peter of Assisi, who freed himself from prison by recognising his errors and praying to St. Francis. Characteristic of these frescoes is a certain hieratic rigidity, yet wholly compatible with a high degree of emotionalism and excitement reflected also in sudden, abrupt movements. The hieratic stiffness is even more pronounced in a picture of St. Peter enthroned, ordered in 1307 by the Compagnia di S. Pietro in Florence for the Benedictine church of S. Pietro Maggiore (now S. Simeone), where this body used to hold its meetings: a typically ecclesiastical motive ordered by typical ecclesiastically minded patrons.

The two principal altarpieces by this master are those with the stories of St. Cecilia (Uffizi, painted for the church of S. Cecilia; Pl. 11) and of St. Margaret (S. Margherita a Montici, near Florence). We have already remarked

how the arrangement of his altarpieces—the surrounding of the large central figure of the saint with many small picture-scenes—adheres to the more universally comprehensible type of the thirteenth century (Pl. 10). Their whole vividly narrative style is still a continuation of Cimabue's and Coppo's emotional manner, and shows relatively few traces of Giotto's concentration. The artist relates the story of the martyrdom of the two saints in countless small scenes (Pl. 12a, b) in what at first sight appears to be a surprisingly naturalistic and free manner, moving and mobile, intense and stirring. His naturalism is quite different from Giotto's, and far less a matter of principle. Space for him is not really spatial; his very long, expressive figures, whose extreme slimness marks the transition from the *maniera bizantina* to the Gothic, have none of Giotto's monumentality and but little of his plasticity. Space and figures are not a consistent unity. Nevertheless, his work contains a surprising number of attempts at perspective foreshortening; he took particular delight in the detailed representation of architecture, and made great use of shadows and even of different kinds of lighting in a pictorial manner. His details are extremely naturalistic, and the martyrdom scenes include female nudes. But just as his space has a merely decorative surface value, so his figures remain on the whole decorative, expressive ones. In short, his style is, as compared with Giotto's, more conservative in character. It has many popular elements which are more marked in the early Franciscan frescoes, and at the same time a somewhat distinguished, almost aristocratic, refinement, related to but exceeding that of the early Duccio, which is more pronounced in the later altarpieces. A certain preciosity in altarpieces executed by his own hand easily degenerated into coarseness in the works of his assistants and pupils.

Still lower in the social scale, though also well-to-do, was the public of a third Florentine artist, Pacino da Bonaguida, active from about 1303 until after 1320. Decidedly more archaic and schematic than the Master of S. Cecilia, he is even more bound to the thirteenth century. Pacino's popular style is both highly expressive and severely hieratic. The subjects of his altarpieces—they were often domestic altarpieces and frequently represented scenes of the Passion —are treated with an intensity of a different and less cultivated character from that of the Master of St. Cecilia. Pacino's intensity had nothing of the latter's refinement; it is much more primitive and simple, and its effectiveness is due in particular to an expressive simplification of gestures. Thus the stiffly raised, parallel arms of the mourning Magdalen in the scenes of the Lamentation (Pl. 17b)—a tradition from thirteenth-century painting—appear to be one of Pacino's favourite motives. The saints are often larger than the other assistants at the scene. All his figures are coarse, heavy and ugly, the same types recurring again and again. They are also quite flat, without plasticity, and in all his work pure two-dimensionality dominates.

Most typical of this style is the most "popular" of his paintings, probably

an early work, his Allegory of the Cross (Pl. 14), painted for the Convent of the Franciscan Poor Clares at Monticelli, a suburb of Florence (now in the Academy, Florence). This allegory illustrates the Redemption. The stem of the cross on which Christ died to redeem mankind is identified with the tree of life from Eden, mentioned incidentally in the Revelation of St. John, which was planted on Adam's grave. This mystical motive dating from the Middle Ages was a favourite one with both official Franciscans and Spirituals, and had been specially disseminated by the *Lignum Vitae* of the Franciscan General St. Bonaventura.[37] The pictorial representation of the tree of life in fourteenth-century Florence, like all other mystical or legendary imagery connected with the Holy Cross, was therefore particularly common in Franciscan convents. The theme itself and the equally popular consequent style are typical of that combination of the symbolical-didactic art of the Middle Ages and the new emotional accentuation brought about by the mendicant Orders, chiefly for the lower sections. That numerous members of the convent of Poor Clares at Monticelli came from the upper middle classes does not gainsay this, for, in spite of it the whole artistic orientation of this monastic milieu was a "popular" one.

Pacino's picture follows Bonaventura's text in every detail.[38] The crucified Christ is shown as the trunk of the tree, from which spring twelve branches bearing explanatory texts. Each of these has four medallions (fruits in Bonaventura's text), each with a scene from the life of Christ. On the two lower double branches are illustrated the Saviour's childhood and public ministry,[39] on the middle branch his Passion, and on the upper ones his Glorification—forty-seven medallions in all. Each scene carries an inscription, the title of the corresponding passage in Bonaventura. In accordance with the allegorical purpose of the whole work, seven scenes from the First Age of Man, starting with the creation of Adam and progressing—with particular emphasis on the Fall—to the expulsion from Paradise, are shown at the bottom of the picture (Pl. 15). Above the two saints of the Order, St. Francis and St. Clare, with Moses and St. John the Evangelist, are holding up explanatory scrolls,[40] and this is repeated by two other saints at the top of the tree. Between these last two, above the cross, is the pelican in her nest, the symbol of the Saviour dying for mankind. The whole is crowned by Christ in Glory, above rows of schematically ranged figures of alternate angels and saints.

Preference for symbolic subjects on the one hand, and on the other, but by no means in contradiction, detailed delineation of scenes from the Passion, are typical of the popular art to which this picture belongs. Both features are amply illustrated in the medallions, where the Crucifixion, for example, is represented three times in its various phases. Moreover, the tensely emotional type of Lamentation, in which the body of Christ lies outstretched on the Virgin's lap, a survival from the thirteenth century which almost disappears in the upper-bourgeois period, is still retained here. This dual character of popular art also

implies a combination of stiff and hieratic figures on the one hand, and of excited and agitated ones on the other; a combination which strikes the eye far more in Pacino than in the Master of St. Cecilia, since the former is much less naturalistic. Scrolls and inscriptions, to which the Church in the Middle Ages had usually given greater prominence than to the painting itself, continued to be used liberally, even in representations of the bourgeois fourteenth century, wherever the Church had to employ them to make religious painting intelligible and "readable" to the less cultured or to the small man: particularly in symbolic-dogmatic representations which she was particularly anxious to popularise and which appealed especially to these sections.[41] This, then, explains why Pacino's style is nowhere so markedly old-fashioned and schematically hieratic as in this Allegory of the Cross, with its figures ranged in rows, planned to suit the taste of the culturally backward.[42]

Pacino was not only a panel painter but above all a busy miniaturist,[43] working with many assistants for a numerous public. One of his illuminated choir books (formerly in the Hoepli Gallery, Milan) was commissioned, characteristically enough, by the Dominicans. Even at the beginning of the fourteenth century (and in its course this tendency was to become increasingly pronounced) the Dominicans, who were rapidly outpacing the Franciscans, began to exert a marked influence over the general public. Wherever, therefore, from Pacino's time an artist's workshop catered for the needs of a broad clientele, that is to say, one composed of people of relatively small standing, we shall find that it had some sort of connection with the Dominicans. Moreover, the archaic style of Pacino's miniatures bears a resemblance to those executed by the Dominicans themselves for the decoration of their own graduals and antiphonaries. In Pacino's most important manuscript, dealing mainly with the life of Christ (New York, Pierpont Morgan Library), the Passion—the most popular and stirring of themes—is depicted with great detail and with many affecting touches. It contains the moving scene, usual in Siena, but in Florence scarcely ever portrayed elsewhere, of the suffering Christ ascending the cross by means of a ladder. The landscape repeats the convulsive shapes of the figures, in spite of and because of its schematic character, for example the rugged, skyward-jutting rocks in the Lamentation over the Dead Christ (Pl. 17b). The colouring in these miniatures is typical: far from being delicate, it is intense and immediate in its effect (crude blue, sealing-wax red).[44]

This then was the aspect of painting in Giotto's lifetime in three different underlying social strata: in Giotto it may be summarised as concentration, in the Master of St. Cecilia as realism of detail, in Pacino as schematisation.

How did the styles of these strata develop after Giotto's death, during the initial and ever-increasing disintegration of the upper middle class? We will begin with the paintings destined for Giotto's former public, the most wealthy

and cultivated section of the upper middle class, and then turn to those of the strata below.

We will pass in review the donors of the outstanding post-Giotto paintings in fourteenth-century Florence, especially of those depicting the lives of Christ, the Virgin, or the most commonly occurring saints; and firstly some of the great commissions placed by the wealthiest families and the great Orders. The Baroncelli employed Taddeo Gaddi to decorate their family chapel in S. Croce with frescoes from the life of the Virgin (1332–38; Pl. 19a). Towards the end of the twenties, the family chapel of the Pulci in the same church was painted by Bernardo Daddi with scenes from the martyrdom of SS. Lawrence and Stephen. Maso di Banco was commissioned by the Bardi (Pl. 23), who had close ties with the Pope, to adorn one of their chapels with a subject dear to the Curia, the story of St. Sylvester and the Emperor Constantine (probably between 1336 and 1341). The Strozzi entrusted the brothers Nardo di Cione and Andrea Orcagna with the decoration of their chapel in S. Maria Novella: the former painted the frescoes of the Last Judgment, Hell and Heaven (Pl. 36, 37, 38, 39), the latter the five-panelled altarpiece of Christ enthroned with SS. Peter and Thomas Aquinas (1357; Pl. 40, 41a).[45] The Franciscans of S. Croce commissioned Giovanni da Milano about 1365 to paint the frescoes of the lives of the Virgin (Pl. 48) and the Magdalen in the chapel of their sacristy (Rinuccini chapel), while the principal custodianship of the frescoes was in the hands of the Capitani of the Compagnia d'Orsanmichele.[46] If this order falls partially outside the category of the usual patrician family commissions by reason of its monastic and bourgeois origin, the same applies even more to a greater one, namely, that given to Andrea da Firenze by the Dominicans of S. Maria Novella in 1365, during the period of lower-middle-class ascendency, for frescoes in their chapter-house, financed by the legacy of a rich merchant, Buonamico di Lapo Guidalotti: in addition to two programme pieces of the Doctrine and the Hierarchy of the Church (Pl. 83, 85, 86, 87), the chief subjects of these frescoes are Christ's Passion (Pl. 58, 59, 60) and the life of St. Peter Martyr (Pl. 61a, 62, 63).

The guilds also, especially the rich greater guilds, commissioned paintings, although they generally preferred to earmark civic funds for great architectural or sculptural projects. The Calimala, for instance, decorated a chapel in S. Miniato (1335–42)—they probably also ordered the altarpiece for this chapel with the story of St. Miniato painted by Jacopo del Casentino (Pl. 30, 31)—while in 1367 the bankers' guild ordered an altarpiece from Orcagna for Orsanmichele with the story of their patron, St. Matthew (Uffizi). The commissions for altarpieces for the guild church of Orsanmichele placed by various guilds, and probably employing a large number of artists, provide in fact a characteristic illustration, in the artistic sphere, of the relative power of the greater and lesser guilds.[47] In 1339 and possibly again in 1366 the Signoria decreed that the

Parte Guelfa and the twelve higher guilds—the middle ones were also included—should each erect an altarpiece of their patron saint on one of the pillars of this church, and should celebrate his feast there.[48] Not until 1380, during the period of lower-middle-class rule, did the lesser guilds obtain the right to display such pictures, and even then it appears that two guilds had to share a single pillar.[49] The fraternities also ordered large altarpieces, especially during the democratic period: thus the largest altar picture of the whole period, Jacopo di Cione's Coronation of the Virgin (London) was commissioned in 1370 by the Compagnia di S. Pietro for S. Pietro Maggiore. In general it may be said that the fraternities gave many commissions (sometimes from the proceeds of a legacy left for that purpose) for the execution of altarpieces or frescoes or the erection of tabernacles for themselves, their chapels or the hospitals[50] under their control.

After the *ciompi* revolt it was the Alberti family in particular which placed the largest commissions. Its members, who were among the most important bankers and wool merchants of the city, succeeded in retaining both their power and their wealth through an alliance with the lower middle class. About 1380 Jacopo degli Alberti employed Agnolo Gaddi to decorate the choir of S. Croce with the story of the Holy Cross (Pl. 66, 124), to which the church is dedicated, a favourite subject in Franciscan churches. The rich Benedetto degli Alberti, for long the leading politician of Florence, commissioned Spinello Aretino about 1387 to paint the story of St. Catherine in the oratory of S. Caterina at Antella (Pl. 71), the Alberti family estate near Florence. Benedetto's second commission, also given to Spinello, dates from the time of his exile after the victory of the reaction in 1387: it was for the decoration of the sacristy of S. Miniato, the church of the Olivetans, with the story of his patron, St. Benedict (Pl. 72). In fact, the conservative and aristocratic Benedictines now gave commissions to Spinello for large altarpieces of the Madonna and Saints or of the Coronation of the Virgin, for their various monasteries.

We will add the most important plastic works on similar themes. During our period they were, generally speaking, ordered by the same people who commissioned the building works, namely the greater guilds acting on behalf of the city. The principal enterprises were naturally connected with the sculptural decoration of Florence's greatest building project, the cathedral. The sumptuous decoration of the cathedral Baptistry with its three bronze doors, later so famous, and their reliefs was under the supervision of the Calimala. The first door is Andrea Pisano's with the story of St. John the Baptist, patron saint both of the city and of the Baptistry (1330–36). The reliefs illustrating the programme of salvation which Andrea Pisano, his assistants and successors executed for the cathedral Campanile (Pl. 77b, 79a, b, 91b) under the supervision of the Lana will be discussed later. For the decoration of the cathedral façade itself, as projected in 1357 by Talenti, statues of apostles, saints and

angels were commissioned (probably as part of a very disjointed Marian cycle). These commissions, which had likewise been under the control of the Lana, were carried out intensively and in large numbers only after the middle of the 1380s, when the upper middle class had returned to power. Besides the cathedral the chief sculptural work was for Orsanmichele: as a result of the plague of 1348 the Compagnia d'Orsanmichele received so many donations that it commissioned Orcagna in 1349 to make a large tabernacle of the Virgin with reliefs from her life, with the Virtues and prophets and statues of the apostles (1352–59).[51]

The Florentine artists of the upper middle class who followed Giotto were unable on the whole to maintain his high level. The sculptor Andrea Pisano (1273–1348) who was almost contemporary with Giotto and had worked on the Campanile reliefs under his initial direction and in close contact with him, alone produced works, the bronze reliefs of his Baptistry doors with the story of St. John the Baptist (1330–36), which—or rather some of which—are a certain equivalent to Giotto's severe style,[52] although they are more two-dimensional and betray the beginnings of a Gothic linear rhythm. In general Giotto's towering personality as an artist had a paralysing influence on his successors; his severe, systematised, formal style could not become universal. For there was in fact no longer that ideological self-assurance which in Giotto's time the victorious upper middle class still possessed. The bankruptcies of the Bardi and Peruzzi and later the great plague of 1348 brought stagnation to the entire economic life of the city, caused widespread impoverishment and undermined the power of the upper bourgeoisie, which now had to wage a continual struggle with the classes pushing up from below. No longer able to retain fully their former pre-eminence, lacking the victorious élan of the days when with the help of the lower classes they rose to power, the upper bourgeoisie were now compelled to make continual concessions—ideological and artistic as well—to these strata. Since, however, their ideological position was already so firmly consolidated, the points they yielded were neither important nor consistent, at any rate during the first generation of the fourteenth century. Stylistically this implied, on the one hand, that after Giotto painting was no longer capable of Giotto's severe rationalist conception and compactness of composition, nor of maintaining his achievements in spatial clarity and body-construction—since the general situation was now no longer unambiguously favourable to the upper bourgeoisie. On the other hand, painting, despite this, did not become consistently spiritual or gothicising, for again circumstances were not propitious enough for the middle and lower bourgeoisie, still far in Florence from ideological independence. Nor must it be forgotten that the enormous heritage of Giottesque painting was in itself a staying force exercising some amount of influence throughout the century. So, all things considered, the upper middle class, particularly from 1300 to 1350, permitted the infiltration of a certain tendency towards

emotionalism, a realism of detail, which was slowly to disrupt the superficially preserved Giottesque schemes of composition.

How far the "Giotto style" in the narrower sense depends upon Giotto's pronounced personality becomes clear when we examine the style of some of his pupils, those, for instance, who worked at Assisi, or Taddeo Gaddi. In order to show not only how the process of disintegration was already advancing in Giotto's workshop, but also how much even small differences in accentuation contributed to the creation of a style far removed from his, we will first take two pictures from Giotto's immediate circle, and treating the same subject, the Crucifixion. and compare them with one another, and with a picture from outside this circle. The Crucifixion in Munich, part of a polyptych from Giotto's workshop (Pl. 16a),[53] although probably dating from the time of the frescoes in S. Croce, is, in the main, close to Giotto's earlier representation of the same subject at Padua (Pl. 3b), both in feeling and in the idiom of the individual figures.[54] But Mary's suffering is more accentuated: she has fainted, her head has sunk forward, and she would fall to the ground but for her two female companions, holding her firmly under the armpits, whereas, in the painting at Padua, she still stands quite erect, supported only at the elbow. Another Crucifixion (Strasbourg), by a collaborator or close follower of Giotto (Pl. 16b), shows a marked change in the proportions of the figures: they are elongated, gothicising, and this formal idiom helps to emphasise the pervasive sentiment more strongly than do the sturdy figures of Padua or Munich. A good example is the figure of Mary Magdalen who, with raised arms, clings to the Cross in despair, the vertical line being continued high upwards through the figure of Christ (whereas at Padua she is a massive kneeling figure, as is also the St. Francis who takes her place at Munich). In a third Crucifixion (New York, Kress coll.), which originated not in Giotto's workshop, nor indeed in Florence at all, but under strong Florentine influence in the nearby Romagna (Pl. 17a),[55] small changes only are apparent as compared with the Strasbourg picture, yet these make an enormous difference. The picture in the Kress Collection with its extreme note of passion reveals all those characteristics commonly described as "northern". In any case, it is to a certain degree a "popular" picture, Giottesque, but also "post-Giottesque", while it continues, at the same time, the power of expression of the older Pacino; it was certainly painted for a social stratum whose cultural outlook in some respects differed from Giotto's. The figures are still more distended than in the Strasbourg picture; Christ on the Cross is delineated in pronounced Gothic curves, while other figures, Mary Magdalen and St. John for example, are stiff and wooden. Every witness has an expression of distress verging on the grotesque. Gazing upwards, St. John wrings his hands in wild despair; his figure marks a long, protracted, rigid line that stands out effectively against the sky, one elbow is turned upwards, and the folds of his mantle fall riotously behind him; every one of these details enhances

the expressiveness of the long, vertical line of his figure (he is best contrasted with the relatively quiet attitude of the St. John in the Crucifixion by a Florentine follower of Giotto in the Berenson collection, Florence).[56] This excited picture, in spite of its apparent nearness to Giotto and its undoubted nearness to Florence, is a complete negation of Giotto's balanced conceptions and formal idiom.

The slow, direct disintegration of the Giotto style in the hands of his pupils themselves can nowhere be grasped so well as at Assisi. Individual late works of Giotto's studio executed probably in the 1320s without his immediate participation reveal the vacillation between the master's "classic" aims and the general trend toward Gothic realism of detail, especially, for instance, the cycle with the Childhood of Christ in the right transept of the Lower Church at Assisi, and the frescoes in the Magdalen chapel of the same church. The painters of these cycles abandoned Giotto's centripetal emphasis in order to obtain a fuller narrative; the number of figures is greater, they are individualised and more vehement in their movements, more passionate or more charming; sometimes landscape predominates,[57] and the architecture is richer and more Gothic. To what extent a milieu other than the customary upper-bourgeois one of Giotto implied a necessary change not only in theme, but also in the usual Giotto style, is shown by another set of frescoes in the Lower Church at Assisi, the cycle on the vaults of the crossing, illustrating the Glory of St. Francis and allegories of the three Franciscan Vows (Pl. 78). These allegories will be discussed later; it is sufficient for the moment to mention that here, in the Franciscan shrine of Assisi, where the pilgrims, the general mass of the people, had to be impressed by means of popular, ecclesiastical themes, Giotto's style was transmuted by his own workshop into something popular and hieratic: purely schematic formulas were used and the figures merely arranged in rows. It is possible that the artist, a pupil of Giotto's, called the Master of the Assisi Vault (or Maestro delle Vele), who very likely also painted the frescoes of the Childhood of Christ mentioned above, had by that time severed his connection with the master.

The same occurred when Giotto's pupil Taddeo Gaddi (died 1366) and his assistants painted a colossal fresco in the refectory of S. Croce—in the heart, that is, of the Franciscan Order—of the Allegory of the Cross (Pl. 18), illustrating the doctrine of redemption: Bonaventura's Tree of Life, the favourite theme of the Franciscans. It would be difficult to conceive so "popular" a theme and consequently so archaic and schematic a composition in Giotto's own work, above all in his own specifically upper-middle-class milieu. Taddeo had of necessity to borrow the archaic scheme of composition from Pacino (Pl. 14), who had also illustrated Bonaventura. Instead of scenes from the life of Christ, the medallions now contain the corresponding texts from Bonaventura. At the end of the branches, the prophets are introduced as foretellers of Christ, each holding in his hand a scroll with his prophecy. In the foliage of the top and

bottom branches kneel the four evangelists. The upper part of the composition is thus occupied to a greater extent with scrolls and inscriptions and is of a more definitely theological character than Pacino's work with its detailed illustration of the life of Christ. But on the other hand Taddeo transformed the lower part into a narrative of the crucifixion: St. Francis is embracing the trunk of the tree; at his side is seated St. Bonaventura, the author of the allegory, holding on his knees a scroll with the words of his invocation to the Cross; further to the right are two other Franciscan saints, St. Anthony of Padua and St. Louis of Toulouse (and, for the sake of balance, St. Dominic), acting as spectators, and to the left (next to the small figure of the donor, a nun) are the biblical witnesses of the Crucifixion. Underneath is a representation of the Last Supper, where the symbolical motive of Judas sitting in isolation on the near side of the table appears distinctly for the first time in Florentine art.[58] The whole is surrounded by scenes from the lives of Christ, St. Francis and St. Louis of Toulouse[59] (and one scene from the legend of St. Benedict). Thus the representation of the Tree of Life quite readily provided an opportunity for effective propaganda in favour of the Franciscan Order, and discloses an intense interest in symbolic art.

Taddeo's quatrefoil panels with the lives of Christ and St. Francis for the sacristy cupboards in S. Croce (now in the Academy, Florence, in Berlin and the Ingenheim coll., Reisewitz) were also painted for the Franciscan Order. Twelve of them illustrate the life of Christ, and twelve that of St. Francis: a reflection of the popular monastic conception of the parallelism between their two lives. In the Nativity the Virgin is represented kneeling: the first step—borrowed, characteristically enough, from the popular Pacino—towards the tender yet hieratic interpretation of this theme, finally to be reached at the end of the century, when Mary kneels in adoration of the Child (Pl. 20a).[60] Taddeo's use of this motive—and of others in the same cycle—is probably to be put down to the influence of the sermons and writings of the Augustinian Hermit, Fra Simone Fidati, active in Florence between 1333 and 1338.[61] Moreover, the picture of the Resurrection is the starting-point of the development of that type of Christ which, following the theologians (e.g., Bonaventura himself) depicts him no longer as arising from the sepulchre, but poised in mid-air, preluding his glorification, and also promising the resurrection of man.[62] Thus Taddeo's art, in contrast with Giotto's, everywhere reveals ecclesiastical and monastic influences and a greater interest in theology.

Even in the Baroncelli family chapel in S. Croce (1332-38) Taddeo Gaddi followed Fidati's sermons in certain motives[63]—a feature difficult to imagine in the upper-bourgeois circles of the preceding generation, considering the more self-assured and creative mentality of Giotto and his patrons. In these Taddeo Gaddi frescoes appears for the first time in Florence, in the Annunciation scene, the motive of the Virgin sitting humbly on the ground—a motive doubtless

based on theological inspirations, for Mary's answer to the angel (*Ecce ancilla Domini*) is often quoted by theological writers as an example of humility.[64] In style, the frescoes show a similar development to those, for example, in the Magdalen chapel at Assisi: Taddeo's work no longer possesses Giotto's dramatically concentrated grandeur, but presents, on the contrary, many more spiritual and at the same time genre traits with numerous naturalistic observations. Thus the angel of the Annunciation—perhaps for the first time in monumental painting—is shown flying down from Heaven. The Appearance of the Angels to the Shepherds is treated as an independent scene enacted in moonlight (Pl. 19a), and the same is true of the scene in which the star appears to the three Magi at night. Taddeo sought motives requiring depth in their treatment. In the Appearance to the Shepherds he for the first time separated foreground and background by inserting a middle distance, while breaking up the solid mass of the mountains inherited from Giotto into confused little segments, without, however, eliminating the disproportion between the individual parts of the picture.[65] What we see in Taddeo is Giotto's art in the process of disintegration, in respect of its austere, heroic content,[66] no less than of its tectonic composition and its plastic modelling of the figures. All Giotto's most advanced, daring and personal innovations have now been and had of necessity to be sacrified. Painterly details, a delight in perspective experiments,[67] now predominates in their stead. Giotto's concentrated colouring is supplanted, and we see the beginning of a delicate coloristic realism of detail. It is the art of an upper middle class somewhat "precious" in its taste, an art no longer fully expressive of the "typical" upper-bourgeois outlook.

Another aspect of these changes after Giotto, especially as regards realism of detail, is the assertion in Florence of influence from Sienese paintings. But in order to understand this relationship during the post-Giotto period in its totality, it is necessary to trace the whole question of the interplay of Florentine and Sienese art from their ultimate source.

If Giotto's art, so modern both in content and in form, could only with difficulty maintain its position even in so progressive a town as Florence, it naturally encountered even greater obstacles to its dispersion in the more backward centres abroad. By very reason of its modernity, this style could only be transplanted slowly, step by step, and with the necessary modifications, to other European countries, where the rise of the urban middle classes began later and proceeded far more slowly than in Italy; in these countries, however, the new nature of religious sentiment equally necessitated modifications in art, both in content and form. It was partly through the Curia, then residing at Avignon, that the new middle-class art of Florence passed into France and thence reached other parts of Europe: for, as we have repeatedly emphasised, the Curia was then a very up-to-date, "modern" institution, and Avignon was consequently the vital intellectual nodal point of Europe.[68]

FOURTEENTH CENTURY: CHRIST ETC. (DEVELOPMENT)

But it is also very significant that the link between Florence and Avignon was forged by Sienese artists. For the city-state of Siena in its social structure stood somewhere between Florence and France; less industrialised and upper-middle-class than the former, more advanced from a middle class point of view than the latter. In Siena, just as in Florence, the upper bourgeoisie were ruling at the end of the thirteenth and throughout the first half of the fourteenth century. Nevertheless, the nobility were far more powerful than in Florence during the same period; they terrorised the countryside and often the town also;[69] street fighting between their different factions was a daily occurrence. The upper middle class were not nearly so economically advanced or so politically secure as in Florence. Even at the height of their power, therefore, they were much closer in mentality and outlook to the nobility and the petty bourgeoisie than was the case in Florence; at the same time, these two latter groups, often in alliance, were *de facto* a continual threat to the supremacy of the former, and in 1355 finally overthrew them. Corresponding to this general social configuration, the artistic taste of the more backward Sienese middle class was on the average less attracted by a secular-rationalist art and more drawn to the various forms of late-Gothic with its closer association with the art of the past, and its stronger bias towards religious feeling, than was that of the upper bourgeoisie in Florence (particularly about the year 1300).[70] This was especially true of a certain courtly-aristocratic tendency in art within the Sienese upper middle class, and it is quite in keeping with the actual artistic conditions in the Italian city republics that it should be precisely this current of Sienese art which gave a Gothic character to the heritage left by Giotto and, in this form, transmitted it to the North.

The principal representative of this Sienese tendency is Simone Martini (1285?–1344) who was summoned to the Curia at Avignon in 1340.[71] Coming originally from Duccio, Martini transposed Giotto's severe art, his unified compositions, and his new treatment of space, into a style which approximated to that of the more backward northern countries and therefore was easier for them to understand. In this style, emphasis is shifted towards the emotional aspect of the subject, towards the decorative and ornamental formal idiom of late-Gothic, its colouring and its realism of detail. In the courtly late-Gothic of Martini (Pl. 113a) rhythm of line, the curves of the very slender figures are particularly pronounced; but in the fourteenth century they are not so much means of expression for an art still deeply anchored in the religious-transcendental, as when Gothic was at its prime in the northern countries, but rather precious and elegant developments of such an art. Particularly in the late style which he developed in France when adapting himself to French art, Martini united elegant, late-Gothic formal idiom and delicate, subtle coloristic sense with the new artistic achievements of Florence and of Tuscany generally— enrichment of subject matter, inner animation of the content, ubiquitous

naturalism. Easily grasped, captivating and relatively modern, Martini's art exercised a tremendous influence which penetrated largely by way of Avignon throughout all Europe.[72] It became a factor of great moment in the formation of a new international style (the Gothic or courtly international style) which at the end of the fourteenth century was generally adopted in the northern countries, both at the courts and at the great bourgeois centres (for example, Paris, Dijon, Cologne, Prague).[73]

It was necessarily in Siena, therefore, that the tendency to emotionalise and gothicise Giotto's art was most direct and pronounced. But Martini's courtly-aristocratic late-Gothic is only one of several artistic currents of the Sienese upper-middle class. Another, more akin to the mentality of the petty bourgeoisie, laid greater stress on the emotional than on the gothicising aspect. In his cycle of the Passion in the Lower Church of Assisi, Pietro Lorenzetti, who derived from Duccio, transposed Giotto's style, instilling into it greater vehemence and expressiveness and combining with it a realism of accessories[74] (this is particularly true of his workshop) even more consistently than the artist mentioned above, from the late Giotto's workshop in his cycle of the Childhood of Christ in the opposite transept of the same church; a similar modification is also observable if we compare the representations of the stories of John the Baptist and John the Evangelist in Pietro's frescoes in the Servi di Maria in Siena (Pl. 21b) with Giotto's treatment of the same subjects (Pl. 21a). The passionate Descent from the Cross by Pietro Lorenzetti at Assisi—where Christ's body falls back lifeless with head and arms hanging, and the mourners pressing round him can hardly contain their grief—is perhaps the most astonishing portrayal of this subject in our epoch. Here Sienese art takes everything from Duccio as well as from Giotto that it needs for its development. From Giotto comes the principle of spatial unity, the capacity for giving large coherent presentation of plastic masses. At the same time, Pietro intensifies Duccio's power of observing and rendering psychological and naturalistic detail; he projects himself with extreme sensitiveness into each of the figures he represents.[75] If the Gothic character which Martini imparts to Giotto's style is chiefly a matter of form and line, Pietro Lorenzetti, on the other hand, dramatises Giotto realistically while the Gothic formal idiom is, generally speaking, of secondary consequence. Pietro Lorenzetti often actually dresses in contemporary costumes the figures he portrays so realistically in order that the scene may have a more direct emotional contact with the spectator. While considerable differences both of content and of form often appear in the styles of Martini and Pietro Lorenzetti, they frequently blend into one another. For though both painters represent artistic tendencies of the Sienese upper middle class, these tendencies do not reflect the real solid essence of that class; they express rather the fluctuating mentality of the upper bourgeoisie as it tries to make contact with other classes. Behind the stylistic currents of Martini and Pietro Lorenzetti lie the upper-bourgeois tendencies

towards the aristocracy and the petty bourgeoisie—two classes which, on the whole, were culturally backward and had more in common with each other than with the upper middle class, which both felt to be too advanced for them.

There is, however, one artistic current which does correspond to the real essence of the Sienese upper bourgeoisie: that is the progressive art of Ambrogio Lorenzetti, Pietro's brother.[76] Ambrogio's religious paintings are intensely felt, yet generally rather subdued. His large frescoes representing the Government of Siena (in the Palazzo Pubblico of that town) are monumental, impressive in their naturalism; yet, with all their richness, their note is much quieter and more precise than in those of Pietro. Pietro, too, had grappled with problems of space and perspective, but Ambrogio's representation of space and landscape, also carrying forward Duccio's achievements, is far more consistent in its development and exhibits a boldness and freedom never previously attained. Ambrogio reveals great coloristic subtlety and combines Giottesque plasticity with a soft, painterly contour. The Gothic play of lines is not carried nearly so far in his work as in that of Martini.

Now that we are acquainted with the main currents of Sienese painting, there can be no difficulty in appreciating how Florentine upper-middle-class painting will react to these tendencies after Giotto's death; how the so-called Sienese influence will find expression in Florence. Florence in the fourteenth century remained pretty well untouched by the new international style of Martini (for though in the last resort this style originated there, it had in the meantime been entirely altered) as it was neither aristocratic enough nor petty-bourgeois enough for the prevailing taste. The Florentine upper middle class was still relatively too solid and ideologically self-confident for this new and much too frankly Gothic style of Martini, especially in its French form, or, for that matter, the style of Pietro Lorenzetti, to exert a really profound influence. For influences can be effective only if they are in line with the development already taking place. Following the recent social development of Florence, a certain inclination towards the emotional, a certain fairly limited degree of detailed realism, or a mere suggestion of Gothic alone, but not a super-expressive style or an arbitrary Gothic linear pattern, was possible for the time being. As has already been pointed out, under the altered social conditions Giotto's outstanding and severely formal art could only have a paralysing effect on his successors of smaller stature. In the stylistic change that now necessarily took place most of them attempted to follow in one way or another some less extreme trend of Sienese art. For Siena, more lower-middle-class and democratic in its social structure, yet rather inclined to the aristocratic in its ideology, could also, as we have seen, offer more moderate and adaptable influences in a form suitable to the artists of the then somewhat vacillating Florentine upper middle class. Thus, towards the end of the 1320s, Ugolino da Siena, the chief pupil of Duccio, painted the high altarpiece of S. Croce with its numerous scenes from the Passion

(now dispersed in Berlin, London, Pl. 22; and Cook collection, Richmond), one of the outstanding artistic Florentine commissions of the time. With their taste for emotional art, the Franciscans—who were also, it should be remembered, closely connected with the Master of St. Cecilia and Pacino—were primarily accessible to the Sienese manner.[77] More suited than either Simone Martini or even Pietro Lorenzetti (by whom there were altarpieces in several Florentine churches) for the role of go-between for Siena and Florence was Ambrogio Lorenzetti, who during prolonged sojourns in Florence displayed considerable activity;[78] Ambrogio, in his turn, was greatly indebted to Giotto, and his art may be said to correspond the most adequately of the three tendencies to the Florentine upper middle class in the prevailing situation.

That is why Maso di Banco (mentioned 1343-53) who more than any other Florentine artist embodied the style of the most solid section of the upper bourgeoisie, was so largely influenced by Ambrogio. In the Bardi chapel in S. Croce, the chapel of the papal bankers, he painted (probably in the early 1340s) the story of St. Sylvester, which in its close association with the baptism of the Emperor Constantine is a theme typifying the power politics of the upper middle class in alliance with the Curia. These frescoes combine really Giottesque composition with a display of perspective and intersection, and, above all, Ambrogio's painterly illusionism, and reveal a striking sense for sfumato-like colouring.[79] Highly dramatic, and unusual in Florence, is the confrontation of the donor of the frescoes, a Bardi, seen rising from his tomb kneeling in a deserted, rocky valley, and Christ, with the angels of the Last Judgment blowing their trumpets high above and separated from him by a vast empty space (Pl. 23).[80]

Bernardo Daddi (active about 1312-48), the other artist of the upper middle class, working as he did for a broader clientele, for that very reason expressed much more clearly the prevailing tendency towards vacillation. From the very beginning he was influenced not only by Giotto, but also by the Master of St. Cecilia, and under Sienese influence, especially Ambrogio's—though also Pietro Lorenzetti's and Martini's—he lost more and more his earlier firm contact with Giotto. He deflected Giotto's essentially upper-bourgeois art in the direction of the Master of St. Cecilia, took up the trail of the latter who, as we have seen, was more "popular" than Giotto, and created a kind of synthesis of both. Like the Master of St. Cecilia, whose pupil he may have been, Daddi reintroduced a vividly narrative art with markedly elongated, expressive figures; his art too is predominantly two-dimensional, a feature which became more and more pronounced.[81] But in this type of figure and this flatness he naturally differs from the Master of St. Cecilia, for Daddi had been through the school of Giottesque plasticity. Moreover, he had assimilated many elements of Sienese Gothic, at any rate in its more restrained form. Daddi's sensitive contours—now more gothicising, now less, sometimes not at all—were particularly suitable for rendering the emotional, especially the tender and the lyrical. But

Daddi's range was a wide one; he could give expression to violence as well as to tenderness: moods tending towards spirituality, which in their manner of emphasis, if very foreign to Giotto's balanced rationalism, were akin to the Master of St. Cecilia and to Sienese painting.

In Daddi a lyrical and sensitive mood predominates: he invented, for instance, numerous variations on the tender, joyous relationship between the Infant Christ and his mother; flowers or birds absorb their attention,[82] the angels hold delicate flowers in their hands, and often a vase with lilies, decoratively arranged, is placed, after the Sienese manner, in front of the Virgin's throne (Pl. 24a). This is also the spirit in which was conceived the most official and, so to speak, "municipal" Madonna of the period, Daddi's great altarpiece for Orcagna's tabernacle in Orsanmichele (1347). The genre-like motive of Mary teaching the Christ-Child to read probably appears for the first time in Florence with Daddi (Daddi workshop, Parma, Gallery). In the work of this artist, we also find for the first time in Florence a type of Madonna which is especially significant in more or less democratic periods or for more or less democratic sections: the Madonna who is seated humbly on the ground, generally on a cushion, and who exemplifies the Franciscan virtue of *humilitas*, the Madonna of Humility. This motive, whose origin is certainly associated with the mentality of the Spirituals, was perhaps first used by Simone Martini,[83] and it is in Tuscany, in addition to the petty-bourgeois Marches and Umbria, that it is most widely distributed. It was probably introduced into Florence by Daddi himself, or possibly by his pupil from the Marches, Allegretto Nuzi.[84] In the domestic altarpiece by Daddi in the Bigallo (1333), in the scene of the Nativity, Mary is seated on the ground and presses the Child to her breast.[85] This is a preliminary step towards the separate Madonna dell'Umiltà; it was only necessary for the group of Mary and the Child to be singled out. Daddi's independent Madonna of Humility appears on the (damaged) back of the altarpiece (painted in 1348 for the church of S. Giorgio at Rubella near Florence) in the Parry collection at Highnam Court, where the Madonna is seated quite low down, probably on a cushion. From now on, this type occurs very frequently in commissions placed by Franciscans and Dominicans, being especially characteristic of the latter—we have already spoken of the theological and symbolical interpretations of the motive by which its original significance was considerably weakened.[86]

Daddi's stories from the life of the Virgin and numerous legends of the saints are conceived in a tender, fairy-tale mood; hosts of angels play a prominent part, and at the same time the number of genre details is greatly increased: e.g. in the predella panels of the Birth of the Virgin (Pl. 25a) and the Nativity (Pl. 20b) of the high altarpiece of the Madonna and Saints, originally destined for the Vallombrosan church of S. Pancrazio (Uffizi). Daddi betrays a partiality for strikingly rich clothing, materials, and architecture. As already

pointed out, the tenderness of Daddi's paintings in no way excluded a heavily stressed dramatic accent: the violent, abrupt gestures of the figures, when stoning St. Stephen or burning St. Lawrence on the gridiron, in the Pulci chapel frescoes (S. Croce), completely determine their bodily postures. The Crucifixion is one of Daddi's most usual themes. In the expressive conception of this subject, he follows the kind of representation which we have seen evolving in Giotto's workshop and modifying Giotto's manner. Even if in these pictures Daddi shows greater restraint than Pacino, in keeping with his more upper-bourgeois, refined mentality, nevertheless the features of his Virgin at the foot of the Cross are really racked with pain, and her swooning is underlined with deep intensity.[87] The first representation in Florence of the Virgin sitting on the ground lamenting at the foot of the Cross also occurs in paintings of the Daddi workshop (Fogg Museum, Cambridge, U.S.A.). The new interpretation in Daddi's pictures is further emphasised by delicate, precious colouring, and "changeant" colours (red-yellow, red-green) are utilised.

Both in its roots and in its constituent elements, Daddi's expressive narrative art parallels in its complexity that of the Master of St. Cecilia. The blended stylistic elements—those tending more to the popular on the one hand, and to the aristocratic on the other—are as difficult to differentiate clearly as in the Master of St. Cecilia, or in Sienese painting. It seems that the works with most pronounced traces of Daddi's own hand incline more towards the aristocratic, while paintings which more clearly bear the stamp of his studio or his circle[88] are much more popular in character than would have been possible with the Master of St. Cecilia. The whole of Daddi's composite style—and Daddi is the determinant artist of these decades—corresponded exactly to the mentality of the Florentine upper middle class of this generation: it is no longer so self-assured, and is compelled by necessity to accommodate itself in this or that particular to lower-middle-class taste; at the same time, it has shed something of its puritanical severity and reveals an inner leaning towards the aristocratic. This situation, ideologically rather complex, is characterised by the growing popularity of small, portable, delicately painted domestic altarpieces, a sign at once of the increasing intimacy and the exclusiveness of religious devotion—features already noticeable in Giotto and Pacino, seen later in Taddeo Gaddi and well established in Daddi; these small altarpieces tend to become daintier and more sentimental,[89] and, characteristic of the changing times, the Crucifixion, apart from the Madonna, is their most popular scene.

An approximation once more to a rather ecclesiastical outlook as comprehensible to the lower orders signified at the same time greater reliance upon the Church by the upper middle class in times of increasing insecurity. Thus Daddi's Berlin triptych with the Coronation of the Virgin as the centre panel—another theme which became very popular from Daddi onwards—reveals not only a greater delicacy than the Baroncelli chapel altarpiece of the same subject by

the Giotto workshop, but also a return to the orthodox hierarchy of the nine orders of angels, in strict accordance with Dionysius the Areopagite, which Giotto had already abandoned.[90] Nor is it a mere accident that from the time of Daddi and Daddi's generation the commissions placed by the Dominicans continually increased in number; for in these commissions the whole policy of concessions to the lower middle class which the situation in Florence required, and, consequently, the increasing conservatism and orthodoxy of art, are most clearly expressed. The existing predella panels of Daddi's lost altarpiece with three Dominican saints for S. Maria Novella (1338), a gift of the Dominican Guido Salvi, illustrate the legend of St. Dominic and St. Peter Martyr in a very lively, naturalistic style (Yale University; Paris, Musée des Arts Décoratifs; Posen, Museum). One of them represents the Vision of St. Dominic—a theme containing the whole programme of the Dominican Order—in which SS. Peter and Paul appear to the Saint handing him the book and the sword (Pl. 25b).[91] Daddi was even commissioned, perhaps shortly before his death, to paint the high altarpiece of S. Maria Novella, a Coronation of the Virgin with saints and angels. The picture (Florence, Academy) was executed by a pupil; it is a monotonous repetition of the usual large painting of the Coronation of the Virgin, with the saints schematically arranged in rows one above the other; but here, of course, Dominican saints predominate. Traditionally hieratic and in keeping with conservative Dominican mentality, this picture contrasts strikingly with that painted twenty years earlier by Ugolino for the high altar of the Franciscan church of S. Croce, with animated scenes from the Passion on the predellas. This feeble work by a pupil conveys very little of the sensitiveness so characteristic of Daddi, even if Daddi's is never quite so intense as Ugolino's.

As the outstanding painter of the time, yet one who already emitted a certain suggestion of popular art in his painting, Daddi naturally influenced those lesser men who, like the Biadaiolo Illuminator or the Master of the Dominican Effigies, worked for a broader and less cultivated public. But whereas Daddi, the artist of the upper bourgeoisie, derives from Giotto and the Master of St. Cecilia, these lesser artists stem not only from the latter, but still more from Pacino, whose style they may be said to carry on. Now that art was slowly becoming more popular in character, it was inevitable that the style of the more archaic and popular artists of the previous period should make itself felt more clearly in the circle round Daddi, the leading artist. The idiom of these lesser men, like Daddi's own, is two-dimensional and expressive, showing a similar elongation of the figures, but their types, generally speaking, are not capable of expressing such varied shades of emotion; they are cruder, more conventionalised, stiffer, and much more schematic in colouring; the Sienese influence is as vigorous as in Daddi's work, but it expresses itself in a somewhat different manner, is transposed into a different key. The stylistic bridge to these "archaic-popular" lesser masters of Daddi's generation, from the principal works executed by Daddi

himself, is by way of the numerous pictures, often domestic altarpieces, painted by artists of Daddi's workshop.[92] We have only to compare two altarpieces of St. Catherine by two different artists of this circle to see the easy transitions with which pupils and followers from Daddi's workshop in a broader sense, could slide into a mere popular milieu. The first (Pl. 26a), painted for the cathedral (where it still hangs) and showing the Saint accompanied by a distinguished donor, probably of the banker family Guadagni, is close to Daddi himself and exhibits something of his graciousness.[93] The other (Florence, Academy, depot; Pl. 26b), from the church of S. Piero Scheraggio and possibly painted for the chapel of the Compagnia della Ninna, shows the Saint in the same frontal attitude and with the left hand holding the book similarly placed, yet it differs completely in her pronouncedly hieratic stiffness. Two angels are in the act of crowning St. Catherine: a somewhat unusual popular-ecclesiastical motive, which gives her something of the appearance of the Virgin. The Saint lacks any suggestion of limbs and is perfectly immobile; her dress, more elaborately and heavily patterned than that of the other St. Catherine, stands rigidly around her, unrelieved by any attempt at falling folds.

Not, as in the case of Daddi, for the wealthiest section of the middle class, but nevertheless for a very well-to-do public, another artist of interest and some importance was working, who comes directly from Pacino and the Master of St. Cecilia, and who is also influenced by Daddi and the Lorenzetti. Active, too, in the second quarter of the century, he is known as the Biadaiolo Illuminator[94] from the manuscript of the so-called *Biadaiolo fiorentino* (Pl. 93b, 94, 95), the Florentine corn trade, which he illuminated for a wealthy grain-merchant. We shall return to these illuminations, influenced by Sienese art, when speaking of secular painting. But it is worth remarking here that the artist who treated the most secular theme, and the one nearest to everyday life in the Florentine art of the fourteenth century, with extreme realism, at the same time produced a typical Dominican altarpiece (his principal work after the Biadaiolo manuscript). This is the five-panelled altarpiece now in the Lehman collection, New York.[95] The pediment, influenced by Pacino's Tree of Life, contains a most turbulent representation of the Last Judgment: at the same time it includes the hieratic motive of the two angels with scrolls in their hands, bearing the names of the elect and the damned. The individual compartments, besides the Nativity and the Crucifixion, contain a Madonna with two saints, the more important of whom is the Dominican St. Peter Martyr. In addition, a panel is wholly devoted to the Glory of the teacher, St. Thomas Aquinas (Pl. 41b). Two saints with scrolls in their hands stand on either side of him—probably intended to represent two Evangelists inspiring him; rays stream from the figure of the teaching saint to descend on the audience of friars and laymen sitting in the foreground, while directly at his feet is the prostrate figure of the freethinking Arab philosopher, Averroes, felled by the power of the same rays.

The Nativity on another panel of the same altarpiece is treated with much genre realism—especially the washing of the infant—and above all, with a surprising spontaneity. The figures of this altarpiece are either of a protracted even if not very decidedly Gothic linearity, or else heavy and massive; in every case, however, they incline to be ornamental and are very impressive, spontaneous gestures emphasising the bodily contours. This whole blend of theological dogmatism and realism in the most vividly expressive style of one and the same artist, his open attitude to life simultaneous with submissiveness to the didactic-ecclesiastical spirit of the Dominicans, provides a clear image in art of the workaday mentality of the orderly, well-to-do middle class.

As wide, perhaps somewhat wider, than that of the Biadaiolo Illuminator was the public of the Master of the Dominican Effigies, who was active in the late thirties and forties under the direct influence of the former artist, and Pacino, and, of course, Daddi. Even the name—derived from his main work— by which he is known in the literature of art history[96] indicates his close contact with the Dominican Order, the necessary corollary of his "popular" public. This main work of his (Pl. 34), a panel picture in the Dominican church of S. Maria Novella (painted between 1336 and 1347, quite possibly even before 1342),[97] is a most intensive piece of propaganda for the Order. Below the enthroned figures of Christ and the Virgin seventeen sainted and beatified Dominicans are ranged in long rows. The enumeration of the Order's main representatives—led by St. Dominic, St. Thomas Aquinas and St. Peter Martyr —served as a method of propaganda for the Dominican Order similar to, while much more intensive than, that employed in the Tree of Life allegory by the Franciscans. The disposition of the figures in ranks running from top to bottom is rigid and in a dead-straight line, the old-fashioned form of composition taken over from Pacino by the Daddi workshop.[98] The Dominicans are standing exactly one above the other, five in each of the two outer rows, and their black and white habits accentuate yet further the heraldic impression of the whole. Most of them are holding books, for intellectual power had always to be emphasised where the Dominicans were concerned.

The artist in his early period worked as a miniaturist, probably under Pacino, and afterwards himself ran a much sought-after workshop for illuminations. These witness that he worked for the rank-and-file public of the Compagnie, which were recruited from the middle and lower classes. Admittedly he was also employed by the Compagnia d'Orsanmichele, which was composed of the wealthiest citizens, but, as we shall often find, the art of the Compagnie was always, to a great extent, popular. Likewise, he illuminated missals and choir books for the Dominicans—characteristic of the altered circumstances, for the equally popular Pacino used to work mainly for Franciscans—and this contact also emerges markedly from the stylistic standpoint. For the similarity in style between the miniatures executed by the Dominicans themselves in the

convent of S. Maria Novella for their graduals and antiphonaries and those produced in the workshops of the popular minor masters is noticeable again and again. The former are also two-dimensional, heraldic, slightly expressive, but they are even more archaic and severe, even more exclusively devoted to the ecclesiastical-religious motive, and all trace of realism of detail is lacking. The Master of the Dominican Effigies also illustrated the *Divina Commedia*, then regarded as the source of all knowledge as sanctioned by the Church. We shall return to this later.

On the whole, this painter was far weaker in quality, and, what is characteristic of his socially very wide and certainly very ecclesiastical public, in style more unambiguously archaic than the Biadaiolo Illuminator. His work is two-dimensional and very stiff, though occasionally not unexpressive; a faintly Gothic sinuosity makes its appearance from time to time, and ugly types predominate. He becomes most naturalistic in the borders of his miniatures where he could let himself go most freely.

Related to him in style is Jacopo del Casentino (active until 1349 or 1358), who, with the help of a large workshop, also catered occasionally for a public of a rather higher social level, and in particular produced a large number of domestic altarpieces. We have evidence that Jacopo was of a certain bourgeois respectability. That his art probably reflected the taste of his average fellow-guildsmen—like all painters, he belonged to the guild of doctors and druggists—is apparent from the fact that he was commissioned to paint a Madonna for the Tabernacle of S. Maria della Tromba, belonging to this guild (to-day it is incorporated in the Tabernacle of the wool guild). His style, moreover, was predestined to be more archaic and lower-middle-class by his provincial origin and by the Sienese influence he underwent in Arezzo. In his early Arezzo period, for example, he was commissioned to paint a picture (now in the Hospital at Arezzo) of the Virgin with two symbolical embodiments of Christ beside her. The Saviour appears once as Christ Triumphant, and again as the Redeemer, his heart encircled by golden rays, his hands radiating beams; one panel of the predella shows us the deserted Mount of Calvary with the instruments of the Passion: all examples of a religious symbolism of the kind in favour with the rather lower-middle-class public. In addition, Jacopo took over from the Master of St. Cecilia the old popular form of arrangement of the altarpiece, with its many small scenes surrounding the large central figure of the saint. It is interesting to observe that the large altarpiece of the Legend of St. Miniato (probably between 1335 and 1342, S. Miniato; Pl. 30, 31) with this archaic arrangement was probably commissioned by the Calimala guild,[99] which, though no longer of great economic standing, was socially very distinguished and rather aristocratic: another proof of the close connection between the aristocratic and the popular under the common mantle of conservatism. Jacopo's intimate concept of the Madonna and Child still reflects Duccio. Jacopo, open

to the lyrical moods of the Sienese manner, deflected the style of the Master of St. Cecilia, and later that of Daddi, yet further downwards; Giotto's own contribution became less and less, the more conservative the artist and the lower the social scale. Note, for instance, how Jacopo transposed Giotto's Death of the Virgin into a more popular key (previously Loeser coll., Florence): Giotto's elongated and skilfully balanced composition is simply abolished, the central group alone being used, so that Jacopo's picture consists largely of the closely piled halos of the Apostles. In his highly popular, small domestic altar-pieces[100] the serried, overlapping halos of the angels and saints hieratically ranged in vertical or horizontal rows play an equally important part. For even if Jacopo takes over the general arrangement of his domestic altarpieces from Daddi, his figures always appear in stiffer rows, tighter knit than in Daddi, though not so dead straight and heraldic, and more varied than those of the Master of the Dominican Effigies. The degree of rigidity of the figures, then, depends upon how popular was the public for which the picture was destined.

About the middle of the century and afterwards, the social stratification alters, power shifts still more in the direction of the middle sections of the bourgeoisie, and the public becomes a more popular one. As a result, in the artistic sphere, the flat, heraldic style of the middle bourgeoisie, which in the previous generation found expression only in commissions of lesser importance, such as domestic altarpieces, miniatures, orders executed for the Dominicans, now becomes, with certain modifications, the style of monumental painting also.[101] At the same time, there is manifested a strengthening of the tendency towards the emotional and towards realism in accessories. Now, as always, those influences were absorbed which were needful at that particular moment, especially those from Siena; and necessarily, it was not only the "upper-bourgeois" Ambrogio who was drawn upon, but particularly Pietro Lorenzetti, and to a certain extent Simone Martini also. For the more the lower sections in Florentine society found voice, the more the art already created for these sections in Siena increased in influence. Moreover, a new and very important centre of influence operated in the same direction, though, as always, it was also a parallel manifestation.*

A series of frescoes was painted in the Campo Santo in the neighbouring city-republic of Pisa, about, or shortly before, the middle of the century, illustrating, among other themes, the Triumph of Death, the Last Judgment, Hell, and the Life of the Anchorites in the Desert. They were executed, with great probability, by the Pisan artist Francesco Traini and his assistants.[102] They represent the last great artistic enterprise of this declining commercial town[103]

* I deal at some length with this new centre of influence, the Campo Santo at Pisa, and the mentality expressed in the manner of its decoration, because Florence was in permanent contact with this great artistic enterprise, and many Florentine artists later assisted in the further execution of these Pisan frescoes.

and its decaying middle class;[104] and in many ways they clearly express the dominating petty-bourgeois and popular tendencies in its mentality. The general selection of themes is to be explained by the fact that this cycle of frescoes was to serve as decoration for a cemetery and to illustrate the prayers for the dead;[105] it was also influenced by the mood of general repentance caused by the plague of 1348. It seems, moreover, practically certain that the Dominicans of the monastery of S. Caterina had a deciding voice in the elaboration of the whole plan.[106]

The fresco illustrating the life of the anchorites (Pl. 32), though it naturally portrays their struggles with devils and their temptations, is essentially a representation of the eremitical ideal of the religious petty bourgeoisie, the *vita contemplativa* which was about to become the ideal of the Observance movement also. In theme and conception the fresco of the anchorites takes a position midway between the Spirituals, who were particularly vigorous in Pisa,[107] and the strictly ecclesiastical Dominican Observance movement, which was soon to start thence. The literary sources of this fresco in its detail, as of all later illustrations of the same subject, are to be found in the popular book already mentioned, by the Dominican friar Domenico Cavalca. This cleric was himself a Pisan, a member of the monastery of S. Caterina; he wrote on the corrupting influence of wealth and in praise of the *vita contemplativa*, and also preached to the sick and to prisoners. The fresco of the Triumph of Death (Pl. 33, 42, 80) not only shows how death puts an end to all earthly vanity, even that of the mighty (pope, cardinal, bishop, king and queen are among the dead), but also how the ascetic life of the anchorites triumphs over death. These two frescoes with the accentuated meticulous naturalism inherent in their themes, their highly individualised figures, and their emphasis on costume and landscape (especially vegetation) were painted under the direct influence of Sienese art (Pietro and Ambrogio Lorenzetti) and even go beyond their models. But it must be underlined that the naturalism of these frescoes is confined to details; they are very far from conveying that unified bird's eye view of space that we find in the frescoes with landscapes of Ambrogio Lorenzetti; they have very much less sense of space, being composed of horizontal planes inorganically placed one above the other.[108] This flatness is still more pronounced, being conditioned by the traditional theme, in the schematic and hieratic construction of the fresco of the Last Judgment, with its step-like rows of figures. Besides this cycle of frescoes influenced by the Dominicans, Traini also painted the two chief Dominican pictures in Pisa: the St. Dominic altarpiece of 1354–55 (Pisa, Museo Civico) and the Apotheosis of S. Thomas Aquinas of 1363 (Pisa, S. Caterina; Pl. 84); the last-mentioned, though ordered from him, is not an autograph work but that of an immediate pupil. This picture with its strictly ecclesiastical conception and its extremely rigid and hieratic composition is particularly characteristic; each motive has its accorded place from the Thomist standpoint,[109] and the

size of the figures is carefully proportioned to the importance of the persons; from the formal point of view it is deliberately hard, while its flatness could hardly be surpassed. Although this tendency towards two-dimensionality is unmistakable in the development of Pisan art, it is nevertheless true that Traini's different themes necessitated different compositions. These may, however, be reduced to two main types, although they often merge into one another. The composition is "archaic", simple and hieratic when the subject is purely ritual; it employs expressive figures and naturalistic detail when the subject is narrative. Both kinds of composition are equally "popular" and ecclesiastical, and found equal favour with the Dominican mentality, which in fact was popular and at that time was particularly desirous of being so. These qualities of composition and style satisfied the needs of the middle class both in Pisa, whose general outlook tended towards the petty bourgeois and the popular, and in Florence, where the situation was developing in the same direction. This is why the Pisan frescoes produced so keen an echo in Florence, which was becoming increasingly democratic and therefore afforded continually greater scope to the Dominicans; or rather why the interacting artistic relations of the two towns were now so intensive.[110]

The combined influence of Siena and Pisa is to be seen most clearly in the works of Nardo di Cione (c. 1320–c. 1365). His early frescoes with scenes from the Passion in the Badia (chapel of the Giochi and Bastari families, c. 1350) exhibit Sienese influence (for example, Pietro Lorenzetti) particularly forcibly. Even the subject of the cycle, which hitherto had appeared for the most part only in the popular circle round Pacino, is a sign of the dawn of the democratic period. Although from the stylistic point of view the frescoes of the Badia undoubtedly derive from Maso, Nardo's figures became much more excited. A good example in the scene of Christ bearing the Cross (Pl. 35) is the remarkable motive of the soldier, taken from Sienese painting, who brandishes his sword in front of Mary to prevent her approaching Christ. The Scourging is influenced by the representation of the same scene in Ugolino da Siena's high altarpiece in S. Croce. A very passionate representation of Christ being shown to the Jews was also depicted (only a fragment has been preserved). The suicide of Judas is presented with extreme naturalism; his body has burst open and hangs limp on the tree.[111]

A very important and close Florentine parallel to the Pisan frescoes is to be found in the paintings (Pl. 36, 37, 38, 39, 40, 41a), dating from the '50s with which the family chapel of the Strozzi in S. Maria Novella was decorated; the frescoes (Last Judgment, Hell, Paradise) are by Nardo di Cione, and the altarpiece (Christ with SS. Peter and Thomas Aquinas) is by his brother, Andrea Orcagna. On the ceiling St. Thomas Aquinas appears four times, personifying the four cardinal virtues in a frontal hieratic pose; in each case he is attended by the two appropriate derivative virtues as defined in Thomas's *Summa Theo-*

logiae. This in itself is sufficient to show—and we shall observe similar indications when discussing the altarpiece of the chapel—that the general plan of the decoration was drawn up by a scholarly Dominican. Both the frescoes and the altarpiece of this family and sepulchral chapel were probably inspired in their general scheme by the uncle of the donor, Tommaso Strozzi:[112] the Dominican Don Piero Strozzi, who held eminent ecclesiastical positions.[113] Trained at the Sorbonne in Paris, the Church's bulwark of learning, Piero Strozzi was at first professor of theology at Pisa and later Prior of S. Maria Novella; it is he who took measures against speculation in State loans which had fallen in value (1353); his standpoint was thus more strictly ecclesiastical and at the same time more "popular" than that of the Franciscans. It must also be assumed that another Dominican, the eminent Thomist Jacopo Passavanti, who likewise had previously taught at Pisa and at the time the chapel was being decorated had succeeded Strozzi as Prior of S. Maria Novella, gave advice on the selection of the themes.[114] For a true understanding of the frescoes and the altarpiece, their location must always be kept in mind: a church of the Dominican Order, which set its sails skilfully to every wind, and whose outlook was orthodox and conservative, preferring pictorial representation in a strictly ecclesiastical spirit.[115] These frescoes were painted in the interval between the reign of the Duke of Athens and the *ciompi* revolt, when the petty bourgeoisie were pushing their way forward. For these newly advancing sections of society Giotto's art was too modern, and even that of his immediate successors too refined and precious. During these democratic decades the upper middle class had to make an even greater compromise with those below—and in this the Dominicans certainly played a cardinal part: that accounts for the archaic, at times almost poster-like, idiom, readily comprehensible to any spectator, which is revealed by these frescoes, conceived in so strongly ecclesiastical a spirit and so affecting and full of pathos in their formulas, formulas matched to the mentality of the Dominicans themselves, at once propagandist and conservative, as well as akin to the hieratic style which they favoured and which is disclosed in their own miniatures.

The archaic, hieratic composition of Nardo's Last Judgment probably derives from the representation of the same subject at Pisa. Nardo's fresco of the Last Judgment and still more his Paradise (Pl. 36) are almost purely two-dimensional, consisting of rows of figures one above the other, the heads all in line.[116] Particularly in the Paradise, almost no representation of space is attempted; to be more accurate, faint suggestions of a third dimension appear in the bottom row, but suggestions they remain. In this fresco the rows "behind" are simply placed above the rows in front; the various heads are beside and above one another on the same plane. In their proportions, the figures bespeak the ecclesiastical-supernatural spirit: Christ and Mary on their throne are quite large; the two adoring and music-making angels at their feet are somewhat

smaller; the elect, arranged in twelve parallel lines (as in the case of Pacino, saints and angels alternate with one another) are smaller still.[117] Monotonous, hieratic, heraldic, the fresco in its general effect, while lacking conciseness, yet possesses a monumentality enveloping the entire surface. Both in outlook and style, this "archaising" in no way clashes with the detailed realism of the other frescoes in this chapel, or with the palpable interest in passionate individual movement and gesture and in individual traits. The figures of the Elect and the Damned (Pl. 37) in the fresco of the Last Judgment appear, under the influence of the Lorenzetti and Simone Martini, almost "Sienese"; they are elongated and flexible, often convulsed; particularly striking are some of the female figures among the damned, who are portrayed in contemporary costume, each with a different expression of despair, weeping and wringing their hands in fear. From the time of Nardo di Cione figures in contemporary costume, which helped the common people to understand the pictures, are more frequently represented. No Florentine work of art hitherto had contained so many portrait-like heads as the Last Judgment.[118] Under the influence of Dante and the representation of the same scene at Pisa, Nardo's painting of Hell (Pl. 38) is a variation and intensification of Giotto's treatment of the same subject in Padua (Pl. 4); it is crowded with separate compartments, each packed with varied detail (Pl. 39). The fresco resembles a map filled with individual motives— they include extremely interesting examples of the nude in the most various poses—each intended to be regarded separately, the spectator's attention being directed to it by inscriptions. The whole fresco is a combination of the *Divina Commedia*—in his arrangement of the circles of Hell, the artist follows Dante fairly closely—and a popular penitential sermon.[119]

Archaism and realism of detail, the two essential stylistic qualities in Nardo's frescoes in the Strozzi chapel, both show that the move towards a more popular art, with a greater appeal to the democratic petty bourgeoisie, has now affected monumental painting also. Just as Daddi transposed Giotto's style towards that of the Master of St. Cecilia and, to a certain extent, even that of Pacino, so now Daddi's style is itself deflected towards the Master of the Dominican Effigies. Though it is of a much higher quality and enriched with many of the achievements of the art of the upper bourgeoisie, the artistic style of the middle sections of the bourgeoisie now penetrates into monumental painting, even into these frescoes commissioned by the noble and wealthy family of the Strozzi.

All this is equally apparent in the altarpiece (Pl. 40) of this chapel, though here a stronger inclination towards the upper-bourgeois-Giottesque current is discernible; this picture, dated 1357, was painted by Nardo's brother, Andrea Orcagna (active 1345–68) who may have shared a workshop with Nardo. It shows a strictly orthodox, very ecclesiastical Dominican theme, calculated with unusual exactness: Christ is enthroned between Mary, John the Baptist and a

number of other saints closely associated with the Church (Catherine, Michael, Lawrence, Paul), while before him kneel Peter representing the power of the Church and Thomas Aquinas representing its teaching. The central motive of Christ enthroned between the Virgin and John the Baptist (the intercessors at the Last Judgment) echoes the fresco of the Last Judgment in the same chapel, showing the intellectual unity of the whole decorative scheme. Christ is represented handing the keys, the symbol of the government of the Church, to Peter, and the book, symbolising its doctrine, to the Dominican Thomas Aquinas. St. Thomas, to whom this chapel in the church of his own Order is dedicated and who is here shown under the special protection of the Virgin, occupying the place of honour on Christ's right hand, was also the patron saint of the donor of the picture, Tommaso Strozzi. St. Peter was the patron saint of Don Piero Strozzi, previously mentioned, who certainly inspired the clearly thought-out theme of this altarpiece. Both saints, who look remarkably like portraits, are substituted for the donors. St. Catherine is the patron saint of the donor's wife. These various themes of the Last Judgment, the presentation of the keys and the book, and the picture of intercession with the donors, are formally merged with the scheme of another severely ecclesiastical subject frequently found in Bolognese manuscripts of the Decretals (judicial decisions by the Popes forming the main body of canon law), where Christ symbolically confers spiritual and temporal power on the Pope and the Emperor.[120] The emphasis on the standpoint of the Church is also very pronounced in the predella panels of this altarpiece. Here the Navicella is depicted, a symbol of the power of the Church (legend of St. Peter), and the Sacrifice of the Mass (Pl. 41a), symbol of the purity of the Church's doctrine (St. Thomas falls into ecstasy while celebrating Mass). In the story of St. Lawrence, which repeats the theme of the Last Judgment, the Emperor, Henry II, is weighed in the scales after death and found too light, and is only saved from the clutches of the devil by the saint's intervention (the presence of a hermit is perhaps intended to convey the advantages of an ascetic life, but the democratic implications were not very dangerous, since Florence had no emperor).

The purposeful, concentrated character of the theme brought with it a unification of the composition, also manifested, for the first time in Florence, in the replacement of the usual many-sided polyptych by a more coherent panel. Orcagna's altarpiece is a concisely constructed work, in which Giotto's style has become flat and decorative; the figures, in spite of a strong suggestion of plasticity and of a latent mobility, are stiff and sharply outlined, and are usually shown from the front or in profile; the colouring is unpictorial, the local colours being merely juxtaposed in strong contrasts. Nowhere perhaps is this flat monumentality carried so far as in the predella panel of the Mass of St. Thomas, with its impressively grouped Dominican friars. Though in this typical Dominican picture the compositional tectonics of the upper-bourgeois Giotto-Maso

current is retained, it is transposed into the hieratic, and even the coloristic subtlety of the immediately preceding decades is rejected.

As exemplified in this impressive altarpiece, commissioned by one of the wealthiest families of Florence, the concentrated yet hieratic and two-dimensional idiom of the "upper bourgeois" artist, Orcagna, represents—like that of Nardo di Cione, though with personal differences—a compromise on the part of the upper middle class in accepting stylistic preferences of the lower middle class; or rather it represents a compromise with the style of the mendicant Orders, who sought to increase their religious-ideological influence over these dependent sections.[121] In this period of instability, the upper bourgeoisie naturally attached themselves still more closely than before to the Church and the mendicant Orders, who in their turn relied ultimately upon the upper bourgeoisie and protected their interests, even if with the necessary compromises with those below. In the creation of the artistic idiom which arose in these circumstances, through the medium of strictly ecclesiastical themes, the Dominicans played the determining part.

In Orcagna's St. Matthew altarpiece (Uffizi) which was commissioned by the bankers' guild for their church of Orsanmichele, we again meet his hieratic yet balanced idiom.[122] The archaic disposition of the altar panel with small scenes on either side of the majestic central figure is a conscious return to the thirteenth and early fourteenth centuries. The gold background is unusually widely deployed by Orcagna, but since he is an artist of the upper bourgeoisie, he at the same time exploited it as a compositional formal factor. This also applies to the predella of the Strozzi altarpiece.

Even if Orcagna's art displays greater refinement and reserve in an upper-bourgeois sense than Nardo's, there is nevertheless kinship between it and the rather popular works of Traini at Pisa: probably the artists mutually influenced each other. The Strozzi altarpiece can be regarded in principle as a kind of model for the strictly hieratic Apotheosis of St. Thomas Aquinas of the Traini school. There is a very close relation between Traini's fresco of the Triumph of Death (Pl. 42) with its realism of accessories and a fresco by Orcagna in S. Croce (of which only fragments have been preserved) of the same subject (Pl. 43), which, like Traini's, was probably ordered under the stress of emotion caused by the plague of 1348[123] (here, too, were representations of the Last Judgment and of Hell, but these are no longer extant). As both frescoes were painted about the same time (c. 1350), it is very hard to decide which influenced the other.[124] Orcagna here varied—if we may so put it, for it is possible that the Florentine fresco was the earlier—Traini's figures of beggars and cripples, that is, those whom death rejects, by diminishing their excitement, reducing the extreme realism and toning down their ornamentality which, in Traini, is correlated with their expressive character; he also omitted their still somewhat "medieval" scrolls,[125] although he retained the actual inscriptions. The whole

composition has become more architectonic and compact. All these variations imply a slight shift towards the upper bourgeois and Florentine, as against the more definitely lower-middle-class mentality of Pisa.

A ceremonial frontality similar to that of Orcagna and Nardo di Cione, but yet more popular and severe, is found in the altarpieces of the least important artistically of the three brothers, Jacopo di Cione (died after 1398), who, unlike the two others, survived into the most intense democratic period and probably carried on the family workshop. His workshop, apart from that of Niccolo di Pietro Gerini with whom he also worked, was the largest and most favoured in the Florence of the second half of the fourteenth century. His style is two-dimensional, formally more indefinite than that of the plastic and precise Orcagna, and his faces have uncouth, ugly features. In opposition to Nardo's delicate colouring Jacopo reveals a scheme of strong local colours. In addition he particularly favoured, just as did Sienese painting, richly patterned clothes and textiles characteristic of this phase in Florence when the upper middle class was vacillating more than ever between the nobility and the lower middle class. And although Jacopo produced several versions of the "democratic" Madonna of Humility (Pl. 44a),[126] most of them feature somewhat costly garments.[127] This art was also acceptable to the communal authorities; the Coronation of the Virgin of 1373 (Pl. 45a); with below it the ten saints specially honoured in Florence (Florence, Academy), originally given as a joint commission to Jacopo and Gerini, was executed by the former for the city mint which was conducted by members of the leading guilds. Pictures of the Coronation of the Virgin now become particularly usual, especially in Jacopo's work. That the reins were very much in the hands of the clergy just at this period is exemplified by the very frequent representation which Jacopo had to make of St. Peter, the first Pope, the most "official" saint of the Church—large single figures or scenes from his life. Again, what was probably the largest altarpiece of this whole period, the sumptuous, rigid though not unemotional Coronation of the Virgin by Jacopo in London, with its numerous compartments illustrating the lives of Christ and Mary, was commissioned in 1370 by, as its name implies, a very ecclesiastically-minded corporation, the Compagnia di S. Pietro, for the church of Benedictine nuns, S. Pietro Maggiore. The predella panels, now dispersed (Vatican Pinacoteca, Rhode Island, and coll. Johnson—Philadelphia) all refer to the story of St. Peter.[128]

We have now reached the period of the 1360s and '70s, the zenith of the democratic movement. The more the democratic flood rose and the more painting had to adapt itself to the mentality of the lower strata, the more naïvely religious and at the same time severe and orthodox did it become; for, as already remarked, the clergy proved to have these social strata firmly under their control. Now upper-middle-class painting naturally required, more than ever before, to accommodate itself to the taste of these classes, and this in practice

implied a tendency, as previously, towards flatness, hieratic and naturalistic detail; an ever more pronounced approach to Gothic formal idiom, hitherto generally resisted by Florentine upper-middle-class mentality, was also noticeable. Sienese or North Italian naturalistic genre motives were now often superficially and arbitrarily grafted on to the Giottesque pictorial schemes, already transposed into the two-dimensional.

Florence now of necessity became increasingly subject to infiltration by Sienese art. For in Siena the political and consequently the ideological and artistic situation had shifted even more radically than in Florence. Here the upper bourgeoisie had been effectively overthrown since 1355, and the petty bourgeoisie were ruling—at first, characteristically enough, in alliance with the nobility.[129] During the following decades, political power passed more and more to the masses.[130] The position of the nobility by the side of the petty bourgeoisie had become rather significant, particularly after 1368, while from 1371 the wool workers also had a certain share in the government. The democratic period was at its height between 1371 and 1385. Artistically, the years after the overthrow of the upper middle class are characterised by a disintegration of the tradition of Ambrogio Lorenzetti and a revival of that of Martini, whose style is now combined with that of Pietro Lorenzetti, but both on a new popular basis. This transposition of the courtly Martini into terms of popular art exactly conveys the culture of the conservative petty bourgeoisie related to the nobility. The Sienese painters now introduced new themes, more stirring and popular in their appeal, with genuine devotional images, such as Barna da Siena: Christ carrying the Cross, showing only the detached figure of Christ[131] (New York, Frick coll.; Pl. 46) and the single group of the Virgin, holding the body of Christ in her lap (American private collection). Moreover, the artists employed popular forms: the natural scale of proportions is reversed and the figures vary in size according to their importance as regards the subject-matter and their capacity to move the spectator[132] (e.g. Barna da Siena: frescoes of the Passion, San Gimignano, Collegiata; Pl. 57). Barna is acquainted with Giotto, whom he de-rationalises. The actual figures, especially in the work of Bartolo di Fredi (active 1355-1407), the chief artist of the democratic period, are sharply outlined, frontal, ornamental and flat, but at the same time appear as if carved out of wood or metal, gothicising (Pl. 50, 107a). Whereas in an earlier period the aristocratic features of Martini's late Gothic style (Pl. 113a) were still further intensified (for example by his pupil, the Master of the Codex of St. George, Pl. 22a),[133] Barna now wildly vulgarises them, while Bartolo di Fredi or Andrea Vanni (1332?-1414?) give them the false and crude "refinement" of a pseudo-courtly convention. The two latter artists, the chief representatives of Sienese art in the second half of the century, were also very active politically on the side of the petty bourgeoisie: Bartolo was several times a member of the city government; Andrea Vanni took part in the rising of 1368,

was later ambassador at Naples and to the Curia, and once even occupied the position of Capitano del Popolo. In Florence, where the lower middle class were rapidly gaining in influence though they did not actually govern the city, Sienese influence underlined the trend of local artistic development. The direct transmission of this Sienese style was naturally much facilitated by the fact that Barna himself worked in Florence.[134]

Even Giovanni da Milano (active between 1350 and 1369), probably the leading upper-middle-class artist of this generation, who in his later period also executed large commissions for the Pope, was impregnated with Sienese influence. This influence is still more pronounced in works commissioned by the Franciscans or fraternities or connected with them. About 1354 Giovanni painted the high altarpiece of the Hospital Church of S. Barnabà della Misericordia in Prato. In 1365, Giovanni painted a Lamentation, or rather a Dead Christ, standing erect in the posture of the Man of Sorrows, within the framework of a Lamentation (Florence, Academy). The picture, bearing the coats-of-arms of the Strozzi and the Rinieri, and executed for the convent of the Poor Clares of S. Girolamo e Francesco sulla Costa in Florence, is painted with exceptional anatomical skill, at the same time stiff and moving, following popular tendencies in its appeal, and for that reason, more closely related to northern art: the usual half-figure scheme has been abandoned, and Christ's suffering, moreover, is emphasised far more insistently than was usual in Florence. The concessions made to popular taste appear, if possible, even more clearly in the dolorous and agitated Pietà formerly of the collection Leroy, Paris (Pl. 47). It is perhaps the only example in Florentine fourteenth-century art of the Pietà motive proper: the group of two figures, isolated from all extraneous action, with the body of Christ seated in the Virgin's lap.[135] (Here it occurs, however, in the work of a north Italian artist working in Florence who, as a result of his Lombard schooling, was very open to the influence of Sienese art.)[136] The wound in the breast dominates Christ's entire body, a piteous figure, fragile and delicate.[137]

In the chapel of the sacristy of S. Croce (Rinuccini chapel), under the supervision of the Capitani of the Compagnia d'Orsanmichele, Giovanni in 1365 painted frescoes for the Franciscans, with the stories of the Virgin (Pl. 48) and the Magdalen (they were not, however, finished by him) which show direct relationship with Martini, Barna and Bartolo di Fredi. But this Sienese tendency is in no way opposed to the marked originality of Giovanni's whole conception, combined as it is with a profound knowledge of nature. As embodied in the work of a painter of importance, it is precisely this combination which is typical of the art of this transitional phase of the upper middle class, the phase when they were most compelled to accommodate themselves to the rising, daily more powerful lower middle class. It is characteristic that in Giovanni's frescoes in the Rinuccini chapel, the wall space, despite accurate perspective, is never fully utilised, the figures in general being arranged near the lower edge in the

foreground of the picture.[138] These figures are the most elongated and gothic-
ally curved so far found in Florentine painting. But their curvature is not scroll-
like and ornamental; since they are at the same time plastic they have a certain
abstract, very effective, unadorned woodenness. The rich Gothic style of the
drapery appears to have been influenced by Martini, the whole character of
the Gothic figure idiom is most obviously related to that of Barna, and also,
though it is more distinguished, to that of Bartolo di Fredi.[139] The most sur-
prising feature in Giovanni's work is the spontaneity of his narrative, as, for
example, in powerful and sharply observed genre figures or in frequent and
abrupt intersections.[140] It is worth noting that Giovanni often introduced
unaccustomed motives of a popular tendency into his stories in order to enliven
them. Thus in his painting of Christ eating meat at the Pharisee's house, he
included the seven devils which—according to the Gospel of S. Luke—went
forth from the Magdalen and are here seen flying away over the roof.

Of all the artists of his generation it is perhaps Niccolo di Tommaso (active
1339—after 1376), a native of Florence and a member of the intimate circle of
Nardo di Cione, whose art reveals the most intensive Sienese infusion. Merely
from a Florentine point of view, he was most deeply indebted to Nardo and
Giovanni da Milano. But the essential point about him is that he transformed
Giovanni da Milano's very distinguished figure style into something so popular
and in such a manner that he can have found the necessary models at this
period only in Siena; Bartolo di Fredi stands out pre-eminently in this regard.
To Giovanni's long-drawn-out figures Niccolo added a schematic and heraldic
formal idiom, by which the former woodenness is made into a sort of heavy,
doll-like inflexibility. This is a somewhat similar change to that which Bartolo
di Fredi in Siena had brought about in Barna's figures, a stylistic change condi-
tioned by the fast-growing influence of the democratic lower middle class. Added
to this is, naturally, flatness and in the details—as in Siena—a preference for
rich, highly coloured clothing, scrolls and inscriptions. That Niccolo, like Bartolo,
painted dramatically animated scenes of action and imparted to his figures the
forcible expression revealed in their ugly, distorted features is a pointer in the
same direction. And it is just this combination of dramatic action and rigid,
stick-like figures which hallmarks this popular style. It was the dramatic which
Niccolo sought for in Sienese art. His Descent from the Cross (Rome, coll.
Massimo) is at bottom only a free variation of Martini's late picture in Antwerp.
His crucifixions are also dependent on those of Martini. The Massacre of the
Innocents (Uffizi, depot; Pl. 51), probably only a workshop picture, which is
composed of numerous individual scenes of fighting and lamentation—a theme,
on the whole, very rare in Florence, though much favoured in petty-bourgeois
circles—is similarly to be traced back to wild Sienese versions of this subject
and not to Giotto; that is to say, ultimately, to Giovanni Pisano's pulpit relief in
Siena, while its more immediate models were P. Lorenzetti's fresco in S. Maria

dei Servi, Barna's frescoes in S Gimignano, and possibly also a composition by Bartolo di Fredi (formerly coll. d'Hendrecourt, Paris; Pl. 50).

Niccolo did not work for an exclusive upper-middle-class public, as Giovanni da Milano sometimes did. His art is even more typical of a democratic period[141] and of the corresponding purchasers. He painted many small Madonnas, small altarpieces for minor monasteries and less well-to-do circles. He worked a great deal for the unpretentious Order of the Antonines, founded in honour of the hermit saint, whose members collected money for hospitals in which the sick were nursed free. For one of the houses of this Order, the monastery del T[142] in Pistoia, Niccolo painted frescoes with the story of the Creation[143] in which the stiff, doll-like figures were conceived in a particularly popular-narrative manner. In the Creation of the Animals (Pl. 52), the creatures are arranged schematically in parallel lines, next to one another, as the birds used to be represented in thirteenth-century pictures of St. Francis' Sermon: the connection between these two schemes of composition is specially significant in this democratic monastic milieu. The fresco with the Fall and the Expulsion from Paradise (Pl. 53) has a tapestry-like, schematic and decorative background of plants in which the cowering figures of Adam and Eve are hiding, but God the Father discovers them and stretches his arm over the hedge.[144]

Niccolo's version of the Nativity (Vatican Pinacoteca: Pl. 54) is of great importance, because it is the first example of that new type, pitched on a more emotional yet more ecclesiastical note, which very shortly is definitely to replace the older interpretation, felt to be too indifferent and naturalistic. The change of most consequence is that the Virgin no longer lies in childbed, but kneels in adoration of the Child, and Joseph participates in this act of homage. Preparatory stages in the evolution of this type can be traced in the work of Pacino, Taddeo Gaddi (Pl. 20a), Daddi (Pl. 20b) and his pupil Nuzi, but in these cases the kneeling position of the Virgin was still of a somewhat genre-like character. The new representation which emphasises the divine birth of Christ goes back to a vision of St. Bridget. This saint and mystic—she is even shown in Niccolo's picture—had been canonised in 1391, soon after her death in 1373. As Niccolo most likely died in the 1370s, the picture was probably painted previous to her canonisation; particularly popular figures were often revered and portrayed as saints even before their canonisation. The reasons why the visions of this mystic found credulous recognition have already been stated; she discovered confirmation for the Papal measures in the words of Christ and founded an Order based on a strict rule of life, an Order which preluded the new Observance movement. For a short time St. Bridget also resided in Florence,[145] where she made numerous disciples among the wealthiest of the upper middle class who sought a further spread of her veneration in the lower popular strata ripe for the Observance movement,[146] as, for example, Niccolo Acciaiuoli's sister or Antonio degli Alberti, the last of whom founded a convent of her Order, its rule supposed to be

dictated by Christ.[147] This saint considered the naturalistic description of the Nativity given in the *Meditationes* as insufficiently dignified, and finally received a vision of the actual event from the Virgin, when she was in Bethlehem in 1370.[148] This new motive, like all other visions of the Saint described in her *Revelationes*, was immediately portrayed in Niccolo's picture—it was in Florence, then, that it first appeared in painting—and in truly hieratic popular form. The schematically drawn figures of the Virgin and Joseph, standing in adoration on either side and inclined towards each other, are also related by many compositional links, such as the semi-circle of primitive rocks, the stiff and severe, heraldically composed phalanx of angels with the symbolical head of Christ as the apex. The whole picture thus appears to be covered in an ornamental manner, the more so since the upper part is patterned by a uniform firmament of stars.[149] Inscriptions explain the action. It speaks for the popularity of this new type that two other similar versions by Niccolo himself are extant (Johnson coll., Philadelphia; Griggs coll., New York). So it would appear that the intensely religious, lower-middle-class public could easily be won over to the more austere and ecclesiastical, and especially more mystical treatment of a motive in pictorial representations—the Christ Child, moreover, was more and more surrounded by rays of light—provided the schematism of the composition was plainly understandable, as in the case of the highly popular Niccolo di Tommaso.

The general trend towards both a more ecclesiastical and a more democratic art during the period of lower-middle-class influence is nowhere more marked, however, than in Andrea da Firenze (mentioned 1343-77), who executed mainly monastic commissions besides municipal works in smaller towns Pisa). From 1366 to 1368, he and his assistants were occupied in carrying out the greatest commission Florence had to offer at that time: the decoration of the chapter-house (later known as the Cappella Spagnuola) of the Dominican friars of S. Maria Novella, the Dominican intellectual milieu *par excellence*, with a pictorial programme, undoubtedly invented by the Prior of the convent himself. Both the building and the frescoes for a new chapter-house were the gift of a wealthy merchant, Buonamico di Lapo Guidalotti, made in his will under stress of the plague.[150] His friend, the Prior of the convent, Fra Jacopo Passavanti, persuaded him to make these bequests, which helped to raise the reputation of the Order. Passavanti died in 1357, but his influence persisted, both on the theme and on the whole disposition of the decorations,[151] in which many ideas from Dominican theology, and particularly from his *Specchio della vera Penitenza*, were used.[152] The *Specchio* is a religious tract enlivened by numerous examples and stories on the necessity of repentance, and the best methods of evoking it. It is mainly a compendium of numerous sermons preached by Passavanti in Florence, especially in 1354[153]—a fact very essential for the appreciation of the whole spirit behind this cycle of frescoes.

The subjects illustrated in the two monumental frescoes, which cover the main walls, are the Doctrine of the Church in the guise of the Apotheosis of St. Thomas (Pl. 83, 85) and the Government of the Church (Pl. 86, 87), which is essentially a glorification of the activities of the Dominican Order. In a calculated, textual association with these "thesis-frescoes" of allegorical content are the narrative paintings on the other two walls, illustrating the Carrying of the Cross, the Crucifixion (Pl. 58, 59), Christ in Limbo (Pl. 60), and further, the story of St. Peter Martyr (Pl. 61a, 62, 63), while on the ceiling the Resurrection, Ascension, Pentecost and the Navicella[154] are portrayed. But the relation of the two within the framework of an extended general programme is not quite so close that a technical separation of the frescoes of allegorical content from those of a more narrative subject-matter is not permissible. The first will be discussed in the chapter on symbolic and allegorical art, but the narrative will be treated here with the other Florentine paintings of similar content, so that the significant stage of development shown in the frescoes of the Cappella Spagnuola, namely the style of Andrea da Firenze, may also be elucidated as regards representations of religious stories.

Like the contemporary work of Giovanni da Milano in the Rinuccini chapel, these frescoes eminently reflect the transitional phase of upper-middle-class decline and the growing influence of the lower middle class; the work of each represents a variously pitched combination of fairly similar stylistic properties. While the frescoes commissioned by the Franciscans and the Compagnia d'Orsanmichele are somewhat closer in spirit to the upper middle class, those in S. Maria Novella are nearer to the lower middle class in their whole orientation, in accordance with the Dominican policy of adaptability to existing circumstances. Although the paintings of the chapter-house were, naturally, in the first instance intended for the Dominicans themselves, whose cultural conservatism was in itself related to popular tendencies, they nevertheless also reveal in this period of the rising lower-middle-class qualities definitely intended to make them intelligible to the masses; the fact that the programme of frescoes was inspired by very effective and persuasive sermons preached in Florence where the traditional world of ideas was enlivened by realistic *esempi* reinforces this impression. Andrea's frescoes were thus intended to appeal in a generally comprehensible manner to the religious feelings of the uneducated masses as well.

These frescoes represent the qualitative zenith of popular tendencies in art, a zenith possible only in the concrete situation of a rising lower middle class. While Giovanni da Milano's works are to be explained by the inclination of the upper middle class, declining in power, to compromise and represent the second and naturally greater wave of the upper-middle-class policy of concessions in art which began with Daddi, Andrea's works mirror a still more positive disposition in this direction; the result as seen in Andrea's frescoes does

not imply the existence of a truly lower-middle-class art, but it does at any rate suggest a closer contact with that class. Now in the 1360s and 70s, when the rise of the lower middle class had greatly accelerated, these positive, popular tendencies no longer manifested themselves merely in small altarpieces and miniatures, such as those of the Master of the Dominican Effigies, belonging to the previous generation, but in great fresco cycles. And equally naturally the quality of these more popular works also improved, especially in the large cycles, although they always remained to some extent behind the more "upper-middle-class" works so far as sheer skill and technical mastery were concerned. For Andrea da Firenze, the stylistic consequence of this general situation implied a continuation of the tendencies displayed by Traini, Orcagna and Nardo di Cione and the more extensive employment of the stylistic elements, well known to us, denoting an ecclesiastical and democratic art, and a renewed contact—for obvious reasons—with Sienese influence.[155]

In the immense Crucifixion fresco (Pl. 58)—it is the main picture on the rear wall—the subject is treated in greater detail and contains a vaster crowd of figures than perhaps ever before in Florence (we are here far from Giotto's concentration); a similar elaboration might at most be found in the Daddi circle, but it was common in Siena in the work of Pietro Lorenzetti and Barna da Siena. That this theme is the kernel of the story of the Redemption surely plays a certain part in the intricate treatment of the Crucifixion in such a place as the Cappella Spagnuola. The motive of the crowd—a typically democratic one—is vividly presented and spun out in manifold variations: variations of sorrow, wonder, hatred. Each individual figure has a different attitude to the event in progress, but the bearing of the crowd suggests a predominant mood of sympathy; even many of the soldiers appear to be converted, although a section of them are savagely attacking the mourners, and freely using their swords (Pl. 59).[156] The conception of a vast and highly agitated crowd was certainly influenced by Pietro Lorenzetti's fresco of the Crucifixion at Assisi and by that of Barna in S. Gimignano (Pl. 57). Details were taken from both these works: from Barna, for instance, the motive, unusual in Florence, of the grotesque devils carrying away the soul of the wicked thief. Barna had intentionally altered the proportions of the figures to which attention was to be drawn, and Andrea also used formal means of expression to render every detail—all are sharply outlined—clearly visible. Thus the lamenting figures, the spectators and the horsemen are not distributed in space, but arranged in the popular archaic manner, for the sake of visibility, in long rows one above another.

The many-figured composition of the Carrying of the Cross also rather suggests the influence of Pietro Lorenzetti's and Barna's corresponding frescoes. Here too, as in the Crucifixion, the figures are ranged one above the other; as they move up the steep ascent in the procession, the heads alone are visible, all appear of equal size owing to the absence of any perspective, and for this

very reason are clearly "legible" to the beholder. The arrangement of the Resurrection is similarly archaic. But at the same time the "spiritual" tendency begun by Taddeo Gaddi of showing Christ floating near the sky is here further accentuated, although in a somewhat heavy manner.[157] Arising from the spirit of the programme, the scene of Christ in Limbo (Pl. 60) probably occurs here for the first time in Florentine monumental painting. Andrea depicts the popular, grimacing figures of the devils in this scene with great elaboration and a certain preference for the grotesque.[158]

The same building also houses frescoes by Andrea illustrating the story of St. Peter Martyr,[159] the most zealous heresy-hunter among the Dominicans, the same who destroyed the sect of the Patarini in Florence with great ferocity and later took an active part in the organisation of anti-heretical and clerically influenced Companies. So far it had only been possible to illustrate his life on minor altarpieces or predellas. For instance, the principal company founded by him, the Compagnia Maggiore della Vergine (later called Compagnia del Bigallo) had placed an order, about 1350, with a rather insignificant artist near to Maso for a small altarpiece showing the foundation of the Company in 1244 to combat the Patarine sect (Bigallo; Pl. 45b):[160] St. Peter Martyr is handing the standards, each composed of a long red cross and a red star on a white background, to the Capitani of the Company, the fifteen most distinguished citizens of the city assembled in S. Maria Novella; these burghers are standing respectfully in front of the saintly Dominican, demonstrating their trustworthy ecclesiastical-official frame of mind. When we come to the Cappella Spagnuola, the representation of the story of this saint, popularised by the Dominicans, has been advanced to the rank of a cycle of frescoes. In one of them, which shows the Saint preaching from an open-air pulpit against a heretical bishop (Pl. 61a), the rich and the poor press in an animated throng around him; thus the unity of all sections in the city effected by the Dominicans is implied. Hence the theme of the popular sermon with its crowd of listeners, previously confined in the main to predella panels of vividly narrated legends of the saints, was now introduced into the realm of fresco painting. This fresco, and even more some others from the story of St. Peter Martyr, are already, in effect, almost genre pictures. For in all these frescoes illustrating the life of this outstanding Dominican saint—for instance, in the healing of the sick man who prays to him (Pl. 62) —there is a very striking and unmistakable tendency to portray a very ordinary middle-class milieu and very ordinary middle-class types. The simple yet impressive poses of the figures and the plain, hard local colour are formally in accord with this environment. The use of contemporary costume, already common in Nardo di Cione's work, in that of Andrea da Firenze is greatly extended. The picture most strongly resembling a genre piece drawn from contemporary life is the fresco showing pilgrims and cripples venerating the tomb of the saint (Pl. 63). This is another theme introduced into monumental

painting from the realm of the predella. The various types of sick as they strive in search of healing to touch the sarcophagus decorated with figures of the virtues, are represented with great diversity and clarity. All the small figures of Evangelists and Fathers of the Church painted on the ribs between the frescoes carry inscriptions on rolls, a motive also more frequently employed than before. These several features characterise an ecclesiastical yet democratic style.[161]

Similar in style to those of the Cappella Spagnuola are the frescoes in the Campo Santo in Pisa of the life of St. Raineri the hermit (Pl. 64), patron saint of that city, painted by the same artist in 1377, just before the outbreak of the *ciompi* revolt. The representation of the story of a holy hermit was quite in keeping with the Dominican-Observant attitude as it was becoming crystallised in Pisa at that time. So we may say that Andrea da Firenze's paintings both in the Cappella Spagnuola and in the Campo Santo are of the "popular" nature determined by Dominican mentality. In these Campo Santo frescoes, where in contrast to Nardo di Cione's pictures of the heavenly hierarchies, and even more so, for instance, to Andrea's earlier Crucifixion, very varied scenes are presented, and the arrangement, according to crass formulas, and the two-dimensional appearance of this more popular and therefore more conservative style are all the more striking. The use of continuous narrative is here driven to such extremes that in one fresco, for instance, which illustrates his temptation and his miracles, the saint is seen six times in the foreground, and on four of these occasions is immediately next to himself. The figure of the devil tempting the saint, a great favourite in popular frescoes, crops up equally often. Long inscriptions with dialogue between the main personages issue from their mouths (thus after the repeated failure of his temptations, the devil says: "I can do no more.") The figures are often symmetrically disposed and stand in rigid, cramped, frontal or profile poses next to or above each other, so that the whole painting consists only of verticals and horizontals. As in the Cappella Spagnuola Crucifixion, the formula of the figure contours is already appreciably more Gothic in character than in Nardo. And we find here, as is so often the case in popular styles, that this primitive formal disposition is once more combined with a great diversity of observation as in the St. Peter Martyr scenes: e.g., the singing priests and children with their mouths open (a motive not unusual in Florentine painting, but in Andrea the treatment is much coarser).[162]

Another somewhat later artist of the democratic era, much of whose activity falls within the period after the *ciompi* revolt, is Agnolo Gaddi (d. 1396), the son of Taddeo. The fundamentals of his style are to be traced in the work of his father, whose later manner became very popular in character, and further in that of Giovanni da Milano, from whom he adopted something of the Sienese elements in the narrative art both of Nardo and of Andrea da Firenze. Among the pictures attributed to him as early works, a Madonna of Mercy (Pl. 65), with donors and a number of nuns (Florence, Academy; painted for the Augus-

tinian convent of S. Maria dei Candeli),[163] is particularly interesting as an indication that this democratic and popular theme, hitherto rather uncommon in Florence, though usual enough in Siena, in these stirring times now becomes topical in Florence also.[164] It had already occurred in the popular circle of Pacino.

Agnolo's main work, the frescoes in the choir of S. Croce with the legend of the Holy Cross, were painted about 1380, shortly after the *ciompi* revolt, at a time when the lesser guilds were still in power; the donor was Jacopo degli Alberti, a member of that upper-middle-class family which had assumed the leadership of the lower middle classes. Even the choice of theme is typical of this democratic era. For the legend of the Cross was an essentially popular Franciscan subject[165] with its mystic relation between the Old and New Testaments; the basic motive of this legend, as of the allegory of the Cross, is that the Tree on which Christ redeemed mankind grew from the grave of Adam, who introduced sin into the world.[166] But the stylistic characteristics of the frescoes also correspond to the whole social and political situation we have mentioned. Though conforming in certain respects to the artistic needs of the lower middle class, their appeal is not confined to them alone, but is also directed to the taste of the upper middle class. The frescoes are in the main two-dimensional, stratified and composed of rather unrelated crowds of figures. But there are also occasional tentative diagonal recessions leading from figures in the foreground to the background, and yet more frequently views into the distance within the landscape backgrounds, in which the contrast of mountain and plain, in particular, gives rise to frequent vistas and intersections. Thus we find the first approach to a certain late-Gothic and disjointed conception of space going beyond the earlier flatness. Agnolo's naturalism is as a rule, however, concentrated not on the organic unity of the picture, but on the details, and especially on the individual figures. The latter—Agnolo employs a large number in a naturalistic manner—are frequently massive, with ugly, coarse faces and long noses. Some of these are drawn from the humble, the labourers, and it is precisely this that is characteristic of these years. These types are particularly prominent in the genre-like fresco of the Making of the Cross (Pl. 66), which also shows (on the authority of the *Legenda Aurea*) a hospital with its inmates. Another set of figures again, evidently belonging to the well-to-do classes, reveals more definitely portrait-like features. Finally, there are a striking number of knightly types, as in the fresco (Pl. 124) showing the departure on horseback from Jerusalem of the Persian King Chosroës bearing the Cross with him (similar types appear in Bartolo di Fredi, the most typical painter of the Sienese lower middle class, by whom Agnolo was clearly influenced). All things considered, these frescoes give the impression that we are no longer in so intensely militant a period of democracy as the years preceding the *ciompi* revolt.

This is even more true, naturally, of the second half of the 1380s, when

Agnolo and his workshop were engaged on the frescoes with the stories of John the Evangelist, St. Nicholas (popular on account of his works of charity), St. Anthony the Abbot, and John the Baptist, in the Cappella Castellani at S. Croce.[167] But even here a number of beggars are included in the scene showing St. Anthony distributing his fortune to the poor—the cycle was painted in a Franciscan milieu—and the Temptation of St. Anthony is shown in a vast composition with popular devil-figures (Pl. 67). This last fresco, like most of the others of St. Anthony, was painted by Gherardo Starnina (b. about 1360–5, d. between 1409 and 1413). Although he belongs to a later generation of artists, he must be noted here as the most important of Agnolo's assistants who worked in the Cappella Castellani. This popular hermit theme[168]—an echo of the democratic era—is here represented in Florentine monumental art practically for the first time, and now actually in S. Croce.[169] Starnina's style is distinguished from Agnolo's, as also from that of his collaborators (who are, moreover, clearly influenced by him), by a more modern note: it is more spatial, the figures are fewer in number and much more organically incorporated into the landscape; the colouring has a formative function.[170] Starnina had been implicated in the *ciompi* revolt,[171] and had therefore to flee to Spain at the beginning of the oligarchical reaction, probably immediately after the completion of these frescoes.[172]

Dissimilar in its emphasis, yet not entirely alien to the art of Agnolo Gaddi, is the work of another artist of the democratic era in Florence, Antonio Veneziano (active 1369–88), whose activity in Florence, however, was not of long duration. His style (Pl. 68a) with its proclivity for realism of detail, for lyrical, intimate and at the same time dramatic traits—a style which prepared the later decisive gothicisation in Florentine art—blends the colouring of his North Italian native land with reflections from Taddeo Gaddi, Daddi and especially Siena. In Siena he had himself worked in the cathedral (1369–70), together with Andrea Vanni, the artist of the Sienese petty bourgeoisie, who took a leading part in the political activity of his native town. His chief work in later years, however, was carried on in the provincial atmosphere of declining Pisa, where he was not only active in the municipal Campo Santo (1384–87)—he had to complete the story of St. Raineri, begun by Andrea da Firenze—but also worked (both here and later in Palermo) for smaller fraternities.[173]

With the same inclination for realism of detail, but more markedly two-dimensional and heraldic than Antonio Veneziano, is Giovanni del Biondo (active 1356–92) also for a time active in Siena, who like all Florentine painters of this period working in a popular manner, was apparently influenced by Bartolo di Fredi. Of Florentine artists, Jacopo di Cione as well as Orcagna had a share in the formation of his style. Biondo's formal idiom is heavy and schematic; in unplastic two-dimensional appearance his figures can scarcely be exceeded; they are stereotyped, wooden, and often distorted. Passive and lacking in

vitality, in spite of its brutal, poster-like quality, his style as expressed in his many altarpieces is at once a complement to and a petrification of Niccolo di Tommaso's intense manner, being merely a lame continuation of that of Andrea da Firenze. Biondo's later style, at any rate, was a necessarily lame continuation, for after the suppression of the *ciompi* revolt, which finally put a check to the political rise of the lower classes, external circumstances had changed: it is no accident that in these conditions of exhaustion and slackened intensity, the dramatic potentialities of Niccolo di Tommaso's style were in general allowed to decay. But Biondo's art as a whole is highly characteristic of the passive and conservative mentality of the somewhat lower strata at this period, and is for this reason a necessary complement to that of the other two artists we have mentioned: his definitely undramatic altarpieces—many of them painted for fraternities or private persons in the provinces and in the rural areas around Florence (Pl. 68b)[174]—undoubtedly satisfied the artistic needs both of the more lowly strata[175] and of the more retrograde upper circles (for example, he painted an Annunciation with saints for the family chapel of the Cavalcanti in S. Maria Novella, to-day in the Academy, Florence).

His paintings often show only a single figure, the Madonna—the genre-like motive of the Virgin teaching the child Jesus to read (New York, Kress coll.) appears too in Biondo[176]—or single saints. Very typical of the manner of thought universal in these lesser burgher or more conservative circles in which everything scientific was ostentatiously subordinated to the religious, is the frequent representation by Biondo and others close to him of St. Catherine, the popular-ecclesiastical patron saint of the sciences. One such St. Catherine with donors by Biondo was even painted for the Cathedral (now in the Museo dell'Opera del Duomo). While in Daddi the saint was still relatively simply dressed (Pl. 26a), she is now shown—characteristic of the more popular art of Biondo—in a garment entirely bespangled, like the curtain behind her, with large patterns. But, as always in popular art, the richness of the drapery appears clumsy and exaggerated, and the whole effect is two-dimensional. Another picture of St. Catherine (New York, Mogmar Art Foundation; Pl. 69), attributed to Biondo (but probably nearer to Cenni di Francesco of a later generation)[177] shows the saint if anything more sumptuously clothed, crowned and seated upon a throne, rising above all the other figures in the picture. She is disputing not with the customary scholars, but with the physician saints, Cosmas and Damian. Through this whole manner of arrangement, the tiny donors kneeling in a corner register the fact that their healing belongs in the last resort to the religious sphere (it is worth remembering the views of Petrarch and Salutati on medicine).[178]

Only on rare occasions did Biondo take up the "narrative" tendencies of Andrea da Firenze: for instance, in two predella panels of the Last Communion (Pl. 70) and Extreme Unction respectively (Worcester, U.S.A., Smith coll.) parts of a polyptych illustrating the Seven Sacraments, or perhaps the Office of the Dead.

In these pictures the realistic line of the Peter Martyr frescoes in the Cappella Spagnuola is clearly continued, the first predella frankly relying upon the fresco in which the sick man in his bed is praying to the saint (Pl. 62). But the transformation into the primitive and popular which appears in these genre-like Sacrament predellas by Biondo is very characteristic: Andrea's naturalistic skill has vanished, and his grandeur with it, only a trait of realistic detail remaining here and there; the figures more definitely resemble small heraldic dolls differing in size according to their importance.

It should be noted that the costly clothing favoured by Biondo, as also by Niccolo di Tommaso, and generally by artists of popular tendency, has a heavy, uniform pattern, due to the lesser skill of these painters, and to their great love of sumptuous garments; they are in contrast to the delicacy and elegance of the patterned costumes in the works of the artists employed more explicitly by the aristocratising upper middle class: these religious paintings by Biondo tend to reflect the actual struggle of even the less elevated classes for the right to wear rich clothing.[179] The archaic, popular picture format of the central figure surrounded by numerous small scenes commonly employed by artists from the Master of St. Cecilia to Jacopo del Casentino and again adopted by Orcagna, is especially frequent in Biondo's work, as also are scrolls. The appeal to the social classes above mentioned was now, and particularly in Biondo, centred less on the grand manner, on fresco-painting, than on altarpieces in which it was easier to cater for their outlook and artistic requirements.

After the suppression of the *ciompi* revolt and the final victory of the upper middle class, the development of monumental painting necessarily veered away from the line of Andrea da Firenze, partly even of Agnolo Gaddi, and took a direction more accordant with the outlook on life of the now victorious class. Spinello Aretino (*c.* 1346–1410), probably the outstanding painter of the 1380s and 90s, now underwent a corresponding development.[180] His early works in Arezzo dating from the 60's, 70's and early '80s—mainly painted for confraternities[181]—were still executed in the unspatial, hieratic-popular style of the Orcagna brothers. The transition to a new, more spatial style, to some extent once again modelled on Giotto himself, is revealed in the important commissions which drew him from Arezzo and put him in contact with higher circles: the frescoes with the story of John the Baptist (now lost) painted by order of the Manetti for their family chapel in the Carmine in Florence and the two large altarpieces of the Madonna and saints executed for the exclusive Benedictines. The former of these two last-mentioned which was painted for the monastery of S. Ponziano in Lucca (only a few fragments have been preserved) must have been a great and immediate success, since it was expressly stated in the contract commissioning the second, erected in the monastery of Montoliveto Maggiore near Siena (1384, to-day dispersed in Budapest, Siena, Cologne and Cambridge, U.S.A.) that it was to resemble the one in Lucca.[182]

FLORENTINE PAINTING AND ITS SOCIAL BACKGROUND

A certain "return", at any rate in principle, to the upper-middle-class spatial style of the opening decades of the century is all the more apparent in Spinello's two great cycles of frescoes painted during the '80s for the wealthy Florentine Benedetto degli Alberti, that leading politician of long standing whose name is well known to the reader. This is particularly true of the frescoes with the story of St. Catherine (Pl. 71), executed about 1387 in the church of S. Caterina at Antella (near Florence), on the Alberti estate. Spinello here immediately transcends Agnolo Gaddi's frescoes in the choir of S. Croce, completed only a short time before, though still during the period of lower-middle-class ascendancy; he is more spatial and monumental. The figures in these frescoes become once more solid and firmly planted on the ground; figures and space again bear relationship to one another. The balanced more organic figure composition is now set in a picture-space built up on as wide a perspective as possible; the buildings placed in diagonals (as, in fact, already seen in Agnolo Gaddi's work, especially in the frescoes of the Castellani chapel) form a striking contrast to the schematic frontal, architectural cross-sections of, for instance, Andrea da Firenze.

A yet further stage was reached when, in 1387, immediately after the completion of the work above mentioned, and at the wish of the same Benedetto degli Alberti, Spinello began to decorate the sacristy of S. Miniato; the work comprised sixteen frescoes of the legend of St. Benedict (Pl. 72), the patron saint of the donor and founder of the Benedictine Order, of which the Olivetans —who had acquired the monastery and church of S. Miniato a few years before —were a branch. Alberti commissioned these frescoes when in exile after his banishment in 1387,[183] so that the work can almost be regarded as a commission from the Benedictines, with whom Spinello had the closest connections.[184] It is very remarkable how generally active the Benedictines now became in the sphere of artistic commissions. After the upper-middle-class reaction had set in it was precisely these Benedictine monasteries, hitherto in the background and focussed on the personal and genteel isolation of the individual, which increased in day-to-day importance. In addition, hand in hand with the Observance movement, the eremitical ideal came into great favour both with the upper middle class and with those below. When Salutati wrote a book on the advantages of the monastic life (*De Saeculo et Religione*, 1381) he dedicated it to a Benedictine.[185] It is, therefore, not at all strange that a detailed cycle of the eremitical and monastic life of St. Benedict should be executed just at this moment.

In any case, these frescoes by Spinello in S. Miniato, which exalt the eremitical ideal of the Observance movement, now spreading and fundamentally serving the interests of the upper bourgeoisie, differ completely in style from the Raineri frescoes, painted ten years earlier by Andrea da Firenze for the Campo Santo at Pisa; these latter had depicted the Observant ideal, but in a far more

popular manner. The upper middle class were now slowly beginning to assimi-
late and adopt the new eremitical ideal, which in this new social milieu (though
not elsewhere) was losing much of its original popular character. Hence,
Spinello's frescoes exhibit a tendency away from the popular which is typical
of the new period after the *ciompi* revolt; they clearly represent the new style of
the victorious upper bourgeoisie. But this style is still a very peculiar mixture of
the old and the new. For, once again supreme, the upper middle class, though
steadily growing in outward power, were not and could not be ideologically
unambiguously progressive; they could not free themselves immediately and
completely from the democratic petty-bourgeois adjuncts of the last forty years,
and, moreover, their own economic power was fundamentally undermined.
Only through their outward supremacy were they able to take up a new,
though for the time being compromising, intellectual position and develop a
new, though for the time being ambiguous, art. This is seen in the style, parti-
cularly in the formal details, of Spinello's frescoes in S. Miniato: after the artist
had to a certain extent again taken up the earlier rationalist spatial treatment
and tectonically constructed figures, he was still unable to develop the style
systematically—and just at this point, when he wanted to go further, this became
particularly evident. In his S. Miniato frescoes, Spinello wished to give a greater
sense of space than in his work at Antella. But he was unable to do so in an
explicit and radical way, and was forced to employ a very complicated method.
Occasionally, it is true, he achieved a certain degree of clarification. But, on
the whole, his space construction is illogical and his use of perspective incon-
sistent, and he diverted these factors in a rather unreal direction, continuing
and further complicating that dissolution of space which began with Agnolo
Gaddi. Foreshortening, diminution, intersections, diagonal recession, and a
chiaroscuro particularly dear to Spinello, generally failed to produce a true
spatial unity, but often encouraged a certain painterly confusion, a late Gothic
dismemberment of space. Different parts of the frescoes have separate vanishing
points, areas in the distance are often larger than nearer ones, and those very
sections of space which, judging by their respective scales, should be far apart
frequently merge into one another. The eye must again and again penetrate
into the depth of the picture and again and again perceive different sections of
the foreground and background as visual units. In this way perspective often
serves to create a certain restless, confused general effect, and we are justified
in speaking of gothicised perspective.[186] Moreover, the formal idiom of the
figures increasingly loses its earlier, tectonic solidity, though admittedly it also
loses the clumsiness present, for instance, in Agnolo Gaddi; there is an increase
in late-Gothic curvature and gracefulness, and at the same time a more unified
current of movement in the figures. Thus in Spinello's work the "lower-middle-
class" two-dimensionality is no longer predominant, though the often abrupt,
fragmentary general impression almost amounts in the end to the two-dimen-

sional; nor does the schematic-heraldic formal idiom of the "lower middle class" prevail, though there are relationships here also. It is the style of the upper middle class, but not unequivocally, like that of Giotto and at a later period of Masaccio, but an "interesting", iridescent, compromise style of a period of transition.[187]

This style assimilated an ever larger number of late-Gothic and aristocratising properties in the frescoes which Spinello painted in 1391–92 in the Campo Santo at Pisa, illustrating the stories of SS. Ephisius and Potitus (two Sardinian saints, who, like the St. Raineri painted by Andrea da Firenze, are buried in the Cathedral at Pisa). On the best preserved fresco, in one half St. Michael is giving the banner of victory to St. Ephisius, while in the other both are putting the heathen to flight in an equestrian battle (Pl. 73). Battle scenes imply in themselves a marked secularisation of religious stories, especially in monumental art, for until that time such scenes—with the exception, perhaps, of the so-called pictures of infamy which we shall presently discuss—were in the main confined to secular miniatures, such as those illustrating Villani's Chronicle. Turning to the figural style of the Pisan frescoes, we find that the battle-scene is almost entirely composed of knights, and St. Michael on horseback is, of course, represented primarily as a knight (the story of St. Benedict in S. Miniato had revealed a marked relish for figures of knights). The clumsiness of the Gothic formal idiom of the mid-century has certainly not entirely disappeared, yet Spinello's Gothic figure style is much more delicate, aristocratic and full of movement. In the equestrian battle, the individual motives are intertwined in a gothicising-rhythmic fashion, the chiaroscuro emphasising this interweaving. Spinello's altarpieces of this period (e.g., Coronation of the Virgin, 1399–1401, Florence, Academy, formerly the high altarpiece of S. Felicità, the church of the Benedictine nuns) also manifest a certain tendency for the figures of saints to become slim and distinguished-looking.[188] Spinello ended as one of the most sought-after painters of his time: his native town of Arezzo, Florence and Siena (Cathedral and Palazzo Pubblico) overwhelmed him with large-scale commissions, some of which even he was unable to execute.

Only partly similar to those of Spinello or Agnolo, for the really great customers were wanting, were the patrons of the large and very active studio of Niccolo di Pietro Gerini (matriculated 1368, died 1415), who displayed the character of a regular entrepreneur. Among the grand-scale painters of these decades, he was relatively, though only very relatively, the most "popular". His most extensive cycles of frescoes reveal him in closest relation to "popular" monastic circles, especially the Franciscans, and as employed particularly on the representation of the Passion: frescoes with scenes from the lives of Christ, John the Baptist and St. Lawrence in the chapter-house of S. Francesco in Pisa (1392), another cycle with the Crucifixion, and the stories of St. Matthew and St. Anthony Abbot in the chapter-house of S. Francesco in Prato (about 1395),

(fragments of) a Passion cycle in the sacristy of S. Croce in Florence. Both in his frescoes and in his altarpieces he showed himself still dependent on Taddeo Gaddi and on Orcagna's large-figured and two-dimensional style, just as was the case with the even less plastic Jacopo di Cione with whom he occasionally worked. He had only a share in Spinello's development. He is conservative and popular, frequently employed scrolls, his local colours are strong and at the same time broken; he is clumsy and schematic, without the weight and inventive power of Andrea da Firenze, the representative of the heroic period of the lower middle class. Nevertheless, Gerini's work does not lack effectiveness and— especially in his Passion scenes—he is more intensely emotional in his appeal than the artists working for a more exclusive clientèle. It is probably no accident that one of Gerini's patrons, the rich but not very cultured merchant Francesco Datini of Prato, expressly stated (1390)—though it is not certain whether he was specifically referring to one of Gerini's pictures—that he desired the figures in a painting of the Man of Sorrows to be as pious and expressive as possible and that there should be a large number of them.[189] In his Entombment (Florence, Academy) Gerini painted what was the largest assembly of mourning figures yet seen in Florentine representations of this theme. In the fresco of the Carrying of the Cross in S. Francesco in Pisa, on the whole a continuation of the emotional representations of Nardo and Andrea da Firenze, Gerini made the suffering figure of Christ stand out from the others, in an emphasised manner with evident reliance upon Sienese art. How this conservative-popular work-shop could combine the emotional with hieratic rigidity and severe, symmetrical arrangement is well illustrated in the fresco of the Ascension in the same church (Pl. 74), which reverts in its planimetrical composition, significantly enough, to Traini's fresco of the same subject in the Campo Santo at Pisa: Christ shrouded in a heavy mantle not only holds the banner of victory in his hand, he is also decorated with crown and sceptre; on either side of the fresco symmetrically arranged angels in the white vestments of deacons are holding scrolls which float upwards.

As revealing the complex and adaptable spiritual character of the growing Observance movement, we may note the frescoes of the Passion, executed by Gerini's workshop in the late 'nineties in the Church of the Brigittine nuns and monks founded by Antonio degli Alberti at Bardino near Florence (Pl. 75b).[190] Painted for the "popular" milieu of the new strict Order, these frescoes are much less refined and "progressive" in style than those of the life of St. Benedict by Spinello at S. Miniato; the latter, indeed, were also commissioned by a member of the Alberti family, but for a more private purpose, and though the new Observant ideal enters into them too, it is seen entirely from the standpoint of the Benedictines and the upper bourgeoisie. On the other hand it must be stressed that the frescoes at Bardino do not depict the Passion in the strict sense of the word, that is to say, the sufferings of Christ, but rather the scenes sur-

rounding it—a definite diluting of the "popular" tendency. Executed by assistants in Gerini's workshop, Lorenzo di Niccolo and Mariotto di Nardo, these frescoes lacked dramatic intensity of style.[191] Individual traits derived from the narrative art of Nardo and Barna are occasionally to be recognised, though in a thoroughly weakened form. Here Gerini's assistants make his style still more flat and schematic than elsewhere, and the general disposition is more symmetrical than usual, even for him.[192]

In S. Francesco in Prato—in the Franciscan milieu of a provincial town—Gerini's fresco of St. Anthony distributing his wealth (Pl. 75a) contains a number of beggars so large as to be exceptional even for this theme, and it is equally characteristic both of the provincial town milieu and of the archaic conventions of this workshop that their types are still largely derived from Traini and Orcagna. On the other hand, Gerini also represented in this cycle a Calling of St. Matthew which shows a detailed picture of a money-changer's office (or rather of a toll booth), a subject which until that time had been to some extent proscribed in Florentine monumental painting,[193] but was more possible in this popular middle-class artist. Portrayals of middle-class business pursuits which hitherto could seldom be found in religious art now became more and more frequent in frescoes and altarpieces.[194]

Coming now to a short consideration of the miniatures of the late fourteenth century, a group of more or less popularly illustrated manuscripts, allied both in theme and style, must first be mentioned, namely, those dealing with the legend of St. Margaret, a saint equally popular in all circles, because she was regarded as the special intercessor in heaven for women in child-bed. One such manuscript, for instance, was executed for the Pucci (Laurenziana; Pl. 76b): its miniatures are schematic and disproportioned, yet at the same time vividly narrative.[195] But it is likely that only a part of these manuscripts was commissioned by wealthy and distinguished families (another manuscript, for example, was for the Adimari). Others, less richly embellished, in which the miniatures were still rougher and more popular, more in the nature of coloured pen-drawings (as often in the North), were probably executed for somewhat less well-to-do clients.

So far as concerns monastic miniaturists at the end of the fourteenth century, it was the Benedictines who were particularly active. We have already referred to the relationship of the humanists with individual Benedictines, as also to the early infiltration into the distinguished Benedictine monasteries of the Observance movement: there now appears a certain, even if not very far-reaching, contact with the outer world, above all a certain spiritual aliveness. This is clearly evident in the numerous artistic commissions given to Spinello Aretino, and it is also expressed in the activity of the monks as miniaturists. Most important of these was Don Simone Camaldolese, born in Siena, whose style bears marks of affiliation with Sienese art. He worked in the monasteries

of S. Pancrazio, S. Miniato, and perhaps also in S. Maria degli Angeli,[196] soon to assume great artistic prominence. From the hands of this Camaldolese monk and his circle come the miniatures of numerous antiphonaries and graduals, which, somewhat in contrast to the earlier Dominican manuscripts, develop more and more into regular luxury manuscripts. As we should expect from the general situation, the style of these miniatures is a combination, in a monastic setting, of aristocratic and popular elements. It is not unrelated to the style of Jacopo di Cione and Niccolo Gerini, but has a greater tendency towards the magnificent and at the same time towards a delicate, elegant, "Sienese" realism of detail. It also manifests some approach to Gothic within which all these elements merge.[197]

NOTES

[1] The connection between works of art and atonement for usury is not an uncommon one. Thus in 1315 in his will Rinuccino Pucci endowed a bone lamp to hang in front of Giotto's Crucifix in S. Maria Novella.

[2] The interpretation of these figures varies; they possibly represent the three cardinal virtues.

[3] One of the sons of the donor, Ridolfo de' Bardi, was himself a Franciscan.

[4] The artist was taken as a *familiaris* into the king's suite, and as such had a right to board and lodging in the royal palace. See also p. 273, note 33, and p. 282.

[5] It is possible that the fresco was ordered after the Pope's death by Cardinal Stefaneschi. Whether or not the well-known statue of the seated Pope, intended for Arnolfo's façade of the Cathedral of Florence (now in the Museo dell' Opera del Duomo), probably by one of his pupils, really represents Boniface VIII, even the old tradition in favour of this identification is symptomatic of the close alliance between the Pope and the Florentine middle class. In 1323 a decision was taken to erect a statue of John XXII, the most capitalistically-minded of the Popes of the period, who had in the same year issued his Bull against the poverty of Christ.

[6] As soon as the Lana took over the supervision of the construction of the Cathedral (1331) it elected a supervisory committee of its members, which appointed Giotto chief architect (1334).

[7] The business ability with which Giotto conducted his workshop is shown by his habit of affixing his full and pompous signature to the largest altarpieces ordered from him, the execution of which he left entirely to his assistants: the polyptych of the Coronation of the Virgin, executed by Taddeo Gaddi for the Baroncelli (S. Croce), the polyptych of a Madonna with Saints painted for S. Maria degli Angeli in Bologna (Bologna, Pinacoteca), and the Stigmatisation of St. Francis, produced for S. Francesco in Pisa (Louvre).

[8] It was quite possibly this business activity which brought him in touch with the Humiliati, who were themselves concerned in the woollen industry and for whose church of Ognissanti he painted a strikingly large number of altarpieces, including the Madonna now in the Uffizi, and a famous Death of the Virgin (probably the picture now in Berlin).

[9] This was unusually high, even for Florence. Usually the profit from hiring out looms was limited to 50 per cent.

[10] Davidsohn, *op. cit.*

[11] F. Tocco, *La Questione della Povertà nel Secolo XIV* (Naples, 1910).

[12] This was the opinion of G. Carducci in his introduction to *Rime di M. Cino da Pistoia e d'altri del Secolo XIV* (Florence, 1862).

[13] See p. 110.

[14] Although for a time in difficulties with the Inquisition, he had close relations with one or two Popes.

[15] There is even a tradition which connects the painter and the physician, according to which Abano furnished Giotto with the programme of the astrological frescoes in the Palazzo della Ragione in Padua (the present frescoes date from as late as *c.* 1420).

[16] It is an interesting fact that Bartolo Stefaneschi, who gave the order for Cavallini's mosaics with the story of Mary in S. Maria in Trastevere (1291), was the brother of Cardinal Jacopo Stefaneschi, Giotto's patron.

[17] He is often regarded as a Florentine, and there have even been frequent attempts to identify him with the early Giotto.

[18] Arnolfo's chief patrons were the same as Giotto's: the Pope, the King of Naples and the city authorities of Florence. The main Florentine sculptures from the time of the young Giotto, the statues for Arnolfo's façade of the cathedral, presenting a Mariological programme, are either by Arnolfo himself or at any rate are very similar to him in style.

[19] E.g., the new way of representing the Annunciation (based on the Pseudo-Bonaventura) with the Virgin and angel kneeling. It is also probable that the kneeling apostles in the Ascension of Christ derive from this. R. v. Marle's view (*Recherches sur l'Iconographie de Giotto et de Duccio*, Strasbourg, 1933), that Giotto was not an iconographical innovator, is far too narrow, unless iconography is interpreted in an over-literal and purely mechanical sense.

[20] No wonder that the Last Judgment, with its crowds of pliable, sinuous nudes, still shows numerous borrowings from the corresponding tumultuous mosaic in the dome of the Florentine Baptistry, from the latter half of the thirteenth century. The subjects of this cycle, which was of the greatest importance for Florentine Ducento and early Trecento art, are the Redeemer, the Angelic Host, the Last Judgment, and stories from the Old and New Testaments, including—as was natural in a Baptistry dedicated to St. John—that of the Baptist. See E. F. Rothschild and E. H. Wilkins, "Hell in the Florentine Baptistry Mosaic and in Giotto's Paduan Fresco" (*Art Studies*, VI, 1928). Yet, on the other hand, the comparison demonstrates that, in spite of the borrowings, Giotto's nudes are less stylised and his arrangement more compact than that of the mosaic. A Foratti ("Il Giudizio Universale di Giotto in Padova", *Boll. d'Arte*, I, 1921) tries to establish a relation between Giotto's Last Judgment fresco and the religious plays of the period.

[21] The chronology of the different parts of the frescoes of the Arena is a matter of controversy. The view which seems most likely, namely, that the frescoes were executed in the chronological order of the actual Biblical events, is expressed in C. H. Weigelt, *Giotto* (Stuttgart, 1927) and H. Jantzen ("Chronologie der Arena-fresken Giottos," *Jahrb. der Preuss. Kunstsammlg.*, 1939).

[22] Cimabue's Crucifixion in the Upper Church at Assisi is a most unrestrained interpretation of this subject: St. Francis is prostrate at the foot of the cross, the Magdalen throws her arms high in despair, the centurion and an old Jew point up at Christ, while angels fly wildly lamenting through the sky. In another fresco in the same church, an Assumption of the Virgin, Christ supports his Mother, who rests her head on his shoulder, although she is completely surrounded by the hieratic Mandorla: here perhaps for the first time in monumental painting is the theme of the Assumption combined with the mystical Union of Mary with Christ. (See E. Staedel, *Ikonographie der Himmelfahrt Mariens*,

Strasbourg, 1935.) It is further typical of the effervescent period of the late thirteenth century, of the spiritual outlook of the Franciscans at that time and the still revolutionary middle class, that Cimabue should also have painted in this church the fresco cycle of the Apocalypse, the most stirring theme which art had to offer, and one capable of politico-mystical interpretation. He illustrated the Vision of St. John on Patmos, the Opening of the Seals, the Angels holding the Winds, the Angels sounding their Trumpets, and the Fall of Babylon. The expressive narrative of the mosaics of the Baptistry in Florence, in which he probably collaborated, was of great significance for Cimabue's artistic formation. (See M. Salmi, "I Mosaici del 'Bel San Giovanni' e la Pittura del Secolo XIII a Firenze," *Dedalo* XL, 1930–31).

As regards the period before Cimabue, when the middle and lower sections of the bourgeoisie, still to some degree allied with the upper middle class, made themselves felt, we must refer briefly to the most familiar representatives of Florentine painting at that time: Coppo di Marcovaldo and the Magdalen Master, both of whom worked in the third quarter of the century. The art of the rather provincial Magdalen Master (Pl. 10), with its glowing colours reminiscent of stained glass, shows the usual, but here particularly marked, combination of vehemence with hieratic stiffness. Coppo's activity fell within the period of the decisive struggles of the Florentine middle class, leading to their victory; after the temporary setback at the hands of the allied Ghibellines of Florence and Siena at the battle of Montaperti (1260), Coppo was himself taken prisoner by the Sienese. In his art, particularly in his large paintings of the Crucifix, with Christ's dying in agony, the dramatic tendency of Florentine revolutionary middle-class painting touched a high note. A comparison of a Crucifix (1274, Pistoia, Cathedral; Pl. 2a) by him and his son, Salerno with one by Giotto (for example, that in the Cappella dell' Arena at Padua; Pl. 2b) demonstrates the enormous change which had taken place in the latter artist towards a calmer conception of the subject, a greater knowledge in portraying nature, and a clearer arrangement.

[23] From about the middle of the thirteenth to the first years of the fourteenth century, during the period when preaching became of such great significance for the urban middle classes, pulpit-reliefs were the most prominent works of art. It was mainly in sculpture of this type that Niccolo and Giovanni Pisano revealed their immense importance in the towns which before the final rise of Florence were predominant in Tuscany: Pisa, Siena, Pistoia.

It was in the same towns again, in the newly-built churches of the Mendicant orders, that the pictorial art of the new middle class took shape, as, for instance, their outstanding votive pictures, the great representations of the dead Christ on the Cross: in Pisa (Giunta Pisano), in Lucca (the artist family of the Berlinghieri), and in the Umbrian towns stirred up by the Franciscan movement (the Master of St. Francis). It is not our task to discuss the more or less close relationship between these pictures and the dramatic trend of contemporary or earlier Byzantine painting or ultimately even their incipient flavour of Gothic; nor, for that matter, can we deal with the equally complex stylistic relations of Byzantine and early Florentine art. But we should note that Florentine painting of the twelfth and of the first half of the thirteenth centuries was very much under the influence of those neighbouring towns where the middle class had developed earlier than in Florence: Pisa (maritime trade) and Lucca (silk industry).

[24] In the present position of art history, in particular owing to our incomplete knowledge of Roman painting, nothing definite can be said about the artist who painted the greater part of this cycle. The work is undoubtedly related to Giotto's early style, but points, in several respects, to Rome more than to Florence. Four of the frescoes were certainly painted by the Master of St. Cecilia (Pl. 13), who was possibly a Roman (see p.

217, note 36). For the hypotheses so far advanced see L. Martius, *Die Franziskuslegende in der Oberkirche von S. Francesco in Assisi* (Berlin, 1931). The arguments *against* Giotto's authorship were last summarised by R. Offner ("Giotto, non-Giotto", *Burl. Mag.*, LXXI, 1939), *for* Giotto's authorship by F. Jewett Mather, jr. ("Giotto's St. Francis Series at Assisi", *Art Bull.*, XXV, 1943). The cycle was based on St. Bonaventura's *Life of St. Francis* (B. Marinangeli, "La Serie di Affreschi giotteschi rappresentanti la Vita di S. Francesco nella Chiesa Superiore di Assisi", *Miscellanea Francescana*, XIII, 1911).

[25] Giotto, in addition, used the text of the *Considerazioni* which form the appendix to the *Fioretti* of St. Francis (J. Gy-Wilde, "Giotto-Studien", *Wiener Jahrb. für Kunstgesch.*, VII, 1930).

[26] This is the only definite event that can be used as the *terminus post quem* for dating the frescoes. The *terminus ante quem* is probably 1323, as suggested by A. Peter ("Giotto and Ambrogio Lorenzetti", *Burl. Mag.*, LXXVI, 1940).

[27] By great effort and financial outlay King Robert of Naples induced Pope John XXII to canonise this elder brother of his, who had died while still young. Since his own legitimacy as sovereign was in doubt, he commissioned Simone Martini immediately after the canonisation to paint an altarpiece (Naples, S. Lorenzo Maggiore) in which his brother is crowning him king, thus making Heaven confirm his legitimacy. While in this picture the saint is of course shown in full court splendour, he was painted in a much more unassuming manner by Simone at Assisi and also by Giotto in S. Croce, where there was no longer the same call for so elaborate a display.

[28] The story of the apocalyptic end of the world is now reduced to small, insignificant symbols in quatrefoils.

[29] Gy-Wilde, *op. cit.*

[30] Though in that late work of Giovanni, the pulpit for the Cathedral of Pisa (1303–11), there are equally signs of efforts toward compactness and thematic unity in space—as the older artist still belonging to the earlier phase of Tuscan middle-class development, he could not overtake Giotto's highly evolved, rational, upper-bourgeois style.

[31] Dvořák, *op. cit.*

[32] It is important for the characterisation of this style that the Spiritual Ubertino da Casale, who, as we saw, protested against the sumptuous building of S. Croce, also denounced the *curiositas picturarum*. By this he probably meant paintings which he regarded as unsuitable for a Franciscan church and as departing from tradition. It may probably be assumed that the works which appeared to him too secular were paintings such as Giotto's. (See Davidsohn, *op. cit.*) Indeed, how consciously intellectual Giotto's art appeared to his contemporaries is perhaps shown by the fact that both Petrarch (who bequeathed a Giotto Madonna to Francesco da Carrara) and Boccaccio (in the *Decameron*) repeated the phrase used by Pliny of Zeuxis, that Giotto's art astounded the connoisseur, but left the ignorant cold.

[33] On the late style of the Giotto workshop as shown in the frescoes of the Lower Church of Assisi, see pp. 174 and 239.

[34] It should not be overlooked that, just because of the too petty-bourgeois structure of their city, the Sienese upper middle class were ousted from the business of papal banking in the second half of the thirteenth century by the Florentines. The rise of Siena in a modern sense was thereby made impossible once and for all. The bankruptcy of the largest Sienese banking-house allied to the Curia, the Buonsignori, occurred as early as 1304, long before the huge Florentine crashes.

[35] It is therefore easy to understand why, as early as 1285, a large Madonna was commissioned from Duccio by a Florentine fraternity. The customers were the *Societas S. Mariae Virginis S. Mariae Novellae*, founded by St. Peter Martyr, and usually known as

the *Compagnia dei Laudesi*, because they met once a week for the purpose of singing hymns to the Virgin. The painting they ordered is certainly the Madonna Rucellai, surrounded by the many adoring angels (S. Maria Novella), a characteristic expression of the new, intense cult of the Virgin. On the bottom of the frame is painted the bust of St. Peter Martyr. At the time of the Madonna Rucellai, Duccio was exerting such an influence in Florence that it is difficult to decide whether several pictures produced at that time are Sienese or Florentine.

[36] He was possibly a Roman by birth and upbringing. See A. Parronchi, "Attività del Maestro di S. Cecilia" (*Rivista d'Arte*, XVII–XVIII, 1939).

[37] A popular Italian version of this book also existed. Ubertino da Casale, one of the most influential of the Spirituals, also wrote a book entitled *Arbor Vitae Crucifixae* (1305) in which he used parts of Bonaventura's work (see E. Koth, *Ubertino v. Casale*, Marburg, 1903).

[38] P. Mazzoni, *La Leggenda della Croce nell'Arte Italiana*, Florence, 1914.

[39] How precisely Pacino kept to Bonaventura's text appears, for instance, on two occasions, when he introduces Christ into the Annunciation scene in a quite unusual way peculiar to this author: once as the Holy Ghost, once as an adult man, clinging to Mary's neck. See D. Robb, "The Iconography of the Annunciation in the Fourteenth and Fifteenth Centuries" (*Art Bull.*, XVIII, 1936).

[40] In the middle, under the root, was probably the figure (now erased) of St. Bonaventura, the author of the allegory.

[41] See chapter on Symbolic and Allegorical Art.

[42] That one of his few extant works—a polyptych of the Crucifixion (Florence, Academy) was commissioned by a cleric, Simon, the Presbyter of the Church of S. Firenze, is evidence that Pacino's patrons were also often to be found in ecclesiastical circles.

[43] R. Offner, *A Corpus of Florentine Painting* (New York, 1930). Pacino also illustrated the allegory of the Cross as a miniature in a Biblical manuscript (Milan, Trivulzio collection). Instead of scenes from the Saviour's life, the medallions contain the half-figures of the Prophets, Christ's forerunners, and scrolls inscribed with their prophecies referring to the Redemption.

[44] Berenson considers both these miniatures and the picture of the Tree of Life in the Academy to be Umbrian. This shows how difficult it is to imagine that popular works could also be produced in Florence, whose art is usually judged by the standard and criteria of Giotto.

[45] An even more comprehensive work by Orcagna in the same Dominican church has not been preserved: the decoration of the choir told the story of the Virgin, commissioned by the Ricci and Tornaquinci (about 1348).

[46] After his return to Rome Urban V summoned a large number of artists—including many Florentines—in 1369 to decorate the Vatican, entrusting the supervision of this work to Giovanni da Milano and Giottino.

[47] L. Passerini, *Curiosità storico-artistiche fiorentine* (Florence, 1866) and P. Franceschini, *L'Oratorio di San Michele in Orto in Firenze* (Florence, 1892).

[48] Of all these commissions only the above-mentioned altarpiece by Orcagna has survived.

[49] The St. Martin's altar by Lorenzo di Bicci (Uffizi; Pl. 61b), commissioned by the wine merchants, may have been one of these. See p. 229, note 178.

[50] Examples are quoted by G. Poggi, "La Compagnia del Bigallo" (*Rivista d'Arte*, I, 1904).

[51] A cycle of reliefs representing the figures of the Virtues, commissioned by the city, was executed for the Loggia dei Lanzi (1383–91).

⁵² Even for those most genuinely Giottesque works, the Baptistry reliefs, the "Byzantine" mosaics of the Baptistry on the same theme were still, in many respects, the starting point—so Andrea to some extent repeated Giotto's own line of development. See I. Falk and J. Lanyi, "The Genesis of Andrea Pisano's Bronze Doors" (*Art Bull.*, XXV, 1943).

⁵³ For a reconstruction of this polyptych, which depicts the life and death of Christ and was painted for a Franciscan church, see O. Sirén, *Giotto and Some of his Followers* (Cambridge, 1917).

⁵⁴ In accordance with Giotto's upper-bourgeois outlook, the kneeling figures of the donors in this picture are almost as large as those of the saints. After Giotto, the donor figures, especially in "popular" pictures, became small once more, and so remained for a long time.

⁵⁵ M. Salmi, "La Mostra Giottesca" (*Emporium*, XLIII, 1917).

⁵⁶ Giotto's follower who painted the Crucifixion in the Berenson collection probably also produced the Lamentation of Christ in the Vatican Pinacoteca (Pl. 7); Giotto's representation of the same subject at Padua is translated into one with sweeping movement and eruptive passion, presumably under the influence of Pietro Lorenzetti. (See B. Berenson, "Quadri senza casa", *Dedalo*, XI, 1930).

⁵⁷ This important role assigned to landscape was combined by the Master of the Magdalen Chapel with the so-called principle of "inverted" perspective, the form of spatial conception common in Byzantine art, which was revived in Florentine painting after Giotto. (For a detailed account see O. Wulff, "Die Umgekehrte Perspektive und die Niedersicht", *Kunstwissenschaftliche Beiträge A. Schmarsow gewidmet*, Leipzig, 1927.) This principle consists in selecting a high viewpoint, presenting the object from above, and thus making possible—as in these Assisi works—the representation of a widely spread-out landscape. But, in Italian painting of the fourteenth century, according to the period and the social stratum in question, it was employed not so much for reasons of optical perspective as for attaining a hieratic composition by using a larger scale for the principal figures, the divine persons of the middle distance, and a small scale for the unimportant figures of the foreground.

⁵⁸ Sandberg-Vavalà, *op. cit.*, gives the earlier history of this motive.

⁵⁹ The scene portrayed is that of St. Louis waiting on the poor at table on the occasion of his visit to the same monastery, S. Croce: the Franciscans thereby attempted to justify the emphasis placed on the royal prince. At the same time, this and most of the other representations serve to underline the pious nature of table scenes connected with the legends of saints or the New Testament: these were regarded as the proper decoration for monastic refectories. Taddeo's fresco in S. Croce was the first of a long series of Last Supper paintings in Florentine refectories.

⁶⁰ H. Cornell, *The Iconography of the Nativity of Christ* (Upsala, 1924).

⁶¹ There is documentary evidence for Taddeo Gaddi's relations with Fidati. He asked the friar in a letter to pray for him that his eye trouble might be cured. See J. Maione, "Fra Simone Fidati e Taddeo Gaddi" (*L'Arte*, XVII, 1914). It is characteristic of the "popular" tendencies in Fidati that he even dares to call the famous Franciscan Spiritual, Angelus de Clareno, his spiritual father. See F. Tocco, *Studii Francescani* (Naples, 1909).

⁶² H. Schrade, *Die Auferstehung Christi* (Berlin, 1932).

⁶³ Maione, *op. cit.*

⁶⁴ Meiss, *op. cit.*

⁶⁵ W. Kallab, "Die toskanische Landschaftsmalerei im 14. und 15. Jahrhundert. (*Jahrb. der kunsthist. Sammlng. in Wien*, XXXI, 1900).

[66] The emotionalising of Taddeo's art is typified by one of his late works, the Entombment (Yale University, Yarves coll.).

[67] Compare in this connection the Presentation of the Virgin by Giotto at Padua with the complicated construction of steps in the corresponding scene by Taddeo Gaddi in the Baroncelli chapel. The latter version remained the much-admired model not only of Florence (e.g., Giovanni da Milano), but also of the North (*Très Riches Heures du Duc de Berry*). Nevertheless this show-piece of the stairs is nowise a contradiction of Taddeo's employment of inverted perspective which Giotto had already abandoned—a typical deviation from the latter's upper-bourgeois rationalism: the less important figures from the point of view of content in the foreground are much smaller in scale than the Virgin and her parents in the middle distance.

[68] For a detailed discussion of this point, see M. Dvořák, "Die Illuminatoren des Johann v. Neumarkt" (*Jahrb. der kunsthist. Sammlg. in Wien*, XII, 1901)—an article out of date in several particulars, but in essentials still valuable. See note 72 below.

[69] F. Schevill, *Siena* (New York, 1909).

[70] What is true of Siena is even more true of France; for compared not only with Florence, but with Tuscany generally, and on the whole even with Italy, France was economically and ideologically backward. In France the basic economic activity of the middle class was trade, but there was as yet no capitalist industry, and credit transactions were carried out almost exclusively by Italians (see H. Sée, *Histoire économique de la France*, Paris, 1939). Far less consolidated than in Italy, the French bourgeoisie were ideologically in a less rationalist phase than that of Tuscany or of Italy generally. In Giotto's time, the French middle class was still bound to a far greater extent than would have been possible in Italy to the fundamental religious idealism of the Gothic style, which had originally developed in twelfth-century France as a new urban art from the ideological interplay of the Church, the royal court, a powerful feudal nobility and a rising bourgeoisie. Only a detailed analysis of the changes in the social and ideological structure of France during the various stages of the Middle Ages can show the great differences in the significance of French "Gothic" in different generations and how some elements become more stressed and others recede into the background. M. Dvořák (*Idealismus und Naturalismus*) made this necessary differentiation purely on the basis of a "history of ideas", at the same time deliberately emphasising the fundamentally most important contrasts. References in the text to Gothic in Italian painting are always meant, of course, of the late-Gothic of the fourteenth century.

[71] The same Cardinal Stefaneschi who gave Giotto large commissions in Rome was probably also responsible for summoning Martini to Avignon. He is portrayed as the donor in Martini's Madonna lunette over the portal of Avignon Cathedral. A Sienese pupil of Martini, the so-called Master of the Codex of St. George (Pl. 22a), who carried the late-Gothic formal idiom of his master (Pl. 113a) still further in the direction of French art, was selected by Stefaneschi to illustrate with miniatures the Life of St. George which he had written. The change in Stefaneschi's artistic taste from Giotto by way of Martini to the Master of the Codex of St. George well illustrates the character of the artistic tendencies in the Curia after it had moved to France. It is no accident thta Martini also worked for Petrarch at Avignon (see p. 273, note 31) and that the poet praised his finely aristocratic art. The French and Italian imitators of Martini, who under the leadership of Matteo da Viterbo were chosen by Pope Clement VI, a Frenchman, to decorate the Palace of the Popes at Avignon with frescoes (1342–53), were much more provincial and weaker than the Master of the Codex of St. George.

[72] It would, of course, be wrong to suggest that Sienese art and Avignon represent the only channel through which Tuscan influence reached the northern countries.

Important Italian influences also penetrated, for instance, from North Italy by way of Austria into Bohemia, and spread thence into Germany. The significant part played by Giotto's Paduan frescoes within this Italian penetration, which first affected Austria, is shown by the altarpiece at Klosterneuburg (Pl. 5b), painted as early as between 1324 and 1329, in which Giotto's Crucifixion and *Noli me tangere* (Pl. 5a) are gothicised, transposed into a more fervent style and provided with detailed realism; these qualities are naturally much more pronounced here even than in Sienese painting. But from the point of view of Florentine painting, the first current, namely that of Martini, who stood much closer to Giotto, is the more pertinent.

[73] Even the direct but popular transmutation of Giotto in Spanish painting, in the frescoes of Ferrer Bassa in the monastery of Pedralbes near Barcelona (1345–46), produced a style akin to Martini.

[74] The art of Pietro Lorenzetti is, of course, far more than a mere transposition of Giotto. But it is this aspect of Pietro's art which interests us most from the standpoint of the Florentine development. The same applies to the art of Martini.

[75] It is their common basic attitude in the matter of content which explains a certain stylistic similarity between Pietro Lorenzetti and Giovanni Pisano, although the former is younger by half a century and Giotto's whole development lies between them. "Already" Gothic and "still" Gothic meet in the expressive styles of Giovanni and Pietro; for both lived at times when, even if for different reasons, the position of the upper middle class was not quite secure, and both moved in a milieu which was not unaffected by petty-bourgeois sections of society.

[76] In characterising the social background of the three tendencies represented by Martini, Pietro and Ambrogio Lorenzetti, we have purposely simplified in order to bring out the essential differences. There are, of course, numerous transitions between them; between the brothers Ambrogio and Pietro Lorenzetti, in particular, the distance is not insurmountable.

[77] The popular, miracle-working votive picture of the Madonna in Orsanmichele (now no longer extant; it was replaced by Daddi's altarpiece) was also probably painted by Ugolino. That precisely this kind of commission should be placed with a Sienese artist is equally most significant. Whether Ugolino was also ordered to paint the high-altarpiece of S. Maria Novella is disputed.

[78] Ambrogio was twice in Florence; first at the very beginning of his career, from 1319 until the early twenties; and then permanently 1327–34. During the latter visit he was inscribed in the Florentine painters' guild.

[79] The late style of the Master of St. Cecilia also becomes very colourful, and his earlier linearity ceases.

[80] I deliberately pass over Maso's other works (for basic material see R. Offner, "Four Panels, a Fresco and a Problem", *Burl. Mag.* LIV, 1929), his as yet little-known development and his wholly untraced artistic entourage, as this requires a special study in itself. It is probable that, in his later phase, Maso followed the general trend of development towards a style which was occasionally agitated and emotional, occasionally hieratic, and always becoming increasingly two-dimensional; and it is here that Nardo di Cione links up with him (see H. Gronau, *Andrea Orcagna und Nardo di Cione*, Berlin, 1937). We may add, as regards the knowledge of these decades, that we still have no conception of the art of two key painters of this period, Giotto's pupil, Stefano (who painted, for the principal mendicant Orders, some works, thematically very interesting, which are no longer extant, including, for instance, a curious Allegory of the Cross, for Assisi) and Giottino, who may have been a son and pupil of this Stefano.

[81] For a detailed analysis of this style see G. Vitzthum, *Bernardo Daddi* (Leipzig, 1903).

[82] It is impossible, however, to draw a line between the symbolical and the genre significance of the motive of the Infant Christ playing with a bird (see p. 156, note 37). Both were at first probably closely connected, e.g. already in the work of T. Gaddi, who was particularly fond of this theme, and whose predilection for symbolical art has been noted.

[83] According to M. Meiss (*op. cit.*) its immediate source may be a picture painted in Naples by Martini, now lost. This seems quite possible, as King Robert of Naples, the brother of St. Louis of Toulouse, who gave Martini many commissions, not only assisted the Franciscan Order as a whole, but also interceded on behalf of its left wing, the Spirituals. See Tocco, *op. cit.* According to Goddard King (*op. cit.*) the motive came from Spain to Italy, in particular by way of Naples and the Marches. Indeed, how little "popular" and "courtly" were opposed to each other in the case of Martini and his patrons, is demonstrated by the fact that Martini too is the first artist in Italy to show the Madonna not only with numerous attendants of her court (as Duccio had done already), but also as an earthly queen in rich contemporary dress (Siena, Palazzo Pubblico). This manner of portraying the Madonna, while undoubtedly deriving from French courtly art, also has its parallel in Franciscan lyrics.

[84] M. Meiss (*op. cit.*) adopts the first view; M. Salmi (*Masaccio*, Rome, 1930) considers the second possible.

[85] Also in the domestic altarpiece in Berlin by Taddeo Gaddi (1334). In the fresco of the Nativity in the Lower Church of Assisi by the late Giotto workshop the seated Mary still holds the Child in front of her, but this, too, is an innovation.

[86] *Humilitas*, esteemed by Augustine as the highest Christian virtue, the root of all the others, was regarded by Thomist teaching as a derivative virtue and now assumed great significance in Dominican theology as well, Aquinas having declared it indispensable for the acquirement of the other virtues. Jacopo Passavanti, Prior of S. Maria Novella, whom we shall often have occasion to mention, has a particularly important section entitled "Trattato dell' Umiltà" in his *Specchio della vera Penitenza*, a compilation of thoughts from his Florentine sermons. As the eighth virtue, *Humilitas* had already been represented in Florence by Andrea Pisano on his Baptistry doors, and by Taddeo Gaddi in his frescoes in the Baroncelli chapel in S. Croce, and as one of the derivative virtues by Orcagna in his tabernacle in Orsanmichele.

[87] One of Daddi's followers, a vividly narrative artist active about the middle of the century, even illustrated in a predella (Copenhagen; Pl. 27b) the very rare, very emotional theme derived from Siena of the Virgin falling into a swoon on the closed grave of her Son (see R. Offner, *Studies in Florentine Painting*, New York, 1927). The Man of Sorrows in the Lycett-Green coll., London (Pl. 27a), a picture with an exceptionally touching appeal yet at the same time severely symmetrical in its arrangement, was painted by the same artist (H. Gronau's attribution). Even nearer to Daddi, the Master of S. Martino alla Palma, a painter of particularly wooden and hieratic Madonnas, in one of his predellas, the Scourging of Christ (New York, Kress coll.) shows with all its stiffness the mark of the corresponding agitated scene in Ugolino da Siena's highaltarpiece in S. Croce; in another (Manchester, Barlow coll.), he depicts Christ crowned with thorns (Pl. 28), transposing Giotto's performance in Padua into a wilder, more "vulgar" scene, full of "northern realism"—seemingly, though only seemingly, unusual in Florence of the fourteenth century. In reality, this style continues the tendencies of Pacino, whose brightness of colour it also revives. Yet another artist with emotional tendencies about the middle of the century, perhaps more active in the surrounding country than in Florence itself and apparently associated with commissions for Franciscan churches, was the Master of the Pietà Fogg (Offner, *op. cit.*). His Lamentation in the Fogg Museum (Cambridge, U.S.A.; Pl. 29) presents the figure of Christ, stretched out

in one unbroken line on the ground, dominating the foreground, while over him the figure of Mary, crushed and fainting, forms the centre of the picture. Here is shown once again the very characteristic combination, on the one hand of pre-Giottesque—the artist is, as Dr. Offner has observed, a pupil of Pacino—and on the other of Sienese elements, probably Martini.

[88] Much of the relevant material is brought together in R. Offner's *Corpus of Florentine Painting* (New York, 1935).

[89] In one of the domestic altarpieces of the Daddi workshop, now in Berne, the main panel of which is the Crucifixion, the Madonna is shown—a motive which otherwise appears mainly in Umbria and in the Marches—with the Infant in a cradle (women and men, including two Franciscans, are kneeling in front, whilst beside the Cross St. Francis is to be seen—the picture, therefore, is in close relationship with the Franciscan Order). The domestic, genre-like elements in the pictorial evolution of the Holy Family were invented in large part in Siena, in the circle of the Lorenzetti.

[90] P. Schubring, "Giottino" (*Jahrb. der Preuss. Kunstsammlng.*, XXI, 1900). As another example of such formulations by Daddi, conceived—certainly in accordance with his patrons' wishes—in a severely ecclesiastical spirit, a predella of his great Uffizi altarpiece may be mentioned. Here we see the mystical combination of the meeting between Joachim and Anna with the Immaculate Conception. An angel hovering in mid-air is leading Joachim and Anna towards each other so that they may kiss: the idea being that an angel of God was instrumental in the Virgin's conception.

[91] Even in the thirteenth century, but still more in the work of the Master of St. Cecilia and with ever-increasing frequency in the democratic era now beginning, the representation of the preaching of a sermon, such as the scene of St. Peter Martyr on another predella of the same altarpiece, provided an excellent opportunity for depicting large crowds of people, crowds, moreover, in contemporary costume. A predella of another of Daddi's altarpieces which shows pilgrims venerating the tomb of SS. Stephen and Lawrence (Vatican Pinacoteca) has even more pronouncedly the character of a genre picture drawn from contemporary life.

[92] There is, for example, a characteristically popular type of picture from the Daddi workshop, in one version of which the Madonna, portrayed half-length as if seated at a window, holds out to the donors kneeling in front of her an open book containing a prayer to herself; she is invoked as the miraculous Mary of Bagnolo, a small village near Florence (1334, Museo dell' Opera del Duomo; Pl. 24b.).

[93] Berenson has attributed both pictures to Daddi himself. The author of the second is perhaps the Master of S. Martino alla Palma about whom see page 221, note 87.

[94] R. Offner, *A Corpus of Florentine Painting* (New York, 1930).

[95] Before Dr. Offner made the correct attribution, this picture too was never considered as Florentine, by reason of its popular style.

[96] Offner, *op. cit.*

[97] Offner, *op. cit.*

[98] A Madonna picture of the Daddi workshop, similarly composed though not to the same degree heraldic, with sixteen saints, among whom Dominicans figure prominently, is in the Museum at Montauban.

[99] L. Dami ("La Basilica di S. Miniato al Monte", *Boll. d'Arte*, IX, 1915) also held that the picture was executed for the Cappella di S. Miniato decorated by the Calimala guild. The presence on the altarpiece of a small, probably clerical donor figure—quite possibly representing the Prior of the monastery of S. Miniato—does not disprove the assumption, otherwise very probable, that the picture was commissioned by this guild.

[100] One of Jacopo's domestic altarpieces (Bremen; H. Gronau's attribution) contains

a typically popular-symbolical motive: the Last Judgment is combined with the instruments of Christ's Passion. Another, with the Three Quick and the Three Dead, will be discussed in the chapter on symbolical and allegorical art.

[101] It may be recalled here that it is not only Daddi's late style which tends to become flat in the late forties, but that the same change is also to be seen in the works of Maso, which had previously been so spatial.

[102] M. Meiss, "The Problem of Francesco Traini" (*Art Bull.*, XV, 1933). R. Longhi considers the frescoes to be Bolognese. It is not impossible that Vitale da Bologna, whose style is very close to that of Traini, collaborated in them.

[103] The maritime trade of Pisa declined in the fourteenth century owing to the competition of Genoa, Venice and Barcelona; at the same time its wool industry was crushed by that of Florence. Finally it suffered enormous economic losses through its connection with the emperor Henry VII. The clashing economic and political interests of the maritime trade and the wool industry—the latter necessarily regarded Florence as a competitor, and the former as a customer, since Florence used Pisa's harbour and ships—contributed to the fall of the middle class.

[104] These frescoes were made possible by private donations. About 1370 the commune financed the continuation of the work itself, until in 1392, as a result of general decline, the whole enterprise had to be abandoned.

[105] H. Brockhaus, "Der Gedankenkreis des Campo Santo in Pisa und verwandter Malereien" (*Mitteilungen des Kunsthist. Institutes in Florenz*, I, 1911).

[106] For the influence of the Pisan Dominicans Fra Giordano da Rivalto, Fra Bartolommeo da San Concordio and Fra Domenico Cavalca on these frescoes, see J. B. Supino, *Arte Pisana* (Florence, 1904).

[107] When the Emperor Louis the Bavarian came to Italy, the Left Franciscans who had previously fled to Germany and the Italian Spirituals met together under his protection at Pisa, where they were also supported by the bourgeoisie (1328).

[108] G. Gombosi, *Spinello Aretino* (Budapest, 1926).

[109] For a full discussion of the content of this picture, see chapter on Symbolic and Allegorical Art.

[110] That the pro-Florentine section of the bourgeoisie, the shipowners and maritime traders, had exercised power in Pisa since 1347 and still more since 1369, also contributed to the greater closeness of artistic relations. See P. Silva, *Il Governo di Piero Gambacorti in Pisa* (Pisa, 1912).

[111] For the influence of the so-called pictures of infamy on this kind of representation, see p. 271, note 8. The frequency with which the Man of Sorrows is represented in Nardo's circle is remarkable. Close to Nardo (and Maso) are the frescoes of the Cappella Covone in the Badia, which represent legends of saints, among which scenes of martyrdom—characteristic of the new times—are particularly prominent. Three out of the four fragments preserved deal with this subject

[112] The donor and his wife are portrayed both in Paradise, where they are led by an angel, and among the Blessed in the Last Judgment.

[113] H. Gronau, *op. cit.* It is possible that Piero Strozzi may be represented among the Blessed, immediately beside Dante, in the fresco of the Last Judgment. In this case, the two men by whom the frescoes were inspired—as we shall see in the text, the representation of Hell is drawn from the *Divina Commedia*—would here be shown side by side. See J. Mesnil, "Le Portrait de Dante par l'Orcagna" (*Miscellanea d'Arte*, 1903). As late as 1335 the provincial chapter of the Dominicans in Florence forbade the friars to read the Italian works of "the so-called Dante", probably because in the *Divina Commedia* some of the Popes were consigned to hell. This shows that the *Commedia* was much read

by the friars. By the middle of the 'fifties, when these frescoes were painted, the prohibition must have already lapsed. By the beginning of the democratic period the Dominicans had certainly realised the great propaganda value of the Thomist *Divina Commedia* written by a former pupil of the Studium Generale of S. Maria Novella.

[114] We shall speak later of the importance of Passavanti in relation to the decoration of the Cappella Spagnuola. It was Passavanti who persuaded the Tornaquinci family, to which he was related, to contribute to the cost of Orcagna's paintings in the choir of S. Maria Novella.

[115] There is another fresco cycle by Nardo in the monastery of S. Maria Novella; the chapel of St. Anne contains his early frescoes depicting the life of the Saint.

[116] The Paradise fresco is also certainly influenced by the fresco in the Bargello, carried out by pupils of Giotto and representing the same subject.

[117] In the Paradise fresco St. Dominic is in a far higher sphere among the saints than St. Francis.

[118] For those of the donors, see p. 223, note 112; for those of Piero Strozzi and Dante, see p. 223, note 113; for those of Constantine and Maxentius, see p. 273, note 31. The man in ecclesiastical dress on Dante's right is probably Petrarch—strong evidence of his popularity in Florence even during his lifetime, and also proof of the extent to which he was there considered religious.

[119] In the sermons Passavanti was preaching at the same time, he described in very great detail the torments of hell; this probably had an influence on Nardo's fresco.

[120] It is quite possible that Orcagna was informed of this scheme of representation in the Decretals by Piero Strozzi (H. Gronau, *op. cit.*). We have previously discussed the assistance given by the Bolognese jurists to the ruling stratum of Florence. But here we must draw particular attention to the close ties existing between the canonists who taught in Bologna, and the Florentine upper middle class. The most important canonist of this time, Giovanni d'Andrea (about 1275–1348), who was a Florentine by birth and lectured in Bologna, was frequently asked for legal advice both by the bishop of his native town and by the governing bodies of the upper bourgeoisie. His advice, usually representing a compromise, greatly contributed to the good relations between the two parties.

[121] A kindred artistic idiom appears in most of Orcagna's reliefs on the tabernacle of the Virgin in Orsanmichele. But the reliefs which could be most easily seen from without (Orsanmichele was at that time an open hall), such as the death of Mary, are in a much less compact style, with more expressive figures and more realism in the details (see Gronau, *op. cit.*). Thus Orcagna himself here abandoned that concentration, typical of the mentality of the upper bourgeoisie, which we find in the other reliefs and in the Strozzi altarpiece, in order to conform more closely to popular taste.

[122] The ecclesiastico-religious conception of the Calling of St. Matthew is typical: the main accent is placed on Christ calling his disciple; the money-changer's office—or rather the receipt of custom—is only suggested, since the guild of bankers apparently did not yet wish to have their profession portrayed. It may be remembered that the banker Villani never referred to his profession in his chronicle.

[123] An entry in the *Opera* of S. Giovanni Fuorcivitas in Pistoia (p. 187, note 52) mentions a certain Francesco as living in Orcagna's workshop about the year 1347; if this Francesco is really Traini, there may even have been personal relations between the two artists. Such personal relations are not of essential importance; they only confirm the general intellectual kinship.

[124] H. Gronau (*op. cit.*), who has shown that the more simple general disposition of Orcagna's fresco was different from that of Traini's, considers it possible that the latter modified or developed Orcagna's representation.

FOURTEENTH CENTURY: CHRIST ETC. (DEVELOPMENT)

[125] Traini's frescoes in the Campo Santo show twenty-six different epigrams; but compared with the early-medieval "tituli" of which they are a continuation, they reveal a much more intensive popularisation of the content, while at the same time they already have a certain "secular" independence—all are rhymed and ten of them are sonnets. See S. Morpurgo, "Epigrafi in Rime del Campo Santo di Pisa" (*L'Arte*, II, 1899) and J. Schlosser, "Poesia e Arte figurativa nel Trecento" (*Critica d'Arte*, 1938)

[126] His Madonna of Humility (New York, Lehman coll.) probably goes back to a lost composition of Orcagna, which decisively influenced the later representations of this theme in Florence.

[127] Still richer than the Madonna of Humility, of the Lehman collection for instance, is that of a slightly earlier artist near to Jacopo and to Maso in Bayonne (Pl. 44b).

[128] H. Gronau, "The San Piero Maggiore Altarpiece: a Reconstruction" (*Burl. Mag.*, LXXXVI, 1945).

[129] The bankruptcies of Florence and the plague had a much swifter and more disastrous effect on economic conditions in Siena, where there was less economic stability, than in Florence itself.

[130] It is characteristic of the rule of democracy in Siena that the upper bourgeoisie were there known as "Popolo del piccolo numero", the middle bourgeoisie as "Popolo del numero medio", and the petty bourgeoisie (termed "Popolo minuto" in Florence) as "Popolo del maggior numero". These designations were intended to show that it was actual numbers, not their degree of wealth, which counted.

[131] In the northern countries, which were equally petty-bourgeois, Christ and St. John were extracted from the Last Supper as a separate group.

[132] For the use of "inverted" perspective for this purpose, see p. 000, note 00. In general, this principle of perspective is more important in Sienese than in Florentine art.

[133] See p. 219, note 71.

[134] His frescoes with scenes from the New Testament in the Collegiata at S. Gimignano were painted shortly after 1356, according to S. Faison ("Barna and Bartolo di Fredi", *Art Bull.*, XIV, 1932), those by Bartolo di Fredi in the same place with stories from the Old Testament shortly after 1356. A. M. Gabrielli ("Ancora del Barna Pittore", *Bollettino Senese di Storia Patria*, VII, 1936) places the frescoes of Barna about 1360. M. Salmi ("Gli Affreschi della Cappella Dragondelli in S. Domenico d'Arezzo", *Rivista d'Arte*, XII, 1930) puts them still later. From 1354, S. Gimignano was under Florentine sovereignty: this fact must certainly have contributed to the approximation of these Sienese works to Florentine painting.

[135] Not as, for instance, in Pacino's Allegory of the Cross, where a somewhat similar group is combined with other mourners in a many-figured Lamentation.

[136] The picture was until recently always attributed to the Sienese school.

[137] The Lamentation in the Uffizi, attributed to Giottino, in fact somewhat close to Giovanni da Milano, is also striking in its wealth of expression. It is possible that this picture, as it comes from the church of St. Remigio, was commissioned by the Alberti family. See Schubring, *Giottino*.

[138] His spatial construction is fully discussed by Gombosi, *op. cit.*

[139] The connection between, for instance, Giovanni's fresco of the Birth of the Virgin and the fresco on the same theme by Bartolo in S. Gimignano (S. Agostino) is self-evident.

[140] The artist, who about 1366–69 completed the frescoes begun by Giovanni, the so-called Rinuccini Master, wholly lacks Giovanni's concentration, delicate play of line and optical sensibility. He is coarser and more popular, and uses ugly, uncouth types. Particularly characteristic of his dramatic narrative manner are the predella panels of his altarpiece with the Vision of St. Bernard (from the Augustinian monastery of Le Cam-

pora; now Florence, Academy). As usual, the scene illustrating a sermon from an open-air pulpit—here that of St. Bernard at Sarlat against the heretics (Pl. 49)—provides the fullest opportunity for depicting a popular gathering with realistic individual figures. This altarpiece, which signifies a popularisation of Orcagna's Strozzi altarpiece, was previously held to be an early work of Orcagna, thus being dated much too early. Art-historical researches mistook popular style for immature hesitancy. The right attribution is to be found in R. Offner, *Studies in Florentine Painting* (New York, 1927). Close to the Rinuccini Master is a painting showing St. Anthony the Abbot distributing alms (Florence, Academy; Pl. 56a) in which the beggars closely surround the saint so that the whole has the effect of a genre scene. The very naturalistically painted beggars clothed in rags and with deeply-lined features are small-scale popularisations of the corresponding figures in Orcagna's Triumph of Death. This fairly spatial and very lively picture with glaring colours holds an important place in the Florentine development.

[141] Two very turbulent representations by him of the Lamentation and the Man of Sorrows show the dead Christ tightly clasped by the weeping figures of the Virgin and St. John (one version formerly in coll. d'Hendrecourt, Paris, and another in Grissell coll., Oxford; attributions by R. Offner). The Grissell picture (Pl. 56b), in particular, is reminiscent of T. Gaddi's late Entombment (Yale); it is typical, however, of this demo-cratic period that it is not an Entombment which is represented, but the less narrative scene of the Lamentation. The d'Hendrecourt picture is really little more than a simple devotional image of the Man of Sorrows. With their mournful note, pictures of this type form a link between the Pietà representations by Giovanni da Milano and the work of Lorenzo Monaco.

[142] The T Cross, the emblem of the Antonines, is the heraldic version of the crutched staff carried by the saint on his wanderings. The monks attached a bell to such staves as they travelled from place to place collecting money for their hospitals.

[143] Offner, *op. cit.*

[144] Probably at the same date (1360), Niccolo also executed a provincial commission in the Palazzo Comunale at Pistoia, in the same popular narrative style: a fresco com-memorating the victory of the allied Pistoian and Florentine troops over the army of the Milanese; SS. Zenobius and James (with the city arms between them) point upwards to a tabernacle of the Virgin over their heads, to indicate that the victory was due to her intervention.

[145] Wesselofsky, *op. cit.*

[146] The popularity of the mystic among the lower strata is witnessed by the fact that a rhymed prophecy was at that time—naturally without any authority—attributed to St. Bridget in which a coming rebellion of the people was mentioned; one of many such prophecies which were current before the *ciompi* revolt.

[147] In the neighbourhood of his Villa Paradiso (Bandino near Florence) where the famous literary and social meetings of the *Paradiso degli Alberti* took place at the beginning of the 'nineties, Antonio degli Alberti founded a convent for monks and nuns of the Brigittine Order, even bringing nuns from Sweden for this purpose. This was the first convent of the Order outside Sweden. Alberti, who in general was very much in sympathy with the Observance movement, is said to have gained much popularity, especially with the people, through the foundation of this convent. The conventual church was decorated by Gerini's workshop with frescoes from the Passion of very popular character (Pl. 75b). See pp. 211–12.

[148] This mystic emotionalism directed to the Nativity was, from the historical point of view, a continuation of that of St. Bernard.

[149] The ornamental character is just as pronounced in a fresco in S. Maria Novella,

equally popular, but in its formal idiom slightly more aristocratic and gothicising, dating from the 1390s and painted by an artist in the neighbourhood of Agnolo Gaddi. The fusion of kneeling figures, the angelic host and the grotto is here further emphasised by the ox and the ass kneeling next to each other in a strictly parallel arrangement. Cornel (*op. cit.*) erroneously describes this fresco (in which St. Bridget also appears) as the first example of the new type of representation. Compare a third picture with the same theme (Fiesole, Museo Bandini), probably painted by a distant follower of Niccolo di Tommaso (Pl. 55). Of the three it was this last, certainly, that was painted for the relatively lowest social stratum. Few Florentine pictures of this time still preserved show a like degree of extreme popular conception and manner of representation. Compared with the rough, massive formal idiom of this picture, the elongated figures of the other two paintings appear frankly refined. Its schematic manner is also much clumsier than that of the other two—notice, for instance, the plants, the animals, the gilded pattern of the red blanket. The adoration motive itself, the kneeling posture of the Virgin—here the new type has been only partially accepted—lacks the tenderness of the other two pictures, and, on the contrary, still shows the genre character found in Niccolo's "democratic" precursors, mentioned above, especially in Taddeo Gaddi, where the Virgin is wrapping the Infant in a blanket.

[150] The building enterprise carried out by Jacopo Talenti was initiated by Guidalotti in 1348. Its decoration with frescoes was provided for in his will of 1355 (417 florins) and he died shortly afterwards.

[151] The contract with Andrea da Firenze was not signed, however, until 1365, eight years after Passavanti's death. See J. Taurisano, "Il Capitolo di S. Maria Novella" (*Il Rosario*, 1916).

[152] Numerous passages of the *Specchio* are related to individual frescoes by A. Venturi, *Storia dell' Arte italiana, V* (Milan, 1907).

[153] Passavanti, who had also been vicar-general of the diocese of Florence, was a learned Dominican of a similar type to Piero Strozzi—with whom he was probably jointly responsible for the decoration of the Strozzi chapel in S. Maria Novella—but in accordance with the more democratic period in which he lived his orientation was somewhat more popular. Passavanti had also studied in Paris, and later taught in Pisa, Siena and Rome.

[154] It is possible, moreover, that the frescoes in the chapel belong together with those in the great cloisters, which served as the cemetery (Chiostro Verde), within the framework of a comprehensive programme based on the text of the prayers for the dead. See Brockhaus, *op. cit.*

[155] Formerly the frescoes of the Cappella Spagnuola were actually attributed to Simone Martini.

[156] According to tradition the Duke of Athens is represented in the horseman who pierces the Heart of Christ with his spear. The father of the Prior Jacopo Passavanti, whose influence was paramount in the conception of the frescoes, had been a violent opponent of the Duke in his capacity of Gonfaloniere. See J. Wood Brown, *The Dominican Church of S. Maria Novella at Florence* (Edinburgh, 1902).

[157] Christ descends to earth again in the next scene on the same fresco, the *Noli me Tangere*.

[158] Passavanti's *Specchio* contains numerous effective dialogues with devils who hold forth in robust language.

[159] Originally there were also scenes from the Life of St. Dominic, the founder of the Order.

[160] Dr. Gronau considers this to be by the artist who painted the Madonna of Humility in Bayonne (Pl. 44b).

[161] An impressive picture of the Man of Sorrows which is close to Andrea (Worcester, Smith coll.) reproduces Giovanni da Milano's popular type, but makes it more rigid and two-dimensional.

[162] About 1372, probably under the influence of Traini's fresco of the Anchorite life in the Campo Santo, Pisa, a cycle of frescoes was painted near Florence in a chapel endowed by the Benini-Formichi family in the church of the Augustinian monastery of S. Maria di S. Sepolcro e Columbaja, known as Le Campora; they illustrate the life of the principal hermit, St. Anthony the Abbot, whose story had been depicted in the upper row of frescoes in the Campo Santo. Their theme is most typical of the times, the period of rising democracy before the *ciompi* revolt. The life of St. Anthony in his hermitage is narrated with a wealth of detail quite unusual in Florence. Thus the first fresco shows the saint distributing his fortune to the poor: another, the scene of St. Anthony sharing with St. Paul of Thebes, who has come to visit him in the desert, the bread brought by the raven. The whole style of these frescoes, belonging approximately to the circle of Taddeo Gaddi in his late phase, is archaic, popular and schematic; symmetrical composition, two-dimensionality, a summary and unplastic treatment and pattern-like landscape. See O. Sirén, "Die Fresken in der Capella di S. Antonio in Le Campora" (*Monatshefte für Kunstwiss.*, I, 1908).

[163] For the attribution and dating in the second half of the seventies see R. Salvini, *L'Arte di Agnolo Gaddi* (Florence, 1936). It is, however, possible that the picture is somewhat later, and that it is from the circle of Agnolo, not from his own hand. Of the three predella panels with separate scenes from the lives of various saints from another altarpiece (painted for the convent of the Poor Clares at Monticelli, now in the Academy, Florence) which are also considered to be early works of Agnolo, there is one which is especially characteristic of a democratic period or, at least, of a very democratic environment: this is the very schematically conceived Conversion of St. Paul, with a long inscription issuing from his mouth (Pl. 19b). An Assumption of the Virgin (Vatican Gallery; Pl. 118a), also ascribed to Agnolo in his early period, but stylistically still close to Jacopo di Cione, shows, if anything, an even stronger frontal fixity in the Madonna, and an even more pronounced ornamentalism in the angels than is found in the hieratic Florentine representations of the Assumption.

[164] Another example of the Madonna of Mercy from the same period is a fresco in S. Martino a Maiano at Fiesole, a church of Benedictine nuns, showing bishops, nuns, monks and laity under the protection of the Virgin.

[165] The Cross was the invariable attribute of St. Francis.

[166] The Feast of the Finding of the True Cross, first instituted in 1376, naturally served to popularise this subject. On the growth of the legend of the Cross from a number of originally disconnected sources, see P. Mazzoni, *La Legenda della Croce nell'Arte italiana* (Florence, 1914).

[167] Here, and still more in the later frescoes (Life of the Virgin, Story of the Holy Girdle) in the Cathedral of Prato (1392-5), Agnolo is shown to have been less an independent artist than a large artistic entrepreneur with a large number of assistants to carry out his commissions.

[168] The theme of this fresco is based upon Cavalca's popular book *Vita dei Santi Padri*. Regarding him, see p. 188.

[169] An earlier, very popular version of this theme in a small Augustinian monastery near Florence is mentioned in note 162 above.

[170] U. Proccacci, "Gherardo Starnina" (*Rivista d'Arte*, XV–XVII, 1934–36).

[171] If Vasari's account can be trusted.

[172] For his late style, after his return to Florence, see pp. 321–22.

[173] R. Offner, *Studies in Florentine Painting* and M. Salmi, "Antonio Veneziano" (*Boll. d'Arte*, VII, 1929).

[174] The polyptych given by a certain Buonacorsi Campagni to the church of S. Felice a Ema near Florence (1387) may serve as an example: in the centre (Pl. 68b), the Virgin is attended by the entire and numerous family of the donor, looking as if they had been pasted on to the picture in, so to speak, a heraldic manner and quite documentary in effect, i.e. the two large figures of the parents and, in two long rows, the smaller ones of the sons behind their father, and the daughters behind their mother (including perhaps other relatives); four saints originally formed the wings and the predella panels represent the Man of Sorrows and legends of saints.

[175] Biondo's somewhat inferior social position is typified by the following example. He painted a free copy after Agnolo Gaddi's Marriage of St. Catherine (Agnolo's painting Johnson coll., Philadelphia; Biondo's formerly Murray coll., Florence), though of course with a different donor. His client, who must have been somewhat lower in the social scale than Agnolo's, most likely gave him Gaddi's picture as the model to be followed; at any rate, he had to keep close to it. He transposed Agnolo's picture into the two-dimensional; the figures lose their Giottesque structure, and St. Catherine is given a rich, schematically-patterned dress.

[176] The open book in this picture, containing only a few large words which almost give the effect of an inscription, is a feature of Florentine painting in the democratic period. The evolution of the Annunciation in Florentine fourteenth-century painting also clearly shows the development towards the appearance of this motive. In Giotto, the Madonna holds in her hand a closed prayer book, in Taddeo Gaddi the book slowly opens, in Daddi it is entirely open, in Jacopo di Cione, Andrea da Firenze, Biondo, in the circle of Agnolo Gaddi the Madonna holds the open book towards the spectator or points to it or it lies unfolded on the chest, the words (usually *Ecce Virgo concipiet Filium*) assuming the character mentioned.

[177] The work of this artist is discussed on pp. 330–31.

[178] Very similar in style to Biondo's is another St. Catherine (Pl. 76a), probably painted in the democratic period of the 'eighties, surrounded by the six Virtues (including Humilitas); she is shown in marked fashion as the patroness of science, viz. holding in her hand a round disc on which in seven small circles the Liberal Arts are inscribed (formerly Hadeln coll., Florence). The picture was painted by Lorenzo di Bicci (active about 1370–1427), another "popular" painter fond of using scrolls, who was dependent on Jacopo di Cione (see H. Gronau, "Lorenzo di Bicci", *Mitteilungen des kunsthist. Institutes in Florenz*, IV, 1933). In 1380, during the period when the lesser guilds were in power, Lorenzo was also commissioned by the otherwise quite unimportant guild of wine-merchants to paint a picture of their patron St. Martin dividing his cloak with the beggar (Uffizi; Pl. 61b), a somewhat "democratic" motive—significant of these years—either for Orsanmichele, an important public building or for their own church, S. Martino Vescovo. A provincial fresco from about 1390 attributed to the same artist (Vicchio di Romaggio, S. Lorenzo), illustrating the entry of the Blessed into Paradise (with donors) still relies upon Andrea da Firenze's Cappella Spagnuola painting of the same motive (see R. Salvini, "Un Affresco e una Tavola di Lorenzo di Bicci", *Rivista dell'Arte*, XIV, 1932); in the provinces the blunt, tangible formulas of the heroic period of democracy were still retained.

[179] See p. 33, note 43.

[180] The chronology of Spinello's work is still rather uncertain. Gombosi, *op. cit.* contains numerous chronological errors; see the review by U. Procacci (*Rivista d'Arte*, XI, 1929).

[181] Spinello was himself a member of the *Confraternità di S. Maria della Misericordia*

in Arezzo, which during the plague of 1383 was particularly active in tending the sick and burying the dead, and he painted a Madonna of Mercy for this organisation. For the *Confraternità del S. Sepolcro* in Gubbio he produced a typically popular processional banner of the Magdalen enthroned and holding a crucifix, with the members of the fraternity kneeling before her (New York).

[182] The altarpiece for Montoliveto, perhaps the most elaborately constructed of the whole period, was an exceptionally grand commission.

[183] Although Benedetto had himself been prominently concerned in the suppression of the *ciompi* revolt and had even severed his connections with the lesser guilds three years later, he was exiled merely on account of his former alliance with them against the oligarchic Albizzi clique.

[184] Spinello was also one of the few artists who painted the official Benedictine theme, the Confirmation of the Rule of the Order (Parma).

[185] Salutati wrote, in an epistle: "Nearer to God than the priest stands the monk; nearer than the monk the hermit."

[186] Gombosi, *op. cit.*

[187] Somewhat the same upper-middle-class milieu, whose tastes are reflected in these frescoes painted for Benedetto degli Alberti, is to be found in the *Paradiso degli Alberti*. This novel by Giovanni da Prato, the action of which takes place in 1389, describes the entertainments, the social and literary gatherings which took place in Antonio degli Alberti's Villa Paradiso. Like his relative Benedetto, in order to preserve his political position, Antonio had severed his relations with the lower middle class during the period of reaction, but despite this he too was exiled, though somewhat later. It was the wealthy commercial middle class with their intellectuals who met at these gatherings. These intellectuals were of all sorts: very progressive, humanistic scholars, like Salutati and Marsigli, mingled with conservatives, such as the author of the novel or the musician Landini whom we have already met as defenders of scholasticism. At this period, the differentiation between intellectuals had not advanced so far as it had shortly after about 1400, though to some extent it is discernible in the *Paradiso*. That Alberti's circle should have had intercourse with the Counts of Poppi, the principal feudal lords in the neighbourhood of Florence, is a sign of the incipient aristocratisation of the upper middle class. As already stated, Antonio degli Alberti was an enthusiastic follower of St. Bridget and Giovanni Dominici was later his wife's confessor. It is from just such upper bourgeois circles as that of Antonio degli Alberti that the Observance movement drew its support; and there were other rich merchants mentioned by name in the *Paradiso degli Alberti* who had subscribed large sums to Observance monasteries. It is part of the complexity of this upper middle class that a famous Averroist doctor from Padua should also be found in the same company. An example of the blending of religious and secular, the secularisation of the religious and christianisation of the secular, which characterises this upper-bourgeois circle, may be furnished by the manner in which the day is spent in the *Paradiso*. The priest starts off by saying Mass in the chapel. Then follow dancing, music, games, table-talk, conversations. Novels are read aloud. There are discussions on philosophy, the antique and scholastic problems. Bartolommeo dell' Antella, the parish priest of Antella, where Spinello had painted his first fresco cycle, a broad-minded cleric who kept on good terms with both Commune and Church at once, discusses the problem which was of the greatest interest to this audience, viz. the Thomist doctrine of usury and how money could be made without incurring religious censure.

[188] The ever-increasing Gothic trend, in a purely external sense, close to the Sienese model, is also evident at the end of the Trecento in the construction and framework of large altarpieces.

[189] See Datini's correspondence in R. Piattoli, "Un mercante del Trecento e gli Artisti del Tempo suo" (*Rivista d'Arte*, XI–XII, 1929–30).

[190] To what extent Gerini's bourgeois patrons had already absorbed the ideals of the Observance movement may be seen from the correspondence of the Florentine notary, Ser Lapo Mazzei, with Datini, in which, ever mindful of the latter's salvation, he recommended him, out of sympathy with the Observance movement, to found a church and call it S. Maria degli Umili (1395). Madonnas of Humility by Gerini also exist (Avignon, Musée Calvert).

[191] O. Sirén, "Gli affreschi nel Paradiso degli Alberti" (*L'Arte*, XI, 1908).

[192] The house of the Brigittine monks was a kind of centre for a very popular art. It supplied Franciscan monasteries in and outside Tuscany with pictures and miniatures. See R. Piattoli, "Il Monastero del Paradiso presso Firenze nella Storia dell'Arte del primo Quattrocento" (*Rivista d'Arte*, XVIII, 1936).

[193] See p. 224, note 122.

[194] E.g. in two pictures with scenes from the life of St. Eligius (Madrid, Prado) which were probably painted in the circle of Agnolo Gaddi and show a goldsmith's workshop.

[195] Approximately contemporary, a highly popular altarpiece of St. Margaret with several narrative scenes on either side (Vatican Pinacoteca) is a characteristic counterpart of these miniatures. Among others it shows the miraculous grave of the Saint at which cripples are praying, while above on a beam hang the wax votive models of the feet, arms, and heads of the persons who had been healed. It is a genre picture which in its naturalism surpasses even Andrea da Firenze's fresco of the sick at the grave of St. Peter Martyr.

[196] This monastery was founded by the noble and anti-democratic Guittone d'Arezzo (1293), at one time the writer of chivaleresque love-poems, later religious poet and Frate Gaudente, and a descendant of the Signori of Monreale.

[197] Here (and to some extent in the similarly monastic milieu for which Niccolo Gerini worked) the theme of the Resurrection of Christ was further developed along transcendental lines not unlike the Ascension, already discussed in connection with Taddeo Gaddi's and Andrea da Firenze's work. At the same time—and this is especially true of the Benedictine miniatures—the massiveness shown in the treatment of this type by Andrea da Firenze, whose art, though also monastic, fell in a period of rising democracy, is more and more lost in this era of reaction.

b. Symbolic and Allegorical Art

(a) GENERAL ASPECTS AND SUBJECT-MATTER

WE have seen that the choice of the most frequently recurring religious themes, taken from the lives of Christ, the Virgin and the Saints, like the manner of their representation, was in the main determined by the aims of relating intelligibly, of touching the spectator emotionally, and of leading him directly to God and the Saints. There are, however, a large number of other works of religious content—the distinction between these and the former cannot always be drawn clearly—in which the aim is rather to demonstrate the transcendental truths and mysteries of religion in a perceptible, pictorial form by means of symbols. In these works, the earlier symbolic, dogmatic and didactic character still predominates, though in a rather subdued form often associated with the new emotionalism. We have already encountered some of these types of pictures, just such characteristic ones as the Allegory of the Cross (Pl. 14, 15, 18); and we have observed that they usually occur in the sphere of conservative, popular religious art, corresponding to the more primitive symbolic thinking of the masses. This popular character is also more or less marked in the great majority of the other Florentine works with symbolic and allegorical themes which we shall classify and discuss in this section. The immediate foundation of all these representations is not merely the general symbolism immanent in the Christian religion from its origins, but more especially the universal and systematic symbolism of medieval Christian theology, extending to the minutest detail. The whole theology of the Middle Ages, and all the medieval encyclopaedias are dominated by a symbolic and allegorical manner of thought which is combined with the systematisation so beloved of scholasticism. The symbolic interpretation of the Bible[1] originally began with the Old Testament, whose various events and figures were regarded as symbols and foretellers of those in the New, which in its turn was regarded as the fulfilment of the former; thus the prophets were foretellers of Christ.[2] Scholastic theology in France later elaborated this parallelism (typological interpretation of the Bible) into the most minute particulars. In the course of the Middle Ages there gradually emerged an exhaustive symbolical interpretation of the entire liturgy[3] and the whole of ecclesiastical learning in all their details. The monumental Cycles of Redemption in the visual arts, as especially developed in France during the twelfth and thirteenth centuries, are encyclopaedias of divine revelation in the Old and New Testaments, in which all history, and even all nature as well,

are conceived as one great symbol. It is the Church as the institution continuing Christ's work of redemption, the executrix of God's plan of salvation on earth, the bearer of the systematic doctrine of salvation, which becomes, especially from the thirteenth century onwards, the permanent centre of this symbolism;[4] significantly enough, this process was taking place at the time of the consolidation of the Church's secular power. This concept is the basic theme of the monumental Cycles of Redemption of the "high" Middle Ages, with their imposing cycles of images centred in the idea of salvation.

Since, with the growing importance of the middle classes, the Church of necessity strove to establish an ever closer contact with them, she attempted to make this Cycle of Salvation more and more intelligible, in detail as well as in general purport, to the masses who—and this, of course, is of basic significance—had a natural bias towards symbolism. The general process of development showed on the whole that religious symbolism, which originally, in the early Christian period, was undoubtedly universally understood, had in the course of the Middle Ages become increasingly complicated and unintelligible in its details to the people; but now, as necessity arose, it was again brought nearer to the very masses who, on account of their symbolic thought-process, had always been receptive to it. This is why most of the works of symbolic content are conservative and popular in character. It must, however, be stressed that the Church varied the means through which she attempted to make her symbolism intelligible and to popularise it, according to the social group with which it was concerned. The popularity of the symbolism of numbers is an instance of a stronger tendency towards the exoteric; originally numerical symbolism had expressed the mystical harmony of the universe, but actually the most disparate objects came to be associated on the basis of the similarity of their numbers: this expedient was certainly useful when dealing with the uneducated masses.[5] More interesting for our purpose is the increasing use of allegories which, though represented for their didactic-religious significance, were nevertheless drawn from the secular world, from nature or the realm of ideas. The whole social life of mankind with its many callings spiritually subordinated to the Church, was now treated in all its details. This strong dependence on real life gave different, essentially new shades of meaning to the whole Cycle of Salvation. The decisive transformation of symbolic art in this particular direction, which of course implied the existence of a really progressive and self-assured middle class, was naturally most pronounced in Italy, and above all in Florence.

Even in the monumental art of fourteenth-century Florence there still existed extensive Cycles of Redemption, whose general character, although they also naturally include narrative parts, is necessarily allegorical and dogmatic, or in which the allegorical and dogmatic element at any rate still played the decisive part. The continued existence in the fourteenth century particularly—in the period, that is, which comes after the great French cycles—of such Plans of

Salvation, which may be compared with the ecclesiastical encyclopaedias, and which served to disseminate the ecclesiastical conception of the world, is clearly a consequence of the alliance between the upper middle class and the Curia, and of the strict adherence to official-ecclesiastical Thomism which this alliance demanded of the bourgeoisie. This situation exercised a great influence on the very essence of the Florentine Cycles of Redemption. But of no less significance in the shaping of these cycles was the further fact that the ideology of the Florentine middle class was advanced far beyond the rest of Europe; the innumerable concessions in the ideological sphere which the Church was thereby forced to make, had disrupted the closely-knit structure of the Thomist system, accepted in that city, as far as was possible without destroying its unity of principle. For these various reasons the Cycles of Salvation of the Florentine fourteenth century—the two great cycles of the reliefs of the cathedral Campanile (Pl. 77b, 79a, b, 91b) and of the frescoes of the Cappella Spagnuola in S. Maria Novella (Pl. 83, 85, 86, 87) are the cases in point—necessarily differed to some extent in character from the usual cycles as exemplified in the sculptures adorning the portals and façades of the French thirteenth-century cathedrals. Although the basic conception of the Florentine cycles, that of the Church as the bearer of the universal doctrine of salvation, naturally remained unchanged, and although the underlying unity of the whole scheme was in principle preserved, they no longer show the severe, organic homogeneity which marks these great French cycles of the earlier phase.[6] The growing accentuation of allegories, both ethical and physical, which had played but a minor role in France, together with the tendency peculiar to Florence of attaching even greater significance to the religious stories, led to a loosening of the structure and a rearrangement of the various components of the Cycles of Redemption[7] and brought in their train many new possibilities of combination. Sometimes the emphasis is placed on the secular and specifically middle-class aspect (Campanile), at others on the conservative ideology of the Church (Cappella Spagnuola). But in either case life on earth, still regarded, of course, as only a preparation for the hereafter, was nevertheless treated as an important preliminary condition, by no means to be neglected. The individual allegories which helped to transform the character of the Cycles of Salvation—some of them the original creations of the ecclesiastical writers, others derived by them from antiquity, while others again took shape as illustrations for various tenets of the faith[8]—will be discussed in detail in the following section. We will mention here only the principal amongst them: the Seven Virtues (Pl. 77a), the Seven Deadly Sins, the Seven Liberal Arts, the Seven Mechanical Arts (Pl. 79a, b), the Seven Planets (Pl. 77b), the Seven Sacraments (Pl. 70, 91b), the Seven Works of Mercy (Pl. 88, 89a) and various allegories of human life and death (Pl. 42, 43, 80, 81b, 82). The outstanding characteristics of the Florentine cycles, as compared with the French, which were probably incomprehensible to the layman in many of their details, are real

contact with the public, with the realities of daily existence, a more intelligible presentation of the programme and, in consequence, of the encyclopaedias of scholastic knowledge. The cycles thereby acquired not only a generally comprehensible but also a propagandist character: secular elements and secular aims (an outcome of similar tendencies in the Church herself) now become far more intensely and directly apparent than ever before.

A further more radical change which the symbolical Cycles of Redemption underwent in this democratic period of the late Middle Ages was their translation from the sphere of monumental art, from the art of the cathedral, into that of the manuscript, usually illustrated only with pen drawings.[9] This, however, is of less significance so far as Florence is concerned; such manuscripts were above all typical of the less advanced northern countries, where they were extremely widespread and popular. The principal types are: the *Biblia Pauperum* —the story of Christ—compiled in Germany about 1300 and containing parallel illustrations from the Old and New Testaments, two of the former corresponding to one of the latter; and the *Speculum Humanae Salvationis*, which also originated in Germany, about 1324, in Dominican circles, and illustrated the origin of sin and the salvation of mankind by Christ, with particular emphasis on the Passion (Pl. 90a, b), while to each scene of the New Testament corresponded two or three preceding parallel subjects from the Old Testament (Pl. 91a) and from secular history.[10] Notwithstanding the symbolism inherent in the whole theme, the story of salvation here acquires the additional narrative character of a long historical cycle. This typological, analogising method of biblical interpretation, employing numerical symbolism, naturally served at the same time as a mechanical, easily remembered, if superficial means of instruction. In the northern countries these manuscripts already had, in view of their middle-class clientèle, a certain democratic significance; they were made for the more progressive and cultured circles in those countries, for wealthy citizens and clerics (for originally the *Biblia Pauperum* was certainly not destined for the poor, or for the poor in spirit). But since in Florence the class corresponding to the northern purchasers of these manuscripts, the upper middle class and its intellectuals, were more advanced in outlook, while the poorer classes could not afford these works, although their symbolism would have appealed to them, there was little demand for such popular picture books, and they are almost wholly lacking in fourteenth-century Florence. Throughout Italy, indeed, copies of the northern *Speculum* manuscripts are rare, and of Italian copies with illustrations only two survive, one of these being a Florentine work.

We have already discussed, in general, the "sources" of the symbolical world of conceptions, expressed in the visual arts; moreover it is practically impossible —and it does not fall within the purpose of this book—to distinguish between the ultimate sources and those factors which served merely to spread and popularise this symbolism.[11] Besides the Bible, the Liturgy, whose every detail had a

symbolical meaning, played a large part. The various liturgical treatises and commentaries were thus of great importance.[12] This also applies to the scholastic encyclopaedias[13] written in Latin, which also contained many allegories derived from antiquity. The encyclopaedias written in Italian by laymen and for a lay public and those translated into that tongue contributed greatly, from the end of the thirteenth century, to the popularisation and interpretation of the religious allegories, especially among the Tuscan middle classes:[14] above all, Brunetto Latini's *Tesoretto* and the *Divina Commedia*. The religious drama also supplied many allegorical figures and motives.[15] Such were the means by which the symbolical art of the official Church was brought nearer and made intelligible to the masses, becoming a kind of conservative-bourgeois, popular art

NOTES

[1] The roots of this symbolism are contained in the Bible itself. As a rule no distinction is made in the text between the various biblical interpretations which can be regarded as "symbolical" in the wider sense of the term: between the allegorical, typological, tropological (moral), anagogical (mystical), etc., interpretations.

[2] The manner of choosing these parallels is capable of great variation in detail. See p. 153.

[3] The liturgy of the Mass also provided from the first a solid nucleus of symbolical actions and doctrines.

[4] J. Sauer, *Symbolik des Kirchengebäudes* (Freiburg, 1902).

[5] Numerical symbolism in fact pervades the whole ecclesiastical and secular literature of the period: it is to be found in theology no less than in the *Divina Commedia* or the secular allegorical poetry of fashionable society.

[6] The rigid homogeneity of the Cycles of Salvation of French Gothic—with the Church as the bearer of the doctrine of salvation as their centre—on the whole corresponds to the original rigid homogeneity of Thomist theology, in which, as we have seen, the ideological interests of the Church achieve more powerful expression than those of the middle classes, which at that time were still of little standing in France. But the very fact that the monumental cycles were now subjected to this process of unification and systematisation (in contrast to the still disconnected motives in the twelfth century) in itself already implied some degree of rationalisation—some approach, in fact, to the middle-class attitude. The unification of the cycle was the first step towards rendering them more intelligible.

[7] The scheme for the decoration of the façade of the cathedral of Florence itself—a Mariological programme—also appears to have already lost consistency and clarity. The tendency towards decreasing homogeneity in the iconographic cycles of the Italian cathedral façades, which first became marked in that of Siena cathedral, is discussed by Sauer, *op. cit.*

[8] The date of the first appearance of these summaries of tenets of the faith, later known as Catechisms, cannot be determined with certainty.

[9] In its historical sequence the process was not of course so simple as this. Moreover, the illustrated manuscripts subsequently came in their turn to influence monumental art.

[10] A transition stage between monumental art and these popular books is provided by the vast illuminated manuscripts of the *Bible Moralisée* which were made for various princes.

[11] The sources are fully discussed by Sauer, *op. cit.*; F. X. Kraus, *Geschichte der christlichen Kunst* (Freiburg, 1908) and K. Künstle, *Ikonographie der christlichen Kunst* (Freiburg, 1928).

[12] E.g., that by Sicardus (Bishop of Cremona *c.* 1200) and the *Rationale Divinorum Officiorum* (*c.* 1286–91) by the Dominican Durandus (Bishop of Mende and Papal legate for Italy). These works are essentially reference books for clerics.

[13] The animal symbolism used for certain events from the New Testament was largely taken from the *Physiologus*, a popular theological work of the second–third century, which was much read particularly from the twelfth and thirteenth centuries onwards.

[14] The great allegorical encyclopaedias in stone or paint were most frequently produced during this period in Tuscany: in Florence, Pisa and Siena.

[15] E.g., the Old Testament precursors; also the Tree of Life, the Virtues, the Wheel of Fortune, the Three Quick and the Three Dead, etc.

(b) STYLISTIC DEVELOPMENT

WE have now to consider the first great Florentine Cycle of Redemption, the reliefs of the cathedral Campanile, most of which were executed after Giotto's death. But before doing so, it is worth noting that Giotto himself produced a vast allegorical composition of the "Christian Faith" (now lost) in the Palazzo di Parte Guelfa—the building which symbolised the power of the victorious middle classes. It probably represented the hierarchy of the Church, and it included a portrait of Pope Clement IV, the founder of the Parte Guelfa. It was thus an allegory of the alliance between the Church and the Guelph middle classes of Florence.

We will now turn to Giotto's method of representing the Virtues and Vices, painted beneath the Lives of the Virgin and of Christ in the Arena chapel at Padua. The Seven Virtues (the three theological, Faith, Hope and Charity, and the four secular or cardinal, Prudence, Justice, Fortitude and Temperance),[1] were often—especially after the twelfth century—included in the Cycles of Salvation, for the Church considered the discipline based on them an important element in her teaching, and an efficacious preparation for the Last Judgment and the hereafter. And in Giotto's handling of the theme everything was done that could be done in the interests of compromise between the Church's outlook and that of the middle classes: the modern, bourgeois mentality found such expression as was possible in the general arrangement and interpretation no less than in the purely formal elements. Above all, Giotto's secular turn of mind arrived at the representation of these figures as grisailles so that they should not impair the effect of the narrative scenes and could be viewed, as it were, independently of the latter.[2] These representations of the Virtues and Vices, moreover, take the lay mind far more into account than those previously produced: there is a greater freedom in the conception of the figures and in the disposition of their attributes than is usual in representations of this subject, later as well as earlier, which adhere more closely to the theological tradition.[3] This allowed of a greater concentration and clarity in the formal sphere as well. And yet these characteristics could not here reach that unfettered expression so typical of Giotto's other works; for the hidebound ecclesiastical tradition still made it necessary that these allegorical figures, in particular, should be overburdened with attributes. The central figures of the scheme are Justice (Pl. 77a) among the Virtues and Injustice among the Vices. They alone are raised above picture strips containing additional explanatory scenes; and Justice is given the further distinction of a throne, although she is only a secular, not a theological

Virtue. The panel below Justice contains three scenes: mounted cavaliers with a falcon, a couple dancing to the sound of music, and a merchant, with his servant, riding out on a peaceful errand. The scenes below Injustice on the other hand represent robbery, murder and warfare. Thus to Giotto Justice was the queen of the Virtues, because for him, as for the middle-class mentality of his day in general, she was the personification of all good civil government. This is a secular and bourgeois re-interpretation of an allegory up till then purely religious.[4] The hunting and dancing scenes which had previously been customary only as independent motives, in courtly illuminations, are adduced here to characterise the sound bourgeois régime,[5] and it is significant that Giotto, out of his own, that is, out of upper-middle-class mentality, adds, as an original contribution, that scene of paramount importance to all citizens—the merchant, setting out in pursuit of his peaceful calling. The thematic transposition of the courtly amusements of hunting and dancing in a middle-class sense corresponds to the transposition of formal elements: the Gothic linear rhythm has disappeared, to be replaced by a composition in which an exactly calculated equilibrium, a reduction to essentials, and precisely defined, very material figures, are the salient points.

Yet again it is worth noting how Giotto's workshop, in its later period—or it may perhaps have been a pupil (Master of the Assisi Vault) who had already severed his connection with the workshop—handled allegories, when the milieu was very different from the specifically upper-bourgeois one of the Scrovegni chapel, namely S. Francesco at Assisi, the great pilgrimage-church of the Franciscans. The paintings in question allegorically represent the three Franciscan vows, Poverty, Chastity and Obedience, which are placed on the vault at the crossing of the Lower Church next to the Apotheosis of St. Francis.[6] Here, where the purpose of the paintings was to explain and popularise the Franciscans' programme to the masses of pilgrims, allegory and its artistic rendering take on a character entirely at variance with that which we saw at Padua. The subject in this case seems more complicated, but it is just this accumulating of allegorical figures which brought the widely-known, monastic and popular theme—the subject of poverty, in particular, was universally understood, being a matter of lively interest to the majority of pilgrims—nearer to the masses, even in its details. The sumptuous decoration of the church is in itself evidence that the Order had abandoned the ideal of Poverty, but in theory they clung to their old popular slogan—so far, at least, as it did not become actually perilous. That is why Poverty could still be officially and circumstantially glorified here—but only here, in these purely monastic surroundings, and in provincial Umbria; and of course only as a specifically Franciscan virtue.[7] No less essential is the further fact that a motive originally revolutionary—we saw something similar in connection with the interpretation of the Apocalypse—could now be embodied within the general scheme of the Order's

apotheosis and thus endowed with the sanction of orthodoxy.[8] The theme depicted is the marriage of St. Francis to Poverty— *Sancta Paupertas*—with Christ himself officiating as High Priest (Pl. 78). The marriage motive, universally known in Christian theology, originated in the allegorical interpretation of the Song of Songs,[9] whereby the Bride of Christ was identified with the Church. The particular motive of the marriage between St. Francis and Poverty is common to the whole of Franciscan literature, to the Spirituals[10] no less than to the Conventuals, occurring also in the *Divina Commedia*, and probably in religious drama as well. The fresco is rendered still more generally comprehensible by the fact that the scheme of the composition is simply that of the Marriage of the Virgin. Poverty, clothed in a tattered gown, is shown standing amid a clump of thorns, but lilies and roses bloom above her head. While Caritas offers her the heart and Spes the ring, a dog yelps at her and two boys make a mock of her. A youth gives his cloak to a beggar, an angel admonishes a nobleman who carries a falcon, and a Franciscan appeals in vain to a man who firmly grasps his purse. Up above, angels are seen bearing a gown, a bag and a building—probably the possessions of St. Francis himself—to God the Father, who accepts these gifts with wide open arms. The two other allegories— though probably not quite to the same extent—are similarly easy to grasp, lending themselves to an easy explanation by the priests. These simple, popular compositions consist throughout of schematic rows of vertical, symmetrically grouped figures.

The first theological Cycle of Redemption of the fourteenth century in Florence is contained in the reliefs of the cathedral Campanile,* (Pl. 77b, 79a, b, 91b), executed probably in the 1330's and '40s by Andrea Pisano (some of the earliest possibly from Giotto's designs), his assistants, and Alberto Arnaldi and his workshop.[11] We have here what might be called a State-controlled range of ideas, for it was the Arte della Lana, at the time the chief executive organ of the State, which was not only entrusted with the erection of the Cathedral, but also naturally controlled the choice of the sculptural decoration of the Campanile, in the fourteenth century inseparably connected with the architecture. The rationalist Florentine upper middle class was in principle still officially attached, for reasons we well know, to the conservative theology which had been worked out as a unified system by the inchoate urban culture of France in the thirteenth century. It was thus a matter of course that their attitude should lend itself to the popularisation of the Church's conservative outlook, and the Church's conservative learning, in these reliefs of the Campanile—though, as we shall see, they contain certain essentially new and worldly nuances. On the whole these reliefs still preserve the general scheme of the scholastic encyclo-

* Although the Campanile reliefs do not strictly belong to the history of Florentine painting, we must discuss them in some detail because of their special importance and because, despite this, they have not so far received sufficient attention in scientific literature.

paedias of the thirteenth century.[12] But this art of religious allegories served the same popularising purpose as did the contemporary or slightly earlier didactic encyclopaedic poems of Tuscany, written in the vulgar tongue. The Campanile reliefs in effect translated these didactic poems, so widely read in Tuscany, into the language of the plastic arts. It is this fact which reveals the essential difference, in relation to the public for which they were intended, between these works and the French cathedral sculptures of the thirteenth century. For while the latter were exclusively derived from the contemporary Latin encyclopaedias, with which in all probability the clerics alone were thoroughly familiar, the Campanile reliefs were intended to serve as a popular encyclopaedia intelligible to all; and there is no doubt that they must have been understood by a considerable section of the general public.

The entire Plan of Salvation is embodied in the Campanile reliefs, the whole doctrine of how man, in spite of original sin, can attain eternal redemption. Within the framework of that cycle was represented the entire spiritual and secular life of man, in its subordination to and dependence on the Church.[13] According to the official doctrine incorporated in the encyclopaedias, it is the three divine powers of Virtue, Wisdom and Practical Necessity which mitigate and counteract the effects of original sin. To these three divine powers correspond the three spheres of human activity: ethics, i.e. the Seven Virtues; theoretical science, i.e. the Seven Liberal Arts (Dialectic, Rhetoric, Grammar, Arithmetic, Geometry, Astronomy and Music);[14] and the means of providing for material existence, i.e. the Seven Mechanical Arts (Weaving, Building, Navigation, Agriculture, Hunting, Medicine, Racing). Following this general scheme of arrangement, the reliefs begin by showing the Creation of Adam and Eve, and the toil for daily bread which was made necessary by the Fall. There follow seven inventors who have assisted man in his task of labour, and thus, figuratively speaking, laid the foundations of the Seven Mechanical Arts. We are then shown the Seven Mechanical Arts themselves, and appended to them the Three Visual Arts. These are succeeded by the Seven Planets, under whose influence, guided by angels, lies the elemental life of man. The next group shows the moral and spiritual powers which assist man to rise again after his fall: the Seven Virtues and the Seven Liberal Arts, the latter with their representative figures.[15] The cycle concludes with the Seven Sacraments, for the life of the Christian is completed only by divine grace supplied through the sacraments of the Church.[16]

The broadly conceived Cycle of Salvation is in its entirety far more intelligible, more rationalist, scientific, and moreover closer to life than the corresponding schemes or sections of them found in the French thirteenth-century cathedrals. In the Florentine cycle there is an essential systematic broadening and secularisation in the representation, within the hitherto customary figure-decoration of churches. The Florentine upper middle class retained the old framework, the old categories, the mystical figure seven, and also, in principle at

least, the old underlying unity, but it added all the details close to life, admitted by the Church and described in the encyclopaedias. Thus it came about that many motives were included which had not appeared hitherto, or had occurred only very rarely, in monumental art.

The new lust for knowledge of the Italian middle classes had brought in its train an enhanced popularity for the theme of the Liberal Arts,[17] and these are represented here as the customary allegorical female figures;[18] but it is an innovation as important as it is striking—and one peculiar to Florence—that the Mechanical Arts, hitherto represented both rarely and incompletely, are here shown in their full number and in great detail, and that their representations take the form of scenes from daily life. Although they were basically still allegories they afforded an opportunity for this interpretation which was exploited to the full.[19] This addition to the representatives of the Liberal Arts[20] of a systematic and exhaustive series of the inventors of practical necessities—the first smith, for instance—implies a further conscious step towards the secularisation of the Cycle of Salvation, towards an accentuation of the events and occupations of daily life. It is characteristic that just in these scenes the scheme of the reliefs often follows not only such ecclesiastical encyclopaedists as Isidore of Seville (seventh century), or Vincent of Beauvais (thirteenth century), but also the *Tesoretto* of Brunetto Latini, a work which, despite its strict Thomism, was written by a layman. Moreover, among the representatives of the struggle of everyday life we find Phoroneus, the inventor of law and order—an addition which perfectly reflects the upper middle classes' respect for an orderly existence. In the context of the series of inventors, and even more of that of the mechanical arts, we find introduced not only scenes from country life, which were of course customary in allegorical representations of the seasons or months, but also—a very important innovation—events from the daily life of the burgher. The reliefs in fact contain, besides the traditional peasant, ploughing with oxen— now no longer representing seasonal or monthly occupations, but agriculture as such—also such occupations as weaving (although the female figure shown at this task may possibly be an "inventor" taken from the Bible). Thus does the woollen industry (Pl. 79b), the foundation of Florentine prosperity, find one of its earliest representations in monumental art within the Cycle of Salvation of the Church—the Church which was the ally of the middle classes—in this commission which was administered by the wool guild. Another scene represents a doctor on his dais, examining a sample of urine which a woman has brought him, while other women, carrying straw-covered flasks, are waiting, and in the background are seen the various bottles of his stock-in-trade: this is the representation of Medicine (Pl. 79a). Again, we see the builder and his men at work on a house—the representation of Architecture.

Another daring innovation characteristic of Florence is the addition of all the three Visual Arts.[21] And again it is a sign of the new secular outlook that

whereas in the earlier Middle Ages nudity was still a sign of servitude and low estate, the sculptor, representative of sculpture within the framework of Christian callings, is seen fashioning, not the draped figure of a saint, but a nude. There are seventeen of these representations of the Mechanical Arts and the Inventors, accounting numerically alone for such a large proportion of the Cycle of Redemption, and—a further contrast to the usual procedure in French cathedrals— they are given equal value, are equal in size, to the representations of the Higher Spheres which follow them.

Into the monumental art of Italy, within the Church's traditional Programme of Salvation, were at this time introduced the personifications of the Planets—a derivation from the antique—in place of the previously customary Signs of the Zodiac. The Planets were finally taken over into the ecclesiastical system by Aquinas as a concession to popular belief, originating in antiquity: their movements were supposed to be controlled by spiritual beings—angels— to whom their task had been allotted by God—that is to the same beings to whom He entrusted the guidance of Mankind. The *Divina Commedia* served to strengthen the authority of this belief.[22] And on the Campanile this motive of the Planets, modern in itself, is invested with iconographical innovations of the most radical kind.[23] In these iconographical features the combination of traditional with novel elements once more reveals the characteristic mentality of the Florentine upper middle class; for instance, while Jupiter is shown as a monkish scholar with a large cross in his hand, we find beside him the surprising innovation of Venus, holding a pair of nude lovers (Pl. 77b) of a type suggestive of the antique—a clear anticipation of future developments. This is perhaps the first occurrence in post-classical art of lovers being represented in the nude.[24] Mercury, as protector of the sciences, provides the opportunity for showing a class-room scene.

Another unusual and highly significant turn is to be found in the series of the Sacraments (Pl. 91b). As is well known, the foundation of the Church's influence over men lay in the Sacraments, by whose means the priest is enabled to call down divine grace on the faithful, and without which no escape is possible from original sin and the flames of purgatory. In this case the series— another indication of the development of a more secular-minded art out of themes which had always been strictly ecclesiastical—affords an opportunity of showing the principal moments in the life of the priest, in his intimate connection with that of the laity.

Summarising, then, the content of the reliefs, we find occurring, within the framework of that still fundamentally high-scholastic scheme, the ecclesiastical cycle of salvation, wholly secular themes, and above all events from real life. Both aspects faithfully reflect the mentality of the Florentine upper middle class. For it was adaptation to the requirements of real life and the safeguarding of its secular interests, in art as in every other sphere, which this class expected

to attain through its adherence to the official, ecclesiastical doctrines of St. Thomas.

This constellation explains why Andrea Pisano's cycle adheres on the whole to the compositional manner which had grown out of the world of thought of the Florentine upper middle class, the most advanced of its day; why, in other words, it is composed in the new, comprehensive style of Giotto which came from a profounder knowledge of nature. This "classic" style of Andrea Pisano already tends, in some cases, to a striking dependence on antique sculpture (e.g. the Hercules or the Art of Hunting). The spatial depth noticeable in many of the earlier reliefs—probably still based on Giotto's designs or worked out entirely by Andrea himself—decreases, indeed, in the later ones. In many of the latter, probably executed by Andrea's assistants or successors, such as Arnaldi, there is some tendency to apply excessively plastic figures in successive layers in front of a neutral background. But this change also follows the general trend of development which leads from Giotto to Orcagna,[25] as the essentially concentrated style of the upper middle class grows more two-dimensional. The manner in which pure genre is handled in this style is highly characteristic. Extreme realism of detail is on the whole avoided, the accent falling as far as possible on the essential alone. If we are shown a building scene or the interior of a smithy, details, whether of builder's stones or the smith's tool, are monumentally treated, and occupy a carefully selected place within a balanced composition. In this way the whole process of work is given a concentration and measured quietness, characteristic of the idealised version in which the upper middle class preferred to regard it.[26] Thus, although many crafts are illustrated, not once do we see a real artisan figure—not even in the smith.[27] The most striking, in fact, is the idealisation of the city's main source of economic power, the wool-weaving industry (Pl. 79b), in which, as we have seen, the workers were worst paid and most harshly treated. Another interesting illustration of upper-middle-class mentality is to be found in the building scene: on either side two labourers, reduced in scale, are standing on a scaffold and adding stones to the building without any apparent effort, while between and above them is the supervisor, who is twice their size—something like a saint beside ordinary human beings. In the surgery scene (Pl. 79a), with its many medicine bottles, there is a certain surrender to the delight in realistic detail—although this remains always subordinated to the principle of unification in the composition; for this scene represents no physical labour, which would have to be idealised, but the dignified activities of one of the greater guilds. In the other sequences—this applies rather to the Virtues than the Planets—the attributes sometimes occasion a slight overloading of the composition.

The series of the Sacraments by Arnaldi is particularly instructive in the matter of the relationship between content and form. The compositional schemes are here only partly derived from certain related religious themes (Life of the

Virgin, or legends of the Saints); but we find in addition a number of rather new motives, based to a greater extent on the observation of reality (since this was possible in their case) than are the purely religious stories, with their dependence on traditional formulas. To take an instance, the Sacrament of Baptism, in which a new-born child had to be shown held over the font—a scene which bore no resemblance to the Baptism of Christ—is basically a freshly-conceived pure genre illustration, at the same time enclosed within firmly-marked contour lines. In the relief with the Sacrament of Marriage probably executed by an assistant of Arnaldi (Pl. 91b) the scene represents a betrothal solemnised by the bride's father, and the composition is to some extent, though not entirely, assimilated to that of the Sposalizio; the arrangement, in consequence, is less severe than that of the other reliefs, and the entire family, in particular, is rendered with a surprisingly portrait-like realism of detail. Very impressive and quite novel in appearance is the Sacrament of the Eucharist (though admittedly there are certain parallels and premisses in painting):[28] the scene shows only the priest at the altar, seen from behind as he raises the Host above his head, and the acolyte—massive, block-like figures combined in a block-like composition.

There appears, then, in these reliefs of the Campanile much that is new—it is introduced under the mantle of the ecclesiastical cycle of salvation, old in essentials, but here greatly broadened in detail.[29] The predominantly Giottes-que disposition succeeds in welding together elements both old and new—each equally expressive of the same upper-middle-class mentality—into a compact whole.

Ecclesiastical thought used a number of allegories to illustrate one of its most fundamental ideas: the transitory character of earthly existence as a prelude to eternal life. One of them was the Wheel of Fortune, a symbol borrowed from the ancients, in particular from Boethius, which was now regarded as an instrument of the Divine Will. Later we shall often encounter this motive in the illustrations to allegorical, didactic poems, which, though in the strict sense secular works—the *Divina Commedia* for instance—are nevertheless basically religious in their aim. There are other allegories of the transitory, which, on account of the possibilities of their interpretation, stand somewhat nearer to the lower classes. Among the principal popular themes of this kind were the various allegories of death; the sermons of the mendicant friars—especially the Franciscans—no doubt contributed much to their popularisation. The exhortation to man to prepare himself for the good death on which his fate hereafter depended, was even more often combined with reflections on the vanity of all earthly existence, with ideas expressing dissatisfaction with the prevailing state of affairs, and with the conception of the great leveller, Death.[30] The skeleton and the putrefying corpse were the chief motives of this "democratic" world of thought and its art. The earliest example of a death allegory in Florentine monumental art is probably the fresco by a pupil of Giotto—presumably the Master of the

Assisi Vault—in the Lower Church at Assisi, in which St. Francis is shown pointing towards a crowned skeleton standing in a coffin (Pl. 82)[31] So we see that an allusion to the transiency of kings could be tolerated in the church of pilgrimage of the Franciscans.[32] It is of the nature of this type of art, at once symbolical and progressive, especially of the allegories of death, that they should be distinguished by a strong tendency towards realism in detail—in this case the circumstantial rendering of the skeleton; such allegories tended much more keenly to incite the production of naturalistic genre figures and scenes than did, for example, the allegories of the Cross, which, while no less popular, were much more closely connected with conservative doctrines, and are therefore represented more schematically.[33] Traini's fresco in the Campo Santo of Pisa (Pl. 33, 42), painted after the plague of 1348, a work which exercised great influence in Florence, and Orcagna's fresco in S. Croce (Pl. 43), both illustrating the same theme of the Triumph of Death, are the most famous examples of this category.[34] We have already discussed the figures of beggars and cripples which Orcagna probably took over from Traini, and indicated their persistence in Florentine art.

The legend of the encounter of the Three Quick and the Three Dead—a story of French origin—which we find among other legends at Pisa (Pl. 80), was the outstanding precursor in Italian fourteenth-century art of the far more brutal Dance of Death, which eventually became familiar to the whole of Europe. Three noble youths (they are sometimes raised to the rank of kings) riding out to the chase, are suddenly confronted by three open coffins containing decomposing corpses; these, who are shown as having held the highest offices in life, often rise from their graves to address the youths; the three huntsmen are thereby reminded that death is lying in wait for them, death for which mortals must prepare themselves by good works. The "democratic" theme of this legend—that death spares no one, not even the well-born—which is often illustrated as the vision of a hermit, also occurs in Florentine art, and that even before the date of the Pisan fresco, during the period when the lesser guilds were engaged in bitter political and social struggles. An early example of this kind occurs in a manuscript of the *Laudi Spirituali* (with scores), now in the Biblioteca Nazionale at Florence and originally the property of the Compagnia di S. Spirito,[35] a member of which was probably the author of the miniatures. In one of them a monk, St. Macarius, representative of the ascetic life, is drawing the attention of the three youths to the three corpses. The manuscript as a whole, with its exceptional wealth of illustrations, including not only the usual scenes from the stories of Christ and the Virgin, but also such popular themes as the Virgin seated on the ground and contemplating in despair the tortured Christ at the column, and the Madonna of Mercy, typified the mentality not of the wealthiest circles but of the confraternities. In style the miniatures are wholly under Sienese influence, especially that of the Lorenzetti.[36] The same theme of the

Three Quick and Three Dead also occurs in domestic altarpieces; for instance in one of the Daddi school (Florence, Academy, from the Vallombrosan house, S. Pancrazio) again showing the monk, St. Macarius. Another, in Berlin (of which the centre panel contained the Virgin) was painted during the same period of the '30s or early '40s by that rather popular imitator of Daddi, Jacopo del Casentino, this time without the monk; it shows three kings riding on very wooden horses through a schematically rendered landscape, while the skulls in their coffins are grimacing (Pl. 81b).[37]

During the period when the political influence of the lower middle class was continually growing in Florence—that is, a short time before and for some decades after the middle of the century—religious allegory with a more than normally pronounced didactic intention acquired a further sphere of influence in fresco-painting, the art capable of speaking to the masses. This consideration for the lower classes, or rather this attempt to acquire influence over them, is very evident in the second great Florentine allegorical cycle—the frescoes painted, 1366–68, by Andrea da Firenze in the chapter-house (the Cappella Spagnuola) of the Dominican house of S. Maria Novella. We have already discussed the donor of the frescoes, the merchant Guidalotti, when dealing with the narrative sections of the cycle, and the decisive role of the Prior, Jacopo Passavanti, and of his book, which in part inspired the scheme of the paintings, has also been indicated. The allegorical scheme proper is contained in two vast frescoes which face one another on the two main walls. The one illustrates the Doctrines of the Church, in the form of the Triumph of the Dominican St. Thomas Aquinas (Pl. 83, 85), and the other its Government, mainly by stressing the activities of the Dominican Order in its anti-heretical, soul-curing and teaching spheres (Pl. 86, 87).[38] The other more narrative frescoes, such as the Passion scenes, etc. (Pl. 58, 59, 60, 61a, 62, 63) of which we have already spoken in detail, fall equally within the framework of the general programme,[39] and we shall later refer occasionally to the connection in content between some of them and the two main didactic scenes. The latter—though later in date than the Campanile reliefs—are incomparably more orthodox-ecclesiastical and more strictly homogeneous in their Dominican conservatism. And their composition is as archaic as their train of thought. The mendicant friars, the Dominicans, were anxious to retain the allegiance of the "little man" during this period of democratic agitation; they were making propaganda for their Order, attempting to win over the democratic, lower-middle-class movements (for of the upper-middle-class allegiance they had no doubts); they were trying to exploit that movement in an ideological sense by identifying their very conservative programme with that of the lower sections of society. The proof that they had made no miscalculation is to be found in the confidence and trustfulness with which the *ciompi* came to S. Maria Novella for good counsel shortly before the outbreak of their revolt.[40] They were at pains to prove that the salvation of the Church

was wholly dependent on the activities of their Order and on the acceptance of Thomist theology, and they emphasize how that Order preponderated over all others within the Church. It is also significant that, as we have seen, many of the ideas on which this programme is based had already appeared in a book written in Italian, and particularly so as coming from a cleric.[41] Moreover, it was a book full of allegories, a book summarising the ideas Passavanti had expressed in the many sermons he gave in Florence. The Dominicans reproduced this programme, which had been popularised from the pulpit, in their own headquarters, in the form of a monumental cycle of frescoes and in a didactic, allegorical language appealing as much to the mentality of those on a lower level as to their own; this work was certainly far more intelligible to the masses than the incomparably more complex religious symbolism of the French thirteenth-century programmes, and these frescoes, moreover, were couched in an archaic, popular style.

The first of the two major frescoes is a literal illustration of the system of Aquinas, based on his principal work, the *Summa Theologica* (Pl. 83).[42] On the lower part of the picture there are two long rows of figures illustrating, on the one side, the Seven Liberal Arts,[43] and on the other, in accordance with the *Speculum* of Vincent of Beauvais, the superior group of the Scientia Divinalis, or Theology (four subdivisions), Scientia Naturalis, or Medicine, and Scientia Moralis, or Jurisprudence (two subdivisions); below these allegorical female figures are seated their historical representatives. The gabled backs of the thrones occupied by the Liberal Arts contain medallions with the seven Planets[44] (quite small and far less prominent than on the Campanile), while the medallions on the other thrones show the Seven Gifts of the Holy Ghost. The space above this ecclesiastical encyclopaedia is occupied by the apotheosis of St. Thomas himself (Pl. 85). The great schoolman is enthroned in the centre; on either side are seated those figures of the Old and New Testament who had been granted a divine revelation and on whose books St. Thomas had written commentaries. The Saint holds open in his hand the *Summa contra Gentiles*, while the vanquished heretics Arius, Averroes and Sabellius sit at his feet. Above his head hover the Seven Virtues. And to emphasise that it is only with the help of the Holy Ghost that science can attain to true knowledge, the Descent of the Holy Spirit is shown on the ceiling immediately above this fresco.

From a formal point of view the fresco is simply a planimetric chart with successive straight rows of figures one above the other, St. Thomas on his throne forming their centre and apex. The group of the saint with the open *Summa* raised before him and the fallen and vanquished Averroes at his feet is almost literally copied from the equally two-dimensional Triumph of St. Thomas at Pisa (S. Caterina), executed a little earlier by a pupil of Traini, the other painter of the Dominicans (Pl. 84).[45] But it is also related to the Triumph of St. Thomas of the Biadaiolo Illuminator in his New York altarpiece (Pl. 41b). The

latter circumstance is another example of the phenomenon, which we have often stressed earlier, that the changed political conditions enabled the schematic, hieratic manner of the small-scale painters to turn into large-scale art.[46] But we also found antecedents of this style in major paintings created with a similar aim in a popular, monastic milieu: e.g. the fresco with the Triumph of St. Francis painted at least in principle in a similar style some forty years earlier for the Franciscans in the Lower Church of Assisi by a pupil of Giotto. Although in Andrea's work the figures are mere standard types and their movements schematic—a necessary result of so dogmatically orthodox a composition—his types and gestures are nevertheless often imposing in character. Within the schematic whole there is a great wealth of powerful and expressive heads, particularly in the series of figures from the Old and New Testaments on either side of St. Thomas. The figures representing the Liberal Arts, etc., are more monotonous than the corresponding ones on the Campanile, which is also due to their schematic arrangement in a long row. Greater variety is naturally found in the earthly representatives sitting at the feet of these idealised allegorical figures. Striking among the former is the smith Tubalcain, a figure almost unique in contemporary public art, who, as the representative of Music, belabours his anvil like a real plebeian artisan. On the Campanile Tubalcain as a smith also appears, but there he was far more dignified and calm and rendered with greater concentration in that upper-bourgeois cycle. The detailed realism of the corresponding figure in the Cappella Spagnuola is particularly meaningful: it was undoubtedly a concession, conscious or unconscious, in the manner of presentation similar to the allusions to the humdrum events of daily life which preachers were wont to make, in order to strike a sympathetic note in the hearts of the lesser burghers.

The opposite fresco, as we have seen, shows the life and rule of the Church, and above all the decisive share of the Dominican Order in her work, in leading mankind to salvation (Pl. 86).[47] The fresco is therefore intended partly as symbol, partly as narrative.[48] In the lower left-hand corner the whole organism of ecclesiastical life is shown:[49] Pope and Emperor, representing the spiritual and secular hierarchy respectively, each with his subordinates. No room is left for any doubt regarding the relationship of the two powers and the supremacy of the former, although the equilibrium and good relations between Emperor and Pope, which had been restored by the middle of the fourteenth century, are clearly indicated:[50] the Emperor does not occupy the place of honour on the Pope's right hand, but is seated on his left, and on a very slightly lower level. This section of the fresco should probably also be interpreted as an elect gathering, a tribunal, witnessing the activities of the Dominicans in the preservation of the pure Faith. The whole congregation, the clerics no less than the laymen (both are rendered in the guise of sheep) are watched by the Dominicans, who are depicted as black-and-white dogs in allusion to their name (*Domini canes*) and dress: it is the allegorical summary of this part of the theme. At the lower right-

hand side the principal Dominican saints are shown turning aside the evils which threaten the Church. St. Dominic preaches to the disobedient; St. Thomas Aquinas attempts to convince the heretics, among whom we once more encounter Averroes and other secular philosophers, of the truth of the Gospel. At the instigation of St. Peter Martyr the black-and-white dogs are tearing the heretics, who are represented as foxes, to pieces: a symbol of the Inquisition, of which the Dominicans were in charge. Thus the possibilities of the theme were fully utilised by the Dominicans: their role in the defence of the Church is held up as the only truly worthy one, with continually repeated references to the activity of their three principal saints. The part played by the Dominicans in the central part of the fresco is also very noticeable. The company on the right, dedicated to music and the dance (Pl. 87), may represent either the joys of Paradise or the pleasure-garden of this world.[51] A Dominican is seen giving absolution to a kneeling penitent, for penance alone can save us from the temptations of this earthly life. St. Dominic—who now appears for the second time, this time in the centre of the whole composition—is leading the rescued souls to Paradise. In the form of children they are received by St. Peter at the gates of heaven. Beyond the saints of the Church are waiting, St. Thomas Aquinas appearing here once more. Crowning the whole composition is Christ in Glory, similar in type to the medieval *Majestas Domini*. In front of him is an altar with the Agnus Dei—a reminiscence of the Heavenly Mass (*messa divina*)—between the symbols of the four Evangelists. Christ is surrounded by a choir of angels, led by the Virgin Mary. The painting on the ceiling corresponding to this fresco shows the ship of St. Peter—the connection of content is again patent—symbolising the power of the Church; this conception is continuously repeated in Passavanti's book, where it is often combined with the rescue of the Church through the Dominican Order.

It is interesting to note that, while the first main fresco illustrating the Doctrine of the Church, the Thomist philosophy, is concentrated in a severely hieratic composition, the second, illustrating the Rule of the Church, and glorifying the Dominican Order, stresses the details more strongly and is treated in the loosely rambling manner of an illustrated broadsheet easily "read off". It would be both an exaggeration and an over-simplification to call the former manner "ecclesiastical" and the latter "popular". The two types of composition arose from closely related mentalities:[52] we have repeatedly noticed how persistently the official Church attempted to adapt herself to the requirements of the lower classes, and how their cultural outlooks were, in fact, very close as a result of the Church's own conservatism. In the same way are the "ecclesiastical" and the "popular" types of composition closely related to one another, so closely, in fact, that there was always a latent possibility of the one merging into the other. We saw a similar phenomenon in the frescoes of Traini in the Campo Santo at Pisa, and also, to a certain extent, in the divergence

between Nardo and Orcagna in their decoration of the Strozzi chapel.[53] The nature of the subject alone in each case determined which of the two types of composition would be the more suitable.

In no other major work, not even in the Raineri frescoes by the same Andrea da Firenze in the Campo Santo at Pisa, already discussed, were the most fundamental naturalistic achievements of Giotto, such as spatial consistency and the realistic scale of the figures, so radically overruled as in this programme of theological propaganda illustrating the Rule of the Church.[54] Yet this very fresco, with its irregular and formally unconnected horizontal figure strips, heaped one above the other, with its elimination of perspective connections, and its human beings arranged in schematic full-face or profile views, contains—a characteristic of this kind of popular style—more naturalistic details than almost any other major work of Florentine fourteenth-century painting. There is, for instance, a very circumstantial representation of the Cathedral of Florence, or rather, of a design by Andrea da Firenze, himself a member of the commission for the building—still incomplete at the time—although in the fresco the edifice symbolises the Church in general. Or take the worldly-looking company sitting under trees in the foreground of a rich landscape, and backed by a hedge (we have already mentioned the various interpretations which this group allows of); among them are a woman musician and a huntsman and below them winds a long line of dancing maidens (Pl. 87). Such details are also evidence of the influence of the dancing-women in Ambrogio Lorenzetti's fresco of Good Government (Siena, Palazzo Pubblico) and the corresponding worldly company in the Pisan Triumph of Death. In the Florentine work these figures, representing nobles and elegant citizens, have become slightly less sumptuous and their formal treatment has become schematically Gothic, somewhat clumsy, even heraldic. Moreover the figures of the lower strip, the dancing maidens, are only half the size of those above—this may have been intentional, since they perhaps represent the souls of those free from sin—and in addition there is a youth, the musician for the dance, whose proportions are roughly intermediate between those of the two rows and who simply intrudes from his position in the lower into the upper row.[55] The untrained eye of the spectator—but a spectator, remember, steeped in the symbolism of church lore—could, in fact, wander among and enjoy all these details, each presented in a straight-on view, without intricacy of attitude, each from a distinct viewpoint and succeeding one another, in two-dimensional sequence, and absorb the spirit and lesson of the whole.

Particularly interesting are the illustrations of Charity and of Good Works, for we know what concrete and fundamental importance attached, for the whole life of the middle classes, to the conception of Charity, the compensator of all evil. Therefore few works are as informative about the mentality and the taste of the middle-class public, united in its confraternities, as the fresco with the figure of Misericordia (Pl. 88)[56] painted in 1352 for the Compagnia della

Misericordia, one of the most influential and wealthy confraternities of the town, in the Sala del Consiglio of their headquarters (subsequently known as the Bigallo) which had then just been completed.[57] The artist was probably a follower of Daddi. We see a gigantic figure with folded hands, immobile and rigidly erect, wholly covered by a long stiff cloak which looks as if it had been cut out of paper and falls about her feet. She is surrounded by large inscriptions proclaiming the importance of Charity and Good Works. The cloak is decorated with a wide border hanging down on either side and containing eleven medallions. The upper three contain nothing but inscriptions similar to those already mentioned, while the remaining eight illustrate the Good Works themselves, again with the addition of explanatory texts. These Good Works are represented in the popular symbolic manner by half-length figures. In the two lower corners on either side of Misericordia crowds of men and women representing the faithful kneel in a stereotyped posture and raise their eyes to her in prayer. At the very bottom is a view of the city of Florence with the Cathedral in the centre. The symbols of the Evangelists, the Cardinal Virtues, etc., in the ornamental strip surrounding the picture complete the allegory. This rigid, hieratic work with its intense, bright local colours clearly shows how conservative and how popular in its proclivity for allegory the taste of the wealthy middle class round about the middle of the century could be, when they were gathered together in their democratic organisations, the confraternities, and when the subject was one of such general importance and such close concern for their daily lives. We have here a form of expression as hieratic and schematic as that which was usual in other popular allegories, resembling Pacino's Tree of Life (Pl. 14) in the succession of scenes in medallions to be "read off", and Taddeo Gaddi's Tree (Pl. 18) in the lengthy explanatory text. A rigidity of composition similar to, but even more pronounced than, that of the popular Master of the Dominican Effigies (Pl. 34) is now to be found in a fresco. But the most striking feature is its stylistic similarity to the popular painting of the Madonna-like St. Catherine, in the depot of the Academy at Florence (Pl. 26b), already described as also the work of a follower of Daddi, which could hardly be outdone in hieratic stiffness. The translation of this style into the sphere of monumental art which we find in the Misericordia fresco was achieved on a far more orthodox and popular level and in a far harsher formal language than was the case, for instance, in Nardo di Cione's Paradise fresco in the Strozzi chapel (Pl. 36). The general change of style towards the hieratic and two-dimensional which took place as a result of the advance of the lower middle class about the middle of the century, with the concomitant preference for allegory, finds its perfect example in this fresco, in which the conservative taste of the confraternities plays its part in accentuating its characteristics.

A series of illuminations representing works of charity and executed in the second half of the century show a much more emancipated realism of detail.

They adorn a manuscript translated from French into Italian by the Florentine Ser Zucchero Benciveni, containing a discourse on the Lord's Prayer (Florence, Biblioteca Nazionale); the French version, like the Latin original (*De Vitiis et Virtutibus*) was made by a Florentine Dominican, Guglielmus, and the former was written in 1279 at the wish of King Philip III of France. Probably, then, in Florence, the impulse for its translation into the vulgar tongue and its embellishment with illuminations also came from Dominican circles—an assumption further supported by the pronouncedly didactic character of the text. The patron of this moralising, somewhat popular manuscript was probably an individual wealthy burgher in the "democratic" period. The principal illustrations represent virtues, vices, and the works of charity. There is scarcely another example in contemporary Florentine art of such surprisingly genre-like scenes. The subject-matter and the medium here employed, which was always more easily adaptable to innovations, did, of course, offer excellent opportunities for radically new pictorial representation of the themes, and for the rendering of otherwise unaccustomed naturalistic details. The half-length figures, suggestive rather than representative, of the medallions in the Misericordia fresco, have here been expanded into real independent genre-scenes. The Visitation of the Sick (Pl. 89a) shows a woman carrying food in a pot while a fowl hangs from her wrist; she is accompanied by her husband, a carelessly-held glove in his hand. The "fashionable" appearance of the figures is toned down by the harshness of the treatment, and the colouring is crude. The realism of detail is related to that of Biondo's similarly arranged pictures of the Sacraments, but carried to the far greater extreme permitted by their execution as illumination.

The comprehensive symbolical programme expressed in the earlier monumental art[58] now found a refuge in manuscripts and other works of a more popular type. Its rigid symbolism is here combined with long narrative sequences. Although it does not lose its power of unifying the whole and even retains a number of individual symbolical motives, it is the function of narrative which is now most strongly stressed. Here, then, in the only surviving Florentine *Speculum* manuscript, we find features reminiscent of the narrative religious painting of the day, but with an evident admixture of just that popular conservatism which would be typical of one who commissioned a book so medieval in spirit. There is a more than usually strong combination of two elements: the worldly-aristocratic and the religious-emotional.

The illuminations of this *Speculum* manuscript, now partly in the Paris Bibliothèque Nationale, partly in the Riches collection, Shenley (lent to the Fitzwilliam Museum, Cambridge), were painted at the very end of the century, about 1390–1400.[59] Iconographically this manuscript—one of the very few Italian *Speculum* manuscripts in existence—belongs to a western, apparently French group.[60] The patrons must have belonged to a very affluent circle of citizens, of about the same social standing as those who were so susceptible, at the

beginning of the century, to the art of Pacino; thus the archaic, popular themes of the *Speculum* on the one hand, and the illuminations, unusually rich for a *Speculum*,[61] and nearly picture-like on the other, give rise to a most peculiar, instructive and characteristically Florentine mixture.[62] This mixture is expressed in the close organic combination and interpenetration of two styles: the one extremely popular both in its subject-matter and the motives through which it is expressed, and the other already of a true courtly, aristocratic type, tending at times even to be gothicising.[63] Most striking is the preference for all that is distinguished, the pleasure as of a costumier which the artist takes in rendering the elegance of the cavalier (Goliath and others appear as knights), in sumptuous armour, gilded and elaborately fashioned crowns and fantastic plumes. Many of the scenes from the Old Testament look like illustrations of contemporary court life, the feast of Ahasuerus, for instance, with its jugglers (Pl. 91a). The wholly aristocratic character of the incipient Gothic linear swing makes the illuminations approximate to the style of Spinello Aretino. But the very theme of the *Speculum* made another stylistic element necessary in these miniatures, an element more popular, almost petty-bourgeois in character. It is significant that this latter element is particularly apparent in the more symbolical scenes and in the illustrations to the three independent, non-typological, chapters of mystical character (which this *Speculum*, like most others, has as an appendix): the Passion of Christ, the Seven Sorrows and the Seven Joys of the Virgin. In the Crucifixion scene the Virgin and St. John are seated on the ground, completely abandoned to their grief—the Virgin bending right forward actually convulsed with emotion; such representations do occur, though only in exceptional cases and less powerfully portrayed, in panel paintings of the fourteenth century. Other motives, which are predominantly symbolical in character, and previously never appear in panel paintings at all, found their way into Florentine art through these *Speculum* illustrations. We find the Virgin standing, after the Resurrection, at the open grave, tearing her hair and gazing at the instruments of torture and at the Cross, with the nails still in position and showing the impress of Christ's feet (Pl. 90b). Or she is shown with the stigmata, transfixed by nails and sword. Or again, she is triumphing over the Devil, using the instruments of the Passion as her weapons. Christ bearing his Cross is seen meeting a hermit, who asks how he can serve him best: the Saviour requests him to help carry the Cross (Pl. 90a). In such scenes the figures are far coarser[64] and more instinct with feeling in spite of their schematic treatment and frequent repetitions; their movements are dictated by their emotional excitement, rather than by the elegant Gothic swing which predominates in so many Old Testament stories. As to the conception of space, it must be remarked that the figures are piled one above the other; there are many attempts at perspective, but they are clumsy, and the landscapes are composed of schematic rocks or of those same stereotyped red flowers with green stems which provide a decorative foil for the

scenes. We must finally note, as particularly relevant to our present theme of symbolic art, that there are also a number of illustrations without any figures which are intended as symbols of the Virgin: for instance the Golden Candlestick, the Closed Door, the Tower of David and Solomon's Temple.

NOTES

[1] The teaching concerning these latter virtues was greatly influenced by Aristotle and Cicero.

[2] This also applies to the manner in which Giotto represented Old Testament scenes in the same Cappella dell'Arena. These scenes stand in typological relationship to those from the New Testament, in the manner of the *Biblia Pauperum* or the *Speculum*. Nevertheless it is an important innovation that Giotto separated the former from all the other narrative scenes, placing them in very small panels, defined by the ornamental ribs of the ceiling, and further that he selected only a few Old Testament scenes and did not follow the usual practice of juxtaposing two equally extensive cycles (as had been done earlier, for instance, in the mosaics of the Florentine Baptistry).

[3] In Orcagna's Tabernacle in Orsanmichele, for instance, we find the Virtues, not only the customary seven, but also their eight derivatives, represented in accordance with the particulars found in St. Thomas' *Summa Theologiae*. (See A. de Surigny, "Le Tabernacle de la Vierge dans l'Église d'Or-San-Michele à Florence", *Annales archéologiques*, XXVI, 1869.) We have already remarked on the orthodox ecclesiastical outlook both of Orcagna and of his patrons. His orthodoxy is also shown by his presentation of the theological Virtues in full-length, while the secular Virtues are given only in half-length.

To enumerate every example of monumental art in fourteenth-century Florence in which Virtues are illustrated side by side with religious stories is beyond our scope. In addition to the above-mentioned Tabernacle by Orcagna of this universally customary combination may be indicated Andrea Pisano's reliefs for the Baptistry doors (where the Virtues are shown in the lower zone), Taddeo Gaddi's frescoes in the Baroncelli chapel of S. Croce, and those by Nardo di Cione in the Strozzi chapel of S. Maria Novella (in both cases the Virtues are located on the ceiling).

In course of time these figures of the Virtues split off from their former setting in the Cycles of Salvation (Giotto's work, as we have just seen, being a transition to it). They become almost or wholly independent or enter into new combinations. They frequently appear on tombs and also—another sign of the gradual disappearance of any clear-cut division between religious and secular art—on secular buildings, in the reliefs of the Loggia dei Lanzi (1383–91) for instance, to emphasise that the Virtues must be the basis of Good Government.

[4] G. Frommhold, *Die Idee der Gerechtigkeit in der bildenden Kunst* (Greifswald, 1925). In one pan of the scales held by Justice is an angel, who appears to be crowning an industrious working woman with a wreath (it is difficult to identify the scene because of its bad state of preservation).

[5] For this observation I am indebted to Dr. R. Freyhan.

[6] According to a vision of Brother Leo and, later, on the authority of St. Bonaventura, St. Francis occupied the throne which Lucifer lost through his revolt. Moreover the saint is here shown, again in conformity with Bonaventura's view, as the Standard-bearer of Christ, flying above his head a red flag embellished with a cross and seven stars.

[7] In the vault of the Bardi chapel the three Franciscan vows are only shown in medallions as allegorical half-figures.

[8] The medallions on the ribs in the vaults with the allegories, and also some other ribs of the Lower Church, contain small scenes from the Apocalypse. This much reduced version is probably the last illustration within the sphere of Florentine art of a theme far too dangerous for the conditions of the fourteenth century.

[9] And also in a source from late antiquity, the *Nuptiae Philologiae* of Martianus Capella (fifth century).

[10] It occurs, e.g. in the *Commercium Paupertatis* (about 1247–57) of Giovanni di Parma, the last General of the Order who was a Spiritual.

[11] As to the question which reliefs were carried out from Giotto's designs, which were by Andrea himself and which by his assistants, see M. Weinberger, "Nino Pisano" (*Art Bull.*, XIX, 1937). The reliefs of the Sacraments have been attributed to Alberto Arnaldi by L. Becherucci, "I Rilievi dei Sacramenti nel Campanile del Duomo di Firenze" (*L'Arte*, XXX, 1927), those of the Virtues to the same artist by W. Valentiner (*Tino di Camaino*, Paris, 1935).

[12] E.g. that of the chief of these works, the *Speculum Maius* of the Dominican Vincent of Beauvais.

[13] For a detailed account see J. Schlosser, "Giustos Fresken in Padua" (*Jahrb. der Kunsthist. Sammlg. in Wien*, XVII, 1896).

[14] The first three formed the Trivium, the last four the Quadrivium.

[15] Most of the representatives of the Liberal Arts were added only between 1437 and 1439 by Luca della Robbia.

[16] The statues of the Prophets, Patriarchs and Sybils, which were later placed above these reliefs, continue the programme: for just as they prophesied the First Coming of Christ, mankind is now living in the epoch of Divine Grace and expecting the Second Coming of the Saviour. Probably the whole sculptural work of the Campanile was in the last resort a part of the general, though not very consistent, programme of the Cathedral façade. The Sybils—the figures from heathen antiquity corresponding to the Prophets of the Old Testament—were becoming increasingly popular as representatives of a deeply visionary prophecy, foretelling the Advent of Christ, but standing outside the Bible.

[17] In rapid succession they were illustrated both by Niccolo and Giovanni Pisano in their principal works: the pulpits of Pisa and Siena Cathedrals and the font at Perugia.

[18] The liberal arts were usually portrayed in accordance with the descriptions of Martianus Capella. For a detailed iconographical account see P. d'Ancona, "Le Rappresentazioni allegoriche delle Arti Liberali nel Medio Evo e nel Rinascimento" (*L'Arte*, V, 1902).

[19] It is this exploitation of every opportunity of representing scenes from practical life, combined with strict respect for the orthodox programme, which distinguishes the Campanile reliefs from the majority of works with a similar subject in other countries, even in Italy itself. Where in these other works the Mechanical Arts are included at all (e.g., in the Chartres sculptures), they are incomplete or merely subordinate. Or else, where they are numerous and detailed, they are not meant to represent the Mechanical Arts as such, but the different callings and guild occupations of the locality in question (e.g., the stained glass of Chartres or the reliefs of S. Marco in Venice).

[20] The classic representatives of the liberal arts mentioned in the ecclesiastical encyclopaedias were taken from Cassiodorus (sixth century).

[21] In the French cathedral cycles, on the other hand, only isolated representatives of the visual arts appear, and they only on rare occasions (Sens, Chartres). The role of the visual arts in the general system of ecclesiastical doctrine, and the social position of the artists themselves, are discussed in detail in the relevant chapter.

[22] In the *Convito* Dante also draws a parallel between the seven Planets and the seven Liberal Arts.

[23] The iconography of the Planets was re-shaped at the very modern court of Frederick II, and probably came to Florence by way of Naples. I owe this information to Dr. F. Saxl.

[24] Note in this connection that the beauty of the human form had already been mentioned in Brunetto Latini's *Tesoretto*.

[25] It is just in the later Campanile reliefs, especially those of the Sacraments by Arnaldi, that the first signs of the peep-show-like, over-plastic, yet at the same time planimetric style, typical of the reliefs of Orcagna's Orsanmichele Tabernacle, make their appearance.

[26] It is this idealisation of the process of labour, combined with the suppression of all realism in the details, which forms yet another essential difference between this cycle, so representative of upper-middle-class mentality, and all similar French or North Italian cycles. Nowhere had the upper middle class developed so far above the lower; nowhere was their specific mentality so clearly formulated as in Florence. In all other centres the middle classes as a whole were more petty bourgeois in their outlook, and for this reason real craftsman-types could appear in the art of those centres, and the process of work could be rendered in far greater realism of detail.

[27] Even an idealised weaving scene as an adjunct to the Annunciation was apparently considered in wide circles of the upper middle class as banal and degrading. For it was just in the bourgeois period that the motive of the weaving Virgin, which had its origin in the pseudo-Matthew gospel and had been taken up in the *Legenda Aurea*, also disappeared from the representations of the Annunciation. Only Giotto, the most self-confident bourgeois artist of the period, dared to illustrate, in the Scrovegni chapel, the occupation of weaving; not, however, in the Annunciation of the Virgin, but in that of St. Anne, and it is typical that even there he relegates this occupation to a genre figure, the maid.

[28] For instance, Ambrogio Lorenzetti's picture of the consecration of St. Nicholas as bishop, painted in Florence for the church of S. Procolo (about 1332, Uffizi); Martini's fresco in Assisi representing the Mass of St. Martin.

[29] In course of time the Cycles of Salvation began to disintegrate, and single motives which formerly had their *raison d'être* only within these cycles assumed a greater or less degree of independence. We have already noted this in the case of the Virtues. It applies also to the liberal arts, which appeared as independent frescoes as early as 1322 on the wall of the cathedral school within the episcopal palace at Florence (now lost).

[30] Take, for instance, the poem of Jacopone da Todi, who was a Spiritual, on the might of Death: "Non tardate, o peccatori."

[31] In the previously mentioned allegory of Chastity in the crossing of the Lower Church of Assisi a skeleton also occurs, again as an allusion to Death, but here the context differs, for together with the figures of Penitence and Faith, Death with his scythe drives away the impure desires, represented as the demon Amor and fiends.

[32] Which did not, however, exclude its simultaneous glorification: Simone Martini depicted both St. Louis of Toulouse and St. Louis of France in the same church.

[33] Allied to these Allegories of the Cross was a fresco in the courtyard of the monastery of S. Croce, where the Inquisition held its sittings, symbolising the activities of that body. It showed a yellow cross on a red ground, between two of the "heretic's mitres" which were placed on the heads of those condemned to death; beneath it an inscription proclaimed that here the purity of the Faith was watched over and punishment meted out to those who had strayed. (The fresco is no longer in existence.)

[34] There is a poem, attributed to Dante's son, which treats of Death, the Last Judgment and Hell in a manner similar to that of the fresco cycles in Pisa and S. Croce. The passage dealing with the power of Death in subjecting all ranks to his sway approaches the representations of the Dance of Death. It is quite possible that Petrarch's Triumph of Death—his *Trionfi* are a late work—was also in part inspired by the two frescoes above-mentioned.

[35] Which held its meetings in S. Spirito, the church of the Augustinian Hermits.

[36] It should be noted in this connection that Ambrogio Lorenzetti at one time worked in the chapter house of S. Spirito.

[37] There exists a Madonna with Saints in the Vatican Gallery by Giovanni del Biondo, another painter in the popular manner (through the Moon and Stars, the Virgin is at the same time identified with the Celestial Woman of the Apocalypse) in which an extremely naturalistic skeleton in a state of decomposition occupies the whole lower zone of the picture, like a predella panel (Pl. 81a). This appears to be an abbreviated version of the legend of the Three Quick and the Three Dead. It may have been painted under the immediate impression of a plague epidemic. (Above the Madonna there is the prophet Isaiah, her foreteller, whose tongue an angel is cleansing with a burning coal so that he may be able to announce the word of God.)

[38] This is the view of H. Hettner (*op. cit.*), who also regards the two frescoes as illustrations of the *Vita Contemplativa* and the *Vita Activa* of the Church. J. Schlosser (*op. cit.*) shares this view so far as the former fresco is concerned. F. X. Kraus (*op. cit.*) would confine the meaning of the frescoes to the glorification of St. Thomas and of the activities of the Dominican Order. But the symbolism of these frescoes was most probably intended to admit of several interpretations.

[39] See p. 227, note 154.

[40] See p. 89.

[41] Passavanti also wrote a Latin version of his book for the use of clerics.

[42] The vigour of Thomism in Florence is shown by the numerous illustrated copies of the saint's works, above all of the *Summa*, that have come down to us. On the other hand there is only a single illustrated manuscript of the nominalist Occam: his *Logic* (Laurenziana).

[43] The individual figures are identified by Hettner (*op. cit.*) and Schlosser (*op. cit.*).

[44] We have already noted the important role played by St. Thomas in the introduction of the Planets into the ecclesiastical scheme of the Universe.

[45] In this picture every figure, every gesture, each of the rays which connect the various figures and books, can be traced to passages in Thomas' *Summa contra Gentiles*. See Hettner, *op. cit.*, for further detail. We shall enumerate only those motives which are most characteristic of the Dominican mentality. The rays, signifying inspiration, ultimately emanate from the crowning feature of the composition, Christ floating in his mandorla. Certain rays lead straight down to the figure of St. Thomas immediately below, who is surrounded by a glory of his own and holds the *Summa contra Gentiles* and others of his works open in his hands. Other rays reach him indirectly by way of St. Paul (Epistles), Moses (Tables of the Law), and the four Evangelists (Gospels), who encircle St. Thomas. These, then, are the paths of Theology, of Divine Inspiration. Other rays lead to Thomas from the heathen philosophers Aristotle and Plato, who are standing on a much lower level and are not touched by any divine ray of light, and from their open books (*Ethics* and *Timaeus* respectively). These rays, which do not, like the others, lead to the crown of St. Thomas' head, but to a lower spot nearer his ear, are the paths of philosophical knowledge. Thus is the whole formation of the Thomist system illustrated. Averroes, the representative of extreme rationalism, against whose followers St. Thomas

had conducted a violent polemic, lies prostrate and crushed on the ground, shattered by the ray emanating from the *Summa* with his book face downwards. (In the fresco of the Campo Santo Averroes is banished to the lowest depth of hell, together with Mohammed and Antichrist.) Many rays symbolising instruction lead from the works of Thomas to the world below, represented by the numerous friars (especially Dominicans) and faithful laymen standing on either side of the lower zone. The composition was devised by the Dominican Fra Domenico da Peccioli, prior of the monastery of S. Caterina. The importance of the great heathen philosophers for the Thomist system was thus officially admitted even in a programmatic painting of this kind.

[46] Shortly after the date of this fresco, approximately in the 'seventies, another Florentine, Giusto da Menabuoi, painted in the church of the Augustinian Hermits at Padua frescoes (now lost) very similar in spirit. Their theme was also an allegorical illustration of the doctrine of the Church, but in this case it is the Triumph of St. Augustine surrounded by the most famous members of his Order. See Schlosser, *op. cit.* The theology of the Augustinians was closely related to that of the Dominicans (see p. 94, note 44).

[47] Hettner's view (*op. cit.*) that the fresco was based on St. Thomas' allegorical commentary on the Song of Songs appears to be erroneous. Brockhaus (*op. cit.*), who regards all the frescoes of the chapel as being at the same time allusions to the prayers for the dead, stresses the character of this fresco as also representing the Last Judgment and the entry of the blessed into Paradise.

[48] Kraus, *op. cit.*

[49] This section was probably inspired by Giotto's composition of the "Christian Faith" in the Palazzo di Parte Guelfa. See F. J. Mather, "La 'Fede Christiana' di Giotto" (*Rassegna d'Arte*, XIII, 1913).

[50] F. Ercole, *Dal Comune al Principato.*

[51] The former interpretation is that of Brockhaus (*op. cit.*) based on the text of the prayers for the dead. Hettner (*op. cit.*) regards the company as those who are free of sin, who have conquered worldly desire. The second interpretation mentioned in the text is that of Kraus (*op. cit.*) among others. Each of these three writers also applies his hypothesis concerning this Florentine company to the corresponding group in the Pisan Triumph of Death fresco. According to A. Chiappelli ("Arte Dominicana del Trecento", in the volume *Arte di Rinascimento*, Rome, 1925) it is in the Cappella Spagnuola, and here only, that the Dominican conception of the Vineyard of the Lord is represented, that is, the Garden of the Souls, with St. Dominic as its custodian. The purely exterior motive of music and dance naturally often occurs in Florentine literature too, but, just as in painting, its meaning and scope continually vary according to the whole outlook of the work in question (Dante: *Paradiso;* ascribed to Dino Compagni: *Proemio* to the "*Intelligenza*"; Boccaccio: *Amorosa Visione, Decameron*). For the motive provides numerous possibilities of transition between religious and secular art.

[52] See also p. 193.

[53] In the latter case, the different artistic dispositions of the two painters also play a certain part.

[54] In the same fresco, most of the saints in Paradise appear to have been painted, as Mr. P. Pouncey suggests, by Jacopo di Cione (working from the design of Andrea da Firenze). Thus the artist who brought the style of the Cione brothers' workshop into a popular line received some of his schooling in this Dominican monastic centre.

[55] The motive of the Entry of the Blessed through the Portal of Paradise possibly comes from a similar motive in a miniature, namely, from the Dante illustration of the Biadaiolo Illuminator (Parma, Biblioteca Palatiniense).

[56] The importance of Good Works for the middle classes brought about, in the later Middle Ages, the gradual transmutation of the virtue of Charity, which comprised both the love of God and the love of one's neighbour, into an increasingly independent Misericordia.

[57] Poggi, *La Compagnia del Bigallo*.

[58] In rare cases, indications of the typological connection between the Old and New Testaments still appeared even in the fresco painting of Florence. Thus Gerini included a small picture of Isaac's Sacrifice as the Old Testament parallel to the main theme in the ornamental strip surrounding his Crucifixion (S. Croce, Sacristy); it is significant that this archaic and popular manner should be found surviving in Franciscan surroundings.

[59] B. Berenson and R. James, *Speculum Humanae Salvationis* (Oxford, 1926).

[60] E. Breitenbach, *Speculum Humanae Salvationis* (Strasbourg, 1930).

[61] In the northern countries these manuscripts were almost invariably illustrated with pen drawings only.

[62] It is also quite conceivable that the miniaturist was not a Florentine by birth, or that the manuscript was not produced in Florence itself, but in one of the smaller towns under Florentine rule.

[63] Special research would be necessary in order to arrive at the exact iconographical and formal correspondences and differences between the miniatures of the Florentine manuscript and those others, French or German, which belong to the same group.

[64] There does in fact exist another version of these *Speculum* miniatures in the Bibliothèque de l'Arsénal at Paris, which is stamped by certain relatively minor stylistic variations, such as the schematisation of the figures, uniformity of types, facial ugliness and violent emotional gestures, as a truly lower-middle-class and monastic work. According to Berenson (*op. cit.*) this manuscript dating from about 1400 was probably produced in an Umbrian monastery.

C. SECULAR PAINTING

WITH regard to "purely" secular themes, some of these originated, as we have seen, within religious schemes, in particular as organic parts of the ecclesiastical cycles of salvation:[1] the labours of the various professions and orders of men above all are often represented in scenes from actual life.

Of the more independent secular themes, as a consequence of the emancipation of the State, the city-State itself, the commune, was represented, of course in allegorical form; for allegory played at least as important a part in secular as in religious painting. Giotto (or one of his pupils or followers) painted a fresco in the grand hall of the Palazzo del Podestà The Commune robbed by the Many (now lost). By this was meant the bad, ill-managed, anarchic form of government as conceived from the upper-middle-class point of view. The Commune was shown as a judge, holding a sceptre, seated on a throne. She is being attacked and despoiled, by implication on the part of the other social sections, but the four cardinal virtues protect her (the rule of the upper middle class is preserved by higher powers).[2] The conception was thus similar to that embodied in the illustrations of Justice and Injustice in Giotto's series of the virtues and vices at Padua. In both cases the close connection between secular and religious ideas, the transition from one to the other, and the use of the latter to justify the former, is particularly evident.[3] The same is true of the fresco which adorns the hall of Justice of the Arte della Lana; enough has been said of the uncompromising prejudice which was displayed by the courts of this guild, composed exclusively of employers. The fresco shows Brutus, the first Roman consul, as a symbol of the just judge, surrounded and protected by the allegorical figures of the four cardinal virtues, with the vices assailing them.[4] This boldly conceived fresco is still in existence, though in a ruinous state of preservation; its style is near to Maso's, and it probably dates from the second half of the 1330's.

An important part in secular painting where emphasis on the secular element is really very pronounced is played by the so-called pictures of infamy. Those who had attempted rebellion against the upper-middle-class Commune were branded in the public eye by being painted in effigy on the walls of places of common resort, such as the Palazzo della Signoria or the city gates. Political opponents were sometimes represented in complete battle-scenes (Victory of Campaldino against the Ghibellines, 1289). Those who had evaded capture were usually shown hanging from the gallows (association with the witchcraft of images) often surrounded by elaborate allegorical accessories. It is character-

istic of the middle-class capitalist tendency of these lampoons that they also included one of the Count of Porciano, a feudal lord from the Casentino in the neighbourhood of Florence, who had robbed a merchant travelling through his —that is, Florentine—territory (1291). Equally significant is the fact that Maso di Banco was commissioned by the Archbishop of Florence, Agnolo Acciaiuoli, to paint on the wall of the Palazzo del Podestà (1343) the expulsion of the Duke of Athens, the "tyrant", the enemy of the "liberty" of Florence. The Duke was portrayed in flight, accompanied by his best-known followers, allegorically represented as wild animals in allusion to their names or personal qualities. Maso's fresco has not been preserved; but there still exists a second version of this subject, equally full of allegorical allusions, by a minor and rather popular artist near to Maso and Nardo, in the city prison (Stinche Vecchie). [5] It is the only surviving example of defamatory painting, and even this is in bad condition (Pl. 92). On the right side of the fresco is the Duke, springing from his throne and turning to flee, pursued by an avenging angel. He holds a monster, half animal, half man— symbol of deceit—in his hand, and is treading on the attributes of Justice, the scales and the sword. At this period the participation of a saint was still as a rule considered necessary in pictures of contemporary secular themes; [6] and here the left side of the fresco is dominated by the more than life-size figure of St. Anne, protecting the Palazzo della Signoria and distributing banners to the knights kneeling before her representing the various quarters of the town. The mother of the Virgin herself—on whose name-day the counter-revolution against the Duke was successful—is thus introduced to help in expelling the man who had granted guild-rights to the dyers, and to give her blessing to the recovery of power by the upper bourgeoisie. [7] Next to the threat of political or social revolt, middle-class Florence knew no greater crime than economic dishonesty. Thus fraudulent business men and bankrupts were also branded in official pictures of infamy, painted with a rope round their necks, on the walls of the Palazzo del Podestà or of their guild or business premises. [8]

Perhaps the most important document of middle-class secular painting in Florence is the manuscript known as the Biadaiolo Fiorentino (Florence, Laurenziana) illustrating certain incidents from the recent history of the Florentine corn trade, from 1320 to 1335. The text of this work is the *Diario* of the wealthy corn-dealer Domenico Lenzi, already referred to—one of those tracts composed by merchants at the period when Florence was at the height of her economic power, and dealing with practical trade problems. Lenzi commissioned the illustrations about the year 1340. Characteristic of Lenzi's sober, business-like mentality, the text begins with a list of Florentine corn prices from 1320 to 1335; the story of events within the corn-trade itself is on the other hand interspersed with religious poems by the author. We have already met the artist, the Biadaiolo Illuminator, in connection with his religious paintings. In these miniatures he begins by illustrating the good years, when there was abund-

ance in Florence (he also adds an allegorical figure of Abundantia): the corn-merchant in his shop with his clients (Pl. 93b); harvesters in the fields (Pl. 94); the grain market at Orsanmichele. Then during the famine of 1328–30 the poor are expelled from Siena, Florence grants them hospitality, its citizens distribute food among them. Then Colle di Val d'Elsa fails to supply the corn promised to the Florentines; and in 1335 scarcity and famine assail Florence. We see the fields with their poor crops; and finally famine and wild excited scenes at the corn-market of Orsanmichele (Pl. 95). We have already seen that the Florentine countryside could not supply enough grain for the town, and famine was a constant menace. In other words, the artist was illustrating vital facts concerning the city's food supply. We are presented with incidents as described by a business man who took part in them, and consequently, in the accompanying miniatures, with intimate observations, drawn almost exclusively from daily life; motives which would be unthinkable in the monumental middle-class art of the time, which was entirely subject to religious ideas—unthinkable even in the reliefs of the Mechanical Arts on the Campanile. There are reaping, threshing and harvesting scenes; we see the grain being passed into bins in the market; and dealers and buyers are depicted in the most varied situations. Yet it is highly significant that all this is presented in a religious-apocalyptic framework; both text and miniatures have a didactic purpose. They depict a world governed by the rewards and punishments of God as found in the contemporary writings of Villani. Good and bad harvests are ordained in heaven: angels hover over both the harvest scenes, and from their trumpets emerge long explanatory scrolls, proclaiming the justice of God in reward and punishment. The famine scene at Orsanmichele with the apocalyptic Angel and the Devil above is represented as a kind of Last Judgment; the Devil is receiving a sword from heaven, the shattered trumpets of the angels are flying through the air.[9]

The style of these miniatures is the artistic expression not of the wealthiest and most cultured section of the middle class, but of the average, well-to-do citizen. While the former section shows, especially in Giotto's time, relatively secular tendencies in its religious art, even the secular art of the latter was as a rule largely determined by religious sentiment. On the one hand, religious art generally speaking formed the point of departure from which a more secular art was gradually developing, yet there were still certain definite limits to the development of the new naturalism, limits set by the outlook of the average citizen, with its severely orthodox attitude towards religion. This unshakably religious attitude is clearly traceable, even in these "secular" miniatures. Thus the Biadaiolo Illuminator, whose treatment of the Lehman altarpiece (Pl. 41b) was, as we have seen, so dogmatically Dominican in mentality and so heraldic in its formal idiom, still uses the long medieval *tituli* or scrolls, running right across the picture, even in miniatures such as these, which represent the extreme development of the secular and genre-like in Florentine fourteenth-century art.

At the same time, however, the dramatic movement and lively naturalism which we have already noticed in the Biadaiolo Illuminator's religious paintings are even more accentuated here, because of the far greater possibilities of the theme. Thus the wild scenes at the corn-market, with starving and desperate people penned in by armed guards, are far more realistic than the various representations of the Massacre of the Innocents, from which they evidently derive. The closeness to nature here aimed at, the dramatic spontaneity, the wealth of movement and incident, is simply astonishing. But all this was, for the time being, possible only in the "minor" art of miniature, and not as yet in pictures. The Biadaiolo miniatures mark an extraordinary accentuation in dramatic narrative tendency, which originated with the Master of St. Cecilia and even with the hieratic, popular work of Pacino, and was further developed under the influence of Daddi. Yet, if measured by the standards of the upper-middle-class art of Giotto and his generation, this style, with its elementary figure-conventions, its glaring misproportions and its decorative backgrounds, is somewhat archaic, in spite of all its attempted fidelity to nature.[10] The ability to represent nature was not and indeed could not as yet be adequate to cope with the new subject-matter. In certain instances this style might almost be regarded as religious expressionism.[11]

During the last phase of the democratic era in Florence, in 1386, when the moderately well-to-do and even the lower middle class still had a certain amount of influence, and it was therefore especially in the interest of the upper middle class to parade its charitable activities for the benefit of the poor, it was still possible for a charitable corporation of wealthy citizens, such as the Compagnia della Misericordia (in what is now known as the Bigallo) to commission a fresco with so homely a theme as that showing the Capitani of the Misericordia returning the foundlings they had reared to their mothers (Pl. 96).[12] It was originally on the facade of the building (to-day only a fragment survives, in the Sala del Consiglio) and was painted by Niccolo di Pietro Gerini and Ambrogio di Baldese (or rather composed by the former and executed by the latter artist). We have already discussed the "popular" nature of Gerini's style; and it is significant that this fresco was not the work of the more progressive artists working for the upper middle class. This is typical not only of the "democratic" period, but also—as we have repeatedly noted—of the artistic taste of the fraternities in general, in which a whole group of wealthy citizens collaborated in some more or less public activity. The style of the fresco is decidedly two-dimensional, with figures in simple bourgeois dress depicted in profile or *en face*, like those of Andrea da Firenze.

Much more frequent than the illustrations of prosaic everyday activities of city life, particularly those connected with money-making—which indeed were generally regarded as subjects unworthy of monumental painting—are the illustrations of activities and entertainments connected with the feudal, chival-

rous pursuits of the middle class, with hunting, tournaments, fights,[13] and also with fashionable love-games, music and dancing. At first, this type of subject appears mainly as a subsidiary or background theme, and it was even introduced occasionally, as we have seen, within the framework of the Cycles of Salvation; but such scenes soon became, either independently or as illustrations to some literary text, the favourite subjects of the frescoes with which rich Florentine citizens decorated their fortress-like houses towards the end of the fourteenth century, with the beginning of the aristocratic- upper-bourgeois reaction.[14]

The affluent class had a special preference for those secular subjects which had already been fashionable in the Middle Ages, and which typified the feudal culture of the past: epic cycles, the poetic stories of the feudal nobility and of the courts of chivalry, such as the legends of Arthur and the Round Table, or of Charlemagne and his Paladins.[15] In the house of the Teri, for instance, the story of Tristan and Isolde was illustrated (fragments now in the Museo di S. Marco), while the house of the Davizzi (later known as the Palazzo Davanzati) was decorated with scenes from the French romance of the *Chastelaine de Vergi* (painted probably in 1395 on the occasion of the marriage of Francesco Davizzi with Caterina degli Alberti).[16] In these frescoes (Pl. 97), painted as a frieze on all the four walls of the bedroom, the figures are half-length, and faintly gothic-ising, moving in aristocratic, precious poses before a decorative background of conventional trees; while the lunettes above and, in fact, the main spaces on the walls, are covered with armorial bearings. In the Palazzo Davanzati and also in other houses (fragments in the Museo di S. Marco) we find, moreover, painted friezes composed entirely of vegetable motives—trees, plants, flowers in vases. It is a sign of the new feeling for nature, but the arrangement is elegantly decorative, fan-like in composition, foreshadowing the later tapestries of verdures. These representations of plants are somewhat crude, but the frescoes with the story of the *Chastelaine de Vergi* show a fairly high level of craftsmanship.

Manuscripts of works by secular writers were sometimes illustrated with miniatures, though far less frequently than those of ecclesiastics. Among the illustrations of secular texts those of Dante's *Divina Commedia* form a special group. For one thing they are exceptionally numerous,[17] and moreover the *Divina Commedia* cannot really be classified as secular literature, and indeed was not so regarded. It was read as an encyclopaedia of general, i.e. ecclesiastical knowledge, even by the less well-to-do, more especially by the masses.[18] This conservative taste largely determined the choice and the whole style of the illustrations. These do not, as a rule, include scenes which afford free scope to the artist's imagination (the realistic scenes of hell belong, from the ecclesiastical point of view, to the negative world of perdition, of that which should not be) but are in most cases confined to three stereotyped motives, allegorical rather than dramatic in intention. These are (for the *Inferno*) Dante lost in the wood, meeting Virgil; (for the *Purgatorio*) Dante and Virgil in a boat sailing towards

the Mount of Purification; and (for the *Paradiso*) Dante listening to the voice of Beatrice as he follows her to heaven. God the Father, Christ, the Trinity, and the Virgin are also often introduced, so that the general impression conveyed is that of illustrations of a work by an ecclesiastical writer.[19] The miniatures have a stereotyped scheme, even in their colouring, and their level is usually—though not always—artisan-like. It is noteworthy that miniature illustrations to the *Divina Commedia* exist both by the Biadaiolo Illuminator, so closely associated with the Dominicans (Parma, Biblioteca Palatiniense), and by the popularly orthodox Master of the Dominican Effigies (1337, Milan, Trivulziana).[20] To the page which introduces the *Paradiso* in the work of the latter artist, the representation of the Coronation of the Virgin gives the characteristic note, and more especially the innumerable medallions of angels and cherubs in rows, closely interwoven with one another all round the page. At the bottom of the same page is a smaller scene, intended as a parallel, showing Dante's coronation by Beatrice. It is composed according to the standard formula of those frequent religious scenes in which a saint receives the crown of martyrdom from an angel descending from Heaven. In other words, the severely ecclesiastical conception of the miniature as a whole prevents the artist from finding a new form, even for a new subject.

There are, however, exceptions among the Dante miniatures: there are some which in fact accompany the whole text, and attempt to make it alive. This is the case, for example, with the Codice Poggiali (Florence, Biblioteca Nazionale), which was probably written in the 1330's and contains thirty-two illustrations to the *Inferno* (Pl. 89b). These miniatures are of a more secular nature, but for that very reason their artisan-like technique is more pronounced. For all their attempted liveliness the figures are wooden, stiff and clumsy in effect. A single scheme is again and again repeated: Dante and Virgil stand in the left corner, pointing with a stereotyped gesture to the group of tormented souls, whatever it may be, that occupy the right half of the page. Such miniatures had to be created entirely out of the artist's imagination: he could make no direct observations from nature, such as were possible, for example, in the reliefs of the Mechanical Arts or the Sacraments on the Campanile. Moreover, as we have emphasised, the patrons who commissioned manuscripts of the *Divina Commedia* certainly did not belong to the most progressive circles. The effect of these miniatures, therefore, is hardly more than that of the little scenes with ornament-like figures in thirteenth-century pictures of St. Francis; their style is in fact closely related to the conservative, popular manner of Pacino.

Towards the end of the fourteenth century the Dante illustrations, which greatly increased in number during the democratic age of the third quarter of the century, began to assume a more courtly character, though still on a relatively orthodox, popular basis. Thus in a Dante manuscript of 1398 in the Laurenziana we find in one continuous scene illustrations of consecutive inci-

dents—Dante lost in the wood, Dante meeting the wild animals, Dante assisted by Virgil—which resemble the frescoes with the story of the Chastelaine de Vergi: elegant and decorative verdure-like backgrounds, some attempt at a suggestion of space, courtly figures, gothicising realism of detail in the treatment of the animals.

The illustrations of most of the other allegorical didactic poems of the period are—for well-recognised reasons—hardly more secular in character than those of the *Divina Commedia*. To some extent this applies also to the encyclopaedic, didactic poem *Documenti d'Amore* by the Florentine poet Francesco da Barberino (1264–1348), which was written slightly earlier than the *Divina Commedia*, and a manuscript of which, now in the Barberini Gallery in Rome, contains illustrations—slightly coloured outline drawings—by the author himself. Originally a Ghibelline, Francesco was banished from Florence in 1304, but was permitted to return in 1316, and established himself as an influential notary—the notary and intimate friend of the chief of the Guelphs, the Bishop of Florence; for a time he was even an official of the Inquisition. The poem we are discussing was written by Francesco in his early Ghibelline period, during his exile in Provence (1309–12). It is a moral tract influenced by the Provençal courtly spirit and containing rules of conduct for people of rank in the most varied situations of life. Some of the courtly allegory, as also expressed in the miniatures, is probably more *recherché* than the half-ecclesiastical, half-secular allegory then customary in fashionable and cultured Florentine circles.[21] Certain of the Virtues, Death, the Wheel of Fortune, etc., were no doubt generally comprehensible. The basically ecclesiastical attitude of the author is particularly evident in his treatment of the Wheel of Fortune theme, where Fortune is shown as the servant of God, who is enthroned as Emperor: God holds a long scroll inscribed with his commands and Fortune with her wheel is carrying them out. Amor is not to be understood as sensual love, but rather as spiritual love of all that is good; even so he appears as a naked boy, with nothing but a garland round him. Several of the allegories, on the other hand, were probably invented by the author himself, at least in their details, and were intelligible only to his more sophisticated readers. This must certainly have been the case, for instance, with some of the allegories connected with the Court of Amor. His representation of Industria (Pl. 98a)—one of the Virtues listening to the teaching of Amor—may serve as an example of Francesco's courtly conception of allegory: she appears as a lady of fashion, embroidering an elegant tasselled purse, and resting her feet on a large cushion. The drawing—like all the others from the author's hand—is amateurish, with no more than a rough indication of form. They were all included as models for a professional painter who adopted them in another manuscript (also in the Barberini Gallery)[22] into elegant, coloured miniatures, somewhat gothicising in style (Pl. 98b). This artist seems to be Sienese (or Bolognese) rather than Florentine; his elegance far exceeds that of the Master of St. Cecilia,

as is particularly evident in this figure of Industria. The Florentine miniaturists —and this in itself is characteristic—were probably not aristocratic enough in style for Francesco's taste.[23]

Illustrated books on the secular sciences can hardly be expected at a period when these sciences hardly existed. A medical manuscript of the early fourteenth century, Joannes Mesue *De curis et de medicinis* (Laurenziana) contains small, calligraphic, roughly drawn figures, which indicate by their gestures some affliction of nose, mouth, or ear.

A copy of Giovanni Villani's Florentine chronicle (Rome, previously in the Chigiana, now in the Vatican Library) was illustrated, at the end of the fourteenth century, with coloured drawings. It is necessary to realise in this context that, at the time, numerous extracts were made from this chronicle, both in prose and verse. One, for example, was the work of a shoemaker; the minstrel of the town, Antonio Pucci, also popularised Villani's history as a kind of rhymed, popular chronicle in terza rima, glorifying the town. The illustrations in this chronicle probably represent the largest number of secular events portrayed in Florentine art of the fourteenth century. The scenes are vividly related from world history, chiefly, of course, from that of Florence, and include also battle scenes with many examples of contemporary costume and architecture. This art is even more popular than that of the Biadaiolo. A greater naivety predominates, with a clumsiness in the narration, the figures are more rigid, coarser and more linear, the ability to represent nature is appreciably less. In consequence of the increased number and novelty of the scenes, few of the earlier Florentine picture schemes could be used, and the artist probably made use of foreign, above all of French models.[24] Many of the scenes have a quite extraordinary resemblance to one another, especially in the case of battle scenes (Pl. 99b). But in several more unusual scenes, the dramatic *élan* breaks through, as, for instance, in the description of the Florentines conquering Fiesole, when the weeping women and children move away (Pl. 99a), or again when a mother is able to save her child, as by a miracle, from a lion's claws, or yet again when the death of King Philip of France at a boar hunt is presented.

The few other miniatures in secular works are as a rule confined to portraits of the authors, which however are so idealised that, as often as not, they might be interchanged, whether they are intended for Brunetto Latini or Dante, for Boccaccio or Salutati, for Terence or Cicero.[25]

This brings us finally to the representation of antiquity.

Particularly characteristic of the ecclesiastical attitude to, and interpretation of, the antique are the miniatures illustrating the *Ammaestramenti degli Antichi* by the Dominican friar Bartolommeo da San Concordio of Pisa (1262–1347), a well-known Thomist theologian, who was on several occasions a lecturer in Florence. The work was originally written in Latin, but was translated into Italian, as we already know, on the suggestion of a Florentine; it contains

maxims from classical philosophy which were considered useful and worth popularising from the standpoint of ecclesiastical ethics, and is thus a kind of popular manual of entertainment and edification.[26] It is most significant that the severely ecclesiastically-minded Master of the Dominican Effigies even illuminated two different manuscripts of the *Ammaestramenti* (both in Florence, Biblioteca Nazionale, one of them dated 1342), and that his miniatures never for one moment convey the impression that the book they illustrate is anything but a purely ecclesiastical work. Both manuscripts contain the motive of the Wheel of Fortune, which was taken over from Boethius, and was officially accepted by the Church; and also allegorical figures of the Virtues and Vices—exactly as they occur in religious art of the period. The miniatures are more or less schematic in style, like all the work of this artist, though they include certain naturalistic touches, as for instance in the figures of men turning on the wheel of fortune (Pl. 93a).

Antique motives in Florentine art of the fourteenth century, though far more frequent than in former times,[27] still occur for the most part as isolated instances, within a framework of allegory wholly or partly religious.[28] They rarely strike one as explicitly antique in character, their style is as yet little influenced by their "antique" content. But widely different shades of this influence already appear. Thus the ancient representatives of the Liberal Arts (Aristotle, Cicero, Euclid, etc.) in the strictly orthodox fresco of St. Thomas Aquinas in the Cappella Spagnuola (Pl. 83) have but little to do with the antique; and this is even more true of the illustrations to the story of King Codrus of Athens in the popular *Speculum* manuscript. It is not true, however, of some of Andrea Pisano's "classic" reliefs on the Campanile, which are more in the upper-middle-class taste; e.g. that of Hercules, who is embodied in the scheme as one of the representatives of the struggle against the difficulties of daily life, ridding the earth of its monsters: his figure was in fact probably adapted by Andrea from an antique model.[29] The representation of the planet Venus as a draped female figure in the same cycle certainly has nothing in common with the ancient Venus; but the pair of nude lovers she is holding in the palm of her hand probably show more evidence of antique inspiration than most works of this period in Florence (Pl. 77b).

Although at this time the growth of secularisation and national feeling among the new middle class, combined with the efforts of the most progressive literary men, was bringing about a revival of antiquity, there was as yet no general attempt to represent independently in a "secular" sense, individual figures of the antique world[30] which could at the same time be immediately recognised as such. There is usually little in the schematic, half-length figures of Cicero or Virgil in miniatures which served to illustrate their works, to indicate that they were Romans.[31] Just as little indication is there in the few independent illustrations of events from ancient mythology or history, represented as

they all are in a more or less non-classical way;[32] the scenes from Roman history in the popular Villani chronicle might be included here. Cassoni with paintings from mythology were already beginning to appear in the last quarter of the fourteenth century; although the few examples that have survived of these wedding chests, painted for wealthy families of rank—e.g. with the story of Diana and Actaeon—all date from the last few years of the 1300's. In conception and formal language they resemble the frescoes of the same period, illustrating the poems of chivalry, though they are perhaps a little more artisan-like in technique.[33] But we shall return to this subject in detail in our discussion of the following Albizzi period, in which these cassoni paintings with their very aristocratic renderings of antique themes become exceedingly frequent.

NOTES

[1] In Italy the encyclopaedic picture-cycle frequently served for the decoration even of secular buildings; although in such cases the original consistency of the scheme tended gradually to disappear.

[2] A sonnet written later on this fresco, by the official minstrel of the City, Antonio Pucci, also ends on an optimistic note, confident of the support of the Virtues. Some idea of Giotto's allegorical fresco may be gathered from a relief on the tomb of Guido Tarlatti, Bishop of Arezzo, which has the same theme (about 1330, by Agostino and Angelo Senesi, Arezzo Cathedral). See S. Morpurgo, *Un Affresco perduto di Giotto nel Palazzo del Podestà di Firenze* (Florence, 1897).

[3] The slightly later compositions of Ambrogio Lorenzetti, who had some humanistic education, in the Palazzo Pubblico of Siena (1337–39), also representing the Commune, are only in part allegorical; but the allegories that occur are very elaborately worked out. The frescoes glorify the political ideals of the ruling upper middle class: for peace and against the tyrants (see L. Douglas, *A History of Siena*, London, 1902, and O. Giglioli, "le Allegorie politiche negli Affreschi di Ambrogio Lorenzetti", *Emporium*, XIX, 1904). Good and Bad Government are represented allegorically with the help of numerous Christian Virtues and Vices (the influence of Giotto is evident in some of them)—thus motives of religious art are used for political purposes. Lorenzetti also represents, with genre-like treatment, the fruits of good administration and peace; he here shows, in the most literal fashion, the peaceful life of the citizens in town and country. There is also an obvious connection between this fresco and the narrative strip under Giotto's representation of Justice.

[4] S. Morpurgo, "Bruto, 'il buon Giudico,' nell' Udienza dell' Arte della Lana in Firenze" (*Miscellanea di Storia dell'Arte in onore di I. B. Supino*, Florence, 1930). There was a similar painting (now lost) by T. Gaddi in the Mercanzia, the commercial court made up of representatives of the five major trade guilds: it showed the tribunal of six judges watching Truth tearing out the tongue of Falsehood.

[5] To-day in the Accademia Filodrammatica. It is the same artist who painted the frescoes with stories of saints in the Covone chapel of the Badia (see p. 223, note 111).

[6] The chief extant works of art of this kind are the numerous miniatures for the panegyric poem which the humanist, Convenevole da Prato, Petrarch's master, was commissioned by the town of Prato to write for King Robert of Naples (about 1335, London, British Museum), placing itself under his protection. In this political address,

in which the king was invited to help fallen Rome and to persuade the Pope to return to Italy, Christ, Mary and allegorical figures of religious content were used as illustrations as well as allegorical female figures representing Italy (with torn garment), Rome (shedding tears), Florence, etc.

In this context, it is interesting to remember the frescoes with political allegories (no longer in existence) painted in 1347 by order of Rienzo in various prominent places in Rome (Capitol Palace, S. Giovanni in Laterano and other churches). All of them referred to Rienzo's liberation of Rome, and thus of the Christian Faith also, from the yoke of feudal lords. Rienzo had himself represented as an angel under the protection of SS. Peter and Paul. The city of Rome was in most cases shown as a despairing woman in a sinking ship (this political allegory of the ship was undoubtedly related to the allegory of the Navicella, in which a ship represents the Church). The feudal lords were symbolised by fire or water or as wild animals swimming in the waves and stirring up the storm. Contemporaries recognised them as allusions to various families of the Roman nobility. After Rienzo's downfall, the barons replied with similar satirical frescoes on the Capitol Palace.

[7] In gratitude for the expulsion of the Duke, an altar was erected in Orsanmichele in honour of St. Anne.

[8] Davidsohn, op. cit. These very usual themes must certainly have influenced the naturalistic treatment of certain religious narrative paintings. This was probably the case, for instance, with Nardo di Cione's hanging figure of Judas in the Badia.

[9] Under the Tabernacle of the Madonna at Orsanmichele is seated an official of the Confraternity, collecting alms.

[10] A similar yet even greater realism of detail is to be found somewhat later in the popular poems of the minstrel Antonio Pucci, who describes the market on the Mercato Vecchio.

[11] Purely secular, but on a much lower level of craftsmanship than the Biadaiolo miniatures, are those of a manuscript record of the yield of taxation in Florence (Florence, Riccardiana), written for a certain Antonio di Ventura. The miniatures illustrate the activities of the various guilds. They naturally begin with the Lana, the principal one, and depict for the most part merchants in their shops, but also occasionally craftsmen. They have the character of coloured pen-drawings, and are full of movement, but without correctness of form or individuality of type.

[12] It was the last payment which took place in 1386. It is therefore probable that the fresco was ordered before that date, while the democratic régime was still at its height.

[13] In a book of documents of the Mercanzia (the commercial court) of the year 1320, there is a pen drawing of knights fighting in a tournament, probably done by a clerk of the court, a notary (R. Davidsohn: "Eine Florentiner Karikatur aus dem 14. Jahrh." Repert. für Kunstwiss., XXII. 1899; see also C. Fabriczy, Repert. für Kunstwiss., XXIII, 1900). It is possible, though not certain, that the drawing was intended as a caricature; but in any case it would be wrong to conclude from it that tournaments were unpopular with the middle classes, or that there was any serious opposition to them.

[14] As early as the beginning of the fourteenth century, there must have been such frescoes—perhaps only of an ornamental character—in the houses of certain rich citizens; since in 1303 Fra Giordano da Rivalto especially attacks this form of luxury in his preaching.

The court of the castle of the Counts of Poppi, who were on friendly terms with the Florentine upper middle class, was decorated with the courtly allegorical theme of the Fountain of Youth as early as towards the middle of the fourteenth century. It is significant of the wide development of these secular courtly tastes in France—and the influence of France was now growing in Florence with its increasing aristocratisation—that even in the Palace of the Popes in Avignon hunting scenes were represented.

271

[15] In the didactic poem *Intelligenza* (attributed to Dino Compagni), dating from the beginning of the century, there is a description of frescoes in an imaginary palace with the story of Tristan, Isolde and Lancelot.

[16] The scenes are not, however, based on the French text, but on a Florentine version of this romance (possibly by the minstrel Pucci). See W. Bombe, "Die Novelle der Kastellanin von Vergi" (*Mitteilungen des Kunsthist. Institutes in Florenz*, II, 1912–17).

[17] Of about 170 Florentine fourteenth-century illuminated manuscripts described by d'Ancona (*op. cit.*) ten are secular works, forty have to do with Dante, and all the others are purely religious texts.

[18] Public lectures on Dante were as we have mentioned primarily concerned with the allegorical interpretation and elucidation of the text; for their general conservatism see also p. 109. This is a characteristic parallel to the general effort made at this time to popularise the allegorical themes of religious art among a wider public.

[19] The purely ornamental decorations, too, in the Dante manuscripts are similar to those in liturgical books. See d'Ancona, *op. cit.*

[20] Offner, *Corpus of Florentine Painting*.

[21] Though a certain section in this milieu may still have been noticeably aristocratic in culture at the turn of the century. The survival of aristocratic standards from the previous periods, and their revival at a slightly later date, are often hardly distinguishable in this fashionable circle. Francesco later conceived the complicated scheme for the tomb of his friend, Bishop Antonio degli Orso, who has been mentioned above (Cathedral, 1321). The meaning of the allegory on the lower reliefs of this tomb is no longer fully intelligible to-day, but it certainly expresses a political tendency favourable to the Guelphs: on one side of the Trinity appear the dignitaries of the Church (Pope, Bishop, etc.), to whom eternal life is granted, on the other an Emperor, surrounded by skeletons. It is interesting to note that the tomb was executed by the Sienese artist Tino di Camaino, who not long before had carved the tomb of the Emperor Henry VII in Pisa, and who, like Francesco himself, had changed his political allegiance from the Ghibellines to the Guelphs, as the stronger party.

[22] On the relationship between the two manuscripts and the themes of the miniatures see F. Egidi, "Le Miniature dei Codici Barberini dei Documenti d'Amore" (*L'Arte*, V, 1902).

[23] It is worth mentioning here the illustrations, dating from 1379, for Boccaccio's Latin *Eclogues* (Laurenziana). The scene of Boccaccio reading his poems to an attentive group of monks resembles that of some holy personage preaching a sermon—the popular orthodox milieu is characteristic of the poet's late phase, as also of this whole democratic period. Beneath this scene are two shepherds with their flocks, to whom a muse, with the appearance of an angel, is throwing Boccaccio's book. In this period of lower-middle-class rule the opportunity is seized of using the pastoral poems for a somewhat "democratic" gesture, even if they are, in Boccaccio, of a very allegorical nature. Although a possibility here offers itself of depicting shepherds and their flocks in a new, secular setting, independent of religious art, the scene is really very similar to the usual Annunciation to the Shepherds. These illustrations are crude, coloured pen-drawings with an attempt at vivid movement like that, a generation earlier, of the Biadaiolo Illuminator, but they are technically less skilled and more inflexible. Here too, as in the case of the Biadaiolo Master, scrolls are employed. (For the earlier, much more courtly illustrations of Virgil's pastoral poems by Simone Martini, see p. 273, note 31).

[24] L. Magnani, *La Cronaca figurata di Giovanni Villani* (Rome, 1936).

[25] An exception is the portrait of the much-read Boethius, who was usually shown behind bars in order to indicate that he wrote his book *De Consolatione Philosophiae* in prison.

FOURTEENTH CENTURY: SECULAR PAINTING

[26] It probably had some influence on the conception of the fresco with the Allegory of Death in the Campo Santo at Pisa. See Supino, *op. cit.*

[27] The *Divina Commedia* certainly helped to popularise many of the figures of antiquity. Later the same was true of Petrarch, and even more of Boccaccio.

[28] For further details see Gabelentz, *op. cit.* The fabulous monsters of antiquity sometimes occur even in religious paintings, e.g. the Centaurs, as symbols of evil, of the lower instincts (in representations of Hell (Pl. 39), or in the story of St. Anthony the Abbot).

[29] An instance which sheds light upon the ideological sources of the link-up with classical art and upon the prominence taken in this by the classicising, political ideology of Florence is the inclusion in the municipal seal of the new middle-class government, as early as 1277, of a Hercules with a lion's skin and a club—symbol of the strength and power of the Commune. Usually the medieval seals represented rulers, patron saints or coats-of-arms. See Davidsohn, *op. cit.*, and Paatz, *op. cit.*

[30] In his *De Genealogiis Deorum*, Boccaccio had already explicitly declared Charon and Pluto suitable subjects for a Christian artist.

[31] The Christian Emperor Constantine was apparently an exception. His image was faithfully copied from a Roman coin by Nardo di Cione, when he painted him among the Blessed in his fresco of the Last Judgment. His heathen opponent, Maxentius, who is, of course, placed among the Damned (Pl. 37), is represented in a much more generalised way (see Gronau, *op. cit.*).

Although outside the framework of Florentine art, it may be recorded here that Simone Martini (in his late phase at Avignon) illustrated Petrarch's Virgil manuscript with a miniature (Ambrosiana, Milan). This illustration—typical not only of Martini, but even more of Petrarch—is rather of an allegorical than of a narrative character. Virgil is seen writing in a forest where he is seeking inspiration; he is accompanied by his commentator Servius (his junior by 400 years), who is drawing away from him a symbolical curtain and by allegorical figures, representing his own three main works. That Petrarch considered Martini's courtly Gothic the suitable style for the illustration of Virgil is equally characteristic of his mentality. Virgil, Servius and Aeneas are given long, elegant proportions, curved Gothic attitudes, and extremely rich draperies; the peasants, on the other hand—one of whom (milking the cows) symbolises the *Georgics*, the other (felling a tree) the *Eclogues*—are less sinuous, shorter, and plumper.

[32] As to the iconographical sources and style of these representations of antique themes in Italian art of this period, see F. Saxl, "Rinascimento dell' Antichità" (*Repert. für Kuntwiss.*, XLIII, 1922), A. Panofski and F. Saxl, "Classical Mythology in Mediaeval Art" (*Metropolitan Museum Studies*, 1933) and J. Seznec, *La Survivance des Dieux antiques* (London, 1940).

[33] The fresco series of *Uomini Famosi*, most of which included famous Greek and Roman warriors, were probably connected with French romances of chivalry, and were particularly popular at the feudal courts of North Italy. Even Giotto had to paint a series of this kind for the King of Naples in Castelnuovo (Alexander, Solomon, Hector, Aeneas, Achilles, Paris, Hercules, Samson and Caesar, possibly together with their wives or mistresses) and Giottino did the same in 1369 for the feudal Orsini family in Rome (both series have been destroyed). It must have been towards the end of the fourteenth century, or perhaps early in the fifteenth, that frescoes with twenty-two figures of famous men were painted in a hall of the Palazzo della Signoria (now lost). They included Ninus of Assyria, Alexander, a number of famous Romans, significantly only patriotic statesmen and warriors from the time of the Republic (e.g., Brutus, Camillus, Scipio, Cicero, apart from the poet, Claudian, for he was believed to have been born in Florence), Dante, Petrarch Boccaccio, and others. Salutati composed inscriptions for all of them in Latin verse.

4. SOCIAL POSITION OF THE ARTISTS; CONTEMPORARY VIEWS ON ART

HOW did the social situation of the artists and their methods of production influence the development of the visual arts? Since the artists of the time were generally of inferior social position and to a large extent dependent upon their patrons, their own economic and social conditions affected the development of art less than did those of the patrons, whose outlook on life was the ultimate factor determining the emergence and interrelations of the various styles. We must first, therefore, deal with the contemporary views on art, which had a profound bearing on, and constantly interacted with, the artist's status and especially his social situation during this period.

In the pre-bourgeois era, the Church, as we have seen, was still in general very unsympathetic towards the things of this world, and placed little value on art considered as observation of nature or as representation of physical beauty. The Augustinian-Neoplatonist belief prevailed that art could never give anything more than a pale reflection of absolute beauty, the transcendental beauty of God. It was simply spiritual beauty—a didactic content—that the Church demanded of art. As art's only *raison d'être* was to give a reflection, even though a pale one, of a religious idea, it followed that art divorced from religion could have no meaning,[1] and moreover that a theory of art as such was out of the question; this was true of both pre-scholastic and scholastic philosophy. There could merely be theories of beauty, or more exactly, isolated statements about beauty, and all these of course had their place within a general theological framework and in close conjunction with theological concepts.*

The general development of scholastic theology and its changes in the early middle-class period—together, naturally, with the changes in art—made certain alterations in the formulation of the theory of beauty possible. Hence, in the Thomist system, emphasis on the spiritual virtues of the saints is accompanied by statements about their physical beauty, and even—and this of course was of cardinal importance for art—a general recognition of nature and of the material world: according to Aquinas, God rejoices in all things, for each of them is in real concordance with his own Being (*Summa contra Gentiles*). It is even possible to a certain extent to see in St. Thomas' writings a theory of contemporary religious

* I am dealing shortly here with the various medieval theories of Beauty, although they do not necessarily fall within the scope of this book, so as to give the widest possible framework to the contemporary views on art, and further because it is interesting to follow out in this field the consequence of those theological postulates we have already discussed.

art of the French high-Gothic, with its peculiar balance between idealistic and naturalistic elements.[2] It was only natural that as a result of the new position which St. Thomas took up on so many points, he should finally arrive at new conclusions on the subject of the beautiful. St. Thomas, deviating from Neoplatonism to follow Aristotle, draws a conceptual, methodological distinction between the good and the beautiful. Even though, according to him, the concrete content of both is identical, in theory he separates the two spheres, thereby in principle making an Aesthetic possible.[3]

The concept of the beautiful varies in the different intellectualist or voluntarist systems. In the theological system of St. Bonaventura—in which it is not the recognition but rather the love of God which is the dominating principle—emotionalism plays a greater part in relation to the concept of beauty than it does in the more intellectualist system of St. Thomas. While following St. Augustine, St. Bonaventura—for whom God is the highest beauty, all other beauty being merely the outflow or reflection of the divine beauty—also "modernises" St. Augustine in a Franciscan manner. Thus in connection with the aesthetic impression he particularly stresses the subjective and psychological factor, but in this particular case it does not in the least signify something progressive.[4] A close parallel to St. Bonaventura is his German-Polish contemporary Witelo, who resided at the Papal Court at Viterbo.[5] He likewise attempted a compromise between Aquinas and Neo-Platonism, and this is reflected in his views on the problem of beauty. Yet this is not the only reason why Witelo, and especially his *De Perspectiva* (c. 1270) figures prominently in the early quest for a theoretical basis for art during this period. Starting from St. Augustine and the Neoplatonist theory of emanation and light, Witelo arrived at a systematic and elaborate metaphysic of light, that element which transmits to subordinate physical objects the influence of the heavenly spheres. The age-long succession of interrelated theories of light, which acted as a theoretical accompaniment to the immaterial, gold-glittering art of the early Christian, Byzantine, and early medieval periods, reached its climax with St. Bonaventura—for whom light was the archetype of all things, and the basis of all beauty—and with Witelo himself. In Witelo—standing at the watershed between two epochs and working in progressive Italy, particularly at the modernising Papal Court—this flamboyant Neoplatonism was linked with most exact research in the natural sciences, especially in optics. It was Witelo—and this is his special significance for the later pioneering scientific theorists of art, e.g. Ghiberti—who preserved, besides certain Greek writers on the natural sciences, the optical studies of the Arabian Alhazen, and transcribed them in a generally intelligible form.

Despite these various isolated remarks on beauty, and the incipient study of optics, in the eyes of the Church art as such had no theoretical foundation. Thus in the encyclopaedias and in the *Summae*, painting and sculpture found no place among the seven *artes liberales*[6] which were regarded by the Church as the higher

spiritual disciplines, founded on knowledge and possessed of a theoretical basis.[7] As a rule they did not count even among the seven *artes mechanicae*[8] which were based on practice or skill. From the Church's standpoint they were simply regarded as artisanship, in accordance with their menial, inferior position.[9] Architecture alone was sometimes reckoned among the mechanical arts (e.g. by Honorius of Autun).

Ecclesiastical writers of this period never speak of "art", but simply of the adornment of churches with images and of the purposes of this adornment. The formula that these should serve for the instruction of the uneducated dates back to Gregory the Great[10] (*c.* 600) and originally implied their vindication in defence against the iconoclastic tendency. Nevertheless the frequent repetitions, enlargements, and variations of this original quotation are very striking from the thirteenth century onwards, that is, just when the attacks on works of art were becoming much weaker. Thus for St. Thomas, images serve *primo ad instructionem rudium, secundo ut incarnationis mysterium et sanctorum exempla magis in memoria nostra maneant.* Similarly with Bonaventura, *propter simplicium ruditatem, propter affectuum ruditatem, et propter memoriae labilitatem.* A summary formulation of the didactic purpose of church adornment is given by the southern French Bishop Durandus, who spent part of his life in Italy as a Papal Legate; in his *Rationale divinorum officiorum* (*c.* 1286–91) he deals with painting and church decoration—referring only to iconography—as if it were merely part of the Liturgy, and writes, *pictura et ornamenta in ecclesia sunt laicorum lectiones et scripturae.* All these repeated declarations as to the didactic purpose of art, and its universal intelligibility for the laity, are probably indications of the practical, popularising tendencies of the Church in the new middle-class period of the thirteenth century, especially in its second half; though the concept of art as such had not yet been recognised.

In Italy, the country where the middle class had gained most importance, and especially at Florence, the ideological position with regard to the current attitude towards art was different from that in the northern countries. Although in Florence too the standpoint of the Church was accepted as official on all cultural questions, nevertheless in those fields, and those alone, where such a concession could be made without serious damage to the Church, this ecclesiastical standpoint was adapted by the middle class to fit in with the forward-moving social life of the time. Here also, throughout the period we have so far covered, art was still looked upon in general as a form of manual dexterity. Yet together with the coming of a more private attitude towards religious art, with the relative secularisation of art, and above all with the increasing influence of the laity in artistic questions, can be seen the beginnings of a slight advance beyond this orthodox Church conception of its inferior position. Indeed Petrarch himself had intended to write a book on art based on the classical works on the subject; in this book, judging from his various remarks, he would naturally have allowed

it a far higher and more creative position than was usual in ecclesiastical literature.[11] It is also symptomatic that there existed in Italy a tradition of art-literature going right back to classical times, and never wholly interrupted.[12] Even though this literature consisted in the main of a series of purely technical treatises, yet by this method some parts of classical learning were preserved, and as the secularisation of art increased during the bourgeois period, it became possible to give these treatises a more theoretical basis which could contribute greatly to raising the status of art.

We have already seen how the demand that art should be more generally intelligible was met in practice in Italy. The Statutes of the Painters in Siena in 1355 start with the words, "By God's grace we are called to display to the uneducated who cannot read the wonderful things which have been achieved through and in the power of the holy Faith."[13] The self-consciousness of the artists is thus already deeply underlined; they emphasise the religious-didactic and especially the popularising mission of art, so frequently mentioned by the ecclesiastical writers, because by so doing they are able to increase their own importance. In the reliefs of the Campanile at Florence, that magnificent urban-bourgeois cycle, the three visual arts are represented as a sort of supplement to the mechanical, forming a transition between them and the liberal arts, that is to say, the sciences. On the other hand, in the Spanish Chapel Cycle, where the orthodox Church attitude is expressed, the mechanical and therefore also the visual arts are not even considered worthy of inclusion. Yet Cennino Cennini, a pupil of Agnolo Gaddi, who about the 1390's, in Padua, wrote a treatise on painting which consisted simply of handicraft formulas and recipes,[14] although his general outlook is still very closely linked up with that of the scholastic encyclopaedias,[15] expresses in his introduction the opinion that painting which is assisted by the imagination[16] should no longer be numbered among the mechanical arts, but should be placed immediately after the sciences. Cennini also advises the artist to copy from nature: "Mind you, the most perfect steersman that you can have and the best helm lie in the triumphal gateway of copying from nature."[17] The expression of this request, practically for the first time since antiquity, is of fundamental importance, although Cennini equally stresses imitation of the master's precepts. In conjunction with the emphasis on scientific knowledge as a necessary preliminary to the imitation of nature, this demand was soon to do much towards establishing the theoretical independence of art, and its emancipation from the subordinate position it held in the eyes of the Church. Thus in general we can observe during the fourteenth century, especially towards its close, a gradual promotion of the arts, and an attempt to increase their prestige, though they were still very far from being officially accepted among the *artes liberales*.

At all events, art was still in the fourteenth century regarded simply as one of the manual crafts. The profession of artist had not yet obtained any special

nimbus, and it was not regarded as in any way extraordinary among the poorer classes if, usually for some practical reason, a son should become a painter. In fact, almost all the fourteenth-century Florentine artists came from craftsman, petty bourgeois or peasant circles. Thus, from the start, the artists stood on an incomparably lower social level than their patrons. Neither well-to-do upper-middle-class citizens nor nobles would have become artists, since the profession would still have been rather degrading for them.

As with all other professions, the artists were naturally compelled to join a guild. Painters, sculptors and architects were all organised in separate guilds; in the Middle Ages, the artists were united in guilds with those professions with whom they had some sort of craft connection. The painters, who had originally formed an independent organisation resembling a guild, were joined at the beginning of the fourteenth century[18]—as were also the colour-merchants—to the greater guild of the doctors and apothecaries (*Medici e Speciali*).[19] Not only were doctors members of this guild, but also, among others, the dealers who supplied various wares not only to the doctors and painters, but also to other professions; for example drugs, chemicals (to the doctors), wax (for the churches), dyes, pigments (to the painters, and also to the wool and silk industry) groceries, herbs, spices, etc. Besides these, the guild also contained members of numerous crafts connected with these articles.[20] It was thanks to this association with the doctors and apothecaries, and especially with the merchants who imported the valuable oriental wares, that the painters found themselves organised in a greater guild.[21] The goldsmiths belonged to the silk guild, while the sculptors and architects were members of the lesser guild of the bricklayers and carpenters. But the painters did not benefit very much from their registration with one of the greater guilds, because—and this is of fundamental significance—they were not fully privileged, active members of the guild like the doctors, apothecaries and retail traders, but were classed merely as *sottoposti dell'Arte*. Within the *Medici e Speciali* there was a special organisation—the painters, to which the house-painters and the colour-grinders belonged as well, all being designated merely as *sottoposti*. As was also the case with the saddlers, this group, in contrast to the artisans, who had no rights at all in the guild, obtained in the first decades of the fourteenth century a certain very limited administrative and judicial autonomy.

Supported by the general democratic movement of these years, the painters, whose economic and social standing was steadily improving were able in 1339 or 1349[22] to achieve a further degree of emancipation. They joined themselves to the Compagnia (or Fraternità) di S. Luca, where they had their own leadership and could hold meetings independently of the main guild. Freedom of assembly was the most coveted and fiercely contested prize in the struggles of the various professional groups. But the Compagnia di S. Luca, like all other companies, was not an economic organisation. As to the professional duties of the painters, these were included in the Statutes of the *Medici e Speciali* guild

(1316, 1349). On the other hand the Compagnia was, significantly enough, an ethico-religious corporation of a comradely character. It was under the protection of St. Luke (the painter of the Virgin). Its meetings took place in a church, S. Maria Nuova; it celebrated the feast-days, especially that of its patron; it took part in processions; daily prayers were enjoined upon its members, they were compelled to confess and to communicate on joining, and at least once a year afterwards. The founders and most of the members were painters, though there were also a few wax-modellers, glass-workers, etc. and women too were admitted, in principle, presumably if they worked as painters. We can therefore define the Compagnia di S. Luca as simply one of the numerous religious fraternities of laymen, springing up especially after the plague year of 1348, which gave the middle and petty bourgeoisie an opportunity of "public" activities under the official control of the Church. The Church was very skilful—we saw this reflected in art itself—in keeping the democratic movements of these strata in her own hands, and even using them for her own ends. Nevertheless, the fact that this fraternity could be formed[23] shows that the painters had a certain democratic consciousness and as a group were inclined to be more independent than the sculptors or architects belonging to lesser, craft guilds. This is also evident from the demands advanced by the painters within the guild soon after the *ciompi* revolt: late in 1378 they attempted to enforce full equality of status for themselves with the three ruling groups (doctors, apothecaries, retail traders) and to have their name (*dipintori*) added to the title of the guild. In the actual year of the revolt the name of a painter figures for the first time among the list of the consuls of the guild. But this only occurs up to 1382, and furthermore the aforesaid decision was, in practice, successfully sabotaged by the guild authorities.[24] All the same, the struggle must have had a certain intensity, for the painter Starnina, who was implicated in the *ciompi* revolt, had to escape to Spain when the oligarchic reaction began about 1390.[25]

The painters, when executing frescoes, had to travel from place to place, and thus became better known; those painting panels, especially for use as domestic devotional pictures, came into even closer contact with their patrons.[26] Hence it was that the painters were economically the strongest, and socially the most mobile group among the artists, and were thus generally able to emancipate themselves earlier than the representatives of the other arts.[27] They stood out sooner[28] as individual personalities and figured—this was especially true of Giotto,[29] but also applies, for instance, to Buffalmacco, the well-known witty painter[30]—as the heroes of artists' tales and anecdotes (e.g. Boccaccio, Sacchetti). They gradually assumed a bourgeois class-consciousness;[31] this again applies to no one more than to Giotto, who was already spoken of with appreciation by Giovanni Villani—the first mention of an individual artist in any Florentine chronicle.

The Florentine architects and sculptors as a rule continued to work col-

lectively as members of a masons' lodge[32] up to about 1400. Thus in the municipal builders' corporation engaged on the Loggia dei Lanzi—the same which worked on the Cathedral—real collective work continued right down to the end of the fourteenth century; for example, on the reliefs of the Virtues of the Loggia three or four artists were engaged simultaneously or successively in many cases.[33]

The painters' guild, like all others, naturally had its craft rules.[34] The training of the painter followed the customary course of medieval craft customs. He was apprenticed to a recognised master of the guild, who had full disciplinary power over him.[35] The apprentice had to learn his *métier* from the bottom upwards. He had to begin with grinding the colours and with the preliminary treatment of the surface; he had to acquire all the necessary technical knowledge, learn all the tricks of the trade, and go through a period of many years as an apprentice and journeyman, before he was able to paint in the same way as his master.[36] This must be understood in a literal sense, for the copying of acknowledged masterpieces, especially those by the master himself, was a principal part of the last stage of an apprentice's training.[37] It is only in the light of this training that we can understand the tenacious preservation of the traditional heritage in fourteenth-century painting. The guild also prescribed which materials and colours could be used and which were prohibited (e.g. the use of German blue instead of real ultramarine was forbidden). But on the whole the discipline of the guild in Florence was far milder than that, for instance, in the economically and socially far more backward German towns, and this discipline was relaxed more and more as time went on. Thus, although the conditions of entry into the guild would make financial concessions to relatives of existing members wishing to enter the workshop, and would favour members of this particular guild as against members of other guilds, and also Florentines as against foreigners, yet they had no really rigid regulations or very definite prohibitions in this respect, as was so often the case in the Northern countries. Although in Florence too father and son, or several brothers, would often run a workshop together, yet the Florentine artist-workshops rarely became—as did those in the North—the privileged preserves of a few guild-protected families, into which it was necessary to marry in order to follow the profession. Side by side with the very substantial advantages of family connections with one of the existing workshops, it is certain that individual talent also counted for a great deal in Florence. In fact, numerous painters who had come from other towns were at work there in the fourteenth century.

The artists—including of course the painters—had to satisfy every possible requirement of their clients. For there was, as we have seen, no dividing line between the arts and the crafts in the fourteenth century.[38] Thus the painters did not merely paint frescoes and altarpieces, and complete the works left unfinished by their predecessors, but they also produced church banners, military banners, heraldic shields (even Giotto is alleged to have done this), made designs

for embroideries, painted curtains, applied emblems to horsecloths,[39] and sold painters' goods, inlays, etc.[40] The sculptors in their turn made wax effigies, belt-clasps, goldsmiths' settings, and similar objects. The goldsmiths' trade—which was especially flourishing in Florence—with its typical craft organisation, was a lucrative source for many painters and sculptors. The versatility of the artists, which continued beyond this period, arose originally as a result of the many-sided activity of the medieval workshop; it was a usual practice for a single man to be painter, sculptor, and even architect, and to be conversant with numerous technical processes.

The painter with his apprentices and journeymen formed the workshop organisation. According to the social status of the clientele, and the type of work commissioned in the workshops, either collective work or the individual achievements of the master predominated; collective work was much the more frequent,[41] and the more individual type of work was much less common, but up to a certain point it did not really stand in very sharp contrast to the former. It frequently happened that the collective work would be done by a number of painters forming an association, or, as also often happened, by an *ad hoc* grouping of two or three artists to execute a particular order. The more eminent the social position of the patron and the more the kind of work com-missioned necessitated personal contact between patron and artist, the more highly would the personal achievement of the artist be valued, and his own social standing and his professional consciousness increase.[42] In monastic workshops the individual personalities of the various miniaturists were still entirely sub-merged. On the other hand, it may occasionally have been stipulated in the case of frescoes, altarpieces, and domestic altarpiece commissions, that the principal parts of the work should be executed by the master himself. This seems some-times to have been the practice when it was a question of such famous artists as Giotto, who left to his pupils only the execution of subordinate tasks in his Paduan frescoes. Yet in his old age he worked almost entirely as an artistic entrepreneur,[43] and, in the Lower Church at Assisi he left everything to his pupils.[44] This was more or less the case also with Gerini and Agnolo Gaddi at the end of the century.

In all external matters the artists were very precisely bound by their con-tracts, the amount and terms of payment and the terms of delivery being, of course, most strictly defined.[45] In settling the price, the measurements of the picture and the size and number of the figures portrayed were generally the de-ciding factors, while the expenses to be borne by the artist himself also played a large part—a natural outcome of the whole artisan-like process of work. As a general rule the artist had to pay the wages of his journeymen, while arrange-ments varied with regard to the cost of materials, especially in the case of the most expensive pigments (e.g. ultramarine and gold), which were considered essential for the picture (also by Cennini). Usually, these contracts tended to

deprive the artists of all rights; they had to accept the conditions laid down by the patron, the latter alone being left with any rights or means of redress.[46] It was the same openly one-sided and dependent relationship as that of the ordinary worker, craftsman or any subordinate in every other branch of production.[47] The painters really derived no help in this matter from their rights of assembly in their semi-ecclesiastical Compagnia, which left out of consideration the economic aspects of their profession. Nor were the Consuls of the guild of the *Medici e Speciali* of much use, for owing to their inferior position painters could never obtain election to these offices, and moreover the arbitration courts could apparently do little for them owing to the severe nature of their contracts.[48]

Like those of all other professions, the painters naturally wished to make good money. Cennini—in a typical middle-class fashion—openly admits this.[49] Nevertheless very few of them could ever manage to acquire a house or landed property; the great majority lived with their families in a state of permanent financial stringency. The fees paid to the artists were in general low; often, especially in the case of monastic commissions, the payment was even made in kind. Moreover, the artists, with the exception of the most celebrated, remained unemployed for too long periods to make it possible for them to become in any degree affluent. Giotto—we mention him in particular simply because of his quite exceptional position—was one of the few able to do well for himself, as he worked with many assistants and was a unique celebrity. For example, in payment for the mosaic of the Navicella in the porch of St. Peter's, he received the enormous sum of 2,200 florins, for the altarpiece of St. Peter 800 florins, and for certain frescoes in the choir 500 florins; King Robert of Naples paid him an annuity of ten ounces of gold. Moreover, from 1334 onwards he earned extra fees as city architect, and as we have already seen, he was able to amass a good deal of wealth by lending out money and looms.[50] He also possessed considerable landed property. Thus Giotto actually lived like a wealthy citizen, and by no means as a simple craftsman.

All the major works of the artists would be executed in pursuance of a definite order, and all their principal pictures would be painted for a definite place, and with a carefully specified subject. Small unimportant domestic altarpieces, repetitions of well-known and favourite examples, were however increasingly produced by the Florentine workshops for stock in the fourteenth century, and in the same way small routine pictures were produced (for example in the workshop of Jacopo del Casentino) for mass export, for sale at foreign fairs (especially in Champagne), for Avignon, and for the remoter parts of Italy itself; later valuable cassoni were also occasionally produced for the same purpose.[51] But in general it is true to say that pictures of quality created by an artist merely following his own inclination and intended for future sale were never produced at all at this time.

The freedom of the artist which, of course, did not exist in the modern sense

was confined within the framework of his rigidly prescribed commission. In general it was the rule that the painter was regarded as a craftsman and therefore should have no more freedom with his work than the latter would. Whatever artistic liberty there was, was certainly most pronounced during the dominant phases of the progressive upper bourgeoisie, when certain of the artists were able to regard themselves too as members of the middle class. This was the case in Giotto's lifetime, after the final victory of the upper middle class. Giotto's artistic freedom, though perhaps not evident in his choice of subjects, is felt to some extent in their arrangement, and very forcibly in their treatment. In monastic commissions, on the other hand, the artists had very little liberty, and this was especially the case, for reasons already examined, with the Dominicans; thus Andrea da Firenze certainly had to adhere strictly to the complicated scheme worked out for his frescoes in the Spanish chapel. In general, the patrons stated in the contract their demands as to certain thematic motives and often issued fresh instructions to the artist when the work was already in progress. Nevertheless, in cases where they had to deal with less educated clients, such as priors of provincial monasteries, the artists tried to retain the widest freedom possible over details, and often played pranks on these patrons—as is related in many artists' anecdotes. It would probably only have been after the end of the fourteenth century, since the democratic movements, that the role of the artist in the elaboration of the subjects came to have wider latitude; it is noteworthy that the artists just then attained some equality of status in their guild. Differences of opinion between artist and patron as to the style of a painting were probably rare. The patron would almost invariably have selected artists whom he could expect to work to his satisfaction.[52]

NOTES

[1] J. Schlosser, *Die Kunstliteratur* (Vienna, 1914). He also shows how this attitude arises from, and in a sense sums up, the various tendencies in the ancient world; Neoplatonism and late Stoicism are especially important in this connection.

[2] See Dvořák, *op. cit.*, where he treats in detail the question of the relationship of St. Thomas' three attributes of beauty—*claritas*, *integritas* and *consonantia*—to the characteristics of northern Gothic art. Nevertheless these three concepts, which derive from various philosophical tendencies in antiquity, already appear in pre-Thomist theological literature. R. Boving (*Bonaventura und die französische Hochgotik*, Werl, 1930) tries to establish the influence of ideas from Bonaventura's sermons on the architecture and sculpture of the French high Gothic.

[3] God alone can create ideas, therefore, according to Aquinas, the inner conception of form which determines the artist's work can be only a quasi-idea. See E. Panofsky, *Idea* (Berlin, 1924).

[4] How far St. Bonaventura goes beyond St. Thomas in his emphasis on the subjective and psychological factors in the theory of beauty, and therefore how far St. Thomas himself had emphasised these factors, has been the subject of continual scientific controversy. See especially M. de Wulf, *Études historiques sur l'esthétique de St. Thomas d'Aquin* (Louvain,

1896); E. Lutz, "Die Aesthetik Bonaventuras" (*Studien zur Geschichte der Philosophie des Mittelalters*, Münster, 1913); E. Rosenthal, *Giotto in der mittelalterlichen Geistesentwicklung* (Augsburg, 1924), and the review of this book by E. Panofsky (*Jahrb. für Kunstwiss.* 1924-5); A. Dyroff, "Über die Entwicklung und der Wert der Aesthetik des Thomas v. Aquino" (*Festgabe für L. Stein*, Berlin, 1929).

[5] C. Bäumker, *Witelo* (Münster, 1908), and E. Tea, "Witelo, Prospettico del secolo XIII" (*L'Arte* XXX, 1927).

[6] See the list on p. 241.

[7] In antique literature, at least in principle, speculative theoretical thought and knowledge, the characteristic pre-requisite of the free arts, were alone considered as worthy of free men. The division into "free" and "unfree" arts, one of the several divisions of the ancients, was systematically evolved, in the main, by Varro (first century B.C.) and Galen (second century A.D.). From these Martianus Capella and Cassiodorus took it over, and from them again it passed into the encyclopaedias.

[8] See the list on p. 241.

[9] In classical Greek and partially even in Roman philosophical writings, artists were similarly regarded as artisans who performed manual labour for a livelihood and augmented specialised knowledge but were unable to achieve any free creative activity. Only slowly and hesitatingly did Roman philosophy (in particular that part of it written in Greek) accommodate itself to the prevailing circumstances, namely, the value accorded to art and artists by the lay public (increasing after the fourth century B.C.). By Varro and Pliny, the visual arts were admitted into the scheme of education, Seneca was against them, Dio Chrysostom (*c.* A.D. 100) showed a real enthusiasm for art, Galen held rather to a compromise view. On the individual phases of this literary movement see A. Dresdner, *Die Entstehung der Kunstkritik* (Munich, 1914).

[10] It had already been expressed in pagan antiquity by Dio Chrysostom.

[11] L. Venturi, "La critica d'Arte e Francesco Petrarca" (*L'Arte*, XXV, 1922).

[12] A. Pellizzari, *I Trattati attorno le Arti figurative in Italia* (Naples, 1915).

[13] Gaye, *op. cit.*

[14] Yet it is a sign of a new mentality that Cennini no longer merely strings these recipes together, as the authors of the medieval treatises did, but places them systematically within the framework of the progressive education of the artist.

[15] For example, Cennini excludes woman from the theory of proportion, apparently because she introduced original sin into the world; he is completely ignorant of anatomy and, following the Bible, believes that man has one rib less than woman.

[16] This is an idea derived from antique literature. Cennini even speaks also of the enthusiasm and exaltation of the artist.

[17] Cennini advises the artist to keep huge unhewn blocks of stone in his studio, and to make drawings of them. Thus he retains the well-known medieval formulas for landscape with the schematically-drawn cliffs, having the appearance of steps; all the same, his advice that artists should draw from natural objects is in itself something new. Elsewhere in his writings we also find isolated suggestions implying a new view of art, and he was acquainted, even if only indirectly, with Vitruvius. Despite all his archaic notions, Cennini's treatise stands on the threshold of a new outlook (see Dresdner, *op. cit.*, and Schlosser, *op. cit.*).

[18] R. Ciasca (*L'Arte dei Medici e Speciali*, Florence, 1927) claims that this fusion took place after 1295. According to R. Graves Mather ("Nuove Informazioni relative alle Matricole di Giotto, etc., nell'Arte dei Medici e Speciali", *L'Arte*, XXXIX, 1936) the first artists—including Giotto, T. Gaddi, and Daddi—were not accepted into the guild until 1327. Giotto's entry was previously thought to have taken place about 1312.

[19] This guild was established some time after the middle of the thirteenth century, as one of the last of the greater guilds.

[20] See Ciasca (*op. cit.*) for a description of the enormous variety of professions within the guild, though they all had some common economic bond. In Bologna the painters were organised in a guild together with the paper-makers. In Perugia they formed a guild of their own, but a lesser one.

[21] The doctors' and apothecaries' guild was given supervision over the church of S. Barnabà, and consequently the painters were given the task of decorating it; this church was erected in honour of the apostle Barnabas because it was on his feast-day in 1289 that the Florentine Guelphs had won a victory over the Ghibellines of Arezzo.

[22] It is not certain which is the correct date. L. Manzoni (*Statuti e Matricoli delle Arti dei Pittori delle città di Firenze, Perugia, Siena*. Rome, 1903) believes the earlier date to be the more likely, Ciasca (*op. cit.*) the later one.

[23] Similar corporations of painters were also established in Rome and Siena.

[24] C. Fiorilli, "I dipintori a Firenze nell'Arte dei medici, speciali e merciai" (*Archivio Storico Italiano*, LXXVIII, 1920).

[25] In 1393, after the *coup d'état* carried out by the oligarchic upper middle class against the lesser guilds, the goldsmith Giovanni di Piero was beheaded for having participated in a revolt on the side of the latter and having shouted "Viva il popolo e gli Arti".

[26] How far panel-painting contributed to the social rise of the painter is shown by a passage of Cennini, where he says "And let me tell you that doing a panel is really a gentleman's (*gientile huomo*) job, for you may do anything you want to with velvet on your back".

[27] But much later than the poets and writers, who came from a higher social stratum. It was actually Dante in the *Divina Commedia* who—apart from official documents—was the first to mention painters: Cimabue and Giotto. It is true that artists such as Arnolfo and Giotto received honourable mention in municipal documents, but mainly because of their position as city architects and because, in this capacity, they had helped to beautify Florence. Nevertheless even this honour was possible only at the climax of upper-middle-class self-assurance.

[28] This earlier emancipation of the painters was observed equally in every country, but owing to the earlier development of the Italian towns it took place sooner in Italy than elsewhere.

[29] Giotto's sharp mother-wit, however, contributed a good deal towards his popularity.

[30] It has not yet been possible to establish his artistic identity. Perhaps he is none other than the Master of St. Cecilia.

[31] In one of Sacchetti's tales Giotto amuses himself at the expense of a craftsman who came into his workshop to order a coat-of-arms to be painted on his shield, "as if he were a Bardi". Thus a few artists and writers who already felt themselves to be part of the upper middle class claimed the right to jeer at those craftsmen who evinced a similar desire to rise in the social scale.

[32] In many towns these bodies formed the organisations of the artists before they joined the guilds. In the fourteenth century, these corporations in general still paid no regard to special individual talent among the sculptors; they all had to execute the same impersonal, routine stone-masons' work. See G. Swarzenski's review of A. Venturi's Trecento Sculpture (*Kunstgesch. Anzeigen*, 1906) and K. Rathe, *Der figurale Schmuck der alten Domfassade von Florenz* (Vienna, 1910). Thus there was far less opportunity here for the formation of individual personalities among the sculptors, than was the case

in the painters' workshops. On the other hand, the individuality of the principal archi-
tects already made itself felt much more in the secular corporations of builders in Florence
than in the monastic ones of the north. See Paatz, *op. cit.*

[33] There is documentary evidence of the collaboration of two painters (Agnolo
Gaddi designed it, Lorenzo di Bicci painted it over) and of three sculptors in the work
of the *Caritas* relief.

[34] But apparently numerous conditions were settled in the individual contracts them-
selves as a result of free agreement between master and apprentice.

[35] A number of contracts for the employment of painter apprentices are published
in Davidsohn, *op. cit.*, and V. Ottokar, "Pittori e contratti d'apprendimento presso pittori
a Firenze alla fine del dugento" (*Rivista d'Arte*, XIX, 1937). There was generally an
apprenticeship of four years during which the master usually had no financial obligations.

[36] An indication of the very close relationship that often existed between master and
pupil is seen in the case of Taddeo Gaddi, who was Giotto's godson, and apparently
was engaged in his workshop for twenty-four years.

[37] On the whole question of the training of painters see Cennini's treatise. He speci-
ally emphasises the close dependence of the pupil on the master. Cennini had in mind
the organisation of Agnolo Gaddi's shop, where he worked for thirteen years.

[38] The frame was regarded as just as valuable as the painting itself. For example,
Don Michele da Pisa, Abbot of the Olivetan monastery of S. Maria Nuova near Rome,
paid 50 florins in 1385 for the frame of an altarpiece, 100 florins for the gilding, and 100
florins for the execution—only this latter sum going to the painter of the panel, Spinello
Aretino. When an altarpiece was to be put up in the church of S. Felicità, the frame was
first commissioned in 1395 from the wood-carvers for 80 florins, and the painting itself—
which of course had to be made to fit the frame—was ordered only four years later from
Spinello Aretino, Niccolo di Pietro Gerini, and Lorenzo di Niccolo for 100 florins.

[39] In the 1350s, the statutes of the guild indicate the beginnings of a certain differ-
entiation between the painters proper and those who concentrate on purely decorative
work.

[40] Our information about these various occupations of the painter comes principally
from Cennini, who, among others, also undertook women's make-up.

[41] This was so often the case that it is impossible to base a history of fourteenth-
century Florentine painting on individual artists' personalities, as is still usually done in
the literature of art-history. But naturally the various workshops had each its own parti-
cular, if not always entirely unified, artistic character from which we can draw certain
conclusions as to the master himself.

[42] Tradition has it—it is mentioned by Ghiberti—that in the huge Tabernacle of the
Virgin in Orsanmichele, the figure of one of the apostles in the relief of the Death of the
Virgin is a self-portrait of Orcagna. In fact this particular head is given an individual
twist unlike the typical expressions of the others. This is probably the earliest artist's self-
portrait in Florentine art, and was a sign of the increasing professional consciousness of
the artists.

[43] Davidsohn, *op. cit.*

[44] Weigelt, *op. cit.*

[45] Nevertheless there was often a great deal of friction over the payments (cf. Piattoli,
op. cit.).

[46] In 1341 Ridolfo de' Bardi obtained a distraint on the painter Maso, as a result of
demands which probably arose out of the painting of the frescoes of the legend of St.
Sylvester in S. Croce. Not only were all the paintings in Maso's workshop confiscated,
but even his colours and his painting-instruments were removed. (G. Poggi, "Nuovi

documenti su Maso di Bianco", *Rivista d'Arte*, VII, 1910). In 1361 the Seta, with the permission of the city, authorised the sale of all the belongings, both movable and fixed, of Bencio di Cione, the head of the masons' lodge of Orsanmichele, because they thought that he was too careless. The money obtained from the sale was used towards the building of Orsanmichele. (See La Sorsa, *La Compagnia d'Orsanmichele*, Trani, 1902.)

[47] A. Doren, "Das Aktenbuch fur Ghiberti's Matthäus-Statue an Or S. Michele zu Florenz" (*Italienische Forschungen*, published by the *Deutsches Kunsthist. Institut in Florenz*, 1906).

[48] Piattoli (*op. cit.*) gives a few examples.

[49] Very characteristically he combines this solid middle-class attitude with a homily on the subject of fame; steady work brings fame, fame brings higher payment.

[50] Agnolo Gaddi, who like Giotto conducted a big workshop, also occupied himself, according to Vasari with, mercantile activities, and is alleged to have left 50,000 florins.

[51] Documentary evidence of the export of pictures from Florence is given in the business files of the merchant Datini (1335–1410), which have been published. See also Piattoli, *op. cit.*

[52] This is shown by an entry in the records of the authorities of S. Giovanni Fuorcivitas in Pistoia (*c.* 1347–50) regarding their search for a suitable painter to execute the high altarpiece of their church. The first name on the list—typical of a provincial town— was that of Taddeo Gaddi who had already received wide recognition, and really belonged to an older generation. The second choice fell on the two brothers Andrea Orcagna and Nardo di Cione, who were just beginning to make their name at this time. It was Gaddi who actually obtained the commission. (C. Fabriczy, "Ein interessantes Dokument zur Künstlergeschichte des Trecento", *Repert. für Kunstwiss.*, XXIII, 1900).

III

THE ART OF THE EARLY FIFTEENTH CENTURY

1. THE OUTLOOK ON WHICH IT IS BASED

IN the first decades of the fifteenth century the oligarchy of the upper middle class, composed of a few wealthy families from the greater guilds, was at the zenith of its power. In this period of formal democracy, actual power was concentrated in these few families, particularly the Albizzi, the Uzzano and the Strozzi. By the year 1434 their rule had been broken by the wealthy Cosimo de' Medici, who at first made use of the support of the popolani and the lesser guilds. At the beginning of the fifteenth century, as we have seen, the upper bourgeoisie were already in a state of disintegration owing to the intense economic competition from abroad, even if to all appearances they were stronger than ever, with nothing to fear from the classes below. These few decades, during which the political power of Florence reached its highest point despite incipient economic decline, also saw the ideology and art of the upper middle class at their peak.

The rationalist element in the general outlook of the upper bourgeoisie, of which we spoke at length when dealing with the fourteenth century, was now most pronounced. The mentality of this class, particularly in its topmost ranks, was marked by an almost puritanical sobriety, accompanied in the political field by a "democratic" republicanism, and by great stress upon action. Hand in hand with this general attitude went an intense interest in antiquity—a clear sign of the awakening national feeling of the new bourgeoisie. In the first decades of the fifteenth century this interest was much keener than during the fourteenth, and the approach more understanding and scientific particularly as regards the rationalist elements of antique culture, produced in the heyday of the Greek and still more of the Roman middle class (that is, the time of the late Republic and of Augustus, and partly also the time of the enlightened absolutism of the first two centuries A.D.) In all ideological fields, particularly in the sciences, antiquity provided support for and accelerated their independent, organic development. We have already seen in sufficient detail that for the upper middle class there was no contradiction between the cult of the antique, a scientific spirit, on the one hand and religious sentiment on the other. Even the most far-reaching knowledge of empirical facts then possible was still quite compatible with religious feeling. But among the intellectual élite of the upper bourgeoisie, religious sentiment was now more dispassionate in tone than ever

before. And these intellectuals, even if no others, carried their rationalism and their search for new legitimacies to the length of rejecting scholasticism and its casuistic "realism of detail", although in practice they were far from being hostile to the Church. The city chancellor Bruni is the typical representative of this endeavour to gain a systematic understanding of the world, with the help of classical knowledge. Nothing indicates more clearly the spiritual attitude of the moderns than the words Bruni places in the mouth of Niccoli in his *Dialogi ad Petrum Paulum Histrum:* "All things are wonderfully linked with one another, and the particular cannot be properly known without perception of the abundance out of which it has been taken." In their advance towards a causal comprehension of nature, the upper middle class made increasing use of the secular sciences which they had themselves created, particularly mathematics. Another indication of a more mundane spirit was the new attitude to literature among the most modern intellectuals. Hitherto value had been accorded only to the religious content. Now a new appreciation of form began to appear, and a preference for simplicity and clarity of style, which signified not only the possibility of a profane content, but even more that the religious content was now receiving a more worldly interpretation.

An art in accordance with the outlook of the intellectual élite of the upper middle class was bound to be very novel in character. More than ever before, it became secular and life-affirming, expressed action and energy, was sober, logical and calculated; in religious art these new tendencies were particularly strongly marked. Even in this period of extreme rationalism in art we cannot speak of an irreligious spirit, but only of a relatively secular interpretation of the religious content. The achievements of the profane sciences, of mathematics, such as linear perspective, were now applied to art, religious art included. The study of antiquity also encouraged in art the exact study of nature and facilitated the search for rules and laws, for new principles of arrangement.

But, as we have already seen, this highly developed rationalism was to be found only among the most progressive intellectual élite of the upper middle class, the most secular, the most self-confident. And, as the economic and social basis necessary for this ideology was very soon to change, this scientific world of ideas, dependent as it was on the help of antiquity, could expand in a really consistent way, that is, in a modern, bourgeois sense, only during a very short period.

Moreover, this élite represented only a comparatively shallow stratum at the summit of the upper bourgeoisie. Beneath the surface, the class as a whole was undermined and no longer capable of organic development; all their enterprises were increasingly dominated by the speculative factor. This inner sense of insecurity, as a result of incipient economic decline, found ideological-religious expression among the majority of the upper middle class in a greater or lesser degree of emotionalism, even though rationalist elements were undoubtedly

still active. Since the upper bourgeoisie were now on the down-grade and shrinking in numbers, the culturally conservative majority of the class involuntarily drew spiritually nearer to other bourgeois sections beneath them, which equally strengthened the tendency towards the emotional. The Observance movement, so influential in this period, also illustrates the approach of the various sections to one another; it did not appeal only to the lower sections, like the "Poverty crusade" in the previous century. Another cardinal factor acting in the same irrational direction was the adoption by the middle class of an aristocratic manner of life—again as a result of their lack of certitude.

The self-assurance of the puritanical upper bourgeoisie increasingly lost its power of resistance to the preciosity and splendour of the aristocratic and courtly. The upper middle class, under the actual economic and ideological conditions, regarded the old feudal standard of life of the knights as a distinguished corollary of the actual calling by which they had made their money. Intermarriage and fusion of the wealthy middle class with the nobility also had an influence. Furthermore, the transference of weight from the woollen to the luxurious silk industry strengthened this tendency. But, of course, for all this, it was not simply a question of a mere revival of the mode of life of the landed, feudal nobility, which had previously developed naturally and inevitably out of the conditions of the time. The new inclination for such a conduct of life, for imitating feudal habits, originated in a yearning after nobleness, was parvenu-like and necessarily playful in many respects. Nevertheless, the upper middle class, who built their villas in the surroundings of Florence, enjoyed nature with a new, more conscious intensity unknown to the feudal nobility.[1]

So both factors, the antique as well as the neo-feudal, had greatly augmented among the upper bourgeoisie at the beginning of the fifteenth century. Though opposed in principle, these two ideologies could very well be reconciled in practice. In general, the two outlooks, that of the ideologically most progressive and that of the less progressive sections of the upper middle class, struggled against, interpenetrated, formed compromises with each other. The resulting mentality of the average member of the upper bourgeoisie was a "fantastic" transposition of antiquity, a kind of ideological middle way, a feudal-"antique" outlook with the main emphasis on the feudal.

The conflicts and compromises of these ideologies, the bourgeois-"antique" and the neo-feudal, condition the increasingly independent secular art of the upper middle class and also redound upon the general character of their religious art. This is strongly affected by the cultural approximation, now inevitable, of the conservative part of the upper bourgeoisie to its less advanced sections. These latter strata, still largely constrained by the habit of symbolic thinking,[2] were now, of course, in this period of their complete political impotence, more than ever inclined to religious emotionalism, which also found expression in art, so far as their passive situation allowed. In particular, the emotional religious

ideals of the Observance movement, equally popular both in upper and lower sections, will now frequently be represented. The artistic result of the cultural approach of the upper middle class to the lower sections of the bourgeoisie—a process much more apparent in the early fifteenth than in the fourteenth century —was similar to that of their approach to the aristocracy: for both the aristocracy and the lower bourgeoisie, relatively backward culturally—their affinity in outlook consequently expressed itself in art as well—were prone to greater irrationality in their attitude than the upper bourgeoisie, though in varying nuances. So, apart from the art of the most progressive group of the upper middle class, there will occur between the other sections a certain equalisation within the framework of a more or less irrational, emotional art, into which, however, individual rationalist elements continuously penetrate from above. In spite of this equalising process considerable shades of difference will still appear according to the different strata—as this follows from their whole world of ideas. Emotionalism will show itself, on the aristocratic side, rather in a lyrical delicacy of mood, sometimes approaching preciosity; on the bourgeois side, in a greater animation, sometimes even in passionateness.

NOTES

[1] For full discussion, see H. Hess, *Die Naturanschauung der Renaissance in Italien* (Marburg, 1924). It is significant of this new relation to nature among the early fifteenth-century upper middle class in contrast to that of the fourteenth century that in Bruni's *Dialogi ad Petrum Paulum Histrum*, Niccoli expresses the view that Petrarch's *Bucolics*— which were probably too allegorical for him—contained very little about shepherds and sylvan life.

[2] The continued need of the masses to be able to adore in the visible form of a symbol what could not be expressed in words, is illustrated by the scene which occurred after St. Bernardino of Siena had preached in Florence on Palm Sunday (1424): he showed the crowd a tablet on which the name of Jesus was represented in letters surrounded with golden rays on a blue background, at the sight of which the people, in ecstatic adoration, burst into tears. See G. Puglioli, *San Bernardino da Siena e la sua attività in Firenze* (Prato, 1926).

2. ARCHITECTURE

IN the Albizzi period, when the middle classes stood ideologically at the height of their power and public buildings were erected to an increasing extent as symbols of "democracy", their chief sponsors were much the same as in the fourteenth century, namely the upper bourgeoisie, organised in guilds. Further, the mendicant Orders continued in some degree to participate, while a few eminent families were already exercising their patronage.

The final commission of the Lana to Filippo Brunelleschi (1337-1446), to crown the Cathedral with a dome after his own model, marked the peak of the extensive building activity on this church, carried on with pride and self-confidence by the upper middle class as they once more rose to power in the 'eighties of the fourteenth century, and in fact it coincided roughly with the conquest of Leghorn. Brunelleschi's dome (1420-36), symbol for the whole city, is characteristically, in the first place, a technical and therefore typically bourgeois achievement;[1] for in the case of this Gothic dome, the actual problem was only to carry out an older model of 1367. It proclaimed the power of the Lana—at least in principle the dominant force in the city—at its very highest point. The guild of silk weavers, the only guild now economically on the upgrade, ordered Brunelleschi to build the Spedale degli Innocenti, the Foundling Hospital, begun in 1419. This was the most modern achievement of the Florentine middle class in architecture; it is significant that such an achievement should be attained in an up-to-date type of building, in one devoted to public welfare, and it was Bruni who suggested to the Signoria that they should found this institution. The loggia, with its long horizontal stretch and its crystal-clear designing, shows a structural, calculating, logical rationalism, and at the same time the revival and use, in the same spirit, of ancient Roman architectural ideas and forms (round arches, low pediments over windows, Corinthian pilasters and capitals). Here horizontality, a secular and rationalist tendency, could be brought into play to an extent hitherto unknown. The same clarity of disposition was shown in Brunelleschi's remodelling of the Palazzo di Parte Guelfa (begun before 1425), in which the two storeys are united within a colossal order of pilasters. This is, as we know, the Palace of that organisation which at an earlier date represented the power of the oligarchical upper middle class, but which, in comparison at any rate with their position a century earlier, had declined in importance and were trying to make up for this by outward show.

Brunelleschi's rationalist classicist[2] buildings are constructed in "space compartments" clearly defined by horizontals and verticals. This architecture

derives not only from the Tuscan buildings, classicising in style, of the early Christian and Romanesque periods, such as the Baptistry[3] or S. Miniato in Florence, but has also its direct forerunner in the rational Florentine Gothic of the fourteenth century,[4] the Spedale degli Innocenti being primarily based on the Loggia dei Lanzi. The change towards a classicising style at the beginning of the fifteenth century does not imply an abrupt contrast between the art of the Trecento and the new art of the "Renaissance". Brunelleschi's architecture with its more conscious intellectualism as compared with that of the preceding period shows very wide differences, but it also represents a novel and masterly synthesis of existing elements. It embodies an accentuation of the rationalist, "bourgeois" elements in the style of fourteenth-century architecture—and especially of the tendency towards horizontality—with the vital additional help of borrowed Roman and Romanesque motives, to which Arnolfo di Cambio was already indebted. The fact that, for instance, Gothic decorative forms, which had played a very small part in fourteenth-century Florence, now gave place to classicising forms, does not imply that a "wholly new" art is appearing. What is taking place is a development within middle-class art, an intensification of existing tendencies, but so considerable an intensification as was possible only in Florence, and only in the particular decades under consideration. An architecture was born which expresses with the greatest clarity the ideology of the most advanced of all middle classes. And it is no mere chance that the architect whose buildings incorporated this style was at the same time the most experienced man of his profession in technical questions, that he was also a military engineer, a bridge builder, and the inventor of a naval transport.

Brunelleschi designed not only secular buildings but churches also. The classicistic style of these churches derived even more directly from the rationalist, clearly planned spacious architecture of the Florentine Trecento: the principal source being, of course, the churches of Arnolfo.[5] In date the execution of Brunelleschi's churches belongs mainly to the period of Cosimo de' Medici; in the history of the chief of them, S. Lorenzo, we can actually watch the Medici in the process of seizing power. Originally in 1418 eight families, the Medici among them, had promised to contribute to the new building, in return for which they were to be given family chapels in the church. Giovanni de' Medici, who, as the richest, acted in the name of the others, in 1421 entrusted the direction of the building to Brunelleschi. Later Cosimo de' Medici acquired for his family the exclusive patronage of the church for 40,000 florins, so that instead of the traditional family chapel there actually appeared a family church. Both S. Lorenzo and S. Spirito, which was designed for the Augustinian Hermits (probably between 1432 and 1435)[6] were, in accordance with changed conditions, more worldly in character, and more particularly adapted to the needs of the patrons, and at the same time of the individual spectator, than the Trecento churches of the mendicant Orders: they are, so to speak, the equivalent

expression in architectural terms of the oligarchical democracy of this genera-
tion. The aisles are supplied with a series of small, shallow chapels in which
were to be placed the altars given by members of the wealthy middle class; in
S. Spirito, for instance, there are forty such altars round the church. The
spectator is intended to see these altars through the chapel openings and the
corresponding gaps between the columns, and by the slowing up of the rhythm
is urged to study them from near by.[7] In S. Lorenzo particular importance
attaches to the Old Sacristy (1428), later the burial place of the Medici, in
which Brunelleschi introduced the Roman pendentive, and so was able to con-
struct a flat dome.[8] Brunelleschi built a family chapel (1430–43) for the Medici's
principal rivals, the banking family of the Pazzi, in the cloister of S. Croce, a
Franciscan milieu; it was handed over by the family to the friars for their
chapter meetings. This was a centralised building, that is to say, the most
secular conception possible within the limits of church architecture, and the one
aiming most completely at formal compactness; the most secular, because litur-
gically unsuitable in that it does not allow of the separation of the priest from the
laity.[9] So this classicising chapel presents a curious mixture of religious and secu-
lar elements.

Finally we must mention the fundamental change which came over the
private houses of the upper middle class at the beginning of the fifteenth century,
when they became big, comfortable palaces with numerous rooms.[10]

NOTES

[1] The conservative artisan architects were against Brunelleschi's dome, as it seemed
to them too great an innovation to build it with the aid of centring, without any internal
support. (See W. D. Parsons, *Engineers and Engineering in the Renaissance*, Baltimore, 1939.)
Brunelleschi's most bitter opponent was the conservative writer, Giovanni da Prato, an
imitator of Dante in a popular-allegorical manner, whose own project for the dome was
rejected in favour of Brunelleschi's.

[2] For the term "classicist" see p. 305, footnote.

[3] Brunelleschi certainly regarded this as an ancient building, as presumably Arnolfo
had done before him. The first explicit reference to the Baptistry as belonging to antiquity
was made by Villani.

[4] H. Folnesics, *Brunelleschi* (Vienna, 1915).

[5] The Gothic elements latent in Brunelleschi's churches are indicated in detail in
A. Schmarsow, *Gotik in der Renaissance* (Stuttgart, 1921).

[6] Cosimo de' Medici probably had some say in the choice of architect.

[7] Schmarsow, *op. cit.*

[8] The flat roofs of Brunelleschi's churches again derive from the open beamed roofs
of Arnolfo.

[9] An even more consistent centralised building by Brunelleschi is the new.Camaldo-
lese Oratory of S. Maria degli Angeli, begun in 1434, but left unfinished; it was undertaken
by the Lana through a bequest of the *condottiere* and statesman Pipp Spano (Filippo
Scolari, of the Buondelmonti family), who had made his fortune in Hungary and died

there. The building soon had to be abandoned because the investments in the State loan were spent on war with Lucca. In this church, such bold structural ideas were made use of that they could only be developed much later by Bramante, working for a Curia with a new secular-nationalistic outlook; in the same way it was Alberti who, a generation after Brunelleschi, working in Rome and at the courts of princes, then evolving the new absolutism, carried on his palaces and Latin-Cross churches. For the architectural ideas, just as much as the economics and politics of this modern absolutism, continued those of the early capitalist upper middle class.

It is significant that the classicist architecture of the fifteenth century was created almost exclusively by laymen.

[10] For instance, the palace of the Uzzano had nine rooms on the ground floor, ten on the first, and eleven on the second. Yet judging from the inventory of Angelo Uzzano's estate of 1425, these rooms must have been of a somewhat puritanical simplicity.

3. PAINTING (AND SCUPTURE)

A. GENERAL REVIEW

THE general character of religious painting in the early fifteenth century resembled on the whole that of the fourteenth.[1] Guilds and wealthy middle-class families still commissioned frescoes and altarpieces for their chapels in the various churches and, in the case of the guilds, for the chapels of their guild houses also. The most important works of art, therefore, were still destined for public places. But at the same time, a marked increase is to be observed in the number of domestic altarpieces in private palaces and houses—works often of outstanding quality. Thus, at this time, especially at the end of the Albizzi period, another tendency began to operate which conflicted with, and undermined, the former "democratic" method of displaying works of art. For, as the ruling circles shrank in size and acquired more aristocratic habits, the individual private commissions of a few rich families took on a genuinely personal and intimate character. At the same time, a considerably lesser number of large fresco cycles were ordered by private persons, since the number of families wealthy enough to afford undertakings comparable with those of the first half of the fourteenth century had diminished.

The themes of frescoes and altarpieces, as well as of sculptures, followed the general line of the previous century. Now more than ever the most frequent altar painting was the Madonna with Saints (Pl.131); and it was increasingly the practice to bring the various figures, often including the donor, into close relationship with each other. The principal panels were still usually occupied by ritual representations, the predellas being used more to express a delight in narrative and, in particular, in new artistic achievements (Pl. 104, 108a, 109a, b, 128, 129, 138a). Later on, we shall see in detail which subjects tended to come into prominence or to recede into the background as compared with those of the fourteenth century. The choice of the representations, as well as the whole manner of their conception, was certainly much affected by such phenomena as, on the one hand, the increasingly luxurious and courtly trend of the upper middle class, and on the other their growing rationalist attitude, and still further by the Observance movement. Hence, under the influence of that movement, themes, for instance, which had previously had a certain democratic and popular character, such as the Madonna of Humility (Pl. 109a, 133, 144), or the lives of holy hermits (Pl. 114, 115a, b), became noticeable favourites with the wealthy upper bourgeoisie, even with its aristocratising section. As regards this selection of

themes, we need only notice here that with the frequent delight in detailed illustration went an increase in the number of figures introduced into the majority of scenes—a tendency in which the influence of religious drama, then undergoing intensive development, certainly played a part.[2] Moreover, a preference was growing among progressive artists for scenes affording an opportunity for the representation of the nude human figure (Pl. 101b, 108b) and of landscape (Pl. 100): the Baptism of Christ, for example, or, from the Old Testament, the Sacrifice of Isaac. Scenes and figures from the Old Testament were, in fact, more frequently portrayed than before, since they permitted of greater freedom of narrative (Pl. 140), and gave greater scope for the representation of the nude (Pl. 141, 142, 143a, b). Indeed, they almost constituted a means of transition to secular art. While the symbolical interconnection of the two Testaments was still, of course, taken for granted, the choice of scenes from the Old seems at this time to have been a good deal more independent and elastic than hitherto. At this period of the zenith of the upper middle class, the use of symbolic and allegorical themes in monumental art had generally somewhat weakened as compared with the preceding era. Nevertheless, because of the close approach of the various strata of the middle class to each other, religious symbolism still remained very much alive (Pl. 112a, 122), and indeed, even grew in the case of altar-panels, commissioned by those (often provincials) who did not belong to the highest and most cultivated circle.

As regards miniatures, the situation had altered somewhat since the fourteenth century; for side by side with liturgical books produced for monasteries and churches (Pl. 116a, 118a), a more prominent part was taken at this time by secular manuscripts, particularly those of classical authors, made for commercial purposes for wealthy private persons. It was a sign of the economic decline as well as the political insignificance of the masses in Florence, that the popular illustrated manuscripts of the fourteenth century did not give rise here, as they did in northern countries, to block books and to the production of countless woodcuts to satisfy the needs of the less well-off among the middle class and of the artisans. At the beginning of the fifteenth century, it appears that only a very few woodcuts were produced at all.[3]

A new factor which made an appearance during the period was the portrait—a genuine symptom of upper-middle-class self-assurance and of greater worldliness in that class's artistic requirements. It will be readily understood why the development of donors' portraits in religious paintings (Pl. 150, 151) into pure portraiture (Pl. 152) took place in the first decades of the fifteenth century when upper-middle-class ideology—the ideology of a comparative secularisation—was at its zenith. The figures of donors in altarpieces came to conform more and more in scale to the sacred figures, thus intensifying a tendency already apparent in the fourteenth century. Individual figures in religious scenes were sometimes given the features of the donors, or the donors were simply included as spectators.

FLORENTINE PAINTING AND ITS SOCIAL BACKGROUND

It is significant of the secularisation of religious art during this period that from now onwards, as in the case of Masaccio, the donors were introduced by preference into the Adoration of the Magi (Pl. 104)—the most worldly of the events in Christ's life.

Portraits, however, were still scarce, and the increase in the number of profane works of art in private possession was due, above all, to the practice in wealthy families of having painted cassoni; these chests, carrying family coats-of-arms and given chiefly as wedding presents, were decorated on the frontage with paintings, sometimes in the form of single panels, sometimes tripartite (Pl. 154a, b, 156, 157a, b, 158 b). In a general sense, we can include with cassoni-pictures the painted plates customarily used as birthday or wedding presents (Pl. 145, 155, 159a,b, 160). These types of commission, incomparably cheaper than church frescoes or even altarpieces, are nevertheless a sign of the more luxurious habits of the wealthy middle class.[4] At the same time, this whole genre implies a high degree of secularisation in art, since three-quarters of the cassoni have secular themes for their subjects, giving free rein to the personal taste of the patrons. At this period, the height of bourgeois efflorescence, it is usual to find among the cassoni mere representations of contemporary life (Pl. 154a, b, 155, 159b), particularly of the wealthy and aristocratising middle class. Illustrations of Italian *novelle* (Pl. 157b), too, are fundamentally none other than this. Furthermore, in the cassoni, the antique had now become an independent source of themes: scenes from Greek and Roman mythology and history were depicted (Pl. 159a, 160); above all, since the occasion demanded it, love stories.[5] But in the rendering of antique motives, the same aristocratic taste was exhibited as in the representations of contemporary life mentioned above. Nowhere could a delight in narrative find less restricted scope than in cassoni painting. Like predellas, the cassoni with their long, narrow shape were peculiarly adapted to episodic illustration; yet, in contrast to predellas, whose province was religious art and whose content depended on the subject of the altarpiece itself, cassoni were completely independent of such extraneous determinants, and already embodied purely secular art. Hence, the numerous cassoni now become the main sphere of secular naturalism. Although they were not yet, socially speaking, "grand painting", all the same they were more or less real pictures; while in the previous century, a truly narrative secular naturalism was, on the whole, possible only in a few miniatures such as the Biadaiolo manuscript.

NOTES

[1] On the different types of painting and sculpture from about 1420, see M. Wackernagel, *Der Lebensraum des Künstlers in der Florentinischen Renaissance* (Leipzig, 1938).

[2] The *Rappresentazioni Sacre* contained representations from both Testaments, and served not only to edify but also to amuse. Artists also began to collaborate in the technical properties, decorations and costumes of these plays.

[3] Not a single woodcut of the period has been preserved. On merely documentary evidence, we know that in 1430 a professional card painter (*Pittor di Naibi*), Antonio di Giovanni di Ser Francesco, mentioned in his tax declaration "wood blocks for playing cards and for saints" (see P. Kristeller, *Kupferstich und Holzschnitt in vier Jahrhunderten*, Berlin, 1905).

[4] The adornment of cassoni with pictures indicates that they had become more expensive in contrast to the immediately preceding fourteenth-century "democratic" type of chest with gilded stucco decoration and *carta pesta*, which could be reduplicated and was therefore much cheaper.

[5] For detailed discussion of the themes of cassoni and their sources, see the section on secular art below, and, particularly, P. Schubring, *Cassoni* (Leipzig, 1923).

B. PRINCIPAL COMMISSIONS

THE social status of those who commissioned the most important frescoes, pictures and sculptures during the Albizzi period was generally similar to that of their counterparts in the fourteenth century. We will mention some of the most significant orders placed by guilds or individuals.

The bankers' guild commissioned Lorenzo Monaco to paint frescoes with scenes from the Life of the Virgin for a chapel in S. Trinità (1420–24). In 1433 the linen-drapers' guild placed an order with Fra Angelico for a large folding altarpiece of the Madonna with Saints (now in the Museo di S. Marco) for the chapel of their guild hall.

In 1404 Starnina received a commission from the Pugliese to decorate a chapel in S. Maria del Carmine with the story of St. Jerome (small fragments only survive). The heirs of Cardinal Pietro Corsini in 1422 ordered a big altarpiece to his memory from the Maestro del Bambino Vispo, representing a Madonna in Glory with a choir of angels, to be placed in the Cathedral (to-day dispersed in Stockholm, Bonn, etc.). Palla Strozzi, the wealthiest man in Florence, commissioned Gentile da Fabriano to paint an altar-piece in 1423 for his family chapel in S. Trinità, depicting the Adoration of the Magi (now in the Uffizi [Pl. 105, 109a], one predella in the Louvre [Pl. 108a]). The patrician Berardo Quaratesi, a former Gonfalionere, likewise ordered from Gentile da Fabriano in 1425 a large altarpiece of the Madonna with Saints (now dispersed in London [Pl. 103], the Uffizi, the Vatican Gallery [Pl. 128], etc.) for the church of S. Niccolo oltr' Arno. For Felice Brancacci, a rich silk merchant frequently employed as ambassador of the Republic, Masolino and Masaccio decorated (1425–27) the family chapel in S. Maria del Carmine with frescoes showing scenes from the life of St. Peter (Pl. 100, 101a, b), together with the story of Adam and Eve (Pl. 142, 143a). In 1426 Masaccio received from the Pisan notary, Giuliano di Colino degli Scarsi, an order for an altarpiece with the Madonna, for S. Maria del Carmine in Pisa (now dispersed in London [Pl. 102], Berlin [Pl. 104], Naples, Pisa and the Lanskoronski collection in Vienna). The well-known Florentine artists also received important commissions from other cities. In 1407 Spinello Aretino went to Siena to execute in the Palazzo Pubblico a cycle of frescoes representing the life of Pope Alexander III (Pl. 146, 147).[1] After the termination of the Great Schism the importance of Rome was on the increase. In this connection a commission by that enthusiastic patron of the arts, Cardinal Branda Castiglione, a native of Lombardy, is of particular interest. He commissioned Masaccio and Masolino (probably in 1428) to paint

frescoes from the legends of St. Catherine and St. Ambrose (the patron of Milan) for a chapel in S. Clemente, his titular church. At his birthplace, Castiglione d'Olona, he gave Masolino the order to cover the roof of the choir in the Collegiata with episodes from the life of the Virgin (after 1435; Pl. 119b)[2] and to decorate the Baptistry, as was usual in such places, with the story of St. John the Baptist (1435; Pl. 119a).

In Florence itself, at the beginning of the fifteenth century, an extraordinarily large number of commissions for important altarpieces were given by the various Orders, above all by the two outstanding Observant Orders of the time, which were in very close contact with the public: Camaldolese and Dominican Observants. These commissions were carried out chiefly by members of the Orders: the Camaldolese by Lorenzo Monaco, the Dominican by Fra Angelico (Pl. 135, 137a, 138a, b). As was their custom, the Dominicans also gave a large-scale order for frescoes: to decorate the cloisters of the Chiostro Verde in S. Maria Novella with frescoes of Old Testament themes by different artists (Pl. 140), among them Paolo Uccello (Pl. 141, 143b). In addition to the various commissions, both large and small, given by the Orders, numerous smaller ones, as at the end of the fourteenth century, came from the Confraternities (Pl. 125, 126). A large number of the less important artists were kept busy with these.

As to sculpture*, the large public commissions, especially at the beginning of the Albizzi period, give the same impression as those in architecture—of an upper middle class at the zenith of its power, and at the same time at the height of its efforts to give proof of its "democratic" ideology. The statuary of the Cathedral, as is well known, came under the control of the richest of the guilds, the Lana. The orders for this work, which was begun at the end of the fourteenth century when the Albizzi party rose to power, became very numerous at the beginning of the fifteenth century when the upper middle class were particularly conscious of their predominant position. The four great statues of the Evangelists, for the façade (including Nanni di Banco's St. Luke and Donatello's St. John) were commissioned in 1408 and completed in 1415. As regards the decoration of the side portals, the entrusting of the relief of the Assumption of the Virgin above the Porta della Mandorla to Nanni di Banco specially stands out (1414-21). The cycle of Prophets on the Campanile was carried on in the most concentrated way, and was indeed nearly completed, Donatello being occupied on it from 1415 to 1427. But at the end of the twenties, in consequence of the deterioration of the general financial situation and of the fact that foreign affairs had taken an unfavourable turn, work on the Campanile was interrupted; the sculptures of the façade came to a complete standstill, and the whole building

* I have gone into some detail on the numerous orders for sculpture, not only because of its high place in Florentine art, but also because the whole nature and distribution of these orders throw a particularly clear light on the social position of both patrons and artists.

corporation of the Cathedral went into liquidation. Later on the last statues on the Campanile were completed, and in 1431 and 1433 Luca della Robbia and Donatello secured individual orders for the two choir lofts in the Cathedral on which they represented the Rejoicing of the Angels at the Coronation of the Virgin. In 1401 the Calimala announced a competition for the reliefs of the second Baptistry door, and the winner, Ghiberti, carried them out between 1403 and 1424—the life of Christ (Pl. 139a), the Evangelists, and the Fathers of the Church.[3] In 1425 the Calimala gave Ghiberti the second great commission for the decoration of the third door, this time with scenes from the Old Testament. The resolution of the Signoria of 1404—again at a time, like that of a similar resolution in 1339, of bourgeois consciousness—laid on every guild the duty of placing a statue of its patron saint in one of the niches in the walls of the guild church of Orsanmichele, within a period of ten years. The greater guilds carried out the order in bronze, the lesser ones in the cheaper marble (which cost only an eighth the price of bronze).[4] Most of the statues were completed between 1408 and 1425: among them Nanni di Banco's Quattro Coronati (relief below Pl. 108b)—that is, the four sculptor saints (masons' and carpenters' guild), his St. Philip (shoemakers'), and St. Eligius (blacksmiths'); Ghiberti's St. John the Baptist (Calimala), St. Matthew (bankers') and St. Stephen (Lana); and Donatello's St. Mark (linen-drapers'), St. George (armourers') and St. Louis of Toulouse (Parte Guelfa). However, these works were carried out only under the greatest difficulties, for the lesser guilds were too impoverished and in many cases were unable to afford any statue at all—thus did Florentine "democracy" work out in practice. In this way, nearly all the principal orders, both for the Cathedral and the guilds, came to be divided between Nanni di Banco, Ghiberti and Donatello. Ghiberti appears everywhere as the sculptor of the greatest and wealthiest guilds: the Lana, the Cambio and the Calimala were all patrons of his.[5] It was probably as the principal sculptor of the Cathedral (that is, of the Lana), that Nanni di Banco secured the orders of the lesser guilds which had now lost all independence and initiative. The young Donatello began, like the other two, in the service of the masons' lodge of the Cathedral and soon worked himself up to important guild commissions; even the distinguished Parte Guelfa gave him the order for their princely Patron Saint (1418).[6] And the city itself, at the zenith of its power, ordered statues from him, and, typically enough, subjects symbolising its fame and riches: in 1418 a sitting lion (the Marzocco) for the Piazza di S. Maria Novella (in front of the Pope's apartments then being built in S. Maria Novella as a symbol of the alliance between Papacy and Commune),[7] in 1428 the figure of Abundance (the Dovizia, destroyed in the eighteenth century) for the Mercato Vecchio (probably a revival of an antique statue which previously stood in the same place and was dedicated to the genius of Florence).[8]

But it was the richest members of the guilds rather than the guilds them-

selves who gave the lead in allotting artistic commissions. Thus, for instance, the negotiations with Ghiberti in the matter of the St. Matthew statue (1420–22) were carried out in the name of the bankers' guild by a small art committee set up by them; and the member who played the chief role on this committee was Cosimo de' Medici.[9] This gradually increasing importance of a single personality in the commissioning of works of art, beginning as it does as early as the Albizzi period, is very significant—all the more so since it was he to whom the entire political power was fated to fall. Cosimo began, too, to develop the activities of a collector. Even in his private capacity he ordered direct from Ghiberti.[10] Cosimo's interest in Donatello also began slowly to take effect in these years and became very marked particularly towards the end of the period. At first, the artist showed himself in close association with the upper-middle-class clique which controlled the city—his father's political association with the Albizzi party no doubt played some part here. He obtained the order for the tomb in the Baptistry of John XXIII (1425–27), a notoriously worldly and violent man, who had been deposed by the Council of Constance for simony and general immorality, and from whose hands the Medici, in their capacity of court bankers, had received many advantages. The order was given by a committee, named by the Pope in his will, composed of leading upper-middle-class figures, among them Niccolo da Uzzano and Giovanni de' Medici, both supporters of the Pope in the past. This was the first really sumptuous tomb in Florence, a type not yet customary in the days when the Florentine upper middle class was still puritan: and the first, therefore, to achieve such a one was a foreigner who had ordered it in his will.[11] Donatello also carried out, in 1426, the tomb of Cardinal Rinaldo Brancacci, destined for Naples; the Cardinal had been a compatriot and political associate of John XXIII, and in this case also Cosimo de' Medici was the testamentary executor.[12] At the end of the period, Donatello's connection with Cosimo became still closer. In 1433 he was commissioned to execute a simple tomb for Cosimo's parents, Giovanni de' Medici and his wife, in the Sacristy of S. Lorenzo, the Medici family church.

NOTES

[1] The Florentine *condottiere* Pippo Spano, who held an important post in Hungary, summoned Masolino (about 1426) to decorate his burial chapel in Székesfehérvár (now lost).

[2] The Florentine painter Paolo Schiavo was engaged, as Masolino's collaborator on wall-paintings in this choir, illustrating the stories of the Martyrs Lawrence and Stephen.

[3] The total cost of the door amounted to the enormous sum of 22,000 florins.

[4] It is most characteristic of these days of exclusive upper-middle-class rule that an order of 1401 confined the privilege of setting up *Boti*, i.e. their wax effigies, in the Annunziata to members of the greater guilds.

Concurrently with the above-mentioned reservation of the more expensive materials such as bronze for the richest, we find an increasing tendency towards the use of cheaper

materials, such as terracotta or the entirely mechanically prepared stuccoes, by the less well-to-do. Plastic works in these latter media were probably even cheaper than pictures.

[5] Ghiberti was paid by the bankers for the St. Matthew statue the considerable sum of 650 florins. The guild itself raised the required total of 1,039 florins by imposing a tax on its members. The St. Stephen cost the Lana *c.* 1,000 florins, which, however they were able to meet from the takings and profits of the guild. In 1432 Ghiberti also secured from the Cathedral authorities the order for the reliquary destined to contain the bones of St. Zenobius; he also designed stained-glass windows for the Duomo. But the great foreign patrons too preferred Ghiberti: the Popes, when they visited Florence, ordered their goldsmith's work from him, and the authorities of Siena Cathedral gave him an order in 1417 for two reliefs from the life of St. John the Baptist, for the font in the cathedral Baptistry. Donatello was also given work on this font.

[6] It was possibly of some significance that Donatello's father had been banished after the *ciompi* revolt as a partisan of the Parte Guelfa.

[7] The city expended 1,500 florins on these apartments.

[8] Donatello's most important foreign patrons even at this early period were the Pope and the authorities of Siena Cathedral.

[9] Doren, *op. cit.*

[10] He ordered a bronze casket for the bones of three martyr saints (1426, now in the Bargello) which he had brought with him from Venice and deposited in the Camaldolese monastery of S. Maria degli Angeli where his friend Traversari was abbot.

[11] But at this zenith of Florentine burgher pride some attempt was made, in 1430, to carry out a plan formed as early as 1396, to transfer the remains of the greatest Florentine authors—Dante, Petrarch, and Boccaccio among them—to the Cathedral and there re-inter them in sumptuous tombs (see p. 135, note 5).

[12] Donatello carried out both these tombs in partnership with Michelozzo, who was Cosimo's favourite artist and accompanied him into exile. The humanist, Bartolommeo da Montepulciano (d. 1429), Pope Martin V's secretary and a friend of Bruni and Poggio, also designated these two artists in his will as the makers of his grandiose tomb. It was eventually carried out by Michelozzo alone in 1437 (now Montepulciano, Cathedral and London, Victoria and Albert Museum).

C. RELIGIOUS PAINTING

THIS enumeration of the chief sculptors and their major commissions was fitting, for at the beginning of the century upper-bourgeois rationalism was most strikingly expressed in religious sculpture, both statues and reliefs, whereas its full expression in painting came somewhat later. It showed itself in the anatomical treatment of the human figure, in the manner of rendering the natural weight of the garments, in new principles of spatial construction and composition, and in the reliance upon antique sculpture for the attainment of these aims; for it was inevitable that the representatives of a consistent middle-class rationalist art should link up with the antique, or rather with its classicist and naturalistic elements,* in order to strengthen their own naturalism, and to shorten that long and arduous process.

Even in the 1390's, when the upper middle class were again in power, it is possible, in the case of a few statues, produced by the masons' lodge of the Cathedral in Florence, to detect a classicising style of drapery.[1] Another very early work, much more consistent, is the bronze relief of the Sacrifice of Isaac (Bargello) made by Brunelleschi for the competition arranged in 1401 by the Calimala for the second door of the Baptistry. Here, however, Brunelleschi was not yet entirely successful in bringing the elements borrowed from the antique into harmony with a composition which should have arisen out of the organically-treated figures themselves. It is not surprising that this work, which in 1401 was extremely modern, could not hold its own in competition with Ghiberti's universally intelligible Gothic style. But as the clarion call of upper-middle-class classicism in art, the great architect's relief was of the first importance.

This classicising interpretation of Brunelleschi was continued, though no longer with the same dogmatic power, in the later classicist sculptures of the

* By the classicist tendencies of the antique is meant not so much the Greek art of the fifth century B.C., unknown as such to the Florentine artists of this time, but rather those later currents in antiquity, Augustan art for instance, for which this Greek art was the ultimate norm. We are surely entitled to use the term "classicist" for the rational and formalistic art of the Florentines after 1400. At this time, with growing rationalism, decreasing importance of the religious content, and far higher appreciation of formal elements, imitation of the antique and of nature was becoming the criterion, expressed or unexpressed, of the most progressive art of the upper middle class. This is why the gradual differentiation of this "classicist" art of the early fifteenth century from even the most progressive art of the thirteenth and fourteenth centuries may be regarded as a marked change, in so far as a line of demarcation can be drawn at all in a process of continuous development. This distinction applies when we compare this classicising style with its "precursors" of earlier periods of upper-middle-class predominance, such as that of Niccolo Pisano in Pisa in the thirteenth century, or of Arnolfo di Cambio and Florence at the end of that century.

305

masons' lodge of the Cathedral, especially in the seated figures of St. John (1408–15) by Donatello, in Nanni di Banco's St. Luke (1408–15), and in the same artist's standing figures of the Quattro Coronati (1410) on Orsanmichele. The Quattro Coronati—that is the four sculptors, or rather stonemasons and early Roman martyrs, Claudius, Symphorianus, Nicostratus and Castorius— are represented as unpretentious bourgeois saints. Nanni here shows himself more interested in the problems of the representation of corporeality and of drapery than in expression. The puritanical simplicity of these toga-draped figures is that of those sober Roman Orator statues of the late Republic, by which Nanni was to a great extent inspired; although actually commissioned by Nanni's own lesser guild of the masons, they are the expression of the outlook of the upper-bourgeois intellectuals of the Bruni type. The relief (Pl. 108b) below the standing figures of the Quattro Coronati is particularly characteristic of this style: the four sculptor-saints are busily occupied in their workshop, erecting masonry, carving a nude *putto*, measuring with compasses, and drilling a hole; everything is shown in a simple, clear, and at the same time idealised antique-like style. The principle of this work, in which the plastic figures are set off against a neutral background, is allied to Roman reliefs of the late Republic, which often likewise represent occupations; this arrangement, like its severe composition, built up of horizontals, verticals, and calm diagonals, is reminiscent of Andrea Pisano's reliefs with similar motives on the Campanile, where bourgeois occupations are placed within the framework of the cycle of Salvation, and at the same time idealised (Pl. 79a, b). In Nanni di Banco's relief we find a continuation of this relatively classicist upper-middle-class style, though the later artist certainly showed more penetrative mastery of the human figure and of drapery.

Yet this classicising style of Nanni di Banco was not vital enough to succeed in achieving an adequate organic development of its own. It was soon transformed into a style related to Gothic, without entirely losing the feeling for body and mass gained from the antique. This is true of the elongated figure of St. Eligius on Orsanmichele (1415)[2] and of the relief of the Assumption on the Porta della Mandorla of the Cathedral (1414–21)[3] which is characterised by a sense of religious ecstasy, and shows in certain respects a return to the Gothic formal idiom.

In the case of Donatello, who had the capacity to carry on for a considerable time an upper-middle-class classicism, the close reliance on the antique represented principally the possibility of a freer style, still within the bounds of classicism, but now based on greater knowledge. This is made quite clear by comparing Nanni's relief of the four sculptor-saints with Donatello's of St. George and the Dragon (1416), placed under the statue of St. George on Orsanmichele. The flat and timid classicism of Nanni's four figures standing stiffly together contrasts with the Donatello relief, which is really optically conceived and goes

beyond the limits of a purely antique-imitating style. The scene, severely constructed, yet with painterly freedom of movement, is placed within a cleverly foreshortened framework of landscape and architecture. In his large, standing, draped figures, for example in the various statues of Prophets on the Campanile, Donatello cast aside the stiffness of the Quattro Coronati, occasioned by his all-too-narrow reliance on antique models. Even more than in Nanni di Banco's figures, we are here reminded of contemporary Florentine statesmen and ambassadors—we have seen their importance in this period, parallel to that of the orators in ancient Rome, particularly in the late Republic—men of a thorough yet quick spirit, capable of drawing up and delivering well-balanced speeches of a classicist structure. No wonder one of the prophet figures—destined for the facade of the Duomo and probably only in part Donatello's—soon came to be generally known as Poggio. Donatello endeavoured to render the functional interrelationship of the body to begin with, in the normal, tranquil, stationary posture, gradually more loosely mobile—at first through an intimate study of the antique, but later more and more independently, although even then simultaneous borrowings from the antique occur. Typical of his searching treatment of the body is the wooden crucifix in S. Croce (c. 1415-20), where the pleasure of the artist in the anatomical moulding makes the figure of Christ less divine; indeed, according to one of Vasari's anecdotes it struck contemporary observers as somewhat like that of a peasant.[4] In his relief of the Scourging (Berlin, c. 1420-25), the figure of Christ is Herculean and almost profane;[5] the architectural background has a brilliantly executed perspective. With his tomb of John XXIII (c. 1425-28), Donatello added no small share to the contemporary tendency towards secularised tomb monuments: the principal motive is that of the dead Pope lying on the bier; all religious representations are omitted save for a half-figure relief of the Madonna, and under the influence of the Hellenistic and Roman antique (*amoretti*, genii of death) naturalistic figures of naked *putti* come more and more to the fore. Perhaps the most intense impact of the antique upon Donatello was in the 'thirties rather than the 'twenties, following on his journey to Rome in 1432.[6]

The culminating achievement of this rationalism, which introduced a secular note even into religious art, is to be found in the work of Masaccio (1401-28). It is illustrated especially by his frescoes in the Carmelite church of S. Maria del Carmine (1425-27), telling, besides that of Adam and Eve (Pl. 142), the story of St. Peter, officially the founder of the Papacy, particularly by the centrepiece, illustrating the scene of the tribute-money (Pl. 100). Nothing could be more characteristic of this rationalist art than this choice of subject, which had hardly ever been treated previously. It is a typical example of an unemotional scene from the ministry of Christ, which until now had rarely been illustrated. Felice Brancacci, who commissioned these frescoes—the original order would probably have gone to the more conservative Masolino, and Masaccio would have joined

him only later—in all likelihood wished them to express that the wealth of the State was to be sought on the ocean; he belonged to the important newly-established Board of Maritime Consuls, and in 1422 had been sent to the Sultan of Egypt in Cairo on a mission of great importance to the Florentine middle class, namely, to procure for them the trade with the Orient, based on the recently acquired seaport of Pisa.[7] So the religious story probably carried patriotic and economic implications. Masaccio's interpretation is as unemotional as was the original choice of subject. The tax-collector demands the payment due, and Christ instructs St. Peter to hand it over; the one miraculous feature of the story, the discovery of the money in the fish's belly, is relegated to the background. The action is treated almost as a mere piece of secular reporting, as a rational sequence of cause and effect; it is simply the outcome of volitional actions, first of the tax-collector, and then of Christ.[8] The other scenes from the Petrine legend are interpreted in a similarly intellectual, sober, ecclesiastical or—what at this period amounts to the same thing—upper-bourgeois manner: St. Peter baptising (Pl. 101b), SS. Peter and John bestowing alms, SS. Peter and John healing the sick with their shadow (Pl. 101a), and above all, the scene of St. Peter in Cathedra (on the bishop's throne of Antioch), giving an impression, as it were, of power politics, from the solemnly kneeling entourage of laymen and monks.[9] Even the scenes showing the Saint's miracles and acts of charity are not intended to make any special appeal to the emotions, or to create sympathy by stressing realism of detail in the presentation of the beggars; least of all is this the case in the scene of the Curing of the Sick through St. Peter's shadow, where the Saint passes calmly and gravely by and appears to perform the miracle without even casting a glance at the sick. Most of the stately figures of the Brancacci chapel, full of Roman *gravitas*, display a decidedly Stoic composure, similar to that which Bruni praises in his writings.[10] It also exhibits the more worldly, freer attitude of mind of the upper middle class that room is now found for such innovations as nudes in religious scenes, as in that of St. Peter baptising. This representation of men in their nakedness also implies a certain "democratic", equalitarian point of view likewise deriving from the Stoic philosophy, which proclaimed in principle the equality of men.

Turning to other examples of Masaccio's work, we may note how grave and impassive the Virgin appears in the St. Anne, Madonna and Child, of the Uffizi (from the church of the Benedictine convent of S. Ambrogio, *c.* 1423) and in the London Madonna (Pl. 102).[11] We find the same worldly approach in the naked, sturdy and by no means "attractive" versions of the Infant Christ in his various altarpieces. Even the Madonna of Humility which nearly every artist had felt to demand a more or less appealing treatment, is rendered by Masaccio with a rigid and indifferent expression (Washington, National Gallery, *c.* 1424-25).

To these entirely new interpretations of religious subjects there necessarily corresponded new principles of form, expressing themselves above all in a

logical, rationalistic and systematic construction of the space, of the figures, and in fact of the whole composition.

In painting, Masaccio consistently employed linear perspective, the scientific discovery of an architect, Brunelleschi, who had himself tried it out in paintings.[12] Space was now scientifically organised and logically built up through a system of perspective: an attempt was made to pass beyond merely casual, subjective observation, and to objectivise and rationalise the visual impressions. The exact science of mathematics assisted Masaccio to procure the greatest possible unity in his spatial construction, and to interrelate it in a logical manner.[13] Every object is given its appointed place, an entirely new relationship between the figures and the landscape is built up, the old contradictory proportions are eliminated. Nevertheless, certain discrepancies sometimes still appear between the figures in the foreground, placed side by side, and the background.

The care Masaccio used in treating the human body itself is in conformity with, though of course not dependent on, the conception, taken from the Roman Stoicism then fashionable, of the dignity of the body and respect for it as a masterpiece of divine skill. The figures themselves are modelled on the basis of a scrupulous observation of nature; deep knowledge of individual differences is seen throughout in the heads, the bodies, the draperies. But here too, in the last resort, over and above these differences, it was the employment of scientific principles, in this case those of the objective causality of the body, which really interested Masaccio. Such being his attitude, the study of antique sculpture, which was based on similar principles, was naturally of absorbing interest to him.[14] This is shown, for example, in the celebrated nudes in the Baptism of St. Peter, in the figure of the baptised man, and of the shivering youth who stands behind him. Not only from the point of view of content, but also from that of the formal construction of these nudes, it is a vast step from Giotto's somewhat indefinite and frail Christ in the Jordan—and even this figure of the Arena chapel stands alone in Giotto's work—to Masaccio's classicising, vigorous figures with their obviously real joints and bones: a step on the path towards the deliberate mastery of the nude and the creation of ideal types of physical beauty and perfection. A similar change is seen in the treatment of drapery. For Giotto, body and garment were to a certain extent still a single whole, although as concentrated cubic mass highly effective. In the art of Masaccio the garment, in its natural gravitating function, has, aided by the influence of classical statuary and by that of Nanni di Banco and Donatello, become independent of the body, just as the body itself is also given free development in full dynamic force.[15] At the same time, deep naturalistic colours, the whole manner of lighting, the chiaroscuro, impart to the figures a modelling that is pictorial yet lucid and plastic—in marked contrast to the uniform, bright, two-dimensional colouring of the late Trecento.

The composition is now built up from within, far more than was previously the case even with Giotto. The coherently constructed figures are linked together into groups, which in their turn are joined up with the coherently organised background into a unified composition—though this problem of connecting body and space is not always fully solved.[16] The composition is calm, economical, and grandiose, and is based in the main upon verticals, their effectiveness enhanced by their transsection by a few very straight diagonals. Even the landscape with its sweeping comprehensive lines is subordinated to the rationalistic construction of the whole.[17] Lofty, ponderous mountain ranges have taken the place of the old conventional rocks. Superficial realism of detail is as absent in the landscape as in the figures. The colouring of the whole is harmonised and graded by the employment of aerial perspective.

Like Giotto in his time, but on a still stronger naturalistic basis, Masaccio pierced through to the typical elements of all phenomena, and as a result achieved a monumental, ideal style. We can look upon this restrained, exact, scientific and classicist style of Masaccio, especially as exemplified in the Carmine frescoes, as representing the peak of upper-bourgeois rationalism in religious art, a peak that could be reached only under the rule of a victorious upper middle class. It is, of course, no mere accident that Masaccio reverted to Giotto, and particularly to his latest and most advanced works, the Peruzzi chapel frescoes of the story of the two St. Johns, which just because of their extreme progressive character had never previously been imitated;[18] for these represented the art of the proudest period in the earlier development of the upper middle class, when it did not yet feel itself menaced by the petty bourgeoisie. And just because Masaccio's art was so extreme and towering an achievement, in mentality comparable only with the most progressive Bruni-Niccoli circle, it remained, on the whole, little intelligible to the average middle-class citizen of his day. His works scarcely appealed at all to his contemporaries, and he seems to have received his commissions only as the result of the efforts of a few Carmelite friars[19] who were art connoisseurs,[20] or else his personal friends. Nor was it a mere accident that the great and too progressive artist had no personal possessions, lived in an extremely modest, confined studio, "parte di una bottega",[21] and died heavily in debt.

How profound the ideological and, with them, the artistic contrasts within the ruling stratum of the upper middle class could be, is shown by a comparison between an Adoration of the Magi, a predella panel (now in Berlin; Pl. 104) from Masaccio's Pisan altarpiece (1426–27) and another version of this theme painted in 1423 by Gentile da Fabriano (c. 1370–1427) for Palla Strozzi (Uffizi; Pl. 105).[22] As representations of the Adoration of the Magi are fundamentally self-illustrations of the rich and as such are especially well adapted to serve as a reflection of the ideology of the ruling class, the contrast between the two paintings, executed almost simultaneously, is all the more striking. The action in Masaccio's panel is confined

simply to the most indispensable figures, and to a very small, almost "puritanical" entourage. Only the youngest of the three Kings is dressed in the elegant manner of the fashionable youths of Florence, while the two followers in the fore-ground—the nearer certainly a portrait of the notary, Giuliano di Colino, who commissioned the picture—are wearing the sombre black garb of the wealthy burgher of the time; the patron almost suggests—this is scarcely a forced com-parison—a contemporary representation of some self-assured Florentine am-bassador; he does not wear the idealised costume of antique orators like Donatello's prophet figures on the Campanile, but even his Florentine dress gives quite an "antique" impression. The same simplicity is found in the appearance of the few servants, and above all in that of the Virgin. The picture as a whole is composed of a few concise groups; the individual figures, clearly and massively modelled, are firmly placed on their feet within lucidly constructed space.

Before considering Gentile's Adoration we must briefly describe his per-sonality. Born in Umbria, he moved around a great deal, also at the Courts, became the most famous Italian painter of his day, and secured the outstanding orders which contemporary Italy had to offer—the frescoes in the Doge's Palace at Venice and those in S. Giovanni in Laterano in Rome. He was certainly a cultivated man, and gives evidence of receptivity to a high degree—to that degree, in fact, to which an artist can and must attain when his patrons are such distinguished, though not always very progressive personages as princes, aristo-crats, ennobled burghers and a pontiff such as Martin V. the ally of Florence.[23] At the North Italian courts he absorbed the knightly culture of France, and it was this culture which most appealed to and impressed the aristocratising Florentine upper middle class as a whole.

It was in this spirit that Gentile, when in Florence from 1422 to 1425, painted the picture for Palla Strozzi, father-in-law of that Felice Brancacci who was the originator of Masaccio's very progressive frescoes for the Carmine. Here we find that atmosphere of chivalry, which in representations of the Adoration of the Magi had to a certain extent begun to show itself in Florence from the end of the fourteenth century, carried to an extreme. Gentile must have known that most completely developed specimen of French courtly art, the Limbourg brothers' miniatures in the *Très Riches Heures du Duc de Berry* (finished 1416, Chantilly), among which are illustrations both of the Journey and the Adoration of the Magi (Pl. 107b). He proceeds to graft this late-Gothic, French, courtly art, with its excessive richness, on to the stock of the Florentine tradition, with its similar potentialities.

Gentile's exceptionally magnificent church panel is just an illustration of the life of chivalry, or rather of that favourite knightly pastime, hunting. The picture is mainly made up of a seemingly unending procession of overloaded and overdressed courtiers going forth to the hunt with magnificently caparisoned horses and with dogs and falcons, all correctly equipped for the chase. The

chivalric character of these figures is emphasised to such an extent that, even while in the act of offering his gifts, one of the Kings is having his spurs removed by his esquire (imitating a motive of Martini, who in one of his Assisi frescoes shows St. Martin's spurs being affixed while he receives knighthood). Not even the richest *jeunesse dorée* of Florence could have worn the extremely luxurious court-clothing of these kings (Pl. 106), which was perhaps admired as a possible supreme ideal of fashionable elegance at some princely court in Northern Italy or France. No doubt the aristocratising upper middle class were delighted by the meticulous reproduction of this finery. The partiality for contemporary costume in painting that had made its appearance during the democratic period about 1350–70 continued thereafter and even became intensified, concentrating by this time on the unbelievably sumptuous, aristocratic-Gothic fashions of the well-to-do. Even the Virgin is no longer depicted as a simple woman seated beside the manger; she too must have her entourage. The two women, who according to the legend had assisted her in childbirth, become transformed into two expensively dressed ladies-in-waiting holding gifts in their hands. The bearing of the main figures is lyrically gentle and aristocratically detached, while the others show at most only pleasure in the hunt.

In this painting Gentile employs continuous narrative, such as was usually confined to predellas: above the Adoration itself, in the three arches, are represented the events which preceded it: the vision of the star by the three Magi (even here there is a large retinue), the entry of the Kings into Jerusalem, and their departure from the city. But this splitting up of the unity of the subject is not the only reason why we cannot discern any disciplined construction in the painting. Within the procession itself the figures are so tightly packed that they have to be squeezed together so that only their heads are visible. The spatial interrelationships of the figures are completely obscure, and the whole composition leaves a rather two-dimensional impression. The realism of detail is quite exceptional, and is given especially full scope in the meticulous rendering of the clothing of the rich; the gold ornamentation of the garments is even executed in relief in the old-fashioned craft manner, so that it should strike the eye all the more. But the animals—horses, camels, leopards, dogs, monkeys, and falcons—also show ample evidence of the artist's love of detail and even of foreshortening. Gentile appears to have studied flowers, in particular, with great exactitude; the lateral pilasters of the frame, like the margins of French prayerbooks, are covered with flowers (Pl. 116b), displayed individually and painted with extreme fineness as in a miniature. Certain effects of light on the landscape are also delicately calculated. Nevertheless, this joy in rendering landscape did not prevent the artist from retaining the traditional golden sky as a background. Moreover, the whole minute treatment of detail is carried out regardless of any differentiation between background and foreground. For it is precisely this extreme realism of detail which, in this period, is typical of the courtly, feud-

alising late-Gothic style. Although the artists working in this style, and Gentile in particular, learned very much from upper-bourgeois naturalism, it is nevertheless significant that these adoptions took the form of an exaggerated realism of detail. This type of realism not only prevented the achievement of a concentrated composition, but also made the construction of the figures as real organic units impossible. This lack of corporeal clarity in the figures and their delicate colouring are well matched by their elegant slimness, and by, here and there, soft, linear rhythm: elements which still express the formal idiom of the Gothic. We have here, then, a style very different from the classicistic and upper-middle-class manner of Masaccio. This painting of Gentile, certainly extremely unclassical from Masaccio's point of view, was executed for the same Palla Strozzi who was known to have been a great lover of the antique, and in particular to have fostered the study of Greek at the University of Florence.[24] This is a typical illustration of the way in which, among the wealthy upper middle class, a late-medieval, chivaleresque culture fitted in very well with their own particular conception of antiquity.[25]

So, as we see, the contrast between Masaccio and Gentile, those representatives of two different trends in the Florentine upper middle class, is clear-cut. But if we are to understand the art of Gentile and appreciate its position in the Florentine development, it is not sufficient to confine ourselves, as we have done hitherto, to its aristocratic side alone.

Gentile came originally from an Umbrian (Marches) monastic milieu. His family was closely connected with the Olivetans in Fabriano. Gentile himself was in contact with the Franciscan Observants, who were particularly strong in Umbria; for their settlement in Valle Romita, near Fabriano, he painted a Coronation of the Virgin (now in the Brera). His very rare early works include two versions of St. Francis receiving the Stigmata—one in the predella of the picture above-mentioned, the other an independent representation (Fabriano, Museo Civico). The style which Gentile displays in this early period—and also, in the main, throughout—is of a religious and mystical type, which, in its Gothic calligraphy, combines, as so frequently in Umbria and Siena, the potentialities of popular art with aristocratic elegance. We meet, among Gentile's works, the type of the Madonna of Humility, sentimental, seated on the ground (Pisa, Museo Civico),[26] and at the same time the Madonna of the Knights, a very distinguished, charming lady enthroned in state—one of those ladies of whom the knights sang as the object of their chivalrous devotion (e.g. the London picture; Pl. 103).[27]

In the course of his development Gentile becomes less Gothic and calligraphic and more consistent and naturalistic in details—his Florentine period, and his contact there with the upper middle class, certainly played an important part in this. A comparison between his two versions of the Coronation of the Virgin, painted at different periods of his career, is instructive. In the early work

already mentioned, painted for the Franciscan Observants, the figures are conceived in combination with their clothing, in an ornamental Gothic manner; the draperies, Martini-like, have copious folds flowing in all directions, but at the same time the materials are relatively modest, with either quite simple patterns or none at all. Ecclesiastico-religious motives are prominent in this picture: God the Father, with his stiff, hieratically rendered Cherubim, floats above the principal figures, and in the lower half small angel musicians are posed in medieval manner in the Heavens, depicted as a star-strewn segment.[28] The version in the Heugel collection in Paris, on the other hand, painted at a later date—probably in Florence itself—shows a weakening of the mystical, monastic tendency and a closer approach to the taste of the aristocratically-minded middle class. God the Father with his cherubim has now disappeared, and the arch of heaven with them. There remain only the two principal figures, to whom the angelic musicians are now added as a courtly retinue. Both Christ and the Virgin are attired in the most costly stuffs, covered with patterns of enormous flowers and other over-rich decoration,[29] reminding us of Gentile's Three Kings in their excess of pictorial opulence (see also the lady, Presentation in the Temple, Louvre; predella of the latter picture, Pl. 108a).[30] And yet this over-decorated drapery is more naturalistically rendered than are the simple materials in the Brera picture: the folds, for instance, now follow the law of gravity and tend much more to fall and lie along the ground. Thus it was not only the aristocratic element, but naturalism as well, which was in the ascendant in Gentile's style.

But even in this late period the mystical, somewhat "popular" elements inherent in his art were never completely lost; not even in his contact with the Florentine upper middle class,[31] which was after all the class that supported the Observance movement. With Gentile one can never tell—in the Nativity predella to the great Adoration, for instance—where the mystic, fairy-story elements in representation, details, lighting effects, end, and his widely diffused observation of nature begins. Even the Adoration itself is under the influence not only of the courtly *Très Riches Heures du Duc de Berry* (Pl. 107b), but, still more, of a thoroughly popular Gothic picture, the Adoration by Bartolo di Fredi (Siena, Pinacoteca; Pl. 107a), the principal artist of the democratic period in Siena. Gentile has no doubt imparted a delicate refinement to the schematic and doll-like, richly clothed figures of Bartolo, in their clumsy mimicry of aristocratic art, and above all he has spun out his story with a far more careful realism of detail. Nevertheless their stylistic relationship remains, clearly explaining why Gentile has so obviously taken over from Bartolo not only the crowded general arrangement, but also a number of single motives.

But in order fully to understand the extent of Gentile's positive assimilation of the achievements of upper-middle-class naturalism, we must turn to the works of another artist active in Florence, in whom we find to some extent a

combination of elements similar to those in Gentile. The painter in question is the Camaldolese monk Don Lorenzo Monaco (1371–1425), whose style is more unambiguously late-Gothic than Gentile's. Compared with Lorenzo's representations of the same themes (which we shall discuss in detail later) Gentile's observation of nature appears remarkably accurate,[32] and the abstract Gothic schematism of his compositions and the Gothic swing of his figures seem relatively slight (cf. Pl. 109b and Pl. 109a, another of Gentile's predellas for the Adoration of the Magi). To take another instance, the lighting, the lightening of the colours stand in a far closer relation to the plastic modelling of the bodies in Gentile than in Lorenzo, though not to the same extent as in Masaccio. Courtly finery is expressed in Gentile, as we saw above, by means of circumstantial realism, not, as in Lorenzo, by a redundancy of abstract Gothic drapery folds. Nor, admittedly, does Lorenzo utterly reject the achievements of upper-bourgeois naturalism. For his art is, at bottom, no less closely connected with the aristocratising upper middle class, as could not but be the case with the artistic productions of a distinguished monastery. At the same time, the art of this monk naturally contains strongly developed monastic and mystical elements, combined with a marked tendency towards the popular—and all this much more pronouncedly than in Gentile. The many-sidedness of the mentality of the Florentine upper middle class becomes apparent when we place side by side Masaccio, the representative of its intellectual rationalist upper stratum, Gentile, representing the aristocratising upper bourgeoisie, and finally Lorenzo Monaco. In the case of the last, where upper-middle-class taste finds its expression through an Observant monastery, the difference from Masaccio becomes immeasurable.

Lorenzo Monaco, a contemporary of Gentile, had begun to work in Florence (he is first mentioned there in 1392), even before Masaccio was born, and long before Gentile arrived. After having received his training (possibly under Bartolo di Fredi) in the much more democratic centre of Siena, he came to Florence, where the general situation, despite the closer contacts just then being made between the various social sections, was radically different. Here he lived and worked in the Camaldolese monastery of S. Maria degli Angeli. As we have seen, the distinguished and cultured Benedictine monasteries were at this time, simultaneously with the increasing urge for distinction and culture among the middle class, coming to the fore, and therefore having an important influence on the arts. Following the large Benedictine commissions of Spinello and the activity of Don Simone Camaldolese and his workshop in the sphere of miniatures, Lorenzo Monaco began his most extensive production as painter of altarpieces, frescoes and miniatures in S. Maria degli Angeli. This monastery, which had originally been far from popular, was at this time kept under the rule of the strict Observance, in line with the general movement in the early fifteenth century, by the fashionable humanist Abbot Ambrogio Traversari.[33] So there

was sufficient latent or rather apparent contradiction: in the distinguished Bene-
dictine monasteries, connected with the upper middle class, which were now
attempting through their strict observance to establish contact with the wider
public; in the Camaldolese Abbot Traversari himself;[34] and finally in the art of
Lorenzo, the native of Siena, an art which was the source of large commissions
by various Benedictine monasteries.

But the contradiction within Lorenzo's work between aristocratic and
popular elements—as we have so often mentioned, fundamentally related to
each other—is not very sharp in the purely formal sphere, since both were ex-
pressed in the common idiom of late Gothic. The Sienese-Gothic influence
(Martini, Memmi, Bartolo di Fredi) became a decisive factor in Lorenzo, both
in his manner of emphasising religious emotionalism and in the particularly
strong accent he placed on formal Gothic elements (cp. Pl. 113a and b). The
influence on Lorenzo of the French and Burgundian late-Gothic style of his own
time—these countries were, in an upper-bourgeois sense, less progressive than
Florence—also tended in the same direction, that of Martini. About the middle
of the fourteenth century the art of Florence, that of Giotto, had been trans-
mitted by Martini, that is to say, by way of Siena, then economically and
socially backward, and adapted to the still more backward France. Now,
however, at the beginning of the new century, when the Florentine upper middle
class was declining, this late-Gothic, Sienese-French transformation of the
Florentine style necessarily became topical once more; and so we find the
Florentine style, thus transformed and internationalised, now returning to its
birthplace. Gentile's popularity with the aristocratically-minded middle class
of Florence in the 'twenties was promoted, too, by his association with this
international, courtly style. But Gentile, who arrived in Florence only in 1422,
was already linked with a later manifestation of this international style—with
the extreme courtliness, combined with extreme realism, represented in the
Très Riches Heures du Duc de Berry (finished in 1416; Pl. 107b). And Florence,
as early as the turn of the century, had offered a receptive atmosphere for the
international Gothic style in the general form it had taken between 1370 and
1400, with its aristocratic and, at the same time, emotionally religious tend-
ency.[35] For the majority of the upper middle class, in the grip of the first stages
of decadence and declining fortune, were, as we know, striving after aristocratic
ideals. And, generally speaking, the attitude of the broad upper strata which
follow immediately after the thin layer of the ideologically most progressive, and
were now also economically on the decline, was similar to that of the lower
strata, and of a strongly religious and emotional nature. The Observance
movement, in view of this increasing emotionalism and religious feeling, exerted
a further unifying influence over the various groups within the middle class.
That is why Lorenzo's many-sided art, arising at the turn of the century and
serving the purpose of this movement, was accepted with understanding, by very

reason of its complexity, by the affluent and all the more by the less well off; it was a monastic, late-Gothic art, in which spiritually animated content as well as formal elements and realism of detail each played their part, but in which religious emotionalism was definitely more pronounced than subsequently in Gentile's. And Lorenzo's artistic development, in accordance with the social and ideological changes taking place in Florence during the first decades of the century, was such that his Gothic style tends away from the popular to something much closer to the aristocratic taste—the taste of the aristocratically-inclined middle class.

To arrive at an understanding of this complex style in its individual manifestations, we must first consider the specific subject-matter of Lorenzo's numerous altarpieces, large and small, which he executed generally for Benedictine monasteries and probably on occasion for individuals.

His most usual subject is the Madonna, often surrounded by saints. It was Lorenzo who was largely responsible for the popularisation about 1400 of the Madonna of Humility type, already, though not very frequently, found in Florentine democratic art during the second half of the fourteenth century.[36] The immediate Florentine precursors and parallels of these pictures of Lorenzo, also from a formal point of view, were the gothicising and very sumptuous versions of the Madonna of Humility, referring back to Martini, by the Master of the Madonnas (otherwise Compagno d'Agnolo), who came from Agnolo Gaddi's studio (Pl. 110a).[37] This, the period of the Observance movement, proved particularly favourable to the dissemination of this "sentimental" motive which, though propagated from above, appealed at the same time to the lower orders. Traversari, fundamentally anti-democratic though strictly Observant, calls Humility the mother of all the virtues. To understand how Humility, and with it the Madonna of Humility, was reinterpreted in clerical circles, we may recall the statement of another Benedictine, the Blessed Giovanni delle Celle (see p. 72), in which he contrasted the humility of St. Francis with the "pride" of the Fraticelli.

Lorenzo further carried over the Madonna dell' Umiltà motive into other themes to which it could be adapted. Sometimes he depicted the Virgin seated on the ground (Pl. 139b), weeping beneath the Cross, as found earlier in the *Speculum* manuscript already discussed, and occasionally also in Florentine panel paintings since the time of Daddi. Moreover, the faces of the Virgin and St. John, the two main witnesses of the Crucifixion, now take on a much more convulsed and anguished expression than heretofore.[38] An excited and ecstatic representation of the Crucifixion occurs frequently as Lorenzo's favourite theme, especially in his "popular" early period.[39] For example (in his Crucifixion in the Academy, Florence) he places to right and left of the Cross the instruments of the Passion, the lance and the sponge, which tower up in isolation, silhouetted against the sky, while above the Cross is shown the pelican with bleeding breast.

The whole conception is typically symbolic and popular, a kind of short summary of the whole Passion.[40] The huge painted Crucifixes of the early fourteenth century were also revived by Lorenzo, somewhat in line with penitential sermons, so that this type became popular once more. He adopted the device of cutting the picture to the shape of the outline of the body, so that it became almost a plastic representation of Christ crucified, and the effect, so "close to nature", was extremely striking. In some cases Lorenzo even cut out the whole Crucifixion group, including the lifesize figures of the Virgin and St. John, seated on the ground weeping (Florence, S. Giovanni dei Cavalieri; Pl. 111).[41] During his earlier activity he also represented the very effective and popular motive of the Man of Sorrows, so common in monastic art, which was combined with a number of small symbolical scenes from the Passion, and so set forth didactically the whole Passion history (1404, Academy, Florence; Pl. 112a). This type of representation probably came to Florence directly from pettybourgeois Siena (Bartolo di Fredi) though it was in France with her still more aristocratic and lower-middle-class atmosphere that it was really widespread.[42] The Man of Sorrows, standing in the coffin, is supported and mourned by the Virgin and St. John. Behind them, and above and below the arms of the Cross, the entire golden background is completely covered with small half-figures and other isolated motives. At the extreme summit, sun and moon are mourning for the Saviour (a motive taken from the Crucifixion) while between them is placed the pelican, symbol of Christ; further down, just above the arms of the Cross, come the two scenes of betrayal, with small half-figures of Judas and Christ to one side, St. Peter and the maid-servant to the other. Beneath the Cross, most of the Passion scenes are symbolised by a collection of hands, cut off at the wrists, and holding the instruments of the Passion. Pilate washing his hands, for example, is symbolised by the hands of Pilate and the servant, a pitcher and basin. On the Cross itself hangs the crown of thorns; on a column, the scourge, while the lance and the sponge rise against the sky. In front of the coffin, beside the ointment-jars of the three Marys, is placed the cup containing the blood of Christ. But in the very picture which displays these various popular motives, the sarcophagus is adorned with delicate arabesques, which clearly originated under the influence of Ghiberti's ornament, in his competition relief of the Sacrifice of Isaac—thus making it clear in this context too that Lorenzo was no one-sided, popular artist.

Lorenzo's pictures of St. Benedict and of his legend greatly help towards an understanding of his style. It was naturally the Benedictine saints whom Lorenzo most often placed around his Madonnas, and set in the most prominent positions: chiefly St. Benedict himself, but sometimes others, such as St. Romuald. That is why, also in the narrative predellas of Lorenzo's altarpieces, scenes from the legend of St. Benedict figure largely, as do scenes from the lives of various hermit-saints, such as St. Jerome or St. Onophrius (Pl. 115a). For the majority

of these saints passed the greater part of their lives in solitary prayer and penance, a manner of life which formed the basic character of the Benedictine Order. This hermit-like rule of life implied, for the Benedictines themselves, a dignified withdrawal from the outer world, and a somewhat haughty isolation on the part of the individual. But at the same time, as we have seen, this hermit-life was in our period also the new ideal of the Observance movement, likewise beloved of the poor. Its representation in art, therefore, could also take on a certain popular note. Even the Benedictine monasteries themselves, in their new and more topical situation already indicated, could not completely ignore this new interpretation of a conduct of life which originally meant something quite different; certainly, the Camaldolese, who were at this time under a very strict Observance, a mode of life which inevitably implied some approach to the lower classes, could not possibly do so. Therefore it was precisely from the Benedictines that the representations of scenes from the lives of the hermits received at this time a new impetus, as we saw when discussing Spinello's Benedictine frescoes. But their original "distinguished" interpretation of the hermit life was in no sense overlooked, especially in the case of representations from the life of St. Benedict. Both conceptions connect together and become merged.

Such, then, are some of Lorenzo's main subjects. Even this short description has indicated how his complex style indissolubly linked aristocratic with popular elements. We must now examine how these elements are expressed in the general style of late Gothic, by more or less similar formal means.

Lorenzo's figures seem to be moved, as in the whole international Gothic style, by a soft, ever-repeating, ever-continuous linear flow. This Gothic play of lines, of swaying figures and drapery falling in scroll-like folds, has a rather ornamental effect. Even the landscape and the architecture, the whole composition in fact, was subordinated to this linearism (Pl. 110b).[43] This was all the more so because the composition of each individual picture was partly determined by the altarpiece as a whole, and it was in Lorenzo's hands that these altar-designs, with their ever-richer and increasingly delicate Gothic forms, reached their peak in a profusion of gables, turrets, and finials. In the course of Lorenzo's career, we meet with variations in the manner and degree of his Gothic linearism, variations, too, according to the diversity of his tasks.[44] In his early works his style was somewhat clumsy and popular. The gothicisation, however, soon set in, and grew progressively richer, more calligraphic and more aristocratic in character; but he never completely lost the popular touch. Later, about 1410, his Gothic contours became simpler and clearer, and later still, particularly in his last years, the two-dimensional, calligraphic elements in his style were weakened by a middle-class realist tendency. Lorenzo's Madonnas often vary considerably from one another. His renderings of the Madonna of Humility or the Mary of the Crucifixion tend at first to a somewhat heavy simplicity, and the handling is at times Gothic only in a minor degree. The repre-

sentations of the Madonna on the great altarpieces, in particular the later ones, are on the other hand portrayed with more Gothic elongation, and are at the same time more majestic and distinguished (e.g. the Coronation of the Virgin of 1413, Uffizi). But in the course of his development his treatment of the Madonna of Humility also becomes more supple and distinctly partakes of the international, courtly style. We also find in his art a permanent tendency to emphasise, by the use of Gothic linearism in the Sienese manner, the emotional and the devotional aspects of his subjects. For example, the Madonna's maternal tenderness is emphasised by the soft posture of the slender hands. The very scroll-like Gothic contour determines, by accentuating a motive of Martini which corresponds both in content and form (Uffizi; Pl. 113a), the shy and startled attitude of the Virgin in the Annunciation (Florence, Academy, about 1406; Pl. 113b). Again, Christ praying in Gethsemane is stretched in a long, straight line as he reaches up heavenwards in devotion (Louvre, about 1408). St. Francis is depicted in the same way, as he strains upwards to be able to kiss Christ's wounds.

But the inevitable schematisation made necessary by the linear rhythm does not exclude a considerable number of realistic individual observations; in fact both these elements can be augmented simultaneously. It is this combination which is so characteristic of Lorenzo's style. Especially in his numerous narrative predellas in which the story of the Virgin, and particularly that of St. Benedict and other hermits, is deliberately painted with extreme care, is his naturalism most apparent in all its aspects. These predellas are filled with numerous genre-like features, and the architectural elements, above all the landscape, are given far greater prominence than hitherto. This realism of detail fits in quite satisfactorily with his usually very unreal spatial representation, related at times to Agnolo Gaddi, at others to Spinello. The comparison with Spinello, the other principal painter of the life of St. Benedict, comes naturally to mind. Whereas Spinello seemed to be strenuously labouring to achieve a kind of complicated perspective, Lorenzo used spatial relations to evoke a mood of fantasy, and a mystical impression, as for example in his story of St. Onophrius (Florence, Academy, c. 1420; Pl. 115a) with its desert landscape, seen from a great height. But it is the unusual colouring which mainly conditions the vein of fantasy in his narrative "naturalistic" predellas. He employs completely novel and refined effects of colour and lighting: a characteristic combination of the fanciful and the naturalistic. Lorenzo tones together his generally light colours—white, grey, light-blue, orange—and blends them in an unusually soft and subdued fashion, in contrast to the harsher colours of the main picture. By this means he obtains effects of transparency and an illusion of air. In these forest or desert landscapes, nocturnal lighting effects of twilight and of moonlight, often a gold background, combine to give an atmosphere of the fairy-like and enchanted, created by a man of cultivated spirit.

It will be useful at this point, in connection with these "precious" representations of hermits by Lorenzo, to adduce another contemporary example of monastic art with a very similar theme: a picture of the Thebaid (Uffizi; Pl. 114), formerly considered close to Lorenzo himself but probably produced by Gherardo Starnina, an artist of an earlier generation (born c. 1360–65, died between 1409 and 1413).[45] We have seen[46] that almost all the frescoes in the Cappella Castellani of S. Croce, which depict the popular theme of St. Anthony the Abbot, the best-known of the hermits, are equally likely to have been the work of this pupil of Agnolo Gaddi (Pl. 67). Starnina, having been implicated in the *ciompi* revolt,[47] had to flee from Florence: as a pupil of Agnolo Gaddi he was naturally by no means a "popular" painter, but rather an artist of the upper middle class who apparently, in his younger days, had sympathised politically with the lower orders, or perhaps with their progressive potentialities. Maybe this general outlook was not without interest for his artistic work. Starnina's Uffizi picture is a late one, painted after his return from Spain about 1404;[48] possibly it served as a panel insertion on a cupboard for the refectory or sacristy of a monastery.[49] But the whole conception and tendency of the work suggests that it was executed for one of the mendicant Orders and not for a Benedictine house. It does not depict the hermit-life of an individual saint, belonging to or popular with the Benedictines, as was usual in the case of Spinello Aretino or Lorenzo Monaco, but rather the lives of countless holy hermits in the wilderness, like the Pisan fresco from the middle of the preceding century (Pl. 32); and in fact Starnina's picture can be regarded as a small-scale popularisation of this work. Although within the general Observant tendency, this alone produces a notable difference in the interpretation of the two themes, in themselves closely related to each other; in fact the motive of the anchorites originates precisely from democratic Pisa, whence the Observant tendencies in general penetrated to Florence. It is the Observant ideal of life, seen somewhat from the angle of the democratic lower middle class, which finds expression in Starnina much more than in Lorenzo Monaco: the peaceful and meditative life of the hermit, without contact with any visible or worldly powers.[50] The whole treatment of Starnina's picture is appropriate to its popular religious subject. The descriptive presentation is straightforward, elaborated in a most genial fashion with no exaggerated fantasy. The picture is entirely taken up with innumerable little scenes placed above, below and beside each other, and with the movement of diminutive figures. The hermits are shown at prayer, discoursing with each other, or else, as in the Pisan fresco, occupied in agricultural work (Pl. 115b). This latter popular motive is never found in Lorenzo's representations of hermits, which are conceived in a much more distinguished manner. The wide sweep of the landscape in Starnina is dotted with numerous tiny dwellings and chapels. In the foreground is water with ships and sea-monsters; the background is composed of the usual Trecento step-like cliffs, but they lack the fantastic character of

Lorenzo's; they give a calmer impression and create spatial compartments. Although the picture has no unified point of vision and the foreground and background are on the same scale, yet undoubtedly an attempt at spaciousness has been made in this reversion to Maso, an almost cartographic purpose. This is apparently the first Florentine panel painting, other than a predella, to dispense with the gold background and to replace it with one in ordinary atmospheric tones. There is nothing particularly delicate or distinguished about the idiom of the figures, which on the whole are simple and homely, and can only in exceptional cases (e.g. where women are shown as temptresses) be called even moderately Gothic; compared with those of Lorenzo Monaco, Starnina's figures are much more firmly planted on their feet. Even if the picture undoubtedly has coloristic charm, yet as compared with Lorenzo's refined effects of light and lightened tints, greater simplicity prevails; for instance, drab and deliberately monotonous browns and greys. All things considered, this is a work with certain popular tendencies, but one which nevertheless shows decidedly progressive possibilities; it is the work of a precursor—one which, despite its universal intelligibility in a popular sense[51] points stylistically in some respects to the young Uccello, the young Lippi, and even to Masaccio himself.

That, on the other hand, Lorenzo's style tends rather towards the aristocratically-minded upper middle class can nowhere be better seen than in his miniatures for various richly decorated manuscripts (choir books and missals), destined for use in his own monastery and in that of S. Maria Nuova. They consist mostly of single figures of prophets, often in a state of intense emotional agitation—when they are somewhat reminiscent of Pietro Lorenzetti—but, at the same time, their unreal Gothic undulations pass over into the over-rich decoration of the framework. This latter feature is particularly noticeable in the miniatures of a Sunday Diurnal (*Diurno Dominicale*) executed in 1409 (Laurenziana, originally in S. Maria degli Angeli; Pl. 116a). The scrolls of the drapery, the curves of the foliage decoration, and the long-necked birds in this work together present a typical ensemble of the international Gothic style, fantastic and yet extremely realistic in detail; the influence of aristocratic French miniature painting is clearly apparent. In this connection, it is worth quoting Traversari's remark that the monks in his monastery executed their illuminations "with elegance".[52] In the above-mentioned manuscript another type reaches, in Lorenzo's workshop, a temporary culmination; this is the monastic, transcendental rendering of the Resurrection, taken over from the circle of Don Simone: the Risen Christ, elegantly posed and drawn with all the flourish of late Gothic, is shown floating high up in the air. The mixture of aristocratic and popular which we find in Lorenzo's own miniatures takes a slight turn, in the case of other monastic miniaturists of his workshop or of his milieu in S. Maria degli Angeli, towards the popular,[53] which implies a certain coarseness and some decrease in delicacy and finesse.

Lorenzo's various representations of the Three Magi are particularly good examples of the close affinities and ever-changing variations of aristocratic and popular elements within his late Gothic style,[54] reflecting the specific situation of the upper middle class during these decades and of the Benedictine monasteries with which they were closely linked.

A drawing of the Journey of the Three Magi (Berlin; Pl. 117) of his late period—a theme not very usual taken by itself, and appearing rather in Siena (e.g. Bartolo di Fredi) and the North—is one of the most ecstatic and fantastic works of this whole period in Florence. The drawing is executed with brush on brown paper, and the figures are thrown into relief solely by means of the heightening with white. With their gaze fixed on the guiding star, the three kings are shown riding frantically over the rocks as if possessed. Their bodies and arms, even their horses, all seem to stretch out towards the star. The outlines of the figures, seen together with the horses and the rocks, are tortuously elongated and distended upwards, and all are indissolubly connected with each other through the Gothic line-rhythm. Turreted castles reach skywards from sheer cliffs, and both at top and bottom of the composition are scenes with ships. The effect of the three riders amid this wild and fanciful landscape is almost uncanny. In no other work did Lorenzo so completely throw aside all rational proportions and perspective, the spectator having the sensation of being perched high up in the air; "inverted" perspective is employed,[55] making the figures in the middle distance appear gigantic, those in the foreground tiny. The whole representation is dominated by pure ecstasy, not by aristocratic nonchalance.[56] But it is, so to speak, cultured ecstasy. In fact, the drawing signifies a "popular" moment of a cultivated artist, whose extreme late Gothic formal idiom was closely linked with the aristocratising, polished upper middle class.

How close this link really was is shown by Lorenzo's numerous representations of the Adoration of the Magi, a theme directly connected historically with the scene of their journey. It was Lorenzo who was mainly responsible for continually accentuating the richness of the scheme of this representation—such a favourite with the well-to-do Florentine burghers—and the elegant Gothic sway of the figures. Lorenzo's development, which in the increasing luxuriance of this theme in a sense paved the way in Florence for Gentile, leads from the predella in the Parry Collection at Highnam Court (of c. 1405, originally in the Benedictine Badia) through the Uffizi predella (1413, perhaps from S. Maria degli Angeli) to the huge altar-panel, also in the Uffizi, which the artist painted in his late period (c. 1420-22, probably for S. Egidio).

This last painting marks, within Lorenzo's late period, a certain climax of his aristocratising Gothic. An elegant, richly clothed retinue is shown, even a hound held by an attendant with a hunting horn slung on his back. But it is scarcely as yet the amazing hunting procession that Gentile was soon to paint; the emphasis is on the exotic, the fantastic and the oriental, rather than on the con-

temporary and the courtly elements, and the Magi themselves are therefore not quite so luxuriously apparelled. In contrast to that aristocratic insouciance and that joy in the hunt which we find in Gentile, we notice in certain motives of Lorenzo a more agitated content: one horseman, swinging round suddenly, clutches violently at his head, as another, with outstretched arm, impetuously points out to him the Madonna, and those following in the procession stand back in reverent awe and wonder before the Virgin and Child. This stronger emphasis on the religious content and the tendency towards excitement and fantasy suggest that here also—though not to such a degree as in the Journey of the Magi—we have a move towards the popular. In Lorenzo we find a far greater delight in Gothic play of line, in swaying figures and scroll-like garments, than in Gentile, who inclined more markedly towards the upper-bourgeois naturalistic achievements. Lorenzo's figures are less substantial, more two-dimensional, his landscapes are more fancifully schematised and less attention is paid to perspective. Lorenzo, moreover, was influenced, just as was Gentile, by the popular Adoration of the Magi of Bartolo di Fredi, and although he gave a courtly transposition to this model, he nevertheless kept closer to its conventionalised style. For, as we have so often pointed out, it is precisely this tendency towards the popular which is related to the tendency towards courtly, aristocratic, and formal Gothic:[57] both appear in Lorenzo to a far greater degree than in Gentile, who, in spite of near kinship, is yet more naturalistic.

In his last years, during the climax of the upper-middle-class ideology in Florence, Lorenzo himself developed to a certain extent in the direction of a more progressive upper-middle-class style. Characteristically, this evolution is seen in the frescoes of the Story of the Virgin and in the related altarpiece of the Annunciation (one of the predellas, Pl. 109b), ordered by the bankers' guild, one of the most typical upper-middle-class corporations, for a chapel in S. Trinità (c. 1420–25).[58] It is noteworthy that for these paintings the bankers should have chosen Lorenzo Monaco rather than a consistently progressive artist, and we can be quite sure that they would never seriously have considered Masaccio. For the bulk of the upper middle class was not so radically progressive as its intellectuals; only the potentiality of a genuine progressive upper-bourgeois artistic taste existed, and it was a taste certainly not shared by the majority of this class. So the bankers' guild turned to Lorenzo who, though only moderately progressive, was yet, within his own sphere, a painter of great delicacy and high quality. Moreover, he was himself developing towards their taste, shedding the more extreme courtly and popular elements of his style. Thus arose just the right mixture, the right compromise: the frescoes are more calm and monumental, are all composed from the same point of vision, and possess a limited spatial depth; the figures, many of them at least, have become less scroll-like and show a more solid modelling.[59]

Now that we are acquainted with the main types—the styles of Masaccio,

Gentile, and Lorenzo Monaco—we can find our way more easily among the numerous stylistic variants of the Albizzi period. The complications involved in the description of Gentile's style, and, in particular, of the late style of Lorenzo, necessarily arose from the fact that with the exception of the progressive, upper-bourgeois style of Masaccio there was no pure style in this period; the confusion and lack of precision of the ideologies of the other strata made its existence impossible. During this period it is difficult to distinguish between the two related forms of the Gothic of the bourgeoisie approximating to the petty bourgeoisie and the Gothic of the aristocracy. As to the late fourteenth century, it might in principle be claimed that the former style tended towards a religious animation coupled with moderately Gothic formal idiom, whereas the latter favoured lyrical delicacy of feeling and elongated, scroll-like figures. At the beginning of the next century, on the other hand, the almost universal tendency in the upper middle classes to imitate the aristocracy, and among the lesser burghers to imitate their betters, makes it almost impossible to draw any distinction, even the most general, between the two styles. They exerted a reciprocal influence on one another, continually changed and frequently coincided, so that the most numerous variants became possible. The artistic problem of the Albizzi period can, then, be stated in simplified form in these terms: two currents had somehow to be reconciled, the one the Gothic manner, which penetrated about 1400, arising from two different tastes, that of the lesser burghers and that of the aristocracy (Lorenzo Monaco and Gentile da Fabriano respectively) and thereafter assuming various forms; the second, classicist current, made up of the achievements of a radical naturalism, particularly in the twenties (Masaccio), and having its origin in the rationalist attitude of the most progressive of the upper middle classes.

We may say that the history of religious painting during these decades is really the history of the varying shades of this compromise. It is impossible for us to trace every personal nuance; we must be content to mention a few of the most outstanding.

Probably no artist was so much influenced by Masaccio as was Masolino da Panicale (1383–1447)—that is why their work is so often confused—yet in point of fact the development of Masolino, who was the older by eighteen years, is very different from that of the younger master. Masolino was about twelve years younger than Lorenzo Monaco, from whom he clearly originated; his Munich Madonna dell' Umiltà of about 1423 has the richly-draped-Gothic style of Lorenzo, but a much more plastic substantiality is imparted to the figures. His fresco of the Man of Sorrows in the Collegiata at Empoli (c. 1424–25; Pl. 112b) may be regarded as to a certain extent a classicistic transformation of Lorenzo's painting of the same theme (1404; Pl. 112a); in it the popular elements are given a different manner of arrangement, and at the same time are much reduced: only one instrument of the Passion is shown hanging on the Cross; the sacred

napkin, placed high up in the gable of the picture, dominates the composition, also from a formal standpoint. This represents a compromise between the popular subject-matter and its provincial atmosphere on the one hand, and the new artistic strivings of Masaccio on the other. About 1425 in those sections of the Brancacci frescoes for which he was responsible (e.g. St. Peter preaching and the Healing of Tabitha), Masolino's style approaches very close to that of Masaccio who was working with him. But in the fresco of the Healing of the Cripple are two figures which give us an indication of the contrast between the "courtly" Gothic of Masolino and the middle-class gravity of Masaccio: the two very elegantly dressed, Gentile-like Florentine dandies who stand aside gossiping and take no part in the main action of the scene (probably Masaccio also collaborated in this fresco, though on other details). When about 1428–31, by order of Cardinal Branda Castiglione, Masolino decorated St. Catherine's chapel in S. Clemente in Rome, he was at first, particularly in the fresco of the Crucifixion, very much under the influence of Masaccio, then still his collaborator, who died as early as 1428. Masaccio's mark is still, though not quite to the same degree, evident in the frescoes of the story of St. Catherine and St. Ambrose in the same chapel: here the narrative is less concentrated and the effect much flatter. Another painting by Masolino, also destined for Rome (for S. Maria Maggiore, probably by order of the not very humanistically-minded Pope Martin V) is very typical of his courtly manner of conception. In a section of this altarpiece, the Assumption of the Virgin (Naples; Pl. 118b), where the whole composition is reminiscent of Sienese and northern art, Mary is led up to Christ by a band of elegant, swaying angels like attendant pages, playing musical instruments; replacing the Mandorla, they form, together with the Cherubim, a series of ovals encircling the Virgin (Regina Angelorum; the motive comes from fourteenth-century Sienese painting).[60] The richness of the clothing became increasingly accentuated in Masolino's pictures: in the Annunciation (painted c. 1430, probably for a Florentine church) in the National Gallery, Washington, carried out under the influence of Gentile, particularly of the Quaratesi Madonna, the ruling note is the angel's red dress with its pattern of enormous gold flowers. Of a later date, perhaps c. 1430–35, is a Madonna of Humility (Florence, Contini coll.). It is here that Masolino's change of style is most apparent. The picture harks back, to a great extent, to an early work of the artist, the Madonna of 1423 in Bremen, which is entirely Gothic and was painted before Masaccio's influence made itself felt. That in the meantime he had undergone a Massaciesque phase appears only from the fact that the Contini Madonna is more monumental, more grandiose within the Gothic scheme, than the Bremen Madonna. Now Masolino is once "again" Gothic, in his early period he was "still" Gothic; one phase seems to pass over into the other.

Only from the angle of this re-gothicisation can we also understand the cycle of frescoes in the Baptistry at Castiglione d'Olona in Lombardy, painted

in 1435 for the previously-mentioned Cardinal and depicting the story of John the Baptist. The influence of Gentile (in particular of his Adoration of the Magi) is now perhaps more vigorous than Masaccio's. Unity of spatial relations disappears, and an extreme realism of accessories and delight in externals dominates the frescoes. It is characteristic of this composite style that, for example, in the scene of Herod's feast or of the Baptist's head being brought in on a charger, the courtly modish figures move about beneath foreshortened classicist arcades of columns. Thus even now Masolino employs perspective devices, perhaps more than ever before, in a style which is very far from classicist. Masolino's delight in detail is to be seen also in the nudes which he introduces—as does Masaccio—into the scene of the Baptism; though he lacks Masaccio's grasp of the unity of the human organism. But this love of detail is given fullest rein in his portrait-heads, in fashionable, courtly costume figures, and in landscapes. It is significant of Masolino's style, gothicising and striving for realism at the same time, that whereas, in general, the cliffs are represented, as by Lorenzo Monaco, in a purely schematic step-like fashion, yet certain motives are reproductions of actual recognisable scenery; even a faithful view of the city of Rome appears in the scene of the Annunciation to Zacharias, and one of Castiglione d'Olona itself in a fresco in the Palazzo Castiglione. In the cycle of the Baptist Masolino utilises every possible opportunity of representing court-figures in a realistic way. Comparing his scene in which Salome hands over the saint's head to her mother (Pl. 119a) with the same scene as painted by Giotto in S. Croce (Pl. 21a), we see that Giotto's monumental, bourgeois figures have been transformed into elongated and delicate court ladies in French Gothic costumes; Masolino has also added two girls, their horror at the event betrayed in their agitated gesticulations and expressions. In fact, this Florentine artist was now carrying on the wrought-up religious narrative style of the Sienese middle class, just as a hundred years previously Pietro Lorenzetti had translated the same work of Giotto into Gothic idiom (Pl. 21b). But Masolino combines this style with Gentile's aristocratic composure and distinction, especially in the case of the main figures; for it was natural that the international courtly Gothic to which Gentile adhered should be a vital influence, particularly in Lombardy. After 1435, for the same cardinal, Masolino painted frescoes with the story of Mary, on the vaulting of the Collegiata church at Castiglione d'Olona (Pl. 119b). He now turns most radically towards Gothic, even if we take into account the elongation required by the narrow panels of the vault: his extremely long figures are almost bodiless, the general effect being determined by Gothic verticality and linear rhythm. Thus, from a classicist and naturalistic standpoint, Masolino's development marks a certain retrogression.[61]

Hence, Masaccio's upper-middle-class style could not hold its own even in the case of the artist who had actually worked with him on the masterpiece of this very style. For the wholesale, ceaseless decline of the upper middle class and

its ideology was, of course, reflected in the artistic field; though their individual achievements were not lost sight of, their general artistic aims could no longer be maintained. In the late twenties and during the thirties a certain influence of Masaccio is indeed to be detected, more or less universally. Yet at the same time—this constitutes the compromise we have mentioned—we can see in Masolino and the majority of other painters a slow but steady re-gothicisation. We can regard the whole painting of the Albizzi period, the later part of it in particular, as a kind of equilibration between the various trends which arose from the late Gothic style, sometimes in its more extreme, at others in more moderate forms. The small number of artists who worked in proximity to Masaccio soon afterwards tended to revert to the Gothic manner, as we have seen in the case of Masolino. Numerous artists, on the other hand, belonging to the various successive waves of the international Gothic style, are not entirely free from a certain, albeit slight, leaning towards Masaccio's manner. But it was the style of Gentile, much closer and more easily comprehensible to them, which exerted a far stronger influence in the direction of realism on these gothicising artists.[62] To understand this we need only remember how much more realistic his style is than that of Lorenzo Monaco. But this influence naturally fell far short of such consistent realism as was represented by Masaccio's style, the effect of which only slowly became to any appreciable extent apparent in the work of the most distinguished and progressive artists, such as Fra Angelico or Uccello. On the other hand, we find some among the adherents of the international Gothic style extracting the courtly Gothic elements from Gentile's painting and carrying them to an extreme, quite unaffected by its realistic elements, not to mention those of Masaccio. The manner of this gothicisation or re-gothicisation[63] may thus vary very considerably. We will therefore consider the general run of religious painting, as well as the work of the most important individual artists, starting at the beginning of the Albizzi period, and observe the most typical variants of the style of those times.

During the Albizzi period, Niccolo di Pietro Gerini, who died as late as 1415, was still the most notable painter of large altarpieces in a conservative, popular manner. In addition, we must take into account his pupil and collaborator, Lorenzo di Niccolo (active 1392-1420's) who still retained the archaic division of an altarpiece by surrounding the main figure with a series of separate little scenes; further Mariotto di Nardo (active 1394-1431) who also served his apprenticeship in Gerini's workshop and whose style remains close to Giovanni del Biondo. These workshops, which turned out numerous altarpieces for churches in Florence and the provinces, still tended to cultivate a two-dimensional hieratic style with large figures, deriving from Jacopo di Cione. At the end of the fourteenth century, this artistic idiom was a popular one, but by now, at the beginning of the fifteenth, it had become conservative, even within its popular framework.[64] At the same time these two younger artists, and also

Gerini himself in his very latest works, took over from Spinello and even from Lorenzo Monaco a slightly gothicising formal manner, though they gave it a more popular and schematic twist and did not greatly lessen the roughness and heaviness of their figures. This idiom on the whole represented, in permanent combination with elements of the conservative style previously mentioned, the popular artistic language of the greater part of the early fifteenth century.

One picture from this already gothicising late period of Niccolo Gerini[65] is especially worthy of remark, because in it—perhaps for the first time—the mystical and popular theme of the twofold intercession of Christ and the Virgin for sinners was represented in panel painting (Balcarres, Earl of Crawford and Balcarres; Pl. 121); this theme, which originated from St. Bernard, is often found in northern *Speculum* manuscripts, and occasionally also in Florentine miniatures.[66] Christ displays to God the Father the wounds which, at His command, he has received for the redemption of mankind, while the Virgin shows Christ the breast at which he was nursed. Large inscriptions explaining this double intercession fill the middle of the picture. Thus apparently it was at Florence that this theme, for the first time, was transformed into a real picture, and, with the addition of small figures of the donor's family, became a sort of protective family picture. This actual painting, which may also have been used as a processional banner, was originally in the chapel of the Pecori family in the Cathedral in Florence; the head of the family, shown kneeling in the foreground, was *Gonfalionere della Giustizia*. The picture, therefore, is definite proof that during this period such a popular theme must have suited the taste of a certain section even of the well-to-do middle class. Moreover, the Florentine transformation of this theme into a panel picture implies that the manner of its conception—and this is of fundamental importance—was less popular here than it was in the north, and had become almost more of a cult than of a devotional image. The figures of the divinities are given a more splendid and less pitiable form—as in the picture of the Man of Sorrows—and indeed Christ is not shown as a wretched figure of suffering as in the *Speculum* manuscripts, and more specially in the north,[67] but is represented in the somewhat precious elegant Gothic formal idiom.

The monotonous frescoes of Mariotto di Nardo[68] are especially significant of this mixed popular-conservative style; for example, his cycle of the Life of Christ painted for the Dominicans of S. Maria Novella in the chapel of the monastery (which later became the Farmacia). The schematic arrangement of the figures, with their wooden and inarticulated bodies, becomes particularly obvious if we compare the Deposition in this cycle with the far more coherently constructed picture of the same theme by Niccolo Gerini (Florence, Academy); this older representation was probably the inspiration for Mariotto's fresco, but Gerini's equally popular style still originated contiguously to a period of positive democratic activity. Mariotto's Madonna between SS. Stephen and Reparata,

destined for the hall of the wool guild (Florence, Academy), though somewhat more delicately conceived and already rather gothicising, yet shows that the Lana itself, in the early fifteenth century, was susceptible to this conservative, popular style. Even the Uzzano ordered a picture from Mariotto (Madonna with Saints and Angels, now Oxford, Christ Church). Mariotto was also responsible for one of the most popular themes of these years appearing in a fresco: the Man of Sorrows surrounded by the emblems and scenes of the Passion, in the Chiostro delle Oblate (Pl. 122).[69] This fresco was painted for a location easily accessible to the poor, namely a hospital. It is situated, together with a representation of Christ in Gethsemane, in a chapel which was, at that time, immediately beside the women's ward and which formed part of the nunnery belonging to and adjoining the hospital of S. Maria Nuova, being reserved for the use of the hospital nurses. The body of Christ, placed upright in the coffin, is mourned over by the Virgin, the Magdalen, St. John, and Mary the mother of James. The background is covered by numerous symbolical scenes of the Passion, as in the painting of the same theme by Lorenzo Monaco, from which it probably originated. These scenes of the Passion, showing only the head and shoulders, form two rows above and below the arms of the Cross. They represent: the Kiss of Judas, St. Peter cutting off Malchus' ear, St. Peter and the Maidservant, Judas and the Devil, Christ before Herod, Christ before Pilate, the Crown of Thorns, and, in addition, the various instruments of the Passion, held by hands cut off at the wrist. The fresco with its symbolical theme is painted in a way intelligible to the lower sections, who could "read off" the story; the figures—probably under the influence of Lorenzo Monaco—display a touch of gothicising, decorative, linear rhythm, but are nevertheless coarser than in that artist. This is a typical example of popular monastic art, and it is interesting that this popular theme should have been dealt with even in a fresco—an unusual occurrence in Florence.[70]

An artist even more conservative and popular than Mariotto, and one who therefore only appears in provincial commissions, is Cenni di Francesco di Ser Cenni, an imitator of Agnolo Gaddi, who in 1410 decorated the chapel of the Compagnia di S. Croce in the Church of S. Francesco at Volterra with frescoes illustrating the legend of the Holy Cross (Pl. 125). This cycle, appearing once more in a thoroughly Franciscan milieu, is really nothing more than a free copy of the frescoes on the same theme by Agnolo Gaddi in S. Croce of thirty years earlier (Pl. 124). What had once been popular and progressive had now become popular and conservative, and could have been painted only in the provinces. The slight variations introduced, together with a mild gothicisation of the original idiom, evidence no real possibility of advance, and are very characteristic of this lower-middle-class provincial popularisation. The different motives and personages are all heaped together and repeated, the clothing becomes richer, the colouring cruder, the landscape more complicated, and, probably

under the influence of Spinello, split up by great roads which end, towards the background, in culs-de-sac. In his fresco of the Massacre of the Innocents in the same church, Cenni carried through similar variations as regards Niccolo di Tommaso's painting of the same theme executed almost fifty years earlier. Of the numerous other frescoes in the chapel, a Stigmatisation of St. Francis (Pl. 126) may be singled out as showing a typically popular representation of a theme already popular in itself. Beside the most ecstatic figure of the Saint is a member of the Compagnia di S. Croce, in small scale, represented as a penitent, with a flagellant's whip. Behind and above the Saint rises a landscape with rocks and buildings as if put together from children's bricks. The whole fresco is of the most crude linearity. A comparison of Cenni's fresco of the Madonna in Glory (S. Lorenzo at S. Gimignano) with Masolino's Assumption of the Virgin (Naples) where in both cases Mary is encircled by ovals formed of angelic hosts, shows how the same "Sienese" theme of music-making angels was treated by a provincial artist on the one hand, and by an aristocratising painter who worked for cardinals on the other: in Cenni the angelic figures are much coarser, and the whole linear rhythm determining the composition appears, therefore, far more ponderous.[71]

Apart from Gerini, Lorenzo di Niccolo and Mariotto di Nardo, it would seem that Bicci di Lorenzo (1373-1452), who carried on the workshop of his father, Lorenzo di Bicci, Rossello di Jacopo Franchi (c. 1376-1457), and Giovanni dal Ponte (1385-1437) received the majority of orders for large altarpieces given, of course, only by wealthy middle-class citizens, fraternities, etc.[72] Rossello and Giovanni, who worked especially for provincial churches, were more firmly set than Lorenzo Monaco in a rather popular Gothic, and tried, during the later Albizzi period, to emulate the more courtly aspects of his style. Rossello—the coarser of the two—showed less skill in this attempt, and usually repeated the same hard, brightly coloured altar-panels of the Madonna and saints. Giovanni, more subtle and more interested in the narrative, had greater success with this change.[73] Some pictures by him of c. 1410-20 belong entirely to the Gothic-international style; he later became more plastic under a very superficial influence of Masaccio and Fra Angelico, without however, shedding any of his courtly characteristics (Pl. 127a). A somewhat similar line of development is apparent when Bicci di Lorenzo, especially after Gentile's arrival in Florence, fell under the spell of this extremely courtly painter; Bicci owned a large studio, which catered for very good Florentine circles (even for the Corsini, Uzzano and Medici), as well as for provincial churches. In keeping with the popular nature of his art, Bicci even exaggerated the Gothic elements in Gentile's figures, as, for example, in his free copy of 1433 (Parma, New York [Pl. 129], and Ashmolean Museum, Oxford) after Gentile's London Madonna and its predella with the legend of St. Nicholas (now in the Vatican Gallery; Pl. 128). The way in which the more popular and the more aristocratic types of Gothic merge into

one another is palpably clear in these pictures of Bicci, in which Gentile's figures become slimmer but at the same time more "harsh". And when we consider Bicci di Lorenzo's art from the opposite standpoint—when, that is, we observe how the same artist interprets not a courtly, but a much older, popular picture— we again see how the conceptions "popular" and "aristocratic", "harsh" and "delicate" simply take on different nuances in every combination. Hence, when in his Nativity (1435, S. Giovanni dei Cavalieri; Pl. 127b) he adopted the "popular" scheme of Niccolo di Tommaso (Pl. 54, cp. also Pl. 55), he gave to Niccolo's very coarse idiom an altogether more "delicate", more Gentile-like note. These comparisons all serve to show what a highly aristocratic character is assumed even by the relatively popular art of the 'thirties.

Francesco d'Antonio (1394—after 1449) who, among others, executed the important commission for the painted wings of the organ in Orsanmichele (1429), was easily able to assimilate a shallow influence of Masaccio into his general style, derived from Lorenzo Monaco and Masolino. How easily Lorenzo's style could be transmuted into a popular idiom is well seen in Francesco's early period, when he worked for a Franciscan monastery in the provinces: in the fresco of the Crucifixion in the monastery of S. Francesco at Figline (Pl. 130b), through slight variations, Lorenzo's figures become stiff and grimacing. His London Madonna (Pl. 123b) is from a later period, a time of more intense aristocratisation; with a huge crown on her head, she rises up steeply above the angels who are dressed as elegant and genteel courtiers. Nothing proves better than a comparison of these apparently very dissimilar works how close a popular and a courtly Gothic can be, and with what ease they alternate in one and the same artist. Andrea di Giusto (d. 1455) when acting as assistant to Masaccio on the Pisan altarpiece, executed such an experimental piece of perspective as the Healing of the Possessed Child (Philadelphia, Johnson coll.) with its huge architectural construction divided by arches and foreshortened into the distance. Yet in his later work he tends to swing over towards an aristocratic Gothic while also adopting Gentile's realism. As late as 1435, for the Benedictine monastery of S. Bartolommeo della Sacca in Prato (now Prato, Gallery), he copied the altarpiece of a Madonna with saints painted twenty-five years earlier by Lorenzo Monaco for the monastery of Montoliveto: a sign of monastic conservatism and of the survival of Lorenzo's style. In 1436 Andrea painted an altarpiece for Bernardo Serristori (S. Andrea a Ripalta, near Figline) in the centre panel of which the Virgin is represented, attended solely by the adoring figures of the Three Magi clad in exorbitantly luxurious garments; she herself is seated, yet towers high above them.

In general the later Albizzi period, from about 1430 to 1440, was marked by an intensification of the aristocratising late-Gothic—that is, by a formal continuation and accentuation of the style of Lorenzo Monaco and Gentile of the tens and twenties of the fourteenth century;[74] at the same time, Gentile's

realism so easily comprehensible was frequently taken up, as we know, by these very artists. But neither Gentile nor even Lorenzo took part in this intensification of their own styles; both in fact, Gentile in particular, diverged from it. So there now arose a very marked "influence" of the international-Gothic style, more intense than in Lorenzo Monaco and particularly manifest in its courtly French-Burgundian mould. This accentuation, of course, was only possible since this specially aristocratising current adopted much of the detailed realism of the French-courtly and of Gentile's art but fundamentally little of the naturalistic achievements of upper-bourgeois art.

All this applies to the Maestro del Bambino Vispo (Master of the Lively Child), though he was not, as has hitherto been commonly supposed, a pupil of Lorenzo Monaco, but rather a parallel phenomenon, representing a new and more intense wave of the international-Gothic style (Pl. 130a).[75] It is typical of the international nature of his work that we cannot even tell with certainty whether he was Florentine—or even whether he was Italian at all—in view of the many Spanish, French and German elements appearing in his art. At all events he was certainly active at the court of Valencia in 1415,[76] and it would seem that he must have come to Florence shortly afterwards. Unquestionably, this previous Court painter was much sought after there, and conducted a large workshop. It speaks for his popularity among distinguished people that the heirs of Cardinal Pietro Corsini, charged to commission an altarpiece to his memory, for the Cathedral, from Lorenzo Monaco "or another artist of equal or even greater merit" gave the order in 1422 to the Maestro del Bambino Vispo. In this painter's work the late-Gothic linear rhythms, and the elaborate flourishes in the drawing of figures and drapery are even more pronounced than in Lorenzo Monaco's. He has, among his paintings, elegant enthroned Madonnas, with a great following of angels—paintings, moreover, marked by "Sienese" softness, charm, profusion of flowers and delicate colouring. This tendency, which can be traced back to Daddi, and was later taken up by Lorenzo Monaco, now appears in an intensified form, disclosing a deliberately archaistic harking-back to Daddi (e.g. Madonna, Lord Rothermere coll., London). In the same way, the Maestro del Bambino Vispo used a blend of somewhat aristocratising with somewhat "petty-bourgeois" Gothic, as had Daddi and as later, to an even greater degree, would Lorenzo Monaco.[77] This is evident when the artist introduces the motive of the Madonna of Humility in the Annunciation, as had already been done in isolated cases in the fourteenth century (Taddeo Gaddi, Daddi) and in contemporary art, especially by Mariotto di Nardo: the Virgin receives the heavenly message seated meekly on the ground, while her dress falls in graceful spreading folds around her. His mourning Madonnas, the face almost completely covered, remind us of French *Pleureuse* figures, and their affinities with northern art are even closer than was the case with Lorenzo Monaco earlier. The Maestro del Bambino Vispo came under the influence of

Gentile during his stay in Florence, tending, as often happened with more conservative artists in contact with that painter, towards greater realism, so that his style becomes more plastic and three-dimensional. But since he clung to his earlier, purely late-Gothic style this influence shows itself in a certain frozen stiffness (e.g. Madonna with Saints, Würzburg; Pl.131). The figures indeed are more plastic, but the ornamentality has become rigid and the Gothic drapery-folds have no longer a soft linear character but give on occasion quite a cubist effect.

One or two other anonymous artists are stylistically related to the Maestro del Bambino Vispo, as for instance, the "Sienising" Master of the Strauss Madonna. His female types are particularly refined, and it is once more typical of the combination of aristocratising taste with popular motives that his principal work, an Annunciation, should come from the leper hospital of S. Eusebio sul Prato (now Florence, Academy).[78] The same stylistic combination is the most evident in two pictures by him with SS. Francis and Catherine (Florence, Academy, from the Monastery of S. Jacopo de' Barbetti; Pl. 134a, b). These two figures are unusually elongated even for Florentine painting of these years, but at the same time the St. Francis in particular is portrayed with a certain schematic woodenness that is quite popular.

Even more interesting and many-sided than this artist is the Master of the Judgment of Paris, also close to the Maestro del Bambino Vispo; in his work the French-courtly influence is stronger than in that of any other Florentine painter. If the style of the Maestro del Bambino Vispo can be considered as an ornamentalisation of that of Lorenzo, that of the Master of the Judgment of Paris is an ornamentalisation even of Gentile's style—an accentuation of the courtly, not of the realistic elements of the latter. We shall examine his calligraphic style (and discuss the Tondo in the Bargello showing the Judgment of Paris [Pl. 160] after which he is named) in greater detail in the chapter on secular art, for in profane subjects he could more consistently give expression to his courtly tendencies. In his rare altarpieces both for church and domestic use, his manner is merely "archaising".[79] As especially typical of the mentality of this artist and his patrons may be mentioned a work of his somewhat freer late period, the Madonna in the Collection of the Earl of Southesk (Pl. 132), reminiscent of Gentile, but more delicate, and with the glitter of a precious stone. This picture is one wing of a diptych[80] which, though coming from a country church (Pietra-fitta, near Castellina in Chianti), must have been commissioned by a wealthy private citizen. On another occasion the artist did paint a true Madonna of Humility, but in the previous painting he has attempted a compromise between the Madonna of Humility and the Madonna enthroned, with a strong leaning towards the latter: the Virgin is seated so low down that one gets the impression, at first glance, that this is really an Umiltà; but in fact the extremely opulent cushion on which she is seated forms part of a high Gothic throne. The type of

the Madonna of Humility, which at the beginning of the fifteenth century still varied between the modest and the more luxurious representations, exemplified by the young Lorenzo Monaco and the Master of the Madonnas respectively, had by this time, at least in aristocratically-minded middle-class circles, taken a definite turn towards an intensification of the latter type. This subject, which had become so popular in the upper middle class through the medium of the Observance movement, had by now so far lost all traces of its original "humility" and "democratic" tendency, had also been so entirely transformed by various theological interpretations,[81] that it could, at this period, take on an entirely aristocratic and courtly character in conformity with the ideals of the upper middle class in all other spheres. This tendency reaches its zenith in the above-mentioned work of the Master of the Judgment of Paris. Here there is no longer question of a very popular, schematic and crudely coloured richness in the garments, as in the late fourteenth century, but rather a noble, refined, courtly splendour. Nevertheless, the earlier type was still retained among conservative popular artists, such as Mariotto di Nardo (Detroit), or Cenni di Francesco (Lugano, coll. Thyssen; Pl. 133): and sometimes it is difficult, if not impossible, to draw a distinction—for instance, in the case of the Maestro del Bambino Vispo—between the two types, which correspond to various social strata or, more correctly, represent various tendencies within the middle classes. However, some difference is apparent between this popular and at the same time elaborate type of the early fifteenth century and the similar one of the late fourteenth century (e.g. Jacopo di Cione; Pl. 44a). For in the later period, over and above this kind of picture, an art was being produced more expressly than before for the aristocratising sections of the middle class—the Master of the Judgment of Paris is the best example—which was reflected downwards and there imitated; so this kind of Quattrocento picture sometimes contains shades of difference from the Trecento type, and, moreover, the way was open for many transitional varieties.

Having dealt with these minor but pleasant masters of the late-Gothic, whose tendency was to accentuate the style of Lorenzo Monaco and Gentile in a more or less aristocratic manner, we next come to those artists—in so far as their careers fall within our period—who exhibit, to a much greater degree, the effects of the upper-bourgeois—naturalistic achievements: Fra Angelico, Ghiberti, and Uccello.

The Dominican Fra Angelico (1387–1455), another follower of Lorenzo Monaco, developed along quite other lines than the Master of the Judgment of Paris or the Maestro del Bambino Vispo, though in its earlier stages his style showed certain similarities. It is probable that, in his youth, Fra Angelico received instruction in miniature-painting from Lorenzo Monaco at S. Maria degli Angeli. But it seems that his real artistic activity began only considerably later, round about 1418–20. Soon after his entry into the Obser-

vant monastery of S. Domenico in Fiesole in 1407, he, together with the other inmates, had to leave Florence. This monastery had been founded by Giovanni Dominici, and while the friars of these reformed Dominican monasteries supported Pope Gregory XII, who had raised Dominic to the Cardinalate, the city of Florence and the General of the Dominican Order supported the anti-Pope Alexander V, who had been elected at the Council of Pisa.[82] From 1408 to 1418 Fra Angelico lived in various Umbrian Dominican monasteries in Cortona and Foligno, which kept the rule of the Observance;[83] among his companions was Dominici's principal disciple, St. Antonino, who must certainly have influenced him strongly. After the Papal Schism had been healed at the Council of Constance in 1418, it was possible for both Fra Angelico and St. Antonino to return to Fiesole, to their old monastery of S. Domenico. It had now been endowed by well-to-do burghers, principally by Barnaba degli Agli, a rich Calimala merchant, who had presented to it 6,000 florins; the monastery was under the care of the Calimala and was at first officially called S. Barnaba after its most important patron.[84] Fra Angelico's early artistic activity here consisted partly in decorating costly little reliquaries—commissions closely associated with the Dominican Order. Four of these reliquaries were ordered by the Dominican Giovanni Masi, who collected such objects, and they were displayed on important feast-days on the high altar in S. Maria Novella. The whole artistry of these precious reliquaries lies in the jewel-like, at the same time splendid and minute, character of the painting (Pl. 137a). The charming, tender figure of the Virgin dominates these early paintings, yet she is often given a noble and ceremonial air; her garments and those of the angels are ornamented with gold; the background, in the form of a golden carpet, not only acts as a foil to the rest of the composition, but really determines its whole character. The flowing linear rhythm of these works is clearly influenced by Lorenzo Monaco, and especially by his luxurious miniatures.

During this early period Fra Angelico also executed a number of large altarpieces, principally for the use of his own monastery[85] or for other Dominican monasteries and churches in Florence and elsewhere.[86] In view of its general spirit and the character of its leading personalities, we may say that the monastic milieu in which Fra Angelico worked was highly distinguished and rested on a well-established secular and spiritual basis: its character was determined by the tradition of Cardinal Dominici, as carried forward by his pupil Antonino, Prior of the Monastery from 1421 to 1424, and later Archbishop of Florence and the spiritual ally of Cosimo de' Medici. In this milieu, religious sentiment was not by any means simply a matter of emotion, but was also a potent factor in the calculations of power-politics; this applies particularly to these three leaders who, although closely associated with the upper middle class, could also deliberately look for support from the masses if necessary. This is, indeed, the Dominican Observant milieu *par excellence*, the place which can really

pass as a symbol of the alliance between the upper middle class and the Observance.[87] It was due to these solid, distinguished monastic surroundings in which it originated that the art of Fra Angelico could always preserve a certain dogmatic strength, could be popular when it wished or somewhat courtly, and yet was able, in course of time, to absorb even more of the contemporary achievements of upper-bourgeois naturalism than did most of the lay artists of his generation. The friar Angelico, like Lorenzo Monaco a generation earlier, was now the real exponent of the Observance, patronised alike by Church and upper middle class; with all his appreciation and understanding of the upper bourgeoisie, his art seemingly kept a complete balance between the artistic needs of the different strata.

The main subjects by Fra Angelico at this time were the Madonna and Saints, the Annunciation (Pl. 137a), and the Coronation of the Virgin, together with a number of predellas, often with scenes from the story of the Virgin, and sometimes from the Legend of St. Dominic (Pl. 138a). We must now attempt to analyse the various elements in the content and form of these pictures. In the case of the holy personages, it is not only their delicacy (so frequently emphasised in the literature of art history) which is important, but also their ecclesiastical severity and their obvious distinction.[88] With all her charm, the Virgin is, at the same time, always the noble Queen of Heaven, generally seated on a richly decorated throne and surrounded by a following of angels;[89] or else—characteristic as we have seen, of Observant mentality—the Madonna dell' Umiltà, when the curtain, not the throne, is richly decorated.[90] The divine attributes of the Christ-Child are always in evidence; he holds a scroll bearing words referring to his Divinity, or else is in the act of blessing with his right hand, or holds a globe, while his halo usually includes the symbol of the Cross. With the dogmatic firmness of the conception, the ever-present loveliness of expression and the celestial sweetness of the figures—angels are his favourites—Fra Angelico soon organically combines his increasing naturalistic knowledge. Although a Gothic linear rhythm, especially in the individual figures, is still very marked, yet it has now shed that abstract quality which previously marked its use by Lorenzo Monaco, and more particularly by the Maestro del Bambino Vispo. The drapery too has lost something of its abstractly soft folds and pleating, everything has become straighter and firmer, and the increasing lightness of colouring has no longer such a decorative character as in Lorenzo Monaco, but serves to emphasise plasticity; the body is more clearly visible beneath the clothing, even space is more consistently organised, and attempts at perspective and foreshortening become more usual (e.g. Annunciation, Cortona, Gesù; Coronation of the Virgin, Louvre).[91] So the infiltration of Masaccio's progressive art, or in other words, Angelico's receptive capacity for this influence, was no doubt constantly extant in the friar from the very beginning. But according to his phases of development, the degree of this influence varied, sometimes

coming out in a relatively pure form, sometimes combined rather with stylistic features of Lorenzo Monaco or Gentile. Angelico's naturalistic knowledge is also obvious in a very extensive, cumulative realism of detail. In this respect he even exceeds the courtly-religious art of Gentile. He is the first Florentine artist (probably even before Masolino) who exactly reproduced a definite landscape: in the background of the Visitation predella of his Annunciation (Cortona, Gesù) stretches Lake Trasimene with the tall spire of Castiglione del Lago as seen from Cortona. Another predella of this period excellently illustrates the extent to which Fra Angelico combined this extremely exact observation of nature in all its manifestations with his rigidly ecclesiastical attitude towards art: this is the predella (London) for the Madonna and Saints in S. Domenico at Fiesole, which shows Christ in the centre, flanked by endless tiers of angels, saints and blessed, in serried ranks, against a gold background. The two outer predella panels are exclusively occupied by saints and blessed of the Dominican Order, each identified by an inscription (Pl. 135). We have already met this traditional scheme with its enumeration of the Dominican saints as a method of propaganda for the Order; it is fundamentally the same scheme as that used a hundred years earlier by the Master of the Dominican Effigies (Pl. 34).[92] In this composition it is only minor details that Fra Angelico has changed; the figures are more carefully individualised, there is greater variety in their postures, and the rigid straightness in the ranging of the saints is slightly slackened by small spatial suggestions, by greater skill in the painting, by greater delicacy in the colouring, and by more plastic modelling. Though it is only in these alterations that the whole progress of bourgeois naturalism during the preceding hundred years shows itself, this is certainly no mean achievement, especially if we compare the miniature-like fineness of the notable artist Fra Angelico with the earlier, more popular master. But just as important is the stubborn way in which the old scheme lives on—a tradition which drew its strength from the unchanged power-aspirations of the Dominican Order.[93]

The commission to paint a Last Judgment (Florence, Museo di S. Marco) for the Camaldolese monastery of S. Maria degli Angeli stands out as a typical sign of the times, a symbol of the transference of leadership once again from the more secluded Benedictines to the more active Dominicans. Perhaps nowhere does Fra Angelico's penetrating observation of realistic detail show itself so astonishingly as in this Last Judgment, with its inherently dogmatic scheme (Pl. 136). Even the "Masacciesque" classicistic impress is apparent in the almost didactic perspective, that is, in the way in which the regularly-shaped apertures (for the Resurrected) on the pavement become foreshortened far into the distance. The move in this direction is particularly obvious if we compare this picture with the famous Pisan fresco of the same theme, which, together with Nardo di Cione's fresco, marked the mainspring of Fra Angelico's inspiration. The most remarkable section in the friar's painting is that of the Paradise, where

Dominicans and Benedictines, accompanied by a host of dancing angels, move upwards towards the gates of Heaven, across a meadow strewn with luxuriant flowers (Pl. 137b). A comparison with the heavy dancing maidens (possibly also intended to represent the Dance of the Sinless) in Andrea da Firenze's fresco in the Cappella Spagnuola (Pl. 87) clearly indicates a recent preference for the elegant and more graceful in Dominican mentality.

In 1433, the linen merchants (*Linaioli*) commissioned Fra Angelico to paint a large altarpiece with a Madonna and Saints for the chapel of their guild-hall (now Florence, Museo di S. Marco) for which he received the large sum of 190 florins;[94] though this was a lesser guild, as a result of its particular trade, and of its capitalistic method of organisation, it had great economic and social influence, controlled large financial resources, and possessed sumptuous headquarters. Hence, through the artistic commissions of the Dominicans given to Fra Angelico, in this their period of ascendancy,[95] it becomes evident that the artist quickly received wide recognition and finally achieved an almost official municipal position (in the previous generation commissions from the Benedictines had done much the same for Lorenzo Monaco). It is not surprising that, just as in his time Lorenzo Monaco's development had been decisively influenced by the commission he had received from the bankers' guild, so this altarpiece which originated as a result of an important guild-commission marks a definite stylistic turning-point in Fra Angelico's artistic activity. This change will show itself particularly in the pictures which the artist painted immediately after the Linaiolo altarpiece,[96] which in itself is still a typically transitional work, a mixture of the old with the new. For example the music-making angels painted in a miniature-like style on a gold background round the frame of the centre panel are especially archaistic, being really little more than repetitions of motives from the artist's earlier works. But the saints on the side-panels, his first attempt to portray monumental figures—although still rather empty—betray the unmistakable influence not only of Ghiberti, who was commissioned to make the frame for this same altarpiece, but also to a certain extent already that of Donatello and Masaccio. It should be noticed that the two large-size saints on the inside panels represent St. Mark and St. John the Baptist, the self-same saints whose statues were carved as patrons on Orsanmichele by Donatello for the same guild, and by Ghiberti for the Calimala. The scenes from the Legends of the saints in the predellas especially show Fra Angelico's turning away from the earlier precious miniature-like manner; even some antique-imitating architectural motives are introduced in a striking fashion. This important compromise style was characteristic not only of Fra Angelico but also of a whole group of artists—we saw definite tendencies to it in Masolino's late work. The final development of this style was naturally only to fall in the Cosimo period, that typical compromise period of progressive and retrograde tendencies when it would become a regular official style.

The stylistic development of the sculptor Lorenzo Ghiberti (1384–1465) was very similar to that of Fra Angelico. This arose from the fact that the art of Ghiberti, who worked for the wealthiest guilds and for Cosimo de' Medici, took shape under the auspices of the same very solid power-political constellation, and therefore sprang from a view of life similar to that of Fra Angelico. In 1401 Ghiberti won the prize offered by the Calimala for the bronze reliefs of the second door of the Baptistry (the first of the two he executed), because his model, of high artistic quality, was in a style most likely to suit the taste of the wealthy burghers.[97] Thus on the reliefs themselves (1403–24) the story of Christ was represented vividly, but without undue emotion; Gothic linear rhythm gave unity to the composition, but it was not exaggerated, and in spite of the harmonious flow of the contours did not prevent the artist from displaying a keen interest in the human body and in new gestures; however, this sinuosity of line was more pronounced in the celestial beings, such as the hovering angels, than in the human figures (Pl. 139a).[98] A greater emphasis on the formal Gothic element would have been too aristocratic, a more excited narrative too democratic, a "cold" classicism (such as Brunelleschi attempted in his competition relief) too extreme-bourgeois in mentality, comprehensible only to the few.[99] The penetration of Gothic in Ghiberti's sculpture about 1400[100] bears more or less the same average-bourgeois significance as the style of Lorenzo Monaco (Pl. 139b) in the painting of the same time.[101]

Similarly, the later development of Ghiberti, after his first bronze door, implies a conformity to the ideology of the group ruling the city, as was the case with Fra Angelico when almost at the same time, or very little later, he moved away from Lorenzo. For, although this art tended to lag behind upper-bourgeois classicism, still the latter's modernity was felt to be less extreme, with every five or ten years that passed; more accurately, a certain compromise with this style was achieved. Just as Fra Angelico developed in this direction under the influence of Masaccio, so did Ghiberti under the influence of Donatello. The elegant Ghiberti was neither progressive nor retrograde to excess; he was the very man for the wealthiest guilds and their most distinguished leaders. The standing figures which Ghiberti executed for the three leading guilds (Calimala, Cambio, Lana, behind the second of which stood Cosimo de' Medici himself) at Orsanmichele: after John the Baptist of 1414, still purely in the Gothic ornamental style, St. Matthew of 1419–22 and St. Stephen of 1428 represent the various stages—always at a certain distance from the very progressive Donatello, his junior, moreover, by five years—in the strengthening of the "antique"-naturalistic factor and the gradual, though not complete, disappearance of the Gothic element. St. Matthew, for instance, who represents the middle stage, is an elegant antique orator with strongly gothicising folds extending throughout his drapery.[102] Donatello, who as early as 1403 was collaborating with Ghiberti on his Gothic door and who about 1406 also began with figures in pure Gothic

curves, was soon "in principle" about ten years ahead of Ghiberti, so that the future development of the two was pitched in a very different key. The upper-bourgeois ideology and the classicist art based upon it were not strong enough to develop further along their own lines, and therefore the expression of the latter could only reach a certain point, even in the work of so advanced an artist as Donatello. Afterwards, his artistic development again moved in a new direction, enriched by the achievements of his previous classicist intermediate period —achievements unsurpassed by any other artist, with the exception of Masaccio, who died at an early age. Hence, the "post-classicist" period of Donatello is much richer than that of Ghiberti, whose classicism had never been so consistent, or than that of Nanni di Banco, who had never progressed beyond a very early restrained form of classicism. After Donatello had taken from the antique all that he could and all that he needed, and, indeed, even at times when he was most subject to this influence, he laid aside the cool calm which he had temporarily assumed and readily turned once more to the task of bringing inner life into religious stories, to problems of expression, to representations of movement. So he soon produced once again works which made use of elements akin to the Gothic, but now as it were at a higher level. It is instructive to compare the reliefs which Ghiberti and Donatello made for the font of the Baptistry of the Cathedral in Siena, where, as we know, the stratification was more petty-bourgeois and democratic than in Florence and where the middle class, therefore, favoured a gothicising style expressive of religious emotion. Ghiberti's reliefs (John the Baptist before Herod, Baptism of Christ, 1417–25) are also more pronouncedly Gothic in a formal sense and show some relationship with the works of the late Sienese Trecento.[103] Donatello's relief, representing the Dance of Salome and the Offering of the Head of John the Baptist (1423–27), far surpasses all previous portrayals of the scene in its dramatic excitement (including that in the much more "aristocratic" fresco executed ten years later by Masolino, already mentioned); for the artist's new achievements in naturalism now gave him quite different and greater opportunities for such stylistic development inwardly related to late-Gothic.[104] In a somewhat later relief by Donatello, the Delivery of the Keys to Peter (Victoria and Albert Museum), Christ is placed in the clouds[105] and Masacciesque figures are shown transposed in movement, and almost ecstatic. But measured by the style he was to realise during the Cosimo period, this "post-classicist" style of Donatello which we have just discussed was, even in the late Albizzi period, only in its beginnings: for the time being, he produced only a few "theoretically" post-classicist works.

It was still during the late Albizzi period that Ghiberti began work on the reliefs of the third (Ghiberti's second) Baptistry door (1425–52) which represented stories from the Old Testament from the creation of Adam to the Meeting of Solomon and the Queen of Sheba (there was only a general, not a typological correspondence between these scenes and those from the New Testament on the

previous door). The works committee (Niccolo da Uzzano was its chairman and Palla Strozzi one of the members) prescribed the Old Testament as the general thematic source, the town chancellor, Bruni, chose twenty scenes—it is a characteristic sign of the secularisation of art that it was not a cleric who was entrusted with the selection; Ghiberti could, if he wished, however, make alterations in the programme, and he consequently reduced the scenes to ten. The change of style in these reliefs shows that there was perhaps no other Florentine artist in whose work the ideological change of those in power and of the patrons of the time—in this case the upper stratum of the Calimala—was so clearly and unambiguously reflected as in that of Ghiberti, who secured the most important commissions of the city and very high payment.[106] For although the economically and socially dominant circles of the late Albizzi period were by no means untouched by upper-bourgeois ideology, by then well developed in numerous fields, nevertheless they could not consistently assimilate it to their own viewpoint. With his "antique" outlook Bruni, who in his report to the works committee said of a Biblical theme that he had chosen the most "memorable" scenes, was considerably in advance of the average attitude of those who commissioned him. For, to the ruling circles—that fusion of rich guild-burghers with a feudalising oligarchy—the somewhat petty-bourgeois Gothic as well as the almost non-religious upper-bourgeois classicism were, in their one-sidedness, equally alien. As we have seen, in the contemporary art of Angelico, a compromise style had to be found to express the ideological features of the ruling section, which shied at any extremes. This compromise style is perhaps nowhere to be so clearly seen as in the reliefs of Ghiberti's second door. It is of little importance what name is given to this style: we may call it either gothicising classicism or classicising Gothic. It is a stage-like narrative style portraying incidents in a lively manner and with great detail; it has many new touches, but completely lacks concentration, and fails to make any consistent use either of its considerable knowledge of bodily form and of space or of its acquaintance with antique sculpture. The many possibilities offered, particularly by the scenes from the Old Testament, for naturalistic observation and, at the same time, for a "beautiful" display of figures are naturally not lost sight of. However, the full development of this style will be reached only in the period of Cosimo de' Medici, to which Ghiberti's second door already in the main belongs.

From Ghiberti's style we may appropriately pass to that of the young Paolo Uccello (1397–1475), who actually worked as an assistant on Ghiberti's first door. The earliest of Uccello's surviving works are the frescoes from the story of the Creation in the Chiostro Verde of the Dominican monastery of S. Maria Novella, which were probably painted soon after 1430.[107] Uccello's frescoes are only part of a very extensive Old Testament cycle, most of which was carried out at the same time—that is, when Ghiberti was at work on the reliefs of the second door dealing with a similar subject. The frescoes which cover the walls

of the large cloister of this monastery, and are in the usual cheap monochrome green colouring of late-Gothic frescoes in the open, are probably intended to illustrate the prayers for the dying (the Chiostro Verde was originally a cemetery); after mentioning the Creation of Man, these prayers enumerate the consolatory examples from the Old Testament, of those whose souls were delivered by God. Hence the Chiostro Verde frescoes portray these numerous Old Testament examples: the stories of Noah, Abraham, Jacob, Job and others.[108] Despite this liturgical basis, it is, nevertheless, a sign of the general secularisation that representations from the Old Testament, actually treated by artists almost in the nature of profane painting, now become far more common, and even appear on such a severely ecclesiastical site as this Dominican monastery.[109]

Before we discuss the style of Uccello's frescoes, we will mention briefly some of the other painters working on frescoes in the same cloisters—for, probably in order to accelerate the work, it was entrusted to different workshops. The stories of Abraham were executed by the Master of the Judgment of Paris (Pl. 140), whose aristocratising style in religious pictures has already been mentioned. Here, in the surroundings of the Dominican monastery, the artist's manner diverges only in slight degree from his aristocratising style, and yet these small shades of difference are enough to give the frescoes the effect of popular art. There is a certain primitive effectiveness in the narrative. A very formal, schematic line rhythm prevails in the poses and gestures of the figures and also in the landscape. Though the figures have the excessive length and undulating contours of the late Gothic-courtly art, they are, all the same, rough typifications; the delicate gestures and elegant draperies, such as are seen, for instance, in the Southesk Madonna (Pl. 132), have disappeared, and instead we find broad gestures corresponding on each side, and long, stiff, parallel folds. To compare, for example, the fresco of the banishment of Hagar with that of the meeting of Joachim and Anna by Lorenzo Monaco (S. Trinità), where the composition is similar in arrangement, shows the greater strength of both the aristocratic and the popular elements in this artist's general conception and in his formal idiom. Fundamentally similar, but more one-sidedly popular, is the so-called Pseudo Ambrogio Baldese (stories of Jacob). He schematises the style of Lorenzo Monaco, also in a conservative but less varied and very flat manner, similar to Mariotto di Nardo; the figures are in the Gothic idiom, but without the excessive attenuation of the first fresco-painter.[110]

Stylistically, Uccello's frescoes may be said to stand between the two doors by Ghiberti; they show traits of both, particularly of the second door, but as parts of a combination which is quite different in its general character and far less balanced. The elements of which this style is composed are very different.[111] There is more drama and tension in the manner in which the content is conceived, and the formal means employed are more abrupt than those of the second door by Ghiberti. Influences of Lorenzo Monaco are to be felt, also of Gentile,

and perhaps of the detailed realism of northern Italy (Uccello had probably been just previously in Venice). The landscape of the scene of the Fall (Pl. 143b) is the carpet-like leafy background of the international-courtly style; the landscapes of the other scenes, particularly the rocks, still have a great deal of the Trecento tradition. There is, however, also an intense struggle with problems of space and the representation of bodies; but, compared with Masaccio (Pl. 142), a lack of unity and an eruptive imaginativeness is evident in the manner of handling them. The representation of depth is a rather intuitive one, based on feeling. Uccello delights in the naked body; the figures are much more plastic and cubic than the decorative schemes of the two anonymous fresco-painters, and in the figure of the newly-created Adam (Pl. 141) we recognise that use has been made, with Ghiberti as intermediary, of antique sculpture. On the other hand, Uccello still adheres to a certain extent to the swinging Gothic line; a comparison of the drapery of God the Father in the Creation of Adam by Uccello and in the same scene by Ghiberti shows clearly the contrast between the two artists. Moreover, Uccello portrays the Creation on a kind of ornamental carpet of flowers. Finally, the figure of Adam just mentioned acquires an almost abstract character through a certain over-emphasis of plasticity. The figures in the Fall show a more dynamic energy, but at the same time a more pronounced Gothic decorative rhythm, than those in the same scene by Masolino in the Carmine (Pl. 143a). Yet, apart from these personal nuances, the figure-idiom of the naked bodies in this scene is, in principle, very similar to Masolino. It is indeed remarkable that even an artist as impulsive as Uccello and as absorbed in the rendition of bodily form and of space should bear this kinship with an older artist, actually pre-Masacciesque in style.

In his early work, another artist, slightly younger than Uccello, the Carmelite Fra Filippo Lippi (1406–69) suggests, at first sight, a closer proximity to Masaccio's endeavours and achievements. Lippi's Madonna of Humility with saints and angels (Milan, Castello Sforzesco; as SS. Dominic and Peter Martyr are represented, the picture was certainly destined for a Dominican church) must have been painted after Masaccio's Carmine frescoes, probably during the last years of our period (Pl. 144). Lippi obviously took great pains to compass a spatial arrangement: the angels are grouped in a semi-circle round the Madonna, their draperies so disposed as almost to close the circle. The figures modelled by plastic chiaroscuro are square and voluminous, the faces massive and squat, the clothing shows decided linearity: a combination at once of Masacciesque and non-Masacciesque elements. In attempting to reduce the figures—particularly the Christ-Child—to block-like forms, an almost abstract character results, somewhat more marked than in Masaccio. But the most striking feature of Lippi's picture is the facial expressions of the angelic following: some of them are most un-antique, Florentine urchins with extremely individualised physiognomies, their almost photographic realism far outstripping similar contemporary

child motives of Donatello (with whom, in other respects, many ties exist here) and even producing a suggestion of the grotesque as compared with Masaccio's highly typified characters.

Somewhat later, from the second half of the thirties onwards, Uccello was even to outdo Lippi in his abstract cubism, in his striving for means of shrill expression. Approximately of Masaccio's age, younger than Fra Angelico, the more cautious assimilator, Uccello and Lippi are goaded by strong impulses to create in a new vein. Yet their styles can seldom be called really Masacciesque—Lippi's Milan Madonna is the nearest approach—and indeed became increasingly less so; Lippi was soon to arrive at the usual compromise style of the Cosimo period. The careers of these two outstanding artists illustrate how slowly and inadequately Masaccio's influence was able to exert itself in the altered circumstances following his death. Here once again we see that, since the bourgeoisie were now economically and ideologically on the down-grade, Masaccio's achievements could make themselves felt not only very gradually but equally inevitably, in such styles alone—there were now indeed no others—which implied, as a whole, something quite different from his own upper-bourgeois, rationalist, dispassionate style.

NOTES

[1] At the same time, numerous small figures in relief, surrounded by foliage, were carved on the Porta della Mandorla of the Cathedral, representing Hercules, Apollo, Abundantia, etc., or at least very like these. In many cases there are real nude studies, and there is even a back view made from sheer joy in modelling the body. The Hercules is derived from the similar figure by Andrea Pisano on the Campanile, but the classicising formal idiom, the Polyclitean attitude with the receding free leg, is much more accentuated, probably as a result of a closer study of the same antique model. Round both the Porta della Mandorla and the contemporary Porta dei Canonici, and encircled by leaves, are more or less classicising, purely decorative *putti*, transformed from angels. (See O. Wulff, "Giovanni d'Antonio di Banco und die Anfänge der Renaissance-Plastik in Florenz", *Jahrb. der preuss. Kunstsammlg.*, XXXIV, 1913, and H. Kauffmann, "Florentiner Domplastik", *Jahrb. der preuss. Kunstsammlg.*, XLVII, 1926).

[2] It applies also to the relief below the statue, depicting St. Eligius' miracle with the horseshoe, and representing a blacksmith's forge; its style is more gothicising, there is greater movement, even something genre-like about it.

[3] As often from the early fourteenth century onwards, the Assumption is here linked with Thomas' reception of the Holy Girdle. Through this association, the role of the Virgin as Mediator between Christ and mankind is symbolically suggested.

[4] At the same time this crucifix, made for a Franciscan church, originally had movable arms, so that the figure could be put in a "Holy Sepulchre" during Passion Week.

[5] The pose of the Man of Sorrows in the Victoria and Albert Museum was inspired by the postures of a dying Hercules statue, and of a dying warrior, on an Amazon sarcophagus. See F. Burger, "Donatello und die Antike" (*Repert. für Kunstwiss.*, XXX, 1907), and H. Kauffmann, *Donatello* (Berlin, 1935).

[6] We shall deal with other works by Donatello in connection with Ghiberti.

[7] H. Brockhaus, "Die Brancacci-Kapelle in Florenz" (*Mitteilungen des Kunsthist. Institutes in Florenz*, III, 1930). Felice Brancacci, like his father-in-law, Palla Strozzi, an opponent of Cosimo de' Medici, was condemned after Cosimo's return in 1434 to a fine of many times his total fortune; furthermore, he was given the title of "Grande", in order to deprive him of the right to hold office, and was finally exiled in 1436. It may be that the figures in the fresco of St. Peter in Cathedra portraying Brancacci and his family, and possibly even several other frescoes in the chapel, were destroyed on this occasion. That Cosimo, who ruined the Florentine upper middle class, should also be found to have ordered the destruction of the greatest artistic achievement of that class, would be truly symbolical.

[8] M. Dvořák, *Geschichte der italienischen Kunst*, I (Munich, 1927)

[9] On the ceiling, the Navicella (now lost) symbolising the power of the Church, was also represented.

[10] M. Pittaluga (*Masaccio*, Florence, 1935) has also alluded to the parallel between Masaccio's figures and Stoic philosophy.

[11] A part of the Pisan altarpiece of 1426. For detailed description see Introduction.

[12] The painted architecture in Masaccio's fresco of the Trinity (S. Maria Novella; Pl. 150) stands so close to Brunelleschi that active collaboration by this artist has been thought possible. It may be mentioned in this connection that the earliest example which has come down to us in Florentine painting of this rigid frontal scheme of the Trinity with Christ on the Cross is a picture of Nardo di Cione's workshop (Florence, Academy) which probably refers back to an invention of Orcagna.

[13] For a detailed discussion of this point see E. Panofsky, "Die Perspektive als 'symbolische Form'" (*Vorträge der Bibliothek Warburg*, 1924–25) and J. Mesnil, "Die Kunstlehre der Frührenaissance im Werke Masaccios" (*Vorträge der Bibliothek Warburg*, 1925–26) and *Masaccio et les débuts de la Renaissance* (The Hague, 1927).

[14] Yet only very few direct borrowings by Masaccio from antique sculpture can be established. Even the position of the arms of Eve driven from Paradise (Pl. 142) was not necessarily taken over directly from a *Venus Pudica* of the Praxiteles school, but might have reached Masaccio indirectly by way of Giovanni Pisano through the latter's *Prudentia* on the pulpit of Pisa. See J. Mesnil, "Masaccio and the Antique" (*Burl. Mag.*, XLVIII, 1926).

[15] This manner of representing the body applies even to Masaccio's Madonna of Humility. His reason for showing the Madonna's bare feet (as Donatello also does), which is contrary to previous practice, was less to emphasise her poverty than to satisfy his naturalistic inclination to bring out clearly the construction of the body.

[16] Dvořák, *op. cit.*

[17] Masaccio's painted architecture relies on Brunelleschi's buildings and the models for them, namely, the Tuscan proto-Renaissance. See Mesnil, *op. cit.*

[18] This has the same significance as Nanni di Banco's harking back to Andrea Pisano, or Brunelleschi's to Arnolfo di Cambio.

[19] The Pisan altarpiece was also a commission obtained through the mediation of Fra Bartolommeo da Firenze, vice-Prior of the Carmelites in Pisa. It was probably easier to place Masaccio's work in this provincial town, where he would be respected as an artist from the capital, than in Florence itself. It may well have been due also to the recommendation of the Carmelites that Masaccio was allowed to join Masolino in the Brancacci Chapel in their Church.

[20] An appreciation of the antique had, perhaps, a certain tradition in the Carmelite Order. It was a Carmelite, Fra Guido da Pisa, who after 1336 produced—as the beginning of a history of Italy and of the Roman people up to his own day, *Fiore d'Italia*—the first Italian popularisation of Virgil, very widely read under the title of *I Fatti di Enea*. He also produced a *Fiore di Mitologia*.

[21] He paid a rent of two florins per annum for his studio, while his main creditors an entirely unknown painter called Niccolo di Ser Lapo, could afford one rented at seven florins.

[22] Gentile was given 150 florins for this altarpiece; Masaccio, for the Pisan altarpiece, only 80. But we must also take into account the size of Gentile's picture and the fact that he made much use of gold.

[23] Gentile received from the Pope the high salary of 300 florins a year.

[24] See p. 114, note 22.

[25] It is quite impossible to imagine Masaccio ever painting a hunting scene. Similarly, it is quite natural that Poggio, who represented the peak of upper-middle-class rationalist thought, should be very strongly prejudiced against that love of hunting which was common to the nobility and to the aristocratising middle class.

[26] Gentile's Pisan Madonna of Humility, which may possibly have been painted in Florence itself, has a backcloth of sumptuous brocade. The contrast both in content and form between Gentile's and Masaccio's versions of the Madonna of Humility recalls that between their Madonnas enthroned, discussed in the Introduction.

[27] The whole spirit of Franciscan mysticism clearly explains the close connection between Gentile's two types of the Madonna. St. Francis, for instance, strongly influenced by French chivaleresque ideals, speaks of the knighthood of lowliness and humility, or of his own service to Lady Poverty. (See also p. 221, note 83.)

[28] Another typical motive from Franciscan popular mysticism, also to be found in one of Gentile's fairly early works, the Berlin Madonna (from S. Niccolo, Fabriano), are the little musician angels who sit in the tree-tops like a flock of birds.

[29] During the years in which Gentile was painting the altarpieces with their unrivalled rich clothing for Palla Strozzi and Bernardo Quaratesi, St. Bernardino of Siena was in Florence; he preached in S. Croce the most violent sermons against luxury, and these were followed by the usual bonfires of vanities (1424–25). Here again we see how completely the upper strata of society remained unaffected by sermons of this kind, which were principally directed against luxury among the lower orders.

[30] Two ragged beggars form the pendant to this most elaborately dressed of Gentile's female figures. That the one is offset against the other does not in the least imply a suggestion of provocation, but just the contrary: in a religious picture, the rich and the poor mutually condition each other's existence.

[31] In the predella for the Quaratesi altarpiece which represents the healing of the sick at the tomb of St. Nicholas (New York, Kress coll.) Gentile kept surprisingly close to the "popular" fresco of Andrea da Firenze in the Cappella Spagnuola, depicting the same subject, but as taking place at the tomb of St. Peter Martyr. For the middle part of his story, Gentile used Andrea's general arrangement, literally taking over the cripple to the right, but he deepened the two-dimensional scene in a new spatial sense by the use of steps and sequences of columns.

[32] In spite of the deep theoretical gulf between the art of Gentile and Masaccio, they also have points of contact. For Masaccio, for his part, is not always quite free from the Gothic realism of detail, even though he does make it serve his own distinctive ends, and he also learned from Gentile's much-shaded colouring. That is why Gentile's predellas for the Quaratesi altarpiece, of the legend of St. Nicholas (Vatican Gallery; Pl. 128) could still, a generation or so ago, be accepted as Masaccio's.

[33] We find this same conflict in this monastery between an inclination towards Humanism and antagonism towards it on religious grounds shortly before Traversari: Salutati was on friendly terms with individual monks of S. Maria degli Angeli when his most bitter adversary, Giovanni da S. Miniato, was there.

[34] Among his monks he was careful to observe great piety, and insisted on the strictest Observance, as the Curia at that time favoured such an attitude. That is why Pope Eugenius IV had a liking for him and made him General of the Camaldolese. He was a personal friend of St. Bernardino of Siena, the greatest popular preacher of his time, who had been attacked by the sober-minded Poggio. As to his anti-democratic views at the Council of Basle, see p. 88. In his relations with Niccoli and Cosimo de' Medici, however, Traversari acted as the skilful man of the world; though here again he showed scruples—which he managed to overcome—when these worldly friends asked him to translate the works of a pagan philosopher, Diogenes Laertius (see Voigt, *op. cit.*).

[35] G. Pudelko ("The stylistic development of Lorenzo Monaco", *Burl. Mag.*, LXXIII, 1938) claims that Lorenzo was acquainted with the work of Broederlam, the Flemish painter working for the court of Burgundy in the nineties, one of the outstanding representatives of this style.

[36] On occasion he adopts a variant of this subject in which the Madonna, although in the same position, is seated not on the ground, but on the clouds of Heaven. This version, which had existed in Florence since the end of the fourteenth century, is typical of the tendency to spiritualise a democratic motive.

[37] Evidence that the Benedictines in particular—in connection with the Observance movement—had a partiality for the Madonna of Humility is found in the provenance of an important version of this subject by the Master of the Madonnas (now in the Academy, Florence) from the convent of Vallombrosan nuns, S. Vendriana, built just at this time, around 1400. Another work by the Master of the Madonnas shows the Madonna of Humility—a very unusual variant—as a centre of adoration, surrounded by Benedictine saints, who are presenting the donors to her (previously in the van Stolk collection, Haarlem).

[38] In this respect, Lorenzo is to a certain extent going back to Daddi—whose rather similar art arose from a social and ideological background somewhat akin—and at the same time, to paintings of the later, more democratic period of the fourteenth century. Nardo di Cione, in particular, influenced Lorenzo.

[39] Lorenzo included among the scenes leading to the Passion the particularly moving episode of the Devestment of Christ, very rare in Florence and found only in the popular art of the Pacino circle. It is to be seen on a predella of his early picture of the Agony in the Garden (originally in S. Maria degli Angeli, now in the Academy, Florence). In this picture appears a figure most typical of the attitude of mind of the patrons in Lorenzo's early period—the donor represented inconspicuously, kneeling, in the dress of a poor pilgrim.

[40] From the fourteenth century onwards the liturgical texts included hymns to the lance and the sponge. See Mâle, *L'Art réligieux de la fin du Moyen âge en France.*

[41] It is interesting that this pain-racked Madonna of Lorenzo in fact harks back to the Madonna in the Lamentation of Christ by Niccolo di Tommaso (previously in the Grissell coll.; Pl. 56b; cf. p. 226, note 141), dating from the democratic period in Florence.

[42] In France for example the "Arms of Christ" are put together to form a coat-of-arms and processions took place in which the Emblems of the Passion were carried by the participants (cf. Mâle, *op. cit.*). But in Florence also, and significantly enough in the thirteenth century, during the early middle-class period, events from the story of the Passion were represented symbolically, by clerics sometimes dressed up in special costumes for the occasion. For example, as a commemoration of the division of Christ's garments among the soldiers, the clergy, when they reached this point during the reading of the Passion on Good Friday, used to tear up two strips of white linen laid on the altar in the form of a Cross (see Davidsohn, *op. cit.*).

[43] For fuller details see Siren, *op. cit.*

[44] For a detailed study of Lorenzo Monaco's development see Pudelko, *op. cit.*

[45] R. Longhi ("Fatti di Masolino e di Masaccio", *Critica d'Arte*, 1940) believes this picture to be an early work of Fra Angelico.

[46] See p. 205.

[47] Always supposing Vasari's account is correct.

[48] U. Procacci, "Gherardo Starnina" (*Rivista d'Arte*, XV–XVII, 1934-6).

[49] P. Schubring, *op. cit.*

[50] But see also p. 98, note 99.

[51] It is evidence of the popularity of the picture that numerous copies and variations were later made of it.

[52] E. Muntz, *Histoire de l'Art pendant la Renaissance* (Paris, 1889–95).

[53] We have noticed similar differences among the various miniaturists of the Camaldolese monasteries at the end of the fourteenth century, in the circle of Don Simone.

[54] The same combination appears in his dramatic representation of the Triumph of Death (predella, S. Croce). Death is shown riding on a steer—an unusual motive which points to France—pursuing an elegant youth on horseback, while the figures of beggars are still kept in the Orcagna-Traini tradition.

[55] On this principle of perspective see p. 218, note 57.

[56] To appreciate the difference between this drawing and a truly courtly, and at the same time more realistic, conception of the same theme of about the same date, it should be compared with the very casual procession of the Three Kings in the *Très Riches Heures du Duc de Berry*.

[57] The popularisation of the magnificent and the genteel at this time is well illustrated by the fact that in 1428, just after Lorenzo's and Gentile's paintings had been put up, the Feast of the Three Magi was introduced into Florence.

[58] Generally known as the Bartolini chapel, because it belonged to this family; but in actual fact they had transferred its supervision to the guild of bankers.

[59] On the relationship of these frescoes to Ghiberti, see p. 353, note 102.

[60] A comparison with the very hieratic Assumption ascribed to Agnolo Gaddi (Vatican Gallery; Pl. 118a) reveals how Masolino, while not entirely discarding the stiffness of the earlier period, transformed the composition into one of great elegance.

[61] The failure to recognise this has up to now stood in the way of a correct dating of Masolino's various fresco cycles, and also of a clear distinction between the hands of Masaccio and Masolino. In the past, the following chronological sequence was accepted: Castiglione d'Olona—S. Clemente—Carmine. M. Salmi (*Masaccio*, Rome, 1932) has finally re-established the true chronology on the basis of purely stylistic considerations, though even he erroneously considered that, within the Castiglione cycle, the Collegiata frescoes, that is, the more Gothic of them, were the earlier.

[62] The aristocratic art carried out for the French and Burgundian courts by Flemish artists, which represented such an important constructive factor in Gentile's style, formed, in the north, together with important additional features, the foundation of the naturalistic art of the Flemish towns: the art of Jan van Eyck (which made a link between the two) and the Master of Flémalle. It was the co-existence of the Flemish cloth-manufacturing towns—Ghent, Bruges and Tournai in particular—and their rulers, the Dukes of Burgundy, who were in many ways feudally-minded, which moulded the complex character of Flemish art in the early fifteenth century.

[63] In the articles quoted on page 2, footnote, I first drew attention to this re-gothicisation.

[64] Still more or less within the tradition of the Orcagna workshop, even if already very late-Gothic in its draperies, is, for example, the rigid and striking painting of the doubting St. Thomas (Florence, Academy; Pl. 120b) by the Master of the Griggs Crucifixion (whose work on the whole is close to Masolino). A still more archaic picture which, though by another hand, shows a similar style, is the Man of Sorrows with the blood streaming from his wound for man's salvation, full-length, standing between the Virgin and St. Lucy, in the church of S. Lucia at S. Giovanni Valdarno (Pl. 120a). The particularly popular mystical theme of this picture is apparently very rare in Florence itself—the nearest motive to it here being that of the angels catching the blood of Christ in representations of the Crucifixion—and it is significant that it only appears in a provincial church, and that characteristically in Valdarno, on the way to Umbria. In Italian religious literature, the cult of the Precious Blood is to be found in St. Bonaventura's *Lignum Vitae* (later in St. Bridget and St. Catherine of Siena), and, above all, in Blessed Angela di Foligno (1249–1309, a Franciscan Tertiary), an Umbrian; Blessed Angela, who was in contact with Spirituals, also influenced Ubertino da Casale, whom we mentioned when speaking of thirteenth-century Florentine Tertiaries who experienced the Passion of Christ. In the course of the fifteenth century, this cult was especially marked in the more petty-bourgeois northern countries.

[65] T. Borenius, "A Florentine Mystical Picture" (*Burl. Mag.*, XLI, 1922).

[66] For example, in a miniature now in Berlin with four Camaldolese monks as donors (1420–30).

[67] Panofsky, *op. cit.*

[68] We have already mentioned (pp. 211–12) his co-operation in the execution of the frescoes of the Passion painted in the 1390s for the church of the Brigittine nuns in Bardino.

[69] This fresco is usually considered to be Lorenzo Monaco's. But I think that H. Gronau's and R. Offner's attribution to Mariotto di Nardo is the correct one.

[70] Mariotto di Nardo also made use of the large painted, cut-out Crucifixion type (S. Firenze) in the manner of Lorenzo Monaco. Another picture by Mariotto (Fiesole, Museo Bandini, coming from the Convento del Portico outside Florence) represents the Trinity with Christ on the Cross and beneath it the Stigmatisation of St. Francis and the weeping Magdalen (Pl. 123a): an interesting combination of hieratic and agitated motives, typical of popular monastic art.

[71] Close to Cenni is a picture of a Madonna-like St. Catherine (Vatican Pinacoteca) ascribed to the school of Agnolo Gaddi, very popular in theme as well as in form. The Saint is surrounded by the Virtues, hovering in mid-air (among them Humilitas); her clothing is gilded all over and she stands upon a carpet decorated with gold flowers.

[72] In fact, there also exists the rather unusual case of an altarpiece (Marriage of St. Catherine, Budapest) ordered from Giovanni dal Ponte by a patron of the comparatively low station of saddler; however he was certainly well-to-do—perhaps not from Florence but from a provincial town—and even had his coat-of-arms added to the picture.

[73] As to the various possible combinations of the influences of Lorenzo Monaco and Masaccio in the successive periods in Giovanni dal Ponte's development, see R. Salvini, "Lo Sviluppo Stilistico di Giovanni dal Ponte" (*Atti e Memorie della Accademia Petrarca in Arezzo* XVI, 1934).

[74] Even before Gentile's arrival, there resided in Florence in 1420–22 a painter of delicate gothicising devotional pictures, Arcangelo da Cola da Camerino, a native of the Marches, who was under the influence of Gentile and Masolino. His style took on a more monastic-popular or a more aristocratic tinge according to the locality he worked in, whether the Marches or Florence. He regarded Florence as a suitable field for his paintings,

and it was here that he obtained a commission from Ilarino de' Bardi for an altarpiece in S. Lucia dei Magnoli (in this case Arcangelo received eighty florins for the picture alone, whereas the cruder Bicci di Lorenzo received only twenty-four florins for the frescoes in the same chapel). In 1422 Arcangelo was invited to Rome by Pope Martin V, who was equally susceptible to this courtly style, and who in 1425 was also to summon thither Gentile da Fabriano.

[75] G. Pudelko, "The Maestro del Bambino Vispo" (*Art in America*, XXVI, 1938).

[76] It was there that, about this time, he painted a Last Judgment for King Ferdinand of Aragon (now in Munich), designed to further the King's political aims. In addition to the ruler's portrait there appear among the Saved his ally Pope Benedict XIII, and the Emperor Sigismund,whom the King was endeavouring to win over to the Pope's cause; a second Pontiff—an anti-pope, no doubt—figures among the Damned. Longhi (*op. cit.*) suggests that the Maestro del Bambino Vispo might be identical with the Spaniard, "Gil Master", active in Valencia.

[77] Parri Spinello (1387–1453), whose style approximates so closely to that of the Maestro del Bambino Vispo that an attempt has even been made, incorrectly, to identify the two, and who passes for the main representative of a distinguished, decadent and weary type of late-Gothic, was the chief painter in the lifeless, provincial town of Arezzo; his most important commissions came from the fraternities, and he very often painted Madonnas of Mercy. All this clearly indicates that rather lesser burghers might also be the bearers of an aristocratising Gothic.

[78] In a country church—S. Romolo at Valiana—he portrayed the common popular theme of the Man of Sorrows, surrounded by symbolical scenes from the Passion.

[79] G. Pudelko, "The Minor Masters of the Chiostro Verde" (*Art Bull.*, XVII, 1935).

[80] According to R. Longhi, the other being an Annunciation in the Parry Collection, Highnam Court.

[81] Meiss, *Madonna of Humility.*

[82] Dominici was originally Florentine ambassador to Pope Gregory XII. But when that Pope made him a cardinal, he betrayed Florentine policy which demanded the unity of the Church, and encouraged Gregory in his determination not to abdicate. As a result Dominici was regarded in Florentine government circles as a hypocrite and a careerist. Nevertheless he was able to convince his own monasteries, and apparently other circles also, that he had accepted the cardinalate only under compulsion, and would later return to monastic life. In fact, however, he did not do so, but continued to occupy his benefice till his death. See H. Sauerland, "Cardinal Johannes Dominici und sein Verhalten in den kirchlichen Unionsbestrebungen während der Jahre 1415-6" (*Zeitschr. für Kirchengesch.*, IX, 1888).

[83] The rulers of Foligno, the Trinci, were supporters of Pope Gregory XII. The fact that one of this family, Paolo de' Trinci, in 1368 founded one of the first Franciscan Observant monasteries, is significant of their friendly attitude towards the Observants. At the time of Fra Angelico's exile, the Dominican Federico Frezzi was Bishop of Foligno; he belonged to Dominici's original circle in Pisa, and his allegorical religious poem "Quadregio" was an imitation of the *Divina Commedia*—this being characteristic of the mentality of the whole milieu.

[84] It was so called until 1432. Barnaba degli Agli had decreed in his will that the friars must belong to the strict Observance, and also that the monastery should be called after him and bear his coat-of-arms.

[85] Dominici himself had a decidedly favourable attitude towards art; he encouraged miniaturist activity in his own monasteries, and executed some miniatures himself.

[86] Fra Angelico often worked with other friar-artists in his monastery, and the result was a collective achievement in which separation of the hands of the different artists is not always possible.

[87] The temporary rupture between the upper middle class and Dominici was only a personal affair, and did not in the long run fundamentally affect the close connection between the upper middle class and the Observance.

[88] We should mention here the courtly way in which Fra Angelico represents St. George in a painting, now in Boston (Madonna and Saints with a Donor). This Saint, who as a knight was a particular favourite in Northern Italy, was hardly represented at all in bourgeois Florence of the fourteenth century; he appears in Donatello as the ideal warrior, whereas with Fra Angelico he is depicted, probably for the first time in Florence, as a regular knight, with a banner in his hand and a helmet with open visor.

[89] It is significant of Fra Angelico that the iconographical innovations connected with the Virgin which he introduced into Florentine painting tend towards both intimacy and magnificence. In the Coronation of the Virgin (Louvre) he represents Mary, not seated as hitherto, but kneeling, and in the Assumption too (Boston, Gardner Museum) the Virgin is not seated, but erect, with raised arms, looking upwards. The latter type has doubtless a mystical significance: the Virgin expresses her yearnings, her striving after celestial glory, and probably a reference to the Immaculate Conception (white cloth of purity) is also intended, since, according to the *Legenda Aurea*, this was the reason for her Assumption.

[90] Angelico is related to Gentile not only in the simultaneous representation of the two Madonna types, but often in the courtly style of the pictures as well. This courtly style is particularly apparent in a painting formerly in the Stroganoff collection in Leningrad, a Madonna of Humility, sumptuously garbed (the right attribution in Longhi, *op. cit.*).

[91] It is possible that these altarpieces (and some others, similar in style) date as late as the second half of the thirties; the Coronation of the Virgin, however, was probably painted even before 1436, as it was produced for S. Domenico at Fiesole, and from 1436 onwards Angelico worked mainly for S. Marco.

[92] Another work equally reminiscent of the hieratic style of the Master of the Dominican Effigies is the very stiff and extremely sumptuous Coronation of the Virgin by Niccolo di Tommaso (now Florence, Academy) which is close to Jacopo and Nardo di Cione and also comes from the same Monastery of S. Domenico. Even although Niccolo, who probably died as early as the seventies of the fourteenth century, can hardly have painted this picture for the monastery itself, its presence there is significant for the often "popular" and even archaic artistic taste of the resident friars.

[93] Characteristic of the mentality of the Dominican Order, which at this time could easily combine secular, and even intentionally progressive, with popular elements, is the manner in which Fra Angelico represented the various predella panels for his Coronation of the Virgin in the Louvre (painted for S. Domenico at Fiesole). The main item in the Dominican programme, the Giving of the Sword and the Book to St. Dominic by St. Peter and St. Paul (Pl. 138a), is taking place between sequences of column , in which the perspective has been carefully calculated. In the second panel, the Man of Sorrows is represented surrounded by the instruments of his martyrdom, that is, by a symbolic portrayal of the Passion; in front of him are seated only half-size figures of the Virgin and St. John (Pl. 138b). Despite this popular conception, the space, nevertheless, is real and the figures are placed clearly *in front* of the sarcophagus. In the third panel, a long scroll bearing an inscription issues from the mouth of the dying St. Dominic—a typically popular motive. (It must be noted, however, that the predellas were often executed by work-

shop assistants and that the "retrogression" can be partially explained by this—but naturally only in part, for it scarcely explains the "retrogression" of the conception itself.) Fra Angelico also depicted the scene of St. Dominic and St. Francis greeting and embracing each other (as, for example, in the early Madonna in the Gallery at Parma): this was a favourite scene with the Dominicans, for it placed St. Dominic on the same level as the popular and universally beloved St. Francis. One of the iconographically most interesting themes of Angelico is that of Christ conferring on the apostles the right to bind and to loose. (Paris, coll. du Cars.) No theme could have been more significant of the mentality of Angelico's monastery than this. Two bound heretics are represented, the ropes of one being loosened by one of the apostles at the order of Christ. It is equally illustrative of Dominican mentality that Angelico for theological-doctrinal reasons introduced into some of his early Annunciations (e.g. in Cortona) the Fall in the background, in order to show that the Annunciation of the Birth of the Saviour wipes out the Fall.

[94] The size of the sum is moderated by the clause which stated that Fra Angelico after finishing the picture had to judge for himself whether he had merited this amount or only a smaller one. This was quite an unusual clause, and was probably applied only to this friar-artist. Moreover, in addition to the price of the picture, the framework alone (wood and stone) cost as much as half the full amount.

[95] Fra Angelico's commissions for Dominican churches were undoubtedly a great success. Both the Annunciation, painted for Cortona, and its predellas had to be frequently repeated.

[96] L. Douglas, *Fra Angelico* (London, 1902).

[97] Vasari reports, truly or not, that whereas the other artists kept their models hidden, Ghiberti showed his model "continually to citizens and to any strangers skilled in matters of art who might be passing through the town, to hear their opinion".

[98] For the stylistic development in the reliefs of Ghiberti's first door, see R. Krautheimer, "Ghibertiana" (*Burl. Mag.*, LXXI, 1937).

[99] In his competition relief for the nude figure of Isaac, Ghiberti probably made use of a motive of movement from an antique satyr-torso in his possession, but—in contrast to Brunelleschi's borrowings from the antique (Boy with a Thorn in his Foot)—he subordinated it completely to the Gothic flow of line.

[100] It is also important to note that in the construction of his first door Ghiberti—in contrast to Giotto and Andrea Pisano—followed the vertical principle: as in the cycles of images of the French Gothic cathedrals, his rows begin at the base and lead upwards. See Schmarsow, *Gotik in der Renaissance*.

[101] Compare, for example, the representations of the Crucifixion by the two artists, which are closely related to each other, with their similar scheme of Mary and St. John sitting on the ground (Pl. 139a, b).

[102] The last phase of Lorenzo Monaco's development—his frescoes in S. Trinità, the style of which represents an adaptation to the artistic taste of the upper bourgeoisie—shows that in the treatment of drapery he was strongly influenced by Ghiberti's St. Matthew. It is interesting that both the frescoes and the statues were commissioned by the bankers' guild, for this enables us to determine with certainty the taste of this important upper-bourgeois corporation.

[103] In his *Commentarii* Ghiberti in fact speaks at length and with love of the Sienese artists of the fourteenth century. He considers Sienese superior to Florentine art, and speaks—at the time of Masaccio—of a decline of painting. His general estimate of the art of the fourteenth century is especially high—this is a common feature of any somewhat conservative mentality at this period. Speaking of the works of the German Gothic sculptor Gusmin of Cologne, he says they were "the equal o fthe old Greek sculptors"—

an indication how little Ghiberti was concerned with any conflict between the antique and Gothic.

[104] See, on the other hand, the more classicistic realisation of the same theme in the relief at Lille, done after the journey to Rome.

[105] The theme was treated in a similar manner in Florence in contemporary *Rappresentazioni Sacre*.

[106] This popularity was probably responsible for the fact that Andrea Pisano's door, which, with its reliefs treating the story of John the Baptist, for iconographical reasons rightly formed the main door opposite the cathedral, now had to give place to Ghiberti's first door. And this in turn had to make room for Ghiberti's own magnificent second door, known as the Porta del Paradiso.

[107] G. Pudelko dates the frescoes before Uccello's journey to Venice, which took place in 1425 (Thieme-Becker, *Allg. Lexikon der Bild. Künstler* 33, Leipzig, 1939).

[108] H. Brockhaus, *op. cit.* The great cycle from the Old Testament in the Campo Santo at Pisa is to be similarly explained.

[109] In the fresco cycle of the Chiostro Verde the allegory of the Cross is also represented, but in spite of its Franciscan origin it is translated into Dominican terms: at the foot of the Cross is to be found the winged St. Dominic, and in the branches of the tree of the Cross are medallions with images of prophets and Dominicans and small scenes from St. Dominic's life.

[110] G. Pudelko, "The Minor Masters of the Chiostro Verde" (*Art Bull.*, XVII, 1935).

[111] Cf. G. Pudelko, "The Early Works of Paolo Uccello" (*Art Bull.*, XVI, 1934) and M. Salmi, *Paolo Uccello, Andrea Castagno, Domenico Veneziano* (Rome, 1936).

D. TRANSITIONS BETWEEN RELIGIOUS AND SECULAR PAINTING

AS in the fourteenth century, so in this period it is often impossible to draw a strict line of demarcation between religious and secular art. Following tradition, Old Testament figures were still, as a matter of course, interpreted symbolically; but Christian symbolism was now combined with patriotic exposition. David, for instance, continued to symbolise the victory of Good over Evil. But when Donatello's marble David (now Bargello) carved in 1408 and originally destined, though never used, for the Cathedral, was brought to the Palazzo della Signoria in 1416 and set up in the Sala dei Gigli, it was intended also to symbolise the republic and republican liberty, and received on its pedestal an inscription of patriotic significance; all of which is characteristic of the confident and proud mentality of the Albizzi period. Furthermore, so many new varieties of subject matter were now beginning to break free of the ecclesiastical framework that it would seem proper to treat the most characteristic of these transitional cases separately.

One field of representation in which there is a complete intermingling of religious and secular is the painting of birth-chamber scenes on the birthday plates (*Desco da parto*) given away as presents on the occasion of the birth of a child. Their subject was the Nativity of Christ, of John the Baptist, or of the Virgin, or even an actual contemporary Florentine confinement. To-day it is difficult or even impossible to distinguish between these subjects. The secularisation of the originally purely religious subject-matter of these *deschi* is also indicated by the frequent portrayal of a naked Cupid on the reverse of the plate. A significant aspect of the birth-chamber pictures—especially in favour in the twenties and thirties—is the conflict between the middle class and the aristocratic conception. In accord with the general ideological situation, the aristocratising tendency on the whole predominates, while that of the middle class is present only as an undertone, becoming really evident in a few rare instances alone. Such is the case in a birthday plate very close to Masaccio in Berlin, which depicts a contemporary birth-chamber in the classicistic-naturalistic style of the upper middle class; the emphasis is laid on the simple modest clothing of the visiting ladies, although their presents are ushered in by civic heralds. The more usual, aristocratic type is represented by another birthday plate (New York, Historical Society; Pl. 145) perhaps also intended to represent a contemporary confinement, since it is by no means certain that an artist would have ventured to represent the Nativity of John the Baptist in so pronouncedly aristocratic a form. It was painted in 1428, being thus almost exactly contem-

porary with the Berlin plate. But its whole atmosphere is more aristocratic and courtly: three handmaids are bringing in food to the mother, and a very fashionably dressed lady is even playing to the baby on a harp. Significantly enough, the figures have a Gothic elongation and elegance, stylistically related to some extent to the figures of the Maestro del Bambino Vispo, in contrast to the solid Masacciesque forms in the Berlin work; again, whereas in this plate the figures move in a spacious arcaded court, constructed in the manner of Brunelleschi, in the New York plate the architecture is still of the unsteady "stage décor" type of the fourteenth century.

Motives which hitherto had merely formed subsidiary genre scenes within religious histories now begin to appear independently, though still remaining within a general framework—religious in the wider sense. In a miniature in a Sunday Diurnal (1409, Laurenziana) executed in the monastery of S. Maria degli Angeli by an artist in the closest proximity to Lorenzo Monaco, we find Benedictine monks standing in a church choir and singing from a choral book (Pl. 158a).[1] It is clear how this motive, by no means novel in itself—we may recall, for instance, the similar theme in the Raineri fresco by Andrea da Firenze in the Campo Santo at Pisa (Pl. 64)—gives rise, when isolated, to an intense naturalism, and creates a real genre picture.[2] We find no trace here of that Gothic linear flow, otherwise so common in the miniatures illustrating religious stories from S. Maria degli Angeli. The figures stand firm and erect on the ground; their faces are differentiated, and some of them indeed may be portraits.

While monumental representations of the scheme of Salvation as a whole were still executed in the fourteenth century, certain parts of it had already been achieving an independent existence, and by the beginning of the fifteenth these isolated motives sometimes acquire a purely secular character. In the fourteenth century, the systematic inclusion of representations of the Liberal Arts on an equal footing within the scheme of Salvation was already something of an innovation; now, however, Giovanni dal Ponte, for example, more than once depicts the Seven Liberal Arts together with their representatives as quite independent pictures, in independent cassoni (one in the Prado; Pl. 157a). Distinguished, mostly elderly gentlemen, the more important representatives of the Arts, are conducted by elegant ladies, the allegorical personifications of these Arts, across a flower-strewn lawn to Astronomy, enthroned in the middle, while they are garlanded by naked *putti*.[3] What we have here is, in essence, nothing but a company of elegant, high-born love couples, whom Giovanni dal Ponte has depicted for their own sake without the pretext of any religious allegory as in the case of other cassoni—only the costume, and the motive of the wreaths, are different. The men's as well as the women's figures are elongated, with a Gothic swing in the body and broken lines in the fall of the draperies. Representations of this kind afford a typical example of the tendency to secularise but at the same time to aristocratise material formerly purely religious.

EARLY FIFTEENTH CENTURY: TRANSITIONS

Here may be mentioned the illustrations to the *Divina Commedia*, which was not considered a really secular theme, but at least to the same extent an ecclesiastical one. In these illustrations we find a very gradual loosening of the strict adherence to three chosen themes of which we had occasion to speak in connection with the fourteenth century. But even the new themes are still mostly ecclesiastical and allegorical. Generally speaking, these miniatures show at this time a pronounced courtly and gothicising character, for example, those of a manuscript written in 1413 for the Segni (Florence, Riccardiana).

Even when events of contemporary history, or at least those not drawn from legendary sources, are depicted during these decades, they are seldom purely secular events, but mostly such as are closely bound up in some way with the Church. So, for example, with the series of frescoes in the Palazzo Pubblico in Siena, representing the triumph of Pope Alexander III, who came from Siena, over his opponent Frederick Barbarossa, which Spinello Aretino was commissioned to paint in 1407 to the order and for the honour of that city. The commission originated, as the subject indicates, with the Sienese upper middle class, recently risen once again to power, and in alliance with the Pope. But it is significant of the weakness, still to a certain degree persisting, of middle-class ideology, and of the much stronger ideological tradition of the Church, that the subject commissioned is drawn not from the history of the city, but from that of the Papacy.

These sixteen frescoes, moreover—a late work of Spinello—must be regarded as falling only partially within the domain of Florentine art. In these years, indeed, it would be hard to imagine in the Palazzo della Signoria at Florence such a representation, for example, as that of the foundation of Alessandria by the Pope (Pl. 146), in which by far the largest part of the fresco is taken up by masons working on a wall and the tackle for hauling the materials into place. Such motives, indeed, could at this time occur only in Siena, which even now retained a relatively more democratic character.[4] The Sienese upper middle class was not only related more or less closely to the petty bourgeoisie, but—as a result both of its numerical weakness and its inner lack of independence—was yet more closely associated with the nobility. In correspondence with this attitude, the dominant note in these late Sienese works of Spinello is, not the dramatic, tempestuous quality of his narrative in the Campo Santo at Pisa, but rather a well-bred, undramatic atmosphere. Individual episodes are in the main presented as ceremonial scenes, all portrayed in a manner essentially courtly. One of the points to which Spinello, in these secular frescoes, apparently attached the most importance—and this is characteristic of an aristocratic and precious outlook—was the coloristic surface charm of the many rich materials, circumstantially rendered. In Siena Spinello depicted interiors, mostly luxurious, of ecclesiastical and secular dignitaries (Pl. 147). Here, where secular motives are concerned, he allows himself, to a much more marked degree than in San

Miniato, an extreme naturalism in detail and at the same time an experimental treatment of spatial construction. In the representation of space, he links up in a bold but unsystematic way—very different from that of Masaccio later—with the very advanced late style of Giotto. Using the most diverse illusionist devices, he shows a fortuitously selected section of an interior, almost as if it were a view through a window, and gives great variation to these devices.[5] But still his use of perspective is illogical; he produces not a real impression of space, but one full of anomalies.

Likewise in Florence itself, monumental painting during the Albizzi period does not represent secular events drawn from contemporary history, but only ecclesiastical subjects. In this respect the Church had greater ideological potentialities than the Republic. The latter was not as yet very accustomed to the representation of important events which concerned itself, in a secular sense, without allegories or the help of religious figures.[6] Above all, the Church, rooted in tradition, had no need in this new kind of representation to diverge very far from ordinary religious painting; she could take compositional types of religious stories as a basis and yet with their aid create something genuinely new. Masaccio, for example, about 1425 painted a fresco (now lost) in the cloisters of the Carmine, of the consecration of the church by the Archbishop of Florence, which had taken place three years previously. As far as we can judge from copies and imitations, it was painted in the same style as the Brancacci frescoes, and in its naturalistic, monumental classicism the painter was able to master the problem of portraying rows of spectators, a motive which otherwise so easily becomes monotonous. Less secular, more religious and at the same time more "popular", for instance, is Bicci di Lorenzo, who on the façade of the church of S. Egidio (connected with the Hospital of S. Maria Nuova) represented not so much the consecration of this church by Pope Martin V. in 1420[7] as the moment in which the Pope receives the homage of the Florentines, so that in this way the work approximates more nearly to pure religious painting (Pl.148). Bicci is considerably more two-dimensional in his delineation of the long-drawn-out rows of figures, and at the same time more externally naturalistic in his reproduction of the building, than Masaccio, whose entire space was constructed on a thorough perspective basis.

As a pendant to Masaccio's fresco in 1432, the young Carmelite Fra Filippo Lippi had to paint in the Carmine, also in *terra verde*, the Confirmation of the Carmelite Rule which took place in that year. The context was the regeneration of the Order under the Bull of the reformist Pope Eugenius IV.[8] This reform, with its tightening-up of morale, made certain concessions affecting the daily routine of the individual members; thus, the friars were now given wider opportunities for outdoor exercise, so that it might be expected that aspirants would no longer hesitate to join the Order for fear of its unhealthy way of life. Lippi's fresco is preserved only in fragments. In the foreground the Confirmation of the

Rule by the Pope was probably depicted. The surviving fragments mainly display the scenes in the background showing the beneficial results of the reform. We see a novice, who has not yet received the tonsure, kneeling before an older friar, who extends to him a friendly invitation to join, while a number of Carmelites are enjoying a walk in the landscape background (Pl. 149). Thus it is now possible for an Order to make propaganda, in a manner strikingly different from the strictly ecclesiastical and theological character of the Dominican frescoes in the Cappella Spagnuola, by demonstrating its genial spirit and pleasant way of life. A certain bourgeois tendency, a certain modernity find expression in this conception, and it is perhaps not surprising that Masaccio derived his means of livelihood mainly from the Carmelite Order.[9] It is obvious in these circumstances that Lippi would fall under the influence of Masaccio's numerous frescoes in the Carmine. Never again does Lippi draw relatively so near to Masaccio as in his early period, particularly in these early frescoes, with their emphasis on spatial representation and their grandiose figures. The arrangement of the fresco as a whole, however, with its scattered episodes, is not in Masaccio's manner, but reminds us rather of the fragmentary late-Gothic manner of the early Thebaid pictures,[10] such as that of Starnina (Pl. 115b). And the handling of colour is far from being harmonised with the plastic modelling, as in Masaccio, so that no genuine unity is produced between space and figures.[11]

Among the products of the minor arts which depict contemporary happenings and are at the same time bound up with religious art, the most interesting are the miniatures, wrought in 1417 or soon afterwards, illustrating the description of the journey to Palestine of the Dominican Petrus de Cruce (fragments in the Metropolitan Museum, New York, and in the Albright Art Gallery, Buffalo).[12] It is significant of the mentality from which this account of a journey, or rather a pilgrimage, sprang, that the miniatures are mainly concerned with encounters with the devil, with serpents (Pl. 153), with wolves, from which dangers the friars are rescued by God and his angels. These illuminations thus produce the effect of religious histories, of legends of the saints, much more than of a travel-diary. They were probably executed in a Dominican monastery, perhaps by the traveller himself, and they represent a totally different, more two-dimensional and more sketchy narrative style than the large picture-like miniatures in liturgical books. In conception, style and spatial representation they are somewhat similar to Starnina's "popular" Thebaid picture. They are also close to the illustrations of the *Speculum* manuscript, though they have more the character of merely suggestive and only lightly coloured pen drawings than has this work. There is also a kindred method of representation in layers one above the other, so that, for example, the scene of the meeting with the devil has an effect very similar to that in the *Speculum* manuscript of the Temptation of Christ.

FLORENTINE PAINTING AND ITS SOCIAL BACKGROUND

Nowhere, perhaps, is the fluidity of the frontier between religious and secular art so characteristically demonstrated as in the development of portraiture in these decades. The clearest possible transition from the donor's portrait in the religious picture to independent portraiture is afforded by such a work as the fresco of the Trinity by Masaccio (S. Maria Novella) of c. 1427–8, where for the first time—a most important landmark—the donors are represented life-size (Pl. 150). The donor and his wife—perhaps members of the Cardoni family—the only figures besides the Trinity, the Virgin and St. John, kneel, massive and self-assured, before the painted pillars; the woman indeed is almost peasantlike in her stolidity. An indication of how gradually this progress, which culminated in Masaccio's fresco, took place, is given by a picture painted not long before, in 1418, with the same theme, by the much more conservative artist Mariotto di Nardo (Impruneta, Collegiata): here the Trinity is still shown larger and more dominating and the donors much smaller (Pl. 151).[13]

At first, in the beginning of the fifteenth century, we still find numerically few independent portraits. They are simple busts in profile, in the costume of the prosperous middle class, such as the portrait of a man in Boston (Gardner Museum) by Masaccio (Pl. 152), or the two portraits of the brothers Matteo and Michele Olivieri certainly later, by Uccello (Washington, National Gallery and New York, Rockefeller coll. respectively).[14] To commission a portrait of oneself in Florence, when the sitter was not a prince but a private citizen, was the most essentially personal commission that could be given—one that satisfied no artistic requirements other than the patron's own. Those who, in the first decades of the fifteenth century in Florence, demanded such an individual work of art, were really and truly burghers, burghers in what was then the most advanced sense, as reflected in the frescoes of Masaccio.[15] Here is no reference to knightly costume; here is the deliberate simplicity, the unpretentiousness of the wealthy citizen. But soon after the Albizzi period this also begins to alter: portraits of women, particularly, soon become more courtly, more dressed up and more "precious".

NOTES

[1] M. Ciaranfi ("Lorenzo Monaco Miniatore", *L'Arte*, XXXV, 1932) and R. Longhi (*op. cit.*) consider this to be perhaps an early work of Fra Angelico.

[2] The sculptures of singing and music-making angels, represented as choir-boys, by Luca della Robbia, executed for the Musicians' Gallery of Florence Cathedral (1431–7) —a milestone in the history of Florentine naturalism—can be understood only in relation to these and similar predecessors. These sculptures are not of course pure secular art in the narrow sense of the word, for they form part of the whole programme of decoration in S. Maria del Fiore, illustrating the rejoicing of the angels at the Coronation of the Virgin.

[3] In his *Amorosa Visione* Boccaccio describes frescoes of a Castle of Love (he accords them the highest praise: they are as good as if painted by Giotto), in which a large number

of classical authors and philosophers are shown at the feet of Sapientia, as attendants on the Seven Liberal Arts. Boccaccio identifies the Virtues with classical goddesses (Amato), and Salutati likewise puts the Liberal Arts on a level with the Muses. These fourteenth-century ideas now became generally widespread. Giovanni da Prato's poem *Philomena*, written about the same time that Giovanni dal Ponte painted the above picture, using some of these conceptions and motives, may possibly have been the literary source for this cassone. In this poem the author is conducted by Beatrice (Poetry—Theology) over a flowery meadow to the Seven Virtues, personified by celebrated women, and to the Nymphs, who represent the Seven Liberal Arts. Beatrice is their leader. After this ths author reaches Parnassus, where a succession of poets, authors and artists parade before him. Among the poets are Dante, Petrarch and Boccaccio, among the authors Salutati, and the artists include Phidias, Apelles and Giotto. (Petrarch's and Boccaccio's praise of Giotto had a significance quite different from and more progressive than Giovanni da Prato's, which already contained a strong conservative tinge). The whole attitude of this poem, imitating Dante and Boccaccio, and based on Scholasticism, with its choice of famous men, conservative in tendency, but nevertheless making certain concessions to classical antiquity, is typical of the old-fashioned and popular, only slightly classicising taste of a large portion of the middle class—of that same portion to which Giovanni dal Ponte's cassone made its appeal.

[4] The only work of any similarity in Florentine monumental art occurs, as we have seen, in one of Agnolo Gaddi's frescoes of the Legend of the Cross, in S. Croce, executed about 1380 (Pl. 66), at a time of lower-middle-class supremacy.

[5] Gombosi, *op. cit.*

[6] For example, the Commune, in their pride at having conquered Pisa in 1406, on the Feast of St. Dionysius, commissioned Starnina to depict this Saint in a fresco on the façade of the Palazzo di Parte Guelfa and below it a view of the city of Pisa (both now lost).

[7] The same theme is shown in a miniature from an Antiphoner written in 1421 for S. Egidio, in which the rest of the illuminations relate to the life of St. Egidio—a good example of the kind of framework from which the representation of a contemporary subject emerged. The artist, according to R. Salvini ("In margine ad Agnolo Gaddi," *Rivista d'Arte*, XVI, 1934), is Meo da Fruosino, a pupil of Agnolo Gaddi.

[8] G. Poggi, "Sulla data dell'Affresco di Fra Filippo nel Chiostro del Carmine" (*Rivista d'Arte*, XVIII, 1936).

[9] Further evidence of the artistic progressiveness of the Carmelite Order is the fact that the Sienese painter Domenico di Bartolo, who was very much under the influence of Masaccio and is also stylistically related to Lippi, forming a kind of link between the two, was commissioned to execute the painting for the high altar (now lost) of the Carmelite church of Florence.

[10] There was perhaps a certain Carmelite tradition in art for the representation of a similar subject. It seems quite possible that the structure of the composition and individual motives of Lippi's fresco were suggested to him by a predella of Pietro Lorenzetti, representing Carmelite hermits, strolling and reading at the fountain of Elias, on Mount Carmel, near their early monastery (1329, Siena, Pinacoteca). Pietro's predella in which the landscape plays a pre-eminent role (the other predellas also represent scenes from the history of the Order) is part of his altarpiece painted for the Carmelites in Siena which Fra Filippo, who was there in 1426, would certainly have seen on that occasion.

[11] M. Salmi, "La Giovinezza di Fra Filippo Lippi" (*Rivista d'Arte*, XVIII, 1936).

[12] K. Clark, "Italian Drawings at Burlington House" (*Burl. Mag.*, LVI, 1930). R. Longhi (*op. cit.*) considers these miniatures to be early works of Fra Angelico.

[13] A still earlier stage in the relative proportions of Trinity and donor, where the former predominates still more pronouncedly over the latter, is afforded, for example, by a picture by Gerini (Rome, Galeria Capitolina), dating from the eighties or nineties of the fourteenth century. Some examples of the increasing size of patrons' figures in the course of the fourteenth century are given on p. 157, note 45.

[14] M. Salmi (*Paolo Uccello, Andrea del Castagno, Domenico Veneziano*) attributes the two latter to Domenico Veneziano.

[15] If the coloured terra-cotta bust in the Bargello is really, as is quite possible, a work of Donatello's and really represents Niccolo da Uzzano (see Kauffmann, *op. cit.*) then the earliest extant independent Florentine portrait-sculpture is at the same time the portrait of the leader of the Florentine upper middle class of the Albizzi period. The bust recalls those of the late Roman Republic and of the very early Imperial period.

E. SECULAR PAINTING

THROUGHOUT these decades, in the representation of secular subjects—and especially in those depicting contemporary life—the conflict between the middle class and the aristocratic outlook, and, in association with it, the conflict between different styles, can always be felt. Now that the middle class had reached the fullest consciousness of their own power, accompanied by a relative secularisation in principle of their culture, the independent representation of middle-class life and activities was made possible. But in practice this was prevented from taking effect to any appreciable extent by the ideological aristocratisation of the wealthy upper stratum,[1] and by the imitations of that attitude among the less well-to-do. Hence, in general, middle-class activities are now ousted by scenes from chivalrous life, almost more than in the fourteenth century. Even the Lana, the wealthiest middle-class guild, had a tournament (perhaps that held to celebrate the conquest of Pisa in 1406) represented in one of the two large frescoes in the great room of their guild-hall. Only in the small quatrefoils below and, be it noted, in a more craftsmanlike manner, are depicted the different processes of wool and cloth manufacture—the washing and combing of the wool and the weaving and dyeing of the woollen cloth.[2] Thus, even in their own guild-hall, the burghers at this time assign a greater importance to customs imitated from feudal life than to the trade from which they had derived their wealth.

In the cassoni paintings, the most genuine field of the secularisation of art, this conflict between the middle class and the aristocratic outlook is equally evident. Here, where the individual taste of the patron is the one decisive factor, the aristocratic point of view triumphs more than ever.

At the same time, it was still possible in the Albizzi period—and perhaps then alone—for two scenes representing a popular feast-day to be painted on a pair of cassoni on the occasion of the marriage of a member of the Fini family with a lady of the Aldobrandini in 1417: the first (Cleveland) shows the Palio (Pl. 154a), the city's most important festival, which took place on St. John the Baptist's Day, and the second (Bargello), the procession, which preceded the races, of representatives of the rural districts to the Baptistry, bearing consecrated gifts and banners.[3] But the painter—it was in Rossello di Jacopo Franchi's workshop that these two pendent cassoni originated—has been at pains to do full justice to the distinguished character of this procession as it actually appeared with its richly-dressed horsemen led by the Capitano della Parte

Guelfa and organised by the very aristocratically-minded Calimala guild.[4] He has also attempted to provide an aristocratic touch to the races themselves by introducing occasional groups of elegantly attired persons—no easy matter for him on account of his rough manner. Here, as so often elsewhere, we may observe how exactly the finely-dressed figures, chiefly women, are treated in contrast to the others in an exaggerated gothicising manner. Particularly striking is the unusually strong realism of detail consequent on the subject of the race itself—especially the incident, based on personal observation, of the fallen horse with outstretched neck, its rider hurtling over its head.

Such representations of a popular festival are, even in these decades, an exception. Generally speaking— particularly in the late Albizzi period—scenes of contemporary life depicted on cassoni are only courtly, chivaleresque recreations, love-scenes, festivities and combats. Motives drawn from the amusements of secular society, such as we have met in monumental art in the Pisan fresco of the Triumph of Death, or in the fresco in the Cappella Spagnuola demonstrating the activities of the Dominican Order, lose their ecclesiastical, allegorical meaning and become independent, being at one and the same time spun out in details and more firmly pressed into an aristocratic mould. At the same time, it can be clearly seen that the quality of these different kinds of cassoni is always improving: for the intensive aristocratisation and the cultural development on the same lines of the rich middle class, in particular of the influential oligarchic families, helped to create a larger demand for these pictures, and therefore necessarily encouraged relatively good artists to become cassoni painters, especially cassoni painters of this genre. In the chests of about 1400, representations of the pleasures of the nobility are still quite mechanical: two cassoni in London and Castello Vincigliata, for example, exhibit the simple, schematic alternation, six times repeated, of the two types of a mounted noblewoman hawking and of a lady with her cavalier beside a Fountain of Love—both displaying a sort of primitive Gothic style.[5] Superior in quality is a later cassone by Rossello di Jacopo Franchi in Berlin (Pl. 154b),[6] depicting the rural pastimes of the nobility or of the middle class who emulated them: fishing, eel-spearing, blind-man's buff, dicing, love-making, mandoline playing, and a juggler making a little dog dance on a table. The "distinguished" Gothic manner, which in the Palio cassone is confined to single groups, is here predominant throughout: we can clearly see the strain occasioned to the painter, basically a rough, popular artist, by a subject not particularly congenial to him, though he is at great pains to comply with the wishes of his wealthy patrons. Exactly the same style is to be observed in another cassone of Rossello, representing a fashionable amusement of the international, feudal aristocracy, a court of love (Washington, National Gallery). It is quite possible that the scene, which takes place in a garden where a lady is crowning one of the two young men kneeling before her with a wreath, while the rest of the company looks on in the background, is intended to

illustrate the framework, aristocratic and French-Neapolitan in temper, of Boccaccio's *Decameron*, where the chosen queen crowns the best story-teller of the day.

In connection with these portrayals of outdoor distractions we must mention, on account of its particularly interesting subject-matter, a marriage-plate in the Metropolitan Museum in New York, painted for a distinguished family wedding[7] very probably by Mariotto di Nardo (Pl. 155). It depicts a bridal pair, in courtly dress, and accompanied by another lady, seated on the ground in a hilly landscape listening to a shepherd playing the flute, while another shepherd points at him with a grotesque gesture and grimace.[8] The often music-making shepherds—a familiar motive in religious art in the Annunciation to the Shepherds or in the story of Joachim, as also in representations of the months—are now finally transplanted into secular painting. The picture displays the schematic manner usual with Mariotto di Nardo—the same is approximately true of him as of Rossello—although the dressy garments of the bridal pair suffer less from it than do the hills and the flowers, which are introduced and arranged purely for decorative effect. The picture is important in that we find here for the first time in Florence the theme of the contrasting but complementary characters of town and country folk. A prerequisite for the illustration of such a scene is an intense consciousness, on the part of the urban population, of the joys of rural life, a consciousness made possible by the popularity of residence on their country estates; this ideology was cultivated and refined by the pastoral poems of Petrarch. But to this process of refinement no hindrance is afforded by the type, already common in literature as well as art in Europe in the fourteenth and still more in the fifteenth century, of the "comic" peasant: the care-free, jolly and likewise stupid, clumsy peasant, as the aristocracy and the aristocratic-minded urban population, to whom the rural estates belonged, and which was wont to exploit him, liked to regard him.

The courtly, late-Gothic manner of the cassoni reaches its climax in stylistic accentuation, as well as in quality, at the end of the Albizzi period, and in the early years of Cosimo de' Medici's rule, round about 1430–40: in the secular, aristocratic sphere of cassoni painting this accentuation could develop much more freely than in religious art, for therein was its ideal field of action, afforded at once by the subject-matter and the type of patron. Not only cassoni, but also bridal plates and bridal boxes, which were similarly used as wedding presents, provide prodigal and detailed illustration of aristocratic customs and festivities. Just as the whole way of life of this middle class, imitating the old feudal aristocracy, is nothing but the creation of a dream-world on earth, a projection into and idealisation of the aristocratic life of earlier days, so also, in these pictures themselves, a kind of aristocratic dream-world is brought into existence. This trend towards a mildly archaic outlook is reflected in a mildy archaic style: the pictures have an archaic tendency because life itself tended the same way. Again

and again we find those cavaliers and ladies whom we encountered in Gentile's pictures of the 'twenties, but since his time they have become more fashionable, more elegant, gay, stylistically more strongly gothicising, approximating to the archetype and ideal of high-bred Florentine taste, that is, to France, reverting for instance to the modish, aristocratic figures in the *Très Riches Heures du Duc de Berry*. In a typical Florentine work of this style, such as the marriage-plate (Pl. 159b) depicting a company of elegant people amusing themselves, formerly in the Figdor collection, Vienna—the theme can also be regarded as a kind of allegorical Garden of Love—we find a scene really informed with that spontaneous charming delicacy which Rossello's Berlin and Washington cassoni painstakingly sought to reproduce. Two cavaliers and a lady skip dancing across the scene, a harpist plays, and loving couples flirt and kiss and embrace among the trees by the fountain. These young people would seem to know no other purpose in life than to devote themselves to their pleasures and to display their minutely reproduced, luxurious garments. For members of distinguished society the details of dress were of very great importance, serving—as the civic sumptuary laws directed against the less noble show—as the mark of their wealth and also of their elevated social rank. In these cassoni, and especially in this wedding plate, the elegant are entirely by themselves. And so they fashion for themselves that idealised, playful, somewhat fairy-story style which their taste demands. This style consists in carrying to their ultimate conclusion those tendencies which could only be suggested in the religious stories of the Maestro del Bambino Vispo or of the Master of the Judgment of Paris (Pl. 140), or even in the birthday plate of the Historical Society, New York (Pl. 145), to which this wedding plate is in style fairly closely related. Here the youths and maidens sway in the whirl of the late-Gothic linear rhythm, their elegant over-slenderness and elongation still further enhanced by their high head-dresses. The scenes are arranged one above another, the composition rises vertically, the whole has a flat, decorative effect, the flowers and trees appear in it like the pattern of a verdure tapestry: of the achievements of upper-middle-class naturalism only a very slight and indirect echo is to be detected.

This period also produced secular miniatures, which are closely connected with the themes of these cassoni and wedding plates and in which, consequently, the same intensive, aristocratic, late-Gothic style predominates. They adorn a manuscript (Laurenziana), containing a number of *canzoni* with musical setting[9]—probably, indeed, of the very kind which were played on the recreative occasions described above. The miniatures show not only portraits of the particular musicians,[10] but also marginal decorations, related to the subjects of the individual *canzoni*, and like the *canzoni* themselves, representing scenes of courtly entertainment. Thus one of the marginal decorations shows amidst a surrounding of grotesque ornament an elegantly attired maiden with a burning branch—the symbol of love—approaching a similarly elegant young man, who

kneels before her. Their high, turned-up collars accentuate the Gothic linear rhythm, which dominates this composition throughout.[11]

There exist a number of cassoni with Italian tales as their subject—particularly the universally known *novelle* of Boccaccio. It is interesting to note the choice of stories for illustration.

In two very early companion cassoni, for instance, from *c.* 1400 (Bargello and Harris coll., London) executed for the marriage of an Alessandrini, Boccaccio's story of the Sultan Saladin and the Merchant of Pavia and his wife is illustrated; not only as an example of conjugal fidelity, but also, no doubt, because of the opportunity of bringing in Orientals, horsemen, a prince and sumptuous raiment: all in a manner whose Gothicising tendency, although still hesitant, is plain already none the less. Pictorial representations of Orientals, who were regarded as picturesque and fantastic figures, presented the added interest consequent on the lively trade connection then beginning with the East. This interest is displayed, among other works, by a cassone in Altenburg, later in date than the above, by the Maestro del Bambino Vispo, depicting a cavalry battle between Orientals (Pl. 156).[12] The Oriental riders give the contest—a favourite theme for the aristocratic taste—an added interest, and the flowing Gothic line, which co-ordinates and pervades the agitated throng, is the adequate formal expression of that taste. The potentialities of Gothic linear rhythm, of the exaggeration of the ornamental function of line, suggested in Spinello's battle-frescoes in the Campo Santo at Pisa (Pl. 73), are now accentuated to an extraordinary degree, in the manner of French courtly illuminations, or—to keep to Florence—of Lorenzo Monaco's wildly fantastic drawing of the Journey of the Magi (Pl. 117). And if in the latter an unusual religious theme was chosen so that an unusually high degree of Gothic linear rhythm could be utilised, the Maestro del Bambino Vispo is entirely free in his battle cassone—in which individual motives of riders are akin to those of the drawing—of religious thematic restriction, and can permit his riders and horses to twist and whirl in the wild vortex of unfettered fantasy.[13]

Boccaccio's tales were mostly far too bourgeois in implication to lend themselves to such a chivalrous and courtly way of representation as we find in the line of development from the above-mentioned Saladin stories to the Altenburg cassone. Still less, of course, was such a treatment possible where scenes from Boccaccio were concerned, which were enacted—very different from the "feudal" framework—in a purely middle-class milieu, such, for instance, as the story of the young man who had himself brought into the house of his beloved in a coffin: a subject which, on account of the love-motive, was suitable for a wedding chest. It is found on a cassone in Edinburgh (Pl. 157b), and the artist, in my view again Rossello di Jacopo Franchi, has there used the same compromise-style, wavering between the aristocratic and the bourgeois, and showing gothicising formal idiom only in certain passages, as in the cassone of the Palio

race (Pl. 154a). A theme so robust, emanating from Florentine bourgeois jocularity, could not easily lend itself to a fully aristocratic and Gothic treatment. And the same can be said, with some important exceptions, of many of Boccaccio's stories. This is undoubtedly the reason why illustrations to this author's works, these exceptions apart, become increasingly rare as the fifteenth century progresses. The subjects which superseded them were genuine romances of chivalry and those classical stories which that same Boccaccio had gathered together in his Latin books and which easily lent themselves to illustration in the courtly spirit.

Before turning to the illustration and transposition of antiquity in the cassoni, the significant fact should be mentioned that the great and widely popularised Florentine authors of the fourteenth century, whenever they are represented in person on cassoni, as they sometimes are, also tend to appear in a Gothicising, more or less aristocratising (we may also say a somewhat popular) guise. A picture in the Fogg Museum (Harvard University) by Giovanni dal Ponte, though dating from his late period when he was vaguely influenced by Masaccio, still represents the figures of Dante and Petrarch in a gothicising manner (Pl. 158b), somewhat similar to that of the antique representatives of the Liberal Arts in the other cassone previously mentioned. Petrarch especially,[14] whose general line tended more towards the courtly than that of Dante or Boccaccio, becomes a figure curved in Gothic rhythm. The courtly interpretation of Petrarch is also to be seen in the earliest cassone devoted to the illustration of his text.[15] It shows one of his *Trionfi*, the Triumphs of Fame (*c.* 1400, Munich, Mog coll.) mingled with motives from his *Viris Illustribus*, and from the *Amorosa Visione* of Boccaccio.[16] Men, and women also, are riding in the vicinity of Fame to receive laurels from her. It is a two-dimensional turmoil of distinguished and modishly-dressed figures, among them figures of antiquity sometimes rendered half-naked (e.g. Hercules), and sometimes dressed like the others (e.g. Achilles).

As for antiquity, its general emergence as an independent source of artistic themes dates from this very period.

It is only natural that so progressive an artist as Donatello should already have expressed antique motives in a formal language akin to antiquity, but in our period these motives, as for instance the dancing and music-making *putti* on the font of the Baptistry in Siena, were, strictly speaking, still kept within the framework of religious statuary, were more or less subordinate to the religious programme of the whole. Maybe the dancing *putto* of the Bargello was not made expressly for the font, and was thus outside this programme. But on the whole those works which have an independent, secular theme taken from the antique, quite likely date from as late as the period after the Rome journey of 1433.[17]

The number of manuscripts in our period containing works by classical authors and miniature illustrations undergoes an extraordinary increase as

compared with the fourteenth century; yet in the main they are still confined to more or less schematic portraits of the author, no matter whether he happened to be Aristotle or Virgil. But the chief subjects of cassoni, their love stories, in contrast to the frescoes which had decorated the walls of the aristocratically-minded middle class at the end of the fourteenth century, where fables of French chivalry were the favourite source of themes, are now often drawn from Greek and Roman mythology. This is certainly an important innovation, an indication of the fact that the ideology of antiquity, finding a ready welcome in the national sentiment of the middle class, is gaining ground and becoming familiar. At the same time, it is no less important that the ideology of these illustrations is of the feudal-classic variety suited to this particular kind of patron and to this type of picture: they were commissioned from workshops, often employing artisan-like methods, by the wealthy, aristocratising, not over-progressive, yet to some extent cultured middle class on the occasion of their marriages, and bore their coats-of-arms. Antiquity is here thought of as something at once archaic and distinguished, and appears in these cassoni as an especially elegant, aristocratic dream world. In this connection it should not be overlooked that the sources of these classical love stories are not so much the antique authors themselves—Ovid, for instance, or Virgil—since their texts were often not known to such patrons, still less to the workshops in which the cassoni were painted—but transposed and popularised versions; these were to be found in the works of fourteenth-century writers like Dante, Petrarch, and above all, Boccaccio (especially his encyclopaedia-like *De genealogiis deorum*) and in Italian anthologies of stories, the classical motives of which were derived from the medieval *Gesta Romanorum*.[18] This whole cultural attitude of the patrons and of the artists towards antiquity helps us to understand that in cassoni, classical mythology and history, such as the stories of Diana and Actaeon, the Judgment of Paris, or Tarquin and Lucretia, afforded only the pretext for illustrations similar to the above-mentioned actual representations, or rather idealisations, of contemporary aristocratic life itself: namely, of the festivities, pleasures and amorous adventures of the distinguished ranks of society. There was scarcely even an attempt to depict the characters of antique mythology in a classicising way: they appear in most cases as knights and court ladies, clothed in contemporary fashion, or an idealised form of it, chiefly in the forms favoured by the French and north Italian courts, which embodied, for the well-born, Florentine middle class, the ideal of life. Thus, for instance, in Giovanni dal Ponte's cassoni with various pairs of lovers, it is impossible to decide whether the couples represent ancient characters, such as Paris and Helen, or Theseus and Ariadne, or medieval-chivaleresque ones, like Tristan and Isolde or Arthur and Guenevere.

Probably the most typical of all courtly illustrators of antique subjects is the Master of the Judgment of Paris, named after the bridal plate, a *tondo*, painted by him around the 1430's, and now in the Bargello (Pl. 160). We have already met

with altarpieces and religious scenes from this artist's hand. That courtly and aristocratic mentality which, relatively speaking, was indicated rather than openly expressed in these works, was able to develop freely in his pictures illustrating secular, ancient subjects. The transition between these two kinds of pictures is to be found in a cassone by the same artist, illustrating the story of Judith (formerly Florentine art-market)[19]—a scene drawn characteristically from the Old Testament, which formed, at this time especially in cassoni, a kind of link between religious and secular art. In no other works, however—hardly even among those depicting the amusements of aristocratic society—is the enthusiasm surpassed with which, in the scenes from antiquity, he paints, sometimes faithfully, at others probably idealistically, the costumes of the distinguished Florentine, and above all French ladies. This seems, indeed, to be the main object of these delicate works. So it is with the above-mentioned Bridal plate, showing the Judgment of Paris; so also with another in the Cook collection, Richmond, representing the Rape of Helen (Pl. 159a). In the former picture it is the three goddesses, in the latter several of Helen's attendant ladies; they stand close together, all over-elaborately clothed, in profile and in similar positions. They are garbed rather like the female onlooker in Gentile's Presentation in the Temple (Pl. 108a) that is, in the gala-dress of noble ladies, the so-called houppelande. Without doubt, the stimulus towards this emphasis on rich drapery came to the Master of the Judgment of Paris from Gentile, in a spirit rather akin to the *Très Riches Heures du Duc de Berry*. But whereas in Gentile this superbly-dressed lady is merely an accessory figure, a spectator of the sacred event, in the Master of the Judgment of Paris the whole narration of the classical story is based on the silhouette effect produced by the juxtaposition of the over-elaborate costumes of the principal figures. In the Judgment of Paris, Paris stands opposite to them, but they reappear once more in the same picture, similarly dressed, in the background, where Eris throws them the apple. Despite all similarity between the two pictures, the drapery in the Judgment of Paris is, in details, mostly still more over-decorated even than in Gentile: embroidered collars, lying over the shoulders, envelop the ladies; long ermine tails and scrolls of lace flutter down their sides, their garments acquire rich borders, and the ingenious arrangement of their plaited tresses is given still further height by tall diadems of feathers, or, as in the Rape of Helen, they wear enormous, round headdresses. The figures, in intimate connection with the costumes, have become incomparably taller and more slender—none perhaps in the whole of Florentine art are more attenuated than those of this artist—and at the same time the Gothic curve of their postures is much more accentuated, so that the whole effect becomes extremely heraldic. This heraldic effect does not relax even where movement is depicted, as in the group where Paris is shown in the act of bearing away Helen. The same impression as in the gothicisation of the figures is conveyed by the carefree rendering of natural objects and of space: the

stereotyped plants, for instance, unrelated to the formation of the ground, the two-dimensional animals, the false perspective of the fountain or the super-imposed layers of landscape. This painter, by no means unimportant and un-questionably refined, with his delicate, luminous colours, is no stickler for accuracy in his representation of nature, although he is certainly interested in individual details, so far as they fall within the realm of courtly life. In the matter of organic naturalism the Master of the Judgment of Paris represents a definite retrogression when compared with Gentile—not to mention Masaccio; although, on the other hand, he is not so purely two-dimensional and decorative as the painter of the Figdor wedding plate. His art is at bottom merely a super-ficial and charming popularisation of certain individual achievements of other artists.

We feel quite clearly that for the circles for whom these cassoni pictures were executed, this kind of art, and antiquity with it, had the strongly-marked char-acter of a pleasant pastime, which they wished to enjoy without being troubled by anything problematical. Even if, in some cassoni of this period—Diana and Actaeon for instance—female nudes do occasionally appear, yet precisely in the work of the Master of the Judgment cf Paris, the antique theme has not even sufficient pictorially creative efficacy to cause the deities to appear as nudes, rather than as ladies of the court. [20] Generally speaking, these cassoni painters were certainly not interested in themes derived from antiquity on account of the logical naturalism or the stricter compositional structure of classic art. But as we have seen, this interest in antique art did exist among those artists in the first three decades of the fifteenth century, who embodied the outlook of an advanced middle class and were able to give expression to their outlook—both in painting and in sculpture—in monumental commissions, deriving from the municipality or the guilds, or from specially progressive individual members of the middle class. Thus, while the knowledge and study of antiquity implied in their case a secularisation and rationalisation of religious art, in respect both of content and of form, the part played by antiquity within the secular art of chest painting is—an apparent paradox—mostly much less adequate. In this minor art, where the personal, everyday taste of numerous individual members of the aristocratically-minded middle class finds expression, antiquity is drawn, as we have seen, through the nature of a courtly and aristocratic culture, into a scheme of fairy-tale dream-pictures of a "noble" past and a "more ancient" aristocracy; classical tales are transmuted, in cassoni, into the legends of chivalry. [21] Stylistically, therefore, these pictures, especially those of the thirties, and above all those painted by the Master of the Judgment of Paris, mostly constitute, together with idealised representations of the contemporary life of the aristocratising middle class them-selves, a definite climax in the international, courtly, late-Gothic Florentine style, an enhancing and reinterpreting from this point of view of the style of Lorenzo Monaco, of Gentile and even of the Maestro del Bambino Vispo; and nowhere

is the "influence" of French and Burgundian courtly painting so strong as in these particular cassoni.

The antique-imitating trend bears within itself various elements and potentialities, and it can no more be reduced to an entirely satisfactory common denominator than can the Renaissance itself. The various social strata of the Renaissance period, and the separate generations within these strata, differ entirely in their conceptions of antiquity; each sees in it something different, employs it variously, and gives it diverse forms in the different picture types.

NOTES

[1] Cycles of famous men, mostly found in the fourteenth century only in a feudal milieu, also existed during this period in the palaces of the noblest Florentine middle class. Bicci di Lorenzo painted such a cycle, no longer extant, for Giovanni de' Medici.

[2] W. Bombe, "Florentinische Zunft- und Amtshäuser" (*Zeitschr. für Bild. Kunst*, XXI, 1910).

[3] As in so many other chests, bust portraits of the Virtues are also represented here.

[4] G. de Nicola, "Notes on the Museo Nazionale of Florence" (*Burl. Mag.*, XXVII, 1918).

[5] These chests derive from the convent of S. Maria Nuova, whither they were imported by unmarried girls of the wealthy middle class, who, guaranteed by a life annuity, entered the convent as so-called Beatelle. At their death the chests passed into the possession of the convent. The decoration, of the type described above, of certain of these so-called nuns' chests—many of them, indeed, have no other decoration than a coat-of-arms, which is invariably present—clearly indicates the taste of the social stratum from which these maidens sprang.

[6] By G. Pudelko ("The Maestro del Bambino Vispo", *Art in America*, XXVI, 1938) ascribed to the Master of the Griggs Crucifixion.

[7] According to P. Schubring the coats-of-arms on the plate may be those of the Cassigiani and Monte di Pietà families.

[8] On the companion piece, also in the Metropolitan Museum, is shown a hunt, in which the bridegroom is accompanied by a large number of ladies.

[9] Florence was at this time the most important musical centre in Italy and Florentine music combined elements of popular realism and courtly delicacy.

[10] It is again significant of the continual interpenetration of religious and secular art that the majority of these musicians are clerics. Among the musicians is also represented the scholastically minded Francesco Landini (see p. 112, note 4).

[11] Petrarch's poems, too, are often illustrated in this period. One of these manuscripts (Florence, Biblioteca Nazionale) completed perhaps for the Ricasoli, contains a miniature, illustrating a *canzone*, in which God is depicted showing a skeleton to Petrarch, in order to keep before his mind the vanity of worldly things: so it is, in fact, not a new pictorial invention, but a theme borrowed from the well-known allegories of death.

[12] The theme of the struggle between Mohammedans presumably originates in Spain, but it is quite possible that the artist painted the picture when already in Florence.

[13] G. Pudelko (*op. cit.*) assumes that the cassone is the earlier of the two.

[14] F. Mason Perkins ("A Florentine Double Portrait in the Fogg Museum", *Art in America*, IX, 1921) considers that the figure represents Petrarch rather than Virgil. But the alternative cannot be dismissed out of hand: in this case, we should have the traditional juxtaposition of the two chief characters in the *Divina Commedia*.

[15] D. Shorr, "Some Notes on the Iconography of Petrarch's Triumph of Fame" (*Art Bull.*, XX, 1938).

[16] In the frescoes of the imaginary palace here described, the Triumphs of Fame, of Love and of Fortune are represented. (See also p. 360, note 3.)

[17] The Amor bust of the Widener collection, Philadelphia, is usually dated as early as the first half of the thirties.

[18] Schubring, *op. cit.*

[19] M. Salmi, "Aggiunte al Tre e al Quattrocento Fiorentino" (*Rivista d'Arte*, XVI, 1934).

[20] Even Venus, on the back of the bridal caskets, is still shown draped, though she is attended by a nude Cupid.

[21] Where occasionally individual characters of antique mythology could not be represented as knights and ladies of the court, they were shown in forms resembling the popular, grotesque figures of religious legend: thus, for example, in another cassone by the Master of the Judgment of Paris (formerly in the Nemes Collection, Munich) which depicted the classical theme of the youth of Hercules, Juno's demon-messenger, sent to incite the snakes to attack Hercules, is shown as a winged devil attired in black.

4. SOCIAL POSITION OF THE ARTISTS; CONTEMPORARY VIEWS ON ART

IN the Albizzi period, generally speaking, the majority of artists held very much the same position as in the fourteenth century. Even now they usually counted as craftsmen, and their careers developed within the guild. The type of the work of art in question, the particular artistic requirements of the patrons, still largely determined the method of work, whether it was in the nature of collective output by a workshop or the achievement of an individual artist. Though individual work now occurs more frequently than in the fourteenth century and consequently separate artistic personalities stand out more clearly than before,[1] yet collective work was common, even in commissions for altar-pieces,[2] and still more so, for example, in workshops which produced cassoni. In general, artistic freedom remained extremely limited. Even in Ghiberti's and Donatello's contracts with the guild of the bankers and that of the linen drapers concerning respectively the St. Matthew and the St. Mark statues for Orsan-michele (1410 and 1419), it was expressly stated that the works had to be carried out entirely as the patrons desired (*chome alloro parva* in Donatello's case, *in chel modo et forma che sia di loro piacere* in Ghiberti's).[3] The economic dependence of the artist also continued to be very pronounced. Indeed, precisely because it never occupied itself with the economic problems of the artists, the Compagnia di S. Luca was able to survive when in 1419 numerous lay companies were suppressed. The artists' payments had certainly risen since the fourteenth century, but not very appreciably.[4] In economic matters, those who usually came off worst were naturally needy craftsmen who had to produce cassoni. Giovanni dal Ponte, for instance, was obliged to spend eight months in a debtor's prison in 1424, because his clients would not pay; and even then these patrons still defaulted, though among them were the richest men in Florence, such as the Adimari, Uzzano, Quaratesi, Spini, Strozzi, Tornabuoni and Rucellai.[5] Even a highly esteemed artist like Ghiberti, who worked with many journeymen and apprentices, was entirely bound and without rights in the actual contract, as appears clearly from the documents concerning the St. Matthew ordered by the bankers' guild.[6] No question of reciprocal rights arose; the bankers' guild settled all matters concerning materials, payment, and length and method of work, and to it lay the only appeal in any quarrel which might arise between the parties.[7] So, too, in the contract for the St. Mark between Donatelló and the linen-drapers, it was stated that the payment rested entirely within the discretion of the patrons.

Yet certain changes had taken place as regards the esteem in which artists were held, or at least, individual artists of the upper middle class who had outstanding commissions. For, as art acquired a bourgeois and secularised character, as increasing importance was attached to the affranchised views of the laity, also concerning art, furthermore, as individual artists rose socially from the rank of artisan to that of the middle class, the whole point of view towards art began slowly to alter. The far-reaching views of the Bruni-Niccoli circle as to the value of literature itself, quite apart from its religious content, as to the importance of style and the form of rhetorical construction, which formed the basis for the classicistic aesthetics of the future,[8] were not openly applied to art, yet we gain the impression that in practice they already lay behind certain works of the most progressive artists. Moreover, some common ideas of the humanists, ideas capable of mutually complementing each other, and already formed in the second half of the fourteenth century, were now, in the early fifteenth century, at the apogee of the upper middle class, applied in theory expressly to art and to artists. We refer, in general terms, to ideas already discussed, such as the esteem for scholars and the educated, contempt for money-making, the importance attached to knowledge, the significance of classical learning. Phrases taken from the scientific and philosophical literature of antiquity now come to be applied to art as well, art was brought nearer to science and so given a higher standing, a social prop. And finally, the theory of Florentine national pride—that of Florence as heir to Rome—was brought into association with art.

The clearest summary and co-ordination of these ideas is to be found in the historian and lecturer on Dante, Filippo Villani (Giovanni's nephew, d. *c.* 1405) in his *De Origine Florentiae et de eiusdem famosis civibus*, written in the late fourteenth or the first years of the fifteenth century. A great innovation is signalised by this humanist—who, in fact, was relatively conservative in outlook—when he gave, for the first time, in describing famous citizens of his native town, a somewhat lengthy account of the principal Florentine artists of the fourteenth century and characterised them individually.[9] It is also extremely significant that in contrast to the earlier official-ecclesiastical view he set up, as the essence of art, the principle of the imitation of nature, derived from antique literature. For here, in the humanist, it is no longer a practical recipe as in Cennini, but has become a principle. Filippo Villani, a friend of Salutati, already elaborated that historical conception which in essentials went back to Petrarch, which was applied to art for the first time in Boccaccio and which persisted from then onwards, namely, that ancient art was lost in the course of centuries, and therefore the artists of Florence, in particular Giotto, had brought art back to the study of nature and so to the fundamental principle of antiquity; this is precisely why Villani attached such importance to the Florentine painters. He describes Giotto, to whom this remarkable achievement was due, as a man of education

and of extensive learning[10]—this, too, was a lever for Giotto's social advancement; at the same time, he represents him as one whose effort was directed less towards wealth than fame—a view which sounds just as singular regarding the usurer Giotto as the money-loving humanists. Villani, no artist himself, demanded even more insistently than the painter Cennini that painting—for the practice of which *altum ingenium* was necessary—should have equality of rights with the liberal arts.[11]

The individual artists, who, in this period, begin to separate themselves from the mass of craftsmen, were, characteristically enough, the same whose interests were mainly in scientific and technical questions. What was formerly technical skill was put more and more to the service of scientific innovation based on theoretical knowledge;[12] for it was by establishing a theoretical and scientific foundation for itself that art could obtain greater social recognition, could free itself from the crafts, and so those who practised it could rise from the condition of artisans close to the upper middle class. In this context, pioneering importance attached to the technical and mathematical studies of Brunelleschi, particularly those on perspective. This architect and engineer, who was so deeply interested in technical and mathematical questions and also demonstrated the application of linear perspective to painting, already worked, as has been said, with theoretical scientists. Masaccio, Donatello, Uccello and Ghiberti directed their interests towards the same subjects: technics, optics, and perspective.

Now Ghiberti, who was closely connected with the circle of Cosimo de' Medici, and Niccolo Niccoli, whose libraries he certainly used, undertook to write a really scientific work, the *Commentarii*;[13] this was intended to expound the theoretical basis of art and its rules and laws, the importance of which he constantly emphasised in accordance with the new rationalist outlook. The ultimate aim of his book was to contribute to the improvement of the social position and to the education of the artist. He particularly wanted, then, to make his scientific knowledge accessible to other artists: in the fields of optics, perspective, anatomy, and the theory of proportion. He desired not only to hand on the results of his own experience but also to make available for application to contemporary art the facts and large amount of practical material in ancient writings on art, till then almost unknown to artists;[14] these included above all, of course, Vitruvius (re-discovered by Poggio) and Pliny (a complete manuscript of whom had been acquired by Cosimo de' Medici at Niccoli's instigation) with his wealth of facts and ideas. But although Ghiberti knew Latin, he wrote the book itself in Italian, the language of the artists' workshops. He was the first to translate the stories about ancient artists in Pliny. His book also includes the first artistic autobiography[15] with descriptions of his own works.[16] He begins this with a long passage on the unimportance of acquiring wealth in comparison with the treasures of the sciences and arts. This ideology of self-illusion, initiated by Petrarch and derived from antiquity (from Vitruvius) was thus taken up by

artists, now that the latter had established their connection with the upper middle class and the humanists, and in a much more evolved and consistent way than previously Cennini had done. Ghiberti also gives an account of the artists of the fourteenth century, that is to say, roughly of his spiritual ancestors.[17] He felt no contradiction between his estimate of ancient statuary and his praise of Sienese trecento Gothic, just as his own art was a compromise between classicism and late-Gothic. For Ghiberti, even more than for Filippo Villani, Giotto was the artist who led art back to nature and restored her principles, lost since antiquity. Nature, antiquity and rules are treated more or less explicitly by Ghiberti as on the same level. We have already seen the preparation for this ideology in Filippo Villani, but above all in practical form in the development of art itself, in the works of the consistently classicist artists.

These various ideas and subjects of Ghiberti are clear signs of the new artistic, as related to scientific, thought, and also of the artistic professional self-assurance. It is in this that the great historical significance of the *Commentarii* lies. But Ghiberti was not equal to the scientific task he had set himself. His way of thinking was not so systematic and consistently rational as that of Brunelleschi. His book is a mixture of old and new,[18] combined in a sort of compromise, like his art itself, above all his second Baptistry door. The third commentary, in particular, which Ghiberti considered the most important and which contains the real scientific section of the book, is a confused and often misunderstood mixture from different ancient and Arabic sources.[19] His theory of proportion is based mainly on Vitruvius, his anatomy derives from the Arab Avicenna, his optical knowledge comes from Ptolemy, Witelo,[20] and from the Arabic textbook of Alhazen.[21] But among these various borrowings are also to be found a few personal ideas which are historically new.

Further, Ghiberti, who reports in his book the discovery of ancient works, was one of the earliest to collect antique sculpture. The same is true not only of the humanists, Niccoli and Poggio, but also of Donatello. And it may be mentioned in this context that Poggio was the first to give a summary of the ancient monuments of Rome, still extant (*Ruinarum urbis Romae descriptio*). Brunelleschi and Donatello were the first artists to go to Rome for the express purpose of studying antique art.

It is therefore possible at this period to speak of certain "bourgeois" artists in the upper-middle-class sense of the word, as scholars or technicians, as opposed to the artist-craftsmen, who, however, still formed the mass of practising artists. Moreover, the social origin of these modern artists was often no longer the artisan class; they sprang from middle-class surroundings and became artists from talent and conviction. Masaccio, for instance, was the son of a notary (though a provincial one), and Brunelleschi came of a rich and noble family. Though it must not be overlooked that Brunelleschi, Ghiberti and Donatello were originally goldsmiths, yet these bourgeois artists already felt

FLORENTINE PAINTING AND ITS SOCIAL BACKGROUND

themselves to be in some ways men of science; they were on friendly terms with scientists or scientifically educated laymen from the upper middle class;[22] their social position and their reputation gradually increased.[23] Some of them became household names; for instance, Brunelleschi through his cathedral dome which was to become the symbol of the city, or Donatello particularly through his Dovizia statue which stood on the Mercato.[24] Brunelleschi was actually elected to the Signoria in 1425 as representative of his quarter, and Ghiberti to the Council of the Buonomini in 1444.[25] These artists had real civic consciousness, and just in these decades, as we know, civic consciousness implied a particular emphasis on the entrepreneur's point of view. It is no mere chance that Brunelleschi, with outside help, should have broken the strike among the builders working on the cathedral, and cut their wages. Ghiberti, for his part, bought up an estate cheaply from an impoverished patrician family, showed himself, in its administration, a keen business man, understood book-keeping and clearly displayed great pride in his property.

From their civic consciousness naturally followed the artists' increased professional consciousness.[26] Ghiberti's artistic freedom had clearly increased between the execution of his relief for the competition for the first Baptistry door, which in every respect was exactly prescribed, and that of the reliefs for the second door, that is to say, from 1401 to 1425. We saw that Ghiberti was not closely bound by Bruni's programme, and he himself says of these reliefs: "I was allowed a free hand to execute them as seemed good to me, so that they might be in the highest degree perfect and richly ornamented." Even if this explicit emphasis shows that this was rather an exceptional case, still some other artists, such as Donatello and Masaccio in general, also enjoyed a far greater artistic freedom than had hitherto been possible. It was from his artistic freedom, and from his ultimate upper-middle-class mentality, much more pronounced in such a sensitive and progressive artist than in the bulk of the upper middle class themselves, that Masaccio was able to create an upper-bourgeois and rationalist style which his contemporaries could not in its totality comprehend.

NOTES

[1] This change is striking, for instance, among sculptors of the masons' lodge of the Cathedral, though again only in comparison with the situation in the same group in the fourteenth century.

[2] This is particularly clear, for instance, in Fra Angelico's circle in the monastery of S. Domenico at Fiesole.

[3] Gualandi, *Memorie originali italiane risguardanti le Belle Arti* (Bologna, 1845).

[4] H. Lerner-Lemkuhl, *Zur Struktur und Geschichte des Florentinischen Kunstmarktes im 15. Jahrhundert* (Wattenscheid, 1936).

[5] H. Horne, "Appendice di documenti su Giovanni dal Ponte" (*Rivista d'Arte*, IV, 1906).

[6] Doren, *Aktenbuch für Ghibertis Matthäus-Statue.*

[7] Ghiberti had also, during working hours, to be continuously in his workshop as befitted one who was a wage-earner. In fact in the contract for the first Baptistry door, the position of Ghiberti in relation to his patrons is explicitly stated to be that of a "wage-earner".

[8] Vossler, *Poetische Theorien in der italienischen Frührenaissance*.

[9] The poets, of course, had chronological priority over the artists in this respect too, as is shown by Boccaccio's biography of Dante and the activity of the Dante commentators.

[10] In Petrarch and Boccaccio we already find germs of this attitude towards Giotto, and here, too, conceptions borrowed from ancient writings on art play a part. Villani had some knowledge of Vitruvius.

[11] L. Venturi, "La Critica d'Arte alle fine del Trecento" (*L'Arte*, XXVIII, 1925) and J. Schlosser, "Zur Geschichte der Kunsthistoriographie" (in the volume *Preludien*, Berlin, 1927).

[12] Olschky, *op. cit.*

[13] Although the *Commentarii* were written at the end of his life (probably about 1452–55) that is to say, after the period now under consideration, we have thought it better to deal with them here since, by the generation to which he belonged, Ghiberti was entirely of this period, and his book summarises the views formed during a long life.

[14] When he demands a universal education for the artist he appeals to Vitruvius. His favourite word is *docti*; he wishes the artist to be experienced in the liberal arts, and acquainted with Latin.

[15] It will be noticed, however, that this autobiography, though conceived as a literary work, has still much in common with the *Ricordi*, the dry domestic chronicles most usual in Florence (see J. Schlosser, *Lorenzo Ghibertis Denkwürdigkeiten*, Berlin, 1912). There exists one of these purely business diaries from the hand of Ghiberti dealing with his estate and containing precise lists of expenses.

[16] He says rather self-confidently of the reliefs for his second Baptistry door: "I carried out the work in truth with the greatest care and the greatest love."

[17] In his historical scheme of division into periods, which is more or less derived from Petrarch, Boccaccio and Filippo Villani, Ghiberti takes over from the same new bourgeois outlook, from the same Italian and Florentine patriotic views, an aversion to the "barbarous" Middle Ages, "hostile to art". It is not till later that dislike of the Goths is combined in the minds of artists and intellectuals with a scorn for "Gothic" art.

[18] It is for this reason that opinions on the *Commentarii* can vary so much from the extremely favourable judgment of Schlosser (*op. cit.*) to the very unfavourable one of Olschky (*op. cit.*), according to which elements are emphasised.

[19] Although Ghiberti was probably helped by Niccoli, the texts translated from Greek and Arabic into bad Latin confused him, all the more as his own Latin does not appear to have been particularly good. (See Olschky, *op. cit.*) Ghiberti's introduction is simply the translation of the preface of a specialised work by Athenaeus the elder, an expert in military engineering of the Hellenistic period.

[20] See p. 275. See p. 275.

[21] For a detailed account of Ghiberti's sources see Schlosser, *op. cit.*

[22] For instance, the famous humanist Niccolo Niccoli was a friend of Brunelleschi, Ghiberti, Donatello and Luca della Robbia.

[23] In spite of this, it could happen that even Brunelleschi, just as the Cathedral dome was finished in essentials (1434) should be arrested by the stonemasons' guild, because, being originally a goldsmith and a member of the silk guild, he had not paid his entrance fee or tax to the former guild. In its view, he could not undertake masonic work unless he was admitted to the guild. The authorities of the Cathedral, however, retaliated by

arresting one of the consuls of the masons' guild, and thereby forced Brunelleschi's release within a few days. So, in the last analysis, even this incident is a sign of the weakening of the power and regulations of the guilds.

[24] Donatello, for instance, appears in a *Rappresentazione Sacra* which deals with the story of Nebuchadnezzar: he is commissioned to make a statue of this king, and then remarks how busy he is with the Dovizia and the Prato pulpit.

[25] These two artists attained to wealth. In the declarations of the *catasto* tax of 1427, Brunelleschi is recorded as very wealthy, Ghiberti as fairly so, Donatello as in rather mean circumstances, and Masaccio as in debt (for the deeper reasons for this last fact, see the section on stylistic development).

[26] According to Vasari, Masaccio had given his own features to one of the apostles, as Orcagna had done earlier. M. Salmi (*Masaccio*) recognises the self-portrait of Masaccio in one of the figures in the fresco of St. Peter enthroned. Ghiberti applied a self-portrait on his first, as well as on his second, Baptistry door (on the first one together with his step-father, a goldsmith). According to O. Wulff (*op. cit.*) the sculptor's studio in Nanni di Banco's relief on Orsanmichele (Pl. 108b) shows the artist with his father, himself a well-known sculptor. From the beginning of the fifteenth century we have a painting with portraits of the painters Zanobi, Taddeo and Agnolo Gaddi (Uffizi), probably a sign of family cult: the family is proud of its three artists.

INDEX

INDEX OF PERSONS

The numbers in italics refer to pages of notes

INDEX OF PERSONS

INDEX OF PERSONS

PLATES

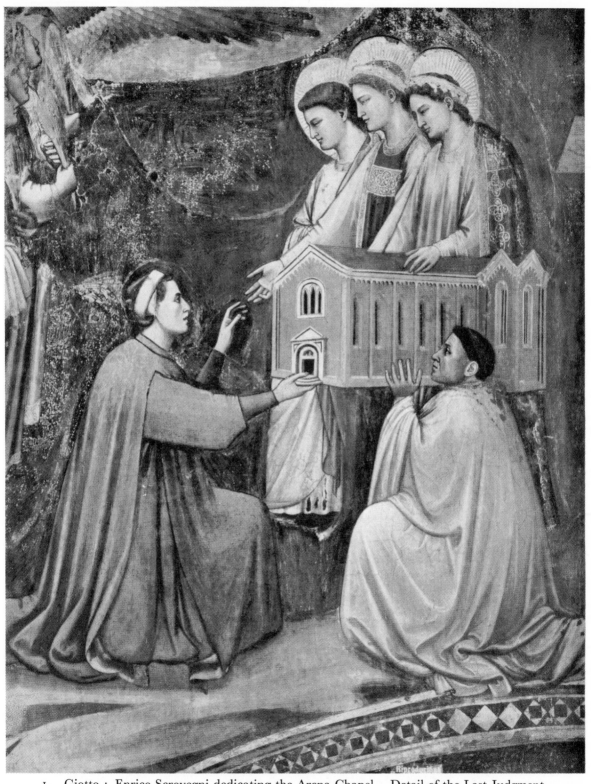

1. Giotto : Enrico Scrovegni dedicating the Arena Chapel. Detail of the Last Judgment.
Padua, Arena Chapel.

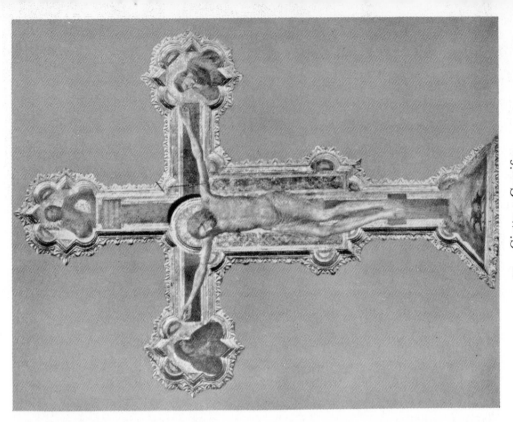

2B. Giotto : Crucifix.
Padua, Arena Chapel.

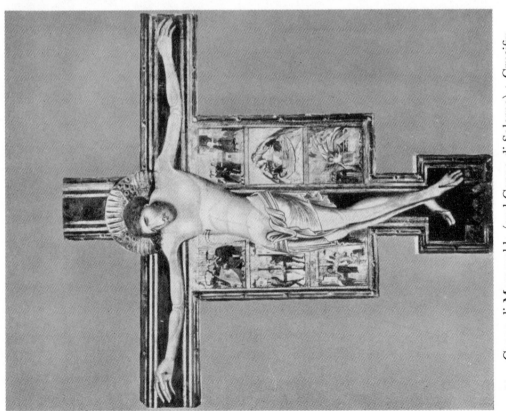

2A. Coppo di Marcovaldo (and Coppo di Salerno) : Crucifix.
Pistoia, Cathedral.

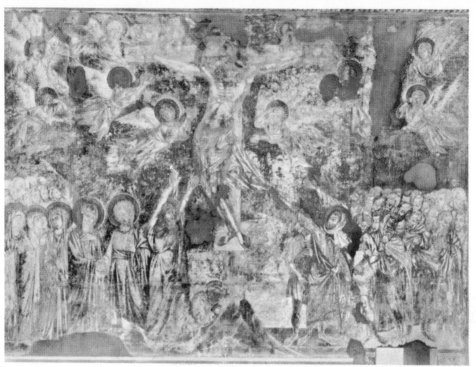

3A. Cimabue : Crucifixion. *Assisi, S. Francesco.*

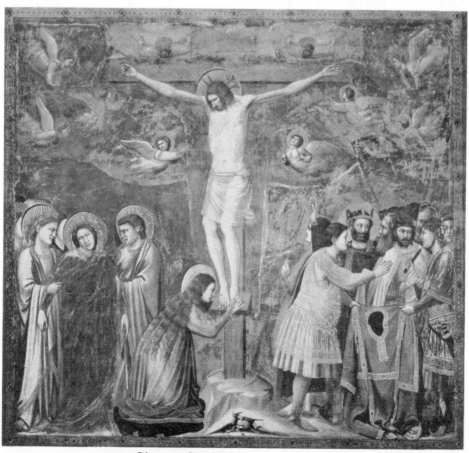

3B. Giotto : Crucifixion. *Padua, Arena Chapel.*

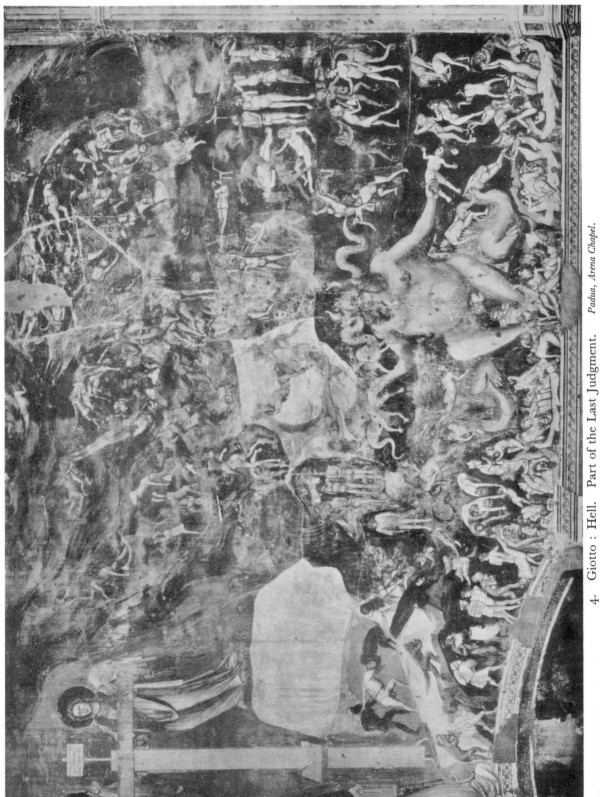

4. Giotto : Hell. Part of the Last Judgment. *Padua, Arena Chapel.*

5A. Giotto : Noli me Tangere.
Padua, Arena Chapel.

5B. Austrian school : Noli me Tangere.
Klosterneuburg, Abbey Church.

6. Giotto : Pietà. *Padua, Arena Chapel.*

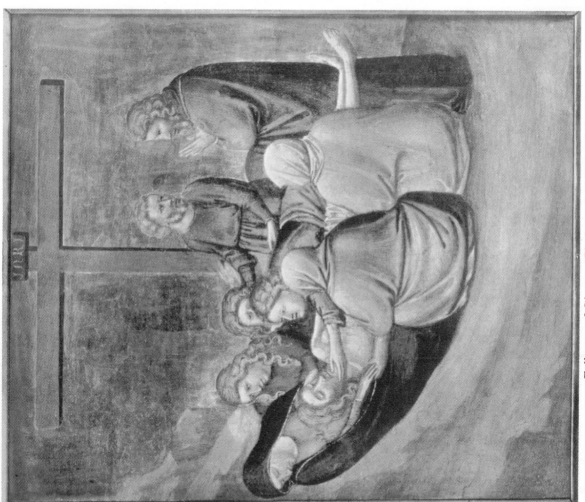

7.　Follower of Giotto : Pietà.　*Rome, Vatican Gallery.*

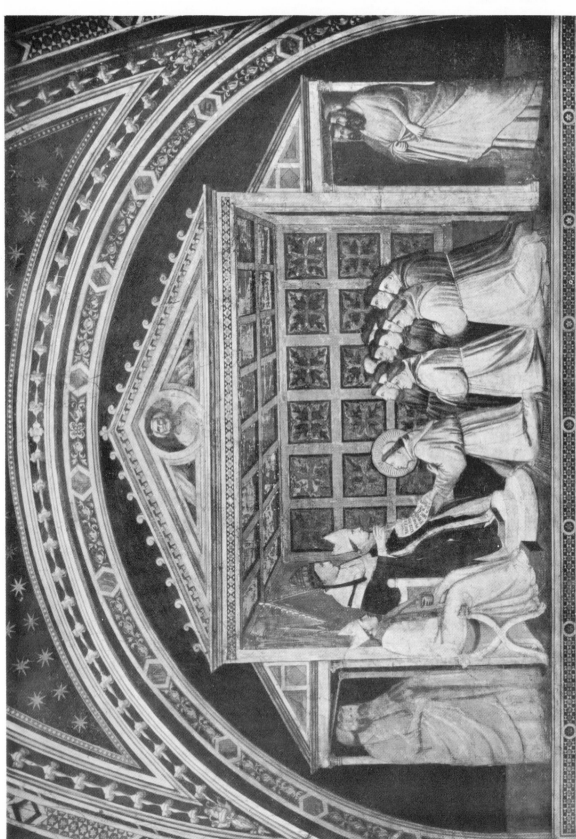

8 . Giotto : Confirmation of the Rule of the Franciscan Order. *Florence. S. Croce.*

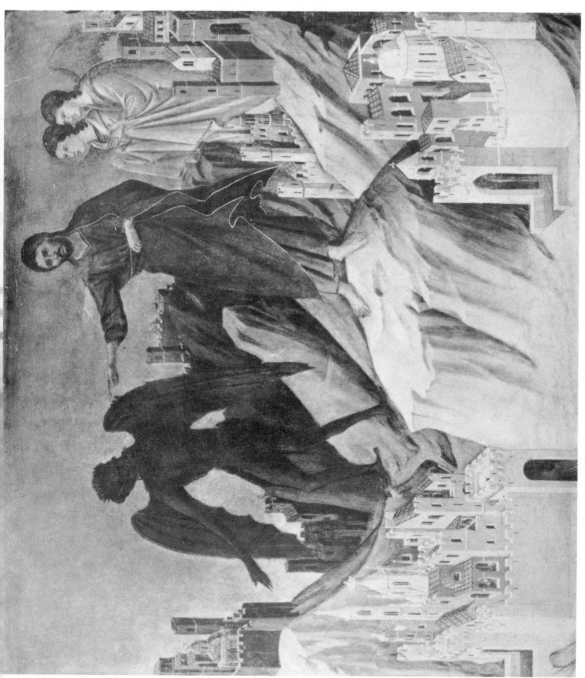

9. Duccio : Temptation of Christ. *New York, Frick Collection.*

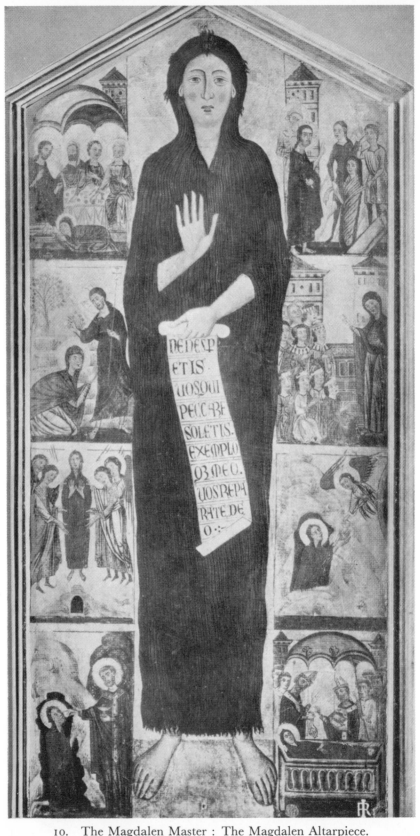

DEDESP
ET IS·
UOSQUI
PECCARE
SOLETIS·
EXEMPLO
O3 MEO·
UOS REPA
RATE DE
O ∴

10. The Magdalen Master : The Magdalen Altarpiece.
Florence, Academy.

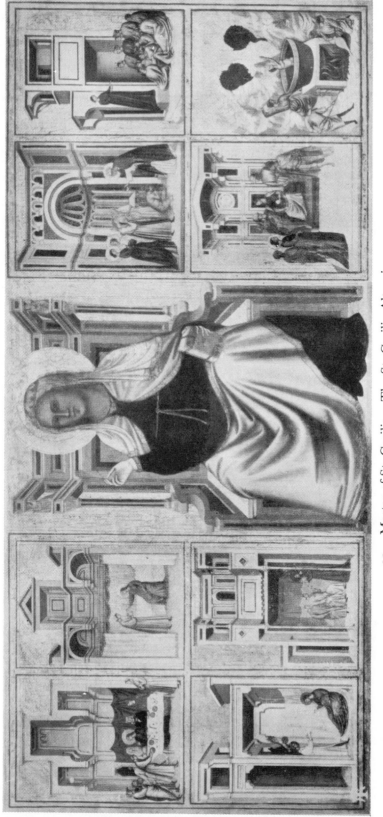

11. Master of St. Cecilia : The St. Cecilia Altarpiece.
Florence, Uffizi.

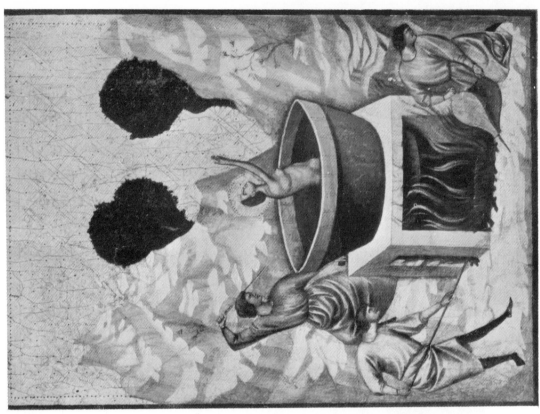

12B. Master of St. Cecilia : Martyrdom of St. Cecilia. Detail

12A. Master of St. Cecilia : St. Cecilia Preaching. Detail

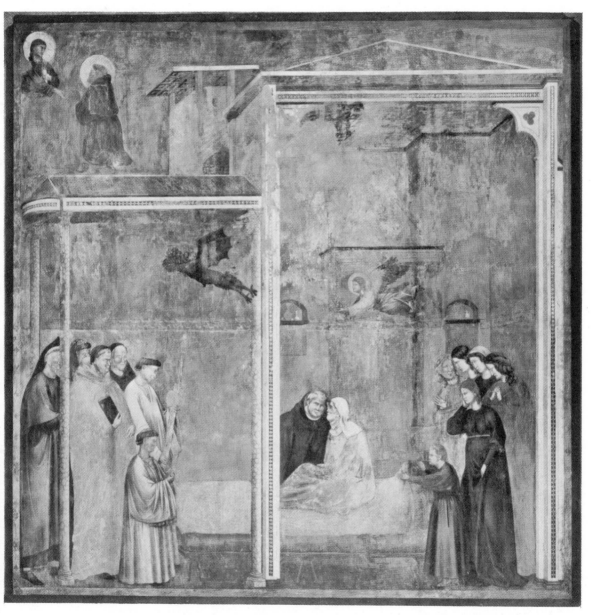

13. Master of St. Cecilia : Confession of the Woman of Beneventum.
Assisi, S. Francesco.

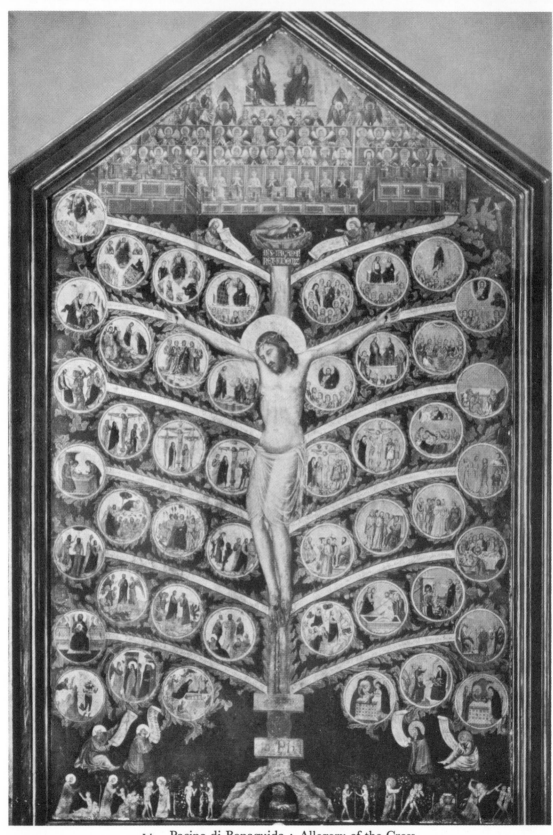

14. Pacino di Bonaguida : Allegory of the Cross.
Florence, Academy.

15. Pacino di Bonaguida : Story of Adam and Eve. Detail of the Allegory of the Cross.
Florence, Academy.

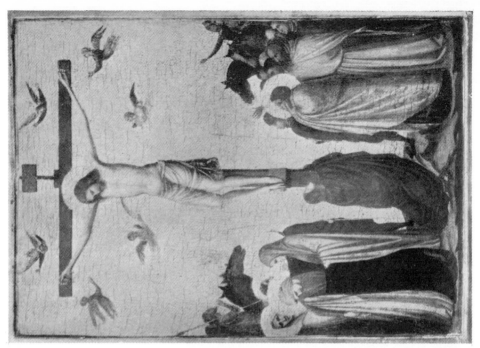

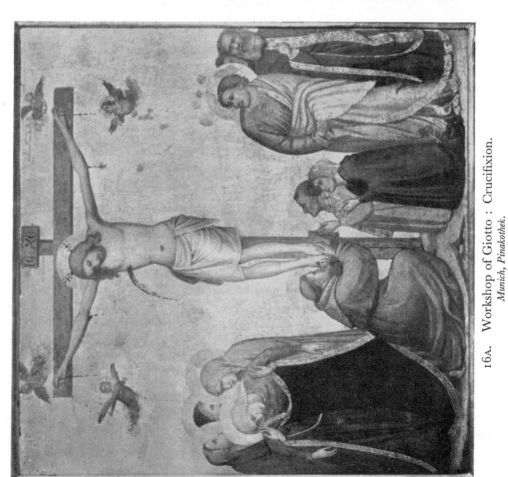

16B. Follower of Giotto : Crucifixion.
Strasbourg, Museum.

16A. Workshop of Giotto : Crucifixion.
Munich, Pinakothek.

17A. School of Romagna : Crucifixion.
New York, Kress Collection.

17B. Pacino di Bonaguida : Pietà.
New York, Pierpont Morgan Library.

18. Taddeo Gaddi : Allegory of the Cross.
Florence, S. Croce.

19B. Agnolo Gaddi ? : Conversion of St. Paul.
Florence, Academy.

19A. Taddeo Gaddi : Annunciation to the Shepherds.
Florence, S. Croce.

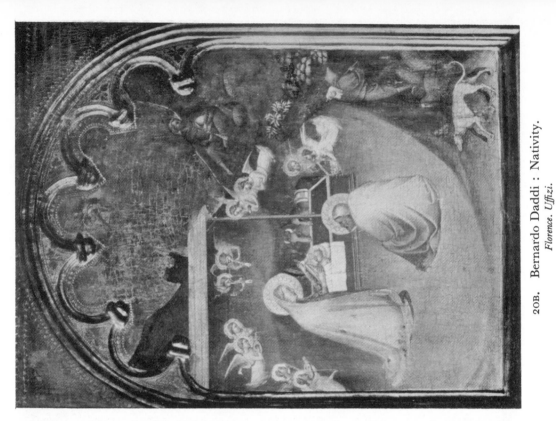

20B. Bernardo Daddi : Nativity.
Florence. Uffizi.

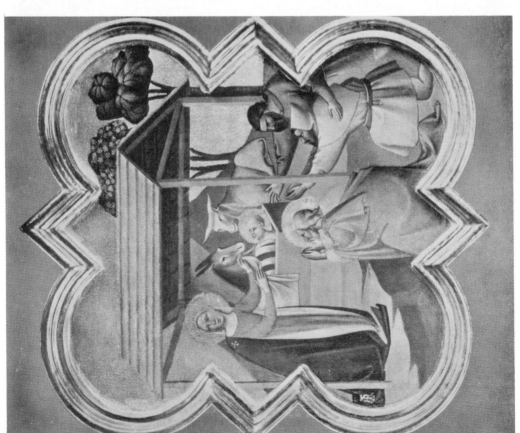

20A. Taddeo Gaddi : Nativity.
Florence, Academy.

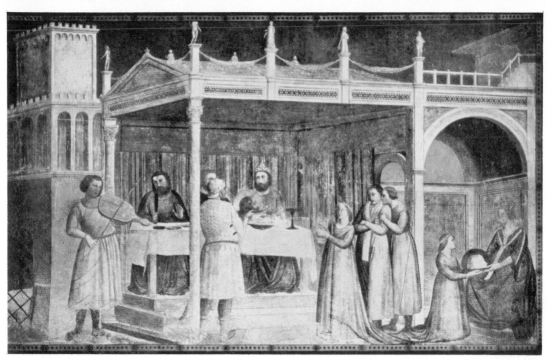

21A. Giotto : Banquet of Herod.
Florence, S. Croce.

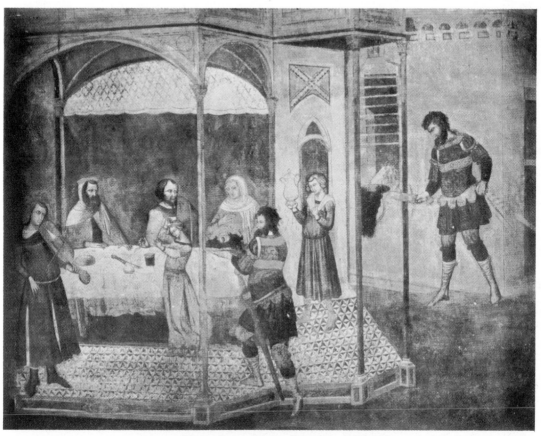

21B. Pietro Lorenzetti : Banquet of Herod.
Siena, S. Maria dei Servi.

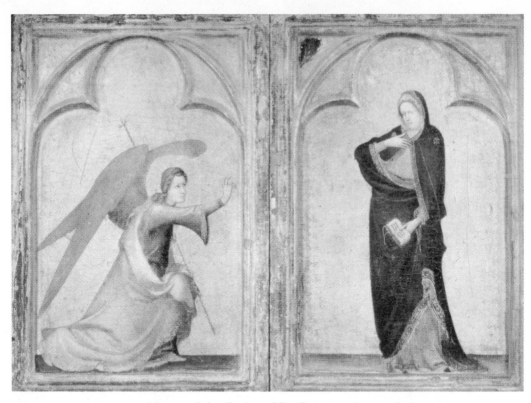

22A. Master of the Codex of St. George : Annunciation.
Brussels, Stoclet Collection.

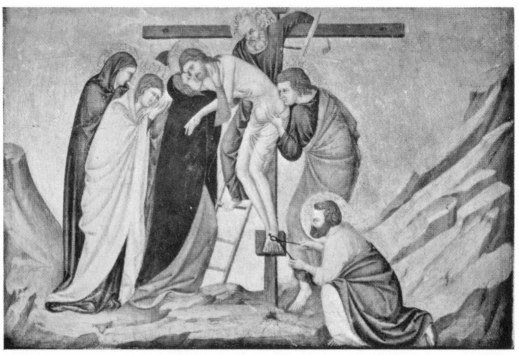

22B. Ugolino da Siena : Descent from the Cross.
London, National Gallery.

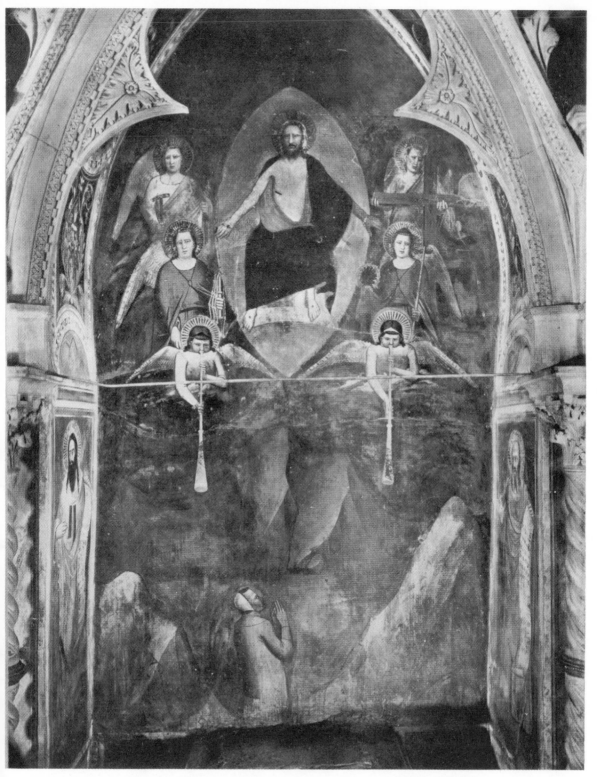

23. Maso : The Last Judgment and a member of the Bardi Family.
Florence, S. Croce.

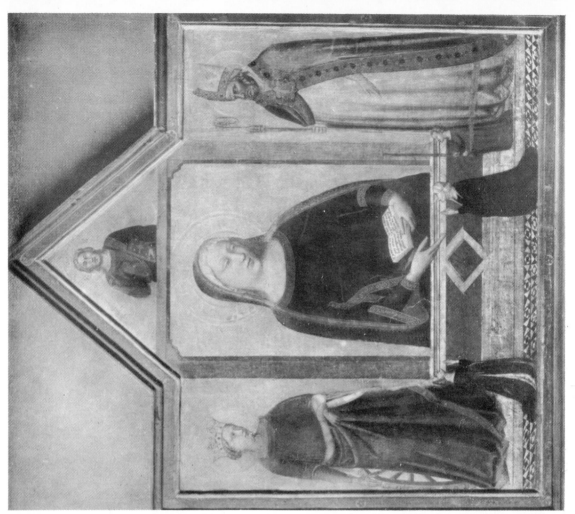

24B. Workshop of Daddi : Madonna with Saints and Donors.
Florence, Museo dell'Opera del Duomo

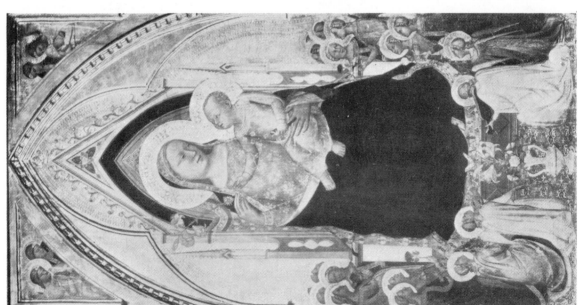

24A. Bernardo Daddi : Madonna and Child
with Angels. *Florence, Uffizi*

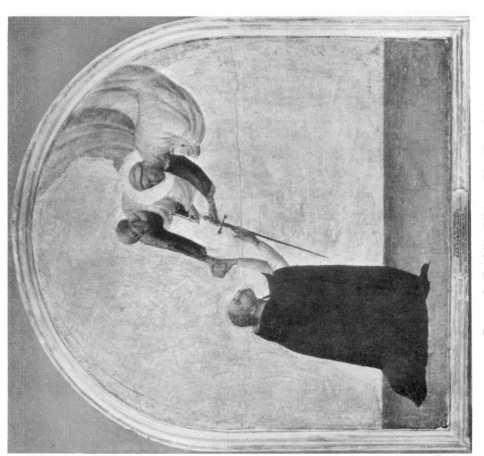

25B. Bernardo Daddi : Vision of St. Dominic.
New Haven, Yale University.

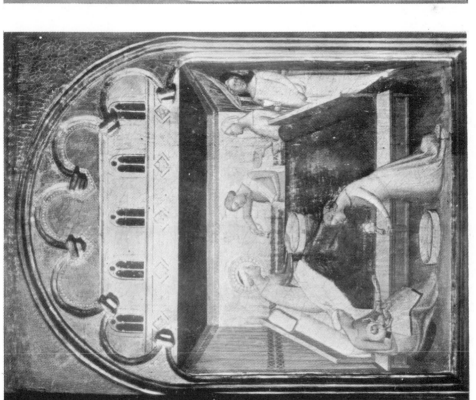

25A. Bernardo Daddi : Birth of the Virgin.
Florence, Uffizi.

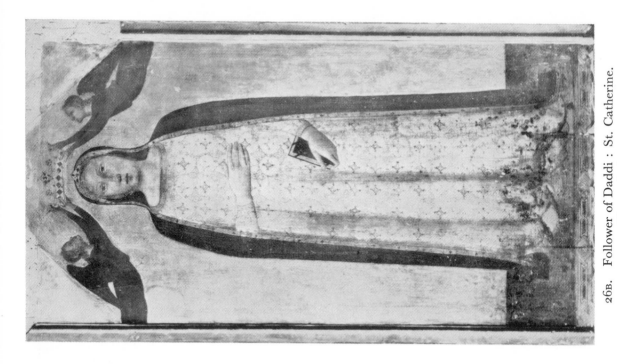

26B. Follower of Daddi : St. Catherine.
Siena, Academy

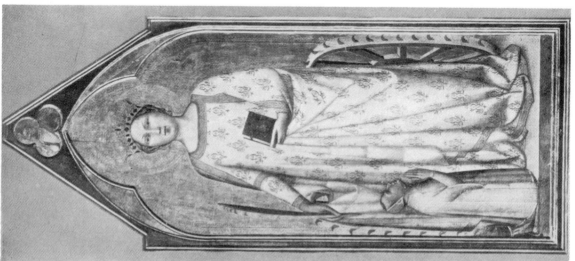

26A. Follower of Daddi : St. Catherine with Donor.
Florence, Cathedral

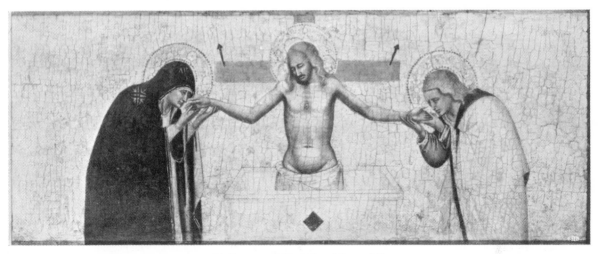

27A. Follower of Daddi : Man of Sorrows.
London, Lycett Green Collection.

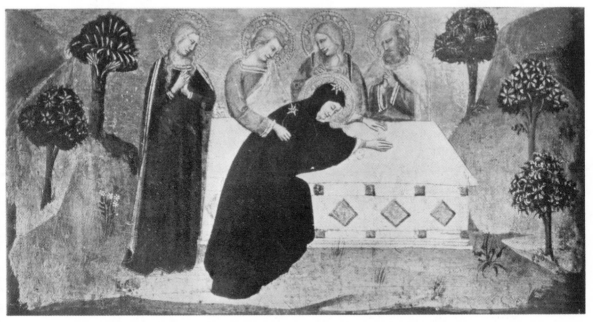

27B. Follower of Daddi : Mary swooning at the Sepulchre.
Copenhagen, Museum.

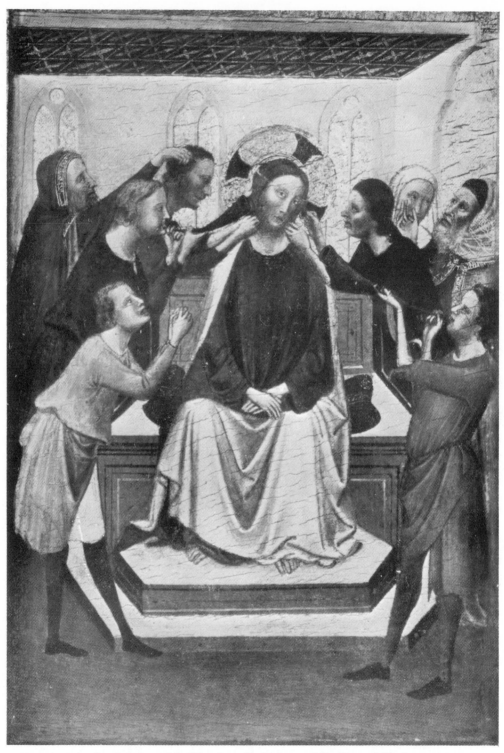

28. Master of S. Martino alla Palma : Mocking of Christ.
Manchester, Barlow Collection.

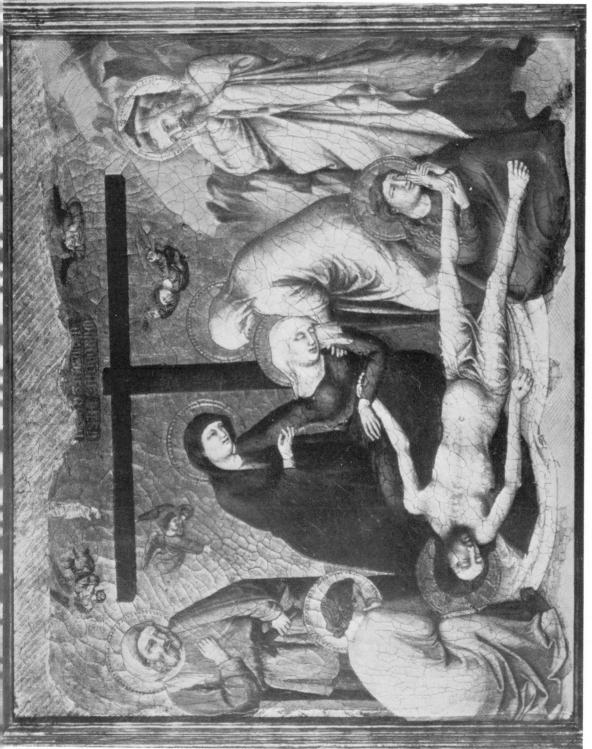

29. Master of the Pietà Fogg : Pietà. *Cambridge, U.S.A., Fogg Museum.*

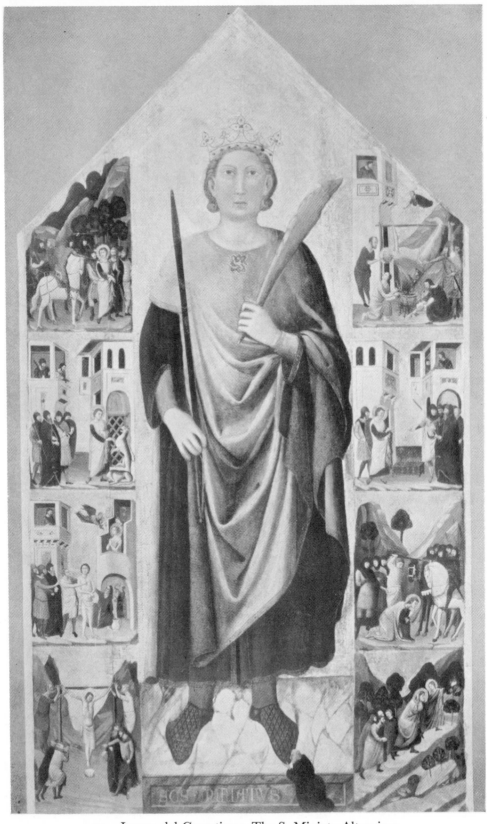

30. Jacopo del Casentino : The S. Miniato Altarpiece.
Florence, S. Miniato.

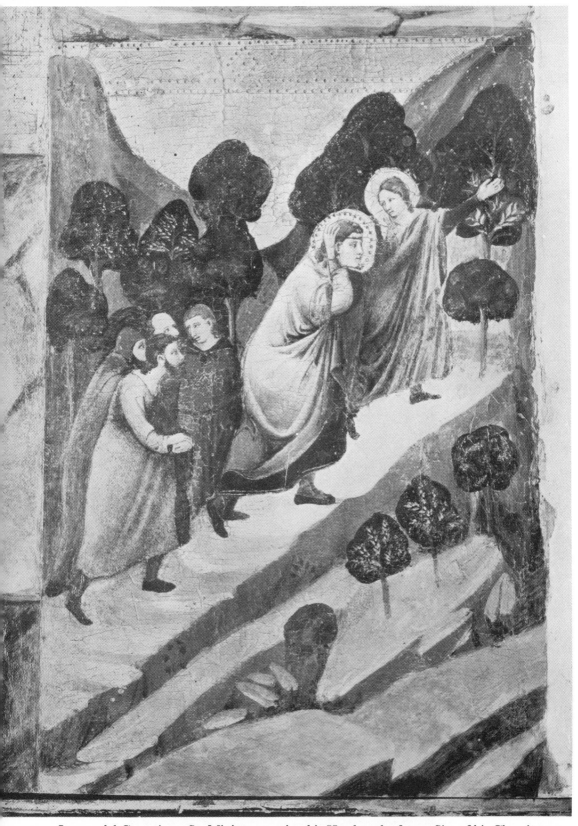

31. Jacopo del Casentino : St. Miniato carrying his Head to the future Site of his Church. Detail of the Altarpiece. *Florence, S. Miniato.*

32. Francesco Traini : Thebaid.
Pisa, Campo Santo.

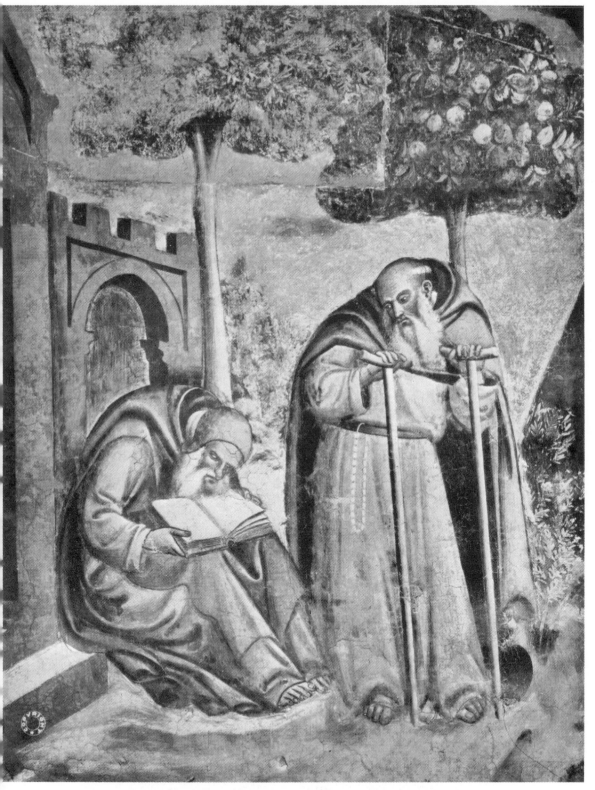

33. Francesco Traini : Hermits. Detail of the Triumph of Death.
Pisa, Campo Santo.

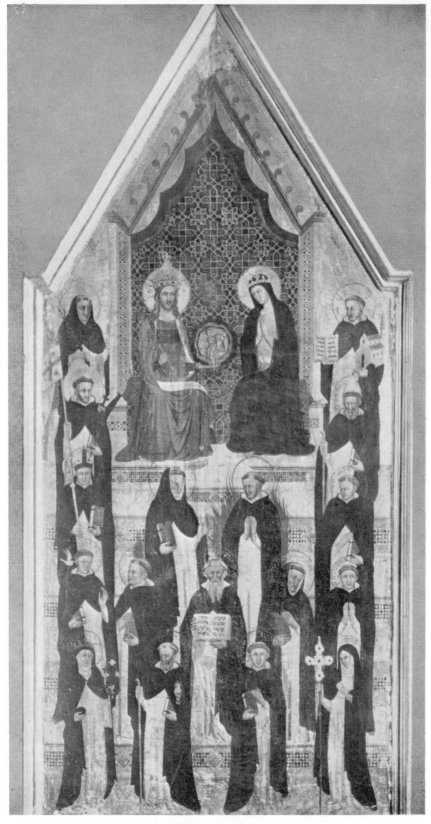

34. Master of the Dominican Effigies : Christ and the Virgin with
Dominican Saints. *Florence, S. Maria Novella.*

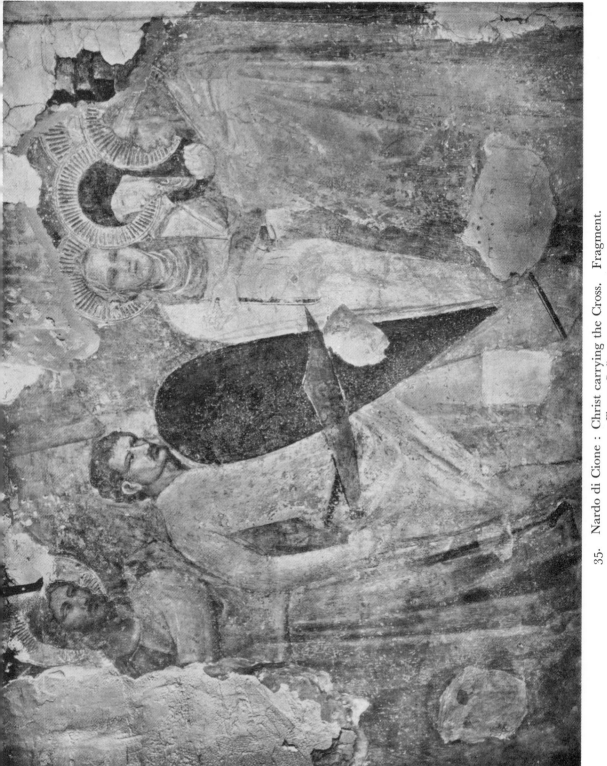

35. Nardo di Cione : Christ carrying the Cross. Fragment.
Florence, Badia.

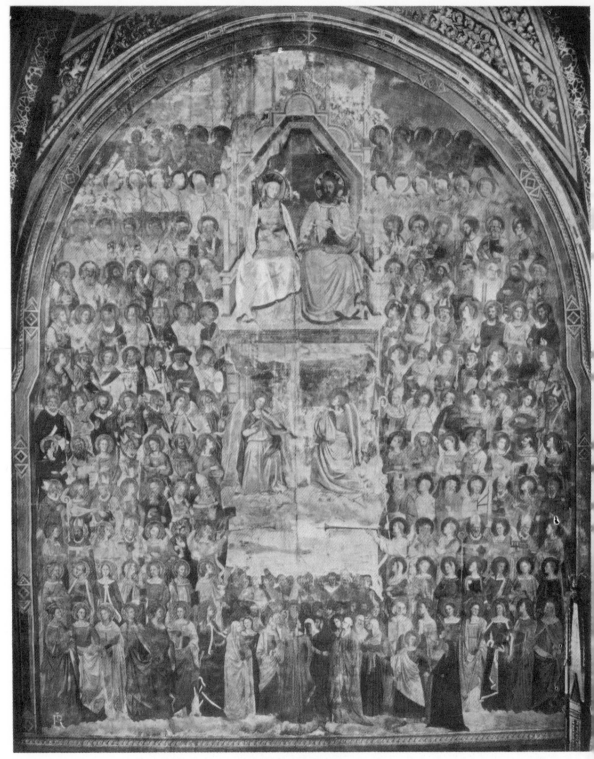

36. Nardo di Cione : Paradise.

Florence, S. Maria Novella.

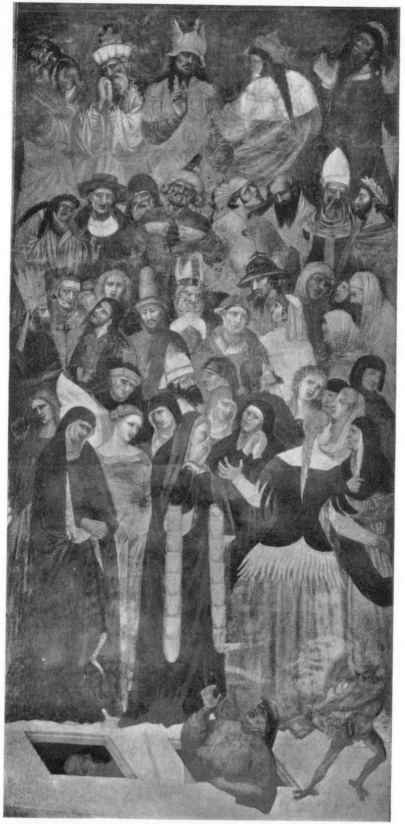

37. Nardo di Cione : The Damned. Detail of the Last Judgment.
Florence, S. Maria Novella.

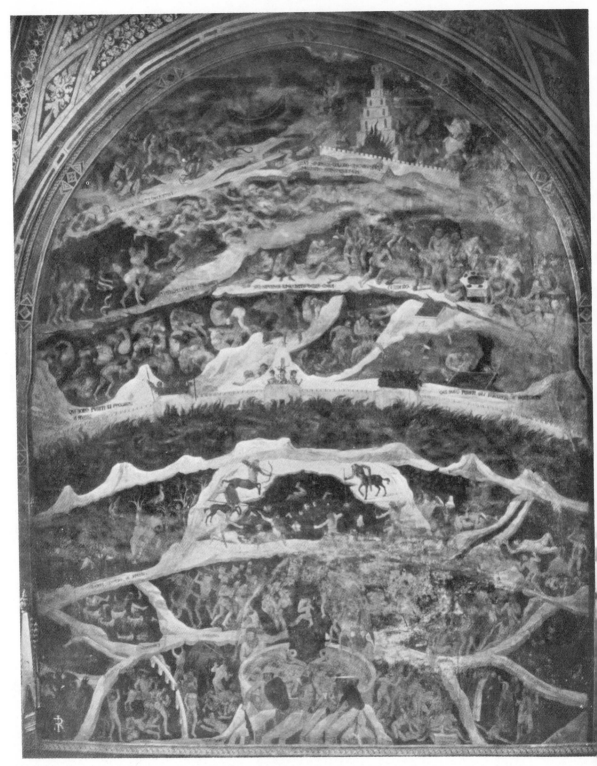

38. Nardo di Cione : Hell.
Florence, S. Maria Novella.

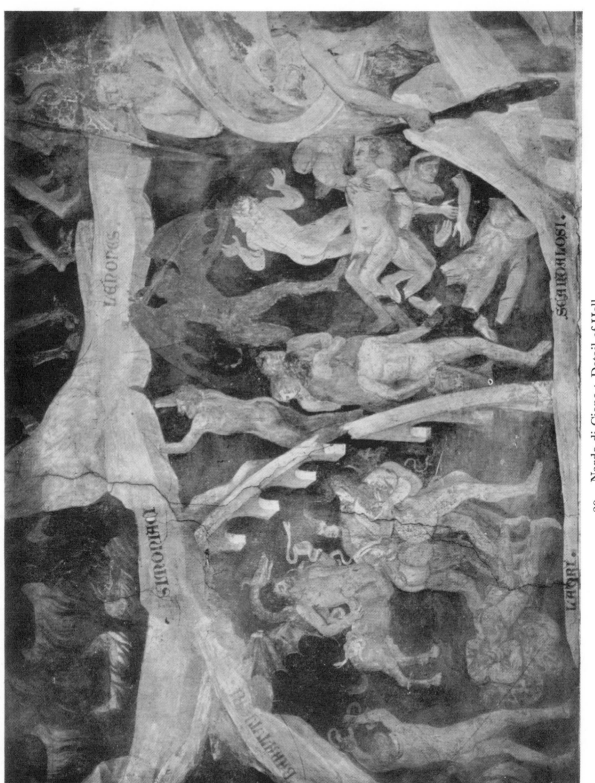

39. Nardo di Cione : Detail of Hell.
Florence, S. Maria Novella.

40. Andrea Orcagna : The Strozzi Altarpiece. *Florence, S. Maria Novella.*

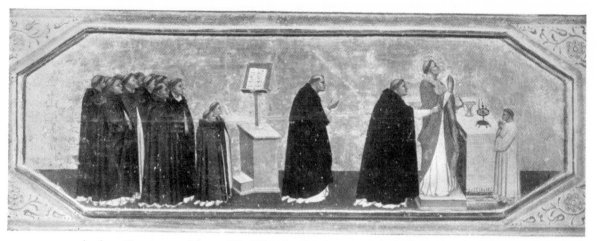

41A. Andrea Orcagna : Mass of St. Thomas Aquinas. Predella of the Strozzi Altarpiece.
Florence, S. Maria Novella.

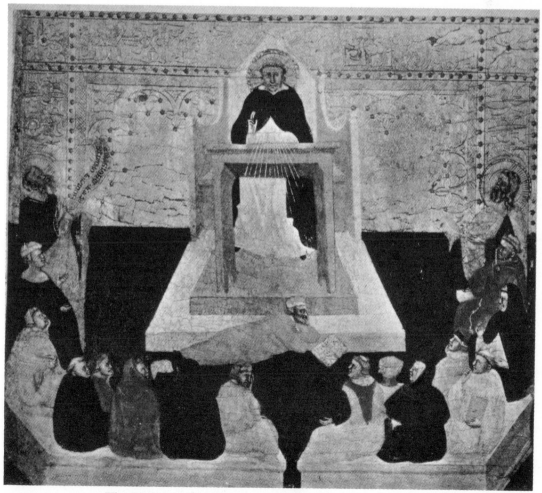

41B. The Biadaiolo Illuminator : Glorification of St. Thomas Aquinas.
New York, Lehman Collection.

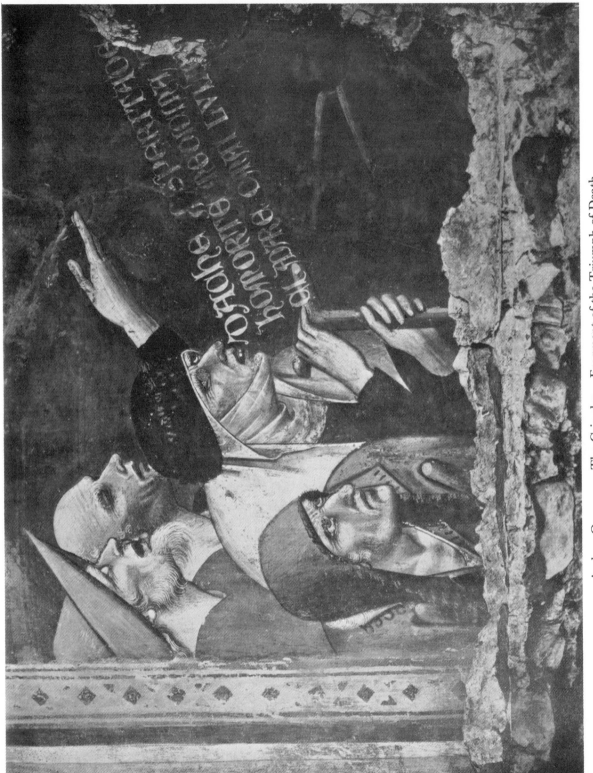

42. Andrea Orcagna : The Cripples. Fragment of the Triumph of Death.
Florence, S. Croce.

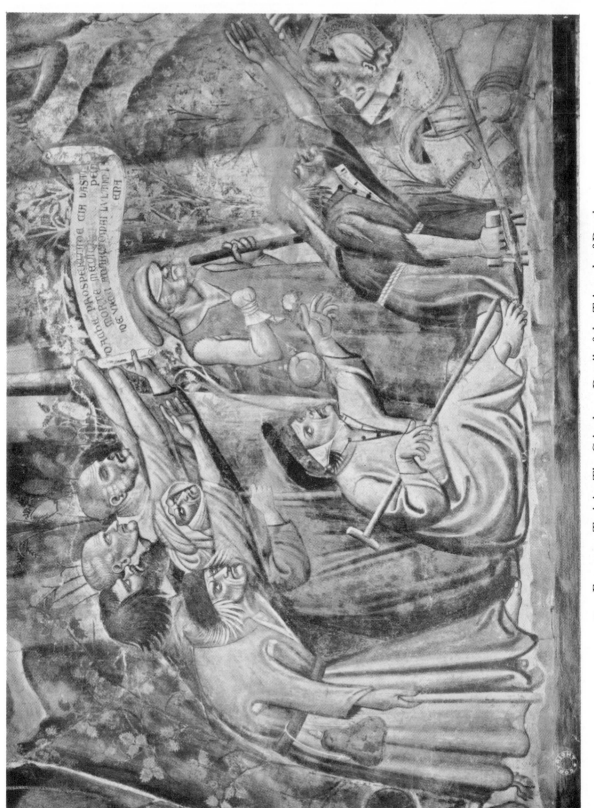

43. Francesco Traini : The Cripples. Detail of the Triumph of Death.
Pisa, Campo Santo.

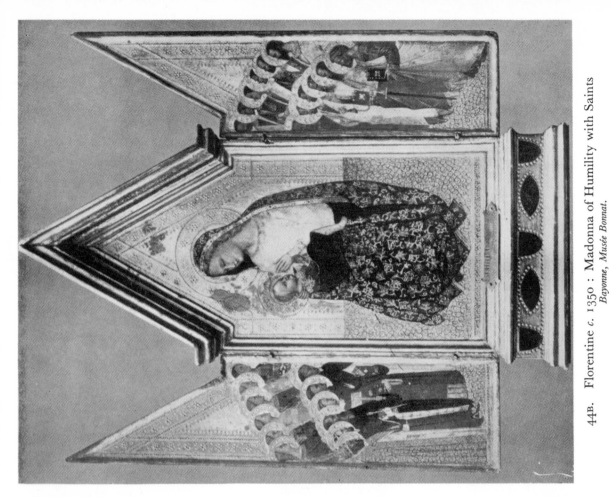

44B. Florentine *c.* 1350 : Madonna of Humility with Saints
Bayonne, Musée Bonnat.

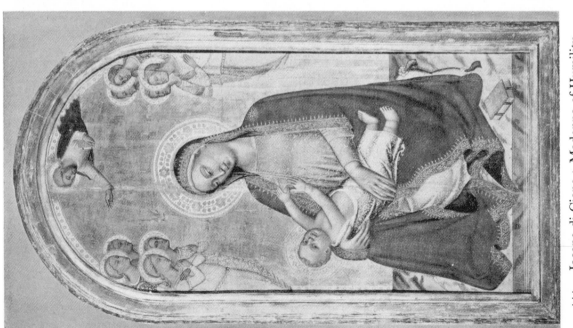

44A. Jacopo di Cione : Madonna of Humility.
New York, Lehman Collection.

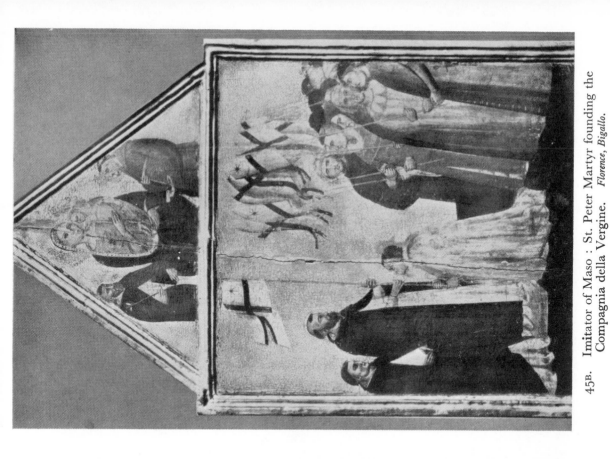

45B. Imitator of Maso : St. Peter Martyr founding the
Compagnia della Vergine. *Florence, Bigallo.*

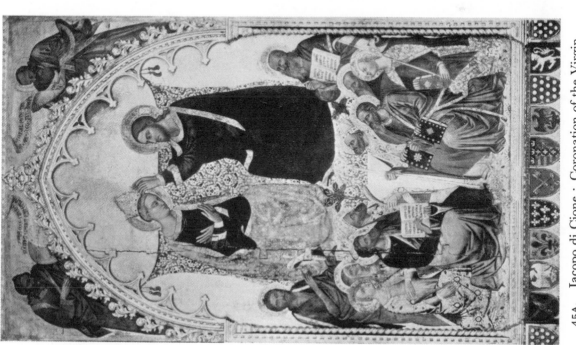

45A. Jacopo di Cione : Coronation of the Virgin.
Florence, Uffizi.

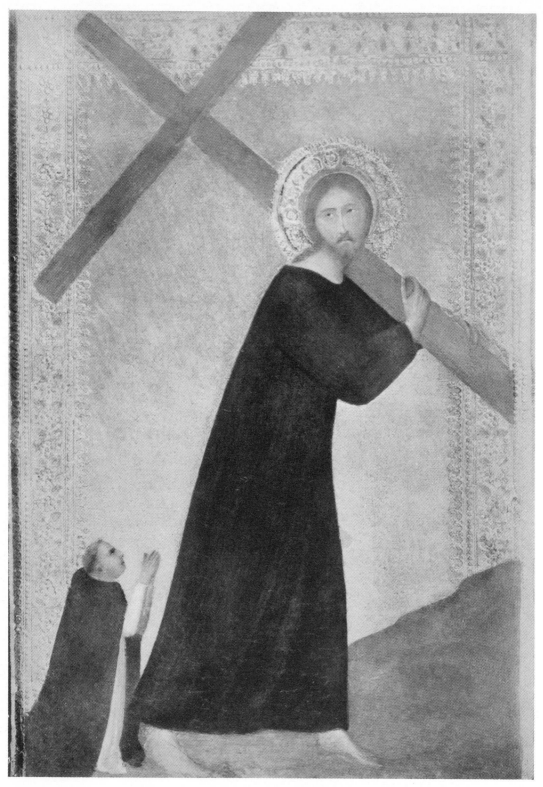

46. Barna da Siena : Christ carrying the Cross.
New York, Frick Collection.

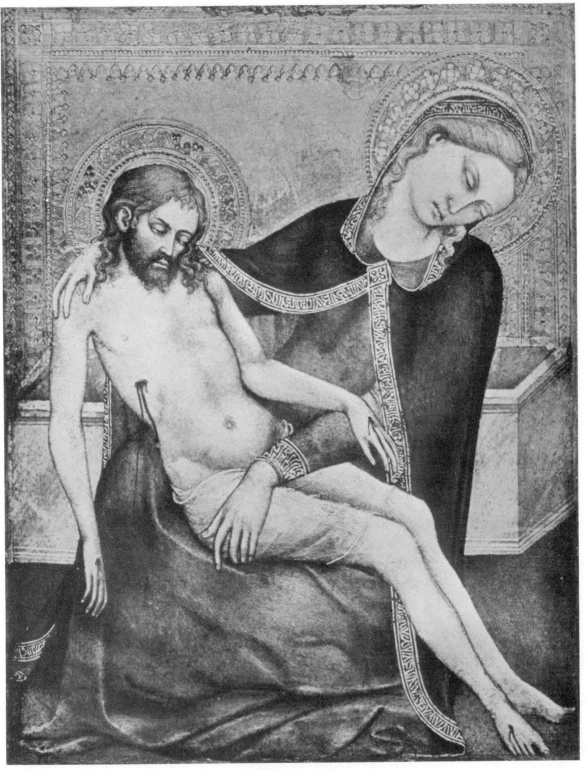

47. Giovanni da Milano : Pietà.
Previously Paris, Leroy Collection.

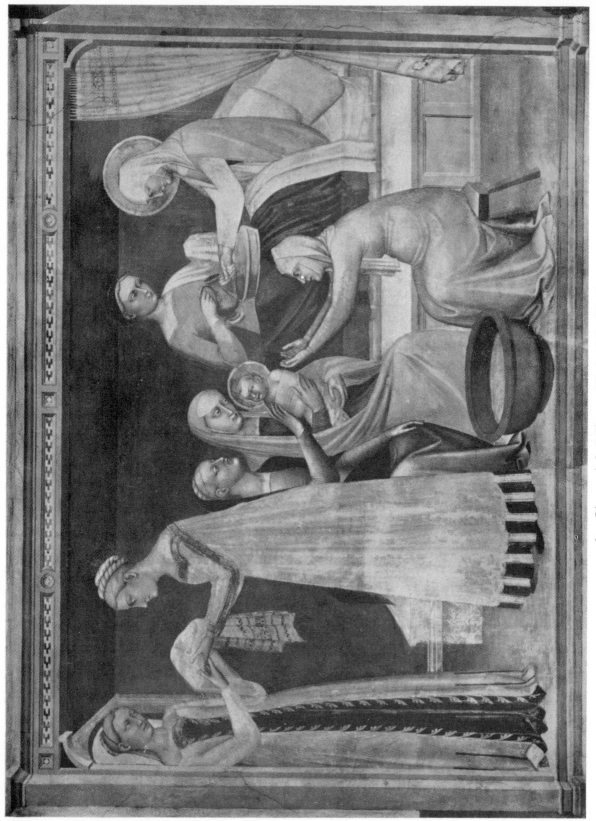

48. Giovanni da Milano : Birth of the Virgin.
Florence, S. Croce.

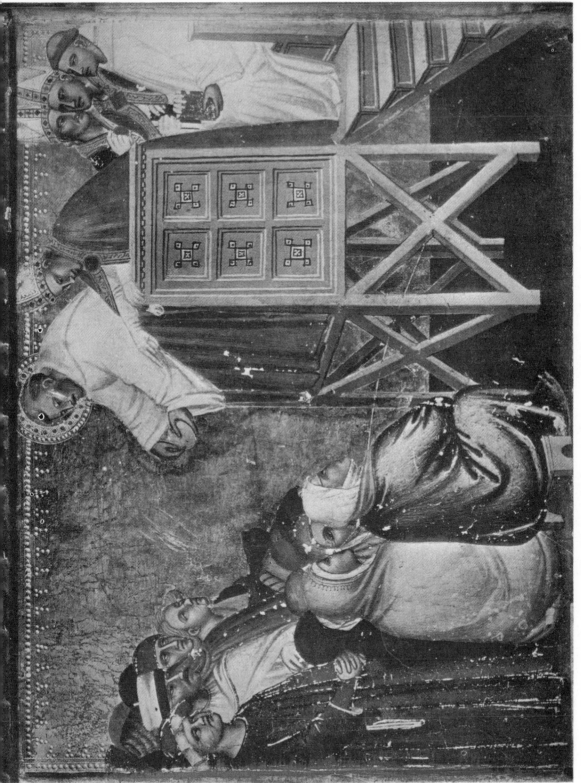

49. The Rinuccini Master : Sermon of St. Bernard against the Heretics.
Florence, Academy.

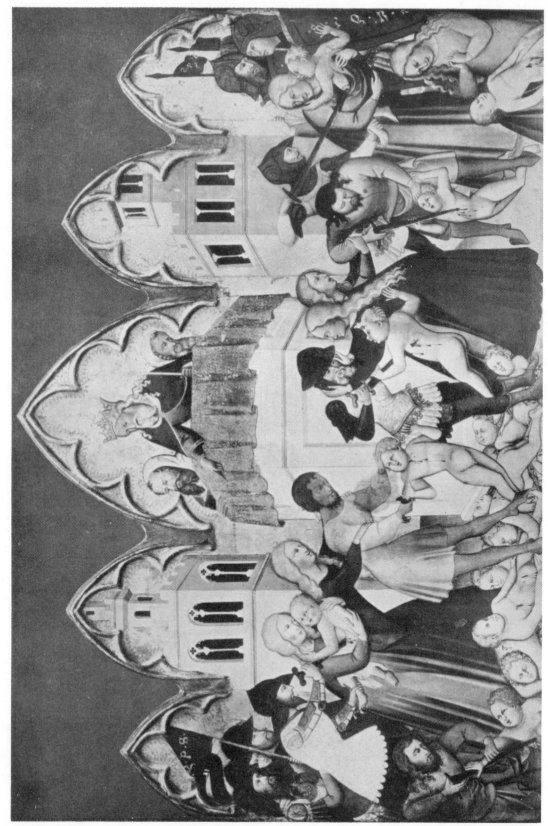

50. Bartolo di Fredi : Massacre of the Innocents.

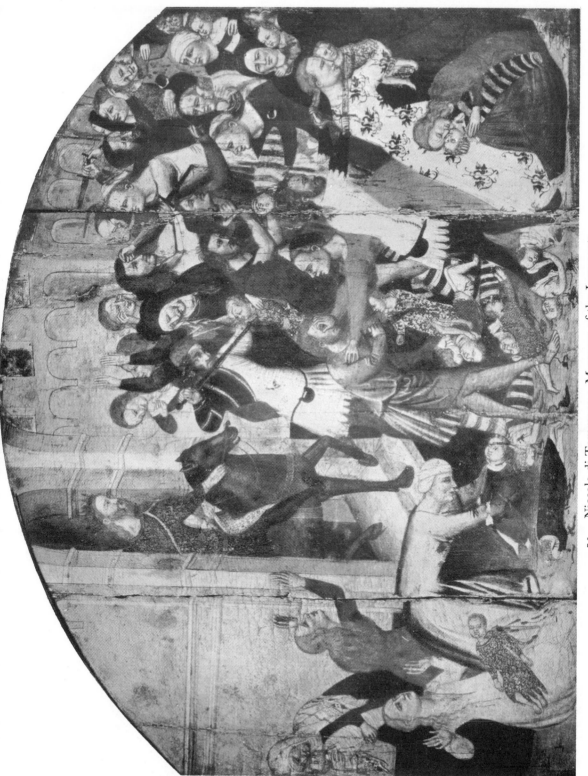

51. Niccolo di Tommaso : Massacre of the Innocents.
Florence, Uffizi.

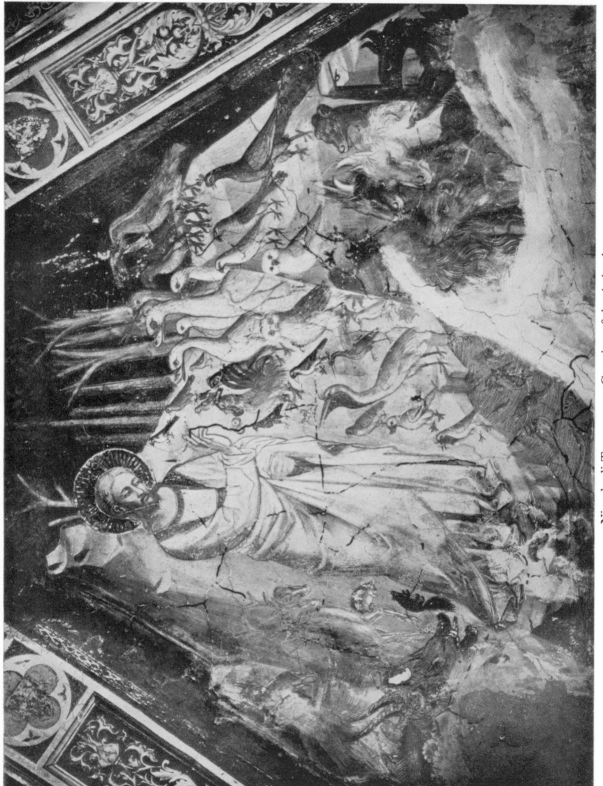

52.　Niccolo di Tommaso :　Creation of the Animals.

Pistoia, Convento del T.

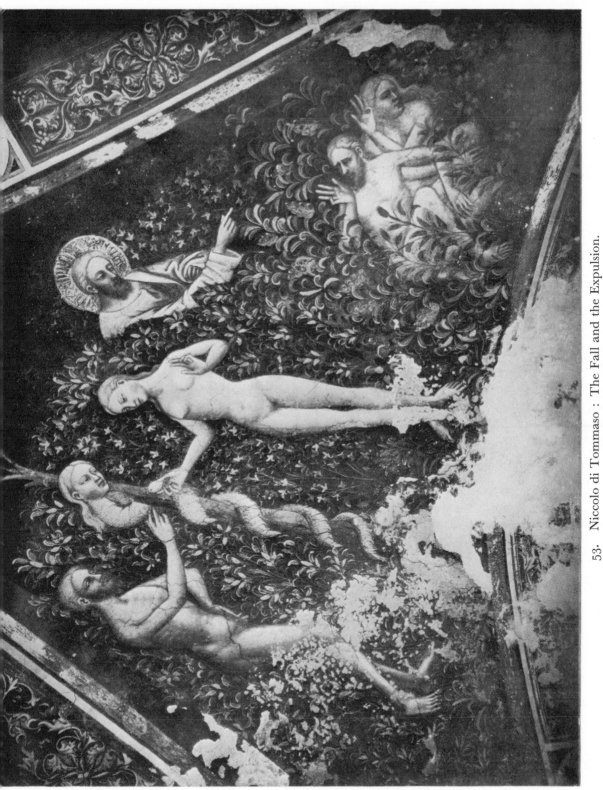

53. Niccolo di Tommaso : The Fall and the Expulsion.
Pistoia, Convento del T.

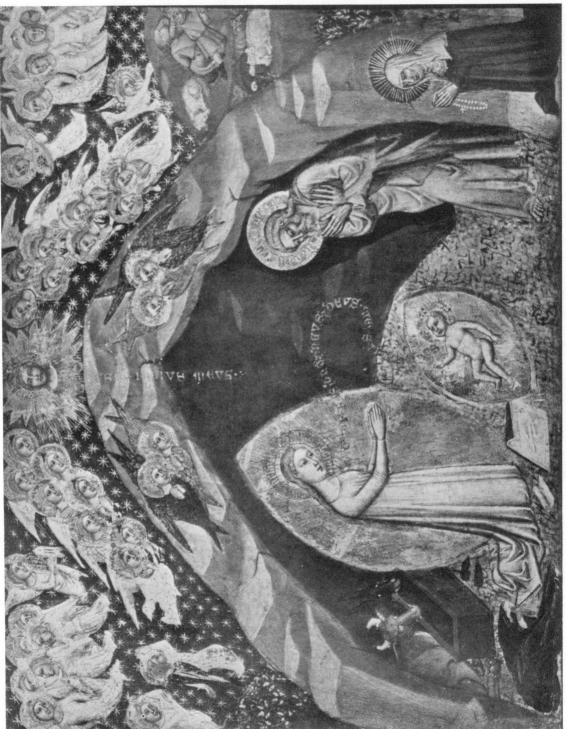

54. Niccolo di Tommaso : Nativity.

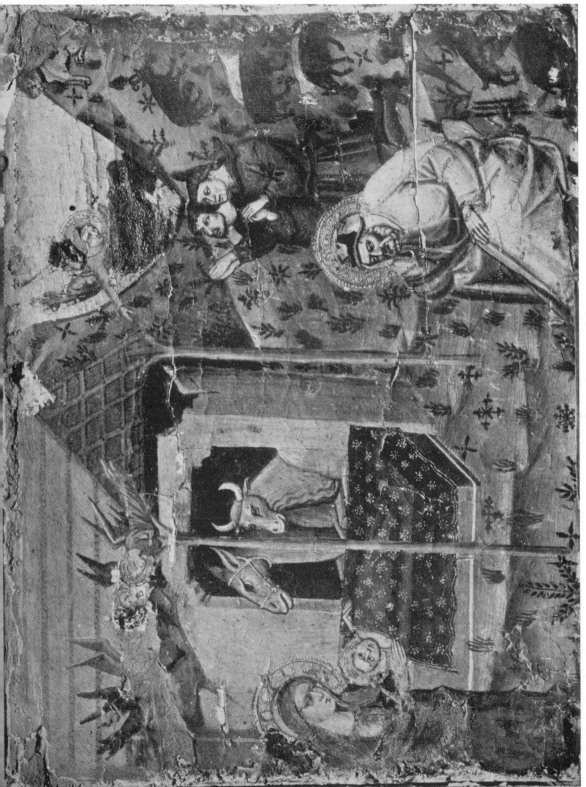

55. Florentine *c.* 1380 : Nativity.
Fiesole, Museo Bandini.

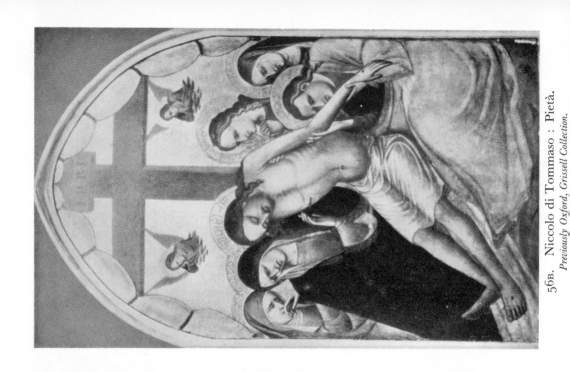

56B. Niccolo di Tommaso : Pietà.
Previously Oxford, Grissell Collection.

56A. Close to the Rinuccini Master : A Saint distributing Alms.
Florence, Academy.

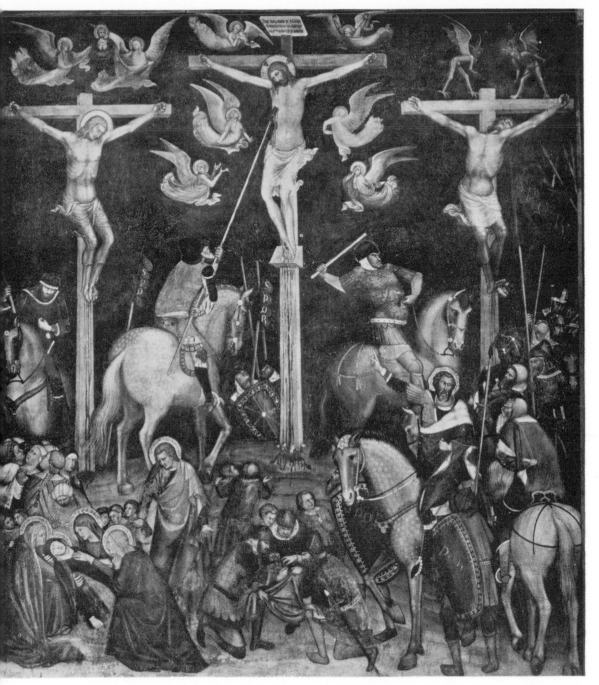

57. Barna da Siena : Crucifixion.
San Gimignano, Collegiata.

58. Andrea da Firenze : Crucifixion.
Florence, S. Maria Novella.

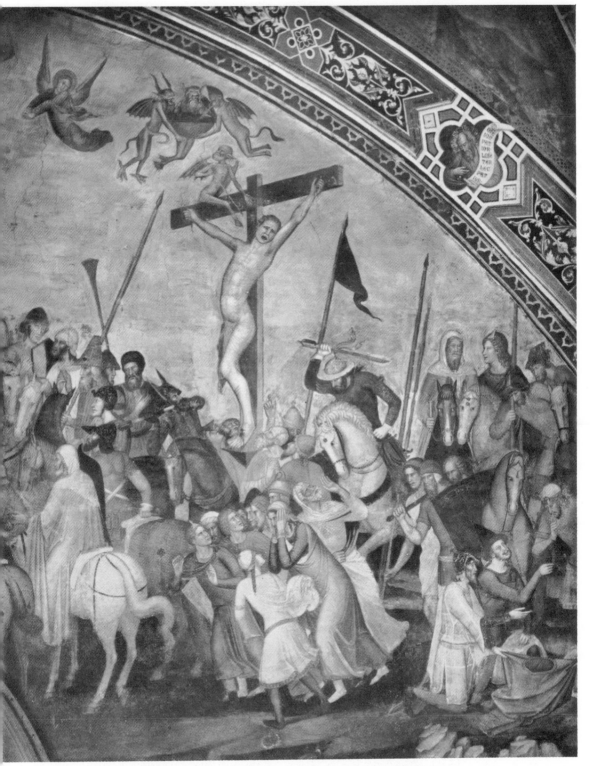

59. Andrea da Firenze : Detail of the Crucifixion.
Florence, S. Maria Novella.

60. Andrea da Firenze : Descent into Limbo.

Florence, S. Maria Novella

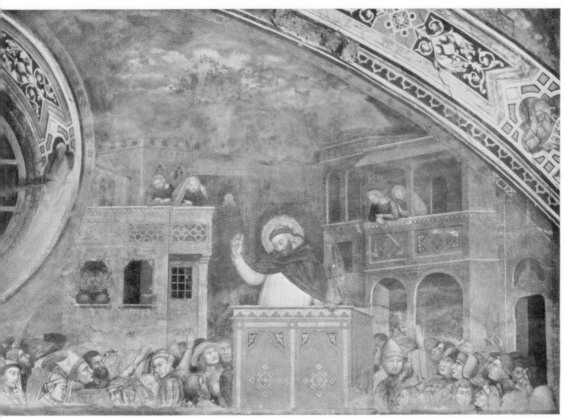

61A. Andrea da Firenze : St. Peter Martyr preaching against the Heretics.
Florence, S. Maria Novella.

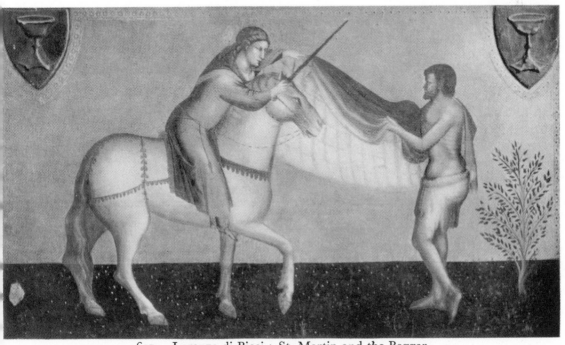

61B. Lorenzo di Bicci : St. Martin and the Beggar.
Florence, Uffizi.

62. Andrea da Firenze : Cure of the Sick Man by St. Peter Martyr.
Florence, S. Maria Novella.

63. Andrea da Firenze : Healing the Sick at the Tomb of St. Peter Martyr.

Florence, S. Maria Novella.

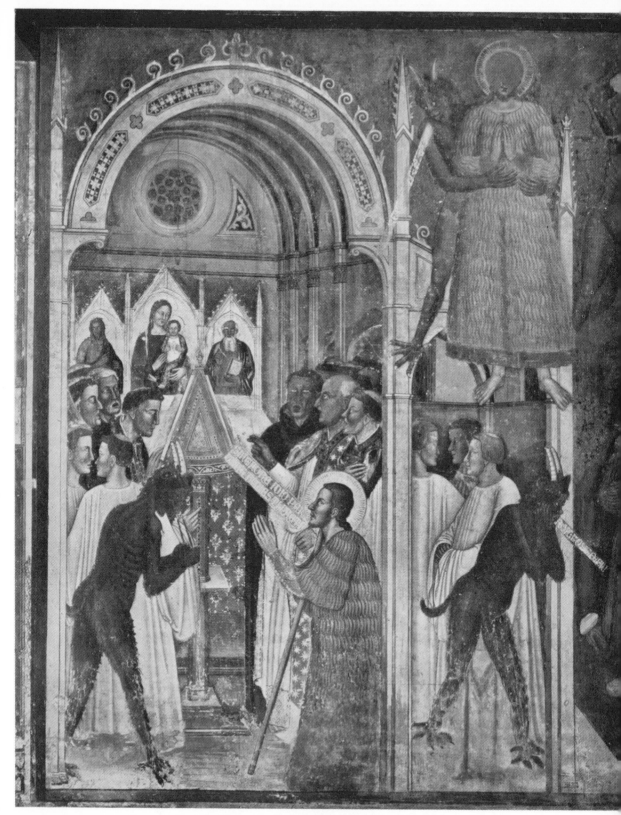

64. Andrea da Firenze : Scenes from the Life of St. Raineri. Detail.
Pisa, Campo Santo.

65. Agnolo Gaddi ? : Madonna of Mercy.
Florence, Academy.

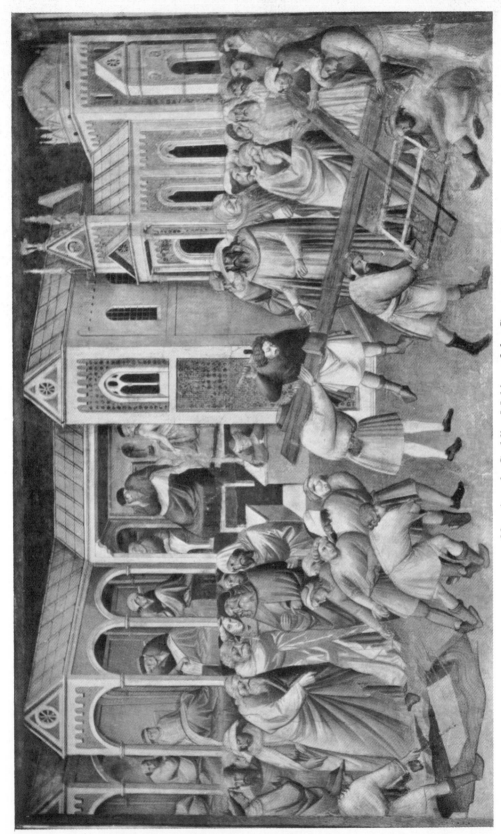

66. Agnolo Gaddi : Making of the Cross.
Florence, S. Croce.

67. Gherardo Starnina : Temptation of St. Anthony. Detail.
Florence, S. Croce.

68B. Giovanni del Biondo : Madonna and

68A. Antonio Veneziano : Madonna and Child.

69. Giovanni del Biondo ? : St. Catherine disputing with SS. Cosmas and Damian.
New York, Mogmar Art Foundation.

70. Giovanni del Biondo : Last Communion.
Worcester, U.S.A., Smith Collection.

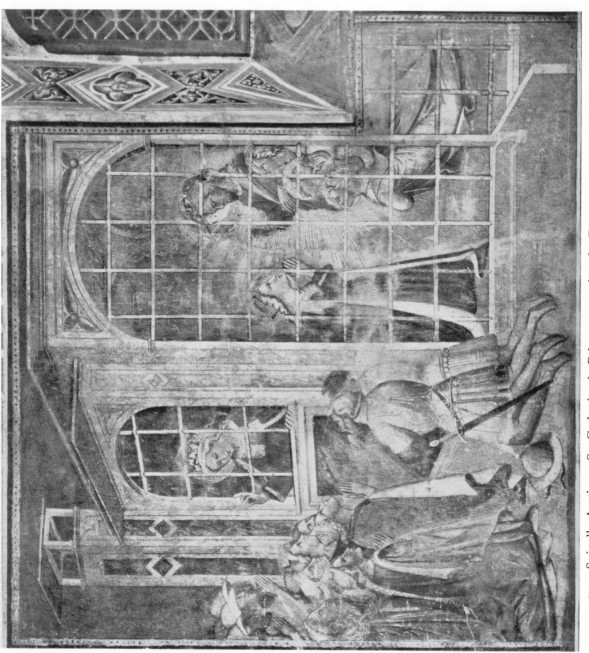

71. Spinello Aretino : St. Catherine in Prison converting the Empress and visited by Christ.
Antella, S. Caterina.

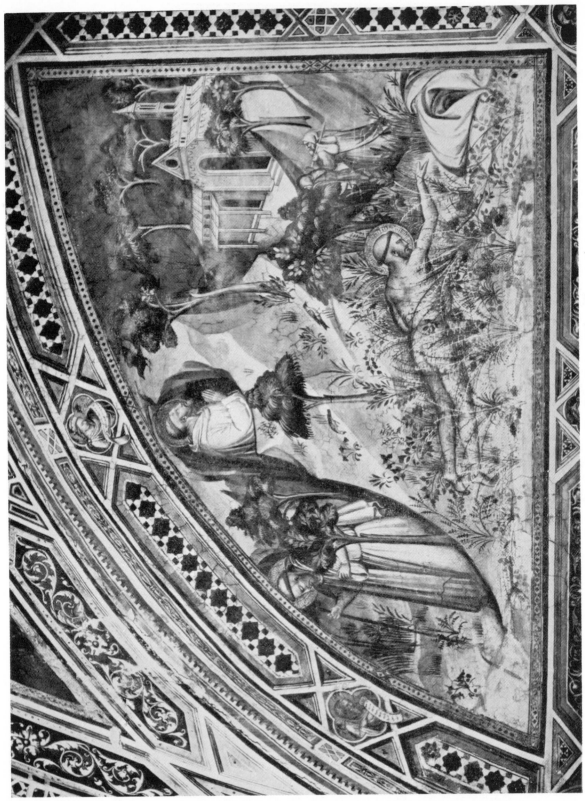

72. Spinello Aretino : St. Benedict resisting Temptation.

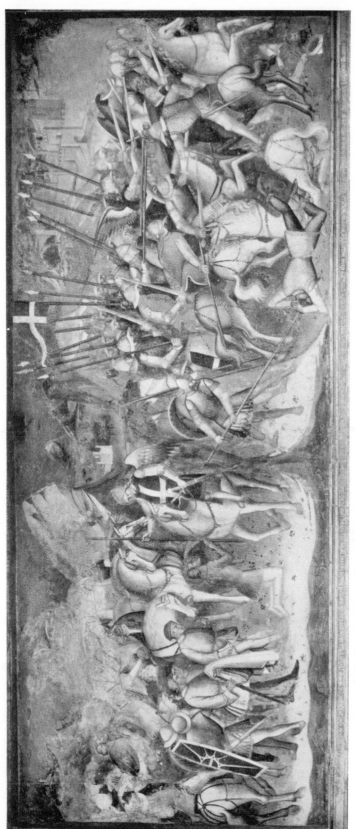

73. Spinello Aretino : St. Michael presents the banner to St. Ephisius ; they put the heathen to rout.

Pisa, Campo Santo.

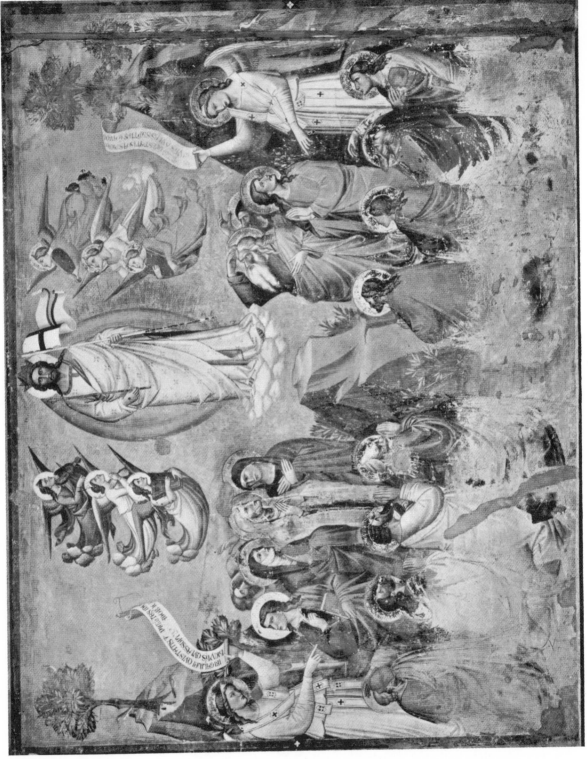

74. Niccolo Gerini : Ascension.

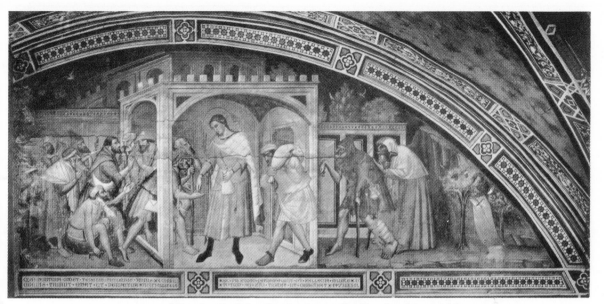

75A. Niccolo Gerini : St. Anthony distributing his wealth.
Prato, S. Francesco.

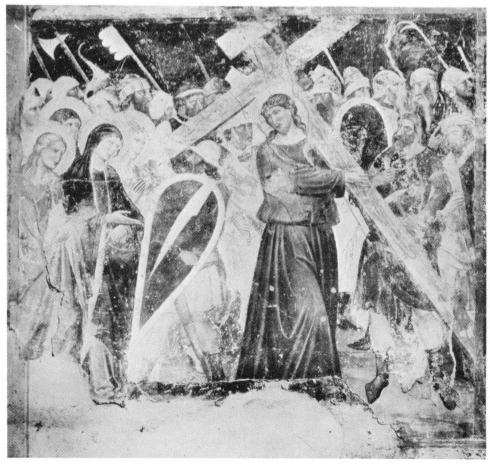

75B. Workshop of Niccolo Gerini : Christ carrying the Cross.
Bardino, former Church of the Brigittines.

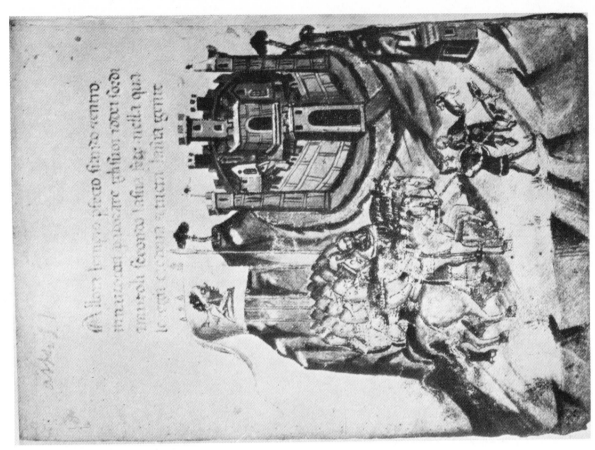

76A. Lorenzo di Bicci : St. Catherine.

76B. The Prefect Olybrius goes out to hunt. Miniature for Manuscript

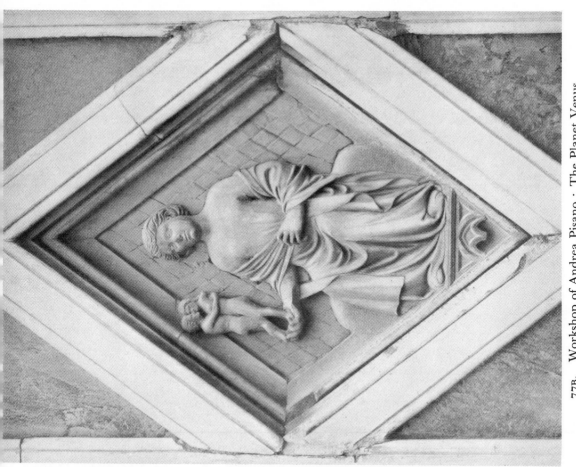

77B. Workshop of Andrea Pisano : The Planet Venus.
Florence, Campanile.

77A. Giotto : Justice.
Padua, Arena Chapel.

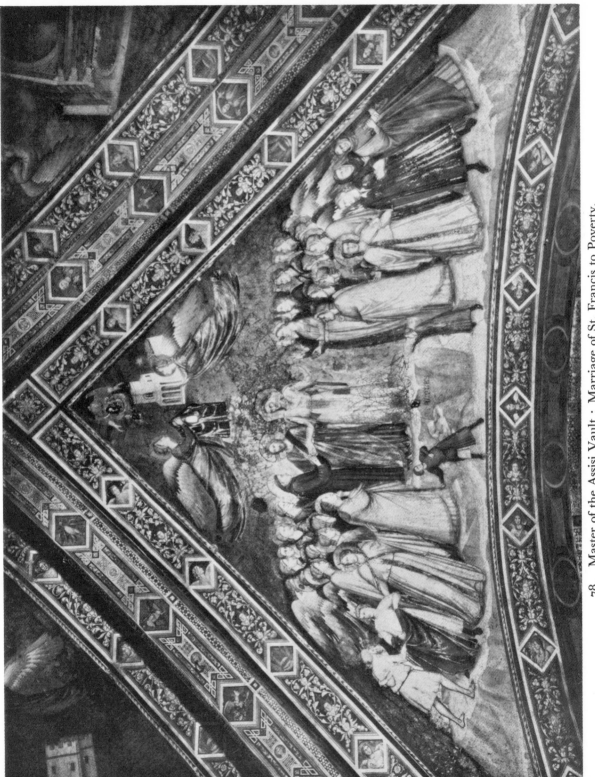

78. Master of the Assisi Vault : Marriage of St. Francis to Poverty.
Assisi, S. Francesco.

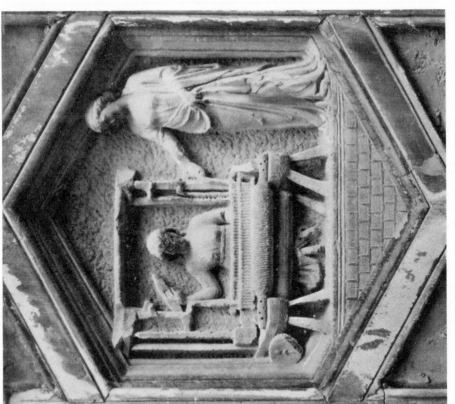

79B. Workshop of Andrea Pisano : Wool-weaving.
Florence, Campanile.

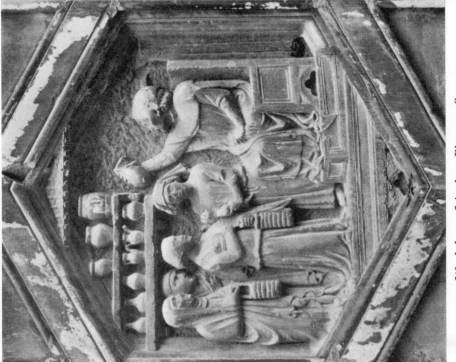

79A. Workshop of Andrea Pisano : Surgery.
Florence, Campanile.

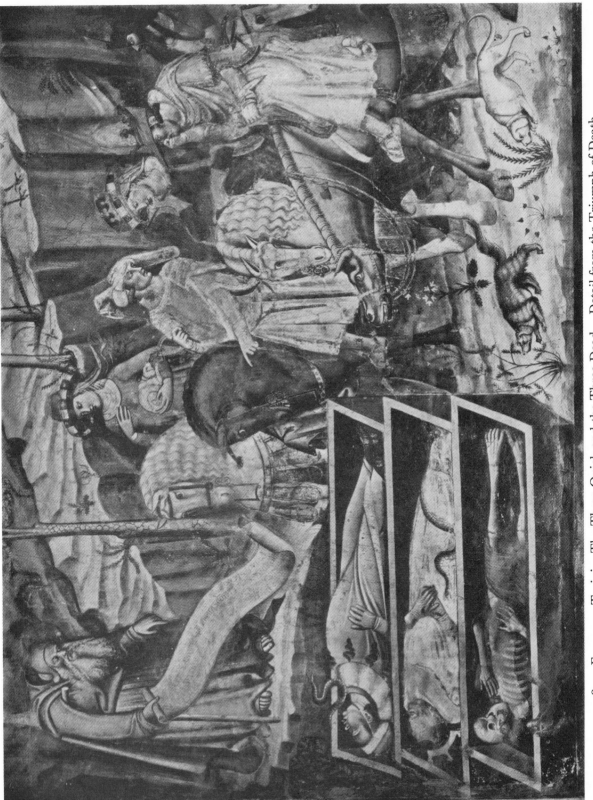

80. Francesco Traini : The Three Quick and the Three Dead. Detail from the Triumph of Death.
Pisa, Campo Santo.

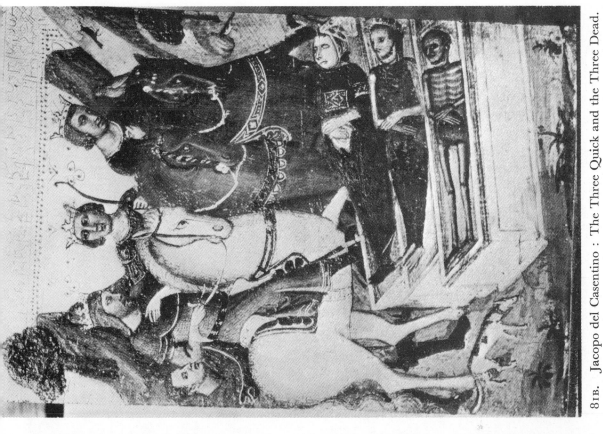

81B. Jacopo del Casentino : The Three Quick and the Three Dead.
Berlin, Museum.

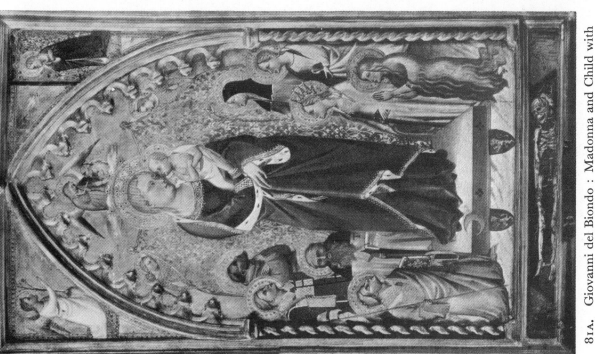

81A. Giovanni del Biondo : Madonna and Child with
Saints and Skeleton. *Rome, Vatican Gallery.*

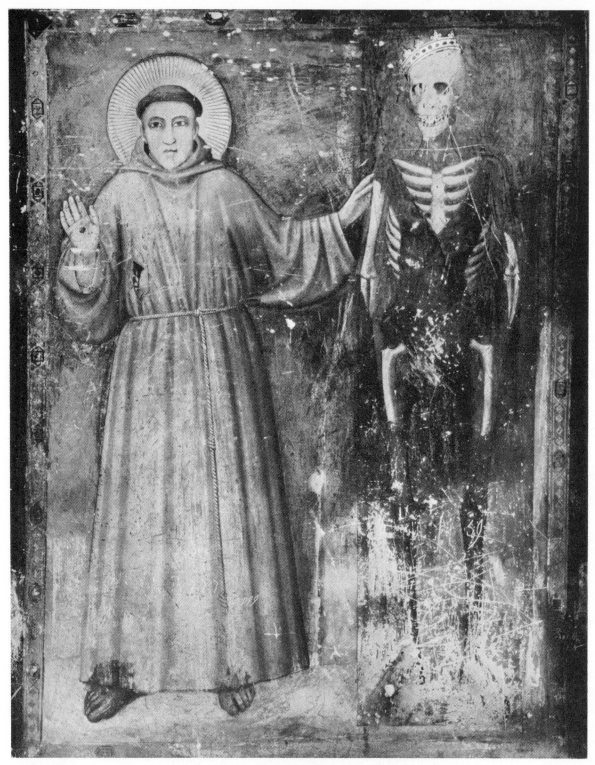

82. Master of the Assisi Vault ? : St. Francis with a Skeleton.
Assisi, S. Francesco.

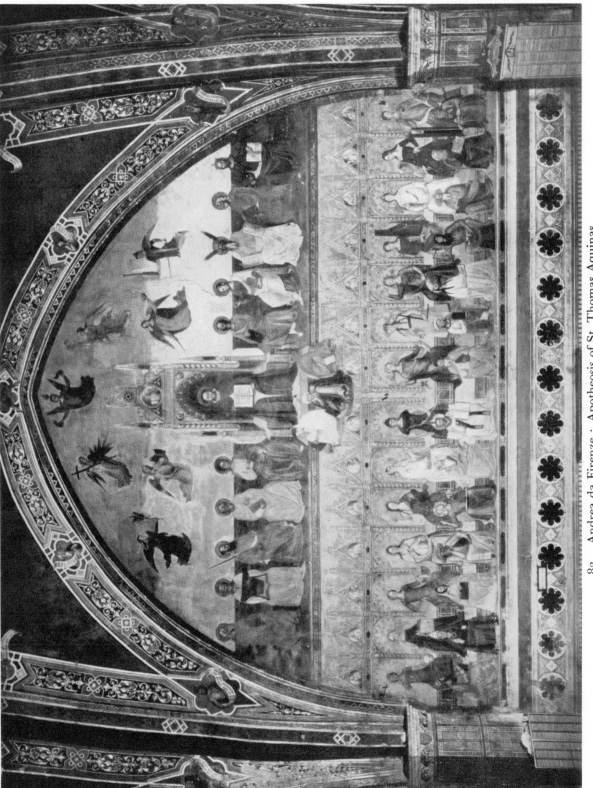

83. Andrea da Firenze : Apotheosis of St. Thomas Aquinas.
Florence, S. Maria Novella.

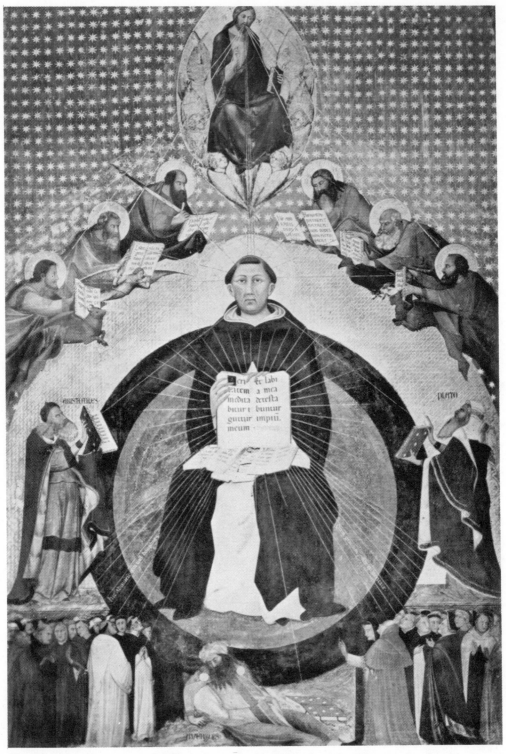

84. Follower of Francesco Traini : Apotheosis of St. Thomas Aquinas.
Pisa, S. Caterina.

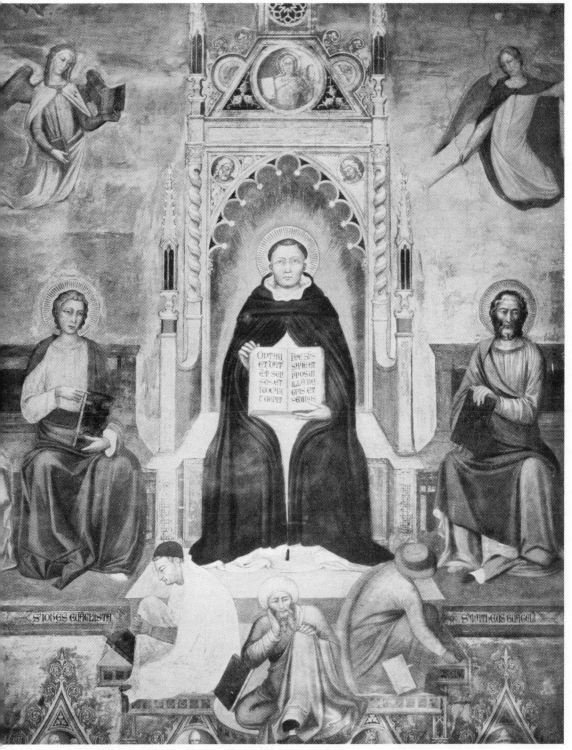

85. Andrea da Firenze : Detail of the Apotheosis of St. Thomas Aquinas.
Florence, S. Maria Novella.

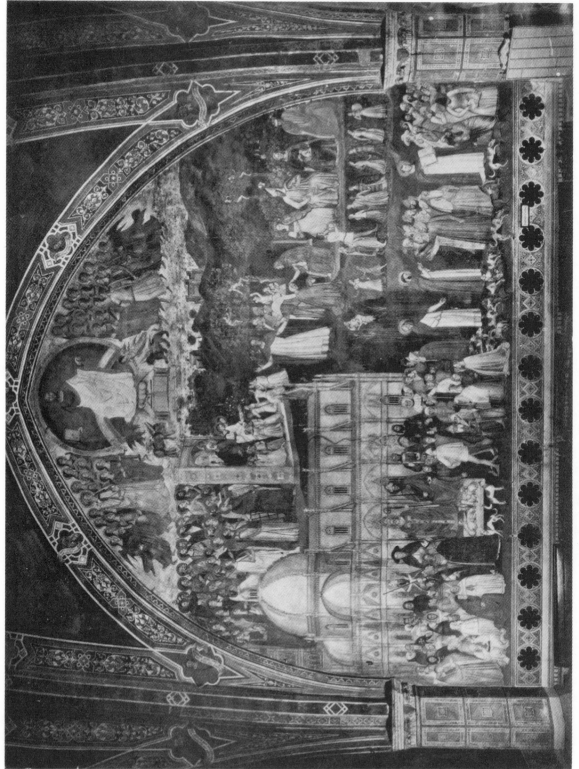

86. Andrea da Firenze : The Government of the Church.

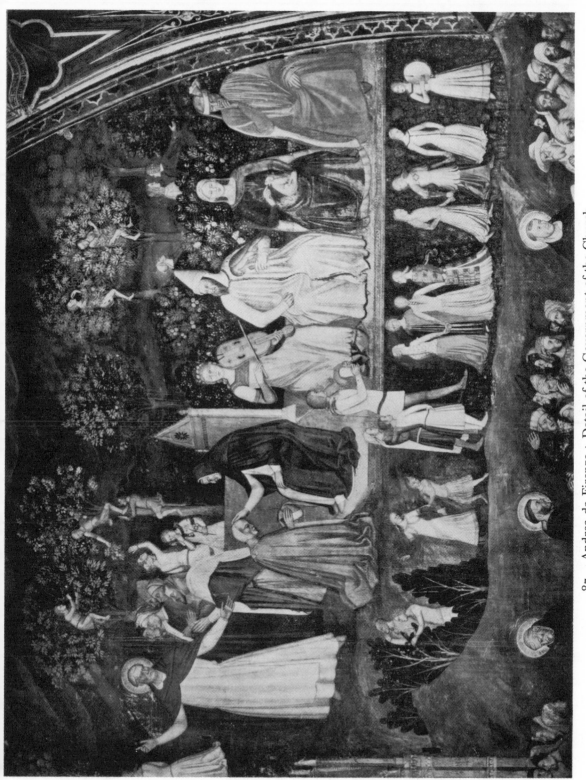

87. Andrea da Firenze : Detail of the Government of the Church.
Florence, S. Maria Novella.

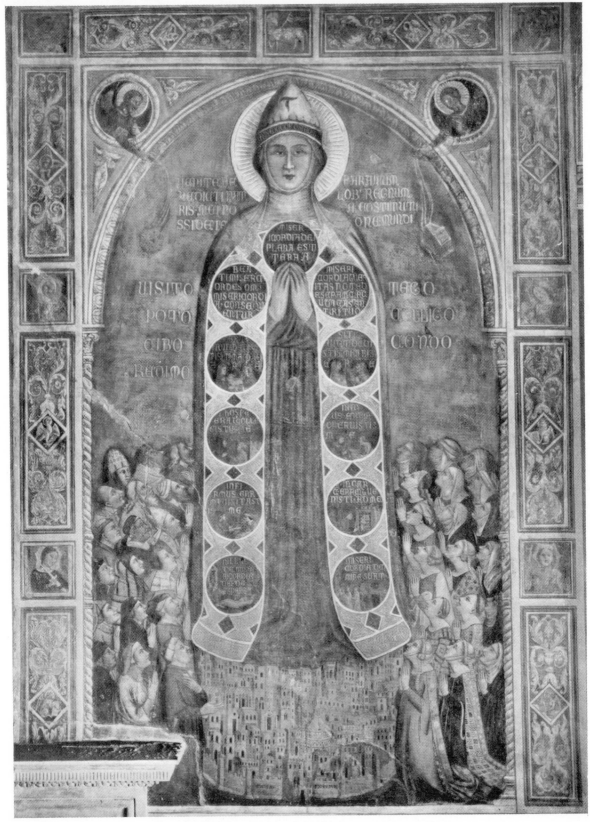

88. Follower of Daddi : Misericordia. *Florence, Bigallo.*

89A. Visitation of the Sick. Miniature for De Vitiis et Virtutibus.
Florence, Biblioteca Nazionale.

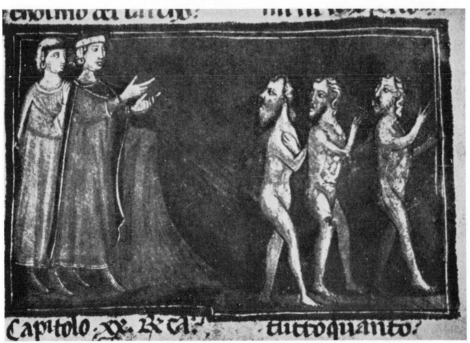

89B. Dante, Virgil and the Soothsayers. Miniature for the Divina commedia.
Codice Poggiali.
Florence, Laurenziana.

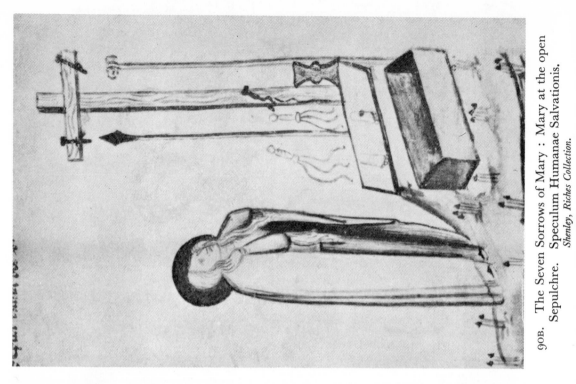

90B. The Seven Sorrows of Mary : Mary at the open
Sepulchre. Speculum Humanae Salvationis.
Shenley, Riches Collection.

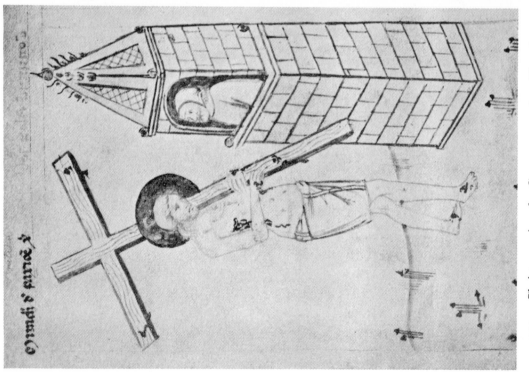

90A. Christ carrying the Cross appears to a Hermit.
Speculum Humanae Salvationis.
Shenley, Riches Collection.

91B. Workshop of Alberto Arnaldi : Sacrament of Marriage.
Florence, Campanile.

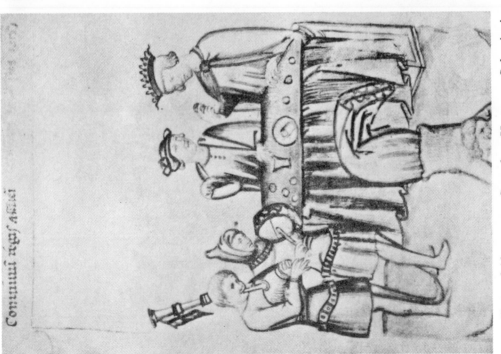

Conuiuiu regis Assul

91A. Feast of Ahasverus. Speculum Humanae Salvationis.
Shenley, Riches Collection.

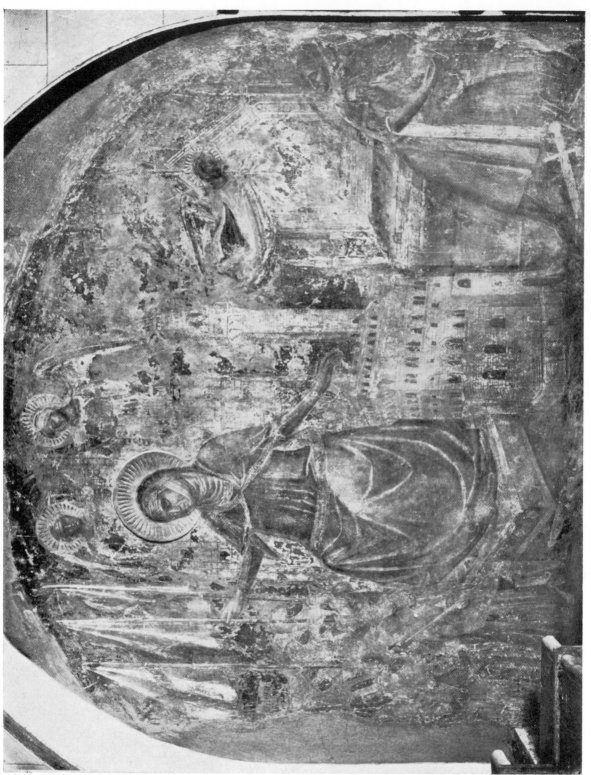

92. Follower of Maso : Expulsion of the Duke of Athens.

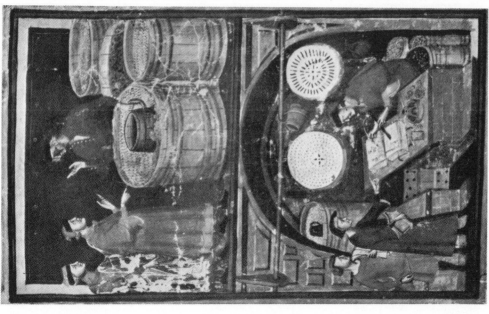

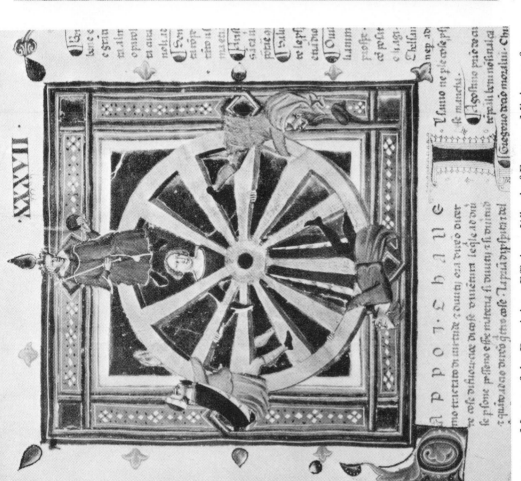

93A. Master of the Dominican Effigies : Wheel of Fortune. Miniature for Bartolommeo da San Concordio's Ammaestramenti degli Antichi.

Florence, Biblioteca Nazionale.

93B. The Biadaiolo Illuminator : Corn Merchant in his Shop.

Florence, Laurenziana.

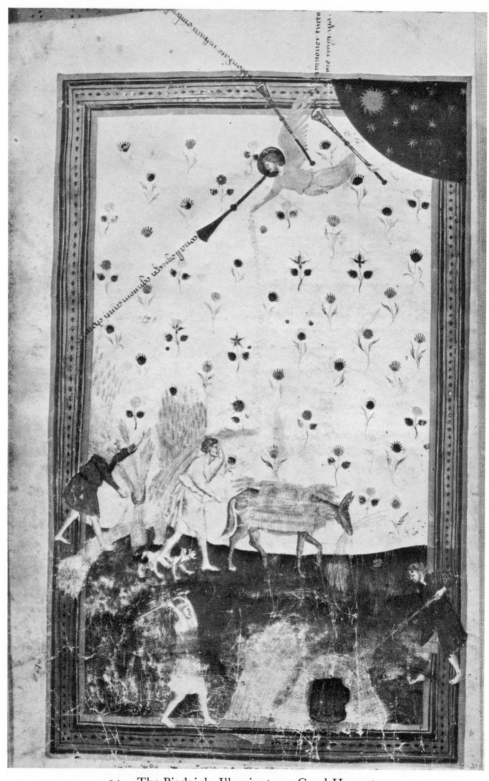

94. The Biadaiolo Illuminator : Good Harvest.
Florence, Laurenziana.

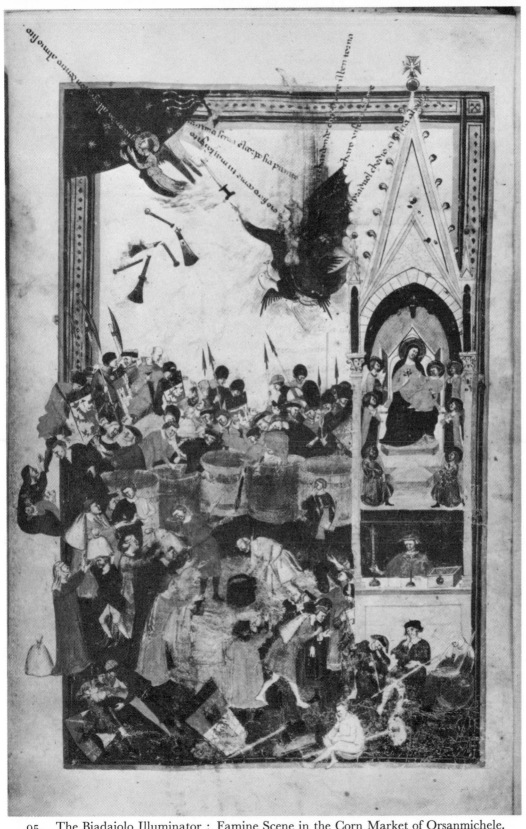

95. The Biadaiolo Illuminator : Famine Scene in the Corn Market of Orsanmichele.
Florence, Laurenziana.

96. Niccolo Gerini (and Ambrogio di Baldese) : The Capitani of the Compagnia della Misericordia return the Foundlings
to their Mothers.
Florence, Bigallo.

97. Florentine *c.* 1395. Story of the Chastelaine de Vergi.
Florence, Palazzo Davanzati.

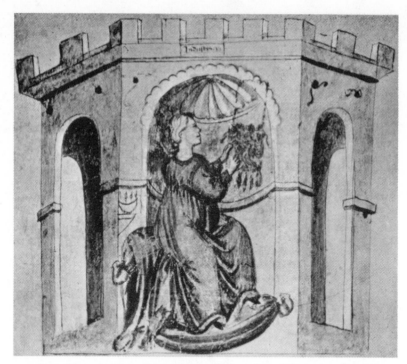

98A. Francesco da Barberino : Industria. Miniature for the
Documenti d'Amore.
Rome, Barberini Gallery.

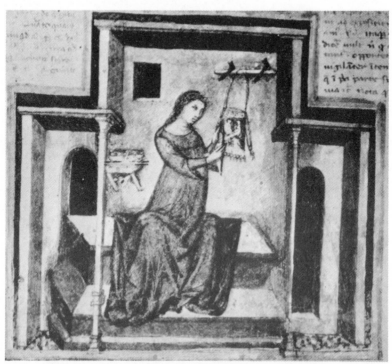

98B. After Francesco da Barberino : Industria. Miniature for the
Documenti d'Amore.
Rome, Barberini Gallery.

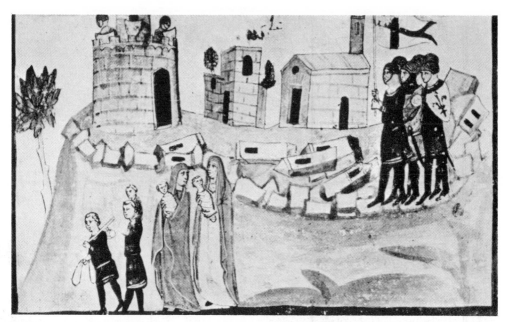

99A. The Florentines capture Fiesole. Miniature for Villani's Chronicle.
Rome, Vativan Library.

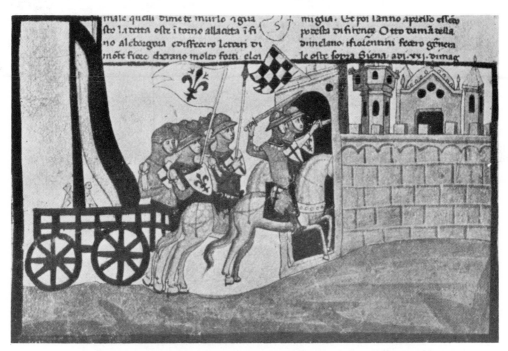

99B. The Florentines capture Carmignano. Miniature for Villani's Chronicle.
Rome, Vatican Library.

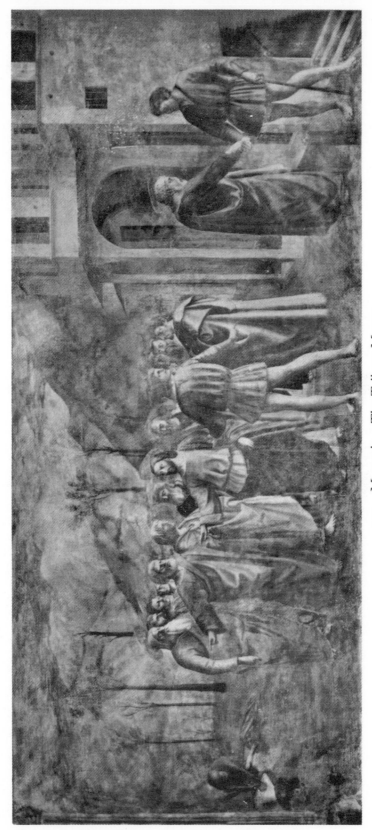

100. Masaccio : The Tribute Money.
Florence, S. Maria del Carmine.

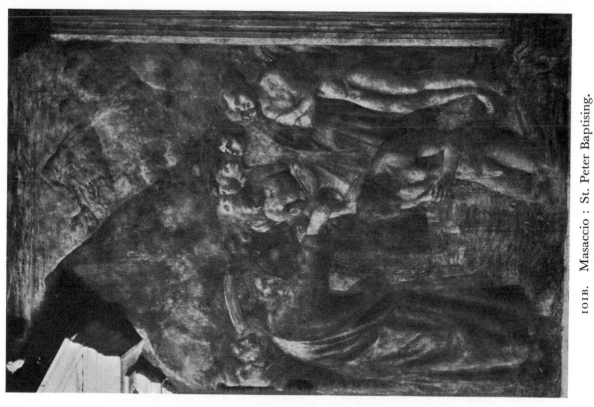

101B. Masaccio : St. Peter Baptising.
Florence, S. Maria del Carmine.

101A. Masaccio : SS. Peter and John healing the Sick with
their Shadows. *Florence, S. Maria del Carmine.*

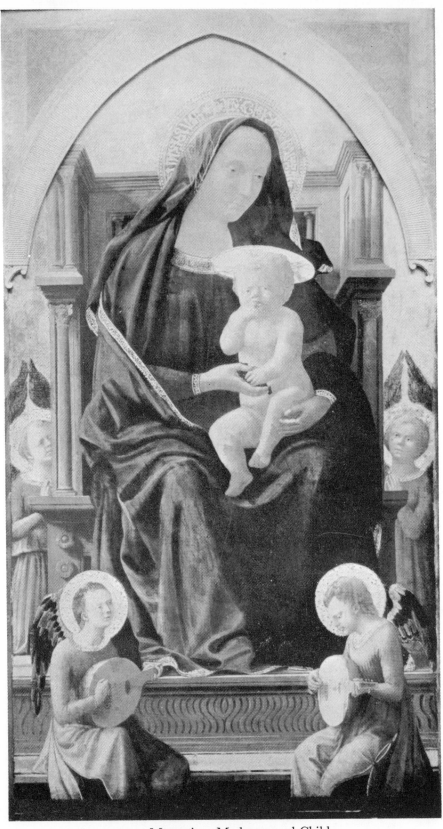

102. Masaccio : Madonna and Child.
London, National Gallery.

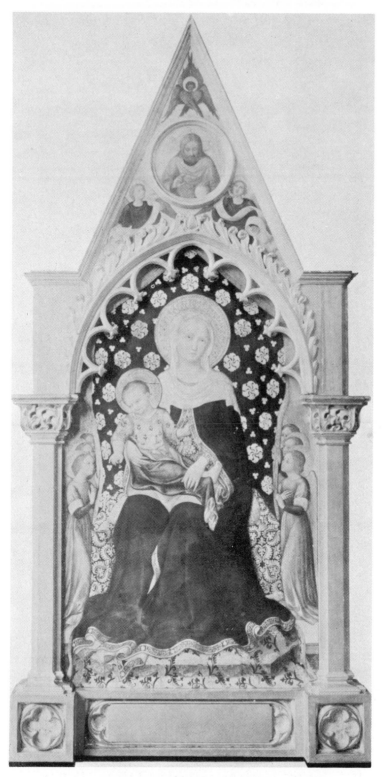

103. Gentile da Fabriano : Madonna and Child.
London, National Gallery. Lent by H.M. The King.

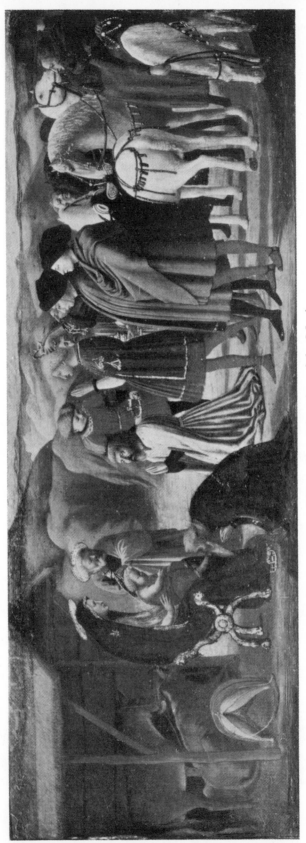

104. Masaccio : Adoration of the Magi.
Berlin Museum.

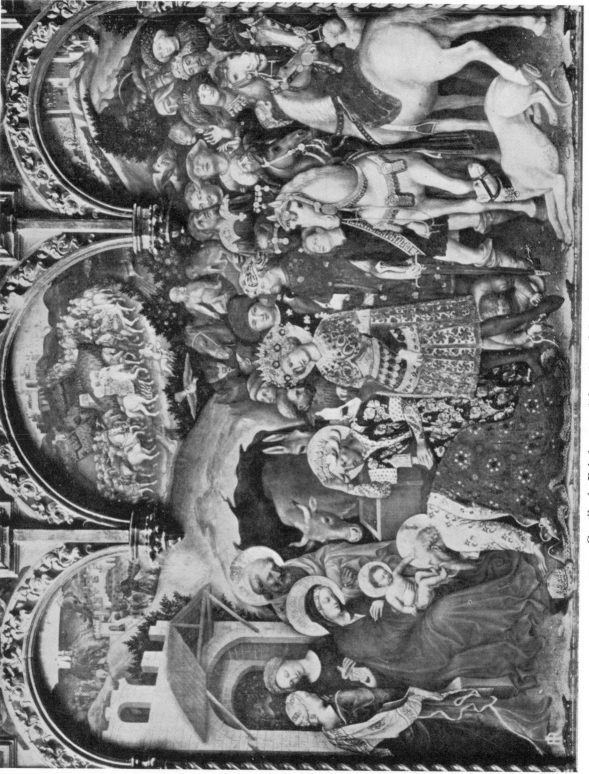

105. Gentile da Fabriano : Adoration of the Magi. *Florence, Uffizi.*

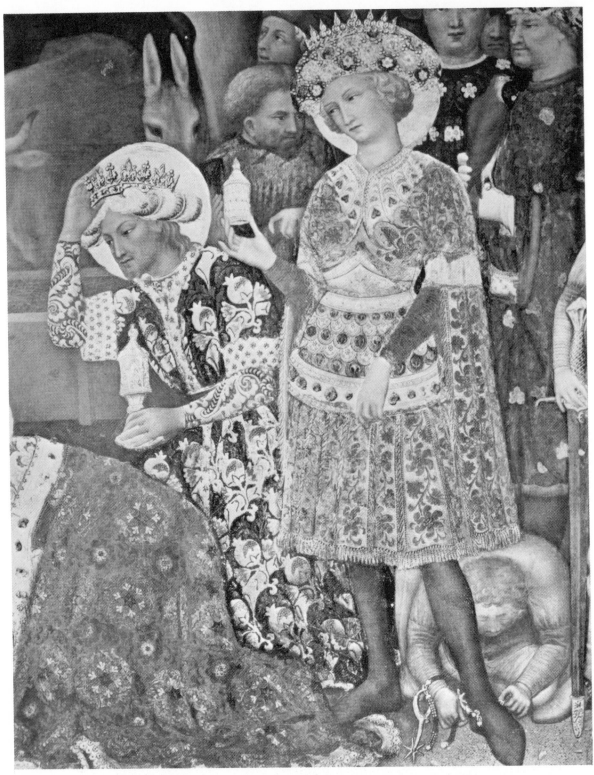

106. Gentile da Fabriano : Detail of the Adoration of the Magi.
Florence, Uffizi.

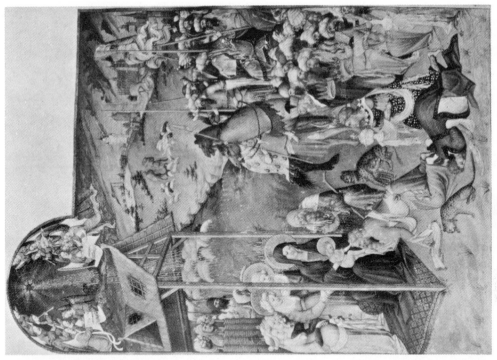

107B. Limbourg Brothers : Adoration of the Magi.
Très Riches Heures du Duc de Berry
Chantilly, Musée Condé.

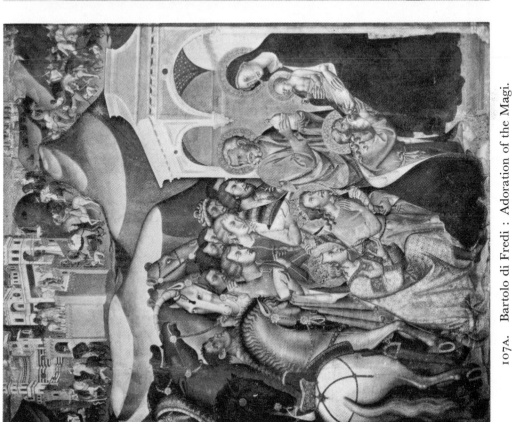

107A. Bartolo di Fredi : Adoration of the Magi.
Siena, Pinacoteca.

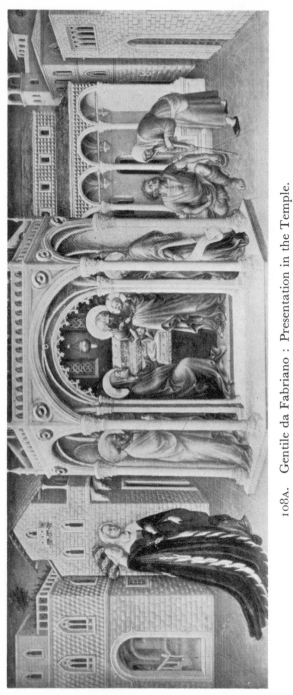

108A. Gentile da Fabriano : Presentation in the Temple.
Paris, Louvre.

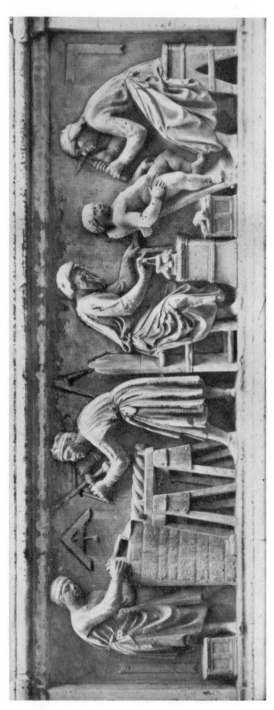

108B. Nanni di Banco : The Four Sculptor Saints in their Workshop.
Florence, Orsanmichele.

109A. Gentile da Fabriano : Flight into Egypt.
Florence, Uffizi.

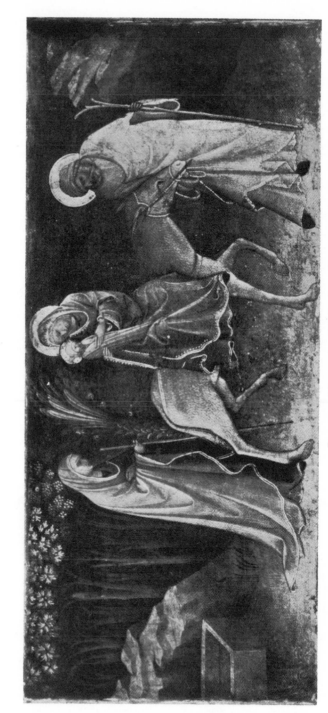

109B. Lorenzo Monacó : Flight into Egypt.
Florence, S. Trinità.

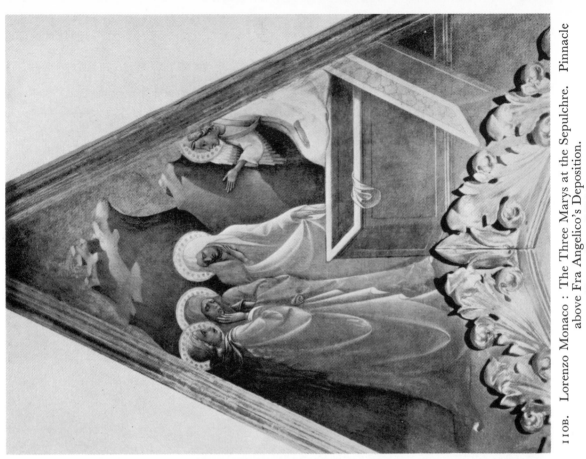

110B. Lorenzo Monaco : The Three Marys at the Sepulchre. Pinnacle
above Fra Angelico's Deposition.
Florence, Museo di Si Marco.

110A. Master of the Madonnas : Madonna of
Humility with Angels.
Berlin. Museum.

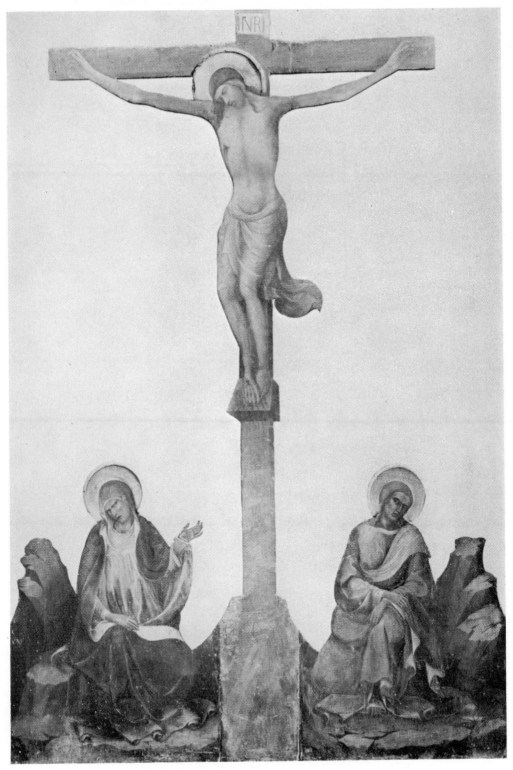

III. Lorenzo Monaco : Crucifixion.
Florence, S. Giovanni dei Cavalieri.

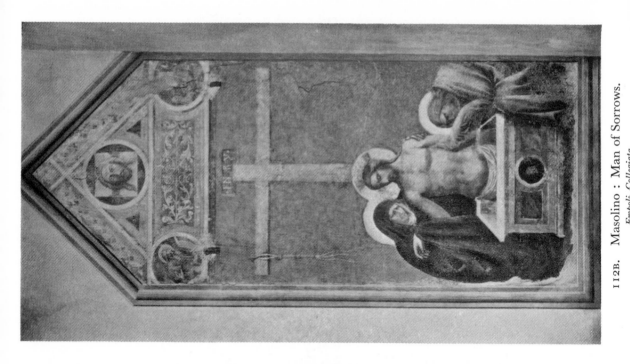

112B. Masolino : Man of Sorrows.
Empoli, Collegiata

112A. Lorenzo Monaco : Man of Sorrows with Symbols
of the Passion. Florence Academy

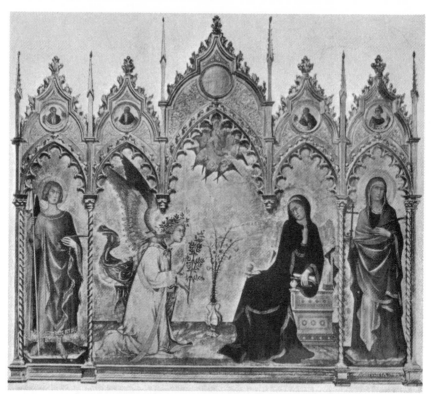

113A. Simone Martini : Annunciation. *Florence, Uffizi.*

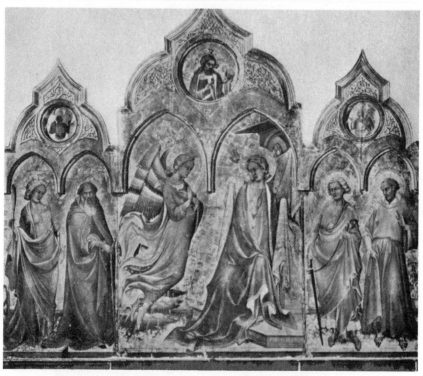

113B. Lorenzo Monaco : Annunciation. *Florence, Academy.*

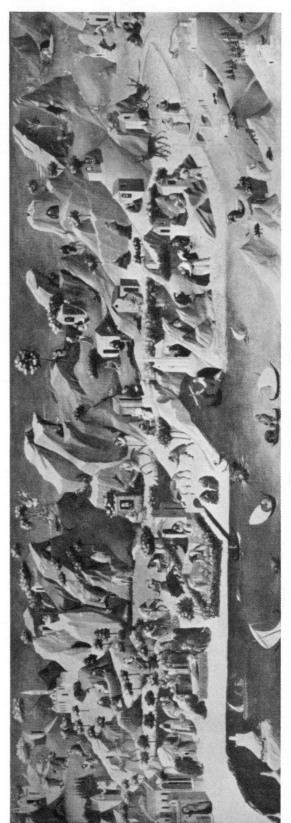

114. Gherardo Starnina : Thebaid.
Florence, Uffizi.

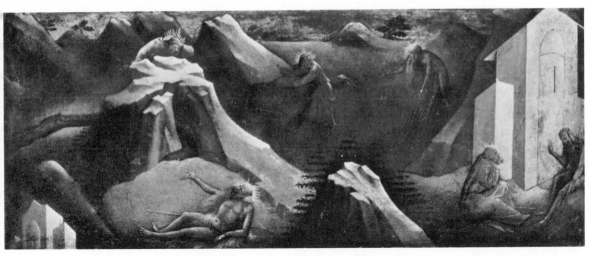

115A. Lorenzo Monaco : Scenes from the Life of St. Onophrius.
Florence, S. Trinità.

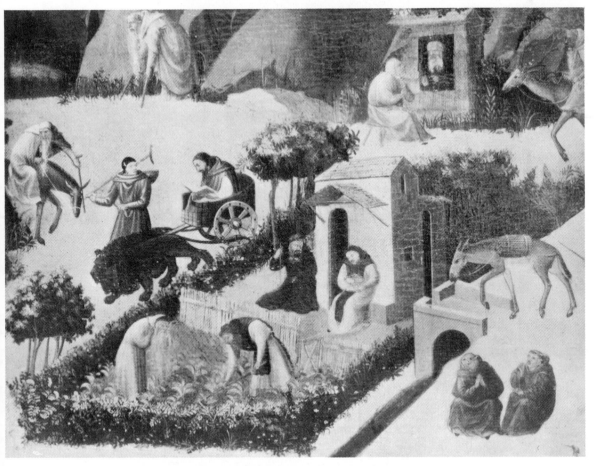

115B. Gherardo Starnina : Detail of the Thebaid.
Florence, Uffizi.

116B. Gentile da Fabriano : Flowers on the framework of the
Adoration of the Magi.
Florence, Uffizi.

116A. Lorenzo Monaco : Prophet. Miniature for a
Sunday Diurnal.
Florence, Laurenziana.

117. Lorenzo Monaco : Journey of the Three Magi.
Berlin, Print Room.

118B. Masolino : Assumption.

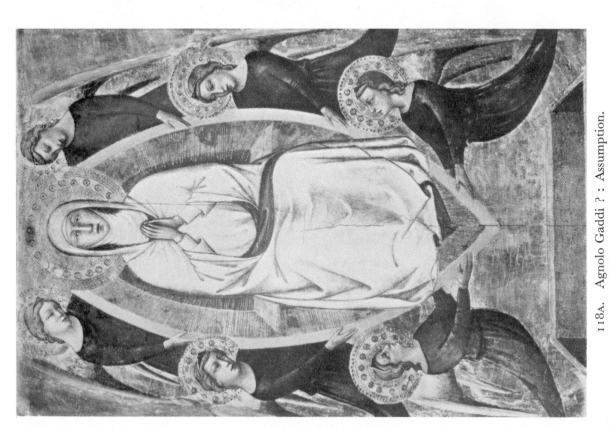

118A. Agnolo Gaddi ? : Assumption.

119B. Masolino : Annunciation.
Castiglione d'Olona, Collegiata.

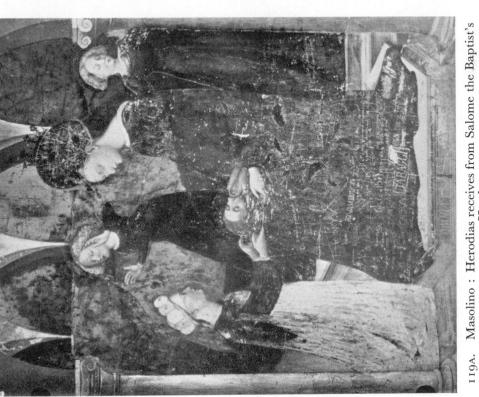

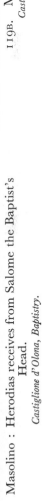

119A. Masolino : Herodias receives from Salome the Baptist's
Head.
Castiglione d'Olona, Baptistry.

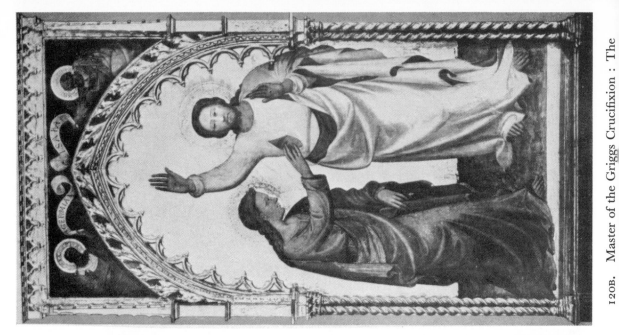

120B. Master of the Griggs Crucifixion : The

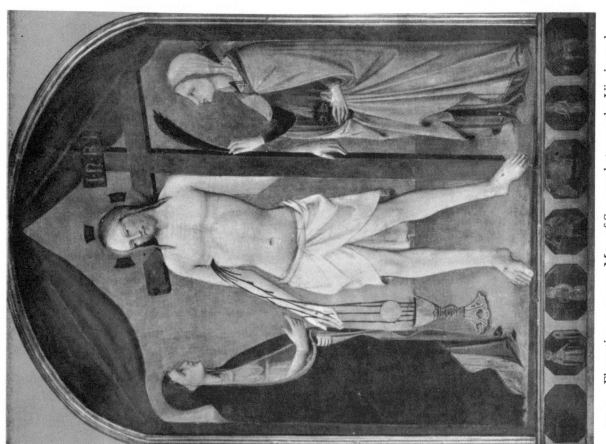

120A. Florentine c. 1410 ; Man of Sorrows between the Virgin and

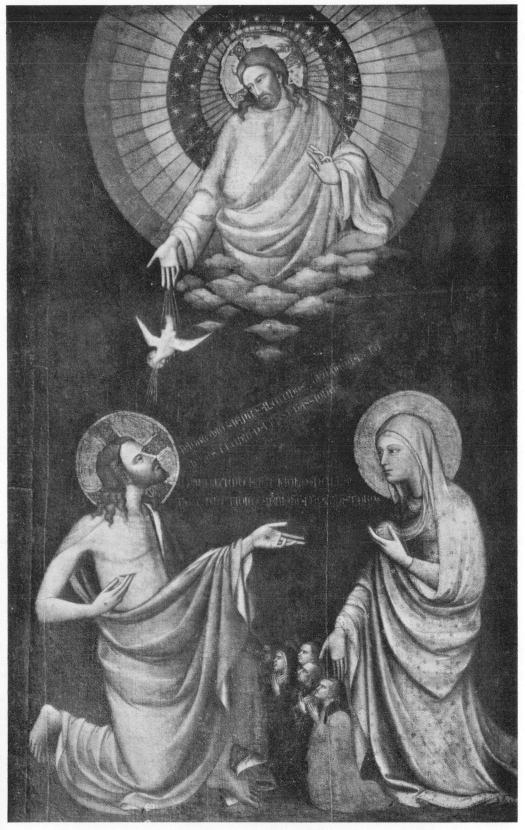

121. Niccolo Gerini : Intercession of Christ and the Virgin.
Balcarres. Collection of the Earl of Crawford.

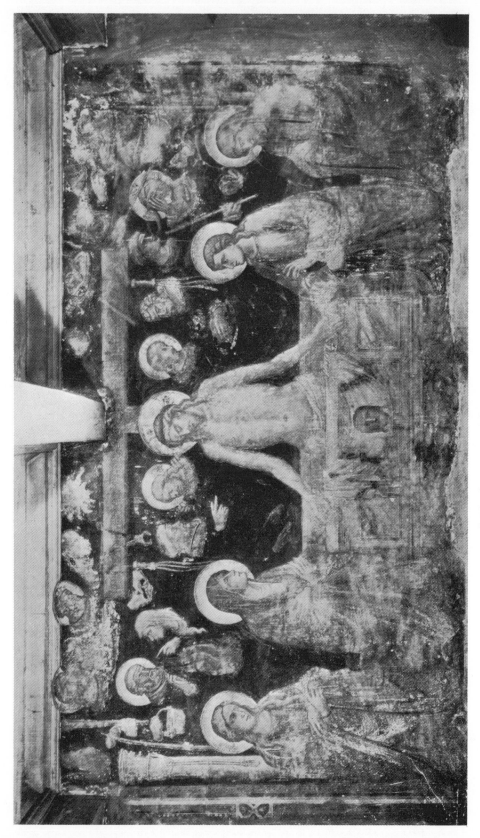

122. Mariotto di Nardo : Man of Sorrows with Symbols of the Passion.
Florence, Chiostro delle Oblate.

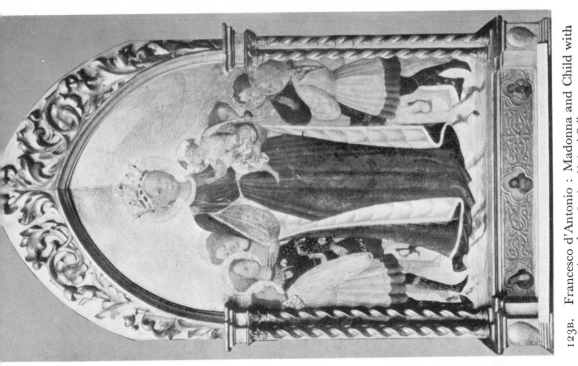

123B. Francesco d'Antonio : Madonna and Child with Angels. *London, National Gallery.*

123A. Mariotto di Nardo : Trinity, St. Francis and the Magdalen. *Fiesole, Museo Bandini.*

124. Agnolo Gaddi : King Chosroës rides out of Jerusalem, taking the Cross with him,
Florence, S. Croce,

125. Cenni di Francesco : King Chosroës rides out of Jerusalem, taking the Cross with him.
Volterra, S. Francesco.

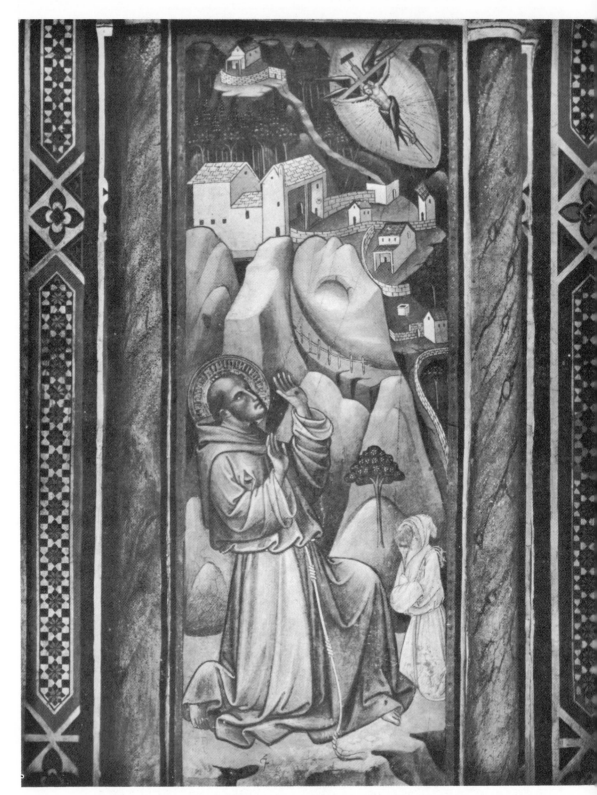

126. Cenni di Francesco : Stigmatisation of St. Francis.
Volterra, S. Francesco.

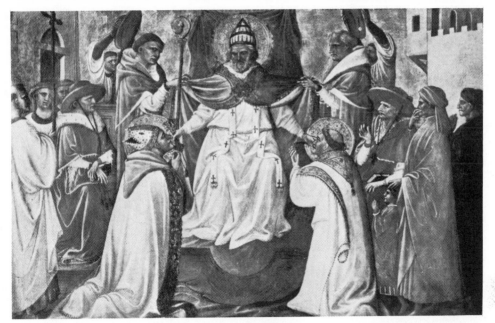

127A. Giovanni dal Ponte : St. Peter distributing Ecclesiastical Dignities.
Florence, Uffizi.

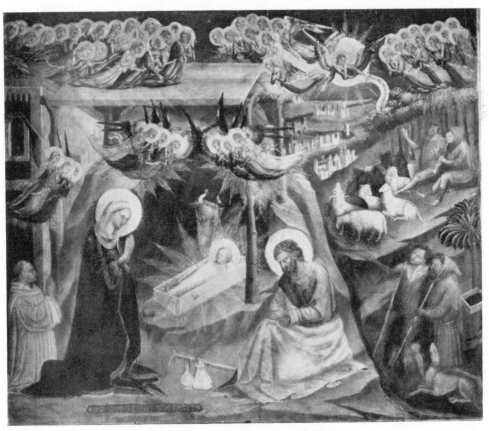

127B. Bicci di Lorenzo : Nativity.
Florence, S. Giovanni dei Cavalieri.

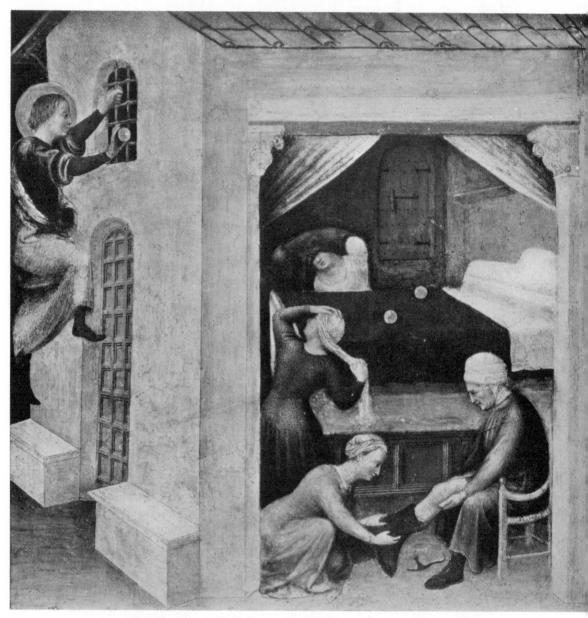

128. Gentile da Fabriano : St. Nicholas saves the Three Girls.
Rome, Vatican Gallery.

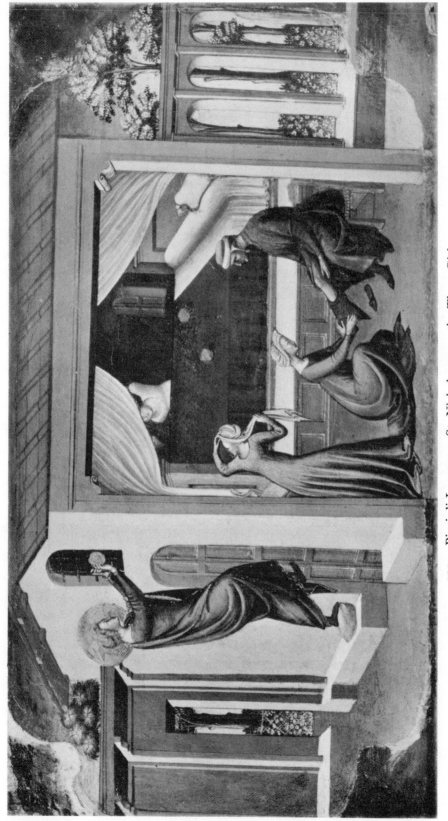

129. Bicci di Lorenzo : St. Nicholas saves the Three Girls.
New York, Metropolitan Museum.

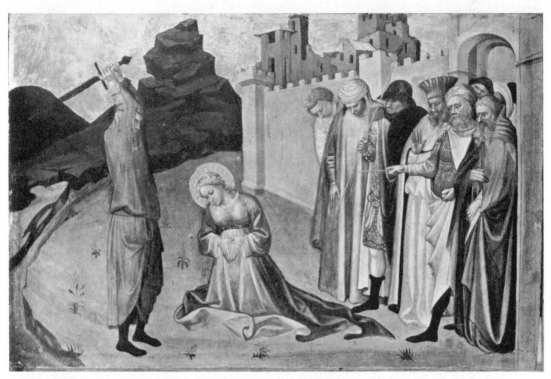

130A. Maestro del Bambino Vispo : Beheading of St. Catherine.
London, National Gallery.

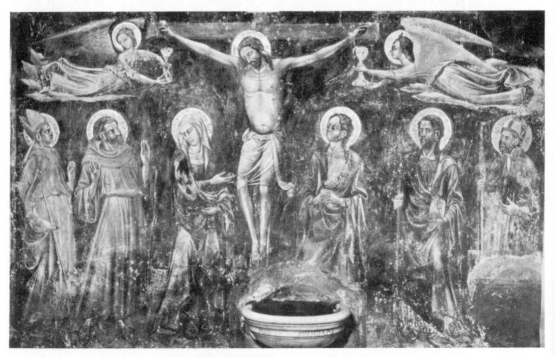

130B. Francesco d'Antonio : Crucifixion.
Figline, S. Francesco.

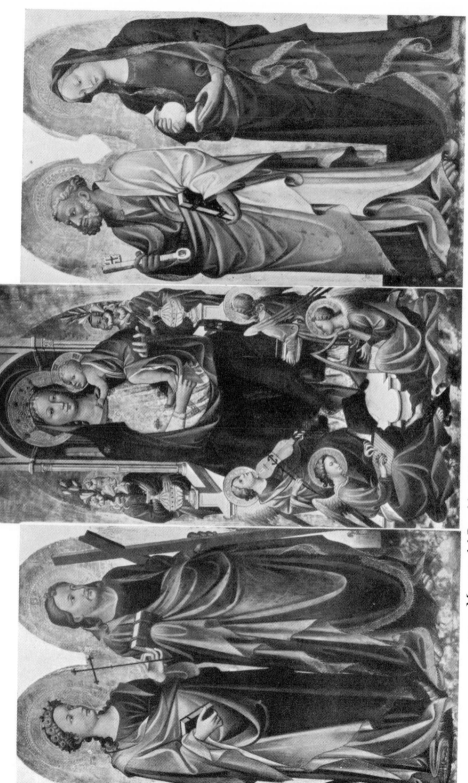

131. Maestro del Bambino Vispo : Madonna and Child with Angels and Saints.
Würzburg, University Museum.

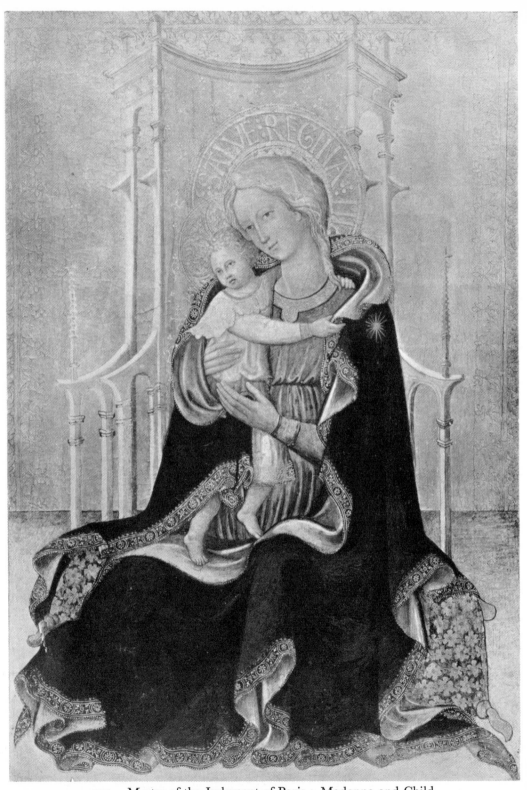

132. Master of the Judgment of Paris : Madonna and Child.
Kinnaird Castle, Collection of the Earl of Southesk.

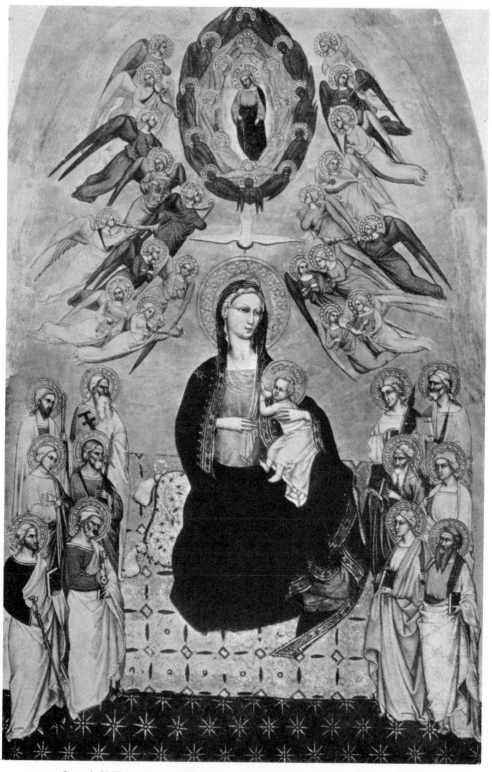

133. Cenni di Francesco : Madonna of Humility with Angels and Saints.
Lugano, Thyssen Collection.

134A. Master of the Strauss Madonna :
St. Catherine.
Florence, Uffizi.

134B. Master of the Strauss Madonna :
St. Francis.
Florence, Uffizi.

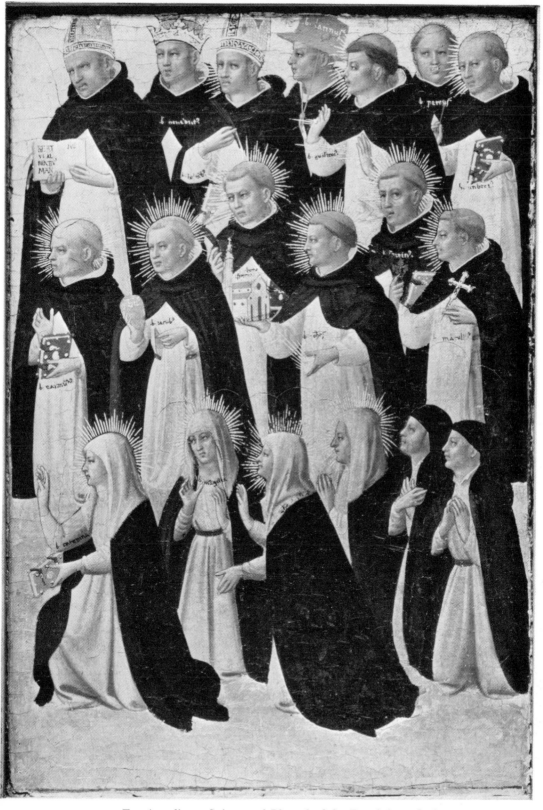

135. Fra Angelico : Saints and Blessed of the Dominican Order.
London, National Gallery.

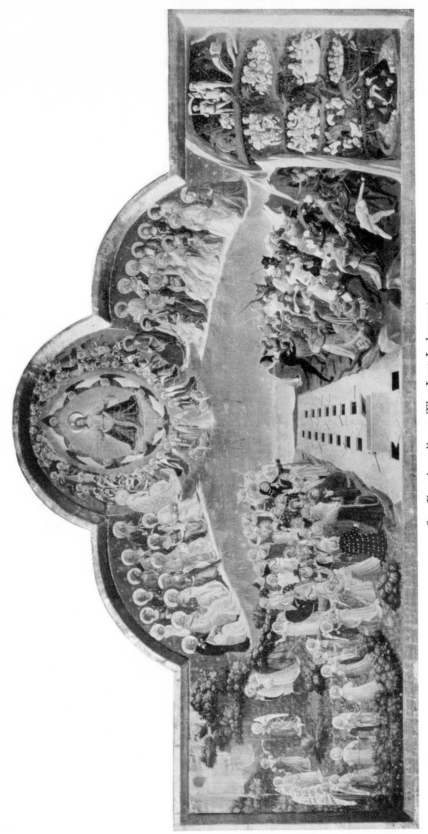

136. Fra Angelico : The Last Judgment.
Florence, Museo di S. Marco.

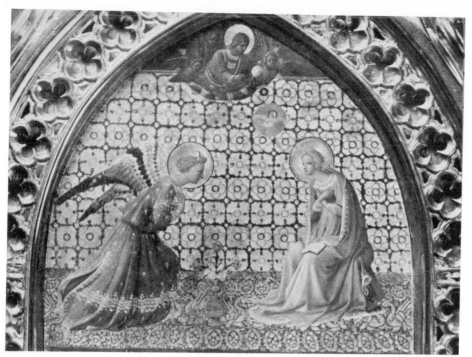

137A.　Fra Angelico : Annunciation.
Florence, Museo di S. Marco.

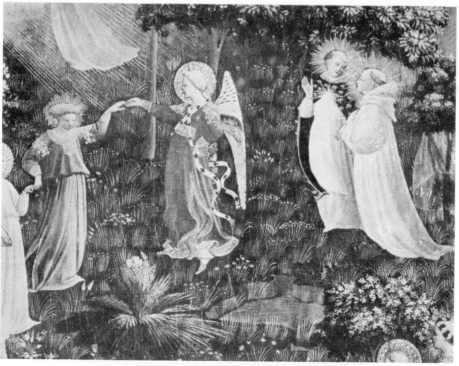

137B.　Fra Angelico : Detail of the Last Judgment.
Florence, Museo di S. Marco.

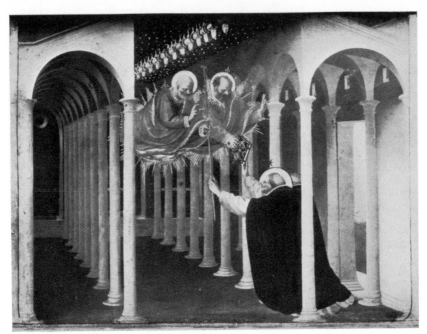

138A. Fra Angelico : Vision of St. Dominic.
Paris, Louvre.

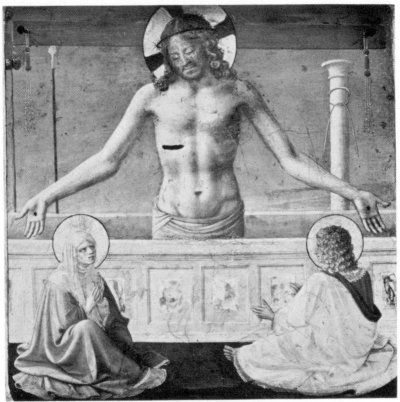

138B. Fra Angelico : Man of Sorrows.
Paris, Louvre.

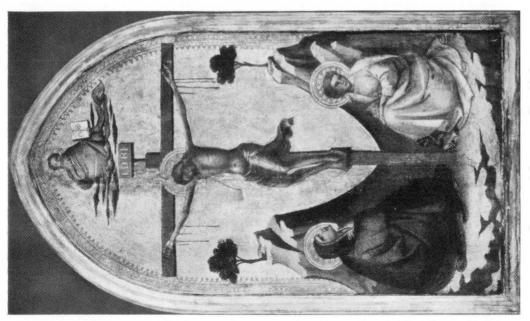

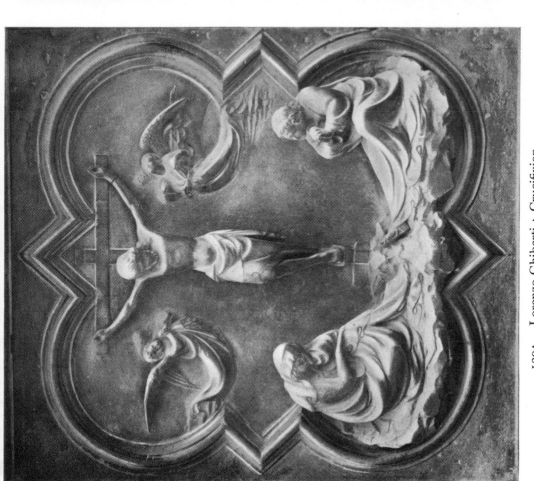

139A. Lorenzo Ghiberti : Crucifixion.
Florence, Baptistry.

139B. Lorenzo Monaco : Crucifixion.
New Haven, Yale University.

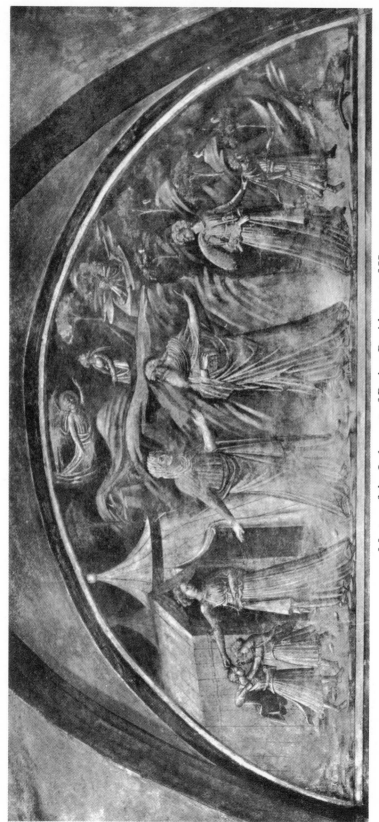

140. Master of the Judgment of Paris : Banishment of Hagar.
Florence, S. Maria Novella.

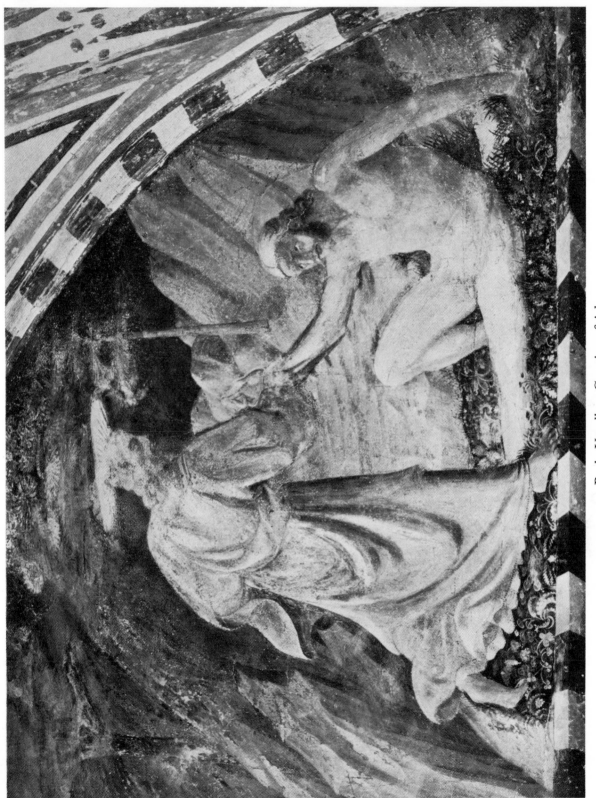

141. Paolo Uccello : Creation of Adam.
Florence, S. Maria Novella.

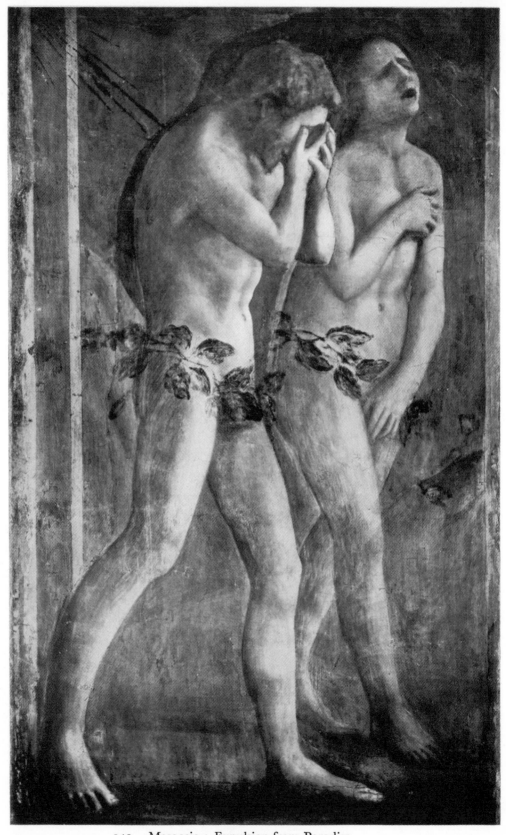

142. Masaccio : Expulsion from Paradise.
Florence, S. Maria del Carmine.

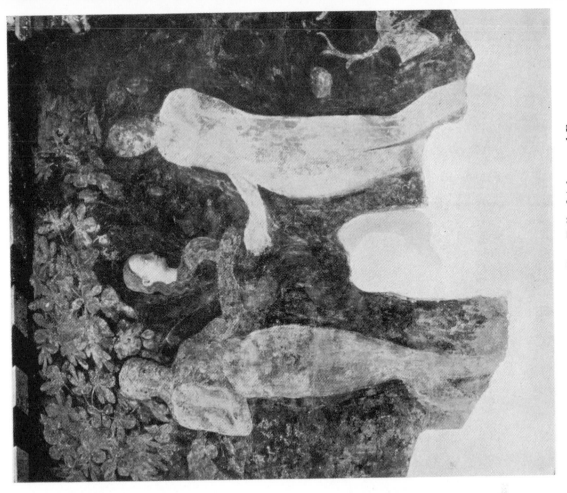

143B. Paolo Uccello : Fall of Adam and Eve.
Florence, S. Maria Novella.

143A. Masolino : Fall of Adam and Eve.
Florence, S. Maria del Carmine.

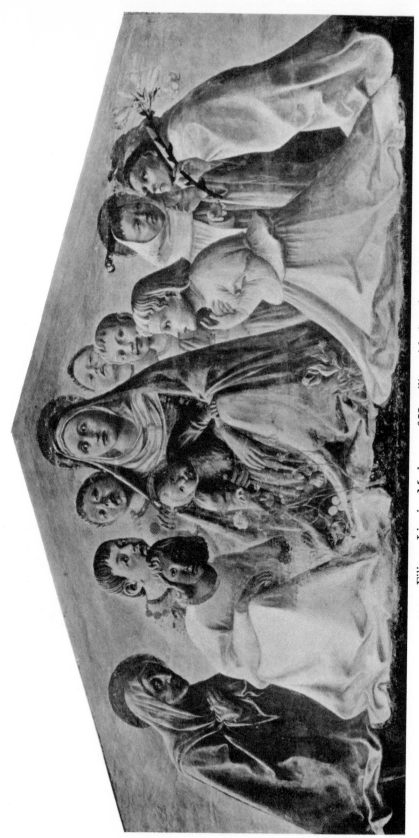

144. Filippo Lippi : Madonna of Humility with Angels and Saints.
Milan, Castello Sforzesco.

145. Florentine *c.* 1428 : Birth Plate.
New York, Historical Society.

146. Spinello Aretino : Foundation of Alexandria by Pope Alexander III.

Siena, Palazzo Pubblico.

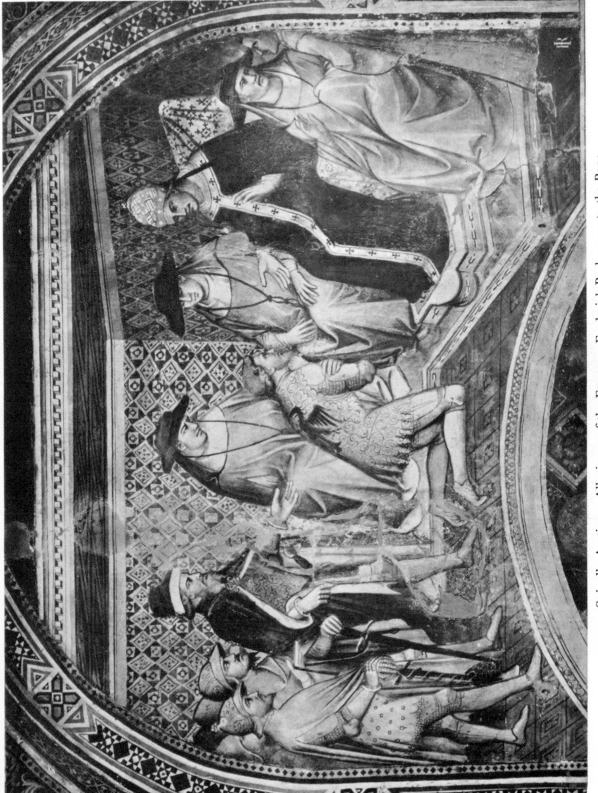

147. Spinello Aretino : Allegiance of the Emperor Frederick Barbarossa to the Pope.
Siena, Palazzo Pubblico.

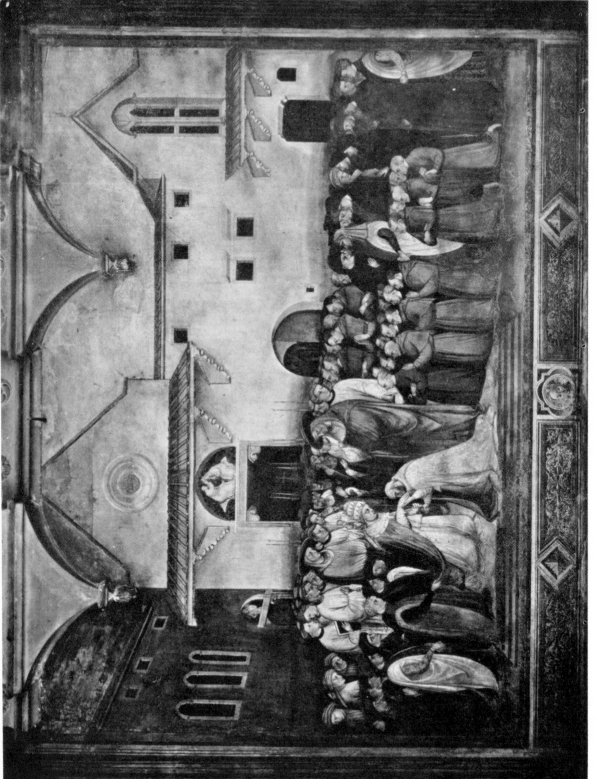

148. Bicci di Lorenzo : Consecration of the Church S. Egidio by Pope Martin V.
Florence, S. Egidio

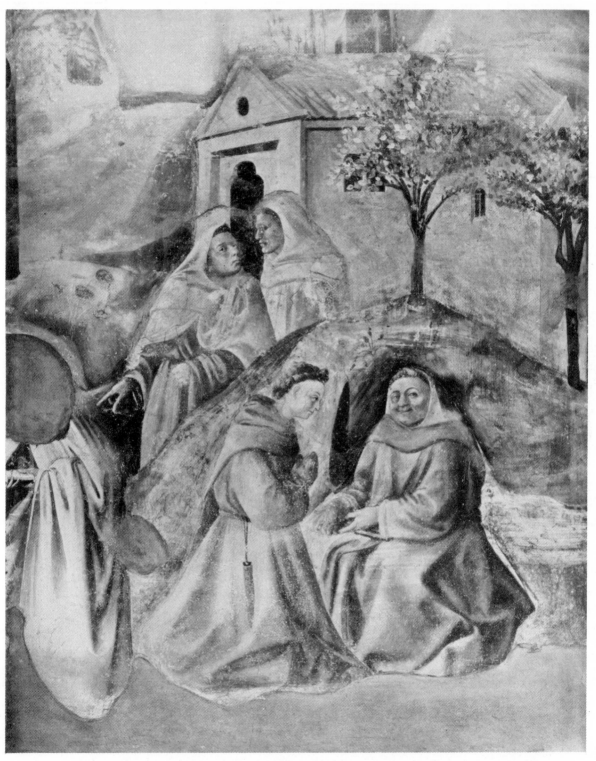

149. Filippo Lippi : Life of the Carmelites under their new Rule. Fragment.
Florence, S. Maria del Carmine.

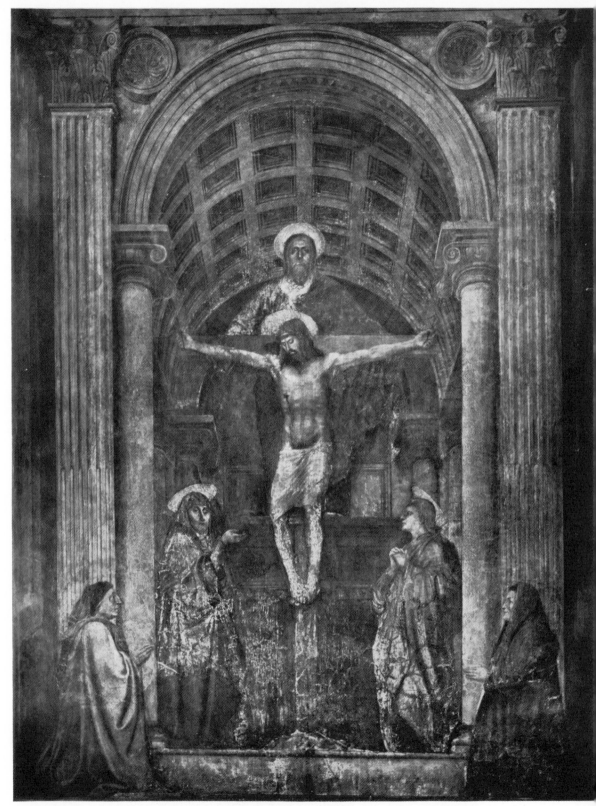

150. Masaccio : Trinity with the Virgin, St. John and Donors.
Florence, S. Maria Novella.

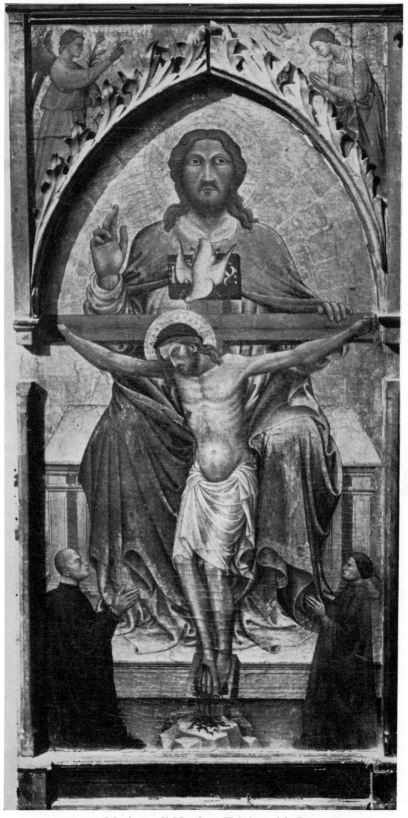

151. Mariotto di Nardo : Trinity with Donors.
Impruneta, Collegiata.

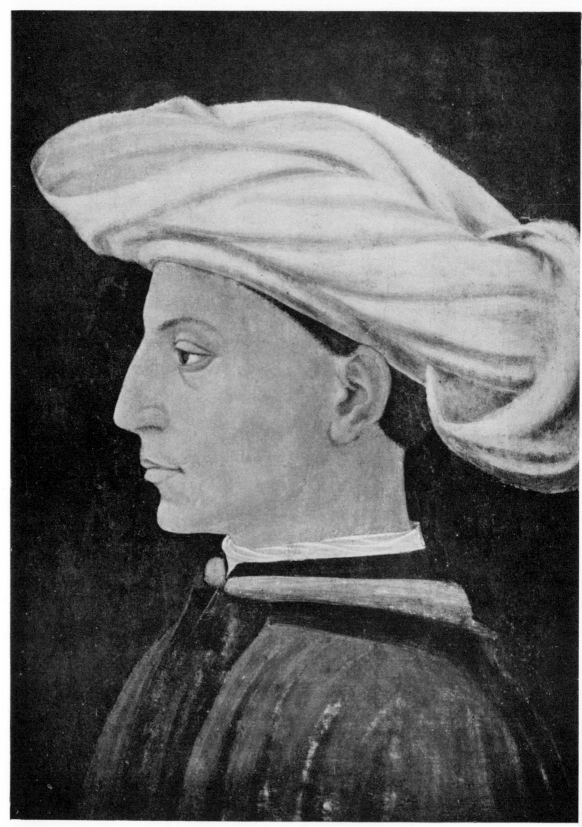

152. Masaccio : Portrait of a Man.
Boston, Gardner Museum.

153. Dominican Illuminator : The Dominican, Petrus de Croce,
encountering the Devil and Serpents.
Buffalo, Albright Art Gallery.

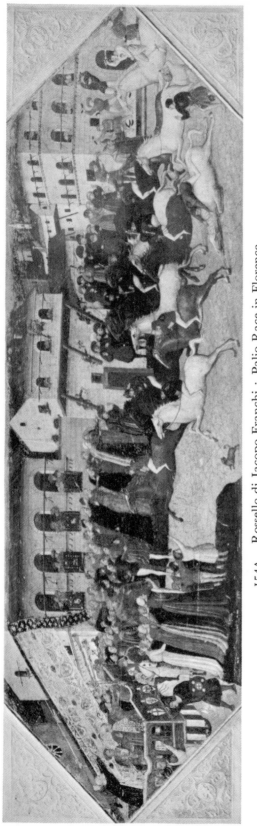

154A. Rossello di Jacopo Franchi : Palio Race in Florence.
Cleveland, Museum.

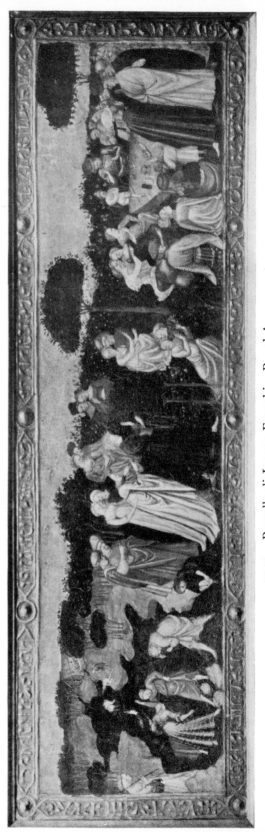

154B. Rossello di Jacopo Franchi : Rural Amusements.

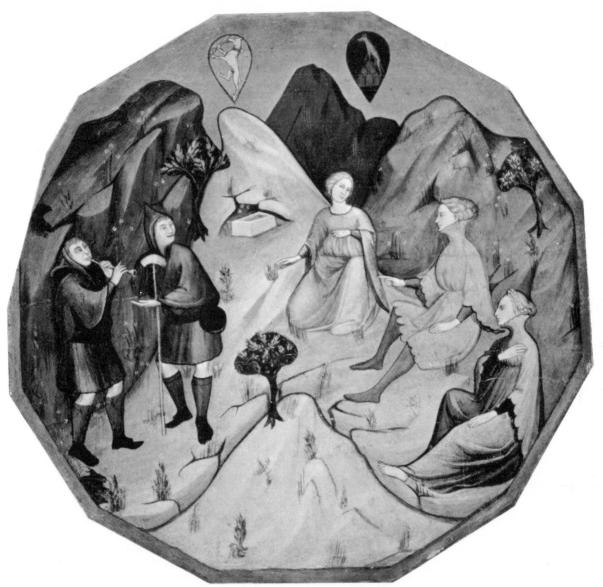

155. Mariotto di Nardo : Bridal Plate.
New York, Metropolitan Museum.

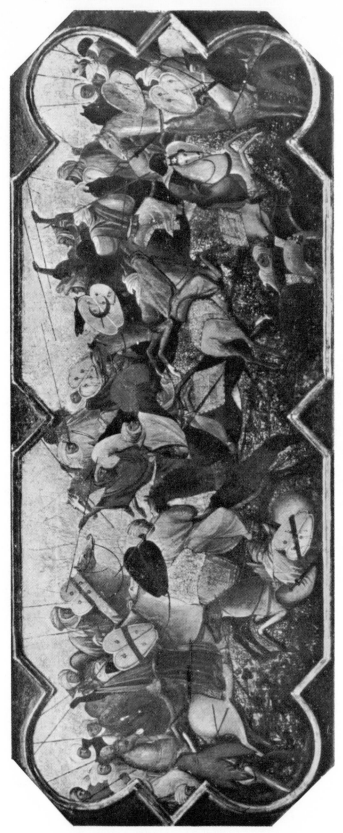

156. Maestro del Bambino Vispo : Battle between Orientals.
Altenburg, Museum.

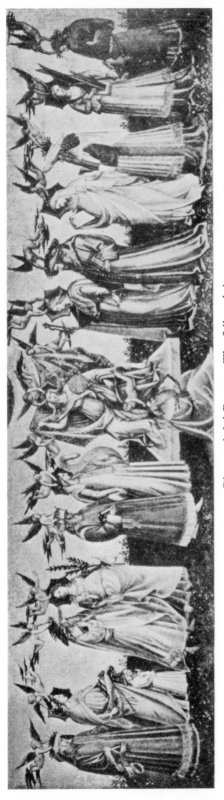

157A. Giovanni dal Ponte : The Liberal Arts.
Madrid, Prado.

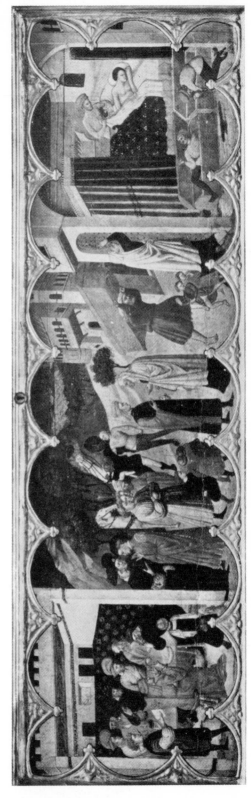

157B. Rossello di Jacopo Franchi : Illustration for Boccaccio's Decameron.
Edinburgh, National Gallery of Scotland.

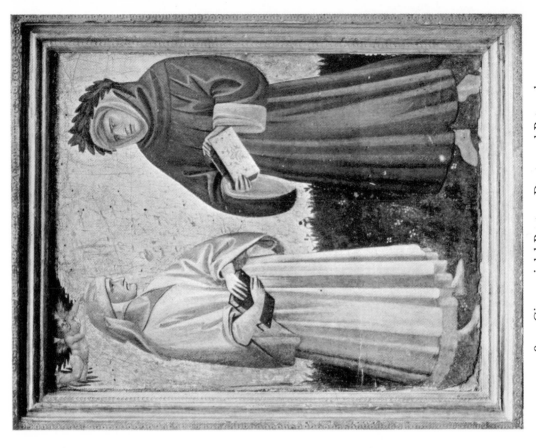

158B. Giovanni dal Ponte : Dante and Petrarch.
Cambridge, U.S.A., Fogg Museum.

158A. Close to Lorenzo Monaco : Monks singing.
Miniature for a Sunday Diurnal.
Florence, Laurenziana.

159B. Florentine c. 1430-40 : Love couples in a Garden.
Previously Vienna, Figdor Collection.

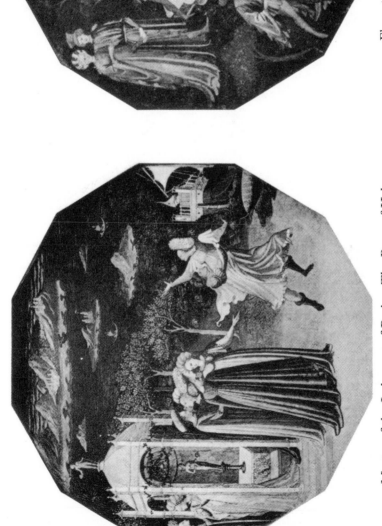

159A. Master of the Judgment of Paris : The Rape of Helen.
Richmond, Cook Collection.

160. Master of the Judgment of Paris : Judgment of Paris.
Florence, Bargello.

Icon Editions

Albarn, K./Language of Pattern $5.95 IN-50
Andrews, W./Architecture in New York $4.95 IN-42
Andrews, W./Architecture in Chicago & Mid-America $4.95 IN-43
Antal, F./Classicism and Romanticism $5.95 IN-18
Ashton, D./A Reading of Modern Art $4.95 IN-5
Avery, C./Florentine Renaissance Sculpture $5.95 IN-38
Blunt, A./Art of William Blake $5.95 IN-45
Breton, A./Surrealism and Painting $7.95 IN-24
Chastel, A./Italian Art $6.95 IN-7
Clark, K./The Gothic Revival $4.95 IN-48
Duvignaud, J./The Sociology of Art $3.95 IN-35
Freedberg, S. J./Painting of the High Renaissance in Rome & Florence
 Vol. I $6.95 IN-13; Vol. II $7.95 IN-14
Gilbert, C./Renaissance Art $4.95 IN-33
Golding, J./Cubism $5.95 IN-8
Haskell, F./Patrons and Painters $5.95 IN-9
Holloway, R. Ross/A View of Greek Art $4.95 IN-46
Honour, H./Chinoiserie $6.95 IN-39
Kouwenhoven, J. A./The Columbia Historical Portrait of New York $7.95 IN-30
Kozloff, M./Cubism/Futurism $4.95 IN-59
Lee, S. E./Chinese Landscape Painting $3.95 IN-10
Lee, S. E./Japanese Decorative Style $3.95 IN-17
Lockspeiser, E./Music and Painting $4.95 IN-40
Leyda, J./Eisenstein: Three Films $4.95 IN-55
Lucio—Meyer, JJ./Visual Aesthetics $7.95 IN-52
Mâle, E./The Gothic Image $4.95 IN-32
Manvell, R./Masterworks of the German Cinema $4.95 IN-47
Mathew, G./Byzantine Aesthetics $2.95 IN-6
Medley, M./Handbook of Chinese Art $3.95 IN-44
Meiss, M./Painting in Florence and Siena $3.95 IN-37
Panofsky, E./Early Netherlandish Painting
 Vol. I $7.95 IN-2; Vol. II $6.95 IN-3
Panofsky, E./Studies in Iconology $4.95 IN-25
Panofsky, E./Renaissance & Renascences in Western Art $4.95 IN-26
Panofsky, E./Idea $4.95 IN-49
Peckham, M./Art and Pornography $3.95 IN-12
Penrose, R./Picasso: His Life and Work $6.95 IN-16
Poggioli, R./The Theory of the Avant-Garde $4.95 IN-1
Richardson, T. and Stangos, N./Concepts of Modern Art $4.95 IN-41
Rosenberg, J./Great Draughtsmen from Pisanello to Picasso $7.95 IN-29
Salvadori, R./101 Buildings to See in London $2.50 IN-20
Salvadori, R./101 Buildings to See in Paris $2.95 IN-31
Stoddard, W. A./Art and Architecture in Medieval France $7.95 IN-22
Stokes, A./The Image in Form $4.95 IN-28
Taylor, J. R./Masterworks of the British Cinema $4.95 IN-60
Weightman, J./Masterworks of the French Cinema $4.95 IN-51
White, J./The Birth and Rebirth of Pictorial Space $4.95 IN-27